NAPOLEON

THE IMPERIAL HOUSEHOLD

EDITED BY

SYLVAIN CORDIER

MONTREAL
MUSEUM OF
FINE ARTS

H
A
Z
A
N

DISTRIBUTED BY YALE UNIVERSITY PRESS, NEW HAVEN AND LONDON

EVROPE

NAPOLEON

THE IMPERIAL HOUSEHOLD

This book is published in conjunction with the exhibition
Napoleon: Art and Court Life in the Imperial Palace
organized and toured by
the Montreal Museum of Fine Arts

with the participation of the Château de Fontainebleau and
the outstanding support of the Mobilier national, Paris

———

UNDER THE DIRECTORSHIP OF
Nathalie Bondil
Director General and Chief Curator
The Montreal Museum of Fine Arts

EXHIBITION CURATOR
Sylvain Cordier
Curator of Early Decorative Arts
The Montreal Museum of Fine Arts

———

CANADA
Montreal

The Montreal Museum of Fine Arts
Michal and Renata Hornstein Pavilion
February 3–May 6, 2018

UNITED STATES
Richmond

Virginia Museum of Fine Arts
June 9–September 3, 2018

Kansas City

Nelson-Atkins Museum of Art
October 19, 2018–March 3, 2019

FRANCE
Fontainebleau

**Musée national du château
de Fontainebleau**
April 5–July 15, 2019

MONTREAL
MUSEUM OF
FINE ARTS

 MONTREAL MUSEUM OF FINE ARTS

 VMFA
VIRGINIA MUSEUM OF FINE ARTS

 The Nelson-Atkins Museum of Art

Château de Fontainebleau

AMERIQUE

ACKNOWLEDGEMENTS

We wish to acknowledge the many people who played a part in making the presentation of this exhibition possible, including:

Atelier David Prot, Atelier Noëlle Jeannette, Isabelle Bedat, Magdalena Berthet, Agnès Blossier, Cadre Exquis, Sophie Caron, Isabelle Chave, Benjamin Couilleaux, Hélène Delalex, Lorraine Dostie, Vincent Dugas, François Filliatrault, Jean-Pierre Galopin, Violaine Garcia, Anne-Marie Geffroy, Hélène Lebedel-Carbonnel, Camille Leprince, Zoé Lessard-Couturier, Hervé Lewandowski, Paul Maréchal, Sophie Mouquin, Laurent Nicols, Marc Poirier, Elodie Remazeilles, François Schubert and Marie Pineau (†), Fernanda Tokunaga, Stefania Tullio Cataldo, Huguette Derouin-Weider, Marc Weider, Louis Weider and Tony West.

We also wish to express our gratitude to the family and friends of Ben Weider, including the Honourable Serge Joyal, P.C., O.C., O.Q, Alexandre de Bothuri Báthory and Élaine Bédard de Bothuri, Roger (†) and Yvonne (†) Prégent, and salute the Fondation Napoléon and its president, M. Victor-André Masséna, prince of Essling, Thierry Lents and Pierre Branda.

And finally, we wish to acknowledge the work of every team at the Montreal Museum of Fine Arts involved with this project, as well as our partners for its tour. We extend to them our heartfelt thanks.

LENDERS

We wish to acknowledge the following people in charge of public and private collections, without whom this exhibition would not have been possible, as well as all those who chose to remain anonymous.

Canada

Montreal

Dufresne-Nincheri Museum
Manon Lapointe, Director General

McGill University, Rare Books and Special Collections
Richard Virr, Head and Curator of Manuscripts
Jennifer Garland, Greg Houston, Anne-Marie Holland

The Montreal Museum of Fine Arts
Nathalie Bondil, Director General and Chief Curator

Ben Weider family
Huguette Derouin-Weider
Marc Weider
Louis Weider

Ottawa

National Gallery of Canada
Marc Mayer, Director
Caroline Coté, Paul Lang, Marie-Claude Rousseau

Toronto

Art Gallery of Ontario
Stephan Jost, Director and CEO
Alison Beckett, Alexandra Suda, Christy Thompson

France

Caen

Musée des Beaux-Arts de Caen
Emmanuelle Delapierre, Directeur
Magali Boubon, Caroline Joubert

Châteauroux

Musée-hôtel Bertrand
Gil Avérous, Mayor of Châteauroux
Michèle Naturel, Directrice
Michelle Trotignon

Compiègne

Musée national du château de Compiègne
Étienne Guibert, Hélène Meyer

Fontainebleau

Château de Fontainebleau
Jean-François Hebert, Président
Christophe Beyeler, Vincent Cochet, Vincent Droguet, Jehanne Lazaj, Sarah Paronetto, Jean Vittet

Montauban

Musée Ingres
Brigitte Barèges, Mayor of Montauban
Florence Viguier, Directrice
Brigitte Alasia

Montpellier

Musée Fabre
Michel Hilaire, Directeur
Magali Robert-Fretay

Nancy

Musée des Beaux-Arts
Charles Villeneuve de Janti, Directeur
Florence Portallégri

Paris

Centre des monument nationaux
Philippe Bélaval, Président
Jean-Marc Boure, Delphine Christophe, Maeva Meplain, Benoît-Henri Papounaud, Jonathan Truillet

Collection Kugel
Alexis Kugel, Directeur Général
Benoît Constensoux, Valérie Sauvestre

Mobilier national
Catherine Ruggeri, Directrice par Intérim
Hervé Barbaret, Former Administrator General
Christiane Naffah-Bayle, Directrice des Collections
Thomas Bohl, Hélène Cavalié, Jean-Jacques Gautier, Marie-Odile Klipfel, Marina Lebaron-Sarasa, Nathalie Machetot, Marie-Amélie Tharaud

Musée de l'Armée
Général Christian Baptiste, Directeur Général
Sylvie LeRay-Burimi, Émilie Prud'hom, Émilie Robbe

Musée des Arts décoratifs
Olivier Gabet, Directeur
Florence Bertin, Agnès Callu, Audrey Gay-Mazuel

Musée Carnavalet
Valérie Guillaume, Directrice
Christiane Dole, Valerie Fours, Maïté Metz

Musée de la Chasse et de la Nature
Claude d'Anthenaise, Directeur
Raphael Abrille, Karen Chastagnol

Musée du Louvre
Jean-Luc Martinez, Président-Directeur
Françoise Gaultier, Cécile Giroire,
Delphine Peschard, Fanny Meurise,
Daniel Roger

Palais Galliera, musée de la Mode
de la Ville de Paris
Olivier Saillard, Directeur
Marie-Ange Bernieri, Alexandra Bosc

Rueil-Malmaison
Musée national des châteaux de
Malmaison et Bois-Préau
Amaury Lefébure, Directeur
Aurélie Caron, Stéphanie Macrez,
Alain Pougetoux, Élodie Vaysse

Sèvres
Cité de la céramique – Sèvres et Limoges
Romane Sarfati, Directeur Général
Coralie Coscino, Christine Germain-
Donnat, Coralie Dusserre, Sandrine Fritz

Versailles
Musée national des châteaux de
Versailles et de Trianon
Catherine Pégard, Président
Laurent Salomé, Directeur
Elisabeth Caude, Jérémie Benoît,
Olivier Delahaye, Frédéric Lacaille,
Marie-Laetitia Lachèvre

Italy

Milan
Duchess Olivia Salviati

Luxembourg

Luxembourg
Collection LUPB-Bruno Ledoux
Georgina Letourmy Bordier

Switzerland

Geneva
Collection Comte et Comtesse
Charles-André Colonna Walewski
Nicolas Monnot

United Kingdom

London
National Gallery
Gabriele Finaldi, Director
Caroline Campbell, Claire Hallinan,
Sarah Hardy

National Portrait Gallery
Nicholas Cullinan, Director
Rosie Broadley, Tarnya Cooper,
David McNeff

United States

Boston
Museum of Fine Arts
Matthew Teitelbaum, Director
Thomas S. Michie, Janet Moore

Charlottesville
Fralin Museum of Art
Matthew McLendon, Director and
Chief Curator
Gerald E. Burke, Assistant Vice President
for Financial Operations, University
of Virginia
Jean Lancaster, Rebecca Schoenthal

Chicago
Art Institute of Chicago
James Rondeau, President and
Eloise W. Martin Director
Camille Grand-Dewyse, Darrell Green,
Gloria Groom, Sarah Guernsey, Leslie
Fitzpatrick, Christopher P. Monkhouse

Hartford
Wadsworth Atheneum Museum of Art
Dr. Thomas J. Loughman, Director
and CEO
Mary Busick, Linda Roth

Houston
Museum of Fine Arts
Gary Tinterow, Director
Maggie Williams Bond

Kansas City
The Nelson-Atkins Museum of Art
Julián Zugazagoitia, Director
Cindy Cart, Stefanie Kae Dlugosz-Acton,
Catherine Futter, Rima Girnius,
Aimee Marcerau DeGalan, Julie Mattsson

Los Angeles
J. Paul Getty Museum
Timothy Potts, Director
Scott Allan, Jennifer Garpner,
Davide Gasparotto, Richard Rand,
Laura Satterfield, Betsy Severance

Los Angeles County Museum of Art
Michael Govan, Director and CEO
Leah Lehmbeck, J. Patrice Marandel,
Nancy Thomas, Cynthia Tovar

Minneapolis
Minneapolis Institute of Art
Kaywin Feldman, Duncan and Nivin
MacMillan Director and President
Jennifer Komar Olivarez, Tanya Morrison,
Ghenete Zelleke

New York
Cooper Hewitt,
Smithsonian Design Museum
Caroline Baumann, Director
Sarah Coffin

Metropolitan Museum of Art
Daniel H. Weiss, President and CEO
Nesta Alexander

Providence
Rhode Island School of Design Museum
John W. Smith, Director
Tara Emsley, Kate Irvin

Stowe
Collection Alexandre de Bothuri Báthory
et Élaine Bédard de Bothuri

Toledo
Toledo Museum of Art
Brian Kennedy, President, Director
and CEO
Lawrence W. Nichols, Elizabeth Spencer

Williamstown
The Clark Art Institute
Olivier Meslay, Felda and Dena
Hardymon Director
Chris Hightower, Mattie Kelley,
Kathleen Morris, Lara Yeager-Crasselt

1, 2
François DUBOIS
After a design by Jacques-Louis
DE LA HAMAYDE DE SAINT-ANGE
Tapestry cartoons for the portieres
in the Gallery of Diana at the Tuileries
The Four Parts of the World
1. *Europe*
2. *America*
1810
Paris, Mobilier national

3
Workshop of Bertel THORVALDSEN
The Apotheosis of Napoleon
About 1830
The Montreal Museum of Fine Arts

4
Andrea APPIANI
*Portrait of Napoleon Bonaparte, First Consul,
in the Uniform of a General in the Army of Italy*
1801
Montreal, private collection

5
Jeanne-Élisabeth CHAUDET-HUSSON
*Portrait of the Princess Laetitia, Daughter
of Caroline and Joachim Murat, Grand Duke
and Duchess of Berg and Clèves,
Holding a Bust of Her Uncle Napoleon*
1806
Château de Fontainebleau, Musée Napoléon I^er
(dépôt du musée national du château de
Versailles)

6
SÈVRES IMPERIAL MANUFACTORY
Movement by Jean-Joseph LEPAUTE
Column clock, given to the princess of Moscow
as a New Year's gift in 1814
Kansas City, The Nelson-Atkins Museum of Art

"WHAT A ROMANCE MY LIFE HAS BEEN . . ."

In memory of Ben Weider

NATHALIE BONDIL, C.M., C.Q.
Director General and Chief Curator, The Montreal Museum of Fine Arts

"What a romance my life has been!" This famous remark made by Napoleon and quoted by the comte Emmanuel de Las Cases, the ever-faithful chamberlain of the Imperial Household, even in exile, is one of the numerous embellishments of his *Mémorial de Sainte-Hélène*, which was to be a handbook of ideological and liberal propaganda to counter the absolutist monarchies of the nineteenth century. But the fake news of the time matters little. This political legacy, the legendary bedrock of reconciliation between the Ancien Régime and the Republic created by the First Empire to restore peace and liberty in Europe would slowly but surely grow as the shadow of the "Corsican ogre" faded into history.[1]

The Napoleonic myth continues to be evoked in the field of politics, from general de Gaulle to the meteoric rise of president Emmanuel Macron. Napoleon, the literary and romantic hero, personifies the providential saviour from social chaos: "A prodigious imagination lay behind this venturesome policy: he would not have been what he was if the muse had not been there; reason carried out the ideas of the poet. Men who are larger than life are always a composite of two natures, for they must be capable of both inspiration and action: the one conceives the project and the other accomplishes it," wrote Chateaubriand.[2] This national, timeless and universal myth of the Promethean man has inspired other empire builders[3] and other peoples . . . as far away as Canada. Napoleon, his life and his fate have been studied in Montreal by two key figures of this exhibition project, two soulmates taken with Napoleonic deeds, the Honourable Serge Joyal and the late Ben Weider.

"One may wonder why the descendants of the French colonists who came to settle in North America before 1760 could have come to identify themselves so lastingly with a figure who at first sight is so foreign to them," remarks Serge Joyal in his exhaustive work on *Le mythe de Napoléon au Canada Français*.[4] The author demonstrates the versatility of the myth and its ability to adapt to different eras: "French Canada is a textbook illustration" of this, notes Thierry Lentz in his foreword. From the implacable enemy to the immortal eagle, the continuity of the legend persists, from French Canada to contemporary Quebec, as the archetype of the man of order and action, the strong, reassuring and charismatic leader who is also the American-style self-made man. Above all, the Napoleonic model, embodying the lost motherland and national pride, became a factor in the social cohesion of French Canadians under British domination.

On his death in 1821, the ogre turned into a martyr: the Napoleonic legend became deeply rooted. "The national feeling," wrote Claude Galarneau,[5] "needed a hero who would serve as a catalyst for the movement of nationalities. How could Quebec have remained indifferent to this myth, Quebec that most needed a hero, that had first lost its motherland in 1763 and then its father thirty years later?" Anthroponymy reveals the popular enthusiasm for Napoleon: baptismal names, names of streets, boats and restaurants, among other things, sometimes with paradoxical associations such as Louis-Napoléon! Scholarly culture also testifies to this "Napoleon mania": the poetry of François-Xavier Garneau and Napoléon Aubin, literature relaying the romantic legend circulated in France by writers such as Balzac, Stendhal and Victor Hugo. The Société française du Canada, founded by French immigrants in 1835, looked back to the Emperor: every year on August 15, it celebrated Saint Napoleon Day (invented under the Empire). Even today, we remember that Quebec's Civil Code originated with Napoleon.

"I was born in Quebec, and that's where my heart is," stated Ben Weider (1923-2008).[6] Born into a Jewish immigrant family from Poland, this visionary businessman founded, along with his brother, a body-building empire.[7] A man of many talents,[8] he was passionately interested in Napoleon Bonaparte, notably because he freed the Jews from their ghettos during the Italian campaign in 1797: "I have always been interested in Napoleon. During my studies and readings here in North America I found him portrayed as a wicked man, a general who wanted to conquer the world. However, during my trips to France and elsewhere I also became aware of his significant achievements in architecture, public works and economic reform. I consider him to have been a man ahead of his time."[9] Founding president of the International Napoleonic Society in 1995, this self-taught historian wrote at least twelve books on the Emperor, many of them claiming that he was poisoned with arsenic. Although this theory has been refuted by Jean Tulard and Thierry Lentz,[10] the international debates sparked by his research have had a real impact on the advancement of Napoleonic studies.

Ben Weider gave us his affection and his collection, with the support of his friend the collector and historian Serge Joyal and that of his family, who are still faithful friends of the Museum. The Montreal Museum of Fine Arts' Ben Weider Collection consists of artistic, iconographic and archival evidence of Napoleon's reign, such as the portrait by the studio of Gérard of the Emperor in its original frame with emblems of the regime, and later works illustrating the infatuation throughout the nineteenth century with the Napoleonic legend, including sculptures by Thorvaldsen, Vela and Gérôme; Victorian images by the painters Potts and Crofts; drawings and prints, among other things. "Living, he lost the world; dead, he possesses it," wrote Chateaubriand. Above all, this donation comprises a collection of historic items directly linked to the Emperor, unique in North America: a silver-gilt milk jug by Biennais that followed him to Saint Helena, a writing case stamped with the name "Napoléon, Empereur et Roi," a cabinet from Malmaison and several pieces of clothing including a rare fur-lined *bicorne* cocked hat, which he wore during the Russian campaign. "Collecting is not simply about ownership. It is important for me to have a feeling for the item, to have a personal relationship with it; this is still the essence of my collection," explained Ben Weider.[11]

This year, the Museum is celebrating the tenth anniversary of its Napoleon gallery as it remembers the late donor, sadly taken too soon, just days before its opening on October 23, 2008. The gallery was reinstalled in 2016 in the new Pavilion for Peace, and has been enriched for a decade thanks to loans from private collections here in Montreal and across the world. We have pursued an active acquisitions policy with our curator of early decorative arts Sylvain Cordier and our president of the decorative arts committee, who is also a great donor, Serge Joyal. We enjoy the generous support of Ben Weider's family—his wife, Huguette, and sons Louis and Marc—and of his friends. Finally, we entrusted to Sylvain Cordier the subject and the curatorship of this exhibition. Taking as his starting point the fascinating study by historian Pierre Branda, *Napoléon et ses hommes. La Maison de l'Empereur (1804-1815)*, his scholarly research has led him over five years to make a number of discoveries both in Europe and in North America. This dialogue between the two sides of the Atlantic on the subject of Napoleon and the remembered splendour of the imperial court is a particular source of delight for the Montreal Museum of Fine Arts.

None of this would have been possible without the first-rate, scholarly and friendly collaboration of all our partners and their teams, among whom I particularly wish to thank Jean-François Hebert, president of the Château de Fontainebleau, and Christiane Naffah-Bayle, director of collections at the Mobilier national. Of equal importance are our American friends, and their teams, Alex Nyerges, director of the Virginia Museum of Fine Arts, and Julián Zugazagoitia, director and CEO of the Nelson-Atkins Museum of Art, pillars of the Franco-American network of FRAME, which brought us together. Thanks to their outstanding support, the exhibition *Napoleon: Art and Court Life in the Imperial Palace* will tour to three leading venues: the Virginia Museum of Fine Arts, Richmond, the Nelson-Atkins Museum of Art, Kansas City, and the Musée national du château de Fontainebleau.

Lastly, we dedicate this book to the memory of a man, Ben Weider, whose endearing powers of persuasion, enthusiasm, contagious passion, honesty and goodness of heart were exemplary, within his own community and abroad.

NAPOLEON: A MODERN-DAY HERO

THE HONOURABLE SERGE JOYAL, P.C., O.C., O.Q.

Napoleon! Why do North Americans find him so fascinating, two hundred years after his exit from the world stage? Why is he still so present, and even at times hated, in the France he was bent on making the shining light of Europe?

There will never be a definitive answer to these questions. What is so extraordinary is the resilience of the little corporal, dressed as a Chasseur de la garde, his favourite uniform, as if to announce that the fight would never end. Even in exile, far removed from the battlefield, he continued to wear this uniform every day, as if to say he had not really given up the fight.

Napoleon is a modern hero: his virtues are those of a larger-than-life figure, a self-made man, who fought his enemies to the very end: "The Guard dies, it does not surrender." Napoleon is as American as the superheroes of the comic strip and contemporary films who face every danger, survive every ordeal, and remain unharmed, without even a bruise. He is the perfect prototype of the popular superhero characterized in films on giant screens with special effects.

The strong feature of the Montreal Museum of Fine Arts exhibition, *Napoleon: Art and Court Life in the Imperial Palace*, is its close study of the inner workings of the machinery put in place by Napoleon to enable the public to see him at all times as a superman.

What we in North America admire especially is that Napoleon came from nothing: like all self-made men, like the powerful and wealthy businessmen of today's America, whose successes prove that everything is possible; like Mark Zuckerberg, who by the age of thirty-three had built a global digital empire, and dreams of becoming the president of the U.S.A.!

It is easy to acknowledge the remarkable genius of Napoleon. He was born in remote Corsica, yet transplanted himself to France, where he had no roots, a place he was to overwhelm through his insatiable ambitions. He quickly imposed his grandiose vision and employed his unparalleled skills to create an empire not seen since the time of Julius Caesar.

Napoleon fully understood the power of images and the influence they exert on the imagination of the populace as they project a magnified, larger-than-life reality, what today is disseminated by means of "selfies"! He was a master of the codes of communication, controlling what he wanted people to think of him and of his imperial authority. To this end, he surrounded himself with counsellors, artists, and event organizers whose responsibility was to stage-manage him and his family in order to establish their political legitimacy, just as our leaders today shine on social media!

In North America as elsewhere, Napoleon is as much a myth as a figure of history. Nonetheless, despite all that is known about him, Napoleon's personal fascination with America is little appreciated. According to those close to him, some days before his Waterloo surrender, he had considered yielding to his American dream, taking with him the legacy of Old Europe's Enlightenment in his baggage.

Without ever having set foot in America, he took to dreaming of the discoveries he could have made with the botanist Monge, a scientist whose writings he often perused. Having an inquisitive spirit, attracted by the unknown, a continent of wide open spaces to be explored freely: he found that such mirages stimulated his imagination. This dream encapsulates the essence of America: a classless society, the bridge between the Old World and the New.

It is the promise of this dream that America offers to everyone! It is a glimpse of the ideal, a horizon open to all possibilities, even if, in fact, for the majority of its inhabitants, reality binds them to the daily contingencies of life.

Ben Weider, the son of a Polish immigrant who had fled famine and hostility to settle in Canada, made this prospect his own, with all the conviction of someone who had to "fight," as his father kept reminding him, "like Napoleon," to get the better of the schoolmates who bullied him in the schoolyard of Saint-Lin, a small village in the Laurentians.

Ben Weider, once settled in Montreal, never lost sight of his childhood's model. He too became a self-made man, who rose from nothing and developed a North American body-building empire with all the symbolism conveyed by the training gear, like an arsenal of weapons, and the impressive outlines of these male and female bodies sculpted like the colossi of antiquity.

Collecting as much as he could find related to Napoleon, Weider always wanted to share his enthusiasm for his "Emperor of fighters" with his brethren: the resilient, the obstinate, the stubborn, those who struggle, and those who never give up, bequeathing the wealth of his collection to the Fine Arts Museum of his city.

For Weider, Napoleon remained a latter-day wonderworker. Whoever became enraptured by Napoleon was uplifted and full of an energy, not unlike feeling invincible, undergoing a shamanic experience. It was this perception of invincibility that aroused the enthusiasm of French Canadians who rubbed shoulders on a daily basis with the Emperor's enemies, proud Albion and Wellington's kin.

How could they thus not take Napoleon as one of their own: to inspire them to resist, to impose their will, to stand up against English domination, to assert their heritage, and above all, to make their language heard, the French spoken by their ancestors who "descended from that noble race . . . [from] that France which, under its Charlemagnes and Napoleons, never yet feared to fight a giant's battle with one or more powers coalesced against her,"[1] and finally, to dream of those larger-than-life characters, those titans, those giants whose worthy descendants they felt themselves to be.

A myth[2] that came true, a near-inexhaustible source of potent energy and militant inspiration, Napoleon is still the eternal leader of an imagination imbued by infinite possibilities and the grandiose vision that seeks to embrace all continents!

CHÂTEAU DE FONTAINEBLEAU

JEAN-FRANÇOIS HEBERT President
VINCENT DROGUET Directeur du patrimoine et des collections

Since the destruction of the palace of Saint-Cloud in 1870 and of the Tuileries in 1871, Fontainebleau has been the royal residence that best reflects Napoleon's deeds and their perpetuation in stone.

This is why the Château de Fontainebleau also contains a museum of Napoleon, which houses a rich collection that focuses on the figure of Napoleon as sovereign, the imperial family, the pageantry of the imperial court and the commissioning of artworks as a demonstration of majesty.

This is also why in recent years the Château has presented many exhibitions devoted to the First Empire. Three of these highlighted the renaissance of this building, which Napoleon, in exile on Saint Helena, brilliantly described as "the real abode of kings, the house of ages." The themes of these exhibitions included, in 2004, the reception of Pius VII by Napoleon at Fontainebleau, in 2016, the Emperor's first chamber at Fontainebleau, and in 2017, the work of Charles Percier, the matchless architect of the imperial palaces.

These palaces, returned to their ceremonial function, were naturally the settings for the imperial family's appearances in lavish court ceremonies, such as the wedding to Marie-Louise, which was the subject of an exhibition in 2010, and the baptism of the King of Rome, featured in another exhibition in 2011.

The fourth dynasty founded by Napoleon was governed by the statutes of the imperial family, known as "the Imperial Household." The family salon at Saint-Cloud was evoked by the elegant standing portraits of the princesses exhibited in *Peintre des rois, roi des peintres. François Gérard portraitiste* in 2014, while the political implications of the family system were examined in the show devoted to Jerome Napoleon, king of Westphalia.

Lastly, the links with European monarchies were broached in 2013 in the context of the *surtout* centrepiece given by Charles IV to Napoleon, and in 2015 by a major exhibition devoted to the strained relationship with Pius VII.

It was clearly inevitable that the project undertaken by the Montreal Museum of Fine Arts—an exhibition devoted to the "Imperial Household"—should lead to Fontainebleau. This ambitious proposition was immediately greeted with enthusiasm, followed by a very close collaboration and generous loans, in a singular atmosphere of mutual understanding and friendship. In addition, the quest to find little-known works was successful and links were made and strengthened with other national institutions, in particular with the Mobilier national, guarantees of a long-term partnership for the restructuring of the Musée Napoléon I, long awaited by the public in France and internationally.

It is also clearly obvious that the "house of ages" should be as overjoyed as it is to welcome the "Imperial Household."

5

**Château
de Fontainebleau**

MOBILIER NATIONAL

CHRISTIANE NAFFAH-BAYLE

Conservateur général du Patrimoine, directrice des collections

"As a general rule, human beings only construct their psychic apparatus by organizing the space and time around them and in which they are caught. Organizing the world around us better is not necessarily the sign of a personality better organized within, but rather of a personality who has understood that the mind only structures itself by structuring the world, starting with what is nearest."

Serge Tisseron, *Comment l'esprit vient aux objets*, 1999

Arranging and organizing the places—the household and its services—from which a man leaves and where he comes home to, to make of this a metaphor, a picture of human power for all to see, a masterpiece: this is a task worthy of an Emperor. It gives shape to his thinking, transforms it into a setting where each person has a place, occupies a space, exercises a function and, consequently, fulfills in his or her own capacity the great destiny of the Empire. The abode is all the more precious because its occupant is so often away on military campaigns between battles and bivouacs.

The Imperial Household, universal and timeless, became the home of the muses within the former properties of the Crown and the recently occupied palaces, the museum in which to use and display furniture and furnishings notable for their beauty, harmony, symbolism, talent and genius. All of these intangible qualities, embodied in materials and technical implementation, required ordinary, basic everyday maintenance and conservation. Those who carried out this work operated outside of time and space, aware that such a simple task, executed correctly, carefully and with humility, carried within it the promise of elegance.

Like the Royal Household, the Imperial Household governed the imperial furniture storehouse called the Garde-Meuble in the period between the Garde-Meuble of the Crown and the Mobilier national of the Republic. The former, established by Henry IV and developed under Louis XIV by Colbert, had no specific site before 1774, when Ange-Jacques Gabriel built a monument alongside the Place Louis XV, today the Place de la Concorde. Two years later, the galleries of the Garde-Meuble opened to the public on the first Tuesdays of the month between Easter and Saint Martin's Day (November 11), heralding the first museum of decorative arts in Paris.

The Revolution did away with the administration of the Garde-Meuble, which was reborn as the Service de l'ameublement under the Directory, the Garde-Meuble of the First Consul's Household, and finally as the imperial Garde-Meuble, with a strict and rigorous operating system unknown during the Ancien Régime. Its staff, basically career soldiers, wore a dragon-green, white and gold uniform testifying to their rank in the hierarchy and including the gilt buttons with the arms of His Majesty, with the stamp "Mobilier Impérial."

Among these officers, Henri Beyle, later known as Stendhal, served as inspector of the Crown book-keeping and buildings for the Mobilier Impérial. Through commissions that increased in number with the many furnishing projects, the imperial Garde-Meuble promoted the work of cabinetmakers and bronze-workers, carpenters, sculptors and gilders, tapestry makers, upholsterers and weavers, playing a major role in the arts, as this exhibition demonstrates.

The imperial Garde-Meuble had no fixed home, but rather occupied available spaces, making use of annexes outside of Paris in imperial chateaux and thus physically manifesting the mobility required of its content. This volatility followed the ups and downs of history until 1937, when the Mobilier national, named thus in 1870, moved into a building designed by Auguste Perret on the site of the Gobelins, celebrating at the same time its fusion with the manufactories of tapestry and carpets, which had also received the support of the Emperor. He "decided that no tapestry would be started without his orders, and that, even when he was on campaign, nothing would be commenced unless he had been consulted."[1]

Today, the Mobilier national, under the Ministère de la Culture, furnishes the important places of the Republic—presidential residences, ministries, embassies, great State institutions—from its collection of 100,000 cultural treasures, including furniture, bronzes (chandeliers, lamps, clocks), carpets, tapestries and their cartoons. Seven restoration workshops for cabinetmaking, chair joinery, bronze chandeliers, furnishing tapestry, decorative tapestry, upholstery and carpets perpetually work on the conservation of this heritage, which is annually added to by new loom-finished weavings from the manufactories and by design prototypes created in the Atelier de Recherche et de Création (ARC).

Its intangible cultural heritage, the traditional techniques of the arts and crafts, is passed on and renewed, and its heritage collections from the seventeenth to the twenty-first century provide deposits and loans to museums, châteaux, historic monuments and scholarly exhibitions. This exhibition is a trans-Atlantic show in which the Mobilier national is proud to participate, all the more because the catalogue will continue to be a reference work for our institution. We wish to express our warmest gratitude to Nathalie Bondil, Director General of the Montreal museum, and to Sylvain Cordier, the exhibition's curator.

Some fifty items from the cultural holdings of the Mobilier national are included here. Some of them are little known or are being shown for the first time, such as the two sets of painted cartoons for Gobelins tapestries commissioned by the Emperor, the covers for seats meant for his Grand Cabinet and the portieres for the Gallery of Diana in the Palais des Tuileries. These showpieces, restored for the exhibition, allow viewers to imagine the look of some of the vanished decor in one of the palaces that particularly attracted the Emperor's attention.

FRAME

French American Museum Exchange

WILLIAM B. BEEKMAN President FRAME America
MARIE-CHRISTINE LABOURDETTE President FRAME France, directrice des musées de France

Napoleon never saw America, and his interest in re-establishing French influence on this continent was of short duration. For example, the sale of Louisiana to Thomas Jefferson in 1803 and the non-interventionism in Lower Canada on behalf of Canadians of French descent seem to denote a merely secondary interest in these two countries on the part of the First Consul and later of the Emperor. However, this attitude cannot be interpreted as a sign of his indifference to North America, a territory that might prove to be of strategic interest to the chessboard of international relations and particularly to the conflict between France and England. Moreover, when he was forced to abdicate in 1815, it was to the United States that he first thought of fleeing, before he was deported to Saint Helena by the English. During his exile, the Household that had helped to forge the monarchical identity of his reign survived on a smaller scale in the middle of the Atlantic Ocean, perpetuating the imperial aura and participating in the construction of the Napoleonic legend.

This myth, carefully forged during the Emperor's lifetime, came down through the centuries and became stamped in the collective imagination, including in America, where several artworks and objects that contributed to the splendour of the Napoleonic regime have been found. It is this remarkable, little-known heritage that the exhibition *Napoleon: Art and Court Life in the Imperial Palace* proposes to put into context. Brought together from the distinguished collections of the national museums of the châteaux of Fontainebleau, Compiègne, Malmaison and

Versailles, together with equally important loans from the Mobilier national, the Musées du Louvre, the Musée de l'Armée and the Musée de la Chasse et de la Nature—most of which are being presented in Canada and the United States for the first time—the rediscovery of the works preserved in North America is a contribution to the ongoing Franco-American cultural dialogue regarding the etiquette and ambiance of the court of the First Empire.

The plan to tour this exhibition arose in the context of FRAME (French American Museum Exchange), an association of cultural co-operation that fosters intellectual exchanges between France, the United States and Canada, which brought together three distinguished institutions—the Montreal Museum of Fine Arts, the Virginia Museum of Fine Arts in Richmond, Virginia, and the Nelson-Atkins Museum of Art in Kansas City, Missouri—to have the show travel. A culmination of the celebrations of the bicentenary of the Napoleonic saga, the North American tour of the exhibition testifies to the dynamic of a network that produces projects of international interest under the umbrella of FRAME. Conceived by Nathalie Bondil, Director General and Chief Curator of the Montreal Museum of Fine Arts, and brought to fruition through the meticulous research of Sylvain Cordier, Curator of Early Decorative Arts at the same museum, *Napoleon: Art and Court Life in the Imperial Palace* is the second exhibition to be mounted under the auspices of FRAME in Montreal, and the network's twenty-third show.

The National Bank is proud to support the Montreal Museum of Fine Arts in presenting the exhibition *Napoleon: Art and Court Life in the Imperial Palace.*

Our institution has always cherished a feeling of pride in our cultural heritage. We believe that art encourages exchanges that enrich society and thus contribute to the development of the community.

Culture tells us a great deal about the world. The exhibition *Napoleon: Art and Court Life in the Imperial Palace* reflects this: an experience characterized by historic moments and artistic discoveries.

May you enjoy your visit.

Louis Vachon

President and Chief Executive Officer, National Bank

AUTHORS

Christophe Beyeler
Conservateur en chef du patrimoine,
chargé du musée Napoléon Iᵉʳ et du cabinet
napoléonien des arts graphiques
Château de Fontainebleau, musée Napoléon Iᵉʳ

Thomas Bohl
Conservateur du patrimoine,
inspecteur des collections
Mobilier national, Paris

Nathalie Bondil
Director General and Chief Curator
The Montreal Museum of Fine Arts

Bernard Chevallier
Conservateur général honoraire du patrimoine
Former Directeur
Musée national du château de Malmaison

Sylvain Cordier
Doctor in Art History
Curator of Early Decorative Arts
The Montreal Museum of Fine Arts

Hélène Delalex
Conservateur du patrimoine,
chargée de la Galerie des Carrosses
Château de Versailles

Virginie Desrante
Conservateur du patrimoine
Ministère de la Culture,
Service des musées de France, Paris

Anne Dion-Tenenbaum
Conservateur général du patrimoine,
département des objets d'art
Musée du Louvre, Paris

Daniela Gallo
Doctor in Art History
Professeur des universités en histoire
de l'art moderne
Université de Lorraine, Nancy

Jean-Jacques Gautier
Inspecteur des collections
Mobilier national, Paris

Audrey Gay-Mazuel
Conservateur du patrimoine,
département XIXᵉ siècle
Musée des Arts décoratifs, Paris

Sylvie Le Ray-Burimi
Conservateur en chef du patrimoine,
chef du département des peintures et sculptures,
du cabinet graphique et photographique et du
centre de documentation
Musée de l'Armée, Paris

Cyril Lécosse
Doctor in Art History
Maître-assistant en histoire de l'art moderne
Université de Lausanne

Chantelle Lepine-Cercone
Doctor in Art History
Art Historian

Sacha Marie Levay
Conservation Technician
The Montreal Museum of Fine Arts

David Mandrella
Doctor in Art History
Art Historian

Michèle Naturel
Director
Musées de Châteauroux

Christian Omodeo
Doctor in Art History
Art Historian

Benoît-Henry Papounaud
Administrateur
Centre des monuments nationaux, Paris

Émilie Robbe
Conservateur du patrimoine,
département moderne
Musée de l'Armée, Paris

Jean-Pierre Samoyault
Conservateur général honoraire du patrimoine
Former Administrateur général
Mobilier national, Paris

Agata Sochon
Conservator, Paintings
The Montreal Museum of Fine Arts

Marie-Amélie Tharaud
Conservateur du patrimoine,
inspecteur des collections
Mobilier national, Paris

Charles-Éloi Vial
Doctor in Art History
Conservateur des bibliothèques,
département des manuscrits
Bibliothèque nationale de France, Paris

Laura Vigo
Doctor in Art History
Curator, Asian Art
The Montreal Museum of Fine Arts

Jean Vittet
Conservateur en chef du patrimoine
Château de Fontainebleau

CATALOGUE

This publication is issued by the
Publishing Department of the Montreal
Museum of Fine Arts in collaboration with
Éditions Hazan, Paris, in conjunction with
the exhibition *Napoleon: Art and Court
Life in the Imperial Palace.*

EDITED BY
Sylvain Cordier
Curator of Early Decorative Arts
The Montreal Museum of Fine Arts

MAIN PUBLISHER
The Montreal Museum of Fine Arts

Publisher
Francine Lavoie
Head, Publishing Department

Publishing Assistant
Sébastien Hart
Publishing Assistant, Publishing Department

Editorial Supervision and Revision
Clara Gabriel
Translator-Reviser, Publishing Department

Translation
Jill Corner, Alexis Diamond

Research Assistant
Chantelle Lepine-Cercone

Documentation
Manon Pagé

Photo research
Anna Ciociola

Technical support
Johanna Mongraw

Copyright
Linda-Anne D'Anjou

Proofreading
Kathleen Putnam
Johanna Mongraw (back matter)

Graphic Design
Paprika, Montreal
Joanne Lefebvre, Louis Gagnon
René Clément

ASSOCIATE PUBLISHER
Éditions Hazan, Paris

Publication Coordinator
Jérôme Gille

Production
Claire Hostalier, Pierre Hamard

Photoengraving
Reproscan, Orio al Serio, Italy

Printing
Graphicom, Vicenza, Italy

© 2018 The Montreal Museum of Fine
Arts / Éditions Hazan, Paris

ISBN The Montreal Museum of Fine
Arts: 978-2-89192-414-6

ISBN Éditions Hazan:
978-0-30023-346-9

Distributed by Yale University Press,
New Haven and London
Library of Congress Control Number:
2017959363

A catalogue record for this book is
available from The British Library

Aussi publié en français sous le titre :
Napoléon. La Maison de l'Empereur

ISBN Musée des beaux-arts de
Montréal: 978-2-89192-413-9

ISBN Éditions Hazan: 978-2-75411-041-9

All rights reserved.
The reproduction of any part of this
book in any form or by any means
without the prior consent of the
publishers is an infringement of the
Copyright Act, chapter C-42, R.S.C.,
1985.

Legal Deposit: 1st quarter 2018
Bibliothèque et Archives nationales
du Québec
National Library of Canada

The Montreal Museum of Fine Arts
www.mbam.qc.ca

Éditions Hazan
www.editions-hazan.fr

Printed and bound in December 2017
by Graphicom, Vicenza, Italy.

Note:
References herein to French sources
of the period in question maintain the
spelling of the time.

Cover: ill. 160

MONTRÉAL
VILLE UNESCO
DE DESIGN

TABLE OF CONTENTS

ART
AND
COURT LIFE
IN THE
IMPERIAL PALACE

———

AN EXHIBITION

SYLVAIN CORDIER

"Everyone from the Court, all the ministers in ceremonial costume, the solemnity of the State apparatus, the glory of which all this display was but an expression, all of it produced a matchless impression of respect and admiration. Brilliance, power and triumph presided there; men may have bowed down like slaves, but man was exalted, and the legacy of the centuries seemed to dissolve in the relishing of a moment. Yet, as I have said, and without altering this perfectly accurate picture, I repeat, that weariness would have set in had interest not stifled it."
Mémoires de Madame de Chastenay, 1771-1815

In describing Napoleon's court in her *Mémoires*, Victorine de Chastenay was ambivalent in her judgement. At a time when France claimed it had put an end to revolution, the reaction of this aristocrat, reared on the principles of the Ancien Régime, betrays her incredulity at finding herself invited to associate with the elites born from the recent upheavals. Also apparent is not only an honest recognition of the spectacular nature of those scenes, but also of their dispiriting dimension. There was little enjoyment there, although people realized that they were witnessing the unique and incredible spectacle of an encounter between the old world and history in the making, between time passing and standing still.

Administering the inner workings of this extravagant and cold court was from 1804 to 1815 the responsibility of a sizeable institution, referred to as the Imperial Household. The mandate of its staff was to shape the framework and etiquette for an imperial regime designed to last and to establish the Bonaparte dynasty at the helm of France. The Household was responsible for the daily lives of the brand-new imperial family and the day-to-day existence of the former republican general turned monarch. It was fundamentally based on the Royal Household of the Ancien Régime, taking on part of its structure and validating for the new Emperor the ideas of a staff of noble courtiers and a hierarchy of servants around him performing the services due to his person. The restoration of a court was by definition a contradiction of the revolutionary principles that, fifteen years earlier, had in theory made the French people equal citizens before the law with equal access to public honours. Without reinstituting the privileges of the nobility, the Household participated in a profound transformation of the French national ideal of 1789. It would, however, be wrong to look strictly at the kings of the past to understand the powers granted to the members of this Household and evaluate the stakes involved in their closeness to the Emperor. The Household installed in 1804 was also the recent inheritor of the embryonic

"consular court" gathered around the general and First Consul after the *coup d'état* of the 18 Brumaire, comprising the family and friends of the Bonaparte couple and the members of his military entourage.[1] This court, in many respects, simply put on new clothes—actually inspired by some republican designs for ephemeral civic costumes[2]—when the Consul put on a crown and gave the Republic a throne.

The exhibition *Napoleon: Art and Court Life in the Imperial Palace* highlights the importance of the social, ideological and artistic role played by this institution. It hinges on recreating the settings and order of Napoleon's power, and defining and depicting the prevailing etiquette within the imperial palace. The mysteries of the monarchical aura are here combined with delightful anecdotes about everyday life at court. The great story unfolds, with its battles, treaties, marriages (as well as a famous divorce), and alliances—all those events that the Household dressed up with the accessories of court life and shaped in accordance with the imperial etiquette.

The Imperial Household consisted of six departments, each headed by a Grand Officer. The Grand Chaplain, the Grand Marshal of the Palace, the Grand Master of Ceremonies, the Grand Chamberlain, the Grand Equerry and the Grand Master of the Hunt were all involved not only in palace life, but also in the political history of the reign. Whether from a military or civil background, almost all of them members of the nobility, they were courtiers, colleagues and also rivals for Napoleon's favour, surrounded by their staffs as well as by the artists and artisans from whom they commissioned numerous works. They had to collaborate in order to participate, each with his own prerogatives, in the smooth running of everyday life at the palace and in the grand official ceremonies. The functioning of this court, the decoration and furnishing of the palaces, the protocols of behaviour and customs, were all dependent on their effective co-operation and whole-hearted involvement.

Europe's Napoleon, America's Napoleon

Missing from the political, social and institutional history of the Household[3] has been an exhibition like this one to illuminate what art history could reveal about the subject. Of course, it was necessary to look for relevant works of art in France, and we are deeply grateful to our partners and lenders, both institutions and private individuals, for their generous demonstrations of support and trust. It is a pleasure to mention first and foremost the Mobilier national and the Château de Fontainebleau. It was also necessary to search elsewhere, and hosting the exhibition in North America provided a splendid opportunity to

9

search in Canada and the United States for the many examples of art reflecting court life and the Imperial Household, which in the course of the nineteenth and twentieth centuries crossed the Atlantic and eventually found their way into a number of museums and private collections. In this respect, the generous help of the FRAME network (the French American Museum Exchange) in establishing contacts with fellow curators and identifying works of interest cannot be overestimated.

The exhibition also casts light on little-known historical links between the Imperial Household and North America. It should be recalled that three of the six Grand Officers of the Household had travelled to the young United States: the future Grand Master of the Hunt and the Grand Master of Ceremonies, Berthier and Ségur, respectively, went to fight in the War of Independence (Berthier was elected to the Society of the Cincinnati), and the future Grand Chamberlain Talleyrand fleeing the Terror, spent the years 1794 to 1796 between Boston and Philadelphia. Moreover, the discovery of a family portrait of the Marescots revealed the Canadian origins of Cécile and Samuel de Marescot, a lady-in-waiting and one of the Emperor's pages between 1805 and 1808.[4]

As a result of the tumultuous history of its institutions and successive revolutions, contemporary France has an ambiguous relationship with the idea of monarchy. In a country where the present constitution states that sovereignty can no longer be exercised by a single individual, the term "monarchical" is often an irrefutable qualifier for condemning the authoritarianism of a political decision or the excessively lavish orchestration of a State ceremony. Paradoxically, the emotional relationship with their national history and the memory of the kings who once ruled the land are still very much present and appeal to the collective imagination of the French: together with Louis XIV, Marie-Antoinette and Francis I, Napoleon is regarded at times as the glorious incarnation of the nation's spirit, and at others as a gravedigger of the democratic impetus. It is a paradox: kings and emperors are no longer wanted, but their memory is honoured, while the historical and heritage aspects of their reigns define part of the national identity to an extent that it would be wrong and pointless to reduce differing political opinions to a simple divide between conservatism and progressivism.

In North America, if the character of the Emperor is found fascinating, it is because he represents not the State or the exercise of power, but the edifying example of an individual who rose from nothing to impose his will on the history of humankind. It is little understood in France—and it is a French historian settled in Canada who writes this—how much the image of Napoleon shaped part of

the identity of the Canadian population, mainly but not exclusively the French speakers. Readers are advised to consult Serge Joyal's work devoted to the *Mythe de Napoléon au Canada français*[5] to grasp the importance of this figure, very different from the image retained by the French and the Italians, who were actually the subjects of Napoleon.

In Canada, several exhibitions held in recent years testify to the public interest: *Napoleon . . . at Île Sainte-Hélène* at the Stewart Museum (1999), situated on the aptly named island facing Montreal, then *Josephine, the Great Love of Napoleon*, also at the Stewart Museum (2003), and more recently *The Treasures of Napoleon* at the Basilica of Notre-Dame (2015) and *Napoleon and Paris* at the Canadian Museum of History in Gatineau, near Ottawa (2016).

Since 2007, under the leadership of Nathalie Bondil, the Montreal Museum of Fine Arts has established a section in its collection, unique in North America, devoted to the Napoleonic period, initiated by the generous donation of the artworks and objects collected by the industrialist and philanthropist Ben Weider and his family. To the choices of this collector—fascinated from childhood by the destiny and personality of Napoleon, and who tirelessly sought out relics of his hero—the Museum has taken an art-historical approach, profiting from the generous assistance of donors, lenders and benefactors to present its vision of the man and his times, and making a number of important acquisitions. These include a pair of spindle vases from Sèvres with decorations of *Fire* and *Water* commissioned by the Household's intendance for Napoleon as king of Italy (**8**), an ice pail from the service "gold marly with grey-painted laurel leaves and cameo-style heads" given by the Household to the king of Württemberg (**229**), and a pair of Dihl et Guérhard biscuits from the collections of marshal Berthier, prince of Neufchâtel and Wagram, vice-constable of the Empire and Grand Master of the Hunt in the Imperial Household. Just recently, the Museum acquired the hitherto unknown sketch for a large painting by Horace Vernet commissioned by the same marshal Berthier towards the end of the Empire and never completed, *Napoleon on the Eve of the Battle of Borodino, Presenting to His Staff Officers the Portrait of the King of Rome Recently Painted by Gérard* (**283**).[6]

Displaying the etiquette

Dreams of princes and crowns exist today. There is an obsession with the spectacle of monarchy and the drama of historical romances in which princes, sovereigns and aristocrats love and tear each other apart in the quiet comfort of their palaces, surrounded by their cohorts of servants, guards and advisers.

From *Downton Abbey* to *The Crown* and *Game of Thrones* to *House of Cards*, our audiovisual culture offers innumerable images of court issues and the relationship between art, ideology, communication and power.

The exhibition curatorship evolved between 2013 and 2017, during a period of intense political activity in the three countries concerned with this project. The federal elections in Canada (2015), the United States (2016) and France (2017) issued *ad libitum* a flood of political images and their share of scripted messaging and propaganda for candidates made, more or less successfully, into desirable heroes of the day. Contemplating the Napoleonic phenomenon while witnessing this media styling by powerful think tanks and skilful communications agencies allowed for an understanding of different aspects of a historical subject like the Imperial Household in the light of a present-day world that could still learn lessons from the past.

For those interested in the stormy years in late eighteenth-century and early nineteenth-century France, the *Étiquette du palais imperial*—issued by the Grand Master of Ceremonies and first published in March 1805 and republished in 1806, 1808 and 1810—makes for delightful reading. We can imagine the frenzied efforts of the new courtiers and the recently appointed Grand Officers of the Imperial Household, delving into historical research, some of them frantically searching their own memories as former courtiers of Louis XVI, asking witnesses about the customs of the court at Versailles or consulting foreign diplomats to find out about the rules in other European courts, with a view to establishing solemn statutory regulations in the service of the recently recreated monarchy.

The text of the *Étiquette* is divided into twelve sections explaining the functions and responsibilities of each one of the members of the Household, distributed according to its different departments. It defines the regulations concerning the arrangement of the places of power within the imperial palace, and distinguishes between the public spaces assigned to the pageantry of court life and the display of pomp (the *Grand appartement*, or the State apartment), the luxurious and elegant living spaces of the imperial family (the so-called section of "honour" inside the "ordinary" private apartments of the Emperor and the Empress), and other off-limit spaces, reserved for the private lives of the sovereigns (in the hidden "interior" apartments within the private apartments). The *Étiquette* also establishes the regulations governing comportment for all courtiers invited to enter the palace precincts, spelling out the conventions of a heavily codified protocol drawn up for the daily routine: the Emperor's levees and couchers, masses, processions, solemn feast days, meals and banquets, balls, swearings-in, travels and bereavement. This wealth of detail gives structure to the sections of the exhibition based on the functions of each of the Grand Officers, presenting the key features of their responsibilities in an overview of court life.

The catalogue presents the Household and its role in orchestrating the life of the court under five complementary themes, illustrated by essays and entries on certain works. The first part depicts the personalities of its staff: the painted portraits of the Grand Officers and descriptions of the responsibilities of each department of the Household. It is followed by "The Household and Its Palaces," an evocation of the places and issues involved in the spaces of court life: it looks at the many residences that Napoleon had at his disposal, and "the palace" as a political and sociological concept, including a definition of the codes of behaviour and spatial layout serving the imperial ideology. The third part presents the role of the Imperial Household as a patron of the arts. By offering commissions to artists and craftsmen, under the Empire the Household acted as the main promoter of the Napoleonic image and designer of the visual principles underpinning the regime's propaganda. The catalogue then devotes a section to the multiple definitions of service at court in the various circumstances of the life of the imperial family, their courtiers and their visitors, within the palace precincts and also outside of them, in the processions, in the hunt and at the theatre. Finally, an epilogue discusses the fate of the Household in the context of Napoleon's two successive exiles. It retraces what became of that institution devoted to the monarchic identity in adversity, first on the island of Elba, where Napoleon was allowed to retain his title of Emperor, retiring from the business of the world, and then on Saint Helena, where, on the contrary, his title was not recognized by his British captors, and he was held prisoner as simply "General Buonaparte."

The approach taken in organizing the exhibition spaces considers the exhibition design as a tool for placing the works in context, in the spirit of repositioning them in a certain courtly manner. Two guiding principles apply in this imagining. The first, in order to give a fair idea of the role of artists in the fashioning of court spaces, shows the importance of projects that were still at the stage of preparatory sketches. It is often forgotten how short-lived the Empire was: it lasted only ten years. Many ideas never came to fruition and remained in the early stages of planning, affecting commissioned paintings, hangings, tapestries and monuments, among other things. Who knows what the Tuileries, Saint-Cloud, Fontainebleau or Versailles would have looked like had Napoleon ruled until the 1820s or 1830s? The reality that the aesthetic and decorative discourse of the Empire, designed mainly by the architects of the imperial palaces, Percier and Fontaine leading the way, remained incomplete should be emphasized, for it is a subject in itself. The second driving force was the desire to highlight the fact that the principal residences of the Napoleonic court—the palaces of the Tuileries and Saint-Cloud—no longer exist: they were swept away in the tumultuous history of the nineteenth century. Now known only from pictures, including fascinating photographs from the Second Empire and the Third Republic showing them in ruins, they play their part in the fantasy world that seemed important to expose to the public. These palaces, only ghostly in the collective imagination ever since, had to be conjured up subtly to ultimately reveal the extent to which summoning the memory of the Napoleonic imperial palace illustrates that no empire lasts forever, no matter the splendour of its decors and the recollection of majesty displayed.

*"The interior of the Household now presents the shape and appearance
of a sovereign's residence. The Emperor is surrounded by civil and military Grand Officers
who take his orders, administer the various departments at his service, and represent
him on his behalf . . . He ordered the creation of a great number of chamberlains, equerries,
ladies of the robes, attendants and others under the orders of the Grand Officers in each
department, both for the Emperor and the Empress. There is talk of a coronation ceremony."*

Pierre-François-Léonard Fontaine, *Journal*, August 13, 1804

THE IMPERIAL HOUSEHOLD

—————

PORTRAITS

FUNCTIONS, CUSTOMS
AND
DESTINIES

SYLVAIN CORDIER AND CHARLES-ÉLOI VIAL

Since the Middle Ages, the French court (*curia regis*) comprised the king's family, entourage and collaborators. Over time, it evolved into a structured entity forming a major part of the machinery of State. In the seventeenth and eighteenth centuries, the "Hôtel du roi," the more tangible departments in the sovereign's household, such as the kitchens, stables, guards and servants, became the "Maison du roi," funded by the "Chambre aux deniers," the chamber of monies placed in charge of administering accounts and payments.[1] The king had to be surrounded by officers and staff who were able to manage and exploit his holdings. As the head sovereign, he had to maintain a lifestyle appropriate to his rank.

This distribution of tasks and functions relating to serving the sovereign effectively sanctified duties entrusted to members of the Royal Household (11). Providing table service, assisting the king at bedtime, preparing the way from one place to another became rites unto themselves. At Versailles under Louis XIV, Louis XV and Louis XVI, the Household structured life at court and set in motion the machinery firmly underpinning the pageantry that was the monarchy. By means of its strict control of customs and codes, the Household was able to set the stage—with the greatest solemnity—for the legitimacy of royal power, in all its emanations, with the palace providing the perfect setting.

Other satellite Households depended on the Royal Household: those of the queen, the dauphin, the children and grandchildren of France, and of the king's sisters and brothers. All the important aristocratic families, starting with the princes by blood, set up their Households modelled after the king's, with servants, vassals and bearers of sinecures all jostled together.

The Royal Household was criticized throughout the eighteenth century for its chaotic management style, profuse staff and archaic administration. When he succeeded to the throne in 1774, Louis XVI tried, for better or for worse, to reform it, but came up against family networks occupying the majority of the prestigious positions that refused to see their fortunes reduced or their hereditary offices eliminated.[2]

From the onset of the Revolution in 1789, when abolishing the monarchy was not yet in question, but rather reaching the goal of making it constitutional, the national government tried to reform the Household without eliminating it altogether. "Monarchist" supporters dominated the debates in the National Assembly until 1790. The Civil List Act was passed, which provided the king with an annual allowance of 25 million francs, in addition to significant goods and properties, starting with the châteaux de Versailles, Rambouillet, Compiègne, Fontainebleau, des Tuileries and Saint-Cloud. Despite the abolishment of the

hereditary offices and the nobility, the simplification of the code of etiquette and the gradual departure of members of the court through emigration, this List permitted Louis XVI, just recently the absolute monarch of *France and Navarre* and now the constitutional king of *the French*, to retain a relatively powerful court, which would disappear along with the monarchy in 1792, in favour of the Republic.

Abandoning the royal customs, none of the heads of state who succeeded him between 1792 and 1799, neither Robespierre nor the Directors, sought to re-establish the notion of a Household. At his assumption of power on 18 Brumaire, Year VIII (November 9, 1799) General Bonaparte had a meagre household with but a few servants supervised by a butler, the *maître d'hôtel*.[3] When the First Consul established his regime in the restored palaces of the deposed monarchy, the memory of the majestic administrative pyramid of the Royal Household no longer occurred to anyone. This would soon change.

First Consul Bonaparte and the restoration of the Household
As soon as Bonaparte was appointed First Consul, his entourage thought of reviving the Household to suit current tastes. It was not, however, a move that came naturally to the new head of state: a tireless worker, who spent days, even entire nights, holed up in his study, Napoleon was not fond of holding receptions or of making fashionable small talk, and even less of the idea of being the star attraction in an ongoing spectacle. In contrast, his wife, Josephine, already a leading lady of Parisian salons during the Directory, a true socialite who enjoyed being in the lap of luxury, understood very well the political gains to be achieved through splendour and "society." It was Josephine who convinced Napoleon that without at least some pomp, he would remain cut off from the ruling elites—political, diplomatic and military—residing in the capital, and also from the period's main spheres of influence, and even from the Parisian people, who had enjoyed the concerts, lights and firework displays held at the Tuileries or the Place de la Concorde towards the end of the Ancien Régime.

The decision to form a new Household was therefore a strategic one. It also reflects the profound ambiguity of the Consulate regime, at once republican and authoritarian, placing one citizen above all others to preside over the destiny of the country and "finish" the Revolution (12).

Living in a modest apartment at Petit-Luxembourg, an outbuilding of Paris' sumptuous Palais de Luxembourg, since 18 Brumaire, Napoleon and Josephine moved to the Palais des Tuileries in February 1800. This decision was not insignificant. A gigantic château built at one end of the Louvre between the

11

sixteenth and eighteenth centuries, the Tuileries had been, since Louis XIV, the kings' residence in Paris, the Versailles equivalent in the French capital. Its very location conveyed the young general's metamorphosis into the head of state. Named the First Consul's Household, it slowly implemented a palace administration with a governor, prefects and aides-de-camp for Bonaparte, ladies-in-waiting for Josephine, butlers, staff for the kitchen and office, the stables and the hunt. In early 1804, 176 servants entered into service at the Tuileries. The surge of personnel did not go unnoticed: at the time, a segment of the liberal opposition reproached the First Consul for abandoning with too great ostentation the simple values associated with the republican ideal, and accused him of thinking of himself as a successor to the kings rather than as a defender of the rights of the nation.[4]

The Consulate Household soon proved its worth. Its administration was above reproach, in stark contrast with that of the Ancien Régime. As of 1800, official trips, dinners, concerts and audiences with diplomats and foreign dignitaries took place at the Tuileries as well as at Malmaison, the Bonapartes' country residence. In 1802, Napoleon took possession of the newly restored and refurnished Château de Saint-Cloud as their secondary residence. This was the moment when, although personally indifferent to religion, he regularly and publically attended mass each Sunday, as had been customary at Versailles.[5]

A Household for the new Empire
The Empire was announced on May 18, 1804. From May to July, the Consulate court remained unchanged, the time needed to establish the court's principles of etiquette and structure. The Household that emerged from these few weeks of reflection was unique, at once set in tradition and profoundly new. Until 1814, this Household would serve as a "protective *bubble*"[6] intended to keep the Emperor from everyday troubles, all the while ensuring court operations, in terms of both grand ceremonies and daily life. Slowly, Napoleon grew to enjoy the pomp, becoming accustomed to his new role as monarch and to the stagecraft engineered around him.

When he ascended the throne, the new Emperor restored the Civil List, which had first been set for Louis XVI by the National Convention in 1790. His court renewed the Ancien Régime's seasonal customs of regularly moving between Fontainebleau, Rambouillet, Compiègne and Saint-Cloud. These châteaux, which had essentially been abandoned for fifteen years, were restored in just a few years: the *Grands appartements*—the State apartments reserved for setting the stage of power during grand ceremonies—were refurbished, as well as the

so-called "ordinary" apartments—the private living spaces for the Emperor and Empress—and living quarters for the courtiers and servants. Napoleon could thus receive and house between twenty and fifty guests in his residences.[7]

The circle of the Civil Grand Officers of the Crown
The traditions of Versailles were not all restored, as Napoleon did not wish to make his Household a carbon copy of Louis XVI's. Instead, he devised new positions.

For administrative oversight, he instituted a Household intendance led by an Intendant-General, a post filled first by the incompetent Charles-Pierre Claret de Fleurieu (1804–5), then the loyal Pierre-Antoine-Noël Daru (1805–1811), and lastly Jean-Baptiste de Nompère de Champagny, duc de Bassano (1811–14), a former minister. This office oversaw the *premier peintre* (the "first painter" Jacques-Louis David), the palace architects (notably the Paris team of Pierre-François-Léonard Fontaine and Charles Percier), the administration of palace furnishings, the court physicians and surgeons, and the Emperor's notary. A treasurer-general, Martin-Roch-Xavier Estève, managed the finances from 1804 to 1811, when he was replaced by François-Marie-Pierre de La Bouillerie.

In contrast with the notoriously onerous Royal Household, that of the Empire was rigidly organized, with office operations modelled on those of the ministries. Its members were more civil servants than courtiers. The institution was divided into six departments in charge of particular offices, organized hierarchically. Each department was placed under the direction of a Civil Grand Officer.[8] Their responsibilities were described in great detail in a foundational text, the *Étiquette du palais impérial*. They pledged an oath to the Emperor and ranked among the upper echelons of the hierarchy of honours within the palace. They were supported by officers, adjuncts and assistants of various ranks.

First among them was the Grand Chaplain, a role entrusted to cardinal Joseph Fesch, half-brother to Napoleon's mother, with a suspension in 1809-10 due to political disagreements. Fesch was the religious head of the court and, assisted by his Grand Vicar, his almoners and chaplains, administered the blessed sacraments to the imperial family.

The Grand Marshal of the Palace—the general Jean-Géraud Duroc from 1804 to his death in 1812, followed by Henri-Gatien Bertrand—oversaw a considerable office that ensured the refurbishment, furnishing and decoration of the palaces, as well as the provisioning, preparation and serving of the meals, in addition to the police, security and imperial bodyguard. To accomplish all this, he supervised the governors, prefects and servants of the palace. This office, the most important

10
Jacques-Louis DAVID
The Crowning of the Empress Josephine, also
called *The Coronation of Napoleon* (detail)
1806–7
Paris, Musée du Louvre

11
ANONYMOUS, FRANCE
The King's Levee
Published in the *Album du sacre de Louis XVI*
About 1774
Paris, Musée du Louvre

12
François-Pascal-Simon GÉRARD
*The Signing of the Treaty between France
and the Holy See, July 15, 1801*
1801
Musée national des châteaux de Versailles
et de Trianon

13
Pierre MARTINET
*The Prince of Neufchâtel, Ambassador
Extraordinary, Asking for the Hand of the
Archduchess Marie-Louise on Behalf
of the Emperor Napoleon in the Throne
Room of the Hofburg in Vienna,
March 8, 1810*
1811
Château de Fontainebleau, Musée
Napoléon I^{er}

12

13

15

14
Innocent-Louis GOUBAUD
Napoleon Receiving the Delegation from
the Roman Senate in the Throne Room at
the Tuileries
1810
Musée national des châteaux de Versailles
et de Trianon

15
Jean-Baptiste ISABEY
Napoleon Presenting the Newborn King
of Rome to the Empress Marie-Louise in Her
Bedchamber at the Tuileries
1811
Private collection

16
Alexandre MENJAUD
Napoleon Holding the King of Rome in the
Presence of Marie-Louise, the Comtesse de
Montesquiou, Governess of the Children of
France, the Nanny and a Palace Prefect
1812
Château de Fontainebleau, Musée
Napoléon Ier (dépôt du musée national du
château de Versailles)

16

17

of the six in terms of the scale of responsibilities, was also certainly the one that most reveals the military character of life at court as envisioned by Napoleon. It was a creation inspired by the customs of the Germanic Holy Roman Empire and the Prussian court.[9] The appointment combined two distinct functions in the former Royal Household: the Grand Master of France for the department of the Table (the *service de la Bouche*) and the provost of the king's residence for security.[10] The Grand Marshal followed Napoleon on all of his travels; his mission was to satisfy every need—even when setting up camp outdoors—ensuring proper work conditions and uninterrupted comfort, with the same domestic personnel. The Emperor could therefore continue to deal with affairs of state, even dedicating himself to his representational duties in every possible permutation, as attested to by the renovation projects of the small Château de Querqueville undertaken following Napoleon's trip to Normandy in May 1811 (**57**).[11]

Grand Marshal Bertrand would be the only Grand Officer to accompany Napoleon in exile to the isle of Elba and then to Saint Helena, maintaining his office, and by extension the continuity of the Imperial Household, until the death of his master in 1821.

The Grand Master of Ceremonies was Louis-Philippe de Ségur. Assisted by the masters of Ceremonies, assistants of Ceremonies, as well as a *dessinateur*, the artist Jean-Baptiste Isabey, and a tutor, he was in charge of the conception and staging of every ceremony for any and all possible courtly situations, as well as supervising the heralds at arms who led the official processions. In this capacity, his department had to tackle complex historical research to come up with coherent rules of etiquette inspired by the customs at Versailles and Europe's various imperial traditions, particularly the various courts of the House of Austria and the Holy Roman Empire. The Grand Master of Ceremonies also prescribed the style and hierarchy of the court costumes of the guests invited in the name of the Emperor, and specified what was appropriate to wear in each and every situation.

The post of Grand Chamberlain, the head of the Chambers, was occupied by Charles-Maurice de Talleyrand from 1804 to 1809, and subsequently by the comte Élisabeth-Pierre de Montesquiou-Fezensac from 1809 to 1814. The department oversaw the arrangements for audiences and all palace comings and goings, as well as the smooth running of the Emperor's personal day-to-day activities, ranging from the management of his wardrobe to his private study and his library. Here again, the position entailed functions that prior to the Revolution had been divided between the Grand Chamberlain and the Grand Master of the Wardrobe.[12] Under his command were the First Chamberlain

and the master of the wardrobe, and an ever-growing crowd of chamberlains, in charge of the entrances to the various palace apartments, who in turn managed the ushers and valets of the bedchamber, in conjunction with the departments of the Grand Marshal of the Palace. This department also included the Emperor's librarian, as well as the artist, the very same Isabey already in the employ of the department of Ceremonies. The Chambers department was also responsible for implementing the policy concerning gifts given by the imperial couple for a range of occasions.

Grand Equerry Armand de Caulaincourt was head of the imperial stables, in other words, the extensive travel department—horses, carriages, messengers—as well as the Emperor's personal war arsenal. Assisted by the corps of equerries, he also oversaw the page services. These young boys, recruited from the age of fourteen to sixteen from good, noble or notable families, remained in service until they turned eighteen and joined the army with the rank of non-commissioned officer (**316**). These junior officers guarded the sovereign and his family during ceremonies, were often employed as messengers, reloaded the Emperor's rifles during the hunt, held the torches to light his way and followed him on horseback into battle.[13]

Last but not least, marshal Alexandre Berthier was Grand Master of the Hunt. He was in charge of all that concerned hunting with hounds or shooting in the Crown woods and forests, as well as the Emperor's hunting weapons. He also joined the Emperor on the hunt, always taking the lead. A captain of the hunt commanding the venery assisted him, as did the lieutenants of the hunt and the firearm bearer, who kept and maintained the weapons and the pack of hounds descended from those of Louis XVI. His department helped Napoleon to reinstate the tradition of the royal hunt: usually twice a week, he went hunting with hounds or shooting in the forests of Compiègne, Versailles or Fontainebleau.

The palm tree was chosen as the symbol ornamenting the Household officers' uniforms. Although there are a dearth of sources to explain this choice, it is likely related to the Emperor's remembrance of Egypt. In 1804, the embroiderer Picot included the palm tree symbol in the embroidery of the various civil uniforms (**26**). The motif can also be found on the base of the large Sèvres *guéridon* table of the imperial palaces. Providing fruit and shelter in the desert, this oasis tree presents a subtle and exotic reminder of the duties of the nutritive and domestic institution.

Through the years, the composition of the new imperial nobility lent prestige to the posts in service to Napoleon, as is evidenced in the *Almanach imperial*,

LE DUC DE FRIOUL.

LE DUC DE VICENCE.

23

published once a year. From 1808-9, the surnames of the Grand Officers disappeared in favour of the recently bestowed titles: "His eminence, Cardinal Fesch, and their excellencies, Messieurs Talleyrand, Duroc, Caulaincourt, Berthier and Ségur" were thereafter, respectively, the prince of France, prince of Benevento, duc de Friuli, duc de Vicenza, prince de Neufchâtel and comte of the Empire, and three of them—Fesch, Talleyrand and Berthier—were inclined to use the predicate of Serene Highness. To a certain extent, the "imperial revolution" seemed complete.

At the top of the hierarchy of honours, the Household coexisted and collaborated with other bodies. The "grand dignities of the Empire" were conferred on princes of the imperial family and on two former consuls (Grand Elector, constable, arch-chancellors of the Empire and the State, arch-treasurer and grand admiral), as well as the ministers and the other Grand Officers, like the marshals, inspectors and colonel-generals. In the upper echelons of an imperial State, where honours often accumulate, some of the Civil Grand Officers could also enjoy other prestigious positions. Cardinal Fesch was also the archbishop of Lyon, the Gallican primate, since 1802. Talleyrand was foreign secretary from 1799 to 1807, and Berthier minister of war for the same years as well as vice-constable; both also held other positions as sovereigns of the small principalities Neufchâtel and Benevento. Moreover, the Household served a diplomatic function: his position as Grand Chaplain also meant that cardinal Fesch served as ambassador to the Holy See. As for Grand Equerry Caulaincourt, he was sent as an ambassador to the Russian court between 1807 and 1811, which in fact distanced him from his Household responsibilities. Berthier went to Vienna in 1810 to request the hand of the archduchess Marie-Louise (13) on the Emperor's behalf. Duroc also carried out several diplomatic missions.

Often called away by their other civil or military functions, or by diplomatic missions, the Grand Officers could always count on the First Officers of the Crown, skilled at standing in for them with the Emperor: in Caulaincourt's absence, the First Equerry, the comte de Nansouty, would take over the running of the Grand Stables, while the First Chamberlain, the comte de Rémusat, also in charge of the court theatre, would replace Talleyrand, who was occupied with his ministerial responsibilities and too busy to sign for invoices or supervise the Household underlings. During Fesch's ambassadorial missions, his trips to Lyon and his period of disgrace, the First Chaplain Charrier de La Roche, bishop of Versailles, presided over the spiritual life of the Tuileries. The presence of these First Officers in the Imperial Household showed the proliferation of these prestigious positions around the imperial throne. They were held by men of character chosen by Napoleon for their administrative competence as much as for their ability to represent the new regime.

The profile of an Officer

The Household quickly began operating like a laboratory, creating a fusion between the old and the new society. A number of nobles from the Ancien Régime gravitated towards the new imperial family. Fleurieu, the first Intendant-General (1804-5), had even been minister of the navy for Louis XVI and governor to the dauphin just months before the fall of the monarchy. Soldiers of the Revolution, still unaccustomed to the refined life at court, rubbed shoulders in the same salons with the old aristocracy that had rallied around the Empire, and for whom etiquette was second nature. Starting in 1808, with the establishment of the imperial nobility, all of the above found themselves on an equal footing. Distributing among titled families the posts of chamberlain, prefect, equerry or page, the Household became instrumental in the Napoleonic regime's quest for legitimacy in the eyes of the national elites.

After Napoleon's marriage to Marie-Louise in 1810, the number of survivors from the court at Versailles invited to become chamberlains or ladies-in-waiting increased. By marrying a Habsburg princess, the Emperor joined one of Europe's oldest families, by which he hoped to win over the old nobility. The subsequent appointments certainly reflected this aim, both in terms of numbers and in the individuals receiving appointments. The list of chamberlains cited in the *Almanach impérial* included seven names in 1805. The following year, the number rose to fourteen, sixteen in 1807, and nineteen in 1808 and 1809. Everything changed in 1810, when the numbers jumped to fifty-nine, then to eighty-three in 1811, and ninety in 1812! The Household thus appeared to be a device to unite the great names of the past. Choiseul-Praslin, Turenne (22), Noailles, Beauvau, Gramont, Gontault, Montalembert, Croÿ, Louvois: the sons and nephews of Louis XVI's courtiers arrived one after the other at the Tuileries. There were thus two courts under Napoleon. The first was post-Revolutionary; in the regime's early years, the Josephine era, it was committed to establishing the elites born in the upheavals after 1789. The second, heralded by Marie-Louise's arrival, restored ties with a certain nobiliary magnetism.

An etiquette worthy of history painting: Depictions of the Imperial Household
The place of the Household's Grand Officers and officers in the regime's highly controlled and codified iconography bears closer examination. Although the

23
Benjamin Zix
*Wedding Procession of Napoleon and
Marie-Louise of Austria in the Grande Galerie
at the Louvre*
1810
Paris, Musée du Louvre

Étiquette provides information on the functions of each post, certain paintings and drawings provide a more complete picture in understanding the weight of the institution within the court apparatus.

In the early days of Napoleon's reign, the administration planned several portrait cycles to decorate the galleries and Grand Salons of the French palaces. The group of the marshals, intended for the Tuileries, was the first, followed by one of the ministers. Starting in 1806, the Grand Officers of the Household also merited their own portraits, full-length and in full court dress, in a gallery of the Château de Fontainebleau.[14] The project is a perfect illustration of the powerful aura invested in these courtly posts in the construction of a legitimacy that, far from being based solely on Napoleonic exploits, turned the court walls into a mirror of its very existence. Although a gallery of portraits of the Royal Household was unimaginable under Louis XVI at Versailles, it is evident that in the Emperor's mind, "his" men were expected to contribute to an ideological imagery.

Meynier executed the portrait of cardinal Fesch (1806), Prud'hon that of Talleyrand (1807), and following the latter's dismissal, Robert Lefèvre painted the new Grand Chamberlain, Montesquiou (1810). Caulaincourt was represented by Bonnemaison (1806), Berthier by Pajou (1808), and Ségur by Mme Benoist (1806–7). Gros was entrusted with the portrait of Duroc (1807–8), as well as that of the former Intendant-General Daru, who had recently been promoted to secretary of state (1813). It is worth noting that these last two portraits were produced in two versions: one for the imperial collections, destined for the picture gallery, the other for the private residences of their subjects.

Even though works were produced throughout Napoleon's reign, this project for Fontainebleau involving the head officials of the Imperial Household would eventually be cancelled. In fact, the completed portraits of the Grand Officers and those of the ministers were briefly brought together at the Tuileries, but then, as of 1808, were moved to Compiègne, where it was necessary to oversee an especially spectacular interior design in order to receive and house the Spanish royal family in French custody.

The biannual exhibition of contemporary painting at the Louvre, the celebrated Salon, was crucial, as it was an occasion to present the imperial State's major artistic commissions, which were supervised by the intendance of the Imperial Household. For this reason, it was the perfect place to deploy the regime's visual propaganda and to control the images that the public was to associate with the Empire (**17, 18**). The Salon afforded an opportunity to display the presence and role of the Imperial Household. In this context, the

significance of the Grand Officers and the officers featured among the immense crowd of dignitaries depicted in David's famous *Crowning of Josephine*, also called *Le sacre* [*The Coronation*] (1806–7, Salon of 1808), a reconstituted scene of the ceremony at Notre-Dame in December 1804 (**7**), merits consideration. Although the foreground is filled with the imperial family, the back rows are dominated by the figure of Duroc, Grand Marshal of the Palace, clad in an amaranth red uniform and holding the Grand Officer's staff in his right hand. Around him are some fifteen chamberlains of the Emperor's, and the Households of the Empress and the Princes.[15] Although David did not paint a master or assistant master of ceremonies, nor a palace prefect or equerry, he did feature, next to a group of marshals, Grand Master of Ceremonies Ségur, also identified by his staff. The other four Grand Officers stand on the left side of the altar proper: Grand Chaplain Fesch dressed in his cardinal vestments; behind him, Grand Equerry Caulaincourt; to their left, Grand Chamberlain Talleyrand and Grand Master of the Hunt Berthier, the latter holding the regalia orb. Berthier is notably dressed for the coronation in the full dress of the Grand Master of the Hunt, and not in that of the marshal or minister of war, the dignity and office he also held. An anecdotal detail should be underscored: amid a who's who of particularly serious and contemplative faces, David places a smile on the lips of two Grand Officers, Ségur and Talleyrand. Two survivors of the Ancien Régime familiar with the court of Versailles, the Grand Master of Ceremonies and Grand Chamberlain must have looked upon the coronation of the Bonapartes with some irony. They could also and above all feel perfectly at ease on this day in December 1804. They were at home in the cathedral, having organized the entire ceremony down to the smallest detail. These smiles may have been from the satisfaction of a job well done.

Shown at the Salon of 1810, *Napoleon Receiving the Delegation from the Roman Senate in the Throne Room at the Tuileries* (**14**), by Innocent-Louis Goubaud, invites a rereading of the *Étiquette du palais imperial*, which states that this type of ceremony was considered by protocol to be a "simple presentation."[16] These ceremonies took place on Thursdays and Sundays in the context of a levee, which was "the moment when H. M. leaves his interior apartment for his apartment of honour."[17] Specifically in the case of this painting, the Roman senators came to pay homage on Thursday, November 16, 1809.[18] Custom dictated that a minister present the delegation, but Jerome, king of Westphalia, dressed as a French prince, on the throne's steps, does this. This is the custom described for use in the case of "ceremonies during which His Majesty is on the Throne," which applies here: "If a Prince of the imperial family or a Prince

24

25

of the Empire has some introductions to make, he should advance towards the Grand Master, to the right and in front of the Throne, and two paces closer to the last step than the Grand Master of Ceremonies."[19]

Ségur, Grand Master of Ceremonies, can be seen at the foot of the steps, holding his staff. It is clear that the artist borrowed the exact same pose from the portrait painted by Mme Benoist for the Gallery of Grand Officers. Behind Ségur stands Grand Chamberlain Montesquiou, also recognized by his staff. Behind Montesquiou is the bust of a chamberlain. Grand Chaplain Fesch, dressed in his cardinal's robes, stands on the other side of the throne. At the far right of the picture, behind the group of Roman senators, stands Grand Marshal of the Palace Duroc.

The iconography of the Household also affected the decorative arts, particularly those produced by Sèvres, which undertook between 1808 and 1810 the execution of the famous Austerlitz table, whose tabletop decoration includes the main dignitaries of the Grand Armée involved in the victory of December 2, 1805. It is interesting to note that Duroc and Caulaincourt, depicted among the marshals, are not presented in their military capacity, but rather in their civil uniforms as Grand Marshal of the Palace and Grand Equerry (**19, 20**). The manufactory also directed its resources to the production of three large-scale vases on the theme of the wedding of 1810. Only one of the three was ever completed.[20] The second, started by the important figurist Legay, captured in a long frieze the courtly procession crossing the Louvre's Grande Galerie. This unfinished vase was destroyed in the early days of the Restoration, but the extraordinary watercolour model, executed by Zix, survives (**23**). It is valuable for its depiction of the hierarchies within the imperial circle. Ushers, heralds at arms and pages open the procession, followed by the equerries, the chamberlains and the governor of the Palais des Tuileries.[21] Towards the centre, the five laymen Grand Officers precede the princes and the imperial couple. Chamberlains and equerries of the satellite households carry the trains of the princesses in the distance.

The Empress' Household

The Empress also had at her disposal a Household that was in fact dependent on that of her husband, and financed by an annual budget of 1.2 million francs, of which 506,600 francs went to staffing expenses and 288,000 francs to the salaries of the ladies-in-waiting.[22] As was the case with his own Household, in 1804, Napoleon appointed Josephine's ladies of honour (*dames d'honneur*) and ladies-in-waiting from among the wives of several noblemen of Versailles

who rallied with the Empire (**24**) and some of the wives of the marshals and generals who were military pillars of the regime. Aside from these imposed figures, Josephine surrounded herself with young women in their twenties, the age of her daughter, Hortense.[23] Among the six *dames d'annonce* appointed, two came from the well-reputed educational establishment at Saint-Germain-en-Laye and four from the Legion of Honour's Maison d'éducation at Écouen, both of which were directed successively by Madame Campan, who had been Marie-Antoinette's first maid of the chamber.[24]

In 1810, the Household of the new Empress, Marie-Louise, was assembled with the same amount of care and considerably enhanced, echoing the increase in the aforementioned list of the Emperor's chamberlains. The thirty-six ladies-in-waiting naturally included the Empire's duchesses and comtesses: Bassano, Elchingen and Rovigo, Montalivet and Lauriston, respectively. The old nobility of Versailles was also represented, with the comtesses de Luçay, de Mortemart, de Noailles, de Canisy and de Bouillé.[25] International nobles heralded from Belgium, Italy and Poland, depending on the developments in Napoleon's European policy at the time. This learned assembly of women around the young Empress was a graceful highlight of an otherwise stuffy and strict court. It inspired the creation in 1812–13 of a Sévres porcelain service called "the Ladies-in-waiting": the figure painter Nicolas-Denis Delafosse worked on the portraits of some of these ladies, including Aldobrandini, Du Chatel, Talhouet and Lascarisse de Vintimille.[26] The Empress' Household also appointed a First Chaplain and two chaplains, a lady of the robes (*dame d'atours*), a chevalier of honour, a First Equerry, twelve chamberlains and four equerries. The choice of lady of honour, responsible for managing the domestic service, was particularly political, the Empire's noble families coveting this prestigious post as much as those of the Ancien Régime, all affected by the memory of Marie-Antoinette, Marie-Louise's aunt. Napoleon finally selected the duchess of Montebello, widow of Marshal Lannes, who died in battle in 1809 (**37**). From an old noble Breton family, she was the mother of five children, dignified in all things, and with a thorough knowledge of the court. The unanimous decision seamlessly united the old and new societies.[27]

The satellite Households

As of 1804, several satellite Households were also created to serve the rest of the imperial family, including Napoleon's brothers, Joseph and Louis, then Jerome, and his sisters Elisa Bacchiochi, Caroline Murat and Pauline Borghese. The mix between survivors from the kings' court and former students of Madame Campan,

which Napoleon had already tried in Josephine's Household, was also applied to the Princesses' Households, particularly those of Caroline Murat and Hortense de Beauharnais after her separation from Louis (1810).[28] Laetizia Bonaparte, the Emperor's mother, who was given the title "Madame Mère," had a chamberlain from the very old nobility, the comte de Cossé-Brissac, and an equerry, general de Beaumont, a former page of Louis XVI, aided by several chaplains, a lady of honour with lady companions, a secretary and an intendant.[29]

These princely Households made it possible to increase the number of courtiers in attendance for major ceremonies at the Tuileries, the *Almanach impérial* specifying that they enjoyed court favours.

As he conquered the continent, Napoleon put members of the imperial family on the thrones of Europe—Joseph in Naples (1806) then Spain (1808), Louis in Holland (1806), Jerome in Westphalia (1807), Elisa in Tuscany (1808), Murat and Caroline in Naples (1808). His family members created Civil Lists in turn, bringing their Households with them and padding them with recruits from the local nobility, who were entrusted with posts inspired by those of the Imperial Household. Case in point, Napoleon's Household as king of Italy served prince Eugene de Beauharnais, who, as viceroy, represented him in Milan. In Holland, Louis Bonaparte and Hortense had a Household for some years combining French nobles with the pre-eminent local families: the comte d'Arjuzon, the First Chamberlain, was French, while the baron Roest van Alkemade, Grand Marshal of the Palace, and the baron Van Heeckeren, the Grand Master of the Hunt, were both Dutch.[30] Jerome's court in Westphalia, which was particularly sumptuous, also brought French and Germans together.[31] In Naples, Joseph then Murat handed out court appointments so as to neutralize certain potential opponents belonging to the local great nobility.[32] In Spain, Joseph appointed the marqués de Ariza as Grand Chamberlain, the duque de Fernán-Núñez as Grand Master of the Hunt and prince de Masserano as Grand Master of Ceremonies, while keeping his friend Stanislas de Girardin as First Equerry. Having retained her imperial title following her divorce from Napoleon, Josephine kept a Household in her own right after 1809. As of 1811, with the birth of the heir to the throne, the King of Rome (**15**), the Household of the Children of France was established. Napoleon appointed a governess, the comtesse de Montesquiou, who was none other than the wife of his Grand Chamberlain (**16**). Called "Maman Quiou" by the child, she remained with him constantly, and supervised two undergovernesses from old noble families (the baronesses de Boubers and de Mesgrigny) and a medical service that included a physician, a surgeon and a vaccinator.

The Household of Napoleon, the king of Italy

In March 1805, Napoleon decided to make the Italian Republic a Kingdom and give himself sovereignty over it, keeping Milan as its capital. Henceforward, the "H. M. the Emperor [of the French] and King [of Italy]" would have two crowns. He appointed his son-in-law Eugene de Beauharnais, whom he had just adopted and made prince of Venice, as his representative with the title of viceroy. The establishment of this second crown, officially independent from the first, involved the establishment of its own Household—administered by its own Grand Officers and an intendant—composed of French and Italian titleholders. The new Household took up the administration and decoration of the palaces in Milan, Parma, Venice, and gave commissions to the French manufactories as well as Italian artists and artisans.

The Napoleonic court and monarchy model lasted less than ten years, but the influence of the Imperial Household would be felt throughout nineteenth-century Europe. In Naples, Holland, Spain and Piedmont-Sardinia, the Royal Households restored after 1814 were inspired by those of Napoleon, and their courts often recalled that of the Tuileries, not only in terms of their interior design and furnishings in a number of palaces temporarily linked by the Civil List, like Laeken in Belgium and the Quirinale—then called Monte Cavallo—in Rome. In France, it is important to recall that the structure of the Imperial Household was taken up by the Bourbons, to the detriment of all attempts to return to the pre-1789 system. The Restoration kings were content to simply change some of the commanding posts and to remove the emblems of the overthrown regime. This Household remained in place until 1830, and continued to inspire various heads of state who would take up residence at the Tuileries until 1870, when Napoleon III tried to reinstate a Household modelled on that of his uncle. Under the Third Republic, the first presidents also established a Household, with certain rules inspired by the Consulate and the Empire. Even in the Fifth Republic, the concepts of "household," "civil list" and "court" feed French political culture, quite understandably for politicos and historians alike.

THE GRAND CHAPLAIN

JOSEPH FESCH, CARDINAL AND PRINCE OF FRANCE

"The Grand Chaplain . . . is the Bishop of the Court wherever it may be. He supervises everything related to divine service. He administers the sacraments to the Emperor and to the children of the Imperial Family, and baptizes and marries them in the presence of the Emperor. He also baptizes the Emperor's godchildren. . . . He officiates at the Emperor's prayers and at the imperial feasts, saying the blessing and grace."[1]

Joseph Fesch was the younger half-brother of Laetitia Ramolino-Bonaparte, Napoleon's mother. The son of a Swiss officer in the service of the republic of Genoa, he was ordained in 1785 after studying at the seminary of Aix. As a priest in Ajaccio, he lived close to his widowed half-sister and her children, whom he saw growing up. Expelled from Corsica in 1793, the Bonapartes settled in Toulon and Fesch enlisted in the armies of the republic. Appointed commissary for war, he became responsible for provisioning the troops in Lombardy under the Directory. When Bonaparte became head of state in 1799, Fesch was able to resume his clerical vocation and thereafter rose to great prominence. His participation in the negotiations for the signing of the Concordat in 1801 earned him the archbishopric of Lyon and the primacy of Gaul, the supreme head of the hierarchy of French prelates. In 1803, he was sent as ambassador to Rome, where he received his cardinal's biretta and in 1804 was entrusted with a major negotiation on behalf of his nephew the emperor: to induce pope Pius VII to travel to Paris for Napoleon's coronation. During the early years of the Empire, Fesch, appointed Grand Chaplain in July, 1804, received various honours, positions at court and diplomatic missions to Rome. As a member of the imperial family, he was made a prince of France in 1807.

His portrait by Meynier (27), commissioned in the summer of 1806, is one of a series of full-length portraits of the Grand Officers of the Imperial Household originally executed for a gallery in the Château de Fontainebleau and ultimately moved to the Tuileries then to Compiègne.[2]

Here, the artist repeats the pose and composition of the famous portrait of Bossuet by Rigaud (28), showing his subject as a successor to the great prelate of the court of Louis XIV. Unlike the other Grand Officers, the Grand Chaplain was not obliged to wear any prescribed dress other than the cardinal's crimson vestment: holding his biretta in one hand, he is also wearing the sashes of the Legion of Honour and the insignia of the Golden Fleece.

Fesch wished to be depicted as an active contributor to the religious policy of the Empire. He is proudly pointing to a copy of the Catholic catechism of the Empire, for which he wrote some of the articles and obtained the approval of the Holy See. The only discreet reference to the Imperial Household may be on the table beside him; the bees embroidered on a heavy tablecloth of green velvet, the colour of the imperial livery. Meynier's painting is the most political picture of the cardinal, in contrast to other portraits, such as the one at the Château de Fontainebleau (29), in which the artist celebrates Fesch the connoisseur (the cardinal was undoubtedly one of the most important collectors of the entire nineteenth century).[3]

Throughout Napoleon's reign, there were frequent periods of friction in the relationship between uncle and nephew, caused by the Grand Chaplain's refusal to condone the Emperor's treatment of pope Pius VII after 1808.[4] The image painted by Meynier in 1806, showing Fesch as one of Napoleon's inner circle in terms of policy, hides what was in fact increasingly open hostility. Fesch even lost his position for some months in 1809, and although he agreed to perform the marriage of Napoleon and Marie-Louise (April 2, 1810) and the baptism of the King of Rome (June 9, 1811), he refused the archbishopric of Paris. By this time, the Emperor was in open conflict with the pope, who had been arrested in 1809 when the Papal States were annexed to the Empire. Appointed to preside over the national council of France in 1811, which was convoked to find a solution to the institutional crisis caused by the arrest of the pope, Fesch defended the pontiff. The relationship between the Emperor and his uncle is a fascinating subject: it seems to have been impossible to reconcile the viewpoints of an authoritarian sovereign and an increasingly ultramontane prelate, as well as the emotional strain within a complex family clan. In March 1812, Napoleon exiled the archbishop to his diocese of Lyon. After the fall of the Empire, Fesch made his way to Rome, where the pope welcomed him warmly, and with him other members of the Bonaparte family, most notably Madame Mère. It was Fesch who in May 1821 first learned of Napoleon's death and informed his half-sister. He died in 1839, a recipient of many honours and surrounded by his immense collection of art.

SYLVAIN CORDIER

27
Charles MEYNIER
Portrait of Joseph Fesch, Prince of France, Grand Chaplain, in the Costume of a Cardinal
1806
Musée national des châteaux de Versailles et de Trianon

28
Hyacinthe RIGAUD
Portrait of Jacques-Bénigne Bossuet, Bishop of Meaux
1702
Paris, Musée du Louvre

29.
ANONYMOUS, ROMAN (?), circle of Jean-Baptiste WICAR
Portrait of Cardinal Joseph Fesch
After 1808
Château de Fontainebleau, Musée Napoléon Ier

28

29

THE GRAND MARSHAL OF THE PALACE

GÉRAUD-CHRISTOPHE-MICHEL DUROC, DUKE OF FRIULI

"Assigned to the Grand Marshal of the Palace are: 1. the military command of the imperial palaces and their outbuildings; the supervision of their upkeep, embellishment and furnishings; the allocation of lodgings; 2. meal service; table setting; heating; lighting; silver; linen room and livery."[1]

Born of a penniless family of the minor nobility in Gévaudan, Géraud-Christophe-Michel du Roc took up a military career when very young. After leaving France briefly at the start of the Revolution, he joined the Republican cause. He met Bonaparte in 1793, during military operations in Toulon, and became his aide-de-camp during the first Italian campaign and followed him to Egypt. He was involved in the coup d'état of 18 Brumaire (November 9, 1799) and became governor of the Palais des Tuileries, the new First Consul's Household, foreshadowing his official appointment as Grand Marshal of the Palace in July 1804. An excellent administrator and talented diplomat—he was sent on important missions on behalf of Napoleon to Prussia, Russia and Denmark, and even obtained the abdication of the king of Spain, Charles IV, in Bayonne in 1808—Duroc brought all his efficiency and determination to bear on administering the departments of the Imperial Household, setting himself up as a veritable leader among his Grand Officer colleagues. He was particularly devoted to Napoleon, seeing him perhaps more as a friend than as a sovereign, and the two enjoyed a close relationship. Duroc may have been one of his few real friends.

The portrait commissioned from Gros in 1806 (31) is one from the series of Grand Officers planned for the imperial palaces. Of all these portraits, this one is undoubtedly the most regal in its composition. The painter took his inspiration for the pose from Van Loo (147), even going so far as to copy the red heels of the shoes, which were not regulation wear for officers in civil uniform—Duroc's colleagues are not shown wearing them.

The civil uniform is brilliantly rendered. The amaranth red jacket is tailored à la française, revealing the white silk breeches. This cut differs from the only extant example of the Grand Marshal's uniform, which belonged to Bertrand (113), Duroc's successor; here the jacket falls straight, à l'espagnole.

Duroc is shown on a terrace, leaning in a lordly manner on a Grand Officer's court staff. The Vendôme Column, rendered in shades of white, is in the background, and is quite different from the actual bronze. This detail places the scene somewhere in the gardens of the Tuileries, the first of the palaces to be administered by the Grand Marshal. The column is associated with Duroc's military career, for this monument celebrates the Grande Armée and the victory at Austerlitz. In the painting, it looks like an extension of the court staff. It is not known when the canvas was completed: in January 1807, it was still in Gros' studio, but in May 1808, it arrived at Compiègne.[2] On the other hand, it is known that the statue of Napoleon, commissioned for the top of the column, was not completed until March 1808 by the sculptor Chaudet, and the column itself was cast and erected the following August.[3] Its depiction in the painting therefore preceded its actual installation by several months. Furthermore, the Emperor is depicted in ceremonial dress, holding high the imperial sceptre, while Chaudet's statue depicts him in a classical manner.

The well-decorated Duroc was made duke of Friuli in 1808. He fought in the campaigns in Russia (1812) and Saxony (1813), where he died, cut down by a cannonball at Markersdorf, on May 13, 1813. Heartbroken by the loss of his friend, Napoleon did not elect a successor for some considerable time. For a few months, the Grand Equerry Caulaincourt replaced him, and for a while was considered as the new Grand Marshal. In the end, it was general Henri-Gatien Bertrand (30) who was chosen in November 1813. Although a faithful follower of the Emperor, at the Tuileries he did not establish as close a relationship with him as Duroc had done. And yet it was Bertrand—together with a few Household officers and servants—who alone among the Grand Officers chose in 1814 to follow Napoleon into exile, first to the island of Elba and then to Saint Helena. Throughout these years, he governed the administration of the deposed sovereign's Household. The Steuben drawing, The Grand Marshal of the Palace Bertrand by the Body of Napoleon (375), presents in hindsight a romantic picture of the high-ranking servant's steadfast devotion to his Emperor to the very end.

SYLVAIN CORDIER

30

30
ANONYMOUS (initialled SCF)
Portrait of Henri Gatien, Comte Bertrand, Future Grand Marshal of the Palace, at the Age of Thirty-five
1808
Châteauroux, Musée-hôtel Bertrand

31
Antoine-Jean GROS
Portrait of Géraud-Christophe-Michel Duroc, Duke of Friuli, in the Costume of a Grand Marshal of the Palace
1801-5
Nancy, Musée des Beaux-Arts

THE GRAND MASTER OF CEREMONIES

LOUIS-PHILIPPE DE SÉGUR, COMTE OF THE EMPIRE

The comte Louis-Philippe de Ségur was Grand Master of Ceremonies of the Imperial Household from 1804 until its fall in 1815. This Grand Officer "performs two different kinds of functions: the ceremonies and the introduction of the Ambassadors . . . [H]e writes and signs the protocol [and] dictates the costumes in which those invited must appear. . . . The day of the ceremony, [he] makes sure that all the parts of the protocol are properly adhered to; during the ceremony, he stands in the front, close to H. M."[1] The Grand Master gives orders to the masters of Ceremonies, with the help of the assistants of Ceremonies and heralds, and he also relies on a *dessinateur* of Ceremonies (a position entrusted to the painter Jean-Baptiste Isabey, charged with giving shape to and decorating ceremonial spaces and the costumes) and a coach of Ceremonies.

Ségur was the son of Philippe Henri, marquis de Ségur, marshal of France and minister of war under Louis XVI. From the aristocracy of the Ancien Régime, he was well acquainted with the customs of the court at Versailles. It would be wrong, however, to see him only as an old courtier, concerned solely with preserving the conventions and details of etiquette from one regime to the next. Indeed, his fascinating career represents all of the rich intellectual and liberal identity of nobles in that generation of Frenchmen, born under Louis XV only to find themselves facing the civic and social challenges of the late eighteenth century. His presence at Napoleon's side takes on a particular importance.

A Freemason, in his youth he supported the independence of the United States and fought on American soil, returning in 1783 with the rank of colonel of dragoons.[2] He was then sent by Louis XVI as ambassador to Russia (1784–89), where he earned the friendship of Catherine the Great. A believer in the Revolution, he was appointed ambassador to the Holy See, but the pope refused him entry into the Papal States. He received the same treatment by the king of Prussia, to whom a discredited France had sent him in January 1792. Returning to France, he retired to his estates in Chatenay, where he prudently remained during the most dangerous years of the Revolution. Bonaparte's rise to power won him over. A member of the Legislative Corps in 1801, and then a member of the Council of State, he was appointed Grand Master of Ceremonies with the advent of the Empire. Created a comte of the Empire in 1808, he joined the Senate in 1813. Ségur sided with Louis XVIII in 1814, and then went back to Napoleon during the Hundred Days, even offering to follow him into exile after Waterloo. In the end, he stayed in France. He fell from grace during the early years of the Restoration, but regained his seat in the Senate in 1819. He died in 1830, a few weeks after the liberal revolution that led to the July Monarchy.

Excited by the new ideas of his age, Ségur was a born historian who loved philosophy and literature and frequented the salons of Mme Du Deffand and Mme Geoffrin, meeting La Hapre, Marmontel and Voltaire. He produced numerous works of history and political science, as well as plays, short stories and songs, and his admirable *Mémoires*, on the first part of his life up to the Revolution, all of which are still extant. This dense text reveals the depth of his thinking and his strong belief in the Enlightenment. He was elected to the Académie française in 1803. His literary output was interrupted under the Empire, but he took it up again under the Restoration, notably publishing an *Abrégé de l'histoire universelle* in forty-four volumes (1817), a *Histoire de France* in nine volumes (1824) and a *Histoire des Juifs* (1827). As an enlightened historian, he was admirably suited to carry out the functions of a Grand Master of Ceremonies, for which historical research was often necessary. In order to reconstitute a coherent and relevant etiquette for the court, he delved into the archives of the royal palace and memories of the courts of Europe.

The half-length portrait of Ségur from the Château de Versailles (32) is a work that requires careful study. It is important to note that the original, commissioned by the Imperial Household for the Gallery of Grand Officers, was in fact a full-length portrait. Is this a copy, a replica or actually the original cut down? The original was commissioned from Marie-Guillemine Benoist and executed during the year 1806.[3] It was in the Tuileries, hanging in the Gallery of Diana in August 1807, and then at Compiègne, in the Salon of Ushers in May 1808. On February 13, 1814, it was sent to the Louvre, like the other paintings. Was it then, under the Restoration, given to the sitter's family, as was the case with most of the other portraits of Grand Officers? This is probable, and would support the hypothesis that it was this canvas, as it has been kept at Versailles since 1924, given by the Ségur family.

The Grand Master is standing in front of a heavy curtain that offers a narrow glimpse of a distant horizon. He appears to be holding his ceremonial staff, which tempts us to compare this composition to the portrait of Duroc, Grand Marshal of the Palace, by Gros.

It is no great surprise that it was this portrait—of himself—that Ségur had copied by Isabey, his artist of Ceremonies, to represent the figure of a Grand Officer of the Household in the *Livre du Sacre*, a publication he authored (116G). In 1810, Goubaud, in his turn, made use of it to depict Ségur carrying out his duties in *Napoleon Receiving the Delegation from the Roman Senate in the Throne Room at the Tuileries* (14).

SYLVAIN CORDIER

32
ANONYMOUS, possibly Marie-Guillemine BENOIST
Portrait of Louis-Philippe de Ségur, Comte of the Empire, in the Costume of a Grand Marshal of Ceremonies
1806 (?)
Musée national des châteaux de Versailles et de Trianon

THE GRAND CHAMBERLAINS

CHARLES-MAURICE DE TALLEYRAND-PÉRIGORD, PRINCE OF BENEVENTO, AND PIERRE DE MONTESQUIOU-FEZENSAC, COMTE OF THE EMPIRE

"The Chamber department embraces everything related to the honours of the Palace: ordinary audiences, the oaths taken in the Emperor's Cabinet, royal entries, H. M.'s levees and couchers, festivities, society circles, the theatres of the Palace, the music, the loges of the Emperor and the Empress at the various performances, the Emperor's wardrobe, his library, the Ushers and Valets of the Bedchamber. . . . The Grand Chamberlain is the head of every department of the Chamber."[1]

At the beginning of his reign, Napoleon chose Charles-Maurice de Talleyrand-Périgord, his minister for foreign affairs (Château de Valençay), to hold the solemn office of Grand Chamberlain. The relationship between the two men, compounded of both admiration and insubordination, suggests that this appointment enabled the Emperor to put his minister in a subservient position, in luxurious servitude but servitude just the same. Born of a very old aristocratic family, the Périgords, Talleyrand was bishop of Autun under the Ancien Régime and was present at the coronation of Louis XVI in 1774. Won over by the new ideas of 1789, he played an important role in the early years of the Revolution and developed his taste and talent for diplomacy. His peerless political skill together with his proportionate honesty made him a useful but dangerous member of the Emperor's entourage and of the government.[2]

The portrait of Talleyrand in the costume of the Grand Chamberlain (**33**) was commissioned from Prud'hon in 1806 at the same time as a second work, where he is wearing that of the minister of foreign affairs, as part of the projects for a series of portraits of Ministers and Grand Officers, which were

eventually reconsidered. The domestic nature of the responsibilities of a Grand Chamberlain to the Emperor seems to be underscored here. Talleyrand is depicted in a lavish interior, probably in his residence, leaning against an antique-style bust of Napoleon (an earlier idea of the artist had been to make it a bust of Minerva).

Suspected of treason, Talleyrand was removed from office and fell from grace in January 1809. The comte Anne-Élisabeth-Pierre de Montesquiou-Fezensac was appointed as the new Grand Chamberlain. As Pierre Branda put it, "a representative of one fine old family was replaced by another."[3] Descended from the high nobility of the Ancien Régime, before 1789, Montesquiou had been First Equerry of Monsieur, Louis XVI's surviving brother. Recruited at the beginning of the Empire, he joined the Legislative Corps in 1805. The appointment as Grand Chamberlain came as a surprise to the comte when Grand Marshal Duroc came to tell him of it: "Astonished by this proposal, I asked for information about this post, as I knew nothing of its assignments or of its advantages or disadvantages. He told me that it was a delightful position with nothing about it to worry me or displease me . . . he begged me to give him a favourable answer at once so that he could take it straight to the Tuileries."[4]

In 1811, Montesquiou's wife, Louise-Charlotte, née Letellier de Montmirail, was made governess of the Household of the Children of France after the birth of the King of Rome (**16**), and two of their sons and one of his brothers served as chamberlains.

Unlike Talleyrand, who was more interested in the diplomatic service than in the arcana of the Imperial Household, Montesquiou would be particularly devoted to the Chamber department and to the efficacy of its activities and its budgets.

Its whereabouts unfortunately not known, and appreciated only via an old photograph, the official portrait of Montesquiou as the Grand Chamberlain (**34**) was commissioned from Robert Lefèvre early in 1810. It is worth studying, for it is probably the most interesting attempt in art to combine the static portrayal of a Grand Officer and an accomplished rendering of his duties. More than just a portrait, the canvas shows the Grand Chamberlain performing one of his court functions: introducing a dignitary who has come to pay tribute to the Emperor. The scene depicted follows the protocol defined in the *Étiquette* for the occasion of a "ceremony during which T. M. are on the Throne to receive the homage of public Officials."[5] As spectators of the painting, we are invited to put ourselves in the position of one of these dignitaries. We have just been led into the Throne Room by the Chamberlain of the day, and have made eye contact with the Grand Chamberlain who, standing "one pace away from the last step to the throne,"[6] shows us the way and prepares to introduce us to the Emperor. A composition like this demonstrates the fine line between the court portrait and the history painting of the regime. It is especially interesting to note that the throne is barely visible in the background: only one of the ensigns and the cushion at the foot of the seat can be seen. The care taken not to show the whole throne should be highlighted; a depiction in its entirety at the back of an individual was reserved for portraits of sovereigns.

SYLVAIN CORDIER

33
Pierre-Paul PRUD'HON
Portrait of Charles-Maurice de Talleyrand-Périgord, Prince of Benevento, in the Costume of a Grand Chamberlain
1807
Paris, Musée Carnavalet

34
Robert LEFÈVRE
Portrait of Anne-Élisabeth-Pierre de Montesquiou-Fezensac, Comte of the Empire, in the Costume of a Grand Chamberlain
1810
Whereabouts unkown

34

THE LADY OF HONOUR TO THE EMPRESS

LOUISE DE GUÉNÉHEUC, MARÉCHALE LANNES, DUCHESS OF MONTEBELLO

This portrait of the duchess of Montebello (**37**) follows a pictorial tradition strongly promoted during the Empire, that of the family portrait, whereby the relatives and children of the new aristocracy could establish themselves as the source of dynasties for imperial France. Gérard's studio specialized in this kind of composition, as can be seen in the portraits of members of the imperial family, including Hortense (**105**), Caroline (**104**), Julie Clary (**371**), and others.

Louise-Antoinette-Scholastique de Guénéheuc came from a royalist family of the minor nobility; her father was valet of the bedchamber to Louis XVI. In September 1800, she married the divorced General Lannes (**36**), a close friend of Bonaparte since the Italian campaign. The couple moved to Lisbon, where Lannes had been appointed minister plenipotentiary at the court of Portugal. In 1808, he was made one of the first marshals of France. Created duke of Montebello in 1808, he fought in the Austrian campaign the following year. It was there, at the height of his career, during the Battle of Aspern-Essling (May 22, 1809) that he was struck by a cannonball, and died after a week of agony. His remains were taken back to France and placed in the Panthéon, where he is revered as an illustrious hero.

The grieving duchesse withdrew from public life. However, the following year Napoleon appointed her as a lady-in-waiting to the new Empress Marie-Louise, who treated her as a real friend with whom she could escape from the burdens of palace life. In her *Mémoires*, queen Hortense wrote:

"[The duchess of Montebello] disliked the life of the court. After her husband's death, she found her sole happiness in bringing up her children and in the beloved company of her family and a few friends. Far from disguising how tiresome she found palace life, she seemed to revel in showing it. So whenever she went away for a while, the Empress would write her little notes. She could not do without her. The duchesse's friends were the only French people the Empress knew. Although she never saw them, she knew all about them. On New Year's Day, she spent her time giving pretty little gifts to the duchesse's children. Mme de Montesquiou, governess to the King of Rome, even felt envious on his behalf."[1]

The closeness between the duchesse and Empress is evoked charmingly in the renowned watercolour made by Marie-Louise, under Isabey's advisement, which depicts her visiting the duchesse convalescing in the company of the court doctor, Corvisart (priv. coll.). A copy attributed to Isabey is preserved in the Museo Glauco Lombardi, in Parma (**35**).

Relations between the duchesse and the Emperor were strained. She blamed him for her husband's death and he distrusted her: "Neither ever liked the other . . . I have often heard him say to the Empress, 'You are much mistaken if you think the duchesse is fond of you. She only loves herself and her children. You're a fool to be so attached to her.'"[2]

When Gérard painted her portrait in 1814, the duchesse had been a widow for five years. It was the last year of the Empire. Graceful and dignified, she strolls through the garden of her country estate, Château de Maisons, surrounded by her five

children. The group is passing a monumental statue. Although only the lower part is visible, the figure is immediately identifiable by the sinister presence of a cannonball beside the left foot: this is Jean Lannes, horrifyingly evoked by the grim fate that befell him on the battlefield. Rather than his titles of nobility, it is his death and the appalling manner of it that seem to be the source of the family's honour. This portrait, at first sight joyous and innocent, actually evokes the blood shed by the marshal.

The eldest of the boys, Louis-Napoléon, gazes up at his father's effigy with a calm and serious expression. A younger brother, Jean-Ernest—holding two rackets over his shoulder as if they were guns—is looking out at the viewer. Both boys are wearing whimsical military costumes. In a striking analogy, the little ball lying at the feet of the youngest boy, Gustave-Olivier, mirrors the ominous cannonball beside the statue.

This composition presents a disconcerting interaction between the conventions appropriate to the dramas of adult life and the mischievous world of childhood, the fate of the dead man and the innocence of his orphaned progeny. Gérard gives us an image at once beautiful and cruel, in which personal tragedy expresses the transmission of the noble yet bitter values of heroism.

SYLVAIN CORDIER

35

35
Jean-Baptiste ISABEY
Marie-Louise Visiting the Duchess of Montebello, Taken to Her Bed, in the Company of the Baron Corvisart, First Physician
About 1811
Parma, Museo Glauco Lombardi

36
Jean-Charles PERRIN
Portrait of Jean Lannes, Duke of Montebello, Marshal of France, in the Uniform of a Colonel of the Hussars
Between 1805–10
Musée national des châteaux de Versailles et de Trianon

37
François-Pascal-Simon GÉRARD
Portrait of Louise-Antoinette-Scholastique de Guénéheuc-Lannes, Duchess of Montebello, with Her Children
1814
Houston, Museum of Fine Arts

36

THE GRAND EQUERRY

ARMAND DE CAULAINCOURT, DUKE OF VICENZA

"The Grand Equerry is attributed the duties of the Stables and its various services, the Pages, the Couriers, H. M.'s weapons of war and the oversight and management of the stud farms at Saint-Cloud. He organizes everything to do with travelling, and decides on the places each person should occupy."[1]

This hitherto little known portrait of Armand de Caulaincourt as Grand Equerry of the Imperial Household (39), executed by Ferréol Bonnemaison, was one of the first portraits of Grand Officers to be commissioned for a gallery. The artist exhibited it at the Salon of 1806, and then took it back for completion in January 1807.[2] In August, the canvas was installed in the Tuileries, in the Gallery of Diana, before being sent to Compiègne in May 1808. Taken down at the Restoration, it was stored in the Louvre before being restored to Caulaincourt, who by then was living far from the court of France.

When Caulaincourt, a nobleman of Picardy, was appointed Grand Equerry in July 1804 at the age of thirty, he was the youngest of the Grand Officers of the Imperial Household. A handsome man and an excellent rider–the minimum requirement for this position–he already had a long military career behind him, which started under the Ancien Régime and continued during the Revolution and the Consulate. He had recently won Napoleon's confidence by successfully carrying out the abduction of the duc d'Enghien (March 1, 1804), a sad episode in the march to Empire. In command of the Stables, an enormous department of the Household, he was a notably rigorous administrator. His management of the horses, the carriages, the equipages and the pages was suspended in December 1807, when he was appointed ambassador to the court of Russia. Although he retained his title and his emoluments, his responsibilities now fell to his subordinates. He was made duc de Vicenza on June 7, 1808. He returned to Paris in May 1811 then left again for Russia the following year, this time in the ranks of the Grande Armée to follow Napoleon and conquer the country. This was a crushing defeat for the French. He fought in the German campaign in 1813, and acted briefly as Grand Marshal of the Palace between the death of Duroc and the appointment of Bertrand. He was for a while minister of foreign affairs (November 20, 1813–April 3, 1814), a position he regained during the Hundred Days.

Like his colleagues, Caulaincourt is depicted here in the civil uniform of a Grand Officer of the Household, in the shade of blue reserved for the Grand Equerry and his team, somewhat darker than the regulatory "sky blue." The jacket falls straight in the Spanish style, *à l'espagnole*, unlike those of Grand Marshal of the Palace Duroc (31) or of Grand Master of the Hunt Berthier (40), cut *à la française*. Caulaincourt is wearing the insignia of the Legion of Honour and the Order of Saint Hubert of Bavaria.

The Grand Equerry is shown in an interior featuring a heavy red wall hanging. The presence of an elegant X-shaped stool of gilded wood, on which lies the subject's hat, identifies the space as one of the salons in the State apartments of an imperial residence. The folding stool, a typical piece of court furniture, does not correspond to any known model. The balls projecting from the seat's frame is a stylistic detail that suggests a dating to the years of the Consulate, comparing it to seating from about 1800, like the series of stools in the Council Chamber at Malmaison. The relatively early date of the portrait (1806-7) confirms this notion. This sort of furniture, created in a context influenced by antique styles but still republican, would readily seem functional and relevant in the furnishing of palaces after the proclamation of the Empire and the formulation of the etiquette.

This portrait of Caulaincourt by Bonnemaison was copied about 1808 by Isabey when he was commissioned by the Sèvres manufactory to execute a portrait bust of the Grand Equerry for the top of the Austerlitz table (20). A drawing of this bust is found in a private collection (38).

SYLVAIN CORDIER

38

THE GRAND MASTER OF THE HUNT

LOUIS-ALEXANDRE BERTHIER, PRINCE OF NEUFCHÂTEL, VALENGIN AND WAGRAM

The son of a topographical engineer in the armies of the king, who became chief of staff of the hôtels of the ministries for war, the navy and foreign affairs at Versailles under the Ancien Régime, Louis-Alexandre Berthier entered the royal school of engineering in 1764. He notably played a part in the War of American Independence between 1780 and 1783. Distinguished among the officers faithful to the king, he was appointed chief of staff to the Versailles Garde Nationale in 1789, and thus was able to help Mesdames, Louis XVI's aunts, to flee from France in 1791. Discharged when the monarchy fell in 1792, he was reinstated three years later as brigadier-general of the Army of Italy before becoming division general. In March 1796, he met Bonaparte, who appointed him major general of the Army of Italy. It was the start of a long friendship. Berthier proved to be an excellent administrator of the armed forces of the Republic and a brave soldier on the battlefield. He soon became indispensable to Bonaparte, who was to reward him with gifts and honours: made marshal of France and minister of war with the advent of the Empire, he was appointed Grand Master of the Hunt to the Imperial Household (1804) and major general of the Grande Armée (1805), prince regent of Neufchâtel and Valengin (1806), vice-constable of the Empire (1807) and prince of Wagram (1809). The most faithful of the Emperor's adherents, he followed him through all his campaigns, but in the end rallied to the Bourbon cause in 1814. Exiled in Bavaria during the Hundred Days, he died on June 1, 1815, a few weeks before Waterloo, by falling from a window in his residence.

The establishment of hunting in the style of the Ancien Régime was for Napoleon a major project, part of his attempt to revive an effective and powerful court system. A department of the Hunt was set up even before the proclamation of the Empire. On being appointed Grand Master of the Hunt, Berthier was awarded the Château de Chambord and its immense hunting grounds. He also owned the forest of Grosbois, east of Paris.

Napoleon was a poor huntsman and a notoriously bad shot—he almost blinded Masséna, one of his marshals, during a hunt in September 1808[1]—but he was fully aware of the political role of hunting as an image of royal authority. Although the faithful Berthier is remembered in the history of the Empire more for his talents as a strategist and organizer of the Grande Armée than for his part in imperial hunts, the decision to appoint him chief huntsman was not taken haphazardly. He was in fact the son of a topographical engineer attached to the government under Louis XV and Louis XVI, Jean-Baptiste Berthier, who in 1767 had been ordered to draw up a complete map of the royal hunting grounds. The project was not actually launched until 1774, and the map was only completed just before the Revolution in 1789. In his youth, the future prince of Neufchâtel had assisted his father and often accompanied the hunts of Louis XVI to confirm the topographical data.[2] Thus, like Ségur, the Grand Master of Ceremonies, or Talleyrand, the Grand Chamberlain, Berthier was appointed Grand Master of the Hunt as a direct reference to past customs.

The portrait of the Master of the Hunt by Pajou (40) was commissioned for the Gallery of the Grand Officers at Fontainebleau in 1806 and delivered in 1808, and eventually, like the others, installed in Compiègne the following year. Pajou portrays the prince in his Civil Grand Officer costume, which features the details of the embroidered palm leaves, oak leaves and laurel leaves in the regulation green colour of the Master of the Hunt. The jacket survives and is preserved in the Musée de l'Armée in Paris (111). Although majestic, this is a very conventional portrait. He is shown as a grand butler depicted in the exercise of his function in the tradition of ministerial portraits: standing beside his work table, he is pointing to a document relevant to his post; here it happens to be a map of the imperial forest of Fontainebleau. In the background, a copy of the ancient Greek statue of Artemis the Huntress—also called the Diana of Versailles—symbolizes his position, and a laurel-crowned bust of Napoleon, after the Bartolini, evokes his allegiance to the Emperor.

A second portrait of Berthier in formal dress, a half-length likeness (41), is in the Château de Fontainebleau. It is attributed to Appiani, and datable after 1807.

SYLVAIN CORDIER

40
Jacques-Augustin-Catherine PAJOU
Portrait of Louis-Alexandre Berthier, Prince of Neufchâtel, Valengin and Wagram, in the Costume of a Grand Master of the Hunt
1808
Musée national des châteaux de Versailles et de Trianon

41
Andrea APPIANI
Bust-length Portrait of Louis-Alexandre Berthier in the Costume of a Grand Master of the Hunt
After 1807
Château de Fontainebleau, Musée Napoléon Ier

41

THE INTENDANT-GENERAL OF THE IMPERIAL HOUSEHOLD

PIERRE-ANTOINE-NOËL-BRUNO DARU, COMTE OF THE EMPIRE

The comte Daru was one of the most distinguished figures of the Imperial Household, held in high esteem for his integrity and extraordinary capacity for work. Division head of the war ministry (1800), secretary-general of the war ministry (1801), in 1803 he organized the camp at Boulogne and penned a Military Code. He was appointed imperial councillor of state and Intendant-General of the Civil List in July 1805, then Intendant-General of the conquered countries. He became Intendant-General of the Imperial Household in 1810 and was named "comte de l'Empire" in 1809.

Pierre Daru served this role in conjunction with that of Intendant-General of the Grande Armée (1806–12). He left the Household upon his promotion to secretary of state (1811–13), and then minister of war from November 20, 1813, to April 6, 1814, the date of the first abdication. During the Hundred Days, he was minister of state linked to the ministry of war administration. Elected to the Institut de France in 1806, the Académie in 1816, the Chamber of Peers in 1819, and the Académie des Sciences in 1828, he published his *Histoire de la République de Venise* and translations of Horace, among other works.

Dominique-Vivant Denon, director of the imperial museums, commissioned Gros for the portrait of the comte Daru (**43**) in 1813 for the Gallery of Ministers. At that time, Daru was no longer Intendant of the Household but secretary of state, as reflected in the portrait. The choice of Gros was a sign of the honour and esteem due one of the dignitaries with whom Denon maintained the most active of administrative relationships. Submitted on March 11, 1813, for the approval of the duke of Cadore, Intendant-General of the Crown and Daru's replacement since 1811 (**42**), this choice was made all the more rapidly, as the portrait-sitting sessions had to be scheduled in the short time before the model's departure for Germany—apparently imminent—where he had been charged with replenishing and reorganizing the provision of supplies for the imperial army weakened by the Russian campaign: "I have the honour of asking you, Monseigneur, to advise me if you have approved the choice of three artists . . . in order that he who has been charged with the portrait of M. le comte Daru can have his sittings before the departure of His Excellency, should His Majesty order Daru to accompany him."[1]

In its overall composition, the Musée de l'Armée's portrait subscribes to the imposed program; however, the artists were allowed to adapt details of dress and decor to offset the impression of uniformity and to take into account the personality of the subjects.

Daru is depicted standing in the minister of state's *grand costume*, the official dress with a blue tail coat embroidered with silver, a blue velvet cape lined with white satin and white satin breeches. His hand rests on a red morocco leather portfolio decorated with the gold bees of the Empire's coat of arms, a reference to his post.

He is wearing the Grand Cordon, the Grand Eagle badge and cross of the Legion of Honour, and the Order of the Reunion, symbolizing, as of 1811, the Union of the Baltic, the Atlantic Ocean, the Mediterranean and the Adriatic. His figure emerges from a background that allows a glimpse into a room decorated with flags—a reference to his role in the organization and financing of the Napoleonic campaigns—as well as a desk with an inkwell and a globe, suggesting the European extent of his activities.

The portrait of Daru is in line with the last series of portraits commissioned in March 1813. Finished by summer 1813, it seems never to have reached Compiègne. The painting was certainly one of the portraits of ministers and Grand Officers returned to the sitters and their families under the Restoration between 1815 and 1821. In some cases, copies were made upon the request of the sitters and under the supervision of the artists, which has made it difficult to differentiate between the originals intended for official use and the family replicas. Extremely well executed, the copy shown here was preserved by the descendants of the comte Daru and given to the Musée de l'Armée in 2006.[2]

SYLVIE LE RAY-BURIMI

42

42
Théodore-Auguste ROUSSEAU
After Antoine ANSIAUX
Portrait of Jean-Baptiste de Nompère de Champagny, Duke of Cadore, Intendant-General of the Imperial Household, in the Costume of a Minister
1853
Musée national des châteaux de Versailles et de Trianon

43
Antoine-Jean GROS
Portrait of Pierre-Antoine-Noël-Bruno Daru, Comte of the Empire, Former Intendant of the Imperial Household, in the Costume of a Secretary of State
1813
Paris, Musée de l'Armée
Dépôt de la famille Daru, 2006

"I wish to be housed worthily, but not like the majority of sovereigns,
a prisoner and ill at ease under the gilded ceilings of my home; I must have, in the same place,
behind the same facade, two different things: firstly, the complete residence of a rich
paterfamilias, with all the conveniences of a private man who wants comfort and freedom;
and then, the reception rooms and pomp of the representative of a great nation
to which is owed honour and respect."

Napoleon to Percier and Fontaine, Saint-Cloud, July 1807

THE HOUSEHOLD

AND ITS

PALACES

THE "IMPERIAL PALACE"

AND THE

IMPERIAL PALACES

A COLLECTION OF RESIDENCES

SYLVAIN CORDIER

Published at the beginning of the Empire, the *Étiquette du palais impérial* defined the rules of behaviour and of the design of interiors devoted to the expression of monarchical power. As much an ideological concept as an architectural reality, the "Palace" was both the place in which these practices emerged and the principle that validated them sociologically. Although the text, when presenting the organization of the spaces of the court, mentions in section II the example of the Parisian palace of the Tuileries, it soon became usual to organize all of the Emperor's official residences according to the same strict rules.

The term "palace" comes from the name of one of the seven hills of Rome, the Palatine, on which, in the first century A.D., the city residences of the emperors Augustus and then Tiberius were built. In the history of Europe, since the days of Charlemagne, giving the principal residence of a ruler that name was linking his authority to the memory of Roman sovereignty.

The Ancien Régime in France had nevertheless established a strict distinction: the appellation "palace" was reserved for the buildings located within the medieval boundaries of the capital, such as the Palais de la Cité, which the royal power had long since given up to the parliament, and the Palais du Louvre. The other royal residences, wherever they were, were designated "chateaux." Thus, regardless of its size, its splendour and, in particular, the fact that from Louis XIV to Louis XVI the king spent most of his time there, in the eighteenth century a place like Versailles did not qualify as a palace. No more did the Tuileries, which, although connected to the Louvre by a long gallery running along the Seine, was situated a few hundred metres to the west of the ruined city walls of Charles V, and was hence designated a "château."

Napoleon adapted this principle, considering that it was the presence of the sovereign that "made" the palace, regardless of its location within or outside of the capital. This principle fell within a rational and pragmatic reading of the power conferred on a physical authority, but it was not new. *Ubi Caesar, ibi Roma est*, said the Romans. Indeed, this formula was adapted at the very start of the Revolution with the taking of the Tennis Court Oath by the new deputies of the Estates General to declare their legitimacy as representatives of the Nation: "Wherever its members meet, that is the National Assembly." The Emperor transforming any roof under which he stayed into a palace was part of the same point of view in a long perspective of political history.

The responsibilities for the management of the imperial residences were shared between the departments of the Grand Marshal of the Palace and the Intendant-General, who were obliged to collaborate closely on the smooth running of a cumbersome administration spread across the entire territory of the Empire. The Grand Marshal was in charge of the governance, scheduling and protection of the sites: answerable to Duroc (1804-13) were the officers commanding each of the palaces, designated from 1806 as governors, the first assisted by an adjutant and the others by a deputy governor.[1] The Intendant-General oversaw the services of the architects and the management of the budgets for furniture and the collections of objects. Each palace had its own architect, while the furniture of the Crown was administered by a single office in Paris, consisting of an administrator and a curator assisted by inspectors and auditors.[2] In addition, Napoleon chose to attach three auditors from the Council of State to "inspect and audit the various accounts and the administration of the imperial furniture storehouse called the Garde-Meuble and the buildings," with the obligation of visiting the palace at least twice a year.

Among all the architects associated with the palace, the reputable team of Fontaine and Percier stood apart from the rest. The two associates, architects for the government since the Consulate, were specifically responsible for the Tuileries and the Louvre, as well as their outbuildings in Paris, Fontaine alone acquiring the official title. Their publishing activities, undertaken as of the late 1790s, were enriched by the interior design projects they were required to implement in the Emperor's service. Their famous *Recueil de décorations intérieures*, published in 1801 as a confirmation of the taste of a generation of enlightened citizens worthy of the taste of the ancient Greeks and the "general laws of the true, the simple and the beautiful,"[3] saw some of its republican ideas adapted to the rules of a regal display in the new edition of 1812, which abounds in models of grand palatial interiors reconfiguring a monarchical decorative language.[4]

Sovereign spaces and places to live

Section II of the *Étiquette*, which deals with the distribution of apartments and the admissions to each ("De la Distribution des Appartements et des Entrée dans chacun d'eux"), adapts the common customs of the life of the court and the monarchs of the Ancien Régime, notably in the eighteenth century, when it became necessary to arrange space and time for private life for Louis XV and Louis XVI outside of the daily public parade of majesty. Napoleon expressed in clear terms his expectations with regard to the organization of his everyday living space:

45

44, 45
Charles PERCIER
Pierre-François-Léonard FONTAINE
44. *Civil Wedding Ceremony of Emperor Napoleon and Marie-Louise of Austria in the Galerie at Saint-Cloud*
45. *The Emperor and Empress Receiving Tributes from all Bodies of State on Their Wedding Day, in the Throne Room at the Tuileries*
1810
Paris, Musée du Louvre

46
Antoine-Ignace MELLING
The Palais des Tuileries in Restoration Times
1815 (?)
Paris, Musée du Louvre

"I wish to be housed worthily, but not like the majority of sovereigns, a prisoner and ill at ease under the gilded ceilings of my home; I must have, in the same place, behind the same facade, two different things: firstly, the complete residence of a rich paterfamilias, with all the conveniences of a private man who wants comfort and freedom; and then, the reception rooms and pomp of the representative of a great nation, to which is owed honour and respect."[5]

Armed with this concept of the abode, the Imperial Household defined three principal spaces.[6]

Inspired in principle by the *Grands appartements* of the king and queen at Versailles, established under Louis XIV at a time when the life of a monarch was a continuous spectacle, the first of these spaces was designated the *Grand appartement de représentation*. This State apartment of presentation consisted of a music room, a series of two drawing rooms, or salons, the Throne Room, the Emperor's salon (or Grand Cabinet) and a gallery. This succession of rooms designed for the reception of courtiers provides the backdrop for the progression to the central space of power, leading to the two most prestigious chambers, the Throne Room and the Grand Cabinet.[7] It was the chamberlains' duty to regulate the circulation of each guest according to his or her rank.

The second apartment described in the *Étiquette* was "the Emperor's ordinary apartment," his actual residence, divided into two parts: an *appartement d'honneur*, the official apartment composed of the Guardroom and two salons, and an "interior" apartment, with a bedroom, a study, a back office and a topographical office. This suite of rooms contained a space devoted to receptions and to the Emperor's security, and a space for his private life and work surrounded by his closest secretaries and domestic servants. Few individuals were admitted by the chamberlains into these realms.

Lastly, the Empress also had her own ordinary apartment, divided in the same way between an official apartment (an antechamber, two salons, another room known as the Empress' salon, a dining room and a music room) and an interior apartment (a bedroom, a library, a dressing room, bathroom and back room). It appears that her official apartment was thought of as a place for socializing, and included a room for inviting guests to supper and another for performances.

In March 1806, in a letter to the Household's Intendant-General, the Grand Marshal of the Palace specified that secondary apartments be established in each of the palaces for the other members of the court and the staff invited to reside near the sovereigns:

"The apartments in the imperial palaces, Monsieur, may be divided into the following classes.
- Apartments for the princes
- For the Grand Officers
- For the Officers of the Household
- For junior officers and other persons of this class
- For the butlers, valets of the bedchamber and chambermaids, outriders, etc., for grooms and footmen, polishers, sweepers and workhands, etc.

Most often, the latter are together . . . Another difficulty is that in the same class, some officers may have functions for which they require larger accommodation. Thus, for example, the Grand Marshal of the Palace is often required to represent the Emperor; while another Grand Officer is not usually housed and should not even stay in the palace. It is the same for the lady of honour; it is the same for the officers who have special functions.

The case is the same for the princes. The furnishing for the Princes Joseph and Louis at Fontainebleau will cost two or three times as much as those for the other princes. The same will apply for the same sum that you will fix for the furnishing for the Grand Officers, for example. You should find yourself paying more for some and less for others."[8]

Armed with this advice, Daru drew up regulations for the apartments not used by the sovereigns.[9] It comprised eight classes of accommodation. The first concerned that "which could be suitable for the princes," to consist of an antechamber, a dining room, a salon, a bedroom, a boudoir and a dressing room. The furniture prescribed was of walnut. The second class, for the Grand Officers and ladies of honour, comprised an antechamber, a salon, a bedroom and a wardrobe. The furniture would be of walnut and painted wood. The third class, for ministers, other Grand Officers, the ladies of the robes and the treasurers, consisted of apartments with a salon and a bedroom furnished like those of the second class, together with a wardrobe and a washroom. The fourth class, "for the chamberlains and other civil officers and ladies-in-waiting," were apartments consisting of a bedroom and a washroom. The fifth consisted of a bedroom "for the secretaries, ladies to announce." The furniture was to be of painted wood. The same went for the sixth class, for "ushers, butlers, valets of the bedchamber and chambermaids." As for the seventh and eighth classes, they contained very little furniture—a bunk bed, a table and two chairs for the former, and a trestle bed, a table, a chair and a coatrack for the latter—to house "outriders and coachmen" and "grooms & stableboys."

46

The Tuileries: Centre of power and imperial display

Built in the mid-sixteenth century for queen Catherine de' Medici, the no longer extant Château des Tuileries (**46**) stood to the west of the Palais du Louvre. It was substantially redesigned a century later by Louis XIV, who had a series of lavishly decorated spaces added and expanded the State apartments.[10] But the château suffered after the court moved to Versailles. Rarely lived in by Louis XV or Louis XVI before 1789, it gained a new political importance with the Revolution, when Louis XVI and his family were forced to leave Versailles for Paris.[11] From that date on, because of its location in the centre of the city's institutions, and answerable to them, the Tuileries became the most legitimate residence of the head of state.

Bonaparte moved into the Tuileries shortly after his appointment as First Consul, preferring it to the Luxembourg palace on the left bank of the Seine. The Tuileries had been abandoned in 1792. This choice highlighted Napoleon's determination to build his reign upon the very ruins of the monarchy that had been deposed a few years earlier, to impose his own destiny on the memory of the former kings. "Sad as grandeur,"[12] the expression attributed to him by Roederer when he was moving into the palace sums up his attitude to the appropriation of the Tuileries. He was always ill at ease there, admitting to his brother Joseph, who was leaving to take the throne of Spain, "You'll be better housed than me."[13]

The large panorama picture of Paris by Pierre Prévost (priv. coll.), datable to between 1805 and 1813, offers a rare visual evocation of the Tuileries. Paradoxically, the palace is scarcely visible, as it was left unfinished, and yet the whole picture of Paris is apparent. The artist took as his viewpoint the roof of the Pavilion de Flore, which, because of its height, gives a view of the entire city on both banks of the Seine. What is striking is the way in which the imperial residence is completely immersed in the urban fabric: on one side is the garden, which was open to the public, and on the other was a huge courtyard lined

with private residences. The panorama illustrates the progress of the construction of Fontaine and Percier's major commission for the Emperor, the Galerie Napoléon, between 1806 and 1812 (now the Musée des Arts décoratifs), which would connect the Tuileries to the Louvre. A curious paradox is the absence of the Arc de triomphe du Carrousel, still a mystery, for it was already standing as the principal entrance of the palace from 1808.[14]

The State apartment was situated on the first floor, looking on to the courtyard where the king's *Grand appartement*, chosen by Louis XIV, used to be. The series of linked rooms required by the *Étiquette* ran from the Salon of the Marshals, the Salon of the Grand Officers, the Salon of the Princes (also called the Salon of Peace), the Throne Room, the Grand Cabinet and the Gallery of Diane. On the garden side was the Emperor's "ordinary apartment," extending from the apartment of honour to the south and the "interior apartment" to the north. The doors of Napoleon's bedroom opened directly on to the Grand Cabinet, giving him rapid access to the State apartment on Thursday and Sunday mornings, when the ceremonies of the levee were held there–on the other days of the week the levee took place in the apartments of honour.[15] On the ground floor, on both sides, were the Empress' ordinary apartment, regilded in 1808 for Josephine, and an apartment reserved for the Grand Marshal, in the north wing, before it was allotted to the King of Rome. The space reserved for the sovereigns therefore occupies both floors of the south wing. The Pavilion de Flore, on the Seine side, held the department of the Table (*service de la Bouche*) and the Emperor's secretariat, in which at the start of the reign had been the apartment put at the disposal of the pope during his 1804–5 visit.[16]

The north wing held in a single building numerous spaces designed by Fontaine and Percier beginning in 1805.[17] It contained the ceremonial staircase and the spaces reserved for the Council of State; the assembly room was decorated with a painted ceiling by Gérard depicting the glorious victory of Austerlitz. Similarly, for the chapel, built by Percier and Fontaine, an altarpiece was

47

47
Étienne ALLEGRAIN
Bird's Eye View of the Château, Lower Gardens and Town of Saint-Cloud (detail)
About 1675
Musée national des châteaux de Versailles et de Trianon

48
Pierre-Paul PRUD'HON
Wisdom and Truth, Descending to Earth, to Dispel the Darkness That Covers It
About 1799
Paris, Musée du Louvre

commissioned in 1806 from Perrin, *France, Supported by Religion, Dedicates the Captured Enemy Standards to Our Lady of Glory* (church of Notre-Dame du Val-de-Grâce). Next came the large theatre and ballroom, designed by the same two architects (280-282). The Pavilion de Marsan completed the whole. On the ground floor of the pavilion was the residence of the Grand Marshal after 1811, and on the first floor the apartments were allocated to the Children of France.

Not far from the Tuileries, the Louvre was also regarded as an imperial residence, even though some of its rooms were used as the galleries of the Musée Napoléon. It was here that, as a palace, the religious service of the marriage of 1810 was organized, in the Salon Carré. The failure to appoint a new archbishop of Paris, the result of a falling out with the pope, had made it impossible for the ceremony to be held in Notre-Dame.

The secondary residences

In addition to the Tuileries, the list of imperial palaces consisted of inherited residences mostly in the former royal domain, in the condition in which Louis XVI had left them after the fall of the monarchy.

Saint-Cloud, southwest of Paris, was the Emperor's principal secondary residence, complementing the Tuileries, as it was not far from the capital. The estate had existed since the sixteenth century, but under the Ancien Régime it was a princely domain, not a royal one. The young Louis XIV purchased it to give to his brother the duc d'Orléans (1658), who had it transformed into a sumptuous residence (47) with a magnificent park that included an enormous waterfall. It was repurchased by Louis XVI to give to Marie-Antoinette, and redesigned by the queen's architect, Richard Mique. It is said to have been here, on September 1, 1785, that Louis XVI signed the lieutenant's commission for a young Corsican of minor nobility named Napoleone di Buonaparte.[18]

Saint-Cloud was the setting of the coup of 18 Brumaire (November 9, 1799) that brought Bonaparte to power, the deputies of the Directory having been induced to meet there in order to be better manipulated by the conspirators. In September 1801, the First Consul opted to establish his secondary residence there, and commissioned a year of construction carried out under the direction of the architect Fontaine.[19]

It was also at Saint-Cloud that Bonaparte was informed on May 18, 1804, of the *sénatus-consulte* that transformed the French republic into an Empire. For the new Emperor, the château took on such importance that he initially decided to have a Throne Room built there, as in the Tuileries. The furniture for it was made by Jacob-Desmalter based on a design by Percier and Fontaine, who also designed the painted ceiling. The central work was a painting by Prud'hon that had been there since the Consulate, *Wisdom and Truth Descending to Earth to Dispel the Darkness That Covers It* (48).[20] The idea for a Throne Room at Saint-Cloud was finally abandoned in favour of one at Fontainebleau, and the room became the Grand Cabinet.[21] In this palatial context, the decoration of the State apartments featured, as at the Tuileries, numerous elements handed down from the seventeenth and eighteenth centuries.

It was also at the Palais de Saint-Cloud that on April 1, 1810, the civil marriage contract of Napoleon and Marie-Louise was signed (44), ahead of the religious service celebrated some days later at the Louvre.

Saint-Cloud, much loved by the Empresses as well as the Emperor, saw Napoleon for the last time in November 1813. It was within its walls that the Allies, two weeks after Waterloo, signed the peace treaty on July 3, 1815.[22]

The following apt expression is timeless: Napoleon considered Fontainebleau "the real abode of kings, the house of ages." He clearly had great affection for this immense centuries-old château, full of memories of Philippe le Bel, Francis I, Henri IV and Louis XV, when the Imperial Household took possession of it.[23] The decision to favour Fontainebleau for the court's fall season came with the Empire: the First Consul, preferring Saint-Cloud as his secondary residence, had initially installed the École spéciale militaire at Fontainebleau. It was there that on November 25, 1804, Napoleon received pope Pius VII, who had come from Rome to attend his coronation. In 1805, he decided to completely refurbish the château, mainly to create or restore several dozen apartments intended for princes, courtiers and servants.[24]

The status of the Malmaison estate (51) is a special one, for this small château to the west of Paris was already the personal property of the Bonapartes before they rose to power. As it happened, this was not a question of the appropriation of a royal residence: it was Josephine who, in Napoleon's absence during the Egyptian campaign (1798), negotiated the purchase of this estate, which she had coveted for some years, presenting the general with a *fait accompli* on his return to France. Percier and Fontaine, then Morel, Thibault and Vignon, and finally Berthault were commissioned to completely redesign the decoration of the house. At first an ambitious project was envisaged, since Bonaparte had just been appointed First Consul, before considerations of economy arose. A theatre, a music room, a painting gallery, greenhouses and a sheepfold were built for Josephine. Malmaison provided a pleasant way of life that allowed the couple to forget the weight of their responsibilities. Family and friends were received

in an informal atmosphere, from which Bonaparte must often have withdrawn to his library and devoted himself to work.[25] Aware that Malmaison was more the private manor of a powerful individual than the secondary residence of a prince, he increasingly favoured Saint-Cloud as he moved closer to the throne. The installation of a Grand Cabinet in front of his library was one of the indications that this residence was to be included among the imperial palaces.

Malmaison continued to be Josephine's home. After their divorce (December 1809), Napoleon gave the property to her, and would visit her discreetly from time to time. It was there that she died suddenly on May 29, 1814. After his second abdication (June 22, 1815), Napoleon returned to Malmaison one last time and spoke to his remaining followers before going into exile.

Built in 1719-20 for the comte d'Évreux in the as yet undeveloped neighbourhood of the Champs-Élysées, the elegant mansion known since 1797 as the Élysée had belonged to the marquise de Pompadour, mistress to Louis XV. At the start of the Empire, it was acquired by prince Joachim Murat, grand duc de Berg et de Clèves and Napoleon's brother-in-law, to serve as his residence not far from the Tuileries. Widespread construction and refurbishment projects were undertaken.[26] In 1808, Murat was made king of Naples, an outstanding gift, but one that required him to relinquish to the Emperor all of his possessions in France. Napoleon consequently inherited the mansion that became the Élysée-Napoléon. It would serve as a residence for Josephine in 1808 (October-December) in the absence of the Emperor, who was conducting the campaign in Spain, while her apartments in the Tuileries were under construction. When Napoleon returned to join her, the couple appreciated the tranquillity offered by the Élysée, located between the court and the garden, unlike the Tuileries, where their life was more exposed to the public. It also served to lodge foreign royalties on official visits to Paris.

After their divorce, Napoleon granted Josephine the full enjoyment of the Élysée as well as Malmaison. It soon became apparent that the woman who preserved her title of Empress could not continue to live in Paris so close to the Tuileries and to the new sovereign lady Marie-Louise. The palace was finally exchanged in February 1812 for the more distant château of Laeken, near Brussels.

During the Hundred Days, Napoleon chose to reside in the Élysée rather than at the Tuileries. He returned there briefly after Waterloo to sign his second abdication.

The Château de Compiègne (**49**) in the north of France, only just completed when the Revolution of 1789 broke out, was under the Consulate a school of arts and crafts, which Bonaparte visited a few months before the proclamation of the Empire. The decision to include it among the list of imperial palaces sparked an ambitious restoration program as of 1807, under the direction of Berthault, Josephine's architect at Malmaison. The first guests in the palace, from June to September 1808, were the Spanish royal family, forced to abdicate and driven into exile in France. The apartments designed in the eighteenth century by the architects Jacques and Ange-Jacques Gabriel for the family of Louis XVI were later taken over by the imperial family, while work continued on the construction of a ballroom, which was not completed until after the Restoration. Here again, a growing number of apartments were provided for princes, Grand Officers and servants in anticipation of long sojourns far from Paris devoted to the hunt. The decoration of the imperial apartments was spectacular (**50**). It was here that Napoleon welcomed Marie-Louise on her arrival in France: it was the first palace of which the new Empress took possession (March–April 1810). The couple returned to Compiègne the following year, in September, with the newborn King of Rome, and later in November. Between November 1813 and January 1814, the château was put at the disposal of the Emperor's brother Jerome, the dethroned king of Westphalia, at the moment when the Europe of Napoleon's family and appointees was crumbling.

From the earliest months of the Empire, Napoleon had intended to restore the estate of Trianon in the park of Versailles. His initial idea was to place the Grand Trianon (**52**) at the disposal of his mother and to keep the Petit Trianon for his sister Pauline Borghese. Madame Mère hated the estate, finding it uncomfortable, and Pauline soon tired of it as well. In 1809, the order was finally given to redesign the estate for the imperial couple, to create a simple and tasteful place of leisure (**69B**). Napoleon retired to Trianon after signing the divorce papers, while Josephine travelled to Malmaison. In 1812, when he set off on the Russian campaign, his private apartment was completely refurbished. For Marie-Louise, the Petit Trianon was thoroughly restored (**53**), as was the hamlet built in 1782-83 for her great-aunt Marie-Antoinette (**69A, C, D**). The new Empress was especially fond of the latter, finding in it something of the happy atmosphere of the Austrian homes of her childhood.[27]

The Château Neuf de Meudon, built by Hardouin-Mansart between 1706 and 1709 late in the reign of Louis XIV, was added to the list of imperial palaces in 1807, and was at one time considered as a residence for Madame Mère. The Household undertook to refurbish it between 1810 and 1811, to make it into the residence of the Children of France, after the birth of the King of Rome on March 20, 1811. The little prince was installed there the following year with

49

50

51

51
Auguste GARNERAY
View of Malmaison: Facade of the Château on the Park Side
Between 1812 and 1823
Rueil-Malmaison, Musée national des châteaux de Malmaison et Bois-Préau

52
Antoine-Charles-Horace, called Carle VERNET
Jean-Joseph-Xavier BIDAULD
Break of Cover in front of the Grand Trianon
1810–11
Paris, Musée Marmottan Monet

his governess Madame de Montesquiou, wife of the Grand Chamberlain, her under-governesses and physicians. This was the year of the Russian campaign, and in the absence of her husband, Marie-Louise lived there as well to enjoy the company of her son. The notion of establishing at Meudon the Household of the Children of France involved the creation of a place for the education of the elder children of the rulers of the satellite states of Napoleonic Europe, which had been entrusted to the Emperor's brothers. The young cousins were to occupy the princely apartments organized around the state apartment meant for the King of Rome, and would benefit from the same education, which served the interests of France.

The Château de Rambouillet, thought to be somewhat cramped, was in the list of palaces to serve as a hunting lodge. In March 1814, Marie-Louise, as the queen regent, sought refuge there with her son, fleeing Paris as the coalition troops approached. Other residences of lesser importance that swelled the list were the ancient episcopal palaces of Strasbourg and Bordeaux, and the Château de Marrac, close to Bayonne.

Some foreign residences were added as a result of Napoleon's annexations of territory for France in the course of his reign. This was the case with Laeken, near Brussels, where he stayed in September 1804, and also with the principal Italian cities that had been annexed by the Empire. In Turin, the Emperor stayed at Stupinigi, and in Florence at the Pitti Palace, where his sister Elisa (**55**) reigned in his name. In 1810, when he confiscated Holland from his brother Louis, the palaces of Amsterdam, Het Loo, Haarlem, Zoesdyck, Utrecht and Antwerp were added to the list.[28]

Rome was a special case. The city, seized in June 1809 at the expense of the pope, enjoyed such high prestige throughout Europe at that time that it was regarded as the second capital of the Empire. The imperial palace that Napoleon chose there was to be refurbished with incomparable splendour. This was the pontifical palace of the Quirinale, which the French rechristened Monte Cavallo (**54**). The extensive construction carried out from 1811 to 1814 transformed it into an enormous palatial complex worthy of the successor to the Caesars and intended to obliterate the memory of Pius VII.[29] The magnitude of the artistic commissions came as a boon to the group of painters moving in the circle of the Académie de France in Rome: Ingres, in particular, who was asked to execute two canvases for the ceilings of the Empress' second salon (*Romulus, Defeater of Acron*, 1812, Musée du Louvre, Paris) (**93**) and the Emperor's bedroom (*The Dream of Ossian*, 1813) (**94**).[30] Napoleon never had the opportunity to enjoy his palace in Rome.

Finally, it must not be forgotten that Napoleon, Emperor of the French, was also the King of Italy, and as such had royal residences and palaces in Milan, Monza, Brescia, Modena, Stra, Venice, Mantua, Bologna and Parma.[31]

Travel palaces and palaces of cloth

Moving about on his military campaigns, Napoleon required that the configuration of his accommodations be continually adapted to his lifestyle and to palace regulations. One of the responsibilities of the Household was to ensure, at all times and places, respect for the *Étiquette* and the organization of the spaces surrounding the Emperor's person. Small châteaux requisitioned to serve as lodgings presented real headaches in terms of arranging the necessary series of State salons as well as spaces for work and repose comparable to those at the Tuileries. Pont-de-Briques, a small manor house near Boulogne-sur-Mer, housed the First Consul and then the Emperor for almost twenty-four days between 1803 and 1805.[32] Preserved in the archives of the Grand Marshal of the Palace in the Bibliothèque nationale, a map of the small Château de Querqueville in Normandy, chosen to lodge Napoleon in May 1811, shows the efforts expended in circumstances such as these (**57**).

The same was true in cities conquered or occupied by his forces. As victor, Napoleon frequently moved into the palaces of fleeing enemies, which were reorganized for the duration of his stay. Such was twice the case at Schönbrunn, near Vienna, first in November and December 1805 before and after Austerlitz, then in 1809, in May, before the Battle of Essling, and in June, before Wagram. It was the same case for Potsdam, not far from Berlin, where Napoleon moved into Sanssouci after defeating Prussia at Jena (October 14, 1806).

If not the most luxurious, certainly the most remarkable of the imperial palaces were undoubtedly those that Jehanne Lazaj aptly dubbed "palaces of cloth," which were set up to provide the bivouacking Emperor with a cluster of tents composing an ordinary apartment worthy of his expectations (**56**).[33] These were provided with folding furniture made by the locksmith Desouches[34] and the cabinetmaker Jacob-Desmalter.

Two large-scale projects that were never completed

Preserved by descendants of the architect Fontaine, a collection of watercolours bound in an album testify to an ambitious project for the refurbishment of the Château de Versailles for the use of Napoleon and Marie-Louise. Dated 1810 and long attributed to Percier and Fontaine before Christian Baulez suggested that it might be a proposal by Jacques Gondouin,[35] these plans give a clear

54 55

picture of how a place as full of memories of royal identity as Versailles might be adapted to the organizational regulations of an "imperial palace." The decision to make Versailles habitable, damaged as it was after a decade of revolution, entirely emptied of its original furniture and left derelict, seems to have been taken relatively early in the reign, before the astronomical cost had proved disheartening. Fontaine and Gondouin each put forward their visions of how to redesign the château. Fontaine's proposal called for a major transformation, Neoclassical in style, of all the facades (58). Numerous orders of silks for the refurbishment of the imperial apartments and those of dignitaries were even sent to the manufactories in Lyon.[36]

The Gondouin album invites the reader to take a delightful stroll through the *Grands appartements* of Versailles transformed into the salons of the Empire. Most of the ceilings have been preserved and the king's *Grand appartement* on the first floor became the "State apartment of presentation," laid out as follows: antechamber (Salon of Abundance), concert hall (Salon of Venus), first salon (Salon of Diana), second salon (Salon of Mars), Throne Room (Salon of Mercury), the Emperor's salon or Grand Cabinet (formerly the Salon of Apollo), and the Salon of War opening on to the Hall of Mirrors (59). The Emperor's salon and the Throne Room are the only rooms shown furnished: the seat of the throne is of a type similar to those found in the Grand Cabinet, corresponding to the usual custom at the Tuileries, although the very Louis XVI style of these chairs with oval backs, like the console tables with lion-head protomes and wreaths of carved flowers, are surprising in the year 1810. As Christian Baulez remarks, it is singularly unlike the taste of Percier and Fontaine.[37] In the Throne Room are two of the torch holders designed by Gondouin in his youth for the Hall of Mirrors and executed by Babel in 1769, which had been deposed by the Mobilier impérial in the Throne Room at the Tuileries (14).

Similarly, the former queen's apartment became the Empress' ordinary apartment, encompassing "a hall for banquets, balls and concerts," a first salon (formerly the queen's Guardroom), a second salon (antechamber of the *Grand Couvert* banquet hall), a salon for the Empress (Grand Cabinet of the queen), the Empress' bedroom (the queen's bedroom) and the Salon of Peace giving on to the gallery (59F-I).

It was decided to preserve for the Emperor the tradition of a State bedroom, the one used by Louis XIV having been maintained in the centre of the château by his successors Louis XV and Louis XVI, who did not sleep there but rather in an interior apartment on the first floor. Napoleon's interior apartment was meant to be on the ground floor underneath that of the Empress,

in the former apartment of the dauphin and dauphine. Gondouin designed it with a study, a bedroom, the Emperor's salon, a second salon, a first salon and a Guardroom.

The juxtaposition of Louis XIV-style decors with large paintings or hangings celebrating glorious episodes from the Napoleonic epic provided a masterly illustration of the ideological strategy that made his palace both the legacy of an old monarchical memory and the starting point for a new way of reigning and making history. For example Gondouin kept the bust of Louis XIV by Bernini in the first salon, the former Gallery of Diana.

At the same time, in the context of his marriage in 1810, Napoleon convinced himself of the need to build an entirely new palace in Paris, which would free him from the impression of being a guest in the old residences designed for other monarchs at a time when he foresaw the possibility of an heir. This notion is even more interesting in that it visibly contradicts the bias previously described in the restorations planned for Versailles and his apparent satisfaction with inhabiting Fontainebleau, given that it was "the house of ages." As Jean-Philippe Garric notes, in 1806, the Emperor had in mind a plan, soon abandoned, to transfer the capital of the Empire from Paris to Lyon and to build a totally new residence on the banks of the Rhône.[38]

Napoleon's thoughts on the new palace planned in 1810 were confided to Fontaine, seconded as always by his associate Percier. The pair had the precedent of Versailles as a model, built to offer Louis XIV in his own day a dwelling totally suited to himself. Napoleon chose as a site the hill of Chaillot in the western part of Paris, on the right bank of the Seine facing the Champ-de-Mars. It was to be a huge, rectangular building with a hundred-metre-wide principal facade. Located at the top of the hill and dominating Paris, it would extend downwards in terraces at different levels towards the river (60,61). Its park would encompass the whole of the neighbouring Bois de Boulogne. For the design of the imperial apartments, the model was to be Versailles, with two parallel apartments for the Emperor and Empress on the first or "noble" floor. The exact opposite of the Tuileries, surrounded by Paris, the "palace of the King of Rome"–the name given to the project after the birth of the child in March 1811–would dominate the capital. The elevated position recalled in principle the legendary memory of the residences of the Caesars on the Palatine Hill in Rome, dominating the Forum. Indeed, Napoleon intended to build below the hill a truly administrative city, a new properly Napoleonic Paris organized around institutional palaces for the Archives impériales, the Arts, the University and the Grand Master.[39]

56
Antoine-Pierre MONGIN
*Napoleon's Bivouac near the Château
d'Ebersberg, May 4, 1809* (detail)
1810
Musée national des châteaux de Versailles
et de Trianon

57
DEPARTMENT OF THE GRAND MARSHAL
OF THE PALACE
**Annotated plan of the Château de
Querqueville for the Emperor's stay**
1802–14
Paris, Bibliothèque nationale de France

58

But it was too late in the reign to achieve this dream of an imperial Paris crowned by a new palace. After 1812 and some military reversals, reality set in. The gigantic scale of the project and indeed its very nature were rapidly reconsidered, first in terms of a narrower palace (62), and later, in 1813, what Napoleon described to his architects as scarcely more than a "little Sanssouci, a convalescent retreat." The idea of a modest residence for retirement is interesting in itself. Jean-Philippe Garric sees in it the signs of a possible plan, after the defeat at Leipzig (October 16–19, 1813), to abdicate in favour of his son, which might have satisfied the unanimous demands of Napoleon's European enemies.[40]

The palace of the King of Rome would remain a palace only on paper, an exciting illustration of the mirage of a new dynasty established at the head of France. In its projected place there stand today the Art Deco facades of the Palais de Chaillot (1937), facing the Eiffel Tower.

As consistent and rigid in its protocol as it was multifaceted and various in its topographical, architectural and historical realities, the corpus of the Emperor's palaces presents a vast field for the interpretation of the manner in which Napoleon intended to stage his lifestyle and organize the conditions under which he would exercise his power and monarchical authority. At times happy to take over the dwellings of deposed kings, at times dreaming of new residences fashioned for him alone, the Emperor left an indelible mark on the heritage of France. Even today, the remains of that immense list of palaces which have survived the turbulent history of the twentieth century testify to that fact. Now turned into museums, Fontainebleau, Compiègne and Malmaison—and to some extent the Pitti Palace, the Palace of Colorno near Parma, and the Correr Palace in Venice—continue to demonstrate, two centuries after its fall, the great spectacle of the imperial and royal adventure.

58
Pierre-François-Léonard FONTAINE
*Proposed Design for the Grand Projet to
Reconstruct the Palais de Versailles, Side of the
Entrance Courtyards*
About 1811–13
Musée national des châteaux de Versailles
et de Trianon

59A

59B

59C

59D

59E

59F

59G

59H

59

Attributed to Jacques GONDOUIN
Designs for the Palais de Versailles
1810
Private collection

A. Second floor, State apartment:
 Antechamber–Concert Hall
 First floor: *Antechamber of the Ambassadors*
B. Second floor, State apartment: *First Salon–*
 Second Salon
 First floor: *Hall of the Ambassadors–Dining*
 Room–Antechamber
C. Second floor, State apartment: *Throne*
 Room–Emperor's Salon
D. Second floor, State apartment: *Salon of War*
E. Second floor: *Ceremonial Hall–Grande Galerie*
 First floor: *Vestibule*

F. Second floor, the Empress' ordinary
 apartment: *Guardroom–Hall of Banquets,*
 Balls and Concerts
G. Second floor, the Empress' ordinary
 apartment: *First Salon*
 First floor, the Emperor's ordinary apartment:
 First Salon
H. Second floor, the Empress' ordinary
 apartment: *Second Salon–Empress' Salon*
 First floor, the Emperor's ordinary
 apartment: *Second Salon–Emperor's Salon*
I. Second floor, the Empress' ordinary apart-
 ment: *Empress' Chamber–Salon of Peace*
 First floor, the Emperor's ordinary
 apartment: *Emperor's Chamber–Study*

59I

60A

Coupe sur la ligne A B.

Coupe sur la ligne C D.

60B

Coupe sur la ligne G H.

60C

Coupe sur la ligne E F.

60D

60–62
Pierre-François-Léonard FONTAINE
Design for the King of Rome's Palace
60. First version: sections, elevations
61. First version: bird's eye view
62. Second version: bird's eye view
About 1812
Paris, École nationale supérieure des
Beaux-Arts

61

62

THE TABLE OF THE IMPERIAL, LATER ROYAL, PALACES

Eager to expand the production of the Sèvres porcelain manufactory and demonstrate the potential and the technical skills of its artists and artisans, director Alexandre Brongniart convinced Napoleon and the Imperial Household of the desirability of creating porcelain furniture. Technical tours de force, these pieces were only intended to furnish the official spaces of the imperial palaces. The Sèvres artists began to design tables and cabinets covered in porcelain plaques in various shapes, set in gilded bronze mounts on a hidden oak framework. The process turned out to be extremely expensive and time-consuming, taking several years to complete a piece. Only a few rare examples were ever executed under the Empire.

This table (63) is the last of a series that was to comprise five tables. Named the table "of the Palaces" or "of the Residences," it is now privately owned.[1]

The project of the Sèvres tables actually commenced towards the end of the Consulate period, in 1803, beginning with the table of "the Seasons" (1803-6), painted by Nicolas-Denis Delafosse, which delighted Napoleon when it was delivered, and found its way into Josephine's apartments at Fontainebleau (64).[2] In 1806, the manufactory was commissioned to execute the table "of the Great Commanders," celebrating the great military heroes of antiquity depicted by Louis-Bertin Parant and Antoine Béranger (65), and the table "of the Marshals" or "of Austerlitz," after designs by Percier and painted by Isabey, incorporating portrait medallions of the leading marshals and generals around a standing portrait of Napoleon in ceremonial costume (66).[3] This table was installed at the Tuileries, in the Empress' apartment. Awaiting assignment, the table of the Great Commanders remained in the manufactory and was finally gifted to the king of England, George IV, by Louis XVIII.[4] The table "of Austerlitz" was installed in the apartments of the Empress at the Tuileries. A fourth table, intended to celebrate the collections of antiquities in the Musée Napoléon, was begun under the Empire, but was quite different by the time it was completed, under Louis XVIII. In 1811, work began on the table of the "Palais," probably as a replacement for an immense model of the Palais des Tuileries in biscuit, commissioned by Napoleon but never executed.[5]

The decoration of the tables of the Great Commanders, Austerlitz and the Palais are all composed in the same manner, with a medallion in the centre of the tabletop surrounded by satellite medallions. In the table of the Palais, a view of the Tuileries occupies the centre, while eight other views illustrate the variety of royal residences at the heart of the great Empire. The commission specified images of Saint-Cloud, Fontainebleau, Compiègne, Trianon and Rambouillet, in addition to two Italian palaces, Stupinigi in Turin and Monte Cavallo in Rome, as well as the Château de Laeken near Brussels, the last three being the result of the considerable expansion of Napoleonic France to 130 domains. It was the landscape artist Jean-François Robert who addressed the task of painting these scenes: his views of the Tuileries and Saint-Cloud were taken from those he had painted the year before on one of the vases given in 1811 to king Jerome and the two coolers of the set gifted to the emperor of Austria. The artist sketched Fontainebleau, Rambouillet and Trianon in the course of the year 1812.[6]

The representation of these palaces was accompanied by familiar scenes or charming pastimes. It is the Imperial Household that is celebrated here, most notably the everyday services provided to Napoleon in peacetime by the Grand Marshal of the Palace, the Grand Equerry and the Grand Master of the Hunt. This may explain the choice of design for the wide base of the table, a large, stylized palm, the nutritive tree symbolizing the institution that is incorporated in the embroidery on the officers' court attire.

The table was almost completed by the spring of 1814, when Napoleon abdicated for the first time. The return of the Bourbons resulted in the cancellation of most manufactory products that featured his likeness or the symbols of his fallen regime. But this object, which was ready for its first firing, was spectacular, too beautiful to be destroyed, and the sums of money already committed too great. So the Household of Louis XVIII, which succeeded the Imperial Household, decided to continue its production, but required the decoration to be considerably changed. The views of the palaces beyond the frontiers of France were removed, as the country had surrendered all the territories conquered by Napoleon. They were replaced by views of the châteaux of Saint-Germain, Versailles and Meudon. Naturally, the figures too had to be changed: the features of Napoleon in hunting costume, accompanied by his family, were scratched out and replaced by those of the duc de Berry, Louis XVIII's nephew, a popular member of the royal family. The gilded backgrounds were decorated with the royal arms of France bearing the fleurs-de-lys, the monogram with the double L and the collars of the orders of the Saint-Esprit and Saint-Michel, which replaced the eagles, the Ns and the Legion of Honour of the original commission.

The table was completed in April 1817. It would be gifted by Charles X, the successor of Louis XVIII and father of the duc de Berry, to the king of Naples Francis I, the duc's father-in-law, about 1825.

SYLVAIN CORDIER

63

63
SÈVRES IMPERIAL MANUFACTORY
Tabletop decoration painted by Jean-François ROBERT
Table called "of the imperial palaces," later "of the royal palaces"
1811–14, altered between 1814 and 1817
Private collection

Opposite:
Tabletop decorated with views in medallions of palaces

64

65

64
SÈVRES IMPERIAL MANUFACTORY
Guéridon table called "of the Seasons"
(tabletop)
1803–6
Château de Fontainebleau, Musée Napoléon Iᵉʳ

65
SÈVRES IMPERIAL MANUFACTORY
Tabletop decoration painted by Louis-Bertin
PARANT and Antoine BÉRANGER
Table called "of the Great Commanders"
(tabletop)
1806–12
London, Collection of H. M. Queen Elizabeth II

66
SÈVRES IMPERIAL MANUFACTORY
Design by Charles PERCIER
Tabletop decoration painted by Jean-Baptiste
ISABEY
Bronze work by Pierre-Philippe THOMIRE
Table called of Austerlitz, or of the Marshals
(tabletop)
1808–10
Commissioned by the Emperor in 1806
Rueil-Malmaison, Musée national des châteaux
de Malmaison et Bois-Préau

FIVE LARGE FOLIOS

The large folios dedicated to the Empire residences do not all share the same binding. Only four appear to be contemporaneous. These four bear the mark of the binder Tessier on their cover page. The volume dedicated to Saint-Cloud, also from the Empire period, only has a small mark on the back: "N° 45 / Rue de la Harpe / TESSIER / Relieur Doreur / A PARIS." The binding is similar, except for the back that presents alternating monograms and eagles. The folio entitled *Les deux Trianons* has a less ornate binding, without a border of oak leaves, and without a papermaker's mark.

None of them is dated. Jean-Pierre Samoyault places them about 1812, "under the editorship of the architect Fontaine."[1] Under whose auspices were these plans made? Since September 1811, the duke of Cadore was Indendant-General of the Imperial Household and it was certainly upon his initiative. The Fontainebleau, Compiègne and Saint-Cloud volumes take into account the most recent developments. Thus, for Fontainebleau, we can see the Emperor's interior apartments, requested at the end of a stay in 1807, and the design of the gate in 1810.[2] The Compiègne volume (68B) illustrates the embellishments made for the marriage to Marie-Louise, visible in the arrangement of the new Empress' apartments and the creation of a space for the ballroom in 1809.[3]

The most significant of the folios is definitely the one dedicated to Paris and its outbuildings, not only to the Palais des Tuileries, in two volumes. The grounds and outbuildings of the main imperial residence were taken into account, as were the buildings, like the intendance general of the Imperial Household (Hôtel du Châtelet, Rue de Grenelle), the pages' residence (Rue Fromanteau) (67C), the Imperial Stables (Hôtel de Longueville), the secretary of state's residence (Hôtel d'Elbeuf),

that of Charles-François Lebrun, imperial treasurer (Hôtel de Noailles, Rue Saint-Honoré), that of the prince of Benevento (Hôtel de Matignon, Rue de Varennes) (67B), as well as the estates of Mousseaux (Monceau), Neuilly (Murat), Bagatelle, Le Raincy and the Crown forests around Paris, including Vincennes. On December 11, 1811, Talleyrand sold the Hôtel Matignon to the Domaine extraordinaire, while retaining his enjoyment of it, so he could continue to receive guests "in order to determine the capital's state of mind."[4] It is therefore certain that at least this plate was produced after the date of sale. The plans for the Tuileries provide rare evidence of the layout under the Empire. The folio spread dedicated to the palace's storeys shows the difficulties facing its occupation. The auditorium prevented any and all connections between the apartments and the Marsan Pavilion, which, since 1811, had been turned over to the Children of France.

The book on the Trianon bears the title *Plans des Deux Trianon*. Even though the "Imperial Palace" is constantly mentioned, it is not precisely contemporaneous to the preceding series. His offering it to Marie-Louise (69A-D) attests to the Emperor's wish to impose his image of his new dynasty on Marie-Antoinette's former estate. This was the direction newly taken by the imperial regime since Napoleon's marriage to an Austrian archduchess, which still included the Trianon estate in the Emperor's train of thought, at the moment when he left Josephine the enjoyment of Malmaison. The elevations of the interiors of the hamlet, restored at the behest of the Emperor the year of his marriage and used by the new Empress in July and August 1811, can be seen; in particular, it is possible to make out the painted silks in the salon, provided by Vauchelet on June 5, 1811 (69A), the arabesque decoration with its yellow ground and all the elements sculpted by

Boichard, in white marble from the dairy, in 1811 (69C).[5] Is it possible to narrow down the date? The book shows the absence of the two manufactories destroyed in March 1810,[6] as well as the renovations of 1811, carried out by Fontaine and Trepsat. In the Grand Trianon, the Emperor's study, created by combining two rooms in September 1812, does not appear.[7] Moreover, there is a bit of confusion that needs clearing up. Although the guardhouse and the mill retained their names before the Empire, the boudoir was called the *maison du curé* [curate's house].[8] In use under the Empire, the manufactory known as the "boudoir" retained this name when Marie-Antoinette's dovecote became the curate's house. The book identifies the boudoir as the "curate's house" and the curate's house as the "presbytery"! This seems to attest to the draftsmen's hesitations before the furnishings were arranged, while the inventory of 1810, continued the following year, put it to good use. Was this the beginning of developments in the latter half of 1811? It may be that the Trianon register predates those bearing the Tessier mark, and that he required extending this type of formatted record to all of France's imperial residences. The dynastic foundation would be the reason for this topography.

This group of books solidifies the Napoleonic State's takeover through these topographical renderings, in line with the plans consulted by the Emperor. It makes it possible to measure the scope of the Napoleonic vision in the development of his official residences following the wedding in 1810 and birth of the King of Rome in 1811.

JEAN-JACQUES GAUTIER

Coupe sur la ligne A.B.

67A

Albums of the imperial residences (67-69)
Edited by Pierre-François-Léonard FONTAINE
(1762-1853)
Folio albums
About 1811-12
Paris, Mobilier national

67
Paris et dépendances
A. **Section of the Tuileries**
 Second floor: Gallery of Diana in the State apartment and the Grand Salon in the Emperor's ordinary apartment
 First floor: Concert hall and second salon of the Empress' ordinary apartment
B. **Section of the Benevento mansion, residence of the Grand Chamberlain (1804-9)**
C. **Section of the page's mansion in Paris**
D. **Section of the Tuileries**
 Imperial chapel and premises of the Council of Sate
E. **Section of the Tuileries**
 Performance hall
F. **Section of the Tuileries**
 Second floor: Hall of Marshals
 First floor: Vestibule
G. **Section of the Tuileries**
 Marsan Pavilion: Salons leading to the quarters of the Children of France and the apartment of the Grand Marshal of the Palace

Coupe sur la ligne a b

Hôtel de Bénévent.

67B

Hôtel des Pages. Coupe sur la ligne a b.

67C

Coupe sur la ligne C D.

67D

Coupe sur la ligne E F.

67E

Coupe sur la ligne I K.

67F

Coupe sur la ligne G H.

67G

Fontainebleau.

Plan général du palais, du parc, des jardins et des dépendances.

68A

Plan général du palais de
Fontainebleau.
Rez de chaussée.

68B

68C

68
Fontainebleau
A. "General plan of the palace, park, gardens
 and outbuildings"
B. "General plan of the Palais de
 Fontainebleau. First floor"
C. Fountain Courtyard

69
Plans des Deux Trianon
A. "Hamlet at the Petit Trianon"
B. "Plan of the Grand Trianon"
C. "Marlborough Tower and Dairy"
D. "Petit Trianon's imperial park. Music room,
 Corinthian Temple, French pavilion"

69A

69B

69C

69D

FONTAINEBLEAU,
"THE HOUSE OF AGES"
ATTACHED TO THE
IMPERIAL HOUSEHOLD

CHRISTOPHE BEYELER

"That is the real abode of kings, the house of ages; it is not, perhaps, strictly speaking, an architectural palace; but it is, unquestionably, well calculated and perfectly suitable. It was certainly the most commodious and the most happily situated in Europe for a sovereign."
–Napoleon to Las Cases, *Mémorial de Sainte-Hélène*, August 4, 1816

A royal residence since the thirteenth century, the Château de Fontainebleau, which had undergone considerable renovations between 1786 and 1788, was struck hard by the Revolution. Louis XVI no longer visited, since he was being held in the Tuileries, its Renaissance bronzes collected by Francis I were gone, as they were melted down or sent to the Muséum central des arts at the Louvre, and its furniture was dispersed through public auctions. It had also been given various other vocations, including granary and prison. What purpose could this immense palace with its many courtyards possibly serve during the time of the Terror? Under the Directory, there was a time when it was thought that the Jeu de paume court could be used by the Conseil des Anciens, while the École centrale of the département of Seine-et-Marne set up shop in 1796 in the "new wing" of the Cheval Blanc Courtyard before being evicted by the First Consul. Bonaparte chose instead to install the École spéciale militaire in this "house in a state of extraordinary degradation and abandon,"[1] as Fontaine put it in his *Journal* entry of March 11, 1803. A few weeks after the institution of the Empire, he arrived for an inspection: "the Emperor was received as though at army headquarters,"[2] Fontaine noted on July 14, 1804. Would the new sovereign have any other plans for this place he came to describe as "the house of the centuries"?

Château de Fontainebleau, the stage for imperial pageantry
Fontainebleau, in addition to the Tuileries in Paris and Saint-Cloud, was one of the principal components of Napoleon's system of representation at the height of his power. Having revived the monarchical State, he naturally took over the former Crown's buildings, which he adapted to his purposes. Everybody, from his French subjects to the princes of Europe, understood that the founder of the fourth dynasty was taking his cue from the châteaux of the Valois and the Bourbons.

Pope Pius VII's visit, from November 25 to 28, 1804, days before the coronation in Notre-Dame Cathedral, Paris, hastened the palace's restoration.[3] "The apartments were furnished as though by magic [in nineteen days], thanks to the care and provident foresight of [Grand] Marshal Duroc," recorded Fontaine

in his *Journal*. This "magic" involved speedily bedecking nothing less than "40 master apartments, 200 suites and stables for 400 horses"[4]–before embarking on the more extensive refurnishing program required of a large court, which would come in 1807, 1809 and 1810.

In the wake of the Treaty of Tilsit that invented the Kingdom of Westphalia for Jerome, the youngest of the Bonaparte siblings, Napoleon moved the imperial court to Fontainebleau in the fall of 1807 to enjoy some peace and quiet, receive tributes from the German princes and dazzle Europe. With Germany subjugated and Jerome recognized as king, his marriage to the princess Catharina of Württemberg could take place. The civil and religious ceremonies were celebrated at the Tuileries, and also feted with grand pomp at Fontainebleau on October 14, 1807, and sung by the librarian of Fontainebleau, Rémard. The ballroom, called the Henry II Gallery, was restored to ceremonial use, which had ceased since Louis XIV's reign. After the upheaval of the Revolution, Fontainebleau, now an imperial palace, came back to life as a monarchy's place of splendour.[5] Count Tolstoy, ambassador extraordinary sent by czar Alexander I, was received at Fontainebleau on November 6, 1807.

Back from his victorious Austrian campaign in the fall of 1809, Napoleon informed Josephine of his decision to divorce, and had the passageway between his topographical office and the Empress' study in their private apartments walled off. He returned to Fontainebleau with his new wife in the fall of 1810. The couple would take walks in the Garden of Diana, reserved for them alone.

Ambitious development for an imperial palace
The restoration work took many forms, affecting the estate and the buildings as much as the interior decoration. The aim was to reconstruct the estate marred by the Revolution by buying back disposed properties. The gardens were redesigned. The buildings were transformed. The Ferrare wing, on the west side of the Cheval Blanc Courtyard, was torn down. The idea was entertained to create, before this now open-sided main courtyard with its impressive gateway dominated by two imposing eagles, a semicircular park where three avenues came to a head.

In the Fountain Courtyard, the supports holding up the balconies in front of the Emperor's Gallery were repeated. Between the arches were expressive sculpted motifs arranged with Neoclassical rigour: Jupiter's thunderbolt, lion's muzzle and cornucopia surrounding the "N" monogram belonging to the master of the premises.

71

70
View of the Gallery of Diana in the State apartment at Fontainebleau in its current state
In the foreground, the geographer Edme Mentelle's globe, taken to the Tuileries in 1811.

71
View of the Gallery of Francis I at Fontainebleau in its current state

72
View of the private salon in the Emperor's interior apartment at Fontainebleau in its current state
Guéridon table by JACOB-DESMALTER, about 1805 (called "of the Abdication" after 1814).
Seating and screen by MARCION, 1808-9.
Savonnerie-type carpet delivered by BELLANGER, 1809.
Sévres porcelain mantleclock, 1809.

73
View of the Emperor's second salon at Fontainebleau in its current state
State from the time of Napoleon as of 1810, with the exception of the "Eu panels," 18th-century paintings installed in 1862 in the wainscotting repainted as wood.

The Gallery of Francis I (**71**), renamed the "Emperor's Gallery," was touched up in a manner respectful of history. In order to have this gallery connect with the antechamber of the interior apartment, a double door was added by piercing the wall, beneath the wall-painting *The Royal Elephant*. The sculpted motifs, attributes of warriors, were contrived to go with the trophies in the Renaissance panels in the gallery. The gallery was also decorated with the busts of great men from both the civil and military realms, from antiquity to the contemporary era. Initially intended by the orders issued on March 30, 1800, for the Galerie des Consuls at the Tuileries, some of the busts were sent to Fontainebleau in 1805.[6] At one end of the Emperor's Gallery, commanding the row of busts, was the imposingly large *Bust of Alexander* wearing the helmet that sculptor Dejoux decorated with tamed horses and capped with a plume held by a lion. Thus, the Emperor was placed, in his mind and in that of others, under the auspices of antiquity's greatest conquerors, whom he intended to match, if not surpass. Designs by Bagetti were judiciously arranged around the gallery, notably depicting the Italian antecedents of the brilliant strategist.

Upon the orders of the Emperor, the Gallery of Diana, which had been destroyed at the end of the Revolution, was rebuilt by the architect Hurtault. Deemed beyond restoration, the paintings on plaster by Ambroise Dubois retracing the story of Diana were removed. The plan was to decorate the walls with depictions of victories on the battlefield and to make the gallery a so-called "Salon of the King of Rome," in honour of the yearned-for heir. The fall of the Empire brought the project to a premature end.

Representations of power inside the Emperor's interior apartment

A dedicated living space for the Emperor, the "interior apartment" consisted of rooms where his authority would be staged and exhibited within a setting enjoyed only by a select few.[7] In the extension of the antechamber was the salon for the Emperor's aides-de-camp, who were ever at the ready to carry out their master's orders. Two *Views of Constantinople* after Melling evoke the dreams of the East of the leader forced to retreat from the citadel at Acre in the spring of 1799.

Beyond that was an entirely private space, the washroom (**NAP. 0177**), connected to a passageway of baths, decorated with six *Views of Milan* by Rados and Bellemo, prints with colour highlights dedicated to the wife of his dear stepson Eugene, Augusta-Amelia, vicereine of the Kingdom of Italy. At Fontainebleau, where he spent the day on April 1, 1805, en route to his coronation in Milan, Napoleon, who attached great importance to his Italian

sovereignty, would have taken in these views of the capital city of his Italian realm. The next two rooms, the Emperor's private salon (**72**) and library-study (fixed up in 1811 into a small bedroom with a metal-frame bed), were, for this hard-working man, places in which he could think things through. In one of these adjoining rooms was a small movable table (*guéridon*) and in the other a mechanical table, the type perfected in the Jacob frères workshop about 1800 specifically for the French ruler: the sliding top created a large work surface on which papers could be spread out.

The last room of the private apartment was made into the Emperor's bedroom in 1808 (**75**). It included a gilded-wood State bed, designed and sculpted by Jean-Baptiste Rode. The bed canopy was surmounted by an eagle and two double crowns, and a helmet at each corner, and the head- and footboards were decorated with allegorical figures: Nobility and Glory, Justice and Abundance. The nightstand, delivered by Jacob-Desmalter in 1804, was decorated with a medallion bearing the profile of Diana, the moon goddess presiding over the restless nights of the monarch ever on the alert. The white woodwork was embellished by the brush of Moench, who captured victories in gold grisaille. A Savonnerie-style carpet—described as having "a round centre with antique shield, order of the Legion of Honour, with war trophies and abundance"—was provided by the Sallandrouze manufactory in Aubusson in 1811. The inclusion of the cross of the Legion of Honour, an institution founded in 1802 for both military and civil honours, explicitly alludes to the Emperor—under whose reign "every soldier has in his satchel a marshal's baton"—who rewarded those who served him devotedly.

Order and practicality in the Emperor's private apartment

The ground-floor apartment facing the Garden of Diana—which in 1804 accommodated cardinals Fesch and Caprara, prince Joseph, the Grand Elector of the Empire, and Grand Marshal of the Palace Duroc—were made into private apartments for the Emperor and Empress in 1808-10.

Located beyond an antechamber and a first salon, the second salon for the Emperor (**73**) was graced with carpets by Poussin and Lejeune and a furniture set by Pierre-Gaston Brion consisting of twelve chairs, eleven armchairs, a *bergère* and a *paumier*, a seat invented for cold-sensitive Napoleon, who could nestle into it and hang his feet out over its lower side to warm them by the fire. The fireplace had a gilded wood screen with a sculpted thunderbolt, the hearth with figures of Fame, one of which held a coiled horn and an olive branch and the other figure, holding a laurel crown, raised a straight horn to her lips.

72

73

The fireplace was embellished with a temple-shaped mantle clock composed around a triumphal arch belonging to the centrepiece that Charles IV of Spain transported inside various cases to the Bayonne talks in April 1808. The centrepiece, made about 1791 by the Buen Retiro royal workshop in Madrid—a last great example of production that halted in 1808 due to the manufactory's destruction in combat connected to the French invasion—was given by the king to Napoleon as a diplomatic gift, with the aim of currying favour, but to no avail: having fallen into a trap, the Bourbon royal from Spain was forced to abdicate his throne for Joseph, Napoleon's elder brother. The centrepiece was not fully appreciated by the French. The Grand Marshal of the Palace deemed it of poor taste. Parts of it were removed and recuperated for mantle clocks at Trianon and Fontainebleau. Although the main elements of the centrepiece remained encased, in 1810 a triumphal arch portico was given a mantle clock's movement by Lepaute. Its base bears a medallion with the profile of helmeted Athena, who had the honour of presiding over the strategist's reflections.

The bedroom Napoleon actually slept in was in the Emperor's private apartment. It had a bed of bronzed and gilded wood with Egyptian figures, which Pius VII used at the Tuileries in 1804-5 and which was sent to Fontainebleau in 1805. In 1810, the bed canopy was topped by two crowns of interlocking laurel and oak, held together with a band, and decorated helmets atop the laurel. The conqueror of Egypt slept under the attributes that Scipio Africanus would not have scorned. Candelabra with vestal figures made by the Buen Retiro manufactory adorned the fireplace; given as gifts by the unfortunate Charles IV, they were placed in the room of the leader who, at the Somosierra mountain pass on November 30, 1808, swept aside the Spanish resistance on his march to Madrid.

Near the Emperor's bedroom was the one that lodged Méneval, his closest collaborator. As Secretary of the Portfolio, Méneval bore the heavy burden of transcribing the European leader's dictated correspondence night and day. Further along was the Emperor's wardrobe, the Gardien du Portefeuille room—where the two men who held the "security clerk" post, Haugel and Landoire, took turns keeping guard every twenty-four hours—and the Emperor's three studies.

Connected to these studies was the library, a weapon of war for the exclusive use of the Emperor, who was a voracious, harried reader. These fifteen rows held thousands of books arranged on shelves, providing useful information on most of the countries of Europe. Adjacent to the library was the topographical office—decorated by Lussigny in 1810 with two overdoors, a

Park and a *Victory*—containing three tables placed side by side, creating a vast surface on which Bacler d'Albe, head of the topographical office, would spread out the maps the Emperor sometimes consulted, stretched out on the table, occasionally bumping heads with the Dépôt de la Guerre's chief topographical engineer. A 1791 geographical clock with an enamelled dial representing France divided into départements, a work by royal clockmaker Antide Janvier, was acquired in 1806 at Napoleon's request. It "tells the time in every corner of the Empire"—at least until the seemingly endless expansion of the empire that in 1809 annexed Rome, prefecture of the département of the Tiber and the "second capital of the empire," and in 1810 Hamburg, prefecture of the département of Bouches-de-l'Elbe.

Luxury and pleasure in the Empress' private apartment

The first salon of the Empress' apartment was filled with chairs, all upholstered with violet gourgouran, a *canapé de billard* (a long sofa running the length of one wall) as well as *voyeuses* (chairs with low seats and padded top rails) for men and for women, to accommodate the many guests who flocked there, keen to pay court to the ruler's wife.

The Empress' second salon consisted of thick Naples silk hangings with amaranth red silk embroidery on yellow ground surrounding lavish furniture. A console table commissioned from Jacob-Desmalter in 1808 was an original piece due to its two back posts in metal—an "incombustible" material, following the directions of the architect Fontaine during his visit on April 23, 1808—resistant to the heat emitted through the heating vent situated in the wainscotting. The table bears a decorative gilded bronze frieze by Thomire, after a model by Dupasquier, depicting in bas-relief the *Triumph of Trajan*: a classical procession with twenty-four figures stands out, with Trajan in the middle on a quadriga and holding a figure of Victory. Another smaller console table, placed opposite, fit into the same program at the Empress' private apartment at Fontainebleau, which was the counterpoint to the major construction projects in the capital, including the erection of a column at Place Vendôme with bas-relief decoration depicting the French Caesar as the equal of Trajan, the victor in the Dacian Wars.

The richly gilded bronzes went well with the Empress' yellow salon. Two candelabra in the shape of *Dancers of Antiquity* perched atop a globe mounted on a pedestal held a bouquet of flowers containing candle-rings. Crowning the mantelpiece was a clock designed around the theme of the Ravages of Time, which, for the time being, did not seem to be a cause for concern.

74

74
View of the Empress' bathroom at Fontainebleau in its current state
Cheval glass (*psyché*) and dressing table by JACOB-DESMALTER, 1809.
Savonnerie-type carpet delivered by BELLANGER in 1809 (the addition of the coat of arms of France dates to the Restoration).

75
View of the bedchamber in the Emperor's ordinary apartment at Fontainebleau, (fitted in 1808) in its current state

Beyond a service room equipped with a chest of drawers in lemon and purpleheart wood, inlaid with a figure of Isis, the Empress' washroom (**74**) combined the clever practicality of a couch perched atop a retractable platform revealing a bath built into the ground, and the majestic luxury of a huge cheval glass (*psyché*), in addition to a portable swing mirror on a dressing table. The mistress of the house could prepare herself for both the ostentation of court life and for everyday pleasures—a writing desk in yew wood was in fact decorated with a figurative sconce depicting *The Rape of Europa*.

The Empress' bedroom, which was designed for Josephine, was an ode to feminine grace. The carpet bore motifs of festoons of fruit, lush foliage, musical instruments, such as the harp, pan pipes and cymbals, as well as quivers: Cupid must have been close by. The mantle clock with a movement by Lepaute on the fireplace depicted the figures of Terpsichore and Erato, whose respective etymology is "delight in dancing" and "desired" or "lovely." At the far end of the room was a throne-like, Eastern-spired bed crowned with a bed canopy made up of four archivolts—an appropriate tribute to the lovely widow of Beauharnais, the wonderful mistress of Barras, the unfaithful wife of a republican general. The Empress of the French received hinted reminders of the recent Consulate past from a mahogany commode with bronze ornamentation that had originally been on a commode from the residence the Bonapartes owned on Rue Chantereine—the bronzes reused for reasons of quality and economy at the imperial palace at Fontainebleau. The drawer was decorated with acanthus leaves, griffons and a head of Mercury, and each door bore the figure of a mostly bare-chested dancer within a diamond shape made up of laurel palms. In reference to the Directory, the *somno* presented a frieze of palmettes and poppies, alluding to sleep, a flighty butterfly counterbalanced with a quietly sleeping dog, symbolizing loyalty. This was the pleasant setting Josephine left in tears in 1809.

The Empress' study bore the marks of Napoleon's two wives. It included a sumptuous carpet fringed with garlands of flowers and cygnets, which Josephine appreciated. Over time, Jacob-Desmalter provided various elegant pieces of furniture, including a *guéridon* with a marble mosaic top in 1807, an *athénienne* in 1809, then, in 1810, for Marie-Louise's personal use, a *vide-poche* work table, a letterbox table, a drawing table, an easel and a case for sheet music. In 1810, the dealer Maigret provided a mahogany embroidery frame (**314**) richly ornamented with gilded bronze components combining foliage at the top with double columns attached to the base, cupids playing with a compass rose, and bees around a hive—a double reference to the imperial emblem selected in 1804 and the industrious and meticulous activity attributed to the new Empress bent on mastering the craft of embroidery.

This moment of glory in 1810—when for the first time in his meteoric career Napoleon allowed himself to leave behind affairs of State for the company of his young wife—would not last. In 1812, leading a retreating army decimated by General Winter through the depths of Russia, Napoleon missed the charm of Fontainebleau. On November 5—the eve of discovering the conspiracy against him organized in Paris by General Malet—he wrote to Marie-Louise: "I would have enjoyed travelling to Fontainebleau as much as you did, but we mustn't think about it this year; next year's trip will be far better."[8] The disastrous Saxon campaign, marked by the defeat at Leipzig in October 1813, would make "next year's trip" equally impossible. During the French campaign in 1814, he stopped off at the palace, where there was the threat of defeat, latent betrayal and suicidal despair. On April 20, 1814, Napoleon had to make his exit, and masterfully orchestrated his goodbyes to the Old Guard in the Cheval Blanc Courtyard; posterity would forever associate the "Cour des Adieux," [Courtyard of Goodbyes] as it was later known, with the restorer of the "house of ages" and founder of a new dynasty who wished to live in "the abode of kings."

THE APARTMENTS IN THE NEW WING (1810)

The court's sojourn at Fontainebleau in the fall of 1810 was an opportunity to extend the renovations at the palace, and particularly to put at the disposal of the two princesses of the imperial family, queen Hortense and Pauline Borghese, the two apartments recently completed in the new wing of the château. The archives provide an accurate idea of the way in which the architects of the château and the management of the imperial furniture storehouse, the Garde-Meuble, designed the accommodation for the members of the Imperial Household. Over time, the sumptuous furnishings, which included numerous examples of the repurposing of furniture and textiles from the Ancien Régime, had been dispersed, while the decors survived almost complete in the spaces now for reception at the Château de Fontainebleau and the Musée Napoléon I.

The restoration of the "new wing"

The idea of refurbishing these two apartments goes back to 1807. On October 4, while the court was staying at Fontainebleau, Napoleon decided to fix up the buildings around the Cheval Blanc Courtyard once they had been vacated by the École spéciale militaire (the decree of transfer to the city of Saint-Cyr was signed on March 24, 1808).[1]

On March 25, 1808, the Grand Marshal of the Palace Duroc asked Antoine Leroy, the architect of Fontainebleau, to look into this matter: "It is also important that you draw up plans for the restoration and layout of the wing and buildings occupied by the École militaire . . . I think we should make them into a suite of fine apartments for princes."[2] In October, Napoleon granted 200,000 francs from the budget for 1809 "to work at the École militaire, but on condition that with this money apartments should be built in the part nearest to the palace, and that they will be ready for the first trip," demanding that the project be submitted to the Grand Marshal.[3] Leroy prepared a plan for the layout of the ground floor and the first floor, which he sent in December to the Intendant-General Daru: the second floor was to be laid out in the same way as the first.[4] The architect planned to install kitchens and offices on the ground floor, apartments for princes on the first and second floors, and accommodation for Officers and their suites on the third floor. On January 8, 1809, Duroc made significant criticisms of this project. He felt that the placing of the kitchens on the ground floor was inopportune, given the problems of odours and the risk of fire, and he suggested that they should be moved to the former outbuildings of the École militaire. For the first and second floors, Leroy had designed eight identical apartments that gave an unfortunate impression of uniformity. Duroc pointed out that "of the eight available, there will be little to distinguish between them"; he suggested creating only two large apartments on each floor. Finally, he was less than enthusiastic about the additional pavilion meant to complete the gallery, and advised that the design should be seen by Fontaine, Napoleon's architect, before they showed it to the Emperor.[5] Despite these precautions, he found it "not spacious enough nor majestic enough" and changed the layout to his liking, with the assistance of Fontaine.[6] Thereafter, two large princely apartments were planned for the left-hand side of the wing, one on the ground floor and the other on the first floor. Each of them was to consist of eight adjoining rooms, an antechamber, a dining room, three salons, a bedchamber and two cabinets: the decorative splendour increased as far as the bedchamber. After the 200,000 francs granted in 1809, Napoleon allocated a budget of 550,000 francs in 1810 for the completion of the works ahead of the fall visit. At the beginning of the year, Leroy, who had retired, was replaced by a collaborator of Fontaine's, Maximilien-Joseph Hurtault, tasked with completing the interiors. The refurbishment of the two princely apartments was by this time far along.[7] According to a "Compte historique et analytique des travaux exécutés en 1810" drawn up by the new architect on taking up his post, the plastering was almost finished and the parquet laid, together with some of the other carpentry work, along with the setting of fittings well advanced and the cutting of the marble for the mantelpieces begun.[8] In May, Hurtault was concerned about "the inconvenience of enabling His Majesty to reach his bedchamber," when the Emperor was paying a visit to the princes in their cabinet, since that room was part of his suite, but Duroc replied that "what Mr. Hurtault was told is ridiculous: the layout is fine as it is."[9] At the same time, having realized that the year's budget did not allow him to order the numerous mirrors required, the architect asked for an additional budget of 116,000 francs, but Napoleon allowed him only 50,000 francs, noting that "there are too many mirrors in these apartments already."[10] The problem could not be solved in time, and when the court arrived in the fall, more than half the mirrors were still lacking. Faced with this situation, Napoleon decided to have the rest installed with the 1811 budget.[11] In the "Compte historique," Hurtault describes the tasks he had completed in the two princes' apartments in 1810: stoves had been installed in the antechambers; all the windows had been replaced with new large-paned windows; the mantelpieces had been adorned with gilded bronzes; the cabinetwork completed, notably the frames of the mirrors and the hangings; several rooms had been gilded and others hung with wallpaper, the Garde-Meuble not having delivered all the necessary fabrics in time; a bathroom and a bathtub provided with hot water had been installed in each apartment; and, finally, the grand staircase leading up to the first floor had been repaired, the steps replaced and an iron banister decorated with bronzes and a mahogany handrail constructed (a fine drawing of this project is still extant).[12] The greater part of this decor still exists today, notably the splendid mantelpieces by the marble mason Hersent, the largest of which were decorated with gilded bronzes chased by Forestier.[13]

GROUND-FLOOR APARTMENT–FURNISHINGS
Antechamber.
The walls are covered in wallpaper.
– A stove.
– Five benches and eight painted wooden stools covered in crimson velvet.
– Louis XVI-period lamp with the N monogram, provided by Chaumont.[14]
Two blackened-wood desks.
Dining room.
The walls are covered in wallpaper.
– 24 mahogany chairs with horsehair upholstery.
– Three console tables in mahogany and Sainte-Anne marble.
– Louis XVI-period mahogany dining table, from the Tuileries.[15]

– Delftware with a lamp decorated with gilded eagles.
– Two four-light sconces in the shape of torches.[16]
– Four four-light girandoles.
First salon.
The walls are covered in wallpaper.
– A settee, two wing chairs, two footstools, 10 armchairs, 12 wooden chairs painted "grey set off with matte white" covered in crimson kerseymere trimmed with yellow, and a matching fire screen.[17]
– Two wooden console tables painted grey, "the columnar uprights adorned with new profiles, the apron decorated with antique nails carved in bas-relief," covered with granite marble.
– Small mahogany table.
– *Guéridon* table with claw feet in gilded bronze and granite marble, Louis XVI-period, delivered by the dealer in curio Rieul Rocheux.[18]
– Silver-plated 12-light chandelier with Bohemian crystal drops.
– Two five-branch wall sconces terminating in dragon heads.
– Pilastered andiron with a head of Mercury in diamond-shaped frame.[19]
Second salon.
Hung with green velvet damask in a Virginia creeper pattern framed by a border of poppy red velvet with black palmettes, the latter made for Saint-Cloud during the Consulate.
– Furniture covered in the same fabric as the hangings, consisting of a settee, two wing chairs, two footstools, 10 armchairs, 12 chairs and a fire screen in carved and gilded wood with a motif of palms and laurel leaves, the wood for which was purveyed by Pierre-Benoît Marcion.[20]
– Mahogany and Boulogne marble *guéridon* table with columnar legs.
– Console table, one of a pair, in palisander wood, executed in 1786 by Martin-Guillaume Beneman for Louis XVI's powder room at Fontainebleau.[21]
– 12-light gilded bronze chandelier with Bohemian crystal drops.
– Two six-branch chandeliers shaped like hunting horns.
– Antique andirons, posts with shields.[22]
Third salon.
Hung with Land of Egypt damask patterned with sunflowers framed by a border of brocade with branches of oak and laurel, woven for Saint-Cloud in the consular period.
– Furniture in carved and gilded wood comprising a settee, two sofas for two, two footstools, 10 armchairs, 12 chairs, a fire screen, coverings in Beauvais tapestry in a white ground with motifs of baskets of flowers and musical instruments, the edging with bees and oak leaves, except for the fire screen, which has a military motif.[23]
– Carpet with buff background patterned with vines.
– Two console tables in carved and gilded wood, the uprights in scrollwork and claw feet, covered in Boulogne marble, with a "frieze carved with ornamentation similar to that of the seating."
– Small mahogany writing table.
– *Guéridon* table in ashwood and Boulogne marble.
– Two Louis XVI-period mahogany games tables.
– Mahogany piano by the firm of Érard, acquired in 1807.[24]
– 24-light gilded bronze chandelier, laurel and oak branches, Montcenis crystals, delivered by Chaumont.
– Four candelabra with six branches terminating in dragon's heads.
– Six gilded torches in the shape of quivers.[25]
– Three-branch covered candelabrum.
– Sèvres standing clock in biscuit with the Three Graces, repeating a model created by Chaudet in 1803, delivered by Lepaute.[26]
– Andirons, balls with motifs of winged women and lyres.[27]
Bed chamber.
Hung with amaranth red and gold satin patterned with sprays of flowers, framed with a border of laurel branches.
– Bed of carved and gilded wood. The bed has mountings with palmettes and a lance; the front overhanging, like the sides of the head and footboards and the square canopy, are carved with a tied-up bundle of baguettes.[28]

- Furniture of carved and gilded wood, claw feet, the top of the uprights with Egyptian figures, comprising a *méridienne*, a *bergère* chair, two footstools, four armchairs, four chairs, and a fire screen, covered in satin patterned in laurel wreaths, helmets and rosettes matching the wall hangings.[29]
- Green carpet with squares of flowers.
- Two commodes: one in mahogany with Egyptian figures and sea green marble, purchased from Rocheux, originally for the Emperor, the other called a *console en armoire* in mahogany and Boulogne marble.
- Small desk.[30]
- Pair of bronze six-light candelabra with children, copied from a model delivered in 1809 for the Emperor and the Empress.
- Four gilded fluted torches.
- Large standing clock in sea green marble and gilded bronze representing a standing woman reading delivered by Lepaute.[31]
- Andiron like the one in the previous room.

First cabinet.
Hung with green damask patterned with oak leaves.
- Salon furniture in mahogany, ornamented in gilded bronze, covered in the same damask, comprising a settee, a *méridienne*, a *bergère* chair, two footstools, four armchairs, four chairs and a fire screen (**77**).[32]
- Carpet with brown ground, antique bronze squares.
- Two commodes in mahogany, gilded bronze and Boulogne marble, one in the Turkish style, the other decorated with laurel wreath and spindle vase appliqués.
- A washstand in mahogany, with round mirror, delivered by Maigret in 1809, and a mahogany armchair with yellow leather upholstery.
- Cheval glass (*psyché*) in mahogany and gilded bronze.[33]
- Two candelabra with four candle-flame lights.
- Four gilded candelabra.
- Pilastered andiron with palmettes and figures of winged women.[34]

Second or private cabinet.
Hung with white satin patterned with rosy gold palmettes framed in a lapis blue border, purchased from Grand Frères, Lyon.
- Mahogany furniture like that in the previous room, covered with the same fabric as the hanging, comprising a day bed, a *bergère* chair, two stools, four armchairs, four chairs and a fire screen.[35]
- Marquetry cabinet, attributed to André-Charles Boulle, from the collections of the baron de Breteuil under Louis XVI (**76**).
- Upright mahogany writing desk, one of a pair provided by Lerpsher.
- Mahogany mechanical table delivered in 1809 for the Emperor's Cabinet.[36]
- Two torch-shaped candelabra like those in the dining room.
- Pilastered andiron with crowns.[37]

Water closet and bathroom.

FIRST FLOOR APARTMENT—FURNISHINGS
Antechamber
Dining room
- 24 chairs.
- Three console tables and three games tables.[38]
- Bronze light fixtures like those on the ground floor.

First salon
- Set of chairs, somewhat resembling those on the ground floor, covered in orange cashmere.[39]
- Two console tables in painted wood.
- Small mahogany desk.
- *Guéridon* table with bronze pedestal.[40]
- Silver-plated eight-light chandelier (instead of 12) and two branches like those on the ground floor.
- Andiron with sea-horse motif.[41]

Second salon.
Hung with a blue lampas with a grey and white pattern, late-eighteenth century.[42]
- Gilded wood seating (two settees, 24 armchairs), reuse of furniture delivered in 1804 for the Emperor's salon at Fontainebleau.
- Fire screen carved with lions provided by Jacob for the Empress' salon in 1804.[43]
- Two *bergère* chairs with footstools delivered by the tapestry maker Susse, upholstered with hangings delivered in 1804; this superb brocaded silk fabric, with motifs of vases of flowers, birds and griffons, came from a royal commission before the Revolution.[44]
- Second console table by Beneman taken from Louis XVI's powder room.
- Small mahogany desk.
- *Guéridon* table in figured mahogany.[45]
- Gilded bronze chandelier with 12 lights.[46]
- Two chimney pieces and andiron like those on the ground floor.

Third salon.
Hung with the same damask as on the ground floor.
- Seating in gilded wood covered in tapestry from Beauvais, with rural landscapes and birds.[47]
- Carpet in green, taken from the Emperor's Apartment.
- Two console tables in gilded wood with laurel leaves, one of which had been delivered in 1808 by Marcion for the Emperor's Cabinet at Fontainebleau.
- Late-eighteenth-century *guéridon* table of yew root wood delivered by Rocheux.[48]
- 24-light chandelier delivered by Chaumont.
- Four light branches and six torches like those on the ground floor.
- Covered three-light torch.

- Large standing clock, with black Lepaute marble case.[49]
- Lyre-shaped andiron like the one on the ground floor.

Bedchamber.
Hung with yellow satin sprinkled with violet and lilac rosettes, also purchased from Grand Frères of Lyon, framed in a border of palmettes.
- Four cross curtains in 15/16 yellow with the same border.[50]
- Bed delivered by Jacob-Desmalter. This was the most costly piece of furniture for the princes' wing. The canopy and the front facing are carved with bouquets of flowers.[51]
- Salon furniture of the Louis XVI-period by Georges Jacob, delivered by Susse, comprising a *bergère* chair, a footstool, four armchairs, four chairs, a fire screen, a paravent, commissioned by queen Marie-Antoinette for Versailles.[52]
- Carpet with blue ground, border of eagles.
- Commode taken from Josephine's bedroom of 1804.
- Commode-writing desk in mahogany, gilded bronze and Boulogne marble, delivered in 1810; the leaves are decorated with eagles.
- Small mahogany desk.[53]
- Two lamps with figures of children.
- Four torches like those on the ground floor.
- Vintage Louis XVI-period case clock in gilded bronze delivered by Lepaute.[54]
- Andiron like the one in the previous room.

First cabinet.
Hung with the same green damask as on the ground floor. Seating in mahogany enriched with bronze fittings.[55]
- Aubusson carpet.
- *Console en armoire* identical to the one on the ground floor.
- Writing desk furnished by Lerpsher.
- Cheval glass (*psyché*) in spotted mahogany delivered by Rocheux.
- Dressing table purchased in 1809.[56]
- Pair of thyrsus branches.
- Andiron like the one on the ground floor.

Second cabinet.
Hung with the same satin as on the ground floor but framed in an amaranth red border.
- Seating in mahogany enriched with bronze fittings.[57]
- Mahogany commode decorated with lyre-shaped and laurel wreath appliqués.
- Matching writing desk and chiffonier, the lid of which is decorated with a centaur ridden by a cupid, delivered by Rocheux.[58]
- Two light branches like those in the dining room.
- Andiron like the one on the ground floor.

Water closet and bathroom.

JEAN VITTET

76
André-Charles BOULLE
Chest-high cabinet called "Parrot Cabinet"
About 1680–1700
Musée national des châteaux de Versailles et de Trianon

77
Workshop of François-Honoré-Georges
JACOB-DESMALTER
Armchair
1810
Château de Fontainebleau

76

77

THE MANIFESTATION OF

POWER

IN THE

FURNISHINGS

OF THE

IMPERIAL PALACES

JEAN-PIERRE SAMOYAULT

Although the First Consul for Life had enjoyed a sovereign appearance since the Consulate period, the promotion to Empire made him a true monarch required to surround himself with a court and to demonstrate its dignity by every means available. The palaces' furnishings played a starring role in this demonstration. Already at the Tuileries since 1800, and at Saint-Cloud since 1802, there was a *Grand appartement de représentation*, a State Apartment for the three Consuls, discrete from the private apartments of General Bonaparte and his wife. Beginning in 1804, the reinstatement of monarchical conventions led to the construction of a Throne Room in the State Apartments of these two palaces, an imitation of the one at Versailles. Fontaine and Percier, government architects since 1801, were given the task of providing drawings. Their original work envisaged a new composition comprising a crown-shaped dais, ensign-candelabras topped by an eagle to hold the draping, a throne seat with a rounded back (**80**), six ceremonial armchairs with winged lions (**79**), six chairs and thirty-six folding stools (**84**). The new Empire sought to capture hearts and minds by drawing on antiquity (Roman ensigns) and long-standing royal tradition (folding stools), while asserting its universal power (the armchair connoting the world). Two furniture series were produced by Jacob-Desmalter, differing only in the style of throne, the one at the Tuileries with ball-topped pilasters and that of Saint-Cloud with the figure of Hercules on the lion's shank.[1] The first extremely formal model would be repeated with variations by Jacob in 1814 for the Palazzo di Monte Cavallo (the Quirinale) in Rome (**86**), but the armchair would never be installed.[2]

In March 1805, the same concern about dignity led Grand Master of Ceremonies Ségur to compose the *Etiquette du palais impérial*, partly inspired by that of the Ancien Régime's and then, consequently, to establish the codification of the furnishings of the imperial palaces. The text, which would be published in successive editions, set forth in its title II the distribution of rooms for each of the three main apartments (the State Apartment, the Emperor's Apartment, and the Empress' Apartment) as well as the rank of those, whether staff or outsiders, permitted to enter each room.[3] Thus, the State Apartment included six rooms according to regulations: a Guardroom, a first salon, a second salon, a Throne Room, the Emperor's Salon (which came to be called the Cabinet or Grand Cabinet, not to be confused with the ruler's study), and a gallery. On the other hand, the Emperor's "ordinary" or residential apartment was divided into two parts: an *appartement d'honneur*, an apartment of honour where he would receive guests, and an entirely private *appartement intérieur* (interior apartment). The first section comprised a Guardroom or antechamber,

and a first and second salon; the private section included a bedroom, a study, a washroom and a topographical office. The Empress' Apartment was similarly separated into rooms for receiving in addition to private interior rooms. The details—these State edicts observed at the Tuileries—would be adapted to the layout of the various palaces in question, which continued to accrue during Napoleon's reign: Laeken, Strasbourg and Rambouillet in 1805, Compiègne as of 1807, Bordeaux and Marrac in 1808, the Élysée and Villiers, which Murat surrendered to Napoleon in 1808, the Grand and the Petit Trianon in 1809–10, Meudon in 1811, Monte Cavallo (the Quirinale) in Rome in 1811–12, not to mention the secondary establishments in Antwerp and Mainz. It is important to note that the State Apartment nomenclature only existed at the Tuileries and Saint-Cloud, while at Fontainebleau, Compiègne and the lesser châteaux, it was a part of the Emperor's Apartment. Taking Fontainebleau as an example, the Emperor's Apartment—which closely resembled Louis XVI's—included (as of 1808) a section serving as the State Apartment: antechamber, Pages' Room (second antechamber), salon of the Household Officers (first salon), salon of the State dignitaries (second salon, usually called the Salon of Princes), the Throne Room, the Council Chamber (the Emperor's Salon or Cabinet). Then came the apartment's living quarters, in reverse order of the regulations, starting with two interior rooms, a bedroom and study, and then a section reserved for service and visitors: salon, first salon (for the aides-de-camp) and antechamber. The topographical office, which in 1805 was located in the two last rooms, was moved to the ground floor in 1808, where it was expanded by a small furnished apartment in 1810.[4]

To follow the *Étiquette*, specific rules about the furnishing of official rooms were imposed by a decree issued by the Grand Marshal of the Palace dated July 25, 1805.[5] The choice of furnishings was determined by the room hierarchy. Although the benches and stools were sufficient for the antechambers and the folding stools for the first salon, a grouping of folding stools and two armchairs for the Emperor and Empress was required in all the rooms where the sovereigns might find themselves, such as the second salon, the Throne Room (or Emperor's Salon if there was no Throne Room), the Grand Cabinet (or Cabinet), where the Councils were held, as well as the chapel tribune. It was the same in the royal households, particularly at Versailles, where, as early as 1708, rooms equipped with stools (the salons of Venus, Diana, Mars, the Grand Gallery, the Oeil-de-Bœuf antechamber) were differentiated from those with folding stools (main rooms of the King's Apartments, namely the Mercury and Apollo salons, bedroom, and the Council Chamber).[6] Thus, the folding stool had greater royal

78
Throne Room in the State apartment at
Fontainebleau in its current state

79
Workshop of François-Honoré-Georges
Jacob-Desmalter
**Presentation armchair for the Throne Room at
Saint-Cloud, intended for the Empress or for
Madame Mère**
1804
Paris, Mobilier national

80
Workshop of François-Honoré-Georges
Jacob-Desmalter
The Emperor's armchair throne at the Tuileries
1804
Paris, Musée du Louvre

79

status than the stool, although Saint-Simon said that in practice "the princesses and the duchesses sat on the folding stools or the stools, because there was no difference made between these two types of backless, armless seats."[7] As for armchairs, also in 1708, there were always two in the rooms where folding stools were found. These predecessors attest to the will to base imperial etiquette on royal etiquette.

On the other hand, in contrast with the royal court, the most important room in the palace in Napoleon's time was no longer the sovereign's chambers, but the Grand Cabinet (also known as the Emperor's Salon). As Napoleon himself noted several times,[8] he always insisted on the necessity to make the furnishings as luxurious as possible, particularly at the Tuileries and at Saint-Cloud. Contrary to what one might assume, this room was even more important than the Throne Room.

To evaluate the application of this regulation, let us consider the items produced for the Emperor's Apartment at Fontainebleau, whose temporary furnishings of 1804 were considerably revamped in 1805-6 so that it would conform with the new standards. The first salon (for Officers) was outfitted with new white folding stools in wood and gold made by Marcion (**82**). In the second salon (today the Louis XIII Salon), lovely gilded wood furnishings that appeared in 1804 were reused, after having served the Directory and then Saint-Cloud, retaining two of the armchairs (Mobilier national, Paris) and thirty non-folding stools (**81**). This exception bent the rules of etiquette, revealing the administration's attempt to cut costs, even though the sumptuousness of these seats justified keeping them in use. In the Emperor's Salon, which would become the Throne Room in 1808, the two armchairs and folding stools were redeployments of Louis XVI chairs (some acquired from the comte de Vaudreuil in 1788, others part of the furnishings of Marie-Antoinette's Game Room at Compiègne). In 1808, the interior decoration and throne were added; although intended for Saint-Cloud, they were not installed in this palace (in the end determined to be too close to the Tuileries to require a throne) and sent to Fontainebleau upon the order of Napoleon (**78**). In the Council Chamber, the seats were new. The two armchairs and the thirty folding stools, made by Marcion in 1806, were to go with a large table for the Council that had belonged to Louis XVI (the chairs for the ministers were only brought in when the Council was in session). In 1808, the instructions changed to anticipate two additional armchairs and six chairs, the former for Madame Mère and the kings and queens of the imperial family, and the latter for the princesses (**89**). These chairs were meant to be used during the various ceremonies held in this room, aside from the sessions of the different government councils.[9] At Compiègne, the furnishings of the Grand Cabinet diverged from the *Étiquette*, as it combined salon furniture for receiving company with regulatory furniture (two sofas, twelve armchairs, twenty-four folding stools),[10] while Trianon's was similar to the set retained for Fontainebleau in 1808 (four armchairs, twenty-four folding stools (**83**), to which four chairs were added in 1813).[11]

The largest operation the Garde-Meuble faced was undertaken between 1810 and 1813, and it entailed the refurnishing of the Emperor's Grand Cabinet at the Tuileries, upon Napoleon's orders, which led to a reorientation of the regulations.[12] Of the two successive groups of chairs covered in Gobelins' tapestries (the first, rejected by the Emperor, was sent to Monte Cavallo in Rome and is today in the Palazzo Caserta), the second comprises two large ceremonial armchairs for Napoleon and Marie-Louise (whereabouts unknown), four other less sumptuous large armchairs (Mobilier national, Paris), twelve chairs and twenty-four folding stools (Versailles). The reinforcement of monarchical forms desired by the Emperor required that the sovereigns' armchairs in this room be distinguishable from the other armchairs. To please Napoleon, the former were based on the 1804 model of the throne, with a round back, and this choice would become the norm as of 1810. To the two pairs produced in succession for the Grand Cabinet at the Tuileries (**85**) was added another of the same type for the Throne Room at the Quirinale (whereabouts unknown). Shortly thereafter, two other pairs with round backs were designed as the main pieces for the King of Rome's apartment at the Marsan pavilion, based on a design that was slightly different, but still in keeping with the spirit of imperial splendour (the one delivered for the Grand Salon survives) (**87**).[13] As for the other armchairs, Napoleon sought to return to the 1806 system by limiting their

use. On September 12, 1811, he decided that all the members of the imperial family, kings and queens included, aside from Madame, "due to her age," could only sit on chairs or folding stools,[14] but in fact the existing composition of the seating did not change in any of the palaces.

As for the apartments where the Emperor and Empress lived, the 1805 regulation was rarely applied. At the Tuileries, Napoleon's apartment was entirely refurnished in 1808-9 and outfitted with a number of gilded wood chairs. Against the *Étiquette*, but likely intended as a return to Ancien Régime customs, the room—which became more formal in style—was a bedroom, a private room where no ceremony took place comparable to the levees and bedtimes of the kings before the Revolution. The formal bed, *à la duchesse*, decorated with ivory pilasters and balls inspired by the throne armchair of 1804, had in front of it a railing, as in earlier times at Versailles, and the seating included four folding stools.[15] Neither of the Emperor's bedrooms at Fontainebleau or Compiègne shared this formal presentation.

In the Empress' living quarters, the contrasts were even more marked from one palace to another. At the Tuileries, in 1806-7, the regulation was barely followed in the "honour" section; folding stools were only placed in the Pages' Salon and the number of armchairs was reduced to a single pair in this same salon, in the first salon, the dining room and the music room.[16] The general overhaul of the garden-side apartment in 1808-9 ignored all regulations, although it was only the bedroom furniture that included four folding stools, like in the Emperor's rooms, as mentioned above.[17] At Fontainebleau, in contrast, the main rooms allotted to the Empress were considered in 1806 to be an official State apartment. The first and the Grand Salon, and even the bedroom, received two armchairs and a number of folding stools. In the Grand Salon were also found stools mixed with folding stools, as in the time of Marie-Antoinette. Josephine's State bed also had a railing in front of it (originally made for the throne at Saint-Cloud) (**88**).[18] The circumstances of the Empress' Apartment at Compiègne were again different. The *Étiquette* called for folding stools only in the painting gallery, the third or grand salon and, in 1812, in the small blue salon.[19] In contrast, Napoleon himself complained in November 1811 that there were too many armchairs in this apartment,[20] likely recalling the decision he had made previously on September 12.

All of these examples demonstrate that, although the State apartments at the Tuileries and Saint-Cloud and the Emperor's Apartments at Fontainebleau and Compiègne were furnished according to regulations inspired by the monarchy, absolute rigour was never applied, and the sovereigns' ordinary apartments, aside from the Empress' at Fontainebleau and to a lesser extent at Compiègne, were first and foremost outfitted without reference to these regulations, but rather in deference to pleasure and comfort combined with modernity and sumptuousness. Napoleon, Josephine and then Marie-Louise wished to live outside of the constraints of court life in their interiors arranged to their tastes, and even more simply in the private apartments at their disposal in each residence and whose furnishings sidestepped all rules of etiquette.

81
JACOB FRÈRES
Stool from a series of thirty delivered for the Grande Galerie at Saint-Cloud
1803
Paris, Mobilier national

82
Workshop of Pierre-Benoit MARCION
Folding stool from the Salon of Officers, State apartment at Fontainebleau
1805 (?)
Château de Fontainebleau, fonds palatial

83
BEAUVAIS IMPERIAL MANUFACTORY
Upholstery by François-Louis-Castelnaux DARRAC
Folding stool from the Emperor's Grand Cabinet at the Grand Trianon
1810
Musée national des châteaux de Versailles et de Trianon

84
Workshop of François-Honoré-Georges JACOB-DESMALTER
Folding stool from the Throne Room at Saint-Cloud
1804
Musée national des châteaux de Versailles et de Trianon

81

82

83

84

85

86

87

85
GOBELINS IMPERIAL MANUFACTORY
Design by Charles PERCIER and Pierre-François-
Léonard FONTAINE
Executed by the workshop of François-
Honoré-Georges JACOB-DESMALTER
**Presentation armchair (from a pair), from the
Emperor's Grand Cabinet at the Tuileries**
1807–10
Reggia di Caserta

86
Workshop of François-Honoré-Georges
JACOB-DESMALTER
**The Emperor's throne armchair at Monte
Cavallo, Rome**
About 1810
Paris, Mobilier national

87
Pierre-Antoine BELLANGÉ
**Presentation armchair for the Grand Salon of
the King of Rome's apartment at the Tuileries,
intended for the Emperor and Empress**
1804–15
Paris, Mobilier national

88
**View of the Empress' bedchamber in the
ordinary apartment at Fontainebleau with its
new furniture in its current state**

89
**Grand Cabinet or Salon of the Emperor
in the State apartment at Fontainebleau in its
current state**

88

89

AT NAPOLEON'S BEDSIDE

THE HEADBOARD OF THE EMPEROR'S BED AT THE TUILERIES

This large piece of sculpted wood, composed of two great eagles with outstretched wings linked by a laurel wreath (**90**), is a fragment from the headboard of the bed *à la duchesse* that was delivered in 1809 by the firm of Jacob-Desmalter for Napoleon's bedchamber in his interior apartment at the Tuileries.

The previous bed put at the disposal of the Emperor in his Parisian palace was an older piece, executed in 1787 by the cabinetmaker Jean-Baptiste Claude Séné and the sculptor Alexandre Regnier, under the direction of the sculptor Hauré, and inherited from Louis XVI, who had used it at Saint-Cloud (**92**).[1] Adorned with wood carvings including shields with rhodian suns, a symbol identified with the Bourbons, its re-use typical of the first phase of the refurbishment of the palace under the Consulate and the start of the Empire, which incorporated items rediscovered in storage at the former furniture depository of the Crown. It was replaced by a new bed featuring the imperial emblems, executed by Jacob-Desmalter and draped with Lyon silks by the upholsterer Andry, during the period when the apartments of the Emperor and Empress were being reorganized by the architects Fontaine and Percier in 1808–9 (**91**).[2]

It is interesting to note the long delivery time allowed for this bed compared to the short deadline given in 1804 for the execution of several thrones for the Emperor. In this regard, the Empire was abandoning a highly important custom in the former staging of the monarchy's sacred authority by relegating the sovereign's bedchamber to the spaces allotted to private life, far from the spectacle of power. Although extravagant, the Emperor's bed was no longer a truly political accessory, the

visibility of which informed the collective imagination. Henceforward, it was merely a luxurious object designed for a private space. Breaking with the customs of pre-1789 Versailles, the State bedchamber that was accessible to courtiers was given up, in favour of a Throne Room and a Grand Cabinet specifically created to house the symbol of authority.

The codification of the Levee ceremonies in the imperial etiquette illustrates the evolution of the bed's status. These ceremonial acts, performed in the king's bedchamber under the Ancien Régime, were carried out during the Empire in the second salon of the Emperor's apartments of honour.

Nevertheless, the design of Napoleon's bed was still inspired by the shapes and proportions of the throne, notably in the placement of the pillars at the foot of the bed and the presence of a large circular medallion at the top of the headboard. The bed is surrounded by a gilded wood railing, also created by Jacob-Desmalter, a sign that there was still some blending of the spectacular appearance and the private destination of a piece of furniture that would ultimately be seen by very few people.

Jacob-Desmalter's memoir describes it as being made "to be seen from the foot."[3] In comparison, the Empress' bed, which dates from the same years and is just as sumptuous, has three closed sides, with one side against the wall (**15**).

The rest of the furniture in the room consisted of a settee and armchairs, chairs, folding chairs and a screen, also delivered by Jacob-Desmalter. Being the property of the Mobilier national, some of these pieces are preserved today in the Louvre. Also placed in the bedchamber was the opulent commode by Benneman built in 1786 for Louis XVI at Compiègne.[4]

The bed from 1809 remained in place after 1814 for the use of Louis XVIII, although for obvious reasons the imperial arms and the eagles had been

immediately removed. In 1815–16, they were replaced by cornucopia sculpted by Jacob-Desmalter, possibly after the drawing by Jacques-Louis de La Hamayde de Saint-Ange. The substitution of these symbols, although revealing another aspect of the *damnatio memoriae* of Napoleon, also illustrates a renewal of the ideological discourse, because it is an emblem of prosperity that was chosen to replace the eagles of military glory.

Louis XVIII died in this bed on September 16, 1824, which led the Royal Household to have another made for his successor and brother Charles X by Pierre-Gaston Brion and the silk merchants Grand Frères after the drawing by Saint-Ange.[5] As for Napoleon's old bed, under the July Monarchy it found its way to the Grand Trianon, to the bedchamber of queen Marie-Amélie. It was then enlarged to accommodate two people, king Louis-Philippe being the first French ruler to share a marital bed with his spouse.

The eagle decoration from the headboard removed in 1814 remained in storage at the Garde-Meuble and was eventually added to the collections of the Château de Malmaison. For a while, it was used as part of a frame for a portrait of the Emperor sent to Saint Helena, but it was finally returned to France. Its beginnings were thus forgotten until revealed by the research of Gérard Hubert in the 1970s.[6] It is now on long-term loan from Malmaison at the Château de Fontainebleau.

SYLVAIN CORDIER

90

91

90
Workshop of François-Honoré-Georges
Jacob-Desmalter
After the design by Charles Percier and Pierre-
François-Léonard Fontaine
**Decorative top from the headboard of the
Emperor's bed at the Tuileries: two imperial
eagles holding a victory garland**
1808–9
Château de Fontainebleau, Musée
Napoléon Iᵉʳ (dépôt du musée national des
châteaux de Malmaison et de Bois-Préau)

91
Workshop of François-Honoré-Georges
Jacob-Desmalter
Napoleon's ceremonial bed at the Tuileries
1809
Musée national des châteaux de Versailles
et de Trianon

92
Jean-Baptiste-Claude Séné
Alexandre Régnier
Altered by Michel-Victor Cruchet
Louis XVI's bed at Saint-Cloud
1787
Château de Fontainebleau, fonds palatial

92

THE DREAM OF OSSIAN BY INGRES

A POET IN THE EMPEROR'S BEDCHAMBER

When the Papal States were annexed to the Empire (May 17, 1809), the city of Rome was conferred a unique status among the "French" cities, that of second capital, and the necessity of fitting up an exemplary palace for the Emperor quickly became an issue. The formal papal residence, the Quirinale—renamed Monte Cavallo—was selected.

Its renovations became one of the Empire's most ambitious and costly projects.[1] From 1811 to 1814, dozens of artists and a specialized workforce laboured under the supervision of the architect Raffaele Stern. Transforming the former papal palace required major alterations. It went beyond simply refurbishing the gilding, stucco and woodwork, and modifying the building's architectural structure. Disguising signs of the residence's papal past posed a real challenge for Stern and Dominique-Vivant Denon, director of the Musée Napoléon, who provided guidance from Paris. Rather than calling on Parisian artists, the decision was made to commission only artists living in Rome. The subjects taken from ancient Roman history seemed a given, and Ingres, who had been living in the Eternal City since 1806, was first asked to paint *Romulus, Defeater of Acron* (93) in 1812 for the Empress' second salon. The following year, he was commissioned to paint the ceiling of the Emperor's bedchamber, for which he created *The Dream of Ossian*[2] (94). The idea that the subject was suggested to Ingres by the general Miollis, governor of Rome, has long skewed the story

of the commission. "Apparently, it was around this time that Miollis, a passionate Ossianist, approved this drawing of Ossian already in existence, and commissioned the large painting,"[3] wrote Nicolas Schlenoff. However, it was in fact the baron Martial Daru, Intendant of the Crown Assets, then posted to Rome and brother to the former Intendant-General of the Imperial Household, Pierre Daru, who suggested the subject, initially to the Lucca-born painter Pietro Nocchi. When Nocchi passed on the commission, Ingres was approached.[4] The poem by James MacPherson, which recounts a Nordic saga in the vein of Homer's *Odyssey*, was all the rage in Europe about 1800.[5] Daru mastered the text to perfection, going so far as to translate it into French "at a time when English literature was less well-known in France than it has been since, and before the famous translation by Baour-Lourmian [1801]."[6] The subject of Ossian emerged quite naturally, outweighing stories from history or Roman mythology, which he found already over-used throughout the palace—in contrast, Percier and Fontaine had chosen the figure of Jupiter for the ceiling of the Emperor's bedchamber at the Tuileries. Above all, Daru knew the Emperor's passion for this Gaelic poem. As early as 1797, Jean-Pierre-Louis de Fontanes had written to the young general Bonaparte: "It is said that you always have *Ossian* tucked away in your pocket, even in battle, like some sort of bard of valour."[7]

Daru's instructions on the subject and on the modifications Stern requested of Ingres—so that the work would be incorporated into the room's decor—explains the astounding number of preparatory

drawings, as well as the pentimenti, some of which are readily visible to the naked eye. Although Ingres carried out the commission, he was aware of a lack of balance between the figures in the foreground, whose size had been reduced upon Stern's request, and the mass of indistinct figures in the background, painted to satisfy Daru. In 1815, the fall of the Empire and pope Pius VII's return to Rome brought the renovations at Quirinale to an abrupt end, without Napoleon ever having had a chance to stay there. Several artworks, including *The Dream of Ossian*, whose subject was rather inappropriate for a papal residence, were immediately taken down and shipped off to various palaces and reserves.

Back in Rome in 1835, after having been appointed director of the Villa Medici, Ingres located and repurchased his painting. The artist considered the work unfinished, and began to rework his *Ossian* so that it would measure up against other paintings with the same subjects produced by his contemporaries, including Girodet and Gérard, throughout the first half of the nineteenth century. This is the state in which we find this painting that, twenty-five years earlier, had been intended to watch over Napoleon's Roman nights.

CHRISTIAN OMODEO

93

93
Jean-Auguste-Dominique INGRES
Romulus, Defeater of Acron, Carries the Spoils to the Temple of Jupiter
1812
Paris, Musée du Louvre (dépôt de l'École nationale supérieure des Beaux-Arts)

94.
Jean-Auguste-Dominique INGRES
The Dream of Ossian, ceiling in the Emperor's bedchamber at the Palais de Monte Cavallo
1813
Montauban, Musée Ingres

PUBLIC
ACCESS
TO THE
IMPERIAL
APARTMENTS

CHARLES-ÉLOI VIAL

In the tradition passed down from the Middle Ages, the Château de Versailles was accessible to all the king's subjects, provided they carried a sword.[1] Admirers arrived before the gates, and each day, hundreds of the curious flocked to see the decor or to watch sovereigns pass through the State apartments and dine in public.

During the final decades of the Ancien Régime, curiosity was redirected towards the private apartments, in which the monarchs actually lived. This change in attitude could be traced back to the desanctification of the figure of the king, which widespread opinion reproached for leaving public life behind to lead a decadent life in the sumptuous boudoirs, all while the State's coffers were bare.[2] This view reached its breaking point on October 6, 1789, when the crowd invaded the apartments of Louis XVI and Marie-Antoinette at Versailles: some weeks after the storming of the Bastille, the Parisians forced the court to take up residence at the Tuileries. The somewhat unhealthy curiosity gave way to hatred and violence. The people's incursions into the Tuileries apartments on June 20, and then on August 10, 1792, foreshadowed in spectacular fashion the fall of the monarchy and the advent of the Republic.

Empire palaces open to the public

As of 1804, the State apartments of the palaces were open on holidays. One witness, alluding to their opening upon the occasion of the Saint-Cloud fair, attended by hundreds of thousands of visitors, mentions the public's "great joy."[3] Each year, for the major commemorations and for the Emperor's and Empress' birthdays, the palaces were illuminated. Parisians hastened to the Tuileries to take in free concerts, or made their way to Saint-Cloud and Versailles to see the nocturnal fountains, the Grandes Eaux (95).

The press of courtiers in the palaces was joined by diplomats and foreign princes. On Sundays and Thursdays, within the "levee" protocol reminiscent of some of the Versailles customs, Napoleon passed through the State apartments on his way to and from mass. It was the perfect time to see him, talk to him or simply admire the magnificent interiors. The comte de Rivaz, representative of the département of Simplon in the Legislative Corps, also adopted the habit of appearing at the Tuileries every two weeks, where he "rubbed elbows" with the courtiers.[4] The simple subjects who wished to attend the imperial mass received tickets delivered by the offices of the Grand Chamberlain (98).

Europe discovered the luxuries of the court through dozens of reports describing these visits. As the prince Charles de Clary-et-Aldringen of Austria

noted upon a visit to the Trianon in 1810, "I doubt the Orient itself ever knew such beauties of bronze, embroidered velvet, porcelain, painting, floor and fireplace."[5]

Indiscreet visitors

Since early in his career, Napoleon had been considered a different sort of man. His reputation as a workaholic fascinated the curious; those who had once dreamed of seeing the chambers of Louis XVI now dreamed of visiting his study, imagining maps, plans for conquest and decrees piling up on the desk, as well as secret letters half-burnt in the fireplace.

Napoleon used this curiosity for political ends. In 1802, the former English minister Charles Fox, taking advantage of the peace with France to travel to Paris, was authorized to visit the Malmaison study, which had been staged to receive him: "several written documents in Bonaparte's hand were spread out on a table." Fox then visited the study at Saint-Cloud, decorated with busts of Cicero, Nelson . . . and Fox himself, who was extremely flattered![6]

In the early days of the Empire, some of the curious bribed the staff to gain access to the apartments in their master's absence. In 1806, the Baden statesman Karl Christian von Berckheim visited Malmaison in this manner.[7] Joseph-Henri-Joachim Lainé, member of the Legislative Corps, discovered Saint-Cloud in 1808, but he was disappointed by Napoleon's chambers, which he found too luxurious for a military man.[8] The American lieutenant-colonel Ninian Pinkney, who was in France in 1807, was refused entry to Rambouillet by the concierge, but he alleged in his memoirs to have seen portraits of Louis XIV, which only existed in his imagination.[9] Busybodies also found their way into the gardens: at Trianon, where he stayed on the ground floor, Napoleon complained that he could not work, because of the dozens of curious onlookers pressed up against the windows of his study.[10]

Nevertheless, Napoleon was forced to allow his apartments to be open in his absence, as requests were so numerous. Rules governing the Tuileries tours were written in 1809. Henceforward, a written authorization from the Grand Chamberlain gave groups of visitors access to the palace:[11] accompanied by a servant, they were led on a tour of the apartments, the Council of State rooms and the theatre. They entered in groups of eight or ten, between 10 a.m. and 3 p.m., on Mondays, Thursdays and Fridays.[12] In 1811, Grand Marshal Duroc specified that men had to be in formal dress, with their sword at their side.[13] In 1812, a new rule clarified that the tour had to be carried out in the presence of the concierge so as to ensure the security of the Emperor's papers.[14]

97

98

95
Philibert-Louis DEBUCOURT
Illumination of the Grande Cascade at Saint-Cloud on April 1, 1810, for the Wedding of Napoleon and Marie-Louise
1813
Paris, Bibliothèque nationale de France

96
ANONYMOUS
Design for the Installations and Decorations in the Empress Josephine's Painting Gallery at Malmaison
1807
Private collection

97
ANONYMOUS, possibly JACOB FRÈRES
Cartonnier from the Emperor's library at Malmaison
About 1795
The Montreal Museum of Fine Arts

98
Admission ticket for the mass celebrated in the chapel at the Tuileries, on October 4, 1812, in recognition of the Emperor's victories
1812
Paris, Bibliothèque nationale de France

99
Library of the First Consul, later the Emperor, at Malmaison in its current state

This curiosity did not come to an end with the regime. Czar Alexander I, visiting the Tuileries on April 4, 1814, after the fall of the Empire, exclaimed upon entering Napoleon's office: "What great things were conceived and cogitated in this room!"[15]

Museums in the making
Only the Château de Malmaison was a separate case: following the separation of Napoleon and Josephine in 1809, the property became the private residence of the divorced Empress. Its status as a former palace explains, however, why the place continued to receive visitors. Josephine transformed the Malmaison library-study into a memorial dedicated to preserving the presence of her former husband (99). She did the dusting herself, and invited her guests in to view it: "Everything had been left exactly in the state it was in when the Emperor left his study: a history book on the desk, the page marked where he had left off, the quill he had been using still held the ink that in the very next minute might have laid down the law to Europe: a world map, on which he showed his confidants his plans for the countries he wished to conquer."[16] This immutability

explains the presence of a Louis XVI-style filing cabinet in 1814, today in the collection of the Montreal Museum of Fine Arts (97). One lady visitor declared that upsetting the arrangements of Napoleon's apartments would be a crime, "that posterity had every right to reproach the nation for failing to prevent it. Malmaison ought to become a national property."[17] In one sense, Josephine's residence became the first Napoleonic museum as of 1809.

Having inherited the monarchs' habit of life as performance, the public's curiosity for the palaces foreshadowed their transformation into museums. Even today, hundreds of thousands of the curious visit the places where Napoleon lived and worked. Fontainebleau, Malmaison, Rambouillet and Compiègne still stand, while the Tuileries and Saint-Cloud, which burned down during the fall of the Second Empire, now are the stuff of legend. The public's interest in the places of power and the daily life of these leaders has never waned, as illustrated by the success of the tours of the Palais de l'Élysée, the Canadian Parliament in Ottawa, the public spaces of the White House in Washington, D.C., and the State rooms at Buckingham Palace and Windsor Castle.

———

COURT DRESS

SYLVAIN CORDIER AND CHANTELLE LEPINE-CERCONE

"The coronation date was approaching; a fine court costume was being designed, preparations were being made for unprecedented splendour."
–*Mémoires de Madame de Chastenay, 1771-1815*

Approached from the viewpoint of the role of the Imperial Household in the shaping of court life, the question of court costume reveals the involvement of the department of Ceremonies in the composition of a hierarchized and rationalized rhetoric. This rhetoric borrowed from the customary principles of military uniforms adapted to the codified comportment of the new aristocracy, while drawing from previous images of court attire designating princes, ministers, ladies-in-waiting and servants. Our intention here is to analyze the specific characteristics of these costumes so as to demonstrate the role played by these markers of identity and precedence in the functioning of the imperial palace and its customs. Court dress under the Empire has been the subject of numerous studies.[1] Although the present contribution is based on different sources, we wish to begin by paying tribute to the approach so admirably developed some decades ago by Madeleine Delpierre in her monograph for the Musée Carnavalet's exhibition *Costumes de cour et de ville du Premier Empire* (1958).[2]

Few examples of the court costumes of the Empire are still extant. The famous *Livre du Sacre*–a long-term undertaking begun in 1805, but actually worked on throughout the reign and only completed during the Hundred Days–is the main reference enumerating the various principles defining the prescribed apparel. Its publication was the direct responsibility of the Household, and more precisely of Grand Master of Ceremonies Ségur. A deputy master of Ceremonies, Aignan, was charged with writing the entries, particularly the full descriptions of the various outfits, working with the *dessinateur* of the same department, the artist Isabey, who depicted them. Percier and Fontaine, the architects of the Household's intendance who were responsible for the palaces of the Tuileries and the Louvre, worked on the architecture and ornamentation.[3] This publication followed the text of a decree of the 29 Messidor, Year 12 (July 18, 1804), which established the rules governing court dress. The role of the full-length portraits of the princes and princesses, dignitaries and civil officers was also important for picturing in detail the garments worn in the context of the imperial court.

The definition of official dress was included in the palace *Étiquette du palais impérial*, and from the earliest days of the Empire must have required considerable historical research into former customs at the court of France and other European courts so as to propose a synthesis worthy of the new regime.

The appointment of Jean-Baptiste Isabey as the *dessinateur* of Ceremonies demonstrates the importance assigned to the ornamentation of these lavish garments and their look of nobility. As a pupil of David trained in the rules of heroic representation, Isabey was also a favourite of art lovers owing to his talent as a portraitist and genre painter. His mastery of the various criteria of contemporary taste was to prove vital to the department of Ceremonies under the Empire. Isabey worked in collaboration with a coach, whose job it was "to teach all those who appeared in grand ceremonies what they had to do to ensure the symmetry of the groups, the sequence of appearance, the pacing of steps and the dignity of movement."[4]

Certain principles were paramount. Ceremonial dress followed strictly defined rules that made apparent the rigid social hierarchies. The wearing or not wearing of a coat, the use of gold or silver in the embroidery, the assignation of specific colours to certain titles and functions, were all facets of the policy of dress and a powerful mechanism for creating courtiers. Among these constraints were some areas of relative freedom, notably for men in the cut of their suits: with the advent of the Empire, these could be *à la française*, that is, a jacket with pockets, the skirts of which flared out above the legs, or *à l'espagnole*, that is, with or without pockets and falling straight. Within the strict rules governing the wearing of the heavy court mantle, a certain latitude was granted to the ladies in regard to the embroidery and the colours they wished to wear.

Grand costumes and civilian uniforms: A lavish display of embroidery

The Emperor's *grand habillement* or "grand costume", generally described as the coronation robes, was designed to resemble what the early kings of France wore for their coronations at Reims. Completed for the imperial consecration at Notre-Dame in December 1804, it was not restricted to this ceremony alone. Napoleon wore it again the following day at the Champ-de-Mars for the distribution of the Eagle medals to the army. The *Livre du Sacre* describes this sumptuous costume as follows: "The imperial mantle of crimson red velvet speckled with gold bees: in the embroidery are interwoven branches of olive tree, laurel and oak surrounding the letter N. . . . The mantle is open on the left side, revealing the sword hanging from a white satin sash decoratively embroidered with gold cable stitch, the long white satin tunic embroidered along all the seams with gold and the hem embroidered with gold cable stitch.[5]

The heavy velvet mantle with gold embroidery is no longer extant, but the design for the embroidery by Picot (**101**) is known. The long tunic is preserved at Fontainebleau. Designed by Isabey, this grand costume became a central

101

102A

102B

element of the imperial iconography, seen in all the official portraits of the regime by Gérard, David, Ingres, Drölling, Robert Lefèvre and others.

The department of Ceremonies matched Napoleon's full dress with a *petit habillement*, a less regal outfit worn the day of the coronation before and after the ceremony, which later became the principal costume worn by Napoleon in any ceremonial context (**192**): "A crimson red velvet mantle embroidered in gold and silver; lined with white satin with gold embroidery on the facings and collar. A velvet suit in the same colour, embroidered with gold ears of corn along the seams, the same embroidery on the white velvet lapels and collar. Black felt hat capped with white feathers; diamond braid. Lace cravat and shirt collar . . . white satin sash, decoratively embroidered with gold cable stitch; white velvet slippers with satin rosettes, all with gold embroidery."[6]

This costume set the standard for the rest of the civil garments of the dignitaries of the regime. Three versions of this model–in the Spanish cut in the various depictions–were produced for the Emperor, the first for the coronation, and then in 1806, and finally in 1810 for his marriage to Marie-Louise (**100**). Although the cut remained the same, the embroidery on the costume depicted by Isabey in the *Livre du Sacre* is different from that on the wedding suit preserved at Fontainebleau. The same is true of the presence or absence of pockets.[7]

Designed by Isabey and executed by Leroy after Picot, the Empress' *grand* and *petit habillement* demonstrated a significant degree of modernity. Josephine, considered among the most fashionable women of her time, used her influence to ensure, as Madame de Rémusat recounts in her *Mémoires*, that "there was no thought of resuming the hoop worn under the old *régime*."[8]

Described in the *Livre du Sacre*, Josephine's full dress consisted of "A mantle of crimson-red velvet speckled with gold bees: in the embroidery are interwoven branches of olive, laurel and oak surrounding the letter N. The lining and border are of ermine. The mantle is attached at the left shoulder and clasped to the belt on the left side. The long-sleeved gown is of silver brocade, speckled with gold bees, embroidered along the seams; the hem of the gown is embroidered and trimmed with gold fringes; the bodice and upper sleeves covered with diamonds. The gold crown, studded with pearls and coloured precious stones; the necklace and earrings in engraved stones, enveloped in sparkles; gold lamé lace ruff" (**F116A**).[9] The splendour of this costume was captured and immortalized by Gérard in his 1808 portrait of Empress Josephine, preserved at Fontainebleau. Its defining feature, the luxurious mantle, weighing a heavy eighty pounds, was worn on only one other occasion after the coronation, but this time by Marie-Louise, at her wedding to Napoleon in 1810, as depicted in 1812 by Marie-Eléonore Godefroid in two versions after Gérard (Versailles and Fontainebleau).[10]

Josephine's *petit habillement* consisted of a significantly smaller mantle adorned with ten-inch-wide embroidery, a short-sleeved white satin dress decoratively embroidered and speckled with gold bees and embellished with diamonds, and a pared-down version of the ruffled lace collar (**116B**).[11] All subsequent formal court attire worn by the Empresses, both Josephine and Marie-Louise, was based on this *petit habillement*, although patterns and styles of embroidery could vary. Indeed, this costume set the standard for all women's court dress during the Empire.

104
François-Pascal-Simon GÉRARD
Portrait of Caroline Murat, Queen of Naples,
with Her Children
About 1809–10
Château de Fontainebleau, Musée
Napoléon Iᵉʳ (dépôt du musée national des
châteaux de Malmaison et Bois-Préau)

105
Marie-Éléonore GODEFROID
Portrait of Queen Hortense and Her Two
Sons, the Princes Napoléon-Louis and
Louis-Napoléon
1812
Musées de l'île d'Aix

106
Marie-Éléonore GODEFROID
The Sons of Marshal Ney
1810
Gemäldegalerie, Staatliche Museen zu Berlin

105

106

The court attire of the French princes, the Emperor's brothers (Joseph, Louis and Jerome), was the most ornate of all civil dress after that of the imperial couple. The *Livre du Sacre* describes it as follows: "Mantle, jacket and breeches of white velvet; the mantle and the embroidery speckled with gold bees; the insignia of the Legion on the suit and mantle. Lace cravat . . . black felt hat with white feathers; diamond braid. Slippers of white silk embroidered in gold; gold cloth rosette" (**116E**).[12]

The use of white for the jacket, breeches and mantle is interesting. It appears to mirror the white tunic of the Emperor's *grand habillement*, whereas his *petit habillement* was red. White was also the colour of the royal standards under the Ancien Régime. Its use for the garb of the princes under the Empire may be explained by it making the members of the imperial family stand out from the other dignitaries at ceremonies.

Few garments of the imperial family have survived. The only one to be found in a museum is preserved in Berlin, and it is not known whether it belonged to Joseph or to Jerome.[13] The portraits of Joseph by Robert Lefèvre (**103**), Louis by Gérard (Fontainebleau) and Jerome by Gros (**120**) admirably depict their costumes. A note sent by the Household intendance prior to the coronation indicated that the mantle worn by Joseph at the ceremony was embroidered by the Empress' seamstress, Madame Hengt.[14] At court, having to wear this costume was at times a source of frustration, because Napoleon's brothers were granted thrones outside of the Empire and thus had exchanged the status of prince for that of king. Hence Jerome, king of Westphalia as of 1807, was less than enthusiastic about the order to wear the white garb of a "simple" prince at the wedding of his elder brother in 1810.[15] He was also dressed in white when painted by Goubaud introducing the Roman senators who had come to pay tribute to the Emperor at the Tuileries on November 16, 1809 (**14**).

The costume donned by the princesses of the court—Napoleon's sisters, sisters-in-law and Josephine's daughter, Hortense, and cousin, Stephanie—was described in the *Livre du Sacre* as a "A long-sleeved court gown of white satin embroidered in gold; the court train attached to the belt of coloured velvet speckled and embroidered in gold; ruffled lace collar; white feathers in the coiffure; diamond-studded aigrette, necklace and earrings" (**116C**).[16]

Whereas men's formal garb during the Empire was relatively strictly regulated, the women of the imperial family seem to have been given more latitude in selecting their dress at court. The *Livre du Sacre* illustrates a court train of crimson velvet, yet in David's *Coronation* (**7**), the princesses are wearing an assortment of colours—red, white, dark blue. This variety of dress is also evident in many of their official portraits. The embroidery appears to have been consistently gold, but other creative details were added. In Gérard's *Portrait of Caroline Murat Queen of Naples with Her Children* (**104**), for example, three-dimensional flowers embellish the bottom edges of the princess' gown and court train. These flowers may have in fact been real, or they could have been appliqued painted velvet flowers, which Leroy is known to have used to adorn some gowns gifted to Catharina of Württemberg by her soon-to-be husband in the *corbeille de mariage* in 1807.[17]

Absent from the *Livre du Sacre* are descriptions of the clothes expected to be worn by the children of the court. However, portraits of children, particularly the boys, indicate that there was indeed an etiquette regarding their dress at court. Two types of formal attire are depicted in portraits of the time, which appear to have been assigned to their wearer according to their age. In David's *Coronation*, the two-year old son of Hortense, Napoleon-Charles, wears a red velvet, one-piece suit, the same outfit donned by the youngest son of Caroline Murat in the family portrait at Fontainebleau (**104**). This attire had been inherited from the Ancien Régime, as seen in Élisabeth Vigée-LeBrun's famous portrait of Marie-Antoinette with her children (1787, Versailles). Its white satin belt was knotted in a similar fashion to those of the adult male members of the imperial family and Household. However, it was tied above the waist, under the bodice, almost like the elevated waist of women's imperial court dress.

As seen in Godefroid's portrait of *Queen Hortense and Her Two Sons, the Princes Napoléon-Louis and Louis-Napoléon* (**105**), the second type of costume seems to have been worn by the boys, aged roughly between five and ten, and draws on elements of both men and women's court attire. The gold fringe, lace collar and long sleeves that puffed at the shoulders are reminiscent of the formal costume of the princesses of the court, an association underscored by the belt of blue silk worn high above the waist, in the Empire style. However, the use of white, in addition to this costume sometimes being worn with a matching light blue sash and a black felt white feathered hat (as in Ducis' *Napoleon and His Nieces and Nephews on the Terrace of the Château de Saint-Cloud* [1810, Versailles] gave it a princely air that suited the Empire's young royalty.

Interestingly, a similar costume is worn by the daughter of Elisa Bonaparte in Benvenuti's 1809 portrait of her (Fontainebleau). Offered by Napoleon to his sister that same year, in a pompous display of the hereditary succession of the Tuscan crown, the status of the young Elisa-Napoléone as heiress to this throne is indicated by her being dressed in the court costume of the male children of the Empire.

107
Robert LEFÈVRE
Portrait of François-Nicolas Mollien, Comte of the Empire, in the Costume of a Treasury Minister
1806
Musée national des châteaux de Versailles et de Trianon

108
René-Théodore BERTHON
Portrait of Denis, Duc Decrès, in the Costume of a Minister
About 1806
Musée national des châteaux de Versailles et de Trianon

107

108

It is also worth noting that these styles of dress were not solely for those related to the imperial family; it appears that the children of dignitaries were also entitled to don such attire at court. Godefroid's portrait of the *Sons of Marshal Ney* (106) depicts his sons in similar garb to that worn by the young princes. The youngest child wears the red velvet, one-piece suit, and the eldest son is depicted in the white silk tunic (although, notably, decorated with a silver, rather than gold, fringe), complete with a sword, making for a playful portrayal. Their brother is in a costume stylistically similar to that of his older brother, but made of a peach-coloured silk with a white belt; this colour does not appear to have been worn by any of the children of the imperial family in any official portraits.

Colour codes and hierarchies of functions

The princes, as Grand Dignitaries, were distinguished from the courtiers by their "Velvet suit embroidered along all the seams, as is the mantle; white lining and facings, embroidered in gold; the mantle speckled with gold bees; white jacket, breeches and stockings; gold lamé belt to which the sword is attached; black felt hat pinned up by a braid and a gold button; white feathers; lace cravat; the Grand Cordon on the jacket; the chain of the Legion around the neck; the star on the jacket and the mantle" (116F).[18]

The jacket depicted in the *Livre du Sacre* is cut in the French manner, not the Spanish, unlike the aforementioned male costume. This garb defined the status of the Grand Dignitary, and each function was indicated by a different colour: the Grand Elector wore dark red, the Constable dark blue, the arch-chancellor of the Empire violet, the arch-treasurer black, the arch-chancellor of state light blue and the grand admiral green. It is interesting to note that two of the Grand Dignitaries were brothers of the Emperor: Joseph was the Grand Elector and Louis the Constable. They were thus entitled as princes to wear white garb at court. The design for the embroidery on the jacket and mantle submitted by the Dallemagne workshop featured a combination of laurel leaves and oak leaves (102A). The Musée de la Légion d'honneur houses a Grand Dignitary's suit worn by marshal Berthier when he was vice-constable; he took on this duty together with his many other positions as of 1807, since the Constable, Louis, had been made king of Holland.

The costume of the marshal was of dark blue velvet, similar to that of the Grand Dignitaries. The description in the *Livre du Sacre* seems to confuse the two by asserting that it was the marshals' robes that were embroidered with "leaves of oak and laurel,"[19] while Dallemagne's model for them indicates that they were only embellished with oak leaves (102B). This is confirmed by the suits and fragments still extant, which belonged to Davout (Musée d'Art et d'Histoire, Auxerre), Lannes (Musée de l'Armée, Paris), Oudinot (priv. coll.) and Ney (112).[20]

The civil uniforms worn by the Grand Officers of the Imperial Household indicate their subordinate position in the official hierarchy, because the embroidery on their outfits was of silver and not gold, like those mentioned previously. The *Livre du Sacre* describes them as follows: "Velvet mantle lined with white silk; the mantle and facings embroidered in silver; velvet suit embroidered in silver along all seams; breeches and jacket of white silk embroidered in silver; white silk belt embroidered with silver cable stitch; lace cravat; black felt hat, turned up by a silver braid and topped with white feathers; the Star and Grand Cordon on the suit; the cane of velvet speckled with bees, the pommel a golden crown" (116G).[21]

Similar to the Grand Dignitaries, the six Grand Officers of the Household wore distinguishing colours: the Grand Chamberlain wore scarlet, the Grand Marshal of the Palace amaranth red, the Grand Equerry light blue, the Grand Master of the Hunt green and the Grand Master of Ceremonies violet. The Grand Chaplain was not affected because he wore his cardinal's red when at court. The extant models for the different embroideries assigned to the various members of the Household (26) show that it was the simplification of ornamentation that demonstrated the hierarchical scale between the Grand Officers and their respective subordinates—chamberlains, equerries (25), prefects of the palace, masters of Ceremonies and assistant masters of Ceremonies (116I). The motif of the palm tree, the symbol of the Household, was added to the oak leaves and laurel leaves. Two jackets of Grand Officers are still extant: one, with the Spanish cut, is that of the Grand Marshal of the Palace, made for Bertrand in 1813 (113), and the other, with the French cut, of the Master of the Hunt, for Berthier (111). Each of the official portraits of the Grand Officers shows them in their uniform. Two jackets of Officers of the Household, one for a chamberlain and the other probably for a prefect of the palace, were recently acquired by Fontainebleau (109, 110). Noticeable here is the absence of embroidery on the sleeves, signifying an officer and not a Grand Officer of the Household. There are also slight differences in the embroidered motifs.

At court, the Grand Officers were required to carry a staff. Two are still extant: that of the Grand Marshal of the Palace Bertrand (115) and another, supposedly belonging to marshal Bessières, who was not in fact a Grand Officer (Musée de l'Armée, Paris). The origin of these objects and their design is complicated. Their use at court is proven by the depiction of them in the painting by David (7) and in the official portraits of Duroc, Caulaincourt and Montesquiou (31, 39, 34). But an

109

110

109, 110
Attributed to the workshop of Augustin-François-André Picot
109. Jacket from the costume of a Chamberlain of the Imperial Household
110. Jacket from the costume of a prefect of the palace or a chamberlain of the Imperial Household
About 1804–14
Château de Fontainebleau, Musée Napoléon Ier

111
Attributed to the workshop of Auguste-François-André Picot
Jacket from the costume of a Grand Master of the Hunt, worn by marshal Berthier, prince of Neufchâtel
1804
Paris, Musée de l'Armée

112
Tailored by Chevalier
Embroidery by the workshop of Augustin-François Picot
After a design by Jean-Baptiste Isabey
Jacket from the ceremonial costume of a marshal of the Empire, formerly belonging to marshal Ney
About 1804
Paris, Musée de l'Armée

113
Anonymous, France
Jacket from the costume of a Grand Marshal of the Palace, worn by the comte Bertrand
1813
Palais Galliera, Musée de la Mode de la Ville de Paris

111

112

acknowledgement of delivery by Biennais, before the coronation, of two "grand master's staffs" and two "master's staffs," that is *a priori* staffs of Grand Officers and officers, gives very different descriptions.[22] There are no examples or depictions of these staffs. However, Biennais also delivered for the coronation "staffs *de dieu d'armes*," the description of which coincides with the Grand Officers' staffs but which were described as being meant for the official guards on duty during ceremonies.[23] These staffs are clearly visible on the page devoted to the chief herald of arms in the *Livre du Sacre*. In the preparation for the ceremony there was doubtless some confusion about the destination of these staffs allotted to different functions.

Among the officers, only the chamberlains wore an accessory in the shape of a key (114). Little iconography exists to form an idea of how this object was worn, but a detail in a watercolour by Zix, *The Emperor and Empress Making a Torchlight Visit: The Lacoön Room at the Louvre* (Musée du Louvre, Paris) shows that it was placed at the back at hip level. This is confirmed by the presence of a small hole probably made for this purpose in the lower right part of the jacket preserved at Fontainebleau. That this was actually the case in other courts of the period is seen in a costume sketch at the Louvre by Isabey for his *Congress of Vienna*, in which Stackelberg, a diplomat and chamberlain at the court of Vienna, wears his key over his jacket pocket.

The *Livre du Sacre* describes the ministers' costumes as consisting of "A jacket, mantle and breeches of blue velvet, embroidered in silver; a white silk lining; the facings of the mantle in white silk, embroidered in silver; a white moiré belt decoratively embroidered with gold cable stitch; a lace cravat; the Grand Cordon on the jacket; a black felt hat with white feathers turned up" (117).[24] Although their costumes were adorned with silver embroidery, their rank below the Grand Officers was probably indicated by the fact that the decoration did not extend the length of their jacket sleeve.

Two patterns of embroidery were used to embellish the ministers' jacket and mantle. The laurel and oak leaf motif is seen in the portraits of the duc Decrès, minister of the Navy (108), the comte Portalis, minister of worship (by Gautherot, 1808–14, Versailles) and Clarke, the duc de Feltre, minister of war (by Fabre, 1811–14, Musée d'arts de Nantes). However, the costumes of numerous other ministers–Gaudin, duc de Gaëte, minister of finance (by Vien the Younger, 1809–14, Musée Carnavalet, Paris), Mollien, minister of the treasury (107) and Montalivet, minister of the interior (by Regnault, 1810, Versailles)–are depicted with embroidered decoration of floral patterns. Not specified precisely in the *Livre du Sacre*, both embroidered motifs constituted part of their formal court attire.

The formal wear of the ladies-in-waiting, the Empress' equivalents to the chamberlains in the Emperor's Household, reflected a degree of ornamentation in line with the dress of the officers. Like the Empress and the princesses, they too wore a court dress of white silk with long sleeves, a ruffled lace collar and a velvet court train. Their lower rank within the Household was indicated through a more minimal use of embroidery, done in silver rather than gold, and their jewellery and hairpiece made of pearls, rather than diamonds (116D).[25] These elements of their costume formed the basis for their court attire in general, although, like the princesses, variation was permitted. The watercolour by Isabey depicting the presentation of the newborn King of Rome, portrays numerous ladies-in-waiting, all wearing slightly different patterns of embroidery and much lighter coloured court trains (15). This variety, of course, did not apply to the *dames rouges*, seen in the left foreground of Isabey's watercolour. These "first ladies" to Marie-Louise were named the "red ladies," after their orange-red dress, which was associated with the Maison de la Légion d'honneur at Écouen and Saint-Denis, the institutions at which they had all been educated.[26]

114

115

114
Martin-Guillaume BIENNAIS
Key of the Chamberlain of the Imperial Household, carried by the general-baron Guyot
About 1810
Paris, Musée de l'Armée

115
Martin-Guillaume BIENNAIS
Ceremonial staff of a Grand Officer of the Imperial Household, formerly belonging to the comte Henri-Gatien Bertrand, Grand Marshal of the Palace
1813
Châteauroux, Musée-hôtel Bertrand

116
Jean-Baptiste ISABEY
Illustrations from the Livre du Sacre (1804) by Charles Percier and Pierre-Léonard-François Fontaine
Château de Fontainebleau, Musée Napoléon Ier
A. *The Empress in "Grand Habillement"* (pl. XI)
B. *The Empress in "Petit Habillement"* (pl. XII)
C. *Costume of a Princess* (pl. XV)
D. *Costume of a Lady-in-waiting Bringing Gifts* (pl. XVII)
E. *Costume of a French Prince* (pl. XIV)
F. *Costume of a Grand Dignitary Prince* (pl. XVI)
G. *Costume of a Grand Officer of the Crown* (pl. XX)
H. *Costume of an Officer of the Imperial Household* (pl. XXVII)
I. *Costume of an Assistant of Ceremonies* (pl. XVIII)

116A

116B

116C

116D

116E

116F

116G

116H

116I

117
Jean-Baptiste ISABEY
Illustration from the *Livre du Sacre* (1804) by
Charles Percier and Pierre-Léonard-François
Fontaine
Costume of a Minister (pl. XXII)
Château de Fontainebleau, Musée Napoléon Ier

118
Jacques-Louis DAVID
The People's Deputy, Design for a Civil Costume
1794
Paris, Musée Carnavalet

119
Andrea APPIANI
*Josephine Bonaparte Laying a Wreath on the
Holy Myrtle*
1796
Milan, duchess Salviati

The court's pages were assigned both a *grand* and *petit uniforme*, the expense of which was borne by their parents.[27] Their full dress uniform is described in the *Livre du Sacre* as a "Green suit, trimmed with gold along all seams; green silk aiguillettes, embroidered with an eagle at each end, speckled with bees and decorated with gold cable stitch; red jacket and breeches, trimmed with gold; three-cornered hat edged with gold; white feather" (**316**).[28] It is this costume that was worn by the pages for formal occasions and portraits, as is depicted in Dufau's portrait of the Marescot family from 1806 (**315**). What is presumably the more casual *petit uniforme* is illustrated in a sepia water-colour by Isabey entitled, *Napoleon and the Empress Visit the Manufactory of Mr. Oberkampf* (Versailles). This costume is much less elaborate, and likely consisted of green, rather than red breeches, as is supported by expenditure accounts in the records of the Grand Equerry of the Household.[29]

In 1810, on the occasion of the Emperor's marriage to Marie-Louise, "first painter to His Majesty" David (and, notably, not the *dessinateur* of Ceremonies, the artist Isabey) was commissioned to refresh the uniforms of the pages. The artist proposed the addition of "a mantle, scarf, slacks and a toque" to the original costume.[30] Although the First Equerry Nansouty found David's alterations agreeable, he nonetheless felt they may be "troublesome for the pages, as on a day of ceremonies they will have to climb in front of or behind Your Majesty's carriage and even when they have to serve at table."[31] There is unfortunately no further evidence—visual or archival—that reveals whether or not David's changes were in fact adopted in practice.

Royal examples, the republican aesthetic and Troubadour taste:
Complementarities and paradoxes

While it was important for Napoleon to somewhat distance himself from the legacy of the overthrown Bourbons, the example set by the Ancien Régime was nonetheless the best showcase of the level of pomp and splendour he wished to attain for his new court, and was thus inspired by the formal costumes of this era.[32] The return of a monarchy to France was extravagantly announced with the *grand habillement* worn by Napoleon the day of his coronation. A long-standing tradition existed in France of elaborate coronation robes, with the rules regarding this costume dating back to the twelfth century.[33] The parallels between the coronation attire of Louis XV and Louis XVI, in particular—represented as their *troisième habillement* in their respective *Albums du Sacre*—and the *grand habillement* of Napoleon are overt, notably in their lavish mantles.[34] Uncovering the left shoulder, rather

than the right,[35] in addition to exchanging the Bourbon blue-violet for red and the emblem of the fleur-de-lys for that of the bee, Napoleon's mantle heralded a new regime within a visual lexicon that would be recognized as a continuation of monarchical rule.

Even before he was crowned Emperor, Bonaparte's imperialist ambitions were clearly evidenced in the adoption of regulations of dress that were in line with the traditions established during the Ancien Régime, beginning with his reintroduction of the silk *habit à la française* (worn at royal court pre-1792), for those presented to the First Consul.[36] This directive in part signified that monarchical etiquette reigned in France once more. It also addressed economic necessity, and was implemented to revive the country's flagging luxury textile industry, which had been nearly decimated after the Revolution. The confluence of these factors—regal and economic—was perhaps epitomized when Napoleon wore the *habit à la française* given to him by the silk manufacturers of Lyon when he announced in 1802 the re-establishment of Catholicism as the religion of the majority in France.[37]

Naturally, the prominence of silk as the fabric of choice in France rose once the Empire was proclaimed. Of course, the formal attire of the Household was made of the finest silk, in the form of either satin, used in the warmer months, or velvet, worn during the winter.[38] In addition, officials wore the *habit à la française* as their everyday attire; it also constituted the formal costume of anybody received at court.[39] Indeed, it was recommended that even the court attire of those in the employ of the satellite Households wear only Lyon silk,[40] although it is important to note that there were instances when other materials were worn. The examples of Napoleon's anger over Josephine's preference for muslin are well known, and it appears that the everyday garb of members of the Imperial Household were in fact made of wool, not silk (**110**). It appears that although silk was certainly central to the image the imperial court wished to project, and its use important to the economy of France, there were nonetheless financial concerns and, in the case of Josephine's taste for muslin, fashion concerns that justified leniency from official regulations.

Although the Empire revived a code of dress that revolutionaries thought would remain in the past,[41] the costumes at Napoleon's court were also influenced by the Revolution. The very idea put forth by the Revolution that dress was integral to establishing a particular identity was adopted with force by Napoleon in how strictly court costume was regulated. Furthermore, just as the Revolution found expression of its ideals in antiquity, so too would Napoleon's court.

120
Antoine-Jean GROS
Equestrian Portrait of Jerome Bonaparte,
King of Westphalia, in the Costume of a Prince
of France
1808
Kassel, MHK Neue Galerie

121
Jean-Louis-André-Théodore GÉRICAULT
Equestrian Portrait of Jerome Bonaparte
1812–14
Paris, Musée du Louvre

121

It is clear that Isabey looked to David's designs for a republican style of dress in devising the formal attire for the imperial court. The mantle of the Emperor's *petit costume*, and of the princes, Grand Dignitaries, Grand Officers and ministers, often worn open on one shoulder, was derived from Greek antiquity[42] and was a defining component of David's costume for a *People's Deputy* from 1794 (**118**). Both the republican and imperial costumes also included a sash, tied around the waist in a distinctive knot. Furthermore, the Spanish-style straight-cut jacket so popular during the Empire in fact echoes the straight, short tunic of David's revolutionary dress. These parallels in design are highlighted in Isabey's minister in the *Livre du Sacre* (**117**), who mimics the pose of the figure in David's "People's Deputy" (**118**). The Revolution had inevitably tempered the codes of ancien Régime dress.

And yet, David's costumes for the Republic make references to antiquity so as to embody the Revolutionary ideals of democracy, virtue, heroism and civic responsibility,[43] whereas the mantles and sashes worn by the men of the Empire, made of velvet and silk and embellished with embroidery and jewels, appear in defiance of those principles. In effect, the costumes worn at the Napoleonic court transformed the styles of ancient republicanism into the aesthetic of classical imperialism. Such associations with ancient Rome were further exemplified in the *grand habillements* of the imperial couple. Napoleon's tunic was inspired by classicism and originally intended to be paired with Roman sandals.[44] Josephine's high-waisted gown, which in muslin connoted the democratic ideals of antiquity (**119**), now in silk defined an empress (**156**). Their mantles were of the deep crimson that historically defined imperial Rome.[45] These associations anchored the Empire in the memory of antiquity.

In addition to these citations, there is also an element of sentimental historicism in the design of the imperial costumes, overt notations to France's medieval and Renaissance past. Indeed, nostalgia for the medieval and Renaissance aesthetic, known as *le goût troubadour*, had begun to infiltrate the French imagination in the second half of the eighteenth century, leading to a group of nobles to petition Marie-Antoinette in January 1775 for permission to wear the costume of Henry III at court. Their request was denied, but the incident is telling in that the nobility associated some degree of esteem with such dress.[46] This interest grew in the nineteenth century with artists, including Isabey, drawing on historical styles for theatre costumes, and influential patrons, such as Josephine, promoting the works of Troubadour painters such as Ducis and Garneray.[47] Considering their interest and the potential of this aesthetic to underscore the legitimacy of the current regime through a link to France's illustrious past, it is

unsurprising that elements of medieval and Renaissance styles were adopted as part of official court dress during the Empire.

The feathered black-felt hat and three-quarter length mantle required by etiquette as the formal attire of the princes, Grand Dignitaries and other members of the Imperial Household were also inspired by the apparel of the Renaissance monarchs, particularly that of Henry III and Henry IV.[48] Ties to France's glorious history were underscored further when Napoleon and the princes of the court began sporting a ruffled collar as part of their formal wear. Gros' 1808 equestrian portrait of Jerome Bonaparte (**120**) demonstrates well how these elements of the imperial court costume (the plumed felt hat, the mantle and the ruffled collar) combined to create an image reminiscent of the Renaissance era. Indeed, such associations were not lost on other artists, as Géricault's interpretation of Gros' portrait about 1812–14 so aptly demonstrates (**121**).

Medieval and Renaissance influences were also seen—perhaps even more overtly—in the formal attire of the women at court. While remaining true in form to the high-waisted and straight-cut Neoclassical design of dress, Josephine's coronation gown, and those of the princesses and ladies-in-waiting, were certainly intended to evoke historical associations. The bands of embroidery decorating the bottom edge, waist and front of their gowns were called *à la reine Mathilde*, in reference to the embroidery seen on some of the women's clothing in the eleventh-century Bayeux Tapestry, which had been on display in Paris in 1803 during the planning of France's invasion of Britain.[49] Moreover, by accentuating the puffed sleeves with bands of embroidery and precious stones, Isabey alluded to the Renaissance trend of "slashing," a method of cutting through the first layer of fabric to reveal coloured material underneath.[50]

Finally, and what was considered the highlight of Josephine's coronation gown by Madame de Rémusat, was her *collerette à la Médicis*, or *chérusque*, a high fan-shaped collar of white Alençon lace reminiscent of the one worn by queen Marie de' Medici, as she was depicted by Peter Paul Rubens in his *Coronation of Marie de' Medici in Saint Denis, May 13, 1610* (Musée du Louvre, Paris).[51] This painting, on display in the Louvre at the time, provided the perfect model for Isabey (not to mention, David) to follow. Marie de' Medici had been the last queen of France to have been crowned in such a ceremony; her coronation was therefore the foundational precedent for the crowning of Josephine,[52] which created a glorious evocation of France's past that reflected the new Empire's desire to create a solid and legitimate basis for its rule.

"The sensation sparked by the Salon still inspires the lofty souls of our artists.
This group of enthusiastic volunteers sees in your reign a new Augustan age. They see in you
the era of their glory and good fortune, and they seek every possible way to express their
wishes and their ardour to Your Majesty."

Letter from Dominique-Vivant Denon to Napoleon, September 25, 1804

ART
AND
MAJESTY

THE ARTISTS

OF THE

IMPERIAL HOUSEHOLDS

AND OTHER ARTISTS

EMULATION, RIVALRIES

AND LOW BLOWS

CYRIL LÉCOSSE

"Yesterday, to mark Gros' triumph, a meeting of the most distinguished artists was convened. If Your Majesty could have witnessed their feelings, their effusiveness for you, you would have seen that this class of souls so easily moved, so difficult to govern, feeds but on glory, which is their most pressing need."[1] These few lines, taken from a letter addressed to Napoleon by director of museums Dominique-Vivant Denon, in September 1804, gives a sense of the opportunistic spirit infusing the painters. The new regime's promises of patronage encouraged the mobilization of a number of talented artists who but awaited "an order from their sovereign to march and escort him on the road to glory."[2] The first signs of this waiting game emerged directly after the *coup d'état* of 18 Brumaire (November 9, 1799). To borrow an expression from Étienne-Jean Delécluze, a student of David, the public figure of Bonaparte—a target for the ambitious and the prize for various competing interests—suddenly "afforded an opportunity" to many artists.[3] This phenomenon was naturally heightened by the frustrations that had accumulated under the Revolution. Skilfully encouraged by the First Consul personally, this emulation slowly eroded the egalitarian ideal of the 1790s.[4] Although the fight for distinction stirred up competition and favoured the rapid transmission of new iconographic formulas, it also engendered "jealousies, rivalries, endless complaints and discontent"[5] throughout the Consulate period. The accusations of favouritism for which Antoine-Jean Gros paid dearly after winning, in 1801, the competition decreed by Bonaparte in April 1799 to celebrate the victory at Nazareth, help us to see, if not to evaluate, the intensity of the rivalries then at play in the art world.[6] In order to restore "precious time" to the artists that would otherwise have been wasted in "intrigue"[7] trying to obtain the best ranking during the competitions organized by the regime, Denon established a fair distribution system to parcel out the commissions among the best artists among them. As he said, this entailed "parcelling out the [Emperor's] munificence in such a way as to be useful to all [the painters]."[8] Following a meritocratic rationale, Denon also pushed the Emperor to be lavish with "bonuses" during his tours of the Salon.[9] Official admission to the Legion of Honour was extended to a few artists in 1803 and 1808—including David (**132**), Gérard (**134**), Gros (**135**), Girodet (**137**), Guérin, Houdon and Pajou—the Empire's way of replacing the use of crowns placed on the most remarkable paintings on display at the Louvre.[10] Although the revolutionary idea of equality may seem to have been preserved throughout, this republican ideal nevertheless collided with the pretentions of some of the painters individually singled out by Napoleon. Distinguishing themselves as the Directory's most confirmed artistic talents, the latter—Jacques-Louis David,

Jean-Baptiste Isabey (**136**) and François Gérard—benefited from recognition and a position solely due to their connection to the Imperial Households: David was named First Painter in 1804, Isabey became painter for foreign affairs, artist for the office of the Grand Chamberlain in 1805, and artist for the department of the Grand Master of Ceremonies, while Gérard inherited the title of First Painter to the Empress in 1806.[11] These "court" artists ranked, along with the architect Fontaine (First Architect of the regime), at the peak of the hierarchy of honours, which included the notable privilege of regularly dining at Napoleon's table.[12] The complex relationships—social as well as cultural and economic—woven between the titled artists and the administration will be studied herein, not only the phenomenon of commissions and other requests, but also the disputes and conflicts. Fuelled by the many commissions for official portraits, the lively competition between the court artists and the others will also be revealed.

The court artist's privileges and duties

The court artist—which Isabey, Gérard and David each became under the Empire—was distinct from the artist who worked for the State. By entering into the service of the Emperor, the painter distinguished with a title committed his talent and time to the regime, in exchange for various prerogatives, to be discussed later. This was different from the artists called on to furnish works sporadically in exchange for a specific fee. Such was the case for Antoine-Jean Gros, Anne-Louis Girodet, Pierre-Narcisse Guérin, Charles Meynier as well as Carle Vernet, none of whom benefited from a fixed income. It was also true for the artists employed by Denon at the Grande Armée headquarters, such as Swebach-Desfontaines, Benjamin Zix, Faber du Faure, Bacler d'Albe and Giuseppe Pietro Bagetti.[13] The status of the court artist lay in a contractual and personal relationship of *fidelitas*. The margin of freedom was narrower, but the privileges were many, particularly the guaranteed studio, even an apartment (as was the case for David), as well as steady and prestigious commissions, special access to the Emperor and a monthly stipend. The allowance received by Isabey attained 11,000 francs per annum (916 francs a month)[14]—a large sum given that the food budget for a single individual of modest means living in Paris was only 350 francs a year. Denon and David drew up to 1,000 francs a month.[15] As for the curators with the Musée Napoléon Visconti and Dufourny, they received 416 francs.[16] At the other end of the spectrum, a simple gallery guard only made 100 francs a month, which was less than an army private, whose average salary was about 125 francs.[17] The affluence of the artists attached to the Imperial Households was even greater, as these sums leave out the

123

many works–mainly portraits–commissioned by individuals. These paintings were generally sold for more than those produced for the regime,[18] but the high number of official commissions compensated amply for the price gap. The sovereign's effigy was not only distributed in the imperial residences, the prefectures and the city halls of major cities, but also in the foreign consulates and all the courts of Europe as diplomatic gifts. The full-length, half-length or bust portraits of the Emperor were produced as either large-scale oils or as gouaches on small ivory tablets. These miniatures were often mounted on snuffboxes or on precious boxes handed out freely to foreign diplomats, ministers and sovereigns and other distinguished notables. In this domain, Isabey effectively secured the monopoly, establishing himself as the sole beneficiary of this lucrative production between 1804 and 1807.[19] In this period, the miniaturist provided some one hundred works to Michel Duroc, the Grand Marshal of the Palace, who assembled and transmitted Napoleon's orders to the members of the Household, particularly to the department of the Grand Chamberlain, who was in charge of gifts. Isabey's work is extremely repetitive: using the same prototype, the artist reproduced his portraits endlessly, sometimes changing a costume detail, and, rarer still, the pose–a three-quarters bust view facing right (**127-129**). The business was certainly lucrative: Isabey earned an average of 1,500 francs a month solely for the miniatures produced for the Crown Treasury (24,000 francs just for the year 1807).[20] But the difficulties underlying his enviable status as painter to foreign affairs quickly rose to the surface. The pressure of the delivery dates demanded by the Emperor required the artist to work with urgency, and production reached an almost industrial pace in the early days of 1807 (between 1805 and 1807, the output rose from thirty-five to fifty portraits a year, at a rate of 600 francs a piece). The increase in demand can be explained by the imperial desire to reinforce the sparkle of life at court and by the progressive expansion of the Empire's borders. Given that the time frame to complete a painting on ivory was more or less a week, the miniaturist often found himself unable to guarantee delivery of the ordered works on his own. The necessity of fulfilling the official orders led him to open a replica workshop.[21] Faced with the reduction in quality of the works delivered after April 1807, Duroc called Isabey to account in August, informing him that "H. M. . . . was strongly displeased" with his portraits and that Napoleon "wished him to do better or another painter would be engaged."[22] This comment reveals the flaws in a commissioning system that favoured the activities of a single artist at the expense of variety. The conflict between Denon and Gérard is another illustration of the inconvenience related to a policy of centralized production.

Appointed, as already mentioned, as painter to the Empress in 1806, Gérard also established himself as the top supplier of regime portraits. Supported by an active workshop, he was able to draw on a number of collaborators in order to fulfill his orders, including Charles de Steuben, Paulin Guérin and Marie-Éléonore Godefroid. This central position was secured by two distinct events: Napoleon's refusal to have his portrait painted by David in June 1806 (**152**), and the rejection of a series of portraits of princes and princesses Denon commissioned from Robert Lefèvre, Élisabeth Vigée-Le Brun, Andrea Appiani and Guillaume Guillon Lethière (**125**). The Emperor deemed them so "poorly made" that he ordered the director of museums to send them back to their creators over the course of September 1807.[23] Temporarily spared from this competition, Gérard took advantage of the situation, transforming his studio into "a type of manufactory," where the swiftness of completion would generate "the saddest results," according to Delécluze: "Almost all the portraits Gérard completed at this time were quite weak, and partly issued by hands other than his own."[24] While seeking to claim a sort of monopoly on the Emperor's portraits, the painter excessively copied his works at a discount (1,500 francs a piece) while selling them at the original price (6,000 francs a piece). This monopoly was denounced in February 1808 by Denon, who had already had words on the subject with David in 1803: the artist responsible for the *Sabines* had demanded 24,000 francs for each of three copies–mostly executed by his students Langlois and Rouget–of *Bonaparte, First Consul, Crossing the Alps at the Great Saint Bernard Pass* (**122**).[25]

How much could the administration fight against the self-interested pressure of the artists who became the cornerstones of the Empire's policy of artistic propaganda? The task was anything but easy. Facing the will of the powerful workshops encysted in the Imperial Households, which exerted not only their own tentacles of influence throughout their networks, but also commanded major financial capital, the authorities involved were unable to promote diversification and the widespread distribution of commissions, in other words, competition, without inciting the ire of the artists bestowed with court titles. One of the measures Denon employed to fight against the "minor protections"[26] was the implementation of consistent and reasonable pricing for the commissioned works. But how to guarantee the artistic calibre of portraits delivered to the repository of gifts? The administration could certainly not remain blind to the drop in quality, given that the prices demanded remained just as high, as we have seen. The return to skill-based competition would change the order of things.

124 125 126

The return to healthy competition

Even though Isabey would be hired in August 1807 to "deal with" the twenty-five new miniature portraits commissioned by Duroc,[27] the situation did not work to his advantage. Faced with the uncertain quality of the portraits copied in the painter's workshop, Duroc suggested a return to the competitive system in order to establish "a sort of rivalry of doing better"[28] between several artists, "without regard to such and such painter." This reinstatement of a type of republican-inspired contest, a sharing of responsibilities, had the explicit aim of mediating the negative effects of favouritism. Putting his plans into effect, the Grand Marshal of the Palace also informed several miniature painters, "without regard to such and such," to produce "40 portraits of the Emperor," taking care to add that only those works "recognized as good" would be kept: "Consequently, all the better for he who succeeds."[29] The end result was that the call brought some of Isabey's students out of the shadows of anonymity by playing on their ambitions and their desire to earn more money. Moreover, competition came from outside too. The miniaturists François Dumont and Jean-Baptiste Augustin sought a way to profit from the situation by presenting themselves as rivals to Isabey.[30] Dumont spontaneously sent three portraits of Napoleon to Daru, and Augustin offered to revive the technique of portrait on enamel for Napoleon, which had been used for gifts under the reigns of Louis XIV and Louis XV.[31] The openness to competition for the portraits offered as gifts led to a rise in the workforce in the latter months of 1807.[32] The names Muneret, Aubry, Guérin, Saint, as well as Nitot, Prosper, Paolo-Ferdinando Quaglia and Gauci, then appeared in the commission registers. The recourse to other painters proved nevertheless problematic, in the sense that few among them could approach the Emperor and sketch out his portrait from life.[33] The results were disappointing, since most of the candidates tried to "make a likeness," as Daru reported, that they could "not capture," which "led to other errors."[34] Not needing to see the subject with his own eyes in order to work, Isabey, like Gérard and David, enjoyed a distinct advantage that he was not willing to share with his competitors, at the risk of losing a position so dearly won. Several of his miniature portraits would also serve as specimens for the painters working for the Sèvres porcelain manufactory after 1806.[35] They can notably be found on the Austerlitz (66) table and on the imposing writing desk conceived in 1811 by the director of the manufactory, Alexandre Brongniart (130).[36]

Somewhat powerless, Duroc recommended to artists "to let go of the perfect likeness in favour of the beautiful ideal, while retaining certain traits."[37] This was practically asking the impossible of artists enjoined to work well and quickly.

Following a series of inconclusive trials, the portraitist Robert Lefèvre (133) was called in as reinforcement. If Denon is to be believed, this student of Regnault's trained in the art of the miniature was then one of those few painters who "had the best likeness of H. M. the Emperor."[38] The results were not long in coming: after 1810, Lefèvre became one of the three main suppliers, along with Isabey and his student Jean-Urbain Guérin, of the miniature portraits to be given as gifts. However, Lefèvre was also called on to supply the production of the large diplomatic portraits that had heretofore been entrusted to Gérard (124). Not only did this painter manage to become one of the main suppliers of Napoleon's portraits, but he also ended up claiming "this right with a certain fierceness" so that he would be readily lent "hidden monetary business," as noted by Gaston Lavalley in his study of the artist, adding that "as soon as he learned that his privileges had been cut off and his official portrait business was compromised, he protested loudly": official painting had become for him "a real industry, and, as a practical businessman, he was not satisfied with demand; he also made offers."[39] This indicates how much the opportunities offered by the department of gifts stirred up jealousies in artist circles. Girodet himself, hardly amenable towards a system of patronage that he felt turned artists into good little soldiers,[40] nevertheless offered to orchestrate, in 1811, a repeat of his *Portrait of Napoleon in Ceremonial Robes* (126) for a total of thirty-six copies destined for the "courts of justice" (each worth 4,000 francs). He deferred, as expected, the bulk of the work to his students, offering the copyists a life-sized tracing of the original in order to ensure that the copies remained true and that delivery was made on time.

The policy of openness initiated by Duroc and Denon to counteract the negative effects of favouritism in regard to Isabey and Gérard did bear fruit in the end. The solution was the formation of a small team of artists outside of court, but sufficiently talented and far enough along in their careers to work independently. All things considered, Isabey and Gérard remain the cornerstones of the action plan for the period 1810–14: they were the ones called on first to paint the portraits of the new Empress Marie-Louise and the King of Rome. This preference was due to their talent and their position at court, but also their international reputation, which imbued their works with an artistic value that was superior in the eyes of their contemporaries.

On distinction

Despite the resumption of control of the department of gifts, those that Denon describes as the "financiers of painting"[41] did not cease to play the independence card shamelessly, barely tolerant that an authority other than the Emperor

127

128

could run interference.[42] As Sylvain Laveissière notes, David thought that "the country owed him something more than admiration, and that he could not submit to the rates established by the administration for the others [the artists]."[43] His refusal to lower the price of his *Coronation*, despite the claims of Denon and Duroc, illustrates the rationale of distinction that was shared by Gérard and Isabey during the Empire.[44] It is easy to comprehend the museum director's frustration from then on, what with the constant battle to guide the painters personally recognized by Napoleon back "to the simple modesty of real artists in all countries, whose glory has always entailed producing a lot and living honourably and without pomp."[45] This was an even more pressing need, given the extravagant prices demanded for some "works the government deigned to award them"–David, for example, received the price, "beyond any sense of proportion and comparison"[46] of 100,000 francs for the paintings of the coronation–"which threw the exalted heads [of all the other painters] into such a state that it was no longer possible to oppose their pretensions with reason."[47] These words were repeated in April 1805, in a letter denouncing Isabey's ridiculous demands. This time, the artist was asking, as recompense for a large official drawing, *Bonaparte, First Council, Visiting the Manufactory of the Sévène*

Brothers in Rouen with Josephine (131), the considerable sum of 20,000 francs. As Denon recalls, the fee requested by the miniaturist was almost the same as the amount paid to Guérin for his painting *Phaedra and Hippolytus* (24,000 francs). The report the museum director sent to the Intendant-General of the Household, Fleurieu, attests to the unease caused by the request of the Cabinet's artist: "It would be a great hardship for the arts if he secures such a price, because individuals and the government alike will not be able to pay them . . . if we were to give 20,000 F to M. Isabé [*sic*], what will we be able to offer to a painter who has made a painting of 25 feet depicting a subject from the Emperor's history?"[48] That same day, in a letter to Napoleon, Denon accused the miniaturist of shamelessly exploiting all the resources at his disposal, using his titles and proximity to power as leverage to demand and obtain rates well outside of tolerable standards: "Please permit me to add, Sire, that given your paternal desire to protect the arts and to have memorable things made, the only way forward is to establish a price that is not determined by affection; and then, if some specific reason or particular merit warrants breaking this rule, it should not be because of honours, favours or pensions, and Monsieur Isabey has already found himself in such a state of grace with Your Majesty in this respect."[49]

Par la Manufacture Impériale de Porcelaine de Sèvres

131

130
SÈVRES IMPERIAL MANUFACTORY
Alexandre-Théodore Brongniart, fils
Design for a secrétaire called "of the Imperial Family"
1811
Sèvres, Cité de la céramique

131
Jean-Baptiste ISABEY
Bonaparte, First Consul, Visiting the Manufactory of the Sévène Brothers in Rouen with Josephine
1804
Musée national des châteaux de Versailles et de Trianon

132

133

134

135

136

137

132
Workshop of Georges ROUGET
Portrait of Jacques-Louis David
About 1813-15
Washington, D.C., National Gallery of Art

133
Robert LEFÈVRE
Self-portrait
1810
Musée des Beaux-Arts de Caen

134
François-Pascal-Simon GÉRARD
Self-portrait
About 1825
Musée national des châteaux de Versailles
et de Trianon

135
Antoine-Jean GROS
Self-portrait
1795
Musée national des châteaux de Versailles
et de Trianon

136
Jean-Baptiste ISABEY
Self-portrait
About 1795
Private collection

137
Anne-Louis GIRODET DE ROUSSY-TRIOSON
Self-portrait, in Left Profile
N.d.
Paris, Musée du Louvre

138
François-Pascal-Simon GÉRARD
*Portrait of the Empress Marie-Louise
Presenting the King of Rome*
1812
Musée national des châteaux de Versailles
et de Trianon

The lack of financial precision reigning over this series of official commissions is a fairly good reflection of the difficulty those giving out commissions had in setting a fair fee schedule that respected the hierarchy of genres and talents, which no one sought to exploit more than David, Isabey and Gérard. Thus, in 1809, the latter solicited and obtained, against the advice of Denon and Daru and thanks to the support of the Empress, the considerable sum of 12,000 francs for a portrait that had been commissioned by verbal agreement, which amounted to double the standard rate.[50] A year later, Isabey claimed 1,200 francs for a portrait of Napoleon in the clothes he wore to his wedding—the *petit habillement*—in comparison with the 600 francs normally paid for this type of work, warning Duroc that he would not "suffer any reduction" despite the appraisal mandate entrusted to Denon.[51] Grand Chamberlain Montesquiou, who was forced to intercede, nevertheless had to give in to Isabey's demands, begging Daru to "please authorize the sum," claiming "given that it would be impossible to obtain the reduction."[52] He added that "as for the future, M. Isabey will not supply His Majesty without the price being set beforehand."

These reactions and incessant calls to order made by Duroc, Daru, Denon and even Montesquiou should not disguise the fact that Isabey had become, just like Gérard and David, indispensable to the regime.[53] Moreover, the financial demands formulated by these artists—particularly upon the occasion of major public ceremonies—did nothing (or little) to damage the Emperor's confidence in them.[54] The legitimacy of these painters largely rests on their titles, which were irrefutable signs of recognition in official artistic circles, but even more on their talent, which would have been difficult to replace. However, the archives are rife with items attesting to the resistance of these artists, often forcing the authorities involved to face the limits of their discretionary power. A study of the most distinguished painters of the regime must take into account this ambivalence, between the fierce desire to preserve a specific identity left behind by the revolutionary period and the repeated infractions due to hierarchical duties. As is evident, any thought of conforming to a norm was difficult to enforce since these painters refused to completely cede to a narrow vassalage. Their pretense of self-regulation seems to be but the belated echo—with some distortion—of conduct that kept alive a libertarian ideal born in 1789.

WHEN
FRANÇOIS GÉRARD
WAS
PLANNING
THE PORTRAIT
OF THE EMPEROR

SYLVAIN CORDIER

François Gérard's full-length portrait of Napoleon in full regalia is one of the most iconic images of the imperial regime and a powerful vector of the renewed monarchical ideology in France in 1804 after more than a decade of republican rule. It is also a fine work, a superb composition exemplifying the rich visual culture of an artist trained by Jacques-Louis David and already well on his way to becoming the leading portraitist of European royalty. Paradoxically, it disappeared in the late nineteenth century[1] and is known only from the numerous studio copies executed among the artworks commissioned by the government and the Imperial Household (139).

The circumstances of the commission
Although the whereabouts of the original version is unknown, its original destination has nevertheless been identified. The commission came from Talleyrand, in his position as minister for foreign affairs, for the audience room of his ministry in Paris, in the Hôtel de Galliffet. The commission did not come directly from the Imperial Household, but from a government institution.

On December 22, 1804, while the work was still being painted, the minister of the interior, Champagny, commissioned a series of copies of it in full-length, three-quarter length and bust views. They were intended to be hung in the reception rooms of French diplomatic residences abroad, renewing the old tradition of displaying the image of the sovereign in French institutions overseas. A certain number of these portraits were ultimately given to members of the imperial family and to foreign courts. Of this series, the several canvases still extant are of uneven quality, indicating that the painter's assistants were not all gifted artists.[2] They include what is probably Jerome Bonaparte's copy, found at Fontainebleau, Madame Mère's at the Fesch palace in Ajaccio, the Murats' at the Louvre, Joseph's at the Capodimonte when he was king of Naples and another at San Fernando when he was king of Spain, Louis Bonaparte's at the Rijksmuseum in Amsterdam and Eugène de Beauharnais' at the royal palace in Stockholm. Another copy, given to king Frederick Augustus of Saxony, is in the Gemäldegalerie Alte Meister in Dresden.

The growing reputation of the work led to its being used for gifts and for the production program of the great imperial manufactories, the copies being made at the cost of the Imperial Household. The Grand Officers, in particular, had the right to a copy: in addition to the original version for Talleyrand, there were versions given to Ségur, Grand Master of Ceremonies, and Caulaincourt, Grand Equerry.[3]

A letter sent to Talleyrand in March 1806 by Dominique-Vivant Denon, director of the Musée Napoléon and consultant on the policy of artistic commissions, informed the minister of Napoleon's decision to use his model for executing the Gobelins tapestries:

"Director General of the Musée Napoléon to His Excellency the Grand Chamberlain, Minister for Foreign Affairs.
Excellency,
His Majesty the Emperor has commanded that his full-length portrait executed by M. Gérard hanging in the apartments of your mansion be executed in tapestry; please order it to be sent to me next Tuesday so that I can have it taken to the Gobelins manufactory, since His Majesty will be visiting this establishment this Thursday the 5th inst."[4]

As a result of this decision, but two years later, copies were commissioned from Gérard's studio for full-length and bust versions to be sent directly to the Gobelins and Sèvres manufactories.[5] Those destined for the Gobelins were made available to the Intendant-General of the Household in March 1808.[6] The full-length portrait is now at Versailles. Meanwhile, again on Napoleon's orders, Denon once again instructed that the original painting of the minister of foreign affairs join the other works being sent by Gérard to the Salon of 1806.[7] That same year, an engraving of the work was commissioned from Auguste Boucher-Desnoyers, a print of which was presented at the following Salon (1808).[8]

Beyond the attractiveness of this portrait, administrative correspondence, public presentations and numerous reproductions in various media reveal the part played by members of the Imperial Household in the promotion of official pictures. It is notable that in 1806, the requisition order for the painting was addressed as much to Talleyrand in his role as Grand Chamberlain, as it was to his function as minister, the same person fulfilling both roles. As Grand Chamberlain, Talleyrand was responsible for the gifts given on behalf of the Emperor, a practice that involved the production of tapestries at the Gobelins.

There is some information about the conditions for the execution of the portrait in its numerous versions. The artist received 12,000 francs for the one for the minister of foreign affairs, and the production of the various copies entailed a series of payments to Gérard's studio consisting of 42,000 francs in 1806, 25,000 francs in 1807, 35,000 francs in 1808, 10,000 francs in 1809 and 12,000 francs in 1810.[9] Denon mentions in several of his letters that the artist was asking 6,000 francs per canvas for his *Napoléon*.[10] Taking into account additional costs (notably the framing, estimated at 400 francs), it can be assumed that six copies were produced in 1806, three or four the following year, then five,

140

141

then at least one and then two. A highly profitable venture! In early 1808, Denon expressed to the Intendant-General of the Household his irritation regarding the privileged status of a painter whose prices he considered exorbitant:

"Whenever it is a question of assessing the talent of M. Gérard, I will always place him in the first rank, and he is one of the first I would recommend as a history painter. Beyond that, if he wants to act as a businessman, that is to say, to execute all the diplomatic portraits and all those for presents from the Emperor, this speculation, very lucrative for him, becomes too costly for the government, and too delicate a matter for the arts for me to accommodate administratively.

We have paid all painters three or four thousand francs for original full-length portraits; M. Gérard's talent may deserve twice as much, but the copies he has made for him in his studios for 1,500 francs cannot be sold to the government for 6,000 francs, and any good artist in Paris would be happy to paint such a copy for two thousand francs."[11]

A pointless complaint: despite Denon's exasperation, the 6,000 franc price was never reduced. In 1811, approached by the minister of religious affairs regarding new commissions, this time for sixty copies, Denon suggested that they abandon Gérard and have copies of his work executed by young artists for a thousand francs each.[12] This plan does not seem to have been carried out.

The time and place of the portrait: (Re)composing a kingly image
Before looking more closely at the composition of the portrait, it is necessary to situate it within the chronology of regal images of Bonaparte. The need to depict him in an official manner became apparent with the first Italian campaign, but this was a question of individual undertakings linking the supreme commander and his wife Josephine with some councillors and a small circle of artists. They were all aware of the immense impact of images on public opinion at the moment when the young soldier was becoming the saviour of the nation. From this period were the image of Napoleon at Arcole by Gros (**140**) and the unfinished oil painting by David (**141**), in which the practice of portraiture is conflated with history painting, the image of the hero being associated with the commemoration of an important, conclusive episode of the revolutionary story.[13] This vision is seen again in Appiani's portrait of the First Consul on his return from the second Italian campaign, about 1801 (**4**).[14]

The general's rise to the status of First Consul made it necessary to establish an effective depiction of the leader, to pay him homage and to acknowledge his stature as a statesman. Only a few years after the king's demise, a new strong man, this one without a crown but wielding a real and more extensive power than ever, was reigning over the French nation. The arts had to be a brilliant reflection of this fact.

It was Gros who, in 1802, was given the first official commission for a portrait of the First Consul to be presented to the Second Consul, Cambacérès (**142**). Alone against a neutral background, wearing the Consulate uniform and standing beside a velvet-covered table, Bonaparte lays his hand on a large document recapitulating the victories and treaties that had earned him glory in Italy. Two years later, Ingres was commissioned to paint him in a portrait intended for the town hall of Liège (1804, Musée du Grand Curtius, Liège) commemorating the reconstruction of a suburb of the city burned down by the Austrians ten years earlier. This generous deed is scrupulously recorded on a large sheet of paper that Bonaparte is drawing our attention to in a motion very similar to the one in the Gros portrait. Both of these likenesses celebrate the essential features of the regime's propaganda involving military glory and the restoration of civil prosperity.

It is important to examine the references employed by the artists who were commissioned to execute these early portraits of Bonaparte and the way in which a republican image of the head of state (more than a citizen but less than a king) was constructed. The depiction of numerous documents recalling victories, treaties and memorable political actions was an important part of the sovereign program designed in addition to references to monarchy. These codes of representation, all of them adapted to commemorate the great deeds of the First Consul, evoke certain specific iconographies. The first is that of the ministers of the Ancien Régime, such as Calonne depicted by Vigée-Lebrun (**143**), suggesting that both Gros and Ingres, in these final days of the republican ideal, saw Bonaparte less as an absolute leader and rather as a man responsible for his actions to the people—this highly abstract ruler that for a decade was known as the Nation—called on to justify his right to govern. The second reference for this iconography was the *Portrait of George Washington* by Gilbert Stuart, called the Lansdowne portrait (**145**), the first copies of which had been painted somewhat earlier (1796–1800) and had begun to circulate in Europe in print form.[15] The image of the president of the young American republic was admired by the First Consul,[16] and represented a real gift to artists called on to celebrate the leader of a republic without having to resort to citing past kings. This American influence

143

144

145

certainly diminished with the proclamation of the Empire, but persisted in full-length portraits of Napoleon in uniform (**168, 169**).

More particularly in the case of the portrait by Gros, a third possible reference is the portrait of Charles-Louis-François-Henri Letourneur in Directory dress. He was one of the five chiefs of the executive under the regime of the Directory, which preceded the Consulate and which Bonaparte brought down with the *coup d'état* of 18 Brumaire (**144**). This comparison sheds light on post-revolutionary reflections on the portrait of the leader: each person with his place in the rational framework of functions established by a constitution. The apparel "makes" the prince and symbolizes his mandate, and it must be associated with the features of the man wearing it. The First Consul painted by Gros in the same position as one of his predecessors looks from this point of view as the expression of the replacement, through ceremonial dress, of one regime by another. The attire of the Consul persisted in the iconography of Bonaparte after the establishment of the Empire, as evidenced in the 1804 statuette by Richardot and Wouters (**146**).

Unlike David, Gros or Appiani, under the Consulate, Gérard was less interested in executing a portrait of the First Consul that would be both regal and republican than in devoting his portrayal of Bonaparte to the renewal of history painting, notably in his superb finished drawing of the *Signing of the Treaty between France and the Holy See, July 15, 1801* (**12**). It is also important to mention his perceptive bust portrait of the First Consul in 1803 (Musée Condé, Chantilly).

His Napoleon as Emperor undoubtedly recalls the iconographic culture of the preceding century and a series of images of the Ancien Régime. The earliest of his references is the Louis XIV by Rigaud. The recent rediscovery of the *modello* (**149**) allows us to better understand the composition, and its successors were the royal portraits of Louis XV by Van Loo and of Louis XVI by Callet (**147, 148**). Gérard retains the pose and modifies it only slightly. The wearing of full regalia, the presence of the attributes of a sovereign, scarcely transformed at all, and the position before the throne under a dais look at first sight like a stage setting. This objectively counter-revolutionary choice is clear. It sets the Napoleonic regime within a long historical perspective that erases the memory of the Revolution in order to participate in the restoration of a secular national concord based on the monarchical principle.

Nevertheless, the relationship to the "Rigaud model" of the Ancien Régime is misleading. It actually offers a very superficial analysis of a picture that is much more subtle, that is not in fact a simple resurrection of the sacred status of ancient kings and their decorum, for Gérard chose to diminish the framing of the scene considerably. Unlike the portraits of the kings of France, which invariably open to the left into a wide architectural space, Napoleon appears in a totally enclosed environment. The fabrics on the dais of the throne match the velvet of the robe, the gold on the wood of the chairs echoes the reflections of the regalia filling a restricted space as though to overwhelm onlookers, confronting them with the expression of a visually identifiable power, and confining them in this enclosed space. The environment is entirely filled to better serve as a setting, a trajectory for the forceful gaze of the sovereign standing above his new subjects. The painter offers a perfect compromise between the memory of the "king's body" of former times and the heroic figure inherited from the school of David, notably in his treatment of the frontality, which, from Bailly in the *Tennis Court Oath* (1791, Versailles) to *Leonidas at Thermopylae* (1814, Musée du Louvre, Paris), seems to be addressed to the onlooker and plays the essential role of the one who reveals the historic or dramatic moment that is the subject of the work.[17] The pose, stiff and dignified, and also the point of view, recall as well the *Belisarius* that Gérard had painted ten years earlier (**151**) and gives the impression that Napoleon is walking towards the viewer. Rather than a new king, solemn and distant, Napoleon stands as a man incarnate, whose destiny is evident to anyone who looks him in the face. A hero facing history assessing an onlooker who is immediately transformed into a subject. The face has an antique quality to it; the gravity of the features recalls ancient Roman statuary. A successor to the kings of France, Napoleon is also an heir to the Caesars, and it is tempting to make a comparison with the sculpted head of Augustus of the *Prima Porta* type (**150**).

Another important difference lies in the question of the historicity and reality of the place and time of the imperial portrait. While Louis XIV, Louis XV and Louis XVI were painted out of pure convention before thrones, in settings where each element embodied a symbolic dissertation on the sacred nature of their authority, Gérard's Napoleon is situated in a perfectly identifiable place: the Throne Room of the Tuileries, where the artist has gone as far as to show one of the windows reflected in the imperial orb on the cushion to the Emperor's right, respecting the room's actual layout. The seat of Jacob-Desmalter's imperial throne as it was in 1804–6, that is, while it was still ornamented with the little bronze flowerettes and palmettes around the back that were removed by early 1807, is recognizable.[18] This anchoring in time and reality is vital in order to understand the work and the novelty of its discourse.

Although the wearing of the impressive ceremonial robes evokes the coronation in Notre-Dame on December 2, 1804, it is important to not make

143
Élisabeth-Louise VIGÉE-LEBRUN
Portrait of Charles-Alexandre de Calonne
1784
London, Royal Collection Trust

144
Jean-Baptiste-François DESORIA
*Portrait of Charles-Louis-François-Henri
Letourneur, in the Costume of a Director*
1796
Musée national des châteaux
de Versailles et de Trianon

145
ANONYMOUS
After Gilbert STUART
Portrait of George Washington
1797
London, National Portrait Gallery

146
WOUTERS MANUFACTORY, Andenne,
Belgium
Modelled by Jacques RICHARDOT
Napoleon, Emperor
1804
Geneva, Collection Comte et Comtesse
Charles-André Colonna Walewski

147

148

147
Workshop of Louis-Michel VAN LOO
Portrait of Louis XV in Royal Ceremonial Robes
After 1761
Ottawa, Library and Archives Canada

148
Antoine-François CALLET
Portrait of Louis XVI in Royal Ceremonial Robes
1779
Musée national des châteaux de Versailles
et de Trianon

149
Hyacinthe RIGAUD
Modello for the *Portrait of Louis XIV in Royal Ceremonial Robes*
1701
The Montreal Museum of Fine Arts

150
Effigy of the Emperor Augustus (27 B.C.–14 A.D.), Model Called "Prima Porta"
1st quarter of 1st century
Paris, Musée du Louvre

151
François-Pascal-Simon GÉRARD
Belisarius
1797
Los Angeles, The J. Paul Getty Museum

the mistake of reducing the image to the impact that this ceremony may have had on public impressions. The painting was undoubtedly planned before the event, and cannot be a commemoration of it. Moreover, by linking the Emperor's body to the tangible realities of the Throne Room in his palace at the Tuileries, the portrait pays tribute less to the sacred aspect of the coronation—to which the courtiers paid little attention—than to the concrete realities of established power. Here too, the reference to portraits of the Ancien Régime is misleading. In contrast to a pre-revolutionary monarchy based on the iconography of a tradition and religion, Gérard presents a monarchy founded on the real and positive perception of power in a clearly identifiable place with well-known objects. By choosing a particularly temporal depiction, the Emperor is shown to be a secular head of state. He does not have to be seen as God's lieutenant on earth: Napoleon in majesty, before the throne of the Tuileries, is not a mystical body.

This determination to present the imperial portrait of the sovereign in a material context within a real setting used the image to manifest the principle that distinguished the new Empire from the absolute monarchy of the Ancien Régime, that is, its strictly constitutional nature. The decor suggesting a clearly defined environment, a concrete context for the expression of sovereignty, can be interpreted as the visual reflection of the positive existence of a juridical text establishing the rights of the new head of state: considerable rights and powers of control probably more extensive than in the days of the kings, but rights nonetheless defined by a constitution. The Throne Room and its seat are the Empire in all its tangibility. To depict them faithfully was to reflect the first article of the first section of the Constitution of the Year 7 (1804): "The government of the French Republic is entrusted to an emperor, who takes the title of EMPEROR OF THE FRENCH. Justice is administered in the name of the emperor by the officers he appoints." In its striking frontality, Napoleon's face and his piercing gaze commands the onlooker to witness and reflect on the second article: "Napoleon Bonaparte, present First Consul of the Republic, is EMPEROR OF THE FRENCH." In other words, the decor constitutes the secular setting for a regime that was expected to become hereditary. Napoleon was only the first occupant of a throne instituted with a view to a long line of emperors.

Counterpoints and correspondences
At the beginning of the Empire, other artists were working on the same project. In the summer of 1805, at the request of arch-treasurer Lebrun, David submitted, as the leader of the Neoclassical school and, since December

1804, as first painter to the Emperor, his vision with a painting executed for the public audience room in the court of appeal in Genoa.[19] The work is now known only from an oil sketch (**152**) and various preparatory sketches in the Louvre.[20] Napoleon is standing under the dais of his throne at the Tuileries. The choice of this setting, the same as the one adopted by Gérard, indicates that it was dictated by the sovereign, his administration and the artist. In David's canvas, however, the stern and impassioned pose of the model gives the impression of being exaggerated, in the style of an antique hero's theatrical gestures in a history painting from the 1780s. This dramatic quality, featuring a pose captured in an instant and an expression of firm determination, is typical of David's earliest depictions of Bonaparte, the unfinished portrait in the uniform of the chief general of the Army of Italy (**141**) and *Bonaparte, First Consul, Crossing the Alps at the Great Saint Bernard Pass* (1800–1, Malmaison). The latter work by David displeased the Emperor when it was presented to him in July 1806, perhaps because of the forced look of the pose.[21] It is tempting to compare it with Élie's famous print, *T[alma] Giving a Lesson on Grace and Imperial Dignity* (**153**), disseminated about 1812 in royalist circles, where this theatricality was distorted into a caricature of a sovereign judged incapable of fulfilling his function honourably. In 1807, David produced a second version, much more serene and perhaps too meek, which should be read in the context of the painter's preoccupation with his *Coronation*, commissioned in 1804 and completed for the Salon of 1808. In it, he uses similar decorative elements—a real throne, this time the one from Saint-Cloud, a papal faldistory and regalia—which tends to associate this new image of the sovereign only with the coronation at Notre-Dame. Left in David's studio until his death, this new portrait seems to have been equally displeasing to Napoleon.

There is insufficient space here to provide an exhaustive account of all the attempts at regal portraits of Napoleon as Emperor. The well-known examples of the Ingres portrait (1806, Musée de l'Armée, Paris) and the series of portraits by Girodet have been admirably well studied, and readers are recommended to turn to the texts devoted to them by Todd Porterfield and Susan Siegfried, in addition to Alain Pougetoux.[22]

Less studied is the imperial portrait executed by Martin Drölling (**155**). Although of dubious quality, it is an interesting example of the adaptation of the Gérard model by an artist who was in Denon's circle. The director of the Musée Napoléon offered him this commission on May 7, 1808, for the palace of the government of the Illyrian provinces in Laibach (now Ljubljana,

152
Jacques-Louis DAVID
Portrait of Napoleon in Ceremonial Robes
1805
Lille, Palais des Beaux-Arts

153
ANONYMOUS
T[alma] Giving a Lesson in Grace and Imperial Dignity
N.d.
Montreal, McGill University Library and Archives, Rare Books and Special Collections

154
Martin DRÖLLING
After Élisabeth-Louise VIGÉE-LEBRUN
Portrait of Marie-Antoinette
1789
Private collection

155
Martin DRÖLLING
Portrait of Napoleon in Ceremonial Robes
1808
Private collection

156
François-Pascal-Simon GÉRARD
Portrait of the Empress Josephine in Ceremonial Robes
1808
Château de Fontainebleau, Musée Napoléon Ier

157
ANONYMOUS
After François-Pascal-Simon GÉRARD
Portrait of the Empress Marie-Louise in Ceremonial Robes
After 1812
Château de Fontainebleau, Musée Napoléon Ier

153

154

155

Slovenia).[23] Drölling had already painted Napoleon during the Consulate, and he simply re-used the First Consul's features and draped this model in the sumptuous robe of velvet and ermine, taking his inspiration from Gérard. Working in the limited space of his studio, he proved his originality in his choice of iconographic references. For example, it was to Vigée-Lebrun's *Portrait of Marie-Antoinette*, executed in 1788, that Drölling, himself a royalist, turned for very personal reasons; after 1800, he had at home a copy of this portrait of the queen, painted in 1789 (**154**).[24] This association explains the presence of the column in the background and, in particular, the absence of the stool, which is replaced by a large velvet-covered table for the regalia, clearly taken from the work by Vigée-Lebrun, but inverted.

Following his *Napoleon*, Gérard received commissions for portraits of other members of the imperial family. The standards he had developed to portray the Emperor continued to be applied by the painter and his patrons, whether it was a matter of imitating them or of combining them with complementary ways of depicting forms of sovereignty subject to the supreme authority of the head of the family. To portray Josephine, for example, Gérard does the exact opposite: the Empress looks as if she were crushed by the weight of her robe (**156**). The sweetness of her expression and her indolent nature are both elegantly underscored. Notably, Gérard, by showing her seated, has made a gaffe, in the sense that the throne—the one made by Jacob-Desmalter for Saint-Cloud—is reserved for the use of her husband. In the background is a railing supposedly surrounding the throne, which goes against the rules for the furnishing of the Throne Room. In addition, Gérard has opted for a wider frame, revealing a glimpse of a pair of columns and the end of a palatial gallery—obviously borrowed from Rigaud's painting.

The choice to emphasize the fragility of the Empress' body in contrast to the masculinity of the Emperor was rejected when Gérard came to the portrait of the second Empress. Marie-Louise, standing before the throne in the Tuileries, her hand gracefully resting on the material reality of the imperial seat, gazes into the distance with a confident and determined expression (**157**). Yet this apparent assurance coexists with a not unimportant detail: Gérard has left the stool beside the throne, meant for the regalia, empty. Odd at first sight, this omission is relevant: it highlights the fact that, unlike her spouse, the Empress is a consort and not a titled sovereign. It is notable, however, that Marie-Louise is shown wearing a small crown, the one set with diamonds gifted to her by France at her wedding.

A magnificent image of the authority of the new Emperor, Gérard's portrait of Napoleon has too often been regarded as a servile imitation of the codes of the Ancien Régime, a composition in which the republican ideal is reduced to pomp draped in velvet. But a closer look reveals how this effective legitimizing tool was created and promulgated in order to disseminate and impose the iconographic codes of the new regime in France and across Europe.

By establishing the portrait in the historical context of the French school's reflections on representations of power and the head of state in post-revolutionary France, the complexities of the artistic debate within the Neoclassical generation can be measured. It becomes clear that Gérard, before becoming the "painter of kings" was, for the nineteenth century, the observant witness and attentive portraitist of an Emperor striving for legitimacy. His Napoleon draped in past customs is a modern hero, standing on ground stripped bare by the cataclysms of recent history.

The *Bust-length Portrait of Napoleon in Ceremonial Robes* (160), in a frame surmounted by an eagle and laurel wreath and ringed with bees, is a masterpiece of the collection of Napoleonic works gifted by Ben Weider to the Montreal Museum of Fine Arts in 2008.[1] This oval canvas, executed in the studio of François Gérard, is on the list of copies of the original painted by the artist at the request of the Grand Chamberlain and minister of foreign affairs Talleyrand at the start of the Empire and very soon adopted by the regime as the most accomplished depiction of imperial authority. The recent restoration carried out by Agata Sochon at the Montreal Museum of Fine Arts' Conservation Department (see p. 158) revealed two different styles of painting, one very painstaking, focused on the rendering of the features, the other more energetic, applied to the mantle and ermine collar.

In full-length, half-length or bust format, this portrait was usually commissioned to be offered as a gift by the Imperial Household. Early in 1808, the question arose of putting at the disposal of the imperial manufactories of Sèvres and the Gobelins a bust and a full-length version to enable the image to be promulgated in porcelain and in tapestry.[2] The bust likeness sent to Sèvres is extant, and is now at Malmaison (on long-term loan from the Musée de Sèvres); the one sent to the Gobelins has not been identified. A frame for the tapestry version of the image preserved in Dresden (166) is of the same model as the Montreal work, which might lead one to see a connection between the two works and conclude that the Montreal painting is in fact the cartoon sent to the Gobelins. This theory would be, however, mistaken: details differ in the two portraits—for example, the arrangement of the ermine tails,

the position of the forelock—and it would have made little sense to put so elaborate a frame on a canvas meant to serve only as a cartoon. It should probably be concluded that under the Empire, the same type of framing was used for both painted portraits and tapestry portraits.

In their impressive catalogue of 1912, Maurice Fenaille and Fernand Calmettes listed nine copies of the imperial bust portrait produced by the Gobelins between 1808 and 1814, and three destroyed in their workshops under the Restoration.[3] The recipients were the kings of Saxony (166) and Württemberg, Julie, queen of Spain, the grand duchesses Stephanie of Baden and Elisa of Tuscany, Berthier and his wife, and the duchess of Castiglione. Early in the twentieth century, one of these portraits was in the collection of prince Napoleon, another in that of prince Nicholas Mikhailovich and two in private collections. Some copies are extant today: the previously mentioned one in Dresden and others in the Chalençon collection in Paris[4] and the Lady Lever Art Gallery in Port Sunlight.[5]

As for the copy painted on porcelain, several versions painted on spindle vases (222) have been identified by Bernard Chevallier,[6] and also a copy on a plaque (158).

Unfortunately, the first recipient of the Montreal portrait is unidentified. Several other painted examples are known. There are fewer of them than of the large, full-length portraits, they vary in quality and their provenance is mainly unknown.[7]

In most cases, the canvases and tapestries have not survived with their original frames, and so the association between the container and the contained preserved here is of outstanding interest for studies of court art under the Empire. This fine

piece of wood sculpture—the full deciphering of which is now possible thanks to the patient restoration treatment carried out by Sacha Marie Levay (see p. 158)—features a symbolic vocabulary clearly intended to represent the honours and arms of the sovereign depicted. It was also a question of filling in the missing elements from the painting due to the bust-format reframing of Gérard's full-length portrait of the Emperor standing before his throne wearing the imperial insignia. Since narrowing the focus meant removing from the composition most of these elements so essential to the discourse of power, the gilded frame reproduced these motifs: the eagle at the top recalls the large sceptre Napoleon is holding in his right hand, and the bees around the circumference replace the embroidery on the mantle. The thick laurel wreath imitates the back of the throne at the Tuileries (86), a symbol of the stability of the institutions.

Some comparable frames have survived. Already noted is the one in Dresden, enclosing a tapestry version of the same portrait. Another came on to the art market in 2001, framing a painted portrait of poor quality (163). It had lost its eagle, which was apparently replaced at an unknown time by a laurel wreath.

There is no documentary evidence regarding who made the frame, but the name of the Delporte brothers, who worked in the service of the Musée Napoléon, comes to mind. Frequently mentioned in Denon's correspondence with Intendant-General Daru,[8] in early 1806 the Delportes were working on the frames for the portraits of marshals to be hung in the Caryatids Room at the Tuileries, as well as those for the sixteen portraits of ministers and Grand Officers of the Crown the following year for the galleries envisaged by Napoleon.[9] The sole portrait

158

159

158
SÈVRES IMPERIAL MANUFACTORY
Jean GEORGET
After François-Pascal-Simon GÉRARD
Bust-length Portrait of Napoleon in Ceremonial Robes
1811
Florence, Palazzo Pitti, Museo delle Porcellane

159
GOBELINS IMPERIAL MANUFACTORY
After François-Pascal-Simon GÉRARD
Portrait of Napoleon in Ceremonial Robes
1805–11
New York, The Metropolitan Museum of Art

160
Workshop of François-Pascal-Simon GÉRARD
Frame attributed to DELPORTE FRÈRES
Bust-length Portrait of Napoleon in Ceremonial Robes
Frame with symbols of the Empire
About 1805–14
The Montreal Museum of Fine Arts

of a Grand Officer still extant in its original frame is that of Duroc (31). Incomplete in January 1807, it may not have been one of the sixteen in question, but it is probable that once it was finished, it was entrusted to the same carver for framing. Indeed, the presence of a frieze of bees and husks identical to the one visible on the oval frames of portraits of the Emperor suggests that the same hand was at work.

In their composition, these frames associated with the production of bust portraits illustrate the continuation of the Ancien Régime convention; they strongly resemble some works commissioned for Louis XVI, such as the admirable group now in the collection of the Walters Art Museum in Baltimore (161). This way of framing the sovereign's portrait, in an oval frame surmounted by a decorative Neoclassical motif in the shape of a trophy combining plant forms and symbols of authority, had an ideological significance. Full-length portraits were similarly framed, and often even more elaborately.[10] This treatment seems to have been so much the fashion at that time that it was applied to the likenesses of non-royal personages. Benjamin Franklin, visiting France under Louis XVI, saw his portrait, painted by Joseph Siffred Duplessis and entitled "portrait VIR," collected by high society and sometimes framed in an entirely similar manner (162) in that the sculpted trophy paid tribute to the character, authority and good repute of the sitter.

A project of the goldsmith Auguste to execute gold frames for miniature portraits of Napoleon (165) illustrates similar attributes. They feature the crowns of France and Italy, the sceptre and hand of Justice, the motif of bees and the eagle, which, in this case, does not surmount the work but supports the oval frame that holds the portrait.

That the Museum's oval model continued to be used after the fall of the Empire is proved by the existence of a portrait of Charles X (164). The bees have been replaced by fleurs-de-lys and the eagle by a royal crown, but the relationship is unmistakeable.

SYLVAIN CORDIER

Restoration of the portrait

The recent conservation treatment of this portrait provided an opportunity to closely study the painting, in particular the artist's working method. Moreover, the removal of thick layers of heavily discoloured varnish revealed the actual state of the painting and the physical changes that have occurred over time.

The work was painted on a lightweight, plain weave linen attached to an oval stretcher. No underdrawing was detected; the composition was possibly executed directly on the artist-primed canvas. The presence of small areas of reworking, as in the laurel leaves of the crown, suggests that the artist executed the design freehand.

Oil paint, modified to different consistencies, was used throughout to imitate the many textures depicted in the image. The drape of the ermine collar was rendered by blending buttery, medium-rich paint wet into wet. Thicker paint left furrows that suggest the highlighted tops of the folds of the ermine collar. A diluted oil paint was laid as the base for the ornaments and the flat surfaces of the folds on the sleeve. Ornamental details such as the beads of the laurel leaves, the fabric of the tassel and the eagles on the collar were dotted with low impasto. In general, the artist seems to have worked the paint quickly and efficiently. Some brushstrokes appear to have been applied rather hastily, as in the stroke of brown paint on the edge of the stand-up collar, with its rough end showing through the thinnest of washes depicting the jabot. In contrast, the face was carefully modelled with thin, semi-transparent diluted paint.

The paint surface is in excellent overall condition, but is fractured in a network of cracks. Of particular interest are the drying cracks associated with the differential drying rate of superimposed paint layers. The upper layer "dries" before the lower layers do, often developing a crust of oxidized and inflexible paint sitting on top of still soft paint. As the paint below absorbs oxygen and expands, it exerts stress on the top layers, causing cracks to form. The formation of drying cracks results from the artist's technique and is caused by the thickness of the paint film, the presence of excessive amounts of oil medium or additives and the painter's failure to adhere to the "fat over lean" rule. The cracks are usually only present in the top layers and reveal the colour of the lower layers. For example, the boundary between the dark background and the ermine collar at the proper right shoulder is marked with thin cracks that show the white preparation. Wide cracks with raised edges are seen in the decorated sleeve and in the crown, which have a thicker buildup of paint. Microscopic examination of the surface also reveals defects such as wrinkling where the paint oozed from the soft, oil-rich material of the lower layers and settled into the cracks of the upper paint layer. In other areas, detached islands of the upper paint layer shifted onto the oily layer underneath.

At the edges of the composition are areas of flattened paint and indentations that appear to have been caused by contact with still-fresh paint film, suggesting that the work needed to be handled before the paint had dried completely. The physical evidence described herein suggests that the painting was painted quickly by a skilled hand and was probably meant to be moved from the artist's workshop in an expeditious manner.

AGATA SOCHON

Restoration of the original frame

The restoration of this original frame revealed several interventions made since it was completed in the early nineteenth century. These earlier restorations are difficult to date and show that the frame unfortunately underwent mishandling over time: these caused breakage that needed to be repaired with fill material. The head of the eagle, in particular, suffered damage requiring reconstruction of forms and surfaces. In addition, the liner (the inner part of the frame), which had bent under the effect of humidity, seemed to have been straightened more recently.

When the work came into the Museum's collections, it was observed that the legibility of the ornamentation and the refinement of the original gilding had been distorted and hidden by the numerous superimposed interventions. Over ten layers of accumulated material were removed. Preliminary tests indicated that the surface originally displayed an interplay of varied qualities of sheen, obtained by juxtaposing oil gilding (pearls, leaf-and-dart motifs, inverted cavetto moulding) and burnished water gilding (laurel wreath and eagle, floral elements, bees and smooth surfaces). Our restoration sought to recover this important aspect of the gilding of that era.

Over the years, the original gilding was covered by layers of the following: a new sheet of gold leaf applied with oil size, sealed with shellac, and toned with patina; red ochre paint (undetermined type) and bronzine (bronze powder bound with linseed oil); gesso, Armenian bole, shellac and a third sheet of gold leaf applied with oil size, and a final patina layer. These superimpositions amount to three interventions of varying quality.

Alterations such as these are often found on old frames, too frequently considered of secondary importance to the painting. They are vulnerable to all manner of mishandling, risky restoration and modifications made to meet the tastes of successive owners. In this case, rediscovery of the original appearance required major interventions. Our restoration, which took over three months, consisted of cleaning, refining and smoothing out the overloaded surfaces in order to recreate a satisfying gilded surface respectful of the carved and moulded reliefs.

SACHA MARIE LEVAY

161
GOBELINS IMPERIAL MANUFACTORY
After Joseph-Siffred DUPLESSIS
Bust-length Portrait of Louis XVI
About 1774
Baltimore, The Walters Art Museum

162
Joseph-Siffred DUPLESSIS
Bust-length Portrait of Benjamin Franklin
1778
New York, The Metropolitan Museum of Art

163
Workshop of François-Pascal-Simon GÉRARD
Frame attributed to DELPORTE FRÈRES
Bust-length Portrait of Napoleon in Ceremonial Robes
About 1805–14
Private collection

164
Workshop of François-Pascal-Simon GÉRARD
Frame possibly by DELPORTE FRÈRES
Bust-length Portrait of King Charles X in Royal Ceremonial Robes
About 1825–30
Private collection

161

162

163

164

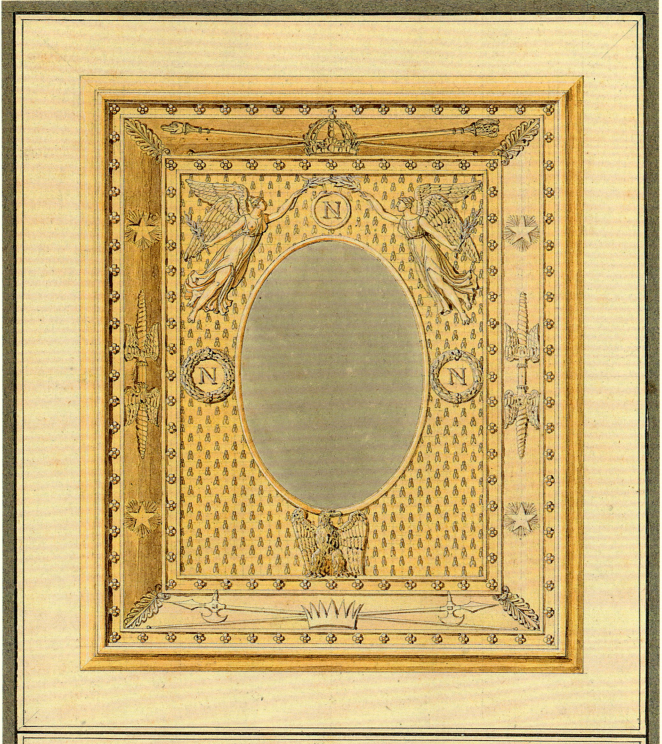

Dessin proposé pour Servir de Tipe aux Bordures en Or destinées à encadrer le Portrait
de S. M. L'Empereur des français et Roi d'Italie.

Ce dessin a été composé de manière à ne pouvoir être employé que pour le Portrait de Sa Majesté. = Le poids de l'or
réduit autant que l'exige la solidité et l'apparence; n'offrira que très peu d'intérêt à en réaliser la valeur. = La
bordure pesera environ 2m 4l. Le fond de la bordure est un semis d'abeilles sur le fond duquel se grouppent deux fÿures de
la victoire tenant d'une main des palmes qui ombragent la couronne de l'immortalité au milieu de laquelle est placé
le chiffre de Sa Majesté, de l'autre main les Victoires tiennent une branche d'olivier. = Sur les parties latérales,
et sur le fond sont placées deux Couronnes, l'une de laurier, l'autre de chêne; au milieu est gravé le chiffre
de sa Majesté. = Sur les moulures qui composent le Cadre, tous les attributs du Sceau de l'Empire français
et du Royaume d'Italie se trouvent distribués. Les Couronnes et les Sceptres, les molettes Semés
sur le manteau Royal d'Italie ainsi que l'étoile rayonnante qui Surmonte le Cartel.
L'aigle Impérial posé sur le fond d'abeilles est placé au bas du Portrait et des Foudres Sont
Suspendues aux Deux côtés comme des Trophées.

Dt. auguste

165
Henry AUGUSTE
Proposed design for the gold borders around the portrait of His Majesty the Emperor of the French and King of Italy
About 1805–8
Paris, Musée des Arts décoratifs

166
GOBELINS IMPERIAL MANUFACTORY
After François-Pascal-Simon GÉRARD
Frame attributed to DELPORTE FRÈRES
Bust-length Portrait of Napoleon in Ceremonial Robes
About 1810
Dresden, Staatliche Kunstsammlungen

PORTRAIT OF NAPOLEON
BY BELLONI'S IMPERIAL SCHOOL OF MOSAICS

This impressive mosaic portrait of the Emperor is a rare example of the output of the École impériale de mosaïque, directed by the artist Francesco Belloni.[1] Born in Rome in 1772 and deceased in Paris in 1847, Belloni was trained by the mosaicists of the pontifical workshops. He left the Eternal City for France in 1797, at the end of Bonaparte's first Italian campaign, hoping to establish in Paris a mosaics manufactory based on the workshops of the artisans attached to the Holy See. He was obliged to wait some years before receiving the assent and support of the minister of the interior, who founded the École parisienne de mosaïque in March 1801 and made him its director.[2] The new institution, with the encouragement of the State, had an unusual policy: it was to employ and teach "all the skills of this art" to pupils chosen from among the deaf-and-mute boarders at the École des sourds-muets in Paris, directed by the Abbé Sicard, for whom he was seeking employment and recognition. Belloni and his pupils presented their works at the Exposition des produits de l'industrie in 1806, to the satisfaction of the authorities, who were convinced that these artisans would soon be able to surpass in quality the creations of the mosaicists of Florence and Rome. The school of mosaics, entitled "imperial" in 1807, was only officially regulated two years later.[3] The monopoly of admission granted only to pupils living with disabilities was finally lifted, thus opening the classrooms of the school to other young persons of promise. Belloni and his students had already successfully completed a number of commissions for the decoration of the palaces: pavés, that is, decorated slabs destined for the Musée Napoléon at the Louvre,[4] and the Tuileries, where they also installed tiled fireplaces, in addition to marble trim and tabletop furniture installed at Malmaison.[5] At the Salon of 1810 in the sculpture category, Belloni exhibited one of his creations for the Louvre, the large mosaic slab from the Gallery of Melpomene, *The Genius of the Emperor Gaining Victory Brings back Peace and Plenty*, after a design by Gérard (**167**), together with "an allegorical subject for a mosaic floor for the service of H. M."[6] For the next Salon (1812) he presented an "octagonal mosaic slab some 22 feet in diameter,"[7] on the subject *Cherubs Racing*.[8]

In 1813, Belloni was looking for new commissions. Approached to arbitrate, on December 14 Denon sent a report to the minister of the interior regarding the activities of the school, in which he mentioned "a portrait of H. M. the Emperor executed after a portrait by M. Gérard, which M. Belloni evaluates at 25,000 francs."[9] The piece, worked on by three students, was almost complete. This was only a few months before Napoleon's abdication (April 1814). It was almost certainly this mosaic, the model for which, of similar dimensions, may be a canvas preserved in the Musée napoléonien on the Île d'Aix (**168**). The reasons for choosing this image of the sovereign, in the uniform of a colonel of the foot grenadiers of the Imperial Guard rather than in ceremonial garb, are unknown, but it testifies to the enduring success, until the fall of the regime, of a less monarchical iconography, in which both the military dress and the pose seem to emphasize the consular image of Bonaparte as a secular head of state.

Although Belloni's mosaics manufactory was founded during the Consulate and he produced his works in Paris, the late date of the commission of this portrait of the Emperor should be seen as an affirmation of the legitimacy of using an art that was culturally Italian to promulgate this sumptuous imperial image. The revival of mosaics not only evoked the art of ancient Rome, but celebrated the enduring popularity of works in *pietra dura*, appreciated by travellers on the Grand Tour since the previous century. During these same years, in fact, the military administrator Daru, intendant of Crown assets in Rome after it had been annexed to the Empire, was working on establishing an imperial manufactory designed to continue the tradition of the pontifical mosaicists.[10] Moreover, as Anne Dion-Tenenbaum points out, the technique developed by Belloni frequently combines several mosaicist traditions: small cubes of coloured glass, following the Roman tradition, coexist with inlays, more in the Florentine manner, of hard stones in marble.[11] A certain rivalry between Paris, the Eternal City, and the capital of the Grand Duchy of Tuscany seems to have fostered a truly imperial art. As mosaics were granted a status comparable with that of tapestries woven at the Gobelins or the porcelain made at Sèvres, the imperial support for this decorative technique originating across the Alps was probably part of the policy of promoting the Italian domains within the various traditions brought together in the *Grand Empire*.

Impossible to sell during the government of Louis XVIII as of 1814, the mosaic would remain in Belloni's workshop under the Restoration and during the first decade of the July Monarchy. It was not until 1840 that the mosaicist suggested that the government of Louis-Philippe should acquire it in the context of the Return of the Ashes of the Emperor to Paris, proposing to integrate it into the design conceived for the tomb of Les Invalides. In his proposal, Belloni insisted on the uniqueness of the work, "the first and only one of its kind to be made in France and in Paris, executed by the undersigned and by the students of the École de Mosaïque founded by the Emperor Napoleon."[12] To no avail; the portrait of Napoleon was to stay with the Belloni family until 1953, the date it was sold to the baron Jacques de Nervo, who donated it to the Musée de Malmaison in 1970.

SYLVAIN CORDIER

167

168

167
IMPERIAL SCHOOL OF MOSAICS OF FRANCESCO BELLONI
After François-Pascal-Simon GÉRARD
The Genius of the Emperor Mastering Victory, Brings Peace and Plenty
19th century
Paris, Musée du Louvre

168
François-Pascal-Simon GÉRARD
Portrait of Napoleon in the Uniform of Colonel of the Grenadier Foot Guards
About 1812
Musées de l'île d'Aix

169
IMPERIAL SCHOOL OF MOSAICS OF FRANCESCO BELLONI
After François-Pascal-Simon GÉRARD
Portrait of Napoleon in the Uniform of a Colonel of the Grenadier of the Foot Guards
1813-14
Rueil-Malmaison, Musée national des châteaux de Malmaison et Bois-Préau

DENON

AND

HIS MASTERS

OLD MASTER PAINTINGS

IN THE

TUILERIES' DECOR UNDER THE EMPIRE

DAVID MANDRELLA

In February 1810, Napoleon was fully ensconced in the preparations for his marriage to Marie-Louise of Hapsburg. As was his wont, he tried to oversee the smallest detail himself. On February 19, he ordered Pierre Daru, the loyal Intendant-General of his Household, to decorate the new Empress' apartment at the Palais des Tuileries. Daru communicated the order to the director of the Musée Napoléon at the Louvre, Dominique-Vivant Denon, who advised the Household on the decor of the imperial residences: Napoleon asked that prints which had "to be removed from the Museum" be hung in Marie-Louise's apartment."[1] Denon replied three days later, upon the request of a rather horrified Daru, expressing disagreement with the Emperor. In his opinion, the museum's chalcography offered only "serious subjects suited solely for instruction and study." A chivalrous man educated in the spirit of the eighteenth century, Denon thought that history prints were incompatible with feminine taste. He suggested instead a selection of paintings that were "agreeable and worthy of decorating this apartment."[2]

This little-known anecdote reveals Napoleon's taste in the area of the visual arts: his preference was clearly for the historical works that instructed the viewer. He particularly enjoyed the exercise of recognizing the paintings' subjects and evaluating whether the artists had managed to render them in a clear, legible manner. His economical bent is also revealed in a striking way, as he was attempting to curb expenditures for the imperial residences by proposing his preference for works from the holdings.

The director of the Louvre was able to draw on the museum's massive collection of paintings, composed in part of the former royal collections and, on the other hand, of the paintings "seized" from émigrés or from Church goods under the Revolution or in the conquered European countries. But Denon lived with the fear that Napoleon's heavy demand for historical paintings would disrupt the coherence of his hanging in the Louvre: too many masterpieces reserved for the residences were being removed from the public eye. Sometimes he schemed, offering to send the palaces older paintings that were slightly out of fashion. Well aware of Napoleon's penchant for history, in 1806, for example, he attempted to decorate Fontainebleau with religious and mythological French religious works from the eighteenth century, a proposal that was immediately rejected by the Emperor, who preferred that all the schools be represented, without one period being favoured over another.[3]

Denon's correspondence shows that he filled the incessant gaps due to the missing early paintings by commissioning new works from contemporary artists. Questions regarding Napoleon's taste for contemporary painting intended to decorate his residences have long begged the attention of art historians.[4] The number of artists and subjects accepted—the latter defined carefully every year—was considerable.

Napoleon's confidence in Denon was complete; the Louvre director's speed and pragmatism kept him in the post until the fall of the Empire. In March 1810, he managed to create a lovely gallery of early paintings at the Tuileries in just a few weeks, in order to give Marie-Louise a welcome worthy of an Empress.

The decor of the Palais des Tuileries has frequently been studied for its paintings commissioned under the Empire, particularly by Paul Marmottan, Gérard Hubert, Guy Ledoux-Lebard and Charles Otto Zieseniss. The latter dedicated a major article to the palace's gallery, the famous Gallery of Diana, decorated with scenes glorifying the Napoleonic campaigns. Zieseniss recounts how, on the eve of the 1810 wedding, haste was made to take down certain military paintings recalling the humiliations inflicted on Austria. Shortly thereafter, it was also necessary to remove Girodet's *Revolt at Cairo* (**185**), because the new Empress would have suffered "a great deal of repugnance" to see in the foreground "an African crouched holding in his hand a head that has just been cut off," and, above all, "an entirely naked Arab figure."[5] Much research has also been undertaken on the Hall of Marshals, where in 1806, eighteen portraits of the Empire's new marshals were hung, which had initially been considered for the Gallery of Diana.[6]

In contrast, the purpose of the present study is to better understand the placement of the early paintings presented at the Palais des Tuileries under the Empire. While documents concerning the art objects installed in the various rooms during this period abound,[7] the knowledge we have of the pictorial decor is spotty, which is astounding, given the detailed inventories extant for the other palaces like Saint-Cloud, Compiègne and even the Grand Trianon.[8]

The Grand Siècle ceilings

The Tuileries was a highly symbolic place when, on February 19, 1800, Napoleon, then First Consul, chose to make it his main residence.[9] The diary of state advisor Pierre-Louis Roederer describes his arrival: "The first time I saw Bonaparte at the Tuileries, I told him, observing the old, dark tapestries and dark apartments, where day never entered: 'How sad, General!' To which he replied, 'Yes, just like greatness!'"[10]

Construction of the Palais des Tuileries started in 1564 at the order of Catherine de' Medici. It was richly decorated under Henry IV, but this interior

170

171

172

decor disappeared when Louis XIV decided to redo everything in the 1660s and 1670s. During the three last hard years of the Ancien Régime, when Louis XVI and his family were living at the Tuileries, the palace had already undergone major alterations; however, the mark of the Sun King remained.

The first transformations wrought by Napoleon in 1800 consisted of erasing all traces of the Revolution, which he derided as "rubbish." The architect Leconte,[11] and then Percier and Fontaine, destroyed the benches of the French National Assembly, built in 1792, and the adjoining rooms, those hallowed halls of the Revolution, replacing them with a chapel and reception rooms.[12]

In the former apartments of the king and queen, only the ceiling decoration still harked back to the golden age of art in seventeenth-century France, called the *Grand Siècle*. The careful restorations of these paintings under the Consulate and in the early days of the Empire attest to Napoleon's wish that they would not be replaced.[13] The mythological vocabulary, elegance, grace, drama—all facets characteristic of the Grand Siècle—he also wished to see in the history paintings of his own period. All his life, he had had a great respect for Louis XIV and a certain compassion for Louis XVI, whom he felt was too "debonair," and guilty of having lacked a certain decisiveness at key moments.[14] As summarized by his famous statement, "It is not enough to be in the Tuileries. We must take measures to remain there."

In the Palais des Tuileries, the Emperor's *Grand appartement de représentation* occupied the most impressive suite on the second floor, which was the king's *Grand Appartement* under Louis XIV. The salons that opened onto the courtyard were redone starting in 1800.[15] The ceiling of the salon of the Grand Officers (former the Guardroom), the work of Nicolas Loir assisted by Jean Cotelle, his father-in-law, displayed a sky from which descended the figures of Fame and Liberality;[16] the archivolts were decorated with painted bas-reliefs connoting royal power. In 1668, in the Salon of the Princes or the Salon of Peace (formerly the king's antechamber) (170), Loir painted Apollo on his chariot preceded by the Hours: the allegory of Time shows him the way, while Spring, represented by a young man, displays the signs of the zodiac, and Fame, to Apollo's right, plays the trumpet; in the archivolts, bronze-painted reliefs featuring the Four Seasons and the Four Times of Day complete the Apollonian theme.

The next room, Louis XIV's grand chamber, became the Throne Room under the Empire. It retained its ceiling from 1670, an *Allegory of the French Monarchy* owed to Bertholet Flémal, a painter from Liège (45).[17] In 1794, the influential art critic Jean-Baptiste-Pierre Lebrun saw it rather as an allegory of Religion, an interpretation that still prevailed in Napoleon's time.[18] The room also had early Gobelins tapestries on the subject of the story of Esther, after Jean-François de Troy (172).

The row of ceremonial salons led to the Gallery of Diana (171), famous for its ceilings that reproduced those of the Farnese Gallery by Annibale Carracci assisted by his brother Agostino. The copies were produced in the seventeenth century by the students of the Académie de France in Rome (Claude II Audran, René-Antoine Houasse, Jean Jouvenet, among others) under the supervision of Charles Errard.[19] It consisted of a large-scale meditation on the various ways that love can affect the senses and the mind, ranging from serenity and joy to cruelty and death. Napoleon's romantic soul, which admired Annibale Carracci, the Bolognese inventor of Classicism, could not have been immune to this decor. Ironically, these copies that at the time seemed "more precious than the originals were al fresco and liable to be destroyed."[20]

After the advent of the Empire, Napoleon wanted even more splendour in this gallery. The ceilings by Pujol, Hersent, Vafflard and Vauthier were restored by Abel, and Monnoyer Baptiste's garlands of flowers and fruit by Le Riche. The work was finished in 1806.[21] The same year, Napoleon commissioned for the Gallery of Diana a series of large paintings illustrating his victorious campaigns (i.e. those of the Austrian campaign, removed prior to Marie-Louise's arrival).[22]

In the Emperor's living quarters off of the courtyard (formerly Marie-Thérèse's apartment), Minerva, goddess of wisdom, dominated as a subject.[23] The fact that she was also the goddess of war could only recommend her to the military commander. The ceiling of the first salon (formerly the antechamber) was decorated by a figure of *Wisdom* by Jean Nocret, the painter responsible for all the rooms in this suite. Marie-Thérèse was depicted as Minerva, while the archivolts displayed the four landscapes attributed to Jacques Fouquières or Francisque Millet. In the adjoining room, the Emperor's Grand Salon (the queen's reception room), Nocret painted a *Triumph of Minerva* and two overdoors featuring Glory and Fame. The ceiling of Napoleon's study (the queen's bedchamber) was dedicated to the *Arts Led by Wisdom*, allegories of the virtues, the arts and sciences, by Nocret, as well as seven landscapes by Fouquières or Millet. The back office[24] (Marie-Thérèse's study) displays—again by Nocret—Minerva and several feminine occupations as well as Millet's landscapes.

The Empress' apartment, on the ground floor off of the courtyard (formerly the king's private apartment[25]), retained few decor elements produced in Louis XIV's time, essentially two ceilings depicting *Flora*[26] and a *Sunrise*, by Nicolas Mignard. Several works were taken down in the 1790s, such as Mignard's

174

175

176

174
Domenico Zampieri, called DOMENICHINO
Erminia and the Shepherds
About 1622–25
Paris, Musée du Louvre

175
Francesco SOLIMENA
The Annunciation
About 1690–1700
Angers, Musée des Beaux-Arts

176
Robert LEFÈVRE
Portrait of Dominique-Vivant Denon
1808
Musée des Beaux-Arts de Caen

177
Carl RUTHART
Bear Hunt
N.d.
Paris, Musée du Louvre

178
Adam ELSHEIMER
Morning Landscape
About 1606
Brunswick, Herzog Anton Ulrich-Museum

179
REMBRANDT HARMENSZ. VAN RIJN
Winter Landscape
1646
Museumslandschaft Hessen Kassel,
Gemäldegalerie Alte Meister

177

178

179

ceiling in the king's room featuring *Apollo and the Four Seasons*, recently found by Jean-Claude Boyer.[27] Redecorated for Marie-Louise in 1810, this apartment would receive the paintings by the Old Masters selected by Denon.

Early paintings

Aside from the grand decor on the ceilings that were preserved, some early masterpieces of European painting decorated the walls of the Tuileries under the Empire. Unfortunately, unlike the art objects,[28] no document has been found that makes it possible to locate the paintings in the palace mentioned in the General Inventory of the collections in the Louvre started in late 1810, jointly called the Napoleon Inventory.[29] Usually acquired during the military campaigns, to the detriment of Europe's princely collections, these paintings were to a large extent redistributed later on, and eventually returned after 1815. Many were from Cassel and Schwerin.

As in the other imperial residences, all the schools were represented at the Tuileries. The works were diverse, sometimes surprising, and all of the highest quality. The number of these paintings was still somewhat limited due to the proximity to the Musée Napoléon, connected to the palace by the Louvre's Grande Galerie and showing the public the best collection of never-before-seen paintings.

At the Tuileries, the Italian school was represented, notably by a painting by Domenichino, *Erminia and the Shepherds*,[30] attributed to Annibale Carracci (174). The Napoleon Inventory also mentions an *Annunciation* by Francesco Solimena (175) from the early royal collections. There is no doubt that it is the painting found today in the Musée d'Angers (175).[31] Two works by Francesco Guardi attributed to Canaletto,[32] illustrate eighteenth-century Venice: a *Coronation of the Doge* (180) and *View of the Inside of the Ducal Palace* (181),[33] from the famous series of twelve paintings seized in 1793 from the comte de Pestre de Seneffe, in Paris.

The Flemish school was characterized by genre scenes, including a painting by Jan Brueghel the Younger, which would be returned to Cassel in 1815, and, by the same artist, a *Landscape with Road, Travellers and Cart*, whose identification was facilitated by a detail in the Inventory: "a green chariot is clearly visible." There were two paintings by David Teniers, a rare religious composition, *Ecce Homo*, and a *Man with Wheelbarrow*, which would be restored to Cassel in 1815.[34]

The Tuileries also housed a small group of Dutch paintings that mostly came from Napoleonic seizures at Cassel and Schwerin. That the French taste for "reality paintings," as well as for animal scenes and landscapes, was so widespread about 1800—a legacy from the last years of the Ancien Régime—is a fact that cannot be ignored. Even though Napoleon preferred history, he did not share Louis XIV's distaste for northern realism. Two small pendant portraits by Gérard Dou were exhibited at the Tuileries under the name Dietrich; they were returned to Cassel correctly attributed to the student of Rembrandt.[35] The *Drinker* by Arie de Vois and *Resting Housewife* by Willem Kalf,[36] a Dutch artist also active in Paris, were two typical genre scenes, while Paulus Potter's *Meadow with Cows and Oxen* embodied to perfection the taste of the time for animals and nature.[37] They recall Potter's famous *The Bull* then exhibited and much admired at the Louvre (now at the Mauritshuis, The Hague).

The Italianizing Dutch landscape artists were represented by Cornelis van Poelenburgh: The *View of the Campo Vaccino at Rome*,[38] considered in Napoleon's time to be a copy after Bartholomeus Breenbergh, as well as a *Mercury and Paris* and a *Mercury and Herse*, both returned to Cassel in 1815.[39] These landscapes evoked Italy, a land Napoleon held especially dear, both for its culture and for its association with his first military exploits.

Also appearing at the Tuileries were some purely Dutch subjects, such as the famous *Winter Landscape* by Rembrandt (179), sent back to Cassel,[40] and a *Landscape with Winding Road* by Jacob van Ruisdael, later presented to the ministry of the navy and, according to the Napoleon Inventory, from the former royal collections.[41] The *Entry into a Fortified Chateau* by Jan van der Heyden[42] completed this group of Batavian painters.

Several German painters also decorated the walls of the Tuileries, including the masterpiece by Adam Elsheimer, *Dawn Landscape* (178), returned to Brunswick, and a *Ceres Scorned* after Elsheimer but at the time considered to

be an original, also restored to Brunswick.[43] A *Bear Hunt* by Ruthart (177) from the Schwerin collections,[44] exhibited at the Tuileries, stayed in Paris after 1815, for unknown reasons.[45]

The private apartment of the Grand Marshal of the Palace Duroc, on the ground floor off of the courtyard,[46] had its own pictorial decor sourced from the national collections. According to the Inventory, it contained a *Sacrifice of Iphigenia* by François Perrier (173), among other works.[47] The painting did not appear in national collections under the Restoration, and nothing is known of its history until it was acquired by the Musée de Dijon at Galerie Marcus, in Paris, in 1971. It seems to have been smuggled out of the Tuileries, which is not surprising since many works disappeared without a trace.

The large number of paintings requisitioned for the imperial residences was increasingly problematic for Denon. Thus, in 1811, when Napoleon asked for the Château de Meudon to be refurnished, first for Madame Mère's place of residence, and then for the King of Rome,[48] Denon informed Intendant-General Daru that "the vast amount of art objects coming out of the storehouses of the Establishment since he became Director, either for the imperial palaces, or for the museums in the Départements, or last but not least for the churches, has exhausted its means & if enough paintings remain that are suitable for this new palace [Meudon], it will be the last that the Museum can furnish."[49] This observation, probably exaggerated, is a good illustration of the concerns harboured by the director of the Louvre, who was constantly fielding requests for quality paintings to the detriment of his mandate to serve the museum. Nevertheless, the Tuileries' pictorial decor shows that Denon, despite his curatorial frustrations, managed not only to satisfy all requests to the letter, but also to surpass even the Emperor's demands on occasion, as he did with Marie-Louise's apartment.

180, 181
Francesco GUARDI
180. *The Coronation of the Doge on the Scala dei Giganti of the Doge's Palace in Venice*
181. *The Doge of Venice Thanks the Maggior Consiglio*
About 1775–80
Paris, Musée du Louvre

180

181

THE EXAMPLE OF THE GALLERY OF DIANA

The plans for decorating the Tuileries to glorify the new power were first presented under the Consulate: Napoleon demanded that the leading artists of his day (who would be chosen by Denon) should be commissioned to execute large-format history paintings, mostly destined for his State apartment at the Tuileries. The most iconic program, although it was never to be completed, concerned the immense Gallery of Diana, which the Emperor intended to dedicate in 1806 to the glory of his military feats, from his campaigns in Italy and Egypt under the Directory to his recent victories over the German States.[1] The canvases were commissioned for 1808, and were to be installed in the palace after being presented to the public at the Salon at the Louvre. Of the eighteen scenes ordered, only eight were completed in time (**182, 184-186, 188-191**). The Emperor was dissatisfied with them and only accepted one, *Napoleon Receiving the Keys to Vienna at Schönbrunn* (**186**) by Girodet. A second order was therefore placed in 1809 (**187**), but was rapidly modified the following year after Napoleon's marriage to Marie-Louise, as it was unthinkable to depict subjects that humiliated Austria or were distressing to the young Empress. It was for this reason that Girodet's

Revolt of Cairo, only just installed, was taken down and reworked (**185**). Turnarounds like this, together with the Emperor's harsh judgments on the artists' works, meant that it was never possible to put in place a complete iconographic program.

This venture sums up the complexity of creating for the Empire, in a continually changing political and diplomatic context, an iconography of military glory fit to decorate a palace that was to be the seat of power and of the court, and also the residence of a sovereign who had risen through the fortunes of war, but who was aware that it is through the peace of alliances that dynasties are built.

These imposing canvases by the generation of artists taught by David, most of them commissioned in vain, were to find under the July Monarchy a new function and relevance in the Château de Versailles, which king Louis-Philippe transformed as of 1837 into a historical museum devoted to "all the glories of France."

SYLVAIN CORDIER

182
Nicolas-André MONSIAU
Members of the Consulta of the Cisalpine Republic
1808
Musée national des châteaux de Versailles et de Trianon

183
Pierre-Narcisse GUÉRIN
Bonaparte Pardoning the Rebels in Cairo, October 23, 1798
1808
Musée national des châteaux de Versailles et de Trianon

184
Jean-Simon BERTHÉLÉMY
General Bonaparte Visiting the Wells of Moses, December 28, 1798
1808
Musée national des châteaux de Versailles et de Trianon

185
Anne-Louis GIRODET DE ROUSSY-TRIOSON
The Revolt at Cairo on October 21, 1798
First quarter of the 19th c.
Musée national des châteaux de Versailles et de Trianon

182

183

184

185

186

187

188

189

186
Anne-Louis GIRODET DE ROUSSY-TRIOSON
Napoleon Receiving the Keys to Vienna at Schönbrunn, November 13, 1805
1806–8
Musée national des châteaux de Versailles et de Trianon

187
Antoine-Jean GROS
The Surrender of Madrid, December 4, 1808
1810
Musée national des châteaux de Versailles et de Trianon

188
Nicolas-Antoine TAUNAY
Led by the Emperor, the French Army Enters Munich, October 24, 1805
1806–8
Musée national des châteaux de Versailles et de Trianon

189
Louis-François LEJEUNE
Napoleon's Bivouac on the Eve of the Battle of Austerlitz
1808
Musée national des châteaux de Versailles et de Trianon

190
Pierre-Claude GAUTHEROT
Napoleon Haranguing the 2nd Corps of the Grande Armée
1808
Musée national des châteaux de Versailles et de Trianon

191
Charles MEYNIER
Napoleon, Surrounded by His Staff Officers, Enters Berlin, October 27, 1806
1810
Musée national des châteaux de Versailles et de Trianon

190

191

WEAVING MAJESTY

THE
IMPERIAL HOUSEHOLD
AND THE
GOBELINS AND BEAUVAIS
MANUFACTORIES

THOMAS BOHL

The Gobelins and Beauvais tapestry manufactories had played a pivotal role in the furnishing of the royal residences since their establishment in 1662 and 1664, respectively. Even though their status differed, they maintained close relations with the furniture storehouse of the Crown, the Garde-Meuble, which was in charge of supervising the delivery and hanging of their highly prized tapestries. Although their future may have been put into question following the Revolution, the two manufactories managed to keep themselves afloat, and their weaving business took off under the Consulate and, in particular, under the Empire. The manufactories revived their mission to deliver wall tapestries and pieces destined to cover seats, paravents and fire screens to the head of state's residences, albeit at a different pace.

The restoration of the Civil List on May 18, 1804, was accompanied by the Gobelins tapestry manufactory's attachment to the Imperial Household. As for the Beauvais manufactory, it was restored to the Civil List only in October. The reason for this delay may have been the Emperor himself, as he seemed little inclined to have his Household served by a costly enterprise, and he was doubtless aware of the financial difficulties Beauvais had encountered in the late eighteenth century. The fact that the Beauvais manufactory had not been added to Louis XVI's Civil List also gave him pause. It was likely Intendant-General Fleurieu who won over Napoleon, arguing the value of having a national manufactory produce the textile decor for the imperial palaces, which begged to be redecorated.[1] Although the two manufactories were from this point on attached to the Household, they were managed by different directors and pursued distinctive artistic directions.

Founded by Louis XIV, the Gobelins manufactory had survived the hardships of the revolutionary years for better or for worse. Since 1795, management had been entrusted to Charles-Axel Guillaumot, who returned to the position he had occupied between 1789 and 1792. In 1804, Napoleon decided to restore Guillaumot's directorial functions. Once back in charge, Guillaumot led an initiative to modernize: the reform of the financial system and the technical upgrading of the weaving looms can be credited to him.[2] He pursued his own policy under the Empire and, taking into account the numerous exchanges with the Intendant-General of the Imperial Household, succeeded in making significant improvements in the manufactory's budget, raised to 150,000 francs.[3]

At Beauvais, the administration, which answered to the minister of the interior, was entrusted to Antoine-Michel Huet in 1800.[4] This former employee of the administration of the manufactories backed by Lucien Bonaparte, remained in the post when the manufactory was restored to the Imperial Civil

List in October 1804. Like Guillaumot, he instigated a policy of reform that first addressed updating techniques. The manufactory acquired the so-called "Vaucanson" looms as of 1806[5] and the use of perforated cards made it possible to henceforward preserve the models. Huet's policy persisted due to the repeated requests the administration received commissioning new models from the manufactory.[6]

On the strength of this desire for recovery and modernization, the Gobelins and Beauvais manufactures were soon solicited for the production of textile artworks. The wall hangings were woven mainly by Gobelins. Although former projects were in progress, like the tapestries *The Striped Horse* and *The Indian Hunter* after Desportes,[7] a new direction was taken under the Empire. The Emperor seemed to want to determine the guiding principles himself as of 1807[8] and certainly after his visit to the Gobelins on March 9, 1808. In fact, Grand Marshal of the Household Duroc reported as much in a letter he wrote to the Intendant-General Daru that same day: "His Majesty was not pleased with the work of this manufactory. They continue to perform a poor sort of work, depicting tired subjects, without merit, in which the subjects are ill suited to current circumstances. His Majesty wishes you to give a new direction to the work of this manufactory, so that all unsuitable work ceases."[9] He later clarifies to Dominique-Vivant Denon: "H. M. wants the Gobelins to make hangings for his apartments, and not to copy paintings."[10] Although this desire was clearly stated, and reinforced by the abandonment of some pieces then on the loom, such as the second copy of *The Sleep of Renaud* after Charles Coypel,[11] the choice of models destined for the loom directly contradicted this new direction. In fact, the majority of the wall tapestry models were selected by the Emperor from the paintings presented at the Salon. The choices were thus guided less by the desire to revive textile creation by breaking with the fashion of copying paintings, than by the desire to have woven the best paintings featuring Napoleon's past exploits, in order to distribute them among the main imperial palaces. Louis XIV's taste for tapestry, several of which hung in the imperial residences, may have fostered this desire to produce new ensembles that could rival the hanging *History of the King*, after Charles Le Brun, who depicted the pivotal episodes of Louis XIV's reign, and which the Emperor was able to contemplate at the Palais des Tuileries as of 1804 (195).[12] Denon was thus associated with the choice of works in view of the completion of this project and sought to assert himself as a de facto art director.[13] Paintings by Gros, David, Gérard, Serangely, Guillon-Lethière and Regnault featuring Napoleon or events in the Napoleonic annals were thus selected at the Salons (192). These works,

SALLE DES SAISONS

193

194

192
GOBELINS IMPERIAL MANUFACTORY
After Gioacchino SERANGELI
*Napoleon Receiving Army Delegates at the
Louvre Following His Coronation, December 8,
1804*
1809–15
Paris, Mobilier national

193
GOBELINS IMPERIAL MANUFACTORY
After Antoine-Jean GROS
*Bonaparte, First Consul, Distributing the Sabres
of Honour to the Grenadiers of His Guard after
the Battle of Marengo (June 14, 1800)*
July 1806–December 1810
Musée national des châteaux de Versailles et
de Trianon (dépôt du Mobilier national)

194
Antoine-Jean GROS
*Bonaparte, First Consul, Distributing the Sabres
of Honour to the Grenadiers of His Guard after
the Battle of Marengo (June 14, 1800)*
1803
Rueil-Malmaison, Musée national des châteaux
de Malmaison et Bois-Préau

195
GOBELINS IMPERIAL MANUFACTORY
Workshop of Jean Mozin, weaver
Cartoons by Henri TESTELIN
After Charles LE BRUN and Adam Frans
VAN DER MEULEN
*History of the King. Louis XIV Captures the City
of Marsal in Lorraine, September 1, 1663*
1665–80
Musée national des châteaux de Versailles et
de Trianon (dépôt du Mobilier national)

195

occasionally destined to decorate the imperial residences or administrations, were thus sent temporarily to Gobelins to serve as models. When the original was unavailable, copies provided the weavers with the cartoon. The completed works meticulously reproduced the models. We can thus admire the excellent execution of the First Consul Bonaparte's face, which demonstrates the heightened use of a number of shades. It also seems that the weavers' ability to reproduce the models with accuracy had been a criterion for the way the work was distributed, as it was "a labourer of the first rank," Claude *père*, who made the tapestry featuring the First Consul[14] (**193, 194**). Nevertheless, the complex process, from selecting the model to the loom, as well as the delicate weaving, slowed down production considerably. Although a large number of Napoleonic subjects were slated for weaving, only four tapestries were completed prior to the fall of the Empire.[15]

Aside from the historiated tapestries, the Emperor also commissioned the Gobelins manufactory for several sets of portieres destined for specific places in his imperial palaces: portieres for the Emperor's Grand Cabinet at the Tuileries (**202**) and the *Four Parts of the World* portieres for the Gallery of Diana in the same palace.[16] The production of full- or mid-length woven portraits featuring the Emperor and Empress also appears to have been one of the manufactory's main activities under the Empire. No less than twenty-five copies went to the loom[17] (**197-200**). As for the chair upholstery—apart from completing the weaving undertaken as of 1803 from a group of upholstery cartoons painted by Laurent Malaine and the weaving as of 1807 of a piece of furniture after earlier cartoons painted by Louis Tessier—from then on it was almost exclusively woven at the Beauvais manufactory, which specialized in this type of work, although Napoleon seems to have wished to develop the production of woven chair upholstery at the Gobelins manufactory: "I wanted to increase the number of labourers at the Gobelins, so we could establish small workshops to make chairs, armchairs [and so on]."[18] The only project based on the modern cartoons to be undertaken by the Gobelins was the fabrication of chair upholstery commissioned for the Emperor's Grand Cabinet at the Tuileries, which occupied the weavers for several years, due the exceptional nature of the commission.[19]

The Beauvais manufactory underwent a major development under the Empire: weaving wall tapestries was abandoned—the last pieces were completed in 1804—in order to focus on the production of tapestried furniture: seat upholstery, screen panels, paravents, portieres and valances. Huet defended the manufactory's output, boasting of its quality based on the almost exclusive use of silk, preferred over wool.[20] A report from 1809 addressed to the Emperor also suggested a preference for tapestries made of silk and other fabrics to upholster the chairs, because of their sturdiness, which has the added "advantage of lasting for a hundred years."[21] From then on, the manufactory had to meet a growing demand for tapestried furniture destined for the main imperial palaces: the Tuileries, Trianon, Saint-Cloud and Fontainebleau. The requests came from the highest level, even during the campaigns, since Daru wrote more than once to the manufactory's administrator from Erfurt and Berlin in order to ensure new pieces went into production.[22] The eighteenth-century models continued to meet with a certain success, like those for "furniture with animals and landscape, surrounded by jasmine,"[23] delivered in 1809 for the Salon of the Grand Officers in the Emperor's apartments at the Trianon, or those for furniture "representing subjects taken from Fontaine's *Fables*," which Daru requested be delivered "to furnish the Palais de Compiègne"[24] on May 7, 1808 (**196**). Several of these pieces of furniture featuring landscape or Fable scenes, sometimes attributed to Oudry, were still on the manufactory's shelves in 1814.[25] Among the old models, Francesco Casanova's were the most successful, and had been since the Consulate. A letter that Huet sent to the minister of the interior on November 14, 1801, reveals that Joseph Bonaparte wished to commission two pieces of furniture based on these models, which had been presented a short while earlier to the minister.[26] These models featuring the *Military Convoys* were painted in 1787 to complement the hanging on the same subject and had been woven several times in the late eighteenth century, for Louis XVI in particular.[27] Since their subjects were the grenadiers, mounted officers, flag bearers or ordinary infantrymen, they met with the favour of the Emperor and the imperial administration. The delivery made to the Garde-Meuble in 1805 included two

pieces of furniture whose designs are based on Casanova's models: those comprising the "military sofa backs (Casanova)" as well as the "military furniture without borders."[28] In 1814, three pieces of furniture based on Casanova cartoons could still be found at the manufactory.[29] The requests for new models reiterated by Huet were answered starting in 1806-7.[30] Ornamental motifs were favoured then: imperial emblems, thunderbolts, eagles and also arabesques and rosettes began to cover the seats of the main imperial palaces, securing Beauvais' reputation.

The two tapestry manufactories seem to have assumed complementary roles, Gobelins providing the main wall hangings, while Beauvais was in charge of weaving the seat upholstery for the furniture that would complete the furnishing of a room in the imperial residences. A joint study of the deliveries made by the two manufactories makes it possible to reconstitute these furnishings, which were commissioned at a constant pace by the Imperial Household's administration, continuously soliciting the weavers of the two imperial manufactories.

196

THE FOUR PARTS OF THE WORLD

TOGETHER AT THE TUILERIES

These four paintings on cardboard are the designs for a group of portieres on the theme of the four parts of the world. Painted by Dubois in 1811, they make manifest the compositions rendered by Saint-Ange. In fact, in a letter Duroc wrote on October 21, 1813, to the administrator of the Gobelins, Lemonnier, in which he broaches the possibility of having three portieres woven for the Emperor's Grand Cabinet at the Trianon, he specifies methods of producing models for the portieres at Gobelins, indicating that "that is how it is always done." He states that "all the small drawings were composed by M. Saint-Ange, draftsman, student of M. Percier, in conjunction with the painter in charge of executing them to scale, and in consultation with the Administrateur du Mobilier as to the types of ornaments and the choice of colours similar to the furnishings of the apartment for which the objects are destined"[1]—which leads to the supposition that the same rule applied for these sketches of the *Four Parts of the World*. The destination of these portieres, long unknown, has been uncovered by Chantal Gastinel-Coural.[2] They were to have been placed in the Gallery of Diana at the Palais de Tuileries. This would certainly explain the astounding choice of green for the ground, as the walls of the gallery were covered by "vellum paper with a green ground,"[3] and the portieres were undoubtedly designed to blend in harmoniously with the decor.

Each piece represents an allegory for one of the known continents according to a relatively traditional system of iconography. These female figures are accompanied by traditional attributes suggesting the cultures and geography they embody: camel and censer for Asia; crown and horse for Europe; bow and lions for Africa; bow, arrow, feathered quiver and tapir for the Americas. Flora and fauna, as well as costumes and weapons, place these figures within a Eurocentric system of representation. The depictions of the four parts of the world had been popular since the sixteenth century in literature[4] and the visual arts, relayed particularly through printing, which could furnish Saint-Ange and Dubois with valuable sources of inspiration. In the field of tapestry, the theme had already met with a certain success in the late eighteenth century. In 1786, the manufactory of Beauvais wove a wall hanging consisting of four tapestries, accompanied by a group of chairs with the same theme, for Louis XVI. However, the tone is entirely different here: the exoticism has given way to a less anecdotal vision—these allegorical depictions could be an echo of the political ambitions of the Empire and its dreams of expansion. They also recall a group that may well have served as a direct source of inspiration: the sculptures Louis XIV commissioned for the Water Parterre of the park at Versailles. The hieratic poses of the figures, placed on a pedestal inscribed with the name of the continent, enhance their sculptural aspect, infusing them with power.

The choice of having Saint-Ange and Dubois join forces in the creation of the models—aside from the affordable price of their labour[5]—might be explained by the success of the models for the portieres of the Emperor's Grand Cabinet at the Tuileries, due to these artists. The similarities between the two sets of portieres are also evident: central allegorical figure, trophies, cornucopias and single-colour ground. It was therefore part of the plan that the door separating the Grand Cabinet from the Gallery of Diana would be covered on one side by a portiere with a red ground and on the other by one of these green-ground portieres, ensuring a harmonious transition in terms of style and decoration from one room to another in the State apartment. However, the *Four Parts of the World* would never be hung, as they were not finished before the fall of the Empire (*Europe*, high-warp weave, April 1, 1811–November 4, 1814; *Asia*, high-warp weave, January 14, 1812–July 22, 1816; *The Americas*, low-warp weave, January 2, 1813–June 12, 1817; *Africa*, high-warp weave, April 17–September 1, 1817). The Restoration would awaken a certain interest in these works, which would be presented at the Louvre in December 1817,[6] during the Exposition annuelle des produits des manufactures. Despite the almost complete absence of imperial emblems, the four tapestries do not seem to have been hung as planned at the Tuileries.

THOMAS BOHL

196
BEAUVAIS IMPERIAL MANUFACTORY
Armchair upholstery depicting subjects from La Fontaine's *Fables* for the furniture at the Palais de Compiègne
1808
Paris, Mobilier national

197-200
François DUBOIS
After the designs of Jacques-Louis DE LA HAMAYDE DE SAINT-ANGE
The Four Parts of the World
Tapestry cartoons for the portieres in the Gallery of Diana at the Tuileries
197. *America*
198. *Asia*
199. *Africa*
200. *Europe*
1810
Paris, Mobilier national

AMERIQUE

197

ASIE

198

AFRIQUE

199

EVROPE

200

THE FURNISHINGS OF THE EMPEROR'S GRAND CABINET

AT THE TUILERIES

Napoleon paid a great deal of attention to the design of the new decor and the commissioning of the furnishings for the Palais des Tuileries. One of the most important rooms of the palace was without a doubt the Emperor's Grand Cabinet, the space reserved for ministerial audiences and the staging of power, located between the Throne Room and the Gallery of Diana. The renovation project of this salon began in 1807. The Emperor wished to create an "extremely sumptuous"[1] space, and intended to solicit the national manufactories. His goal was that "all the hangings would come from Gobelins, same with the portieres and the drapes, and that the furniture would be made at Gobelins or Beauvais."[2] The portieres, whose models were executed, upon Percier's request, by Dubois, after drawings by Blanchon and Saint-Ange, were the first to be sent to the loom in August 1807. The Gobelins was also entrusted with the weaving of the seat covers and the leaves of the screens and paravents, which were started as of 1808, based on painted sketches by Dubois after Saint-Ange's models. In addition to the Emperor and Empress' armchairs, the group was also meant to consist of six portieres, two valances, twelve princess chairs, six prince chairs, twenty-four *pliants* (folding stools), two footstools, one paravent and one screen. The portieres were hung in 1811, and the chairs with their coverings, almost all delivered by the manufactory in 1810, were presented to the Emperor. Still not satisfied, he decided to commission another piece of furniture, deigning the chairs to be ill suited to their destination due to their being too simple.[3] It was decided to keep the portieres and the valances, and the new furniture, whose number was changed by the Emperor—four prince chairs rather than six—had to be completed by January 1, 1813. The first drawings were delayed, possibly due to the many stakeholders involved in their design: Daru, Fontaine, David, Denon, Lemonnier and the painters Lagrenée and Dubois, who were responsible for

transcribing them into models for tapestries.[4] In the end, it was David who produced the final drawings for the new furniture coverings, more sumptuous than the first,[5] and Dubois who produced the sketches (203). In a letter from August 25, 1811, David underscored the new aesthetic direction he envisioned for this furniture, boasting of its "antique character."[6] The choice of antiquity is explained by the desire to create a cohesive decor for this space, in which seating and screens would harmonize with the portieres, but also with the furnishings of the Grand Cabinet. In fact, it is important to note the similar composition of the decoration of the three chest-high ebony pieces built—possibly based on David's designs[7]—in 1811 and delivered in 1812 by Jacob-Desmalter (201), and details in the tapestries woven at the Gobelins manufactory: Winged Victory and spirits, palm trees, crowns and reeds comprise the shared vocabulary of elements reiterated in wool, bronze and gold, according to a skilful interplay of correspondences.

The models at the Mobilier national provide a sense of what this exceptional set must have looked like, given that only one portiere[8] and the paravent (204) are extant. Comparing the models and paravent (205) of the first set makes it possible to see the radical changes made by David. The purely ornamental motifs are replaced with figures inspired by mythology. Thus, the back of the presentation armchairs features a Victory holding a crown (203A)—a subject ideally suited to the chair's destination—which takes its inspiration from a classical relief in the Villa Sacchetti in Rome, where a Victory appears in a similar pose.[9] Similarly, the chimney screen's central section presents an allegory of silence (203E), in the guise of a winged spirit whose form is likely taken from a classical statue of Harpocrates.[10] From this originally Egyptian divinity, somewhat popular during the Roman Empire, David borrowed the trappings of youth, the finger resting on the lips, and the long hair with a pschent at the centre. Once again, the iconography carries meaning, the piece inviting respectful silence in a space dedicated to the staging of majesty. Jean-Jacques Lequeu had

already pictured that the decor would include a figure on a pedestal, "a Harpocrates, god of silence, to warn those entering the second anteroom of M. de Montholon's study to cease speaking"[11]. Nevertheless, David imbued the figure with a more strongly ancient aspect, perhaps inspired by the comparable Harpocrates of the Musei Capitolini. Last but not least, the six leaves of the paravent (204) feature Roman divinities and heroes: Mars, Fame, Apollo, Hercules, Diana and Mercury. Hercules is depicted leaning on his club, his body in contrapposto recalling, like Mercury's armour and helmet or Diana's pose, the number of studies David completed in Rome between 1775 and 1780.[12] Statues, helmets and ornaments thus enriched his repertoire, and he drew on them freely here. Far from being exact copies, David's compositions for the furnishings reveal the success of this undertaking, the affirmation of an "antique aspect" in the area of decorative arts.

The furnishings, with the exception of a leaf of the screen and a leaf of the paravent, was completed, as demanded by the Emperor, prior to January 1, 1813.[13] However, the pieces could not take up residence until the Grand Cabinet's renovations were finished. Thus, it was only as of March 24 that same year that this exceptional set could assume its rightful place. During the Restoration, the furnishings were preserved, with the removal of the imperial emblems: the bees were removed from the armchairs and the upper section of the paravent was unravelled in order to replace the eagles with helmets and fleurs-de-lys,[14] still seen today on each of the leaves.

THOMAS BOHL

201

The Emperor's Grand Cabinet at the Tuileries:
Furniture and tapestry cartoons (201–205)

201
Workshop of François-Honoré-Georges
JACOB-DESMALTER
Low armoire from a series of three
1811–12
Musée national des châteaux de Versailles et de Trianon

202
François DUBOIS
After Jacques-Louis DE LA HAMAYDE SAINT-ANGE
Fame, cartoon for a portiere
1808
Paris, Mobilier national

203B

203C

203
François Dubois
After Jacques-Louis David
A. *Victory*, cartoon for the upholstery of the
back of the presentation armchair
B. Cartoon for the upholstery of the chairs for
the princesses
C. Cartoon for the upholstery of the seat of
the folding stools
D. Cartoon for the upholstery of the seat of
the presentation armchairs
E. *Silence*, or *Harpocrates*, cartoon for the fire
screen tapestry
1811
Paris, Mobilier national

203D

203E

186

204

205

204
Gobelins Imperial Manufactory
Cartoons by François Dubois
After Jacques-Louis David
Screen with six panels
1812
Paris, Mobilier national

205
Gobelins Imperial Manufactory
**Screen with six panels from the
original furniture**
1811
Paris, Musée du Louvre

205

THE FABRIQUE
LYONNAISE
AT THE SERVICE
OF THE
IMPERIAL COURT

MARIE-AMÉLIE THARAUD

Since the eighteenth century, textiles for furnishings have constituted, more often than not, the greatest expense in palace decorations. Yet the rarity of studies devoted to them reveals that they appear to have lost pride of place. This relative disinterest may arise from the difficulty of conserving them in their original states in addition to their almost systematic replacement in châteaux-museums with recent rewoven examples. It is most certainly modern production technologies that have led us to forget the extent to which woven silk represented an exceptionally challenging technique and art form.

When Napoleon set out to relaunch the silk industry of Lyon, he was not only responding to pressing economic needs, but also to the issue of power: he wanted to ensure that France would assume top billing in the field of decorative arts. In fact, beyond their traditional role, which, on the one hand, was functional (protection from the cold, light, drafts, and more), and on the other hand, was ornamental (creating an atmosphere within a room by way of materials, motifs and colours), textiles assumed a highly symbolic value, as they were intended to reflect and assert within the imperial residences the new seat of power.

The revival of the Lyon silk industry

The Canut revolt of 1787, followed by the Revolution of 1789, marked the beginning of a dark period for the Fabrique lyonnaise, a term describing the various crafts involved in the silk-making trade. Many silk manufacturers fell victim to Jacobin oppression in 1793. As of 1792, the imperial furniture storehouse, the Garde-Meuble, directed by Jean-Bernard Restout, put a stop to commissions from Lyon.[1] Of the city's fifteen thousand weaving jobs, two thousand disappeared, and those people employed in the positions that remained were hardly kept busy, save for a few commissions from the Spanish Crown.[2] Indeed, despite the peace reclaimed in 1795 under the Directory, the new taste for rigour now frowned upon lavish expenditures, and fashion as well as decoration conformed to the new order's austerity in the simplicity of fabrics.

It was not until June 18, 1800, that the silk industry of Lyon was given a fresh start, when First Consul Bonaparte lay the first stone for the facades of Place Bellecour and encouraged the city to remember its "original prosperity" (206).[3] He returned to Lyon regularly, taking advantage of his travels to Italy to make stops there. Notably, he stayed for three weeks in 1802, with Josephine, and visited the manufactory of Dutillieu et Théoleyre. As Emperor, Napoleon went back for six days in 1805, during the Lyon Exposition des produits de l'industrie, where he examined the brand-new loom designed by Jacquard, bestowing the inventor a grant to further its research and development.[4]

The return of silk in clothing and furnishings

Napoleon's interest in the silk of Lyon was twofold. On the one hand, it revived the city's economy and trade; on the other hand, it restored the symbol of power and the technical and artistic reputation that this industry had brought France a century earlier. The Treaty of Amiens, signed in 1802, played a part in renewed commercial ties with England.[5] Likewise, upon the First Consul's initiative, new commissions from the Garde-Meuble came in that same year to furnish the palace of Saint-Cloud. Additional initiatives progressively strengthened the role of the silk industry in Lyon while the new court was being established. By 1804, Napoleon ordered by decree that his court wear clothing of silk: silk was allowed only at ceremonies in "velour or taffeta" for the apparel of dignitaries and people permitted to be presented to him.[6] Conversely, the Emperor maintained his position against muslin and cotton fabrics from India, in other words, from English trade. Nevertheless, the effort to shun these materials fell short in the clothing field: in contrast to the reign of Louis XVI, men continued to favour a certain restraint in the range of embroidery used, and women opted for light and transparent materials, embellished with cashmere shawls—Josephine herself becoming the ambassador for this fashion vehemently opposed by her husband.[7]

The revival of silk was mainly felt in the furnishings of the imperial residences (207). From the Consulate era and throughout the Empire period, Napoleon issued many commissions, far outweighing practical needs. It is true that the Revolution had laid the palaces bare and the Garde-Meuble had begun to draw on what remained of the Ancien Régime to set up the Consuls at the Tuileries in 1800, and the government at Saint-Cloud in 1801. Also, as of 1802, future Grand Marshal of the Palace Duroc, then Governor of the Palace, commissioned the silk manufacturer Camille Pernon for furnishings at Saint-Cloud. In 1804, the former royal châteaux were added to the Civil List assigned to the Emperor, who went on to give the job of furnishing them to the Fabrique lyonnaise.[8] Over time, other palaces were also included through subsequent victories, for example Laeken, near Brussels (1804), and Monte Cavallo, in Rome (1809). In 1808, Napoleon also took back the Élysée from Murat, who had recently been promoted to the throne of Naples. Although fabrics were commissioned for a specific palace, it often happened that they would ultimately be used elsewhere. The most famous example of this is Versailles: the materials resulting from the commissions of 1807 and 1811 were never employed there (209, 211, 212). On the contrary, the palaces of the Tuileries, Saint-Cloud and Fontainebleau (208) received the most number of fabrics produced at the time.

207

Dozens of kilometres of fabrics were delivered under the Empire: the only commission of 1811, for Versailles, the largest of all, was for 79,000 metres of silk delivered to the Garde-Meuble by the manufactories of Lyon. Of this huge commission, only 4,000 metres were used at the Élysée and 7,000 metres went to Monte Cavallo during the Empire[9]; the remainder was eventually employed, during the Restoration and the July Monarchy.[10] With these new orders coming in, the Fabrique lyonnaise could breathe again, strengthened by Napoleon's Continental Blockade against England in 1806 and 1811, which allowed him to export to European sovereigns without competition from his British neighbours across the Channel.[11]

The suppliers: From monopoly to diversity

To meet the massive demands initially, the Mobilier impérial mainly called upon Camille Pernon, considered the best manufacturer, and less so on the merchants Cartier and Vacher, before approaching other suppliers. From 1802 to 1807, Pernon filled orders for Saint-Cloud, the Tuileries and Versailles (the latter order was ultimately sent to Compiègne), Cartier supplied Fontainebleau, Laeken and Saint-Cloud, and Vacher had Fontainebleau.[12] However, Pernon lost his lead in 1805, following the "Camille Pernon Affair," during which the Mobilier impérial reproached him for having delivered fabrics with a green tint that changed in the light. The ensuing inquiry lasted more than two years, only to find Pernon innocent and concluding that only the dyer had been at fault. Nevertheless, the silk manufacturer never learned of the outcome in his favour, as he died in the interim, in 1808. His firm was taken over by Grand Frères, which was henceforward in competition with other silk manufacturers. Moreover, the Garde-Meuble responded in kind to pressures from the Fabrique, which wanted to see more manufacturers benefit from the influx of imperial commissions:[13] from then on, suppliers were selected by the chamber of commerce of Lyon, which assigned commissions and oversaw execution. The commissions were conferred to a number of manufacturers, including Bissardon, Cousin et Bony, Cartier, Chuard, Corderier et Lemire, Culhat, Donnat, Dutillieu et Theoleyre, Grand Frères, Fournel, Gerboulet, Gros, Lacostat et Trollier, Pillet et Texier, Rivoiron, Saint-Olive the Younger, Seguin, Seriziat and Vacher. In response to a general economic crisis, the Versailles commissions of 1811 kept many firms in operation.[14] Nevertheless, if the numbers of metres delivered during the Empire were compared, it would be found that the most solicited firms were Pernon-Grand Frères, Bissardon, Cousin et Bony (which furnished more than 5,000

metres of fabric for the Tuileries, Meudon (**210**) and Versailles between 1808 and 1811), Chuard, which supplied 3,000 metres for Versailles (**209, 212**) and the Tuileries between 1811 and 1812.[15]

Garde-Meuble oversight

Up until the Pernon Affair, verification procedures carried out by the Mobilier impérial on the quality of products delivered were greatly reduced. They later became more systematic and codified, involving a rigorous system of control over the sustainability of colours. Similarly, the quality of the designs, execution, quantity of gold used, weight of the fabrics and, compared to all of the above, the price, were reviewed by the Mobilier impérial: an inspector, (Mathurin Sulleau) and an administrator (Alexandre-Jean Desmazis) oversaw all of the aforementioned criteria, under the leadership of the Intendant-General of the Imperial Household (a post filled by Daru from 1805 to 1811, then the duke of Cadore until 1815). The Mobilier impérial later entrusted their fabrics to various upholsterers—Andry, Boulard, Carbeaut, Darrac, Flamand et Susse, Maigret, Poussin et Lejeune, among others[16]—for the production of hangings, coverings for seats, beds, fire screens, paravents and a variety of other items.

The demand for excellence, linked to the desire to have a new style emerge and to promote an emblem of power, ensured the magnificence of the silks supplied to the Garde-Meuble. The number of commissions issued under the Consulate and then the Empire was so high that we now find hundreds of metres of unused material preserved at the Mobilier national. They are a brilliant—and little known—example of the splendour of the imperial palaces.

The Mobilier national silks

Among the many items Napoleon commissioned, nearly eight hundred pieces of silk fabric are today found in the collections of the Mobilier national.[17] They have been studied in detail in the reference book *Soieries Empire*, a publication resulting from the extensive research carried out in the 1970s by Jean Coural and Chantal Gastinel-Coural. These samples of very different sizes—measuring from a few centimetres to dozens of metres long—would have been made for palaces (**210**), but most among them represent commission surpluses that were never used and survive in their original states. This is especially true of the large commission of 1811 for the Palais de Versailles, whose items never made it to their intended destination: instead, these silks were used during the Restoration in other palaces or were kept in the reserves of the Garde-Meuble until now, which explains why they are so remarkably well preserved.

208 209 210 211 212

Not all the silks sent to the Garde-Meuble underwent the same inspection process: although the Garde-Meuble proved itself to be more rigorous in the quality control process of silks received after the Pernon Affair, it did not decree any regulations, save for the large commission of 1811. Potential manufacturers started with sending in a "bid" to the Garde-Meuble, in which they provided details on the fabric's design, quality, weight, dyeing, suggested price and delivery date. The bid had to be accepted by the director of the Mobilier impérial and then approved by the Intendant-General of the Imperial Household. Once the silks were delivered to the Mobilier impérial, they underwent stringent inspection processes via exposure to air and light for several weeks under a glass frame, which heightened the effects of light radiance. The weight, which partly determined the price, was also controlled.[18] It is important to mention that despite the excellent quality of the silk from Lyon, the Garde-Meuble would regularly issue strict critiques of the products received, taking into consideration the design's proportions, the weaving technique—deemed, for example, unsuitable in the choice of velvet for the edging that accompanied the lampas in the Empress' second salon at Versailles (209)— and rendering of colours. Thus, in 1812, the lampas in the first salon of the Empress' apartment at Versailles became a subject for discussion with regard to the right choice between a lilac colour and the use of white, which would require "greater work."[19]

In its concern for protocol, the Garde-Meuble was also sensitive to the hierarchical adaptation of textiles to their settings, which varied in prestige. Thus it assigned to the bedrooms at Fontainebleau, without a specific occupant, an "economical damask", in other words, a two-coloured linen and silk damassade, whose material and technique resulted in a lower cost; for the minister's rooms in the same palace, a silk satin with green and white motifs in serge, a little more worked and costly, was chosen; for his bedroom at Meudon, the Emperor opted for a brocaded lampas with a weft count of nineteen (210), a particularly high count requiring great technical virtuosity and, consequently, significant production time and cost.

The Emperor supported such virtuosity by encouraging innovation and mastery in the textile arts. The regulator designed by the manufacturer Dutillieu offered greater consistency in the weaving process, permitting the development of orthogonal patterns.[20] Similarly, the early nineteenth century saw the peak period of *taille-douce*, a complicated weaving process that imitates the shadowy effects of engraving. Chemical advances were also made in the field of dyeing, with Jean-Michel Raymond's creation of a Prussian blue that replaced

indigo, which had become hard to find as a result of the Continental Blockade.[21] The so-called Jacquard loom, which required less manpower, was another invention made during the Empire, by Joseph-Marie-Jacquard. However, the loom was used in one weaving attempt for the Garde-Meuble that ended in failure; contending with technical difficulties, the Jacquard loom only began to operate fully at the beginning of the Restoration.

These scientific advances were accompanied by parallel developments in patterns, symbols and colours, which were in step with the renewed taste for antiquity that marked the decorative arts and the establishment of imperial emblems. Fabrics began to sport stars and bees, oak and laurel leaves, as well as imperial fritillary (210), all symbols of power. Although flowers often soften the compositions, especially within borders more fanciful than the widths, orthogonal motifs were nevertheless favoured. Geometric compositions captured rigour and majesty. Imperial power was thus symbolized in a style that was as solemn as it was dazzling, and colour represented another break with the eighteenth century. Gone were the pastel shades of azure blue and pale pink. They were replaced by pure colours, including bright green, golden yellow, violet (208), royal blue and, in particular, harmonious pairings of the boldest hues.

Due to the support the Emperor offered to the silk manufacturers of Lyon, the palaces were transformed, as evidenced to this day in the decors at Compiègne and Fontainebleau. Nevertheless, the time it took to weave the sovereign's fabrics outlasted his reign, and a large portion of Napoleon's commissions, namely the silks intended for Versailles, were only used starting with the Restoration. In the decades that followed, successive regimes drew from this vast reserve, sometimes changing the motifs that were overly evocative of the fallen Emperor.

SÈVRES
AND THE GOBELINS
IN THE
GIFT-GIVING POLICY
OF THE
IMPERIAL HOUSEHOLD

SYLVAIN CORDIER

The administration of official gifts reflects a most important activity of the Imperial Household. In the course of Bonaparte's reign, paintings, porcelain, tapestries, furniture, lace, medals, gold boxes and jewels formed part of the wide variety of objects that were gifted, each one symbolic of the political and diplomatic exploits of the regime. Given the artistic merit of the works and the volume of gifts presented, this subject is rich and far-reaching. It would be impossible to give an exhaustive account of it in these pages. Instead, this essay will focus on the part played by the two principal imperial manufactories, Sèvres for porcelain and the Gobelins for tapestry.[1] Napoleon not only promoted the State's manufacturing activities, which he expanded, intending to export their products, but he also followed the monarchical practices of former times. Gift-giving was part of a tradition as old as the manufactories themselves, founded by Louis XIV (Gobelins) and Louis XV (Sèvres): of particular note is the increased output of tapestry hangings starting in the 1660s, destined for the sovereigns of Europe on behalf of Louis XIV, Louis XV and Louis XVI,[2] in addition to the creation of porcelain services sent from the beginning of the 1770s to various foreign courts on the orders of the last two kings of France.[3]

The archives of the Imperial Household hold the evidence of the administration's discussions about the composition of the gifts to be given, the determination of the value of the pieces, as well as their nature and decoration. This large body of documentation has also enabled the identification in Europe and North America of a large number of these works.[4]

In the course of the reign, three phases can be discerned: the re-establishment of a coherent policy for the production and distribution of gifts (from the Consulate to 1809) followed by a period when the gifts emphasized Napoleon's aura and his munificence—from the Treaty of Vienna (1809) to the baptism of the King of Rome (1811)—and then a period of decline, when gifts were given only to the French court and the imperial family in the years that between 1812 and 1814 isolated the Empire within Europe and led to its downfall.

The first of Bonaparte's grand diplomatic gifts: The king of Etruria's Louis XVI Sèvres pieces (1801)
After trying to think up new forms of Republican rewards, the Consular regime soon saw a return to the ways of the monarchy. Karine Huguenaud notes that the decree regarding the giving of boxes of gold and diamonds to foreign diplomats dates from July 1800.[5] The use of Sèvres objects came a year later, with the secret visit to Paris of the count of Livorno, the prince Louis de Bourbon

(1773–1803), who came to receive from Bonaparte the title of king of Etruria, a kingdom created from the territory of Tuscany under the Habsburgs.

The rules governing the public display of Consular power had yet to be fully defined. The national manufactories were gradually being built up again with government support, but it was a slow process. It was in this context that it was decided what gift should demonstrate the Consul's friendship for Etruria. The choice fell on a relatively old but particularly sumptuous Sèvres set that evoked a pre-revolutionary aesthetic that was beginning to be supplanted by the "Empire" style promoted by Brongniart when he became director of the manufactory. The first item was a large Medici vase with a beautiful blue ground from 1784, which had been kept in storage since the end of the Ancien Régime (Palazzo Pitti, Florence). To this was added a large circular plateau composed of biscuit porcelain plaques in bas-relief depicting *Telemachus Recounting His Adventures to Calypso*, mounted on a *guéridon* table (Museo Correr, Venice). Another addition was the dessert service "with a chrome yellow ground and garland of grapes" begun at Sèvres in 1793 (Palazzo Pitti, Florence).[6]

A Bourbon of Parma receiving a crown from the hands of the First Consul of the French Republic: this paradoxical situation may explain the stylistically retrospective nature of the gifts offered that day. Bonaparte was taking a political stance that evoked the principles of the Ancien Régime, notably the "Family Pact" between the Bourbons of France, Spain and Parma (1761) intended to ensure the interests of France beyond its borders. By creating a sovereign without yet becoming one himself, the First Consul was continuing a diplomatic game launched under Louis XV. The new king of the Etruscans died two years later. His very young successor (Charles Louis, born in 1799) lost his title in 1807: Napoleon took away his ephemeral throne and gave it to his own sister Elisa, re-establishing Tuscany's grand ducal title.

The administrative framework of the responsibility for gift-giving under the Empire
The gifts of 1801 instituted a practice that was to expand considerably under the Empire. Napoleon as monarch and commander-in-chief would also stand out for his spectacular generosity.

The *Étiquette du palais impérial* stipulates that it was the Grand Chamberlain who was responsible for gifts: "[He] takes H. M.'s orders for the presents he wishes to give to Crowned Heads, Princes, Ambassadors and others, to be paid for out of the privy purse. He has them made, settles on the prices and orders the payment, as he does for all the objects submitted for his personal

214

inspection."[7] In the early years of the Empire, Grand Chamberlain Talleyrand fulfilled both this function and that of minister of foreign affairs, until he was replaced as minister by Champagny in August 1807. The policy of court gifts was therefore associated during the first three years with the exercise of diplomacy. This responsibility of the Grand Chamberlain suggests a very close collaboration between his services and those of the Household's Intendant-General, who oversaw budgets. As chief administrator of the palaces, the Grand Marshal himself was also frequently involved, especially in how gifts would be presented.[8]

The manufactory directors played a vital role in this regard, in that they made proposals for gifts to the Grand Chamberlain. Although they were mainly occupied with commissions for the decoration of imperial residences, Brongniart at Sèvres and Lemonnier at the Gobelins had to adapt their output to the frequent demands for objects to present as gifts. The lengthy time required for the production of works came into conflict with the often very short and shifting deadlines of diplomatic life: it took almost a year to make a service of Sèvres porcelain and nearly two years to weave a full-length tapestry portrait of the Emperor. Thus dignitaries generally had to wait for their gifts, and the manufacturers had to ensure they had sufficient stocks on hand to produce satisfactory groupings at a moment's notice.

Types and decoration of gifts: Some remarks
The decision to favour products from the Gobelins and Sèvres as imperial gifts was taken by Napoleon on April 22, 1806, as much in order to promote their products as to limit the lavish gifting of diamonds, which was considered ruinous.[9] This decision prompted the administration to define the selection criteria for the types of works in question. For the tapestries, three types were favoured: decorative hangings in several pieces, sometimes inspired by the eighteenth century, that is, inherited from the Ancien Régime; full-length or bust-length portraits of members of the imperial family; and large scenes copied from history paintings exhibited at the Salon. In preparation for the New Year's gifts of 1811, an "Inventory of the paintings in tapestry which can be put at the disposal of T. M. the Emperor and the Empress to present as gifts," of December 1810, provides an excellent example of the types and of their distribution: it includes two tapestries of imperial history, *Bonaparte, First Consul, Distributing Sabres of Honour to the Grenadiers of His Guard after the Battle of Marengo (June 14, 1800)*, after Gros, valued at 16,000 francs and given to queen Hortense, and *Bonaparte, First Consul, Crossing the Alps at*

the Great Saint Bernard Pass, after David, 15,000 francs, to Pauline Borghese; a bust *Portrait of Napoleon* after Gérard, 2,250 francs, to his sister-in-law queen Julie of Spain; two decorative hangings after early paintings, *Two Ducks* and a *Vulture,* after Desportes, 4,375 francs, for cardinal Fesch; and a screen tapestry depicting parakeets, 1,467 francs, for the comtesse de Ségur.[10]

At Sèvres, gifts were manufactured in groupings. The Emperor established a scale of prices congruent with the prestige of the individuals honoured, and made director Brongniart responsible for designing standardized and attractive sets of porcelain for each sum. It was an opportunity for showing off the formal and decorative diversity of the objects and their masterful craftsmanship. The groupings always contained vases of several different sizes and shapes, and usually included one or more cabarets or tea services, and in the case of the most lavish groupings, a dessert service of dozens of pieces. Brongniart often included examples of sculptures in biscuit, intending to continue the dissemination of the Great Men series commenced under Louis XVI, the production of which began to be made again under the Empire. In their diversity, these objects were meant to promote the French taste favoured by the regime.

The iconographic choices were, of course, highly significant. As the primary function was to ensure the dissemination of the Emperor's image and authority, a bust of Napoleon in biscuit after Bosio was often included among the batches of porcelain. At the Gobelins as at Sèvres, numerous copies were made of full-length or bust-length portraits of the Emperor, mainly the one by Gérard.[11] In the case of the latter, in tapestry as in paintings, the oval frame of carved and gilded wood played a particular part, its ornamentation complementing the emblems hidden by the tight framing: the eagle at the top for the sceptre, the rim of bees for the pattern of the mantle and the laurel wreath for the back of the throne's design.

At times, the homage to the Emperor is expressed implicitly in the image. The most fascinating of these is, in some batches of porcelain, the use of references to the ancient world, evoked as examples of just government. The Etruscan-style, drop-shaped vase given to the prince of Prussia in 1807 (214) depicts, in a bold, unadorned style imitating ancient Greek pottery, Napoleon on both faces, on one side as a healer, a compassionate French general at Jaffa, and on the other a Greek hero presenting a wounded man to Aesculapius. In 1809, the two pairs of vases presented to the king of Saxony pictured the magnanimous actions of the victorious Emperor in a comparison with ancient times that also contained an element of intimidation for the recipient. The gestures of the empathetic Napoleon on the pair showing *The*

213
SÈVRES IMPERIAL MANUFACTORY
Decoration painted by Jean GEORGET
After Jacques-Louis DAVID
Spindle vase decorated with *Bonaparte Crossing the Alps at the Great Saint Bernard Pass*, given to Madame Mère in commemoration of the King of Rome's baptism
1811
Paris, Musée du Louvre

214
SÈVRES IMPERIAL MANUFACTORY
Decoration painted by Pierre Nolasque BERGERET
Etruscan drop vase decorated with two scenes on the subject of Napoleon as miracle-worker: *The Plague Victims of Jaffa* and *Napoleon Touching an Invalid under the Watch of Asclepius*, given to the prince of Prussia
1807
Château de Fontainebleau, Musée Napoléon Ier

215
SÈVRES IMPERIAL MANUFACTORY
Service of Plants of Malmaison
A. Basket from a pair
B. Plate
1803-5
Boston, Museum of Fine Arts

215A 215B

Emperor Saluting the Wounded and *The Emperor Visiting a Field Hospital* are compared to the image of the tragic reversal of fortune in the ancient kingdom of Macedonia, the native land of Alexander the Great, finally crushed by Rome, on the other pair showing *The Entry of Alexander into Babylon* and *The Triumph of Paul Émile*.[12] This comparison recalled both the magnanimity of the sovereign military leader and the risk for a small kingdom of being easily crushed by a great empire.

On occasion, the Household was able to adapt the choice of decoration to the identity, personality and even the religious denomination of the recipient. This consideration was not common, however, and demonstrated particular regard for the individual: it does not call into question the impression that the gifts, although valuable, were in general relatively impersonal.

In the composition of the most impressive batches of porcelain, the association of certain decors painted on vases, plates and services reflects the hierarchy of genres in Salon paintings. The imperial portraits hung beside scenes of ancient history, while still lifes and genre scenes seem at times to continue in porcelain the reflections developed by and for lovers of paintings. In this regard, an excellent example is found in the complementarity of the vases given to Jerome in 1811, on the occasion of the baptism of the King of Rome (**220-222**).

Lavish acknowledgements on the occasion of the grand ceremonies of the reign

The grand ceremonies were the opportunity for splendid displays of imperial munificence expressing the regime's gratitude to friends and relations, and to the individuals involved in the ceremony: the gift depended on the recipient and the part he or she played.

Pope Pius VII, who had come from Rome in November 1804 to attend the coronation and bless the imperial couple, was the first dignitary for whom the question of gifts from the new monarchy arose. A budget of 250,000 francs was set aside for them, and at the end of his long stay in France (November 1804-May 1805), in a gallery of the Musée Napoléon, the Emperor presented the pope with two carpets from La Savonnerie, one after a model by Lagrenée, a series of eighteenth-century tapestries from the Gobelins on subjects from the New Testament, superb vestiges of the collections of the Ancien Régime, and a group of Sèvres pieces composed of two blue lapis vases with gilded bronze mounts by Thomire, a bust of Napoleon in biscuit, a breakfast service and a dessert service.[13] The gift included a sumptuous gold and diamond tiara created by Auguste et Nitot, valued at 150,000 francs. Members of the pope's retinue were also rewarded with lace, snuffboxes decorated with a portrait of Napoleon, diamonds and gratuities.

On April 8, 1806, the marriage of Stephanie de Beauharnais, Josephine's cousin, to the crown prince of the German state of Baden was the first royal wedding held in Paris by the imperial court. It was an opportunity to federate the German lands next to France a few months after the Austerlitz victory. The groom was given a series of five early tapestries on biblical subjects from the Gobelins—*Amon's Arrest*, *The Fainting of Esther*, *Joseph Recognized by His Brothers*, *The Expulsion of Heliodorus from the Temple* and *The Vision of the True Cross*—to which the coat of arms of his principality had been hastily added.[14] The future princess was given a sumptuous Sèvres service—made under the Consulate for Josephine—that celebrated her greenhouses at Malmaison (**215**).

The dignitaries taking part in the ceremony were spectacularly rewarded. The cardinal Legate was given 20,000 francs worth of tapestries from the Gobelins: *The Baptism of Christ*, *The Washing of the Feet* and *The Miraculous Catch of Fish*.[15] The four other officiating bishops received batches of Sèvres porcelain valued at 6,000 francs. The crown prince of Bavaria was given a tapestry, *The Wedding of Angelica*, and a Sèvres porcelain plateau mounted on a stand.[16] Champagny, the minister of the interior, was given a spindle vase, with a portrait of the Emperor,[17] Maret, the secretary of state, the remarkable service of Sèvres called "Encyclopaedic"[18] and the arch-chancellor Cambacérès the no less impressive service described as "purple ground, Views of Italy and France and *The Fables* of La Fontaine"(**216**),[19] together with a vase reproducing the signature on the marriage contract. Grand Master of Ceremonies Ségur and his two Masters of Ceremonies Seyssel and Cramayel, who brought the civil registers to the wedding, were each given a pair of vases of the same size but differing, given the hierarchy, in the richness of the decoration, and consequently in value (**217**, **218**);[20] two cabarets, one with Etruscan ground and decoration, the other with pink ground and miniatures, were added for Ségur.[21]

A similar procedure was followed for the other marriages in the imperial family: that of Eugene de Beauharnais to the princess Augusta-Amelia of Bavaria a few months earlier (January 13-14, 1806, in Munich) and then that of Jerome Bonaparte to the Princess Catharina of Württemberg (April 22, 1807, Paris).

Not surprisingly, the Emperor's marriage to the archduchess Marie-Louise (April 2, 1810) intensified these practices.[22] As the first part of the ceremonies was taking place in Vienna, before the young bride's long journey to France, the

216A

216B

Imperial Household drew up several lists of gifts to be given to Austrian dignitaries. The Austrian Grand Master of Ceremonies received a Gobelins tapestry portrait of the Emperor. Presents of gold snuffboxes featuring diamonds were bestowed on the Grand Officers of the courts of Württemberg and Baden, through which the retinue travelled on the way to France, while the mayors and prefects of each of the cities along the way received gold rings.[23]

In Paris, the arch-chancellor Cambacérès and the state secretary of the imperial family, Regnault de Saint-Jean d'Angely, were rewarded, the former by a Gobelins full-length portrait of the Emperor (**159**) and a portrait of the new Empress,[24] and the latter by a set of Sèvres porcelain.[25] Batches of Sèvres porcelain were also given to the "ladies of Italy," the ladies-in-waiting at the court in Milan—of which Napoleon and Marie-Louise were the titular sovereigns—and also at those in Tuscany and Naples, reigned over by Elisa and the Murats.[26]

The grand duke of Würzburg, the bride's uncle, came to France to represent Austria. In June 1810, at the end of his sojourn in Paris, the man who remained one of the greatest victims of French politics among the crowned heads of Europe (Bonaparte had taken from him his Grand Duchy of Tuscany in 1801), was given two pieces from the Gobelins (44,950 francs) on religious subjects after Raphael's Stanze at the Vatican—*The Expulsion of Heliodorus from the Temple* and *The Vision of Constantine*—and Sèvres vases worth 11,500 francs, a pair of Cordelier vases third size painted with landscapes by Demarne—*The New Route to Italy through the Simplon Pass* and *View of the Ourcq Canal*—and a second-size spindle vase with a portrait of the Emperor after Gérard.[27] The following year, Würzburg was made godfather of the King of Rome, and was once again richly rewarded after the baptism.

There was some notion of giving Grand Master of Ceremonies Ségur a Gobelins full-length portrait of the Emperor,[28] but on reflection, given the slowness of the production, a batch of Sèvres porcelain was chosen instead. This eclectic group comprised a large bust of the Emperor and no less than three complete services,[29] two cabarets, a pair of vases and various other objects, together with a series of twenty-four cameo medallions of his own portrait.[30] It is likely that this substitution was not without an ulterior motive, as the medallions were actually meant to be handed out in their turn by the recipient among people to whom he was obliged.

Once again, Masters of Ceremonies Cramayel and Seyssel shared pieces of Sèvres: thirty-six plates and cups, two vases and a cabaret for one of them, and a clock, a large service, two cabarets, two pairs of vases and cameo medallions

for the other. Two other Masters, Hamel and Prié, received services, busts of the Emperor, figures in biscuit and pairs of vases. Dargainaratz and Aignan, assistants to the Masters of Ceremonies, were given large batches of apparently identical cups and compote dishes, which give the impression of objects of lower value put together in haste to reach the price granted to these lesser members of the Household.[31]

The baptism of the King of Rome (March 20, 1811) was a significant occasion for the future of the regime. Several budgets were devoted to the gifts, the main one being of 516,000 francs, 375,000 of which were reserved for commissioning the superb diamond necklace presented to Marie-Louise.[32] Funds were also drawn to put together gifts for the family's two princes, Eugene and Jerome, composed of objects from the Gobelins and Sèvres. Eugene, whom Napoleon had adopted in the early days of the Empire, was given a tapestry, *Francis I Visiting Leonardo da Vinci*, after Menageot, and a sumptuous batch of Sèvres consisting of vases in three sizes, notably bearing a portrait of the Emperor[33] and images of the Seasons, twelve figures in biscuit from the Great Men series, a dessert service with views of Switzerland, a green breakfast service with figures of French warriors, and a bust of his mother, Josephine.[34] In terms of iconography, these gifts (valued at 36,625 francs) highlighted his position as viceroy of Italy and seemed to assure him of Napoleon's affection, since they paid tribute to the former Empress. The set of porcelain gifted to Jerome was comparable,[35] although even more costly (54,640 francs). From the Gobelins came a tapestry, *Arria and Paetus*, and from Sèvres a group comprising two Medici vases (**221**), a pair of Etruscan scroll vases (**220**), a spindle vase with a portrait of the Emperor (**222**),[36] as well as two large vases with figures of ancient Greek dancers, a blue cassolette vase with friezes of children, eight figures of Great Men, a ten-piece breakfast service with a floral design and a black marble mantelpiece inlaid with figures and cameos in biscuit.

Independently of this first budget, expensive gifts were commissioned for the child's godfather and two godmothers. The godfather, who was the grand duke of Würzburg, his maternal great-uncle, was given two Gobelins tapestries: *The Combat of Mars and Diomedes* (36,584 francs) and *Cornelia Mother of the Gracchi* (20,762 francs). From Sèvres he received a group of objects comprising a plaque with a portrait of the Emperor after Gérard (**158**), a bust of the Empress in biscuit after Bosio, an egg vase imitating the cameo celebrating the birth of his godson (Palazzo Pitti, Florence), a large chrome green Medici vase, two others with Egyptian decorations by Swebach (**224**), and two Cordelier vases third size

217 218

219

220

221

222

220
SÈVRES IMPERIAL MANUFACTORY
Decoration painted by Jean GEORGET
Pair of Etruscan scroll vases: *Leaving for the Army* and *Return from the Army*, given to Jerome of Westphalia in commemoration of the King of Rome's baptism
1811
Hartford, Connecticut, Wadsworth Atheneum Museum of Art

221
SÈVRES IMPERIAL MANUFACTORY
Decoration by Jean-François ROBERT
Pair of Medici vases with scenes of the château and park of Saint-Cloud, given to Jerome, king of Westphalia, in commemoration of the King of Rome's baptism
1811
New York, The Metropolitan Museum of Art

222
SÈVRES IMPERIAL MANUFACTORY
Decoration painted by Jean GEORGET, Claude-Antoine DÉPERAIS and Christophe-Ferdinand CARON
Spindle vase with portrait of the Emperor, given to Jerome, king of Westphalia, in February 1812, in commemoration of the King of Rome's baptism
1811
Musée national du château de Compiègne

223

224

painted with flowers by Drouet.[37] The child had two godmothers: Napoleon's mother, Madame Mère, and Caroline of Naples, the latter represented at the christening by queen Hortense. Madame Mère was given a Gobelins tapestry on the subject of *Meleager Surrounded by His Beseeching Family* (24,801 francs) **(219)** and from Sèvres a bust of the Emperor in biscuit (36,700 francs), a cup with a portrait of her daughter-in-law the Empress by Leguay after Isabey, the famous spindle vase reproducing *Bonaparte Crossing the Alps at the Great Saint Bernard Pass* by David **(213)**, a large Etruscan vase with flowers and birds by Drouet, and two Clodion vases from 1809, painted with panels celebrating two festivals in Paris at the Marché des Innocents and on the Place du Corps législatif on the occasion of the Treaty of Vienna.[38] At the baptism, queen Hortense stood in for the godmother who remained in Naples. The present she was given was consequently less valuable than the one gifted to Madame Mère: an *Offering to Pallas* from the Gobelins (18,572 francs) and from Sèvres a bust of the Emperor, a cup with a portrait of the Empress, a pair of Cordelier vases with scenes of hunting at Fontainebleau, and a twelve-cup breakfast service with portraits of the Philosophers,[39] together with a *guéridon* table with porcelain plaques painted by Bergeret depicting *Homer Singing Verses*.

The officiating prelates were richly rewarded. At the time, cardinal Fesch was on cool terms with Napoleon. A partisan of the pope in conflict with the Emperor since 1809, Fesch was uncomfortable with the title of King of Rome conferred on the heir to the throne. However, in his post as Grand Chaplain, he agreed to baptize the baby, in keeping with the *Étiquette*. He was presented with a superb collection of Sèvres, including the iconographic Greek service **(227)**, together with a bust of the Emperor, a cup with a portrait of Marie-Louise, a large egg vase with a tortoiseshell ground and a pair of blue Medici vases portraying the Emperor hunting (a total value of 25,548 francs).[40] Officiating with him were the Grand Chaplain of the kingdom of Italy, the patriarch of Venice and the bishop of Brescia, who were rewarded with costly pectoral crosses and episcopal rings by Nitot.[41]

Finally, the emperor Francis of Austria, the little King of Rome's maternal grandfather, received a group of Sèvres pieces assembled in tribute to the Hapsburgs: to the usual bust of Napoleon were added a teapot painted with portraits of the recipient and his daughter, Marie-Louise, two cups with portraits of Marie-Thérèse and Charles V and a dessert service with various subjects painted in miniature; still extant today are two ice pails painted with views of the chateaux of the Tuileries and Écouen on one and of Saint-Cloud and Saint-Cyr on the other **(226)**.[42]

Gifts for foreign sovereigns and dignitaries, manifestations of intense diplomatic activity

French expansionist policy on the continent during the first five years of the reign led the regime to look continually to the East to ensure the support of the Germanic courts in its rivalry with Russia and Austria.

The elector Frederick William of Württemberg was a very early ally. In December 1805, only a few days after Austerlitz, Napoleon elevated his hereditary duchy to a kingdom and generously redrew his borders. Now Frederick I, he received the Emperor with gratitude in January 1806 in Stuttgart. Following this visit of the liege lord to the vassal, an astonishing present was put together in Paris. From the Gobelins came five early tapestries with "Indian Subjects"– *The Striped Horse*, *The Bulls*, *The King Being Carried*, *The Hunter* and *The Fisherman*–to which were added the arms of the recipient surmounted by his brand-new royal crown.[43] On behalf of the Empress, the gift for the queen and princesses of the family also included an assortment of Sèvres porcelain consisting of a ewer, two breakfast services and five vases, together with a bound collection of engravings. The excellent relations between the two courts culminated in the marriage of Jerome and Catharina a few months later.

With the annihilation of the Prussian forces at Jena (October 14, 1806), prince William of Prussia (1783–1851), brother of king Frederick William III, had the difficult mission of coming to Paris to negotiate a reduction of his country's war levy. Napoleon as the victor appreciated the act. A gift followed, comprising three pieces from the Gobelins (38,966 francs):[44] two subjects from ancient Greek history (*The Recognition of Iphigenia and Orestes* and *The Courage of the Spartan Women*), and an interesting subject from Protestant history, *Admiral Coligny Impressing His Murderers*,[45] as a mark of respect for the obedience of the Prussian court. The gifts of Sèvres (19,270 francs) were strikingly diverse in their decoration: two lapis blue Clodion vases painted with figures by Drölling, two other vases with Etruscan-style decoration of scenes taken from the Egyptian campaign by Bergeret, treated in the manner of ancient Greek pottery,[46] a large cabaret decorated with the *Fables* of La Fontaine **(225)**, another with a chrome green ground, a soup cup and a large bust of the Emperor.

The complex relationship between Napoleon and the czar Alexander produced numerous gifts. These were not only indicative of the incomparable status of the autocrat in the European hierarchy of honours but testified to the relationship of mutual charm that grew between the two emperors. After using it only once, for Jerome and Catharina's wedding banquet, Napoleon decided, after their meeting in Tilsit (July 7, 1807), to offer Alexander his magnificent

225

Olympic service.[47] Given the length of time it took to produce such a group, the pragmatic gift of a "second-hand" service launched a practice specific to the relationship that Napoleon hoped to establish with his Russian counterpart: the gift represented a sharing, between new friends, of personal objects. Inconceivable in a relationship of superiority to subordinate princes, which is to say, in most of the cases in his diplomacy, Napoleon's gift of a service created for him expressed an equality of dignity between giver and receiver. Alexander was also given a pair of spindle vases with grisaille decoration taken from the *Georgics* and the *Bucolics*.[48]

The meeting at Erfurt, held between the two emperors from September 27 to October 14, 1808, in a Saxon city recently conquered by the French, was to confirm the commitments made at Tilsit. At the conclusion of this cleverly staged encounter, the count Romanzoff, the Russian minister of foreign affairs, was given a splendid selection of Sèvres: a large service with a gold ground marli and grey laurels, cameo heads, two Clodion vases, a bust of Napoleon in biscuit, a large cabaret, a soup cup and a jasmine cup, as well as twelve biscuits from the Great Men series.[49] The value of this gift was so great that in February 1809 Napoleon ordered that an article about it be published in the *Moniteur Universel*, the regime's press organ.[50]

At Erfurt, the presents given to the czar himself were of the same friendly kind introduced with the gift of the Olympic service the previous year. This time it was his personal toiletry case, actually two of them, by Biennais, that Napoleon gave Alexander, in an apparently spontaneous gesture.[51] To these were added a group of objects from Sèvres—four biscuit busts with a likeness of Alexander, a biscuit bust of Napoleon and a large cabaret in the Egyptian style.[52]

At the conclusion of the meeting, France also offered the Russian court all the decorative elements brought from Paris to adorn the palace of Erfurt, where the conference was held. Twenty-three tapestries from the Gobelins, including five depicting "Russian Games," thus made their way to Saint Petersburg.[53]

The months of November and December 1809 saw the convergence in Paris of the sovereigns of the various States subject to the Empire to celebrate the peace with Austria. This gathering of kings culminated in a grand ball held in the city hall on December 4 in honour of the fifth anniversary of Napoleon's coronation. The Württembergs, the Saxons, the Bavarians settled in for several weeks. They were joined by the Emperor's two brothers and brother-in-law reigning in Europe: Jerome in Westphalia, Louis in Holland and Joachim in Naples. Dozens of gifts concluded this extravagant visit. King Frederick Augustus of Saxony was particularly well treated. Napoleon required that he be given 60,000 to 80,000 francs worth of gifts from each of the manufactories of the Gobelins, La Savonnerie and Sèvres, and also from the Mont-Cenis crystal manufacturer. These figures were finally scaled down, but the total remained breathtaking, with Sèvres pieces taking the spotlight. In a less than tactful attempt at reigniting the rivalry with Meissen, Duroc insisted that the selection of porcelain should contain "fine vases in larger sizes than those he may possess at home."[54] Thus the king was given two large Cordelier vases illustrating the ancient Greek and imperial subjects alluded to above–*Alexander Entering Babylon* and *The Triumph of Paul Émile*–a pair of chrome green egg vases second size on modern subjects–*The Emperor Hailing Wounded Enemies* and *The Emperor Visiting a Field Hospital*–two Etruscan vases on subjects taken from *The Odyssey*, a Medici vase with a portrait of the Emperor, a cabaret painted with portraits of French writers rendered by Mme Jaquotot, a bust of Napoleon in biscuit, twelve figures of Great Men in biscuit, two other figures in biscuit–*Homer* and *Virgil*–and a series of twenty-four gold marli plates. Saxony asked to be given a portrait of the Emperor after the model by Gérard. Included in his present was a Gobelins bust in a circular frame (**166**).[55]

King Maximilian of Bavaria and his queen received an equivalent group of gifts: from the Gobelins, two pieces from the "Fruit and Animals of the Indies"–*The Zebra* and *The Hunter*;[56] from Sèvres a bust of the Emperor first size, two large Cordelier vases with a gold ground painted by Drölling on the subject of a *Village Honeymoon* and a *Village Festival*, a third vase with a blue ground featuring a view of the Château d'Écouen and *Anne de Montmorency Parting for the Army*, ten figures of Great Men, *Homer* and *Virgil*, a breakfast service with a red ground painted with *Children's Games*, a Picturesque dessert service and twenty-four plates painted with garlands of flowers on a gold ground, with a bouquet in the middle.[57]

The gift presented to king Frederick of Württemberg consisted of a portrait bust of Napoleon from the Gobelins (1,800 francs)[58] and a set of Sèvres (35,200 francs) comprising a bust of the Emperor in biscuit, a large vase called *Triumph of the Emperor*, a pair of Floréal vases with a tortoiseshell ground painted with birds, and two services, an entrée and a dessert service "in gold marli with laurel painted in grey and cameo-style heads in the centre of each piece."[59] This service is the same model as the one gifted the previous year to the count Romanzoff after Erfurt. Still extant is one of the two ice pails, decorated with medallions of figures of Mercury and Perseus (**229**), a plate and a sugar bowl.[60]

Jerome of Westphalia was not neglected, Napoleon presenting him a gift valued at 41,900 francs. The list drawn up by the directors of the Gobelins and

226

227

Sèvres notes two tapestry hangings on the subjects of *The Courage of the Spartan Women* and *Autumn*, and a pair of monumental lapis blue vases a metre high, together with a bust of Napoleon, in biscuit, wearing a crown and standing on a pedestal.[61]

The year 1810 saw the rapprochement with Austria established by the marriage of Napoleon and Marie-Louise. In October, the count Metternich, minister of foreign affairs, was given a bust-length portrait of the Emperor after Gérard from the Gobelins (2,400 francs),[62] a bust of the Emperor in biscuit first size, a cup with the portrait of Marie-Louise, a blue coupe vase depicting a children's bacchanale, a pair of elongated vases "copied from the Etruscan" with cameo portraits of Cicero and Demosthenes, and a dessert service with a floral pattern in mosaic on a blue ground (8,480 francs).[63]

In late June 1810, arrangements were made to transport the gifts made to prince Louis I of Hesse-Darmstadt at the end of his sojourn in Paris. These consisted of four pieces from the Gobelins on subjects taken from *Don Quixote* (18,600 francs),[64] and from Sèvres, in addition to the usual bust of the Emperor in biscuit, a pair of chrome green egg vases third size with figures of Bacchus and Ariadne and Flora and Zephyr (**228**) and four literary figures from the Great Men series—Corneille, Racine, La Fontaine and Molière (7,800 francs).[65]

Rulers, princes and diplomats, who were frequently invited to meet Napoleon in Paris or elsewhere in the context of diplomatic meetings, regularly went home with gifts representative of the productions of the imperial manufactories. The homogeneity in the composition of the different batches reveals a well-organized system at both Sèvres and the Gobelins, designed to bolster international relations based on the survival of the fittest, the most illusory of policies in the long term.

Visits to Sèvres and New Year's celebrations: Two occasions for gift-giving at court

During the first part of his reign, the Emperor's annual visits to the manufactories were opportunities to give presents to the family members he invited to accompany him. Five visits were organized on April 21, 1806, July 21, 1807, August 20, 1808, December 2, 1809 and June 8, 1811, generally while the court was staying at the nearby palace of Saint-Cloud.[66] In comparison with the diplomatic gifts, the gifts of Sèvres porcelain offered during these visits were of much less value. They consisted of a representative sample of the variety of small items produced and the range of types of decoration: plates, paintings on plaques, medallions, milk jugs, water jugs, soup cups and, especially, cups

and saucers. One object stood out, however: the bust of the Emperor first size, given after April 21, 1806, to marshal Bessières, colonel of the Cavalry of the Imperial Guard, who rode beside the Emperor wherever he went and guaranteed his safety (**232**).

The visit in December 1809 was doubtless a separate case, since it coincided with the aforementioned sojourn in Paris of the Germanic kings, and thus could be seen in the diplomatic context. It was probably on this day that the king of Württemberg noticed with interest a gold marli service painted with grey laurels and cameos that, commissioned for another recipient, was given to him a few weeks before his departure.[67] It was also on this occasion that a spindle vase bearing a portrait of the Emperor was given to Hortense.[68] The splendid cabaret called "Famous Women" was commissioned for Pauline (**231**). While waiting, she was given a pair of Etruscan carafe vases (**230**) and a plate of the personal service.[69] Catharina of Württemberg received a more complete group—a pair of Etruscan vases with views of Montmorency, a swan-shaped writing case, a gold marli plate, a jasmine cup and an equestrian statuette of the Emperor. Several ladies-in-waiting of the various princesses present shared simpler sets of plates, bowls and cups.

A notable case among the gifts for the family was Napoleon's concern to have a particularly beautiful Sèvres service made for Josephine. This commission followed the issuing of the divorce decree in December 1809. An Egyptian service was ordered on February 15, 1810, for a fixed sum of 30,000 francs, the Empress having refused all the designs then available in stock at the manufactory. It was delivered to Malmaison two years later (**223**) and dramatically turned down. Josephine had lost patience, considered the decoration "too severe" and wished to have another service made to her own design.[70]

At the Tuileries, New Year's Day was the occasion to witness, in a way that mingled solemnity and sentiment, the favour of the imperial couple. Few traces can be found in the archives of any New Year's gifts offered by Napoleon and Josephine during the early years of the regime (1805–10), although an order addressed to the administrator of the Gobelins in 1804 indicates that this practice existed at the start of the reign.[71] It was only in anticipation of January 1811 that Napoleon established a strict protocol on this question, after the success of a party organized the previous year, and also for the occasion of the first New Year celebrated since the arrival in Paris of Marie-Louise. In fact, on January 1, 1810, shortly after his divorce from Josephine, the Emperor had called all his family around him, and gifts were given to the princesses. A year later, the list was considerably enlarged to include the Empress' ladies. Presents from

230

231

Sèvres and the Gobelins were delivered some days earlier to the concierge at the Tuileries to be stored initially in an empty apartment and then in the Emperor's bedroom—with an indication of their price—to enable him to choose the recipients.[72]

In 1811, Elisa of Tuscany, Catharina of Württemberg, Stephanie of Baden and Augusta-Amelia, vicereine of Italy, were given small cups and soup bowls worth between 240 and 350 francs each. Caroline of Naples was given a more impressive present, a vase with a portrait of the Emperor worth 1,500 francs.[73] Other members of the family received gifts of tapestry of even greater value: woven paintings worth 16,000, 15,000 and 4,375 francs going to queen Hortense, Pauline Borghese and cardinal Fesch.[74] A twelve-cup breakfast service worth 2,290 francs went to the comtesse de Lucay, lady of the robes to Marie-Louise, second in order of precedence to the lady of honour.

From the list of gifts of 1812, Madame Mère's tea service called "Hunting" (3,125 francs) (233) and cardinal Fesch's set with flowers and butterflies (1,820 francs) (236, 237) are still extant. A pair of vases for the duchesse de Istria, the wife of marshal Bessières (400 francs) (235), and a bouillon bowl for the comtesse de Montalivet, a lady-in-waiting (720 francs) (234)[75] have also been identified. Three Gobelins tapestries were also gifted that day: two bust-length portraits of the Emperor after Gérard for Stephanie of Baden and Elisa of Tuscany (2,250 francs) and a standing portrait of Madame Mère (12,000 francs) for Catharina of Westphalia.[76]

The value of porcelain was rising in 1813, undoubtedly the year of the most lavish gifts, although the military and diplomatic prospects were becoming gloomier.[77] For twelve of the guests, the gifts included luxurious cashmere shawls (2,000 francs each).[78] Among members of the imperial family, Madame Mère received a tea service with portraits of the imperial family (5,890 francs) (239); Elisa of Tuscany another depicting different corps of the Imperial Guard (3,385 francs) (243); Augusta-Amelia, vicereine of Italy, a tea service with portraits of the imperial family in cameo form (4,675 francs) (240); Stephanie of Baden, a breakfast service with a gold ground with bunches of flowers (3,905 francs);[79] Pauline Borghese, another imitating a mosaic of hard stones (2,255 francs) (242). The Empress' lady of honour, the duchess of Montebello, was given a breakfast service with views of Egypt worth 2,030 francs (238). Among the ladies-in-waiting, the princess Aldobrandini received an egg vase with an allegorical subject of marriage in imitation cameo, worth 2,500 francs (241); the comtesse de Croix a breakfast service with imperial hunting images worth 3,100 francs; the duchess of Elchingen a spindle vase with a portrait

of the Emperor worth 2,000 francs; the comtesse de Noailles, an Etruscan carafe vase with a medallion celebrating the *Baptism of the King of Rome* worth 1,200 francs.[80]

From the New Year's list for 1814, the last one under the Empire, three months before Napoleon's abdication (April 11), the pieces known today are a pair of spindle vases with portraits of the Emperor and Empress (4,000 francs) (244) for Catharina of Westphalia, already in exile in Paris before the advance of the Allied forces,[81] a breakfast service painted with scenes of the outskirts of Sèvres (2,895 francs) for Caroline of Naples,[82] and another with "Portraits of Former Legislators," for Julie, queen of Spain (245). The vicereine of Italy, Augusta-Amelia, received a breakfast service, the "Cupids and Nymphs Set" (6,425 francs) (246). The most monumental piece of the series, an impressive column mounted on a clock (2,400 francs) (6), was given to a lady-in-waiting, the duchesse de Elchingen, wife of marshal Ney.

Except for a few rare exceptions—notably in the case of Grand Chaplain Fesch in 1812—the New Year's gifts were presented to women. Although Napoleon chose who was to receive them, it was the Empress who officially distributed these presents: the recipients were the princesses of the imperial family who were in Paris at the New Year, the ladies of honour, ladies of the robes and the ladies-in-waiting, as well as some wives of dignitaries. This phenomenon should undoubtedly be seen in the context of the exaltation of the imperial majesty that followed the marriage in 1810. Although the gift-giving was imparted a feminine dimension, the image of the regime was enhanced and seemed to blossom in this symbol of the different nobilities of the Empire, the Ancien Régime and Europe, gathered together in friendship at the Tuileries to celebrate the New Year.

The splendour of the New Year's gifts of 1814 is even more fascinating since the fall of the Empire was clearly imminent. But majesty remained, on this last January 1 of the Empire, like a well-oiled machine in which the expression of power was combined with the ties of affection, maintained as best they could by a family soon to be driven out of their palaces.

In collaboration with the imperial manufactories, the Imperial Household had made use of an impressive decorative language to serve Napoleon's policy of gift-giving. The Restoration, inheriting unfinished pieces or those rendered useless with the fall of the regime, found it easy to dispose of them in its turn, as it did with other formerly royal possessions, the gorgeous remainders of items ordered by the master only a short while before. The superb Sèvres

233

234

233
SÈVRES IMPERIAL MANUFACTORY
Decoration painted by Jean-François ROBERT
Tea service called "of the Hunt," given to
Madame Mère as a New Year's gift in 1812
1811
United Kingdom, private collection

234
SÈVRES IMPERIAL MANUFACTORY
Decoration painted by Jacques-François
SWEBACH-DESFONTAINES
Bouillon cup and saucer decorated with *Race
Dressings* and *Horse Racing at the Champ-de-
mars,* given to the comtesse de Montavilet,
lady-in-waiting, as a New Year's gift in 1812
1811
Château de Fontainebleau, Musée Napoléon Ier

235
SÈVRES IMPERIAL MANUFACTORY
Decoration painted by Joseph DEUTSCH
Pair of Etruscan carafe vases, given to the
duchess of Istra as a New Year's gift in 1812
1811
Private collection

236, 237
SÈVRES IMPERIAL MANUFACTORY
Decoration painted by Gilbert DROUET
Tea service called "green ground, groups of
flowers," and its case, given to cardinal Fesch
as a New Year's gift in 1812
1811
The Montreal Museum of Fine Arts

235

236

237

238

239

240

241

242

243

238
SÈVRES IMPERIAL MANUFACTORY
Decoration painted by Christophe-Ferdinand
CARON and Nicolas-Antoine LEBEL
**Egyptian tea service, given to the duchess of
Montebello as a New Year's gift in 1813**
About 1810–12
Œuvre reconnue d'intérêt patrimonial
majeur par l'État français, en dépôt au musée
Napoléon Iᵉʳ du château de Fontainebleau
In process of acquisition

239
SÈVRES IMPERIAL MANUFACTORY
Decoration painted by Marie-Victoire
JAQUOTOT, Pierre-André LE GUAY and
Jean GEORGET
**Tea service with portraits of the princesses
of the imperial family, given to Madame Mère
as a New Year's gift in 1813**
1812
Château de Fontainebleau, Musée
Napoléon Iᵉʳ

240
SÈVRES IMPERIAL MANUFACTORY
**Tea service with cameo portraits of the impe-
rial family, given to Augusta-Amélie, vicereine
of Italy, as a New Year's gift in 1813**
1812
Rueil-Malmaison, Musée national des châteaux
de Malmaison et Bois-Préau

241
SÈVRES IMPERIAL MANUFACTORY
Decoration painted by Marie-Philippe COUPIN
DE LA COUPERIE
**Egg vase third size, given to the princess
Aldobrandini as a New Year's gift in 1813**
About 1811
Private collection

242
SÈVRES IMPERIAL MANUFACTORY
**Tea service imitating mosaic, given to Pauline
Borghese as a New Year's gift in 1813**
1812
New York, Cooper Hewitt, Smithsonian
Design Museum

243
SÈVRES IMPERIAL MANUFACTORY
Decoration painted by Jacques-François
SWEBACH-DESFONTAINES
**Tray from the tea service given to the grand
duchess Elisa of Tuscany as a New Year's gift
in 1814**
1813
Hamburg, Museum für Kunst und Gewerbe

244
SÈVRES IMPERIAL MANUFACTORY
Decoration painted by Abraham CONSTANTIN
**Spindle vase with portrait of the Empress
Marie-Louise, given to queen Catherine of
Westphalia as a New Year's gift in 1814**
1811–13
Œuvre reconnue d'intérêt patrimonial
majeur par l'État français, en dépôt au musée
Napoléon Iᵉʳ du château de Fontainebleau
In process of acquisition

244

245

246

245
SÈVRES IMPERIAL MANUFACTORY
Decoration painted by Antoine BÉRANGER and
Jean-François PHILIPPINE
**Tray from a tea service given to Julie, queen
of Spain, as a New Year's gift in 1814**
1813
Stockholm, Nationalmuseum

246
SÈVRES IMPERIAL MANUFACTORY
Decoration painted by Étienne-Charles
LE GUAY and Jacques-Nicolas SINSSON
**Tea service *Cupids and Nymphs Playing*, given
to Augusta-Amélie, vicereine of Italy, as a New
Year's gift in 1814**
1813
New York, The Metropolitan Museum of Art

247
SÈVRES IMPERIAL MANUFACTORY
After the design of Charles PERCIER and
Alexandre-Théodore BRONGNIART, père
Decoration painted by Gilbert DROUET and
Christophe-Ferdinand CARON
**Estruscan scroll vase, called "Londonderry
Vase"**
1813
The Art Institute of Chicago

pieces that on the orders of Louis XVIII made their way to England are the most striking examples. A monumental scroll vase with flowers and birds painted by Drouet and Caron, which had cost the manufactory a decade of work, was only just completed when the Empire fell. It was left for some time in storage at Sèvres, and was sent in the summer of 1814 to the British minister of foreign affairs, Lord Castlereagh, the second marquis of Londonderry (**247**). The same voyage was made by the table of the Great Commanders (**65**): "je m'en parerai toute ma vie," the prince regent—the future George IV—exclaimed in French in amazement when in February 1817 it was offered to him as a gift on behalf of the French.[83] As for the victor of Waterloo, the Duke of Wellington, in 1818 he was given most of the Egyptian service commissioned for Josephine six years before (**223**): Louis XVIII had added to this gift a polite little note for the military leader to whom he owed his throne: "Do little gifts—Keep friendship alive. . . . Louis."[84] This is doubtless the appropriate way to conclude a study of the Emperor's gift-giving policy: *Vae Victis!* we say to the man setting off into exile. It falls upon his successor to take possession of his treasures and disperse them in his turn, even though that means forgetting that he is paying an involuntary tribute.

THE GREAT
SÈVRES
TABLE
SERVICES

VIRGINIE DESRANTE

When the new Emperor of the French was forming his Household, the national manufactories were put under this administration. The head of the Sèvres Porcelain Manufactory was Alexandre Brongniart, appointed to the post in 1800 by Napoleon's brother, Lucien Bonaparte, then minister of the interior. The young scientist's mandate was to restore an institution somewhat ruined by the Revolution, to increase production and to turn it into a model and benchmark for the entire French ceramic industry.

When he arrived, the workers had not been paid for months and the coffers were bare. The Consulate administration was deaf to his initial demands for financial assistance, so Brongniart organized several sales of previous production lines in storage. He managed to get his staff back to work by 1801.

The Sèvres services: Composition and legacy
Anxious to re-establish the pomp of court known during the Ancien Régime, Napoleon equipped each of his residences with a formal service. Although he personally detested official dinners, he was aware of their usefulness in showcasing the brilliance of his reign, but nevertheless wished them to be relatively rare occurrences, as only eight *Grand Couvert* dinners (feasts held in public) took place under the Empire.[1] Thus, in December 1804, the manufactory delivered a service with "tortoiseshell ground with figures imitating bronze," for the Tuileries (249), used for the first grand banquet of the reign, December 5, 1804, at the close of the ceremonies around the Coronation and the distribution of the eagle standards to the army.

Each service delivered by the manufactory was, in fact, doubled, comprising a main service and a dessert service. This policy, despite Brongniart's decision to produce only hard-paste porcelain, attests to upholding the service *à la française* and the tradition, implemented under Louis XV, to reserve pieces of soft-paste porcelain for the main course and dessert, while roasts were served on less fragile metal plate.

When only one service was delivered by the manufactory, it was inevitably a dessert service and always the most ornate, because, since the eighteenth century, this course was the grand finale of the formal meal. The "fruit" service, as it was also called, was also the most sumptuous in the customary order of the service *à la française*, which lent the table its sumptuousness and its greatest originality. For this course, which required numerous staff and rigorous co-ordination, the dishes were served successively, in three to five services, and arranged on the table symmetrically. Guests helped themselves to their choices and then the dishes were removed, leaving room for the next series, and so on.

In the complex and spectacular organization required for this way of serving, it was the dessert service that best perpetuated the eighteenth's century's refined taste. Aside from the often more lavishly ornate plates compared with the dinner plates used for the main course, this service comprised numerous serving dishes of various forms for bigarades and compotes, sugar bowls, sorbet bowls, wine and liqueur coolers with crenellated edges, ice buckets, fruit baskets, punch bowls, sugar jars, cups and saucers. Of the some 350 services listed among the pieces produced at Sèvres under Brongniart's leadership, approximately three-quarters were dessert services,[2] which is evidence of their importance in the *mise-en-scène* of the French table of the period, even though in the early nineteenth century, it was the *à la russe* style, in which the dishes are served by the plate to each guest, that was adopted over time.

The compositions of the services may have varied, but the types of objects remained the same, in particular on the official tables in which the forms and uses evolved but slowly. For example, this was the era that saw the progressive disappearance of the many buckets to chill bottles and glasses, which had been crucial elements in the previous century. In fact, although it was customary in the eighteenth century to drink alcohol (wine and liqueurs) quite cold, in chilled glasses, this practice became obsolete after 1810.[3]

The only innovations made in the First Empire period were the proliferation of baskets and the appearance of tiered servers. The Cité de la céramique has in its graphic collection a drawing by Alexandre-Théodore Brongniart, father of the administrator, which dates the drawings for the Olympic service between 1804 and 1806, including the proposal for one of these new forms (252D).

To respond to the radical change in taste, the style of shaped pieces was completely reinvented, rejecting those illustrated in 1751 by Duplessis, which nevertheless endured until the end of the Ancien Régime. Although some classical forms that appeared in the 1780s were often reworked, almost forty new forms appeared under the Empire, most of them designed by Brongniart senior. Among the most emblematic forms, we might also mention the eagle sugar bowl of 1806 (253), whose designer remains unknown, or the Etruscan sugar bowl of 1808 (255), designed for the Emperor's personal service, perhaps by Dominique-Vivant Denon.

Bedecking the dining table in the imperial residences
In 1802, the Sèvres manufactory delivered a series of disparate plates for the First Consul to Saint-Cloud, attesting to its slow resumption of work. The services identified from this time, like that purchased by Laetitia Bonaparte in 1803,

248

249

250

251

252A

252B

252C

252D

248
SÈVRES IMPERIAL MANUFACTORY
Plate from the service with nankeen ground:
Rhetoric (or *Eloquence*)
1802–3
Château de Fontainebleau, Musée
Napoléon Ier

249
SÈVRES IMPERIAL MANUFACTORY
After the design of Charles-Éloi ASSELIN
Plate from the service tortoiseshell ground figures
1803
Château de Fontainebleau, Musée
Napoléon Ier

250
SÈVRES IMPERIAL MANUFACTORY
Plate from the dessert service called "with red ground, butterflies and flowers," for the Palais de Fontainebleau
1809
Château de Fontainebleau, Musée
Napoléon Ier

251
SÈVRES IMPERIAL MANUFACTORY
Decoration painted by Marie-Victoire JAQUOTOT
Plate from the Olympic service: *Apollo and Daphne*
1804–14
Sèvres, Cité de la céramique

252
Alexandre-Théodore BRONGNIART, père
Olympic Service
A. *Overall Design for the Centrepiece*
 Between 1800 and 1813
B. *Design for a Bowl*
C. *Design for the Form and Decoration for the Sugar Bowl*
D. *Design for Tiered Plates*
1806
Sèvres, Cité de la céramique

253
SÈVRES IMPERIAL MANUFACTORY
Decoration painted by Gilbert DROUET
Sugar bowl with eagle-head handles from the service "garland of flowers on gold ground"
About 1808
Private collection

254
SÈVRES IMPERIAL MANUFACTORY
Antique cornet vase from a pair, from the Olympic service
1807–13
Paris, Musée du Louvre

253

254

the one with a sky blue ground offered to Cardinal Caprara (Hermitage State Museum, Saint Petersburg) or the service with the lilac ground, were still very much influenced by the aesthetic from the end of Louis XVI's reign.[4] Continuing in this vein, Brongniart pursued, in particular, the production of pieces with tortoiseshell ground, a style that began in the 1790s. These pieces attest to his predilection for imitating materials, particularly hard stone, reflecting his background in mineralogy, which would characterize production under his management.

In the very early days of the Empire, in November 1804, the Sèvres manufactory delivered a first service to the Emperor for the Château de Fontainebleau (**248**).[5] The service, with its "nankeen ground with bas-relief figures, floral garlands" was sent for a very special occasion, and offers great insight into the relationship between the manufactory and the Imperial Household. Its production began without a clear commission, in 1802, and required two years to complete. It was the arrival of pope Pius VII, who had to stay at Fontainebleau before travelling on to Paris for the coronation, that obliged the First Prefect of the Palais Luçay to pay Sèvres an emergency visit in order to select a ready-to-use service from the showroom.

During the period in question, Brongniart reigned supreme over the production of the manufactory, selecting its artists, themes and programs. Sèvres was thus essentially in the State's employ, and the main role of the director was to foresee and organize the work, to anticipate the needs of the regime in order to ensure that the storehouses were supplied with pieces, and to have the ability to respond immediately to all orders, often unclear and always urgent.

In a letter from April 29, 1806, Alexandre Brongniart explains his basic policy:

"The porcelains I put into production have no particular destination except when they are ordered for some special purpose. In the ordinary course of work, these are intended to enrich the warehouse with all the pieces that can be requested for the service of the Emperor or bought by trade. . . . It is in accordance with my experience of these rather frequent requests, the nature of the pieces that are preferred, the high value expected of them, and the rapidity with which they must be delivered, that I direct the work at the manufactory."[6]

One of the first services introduced by Brongniart for the new regime was the Olympic service, some of whose plates date to 1801 (**251**, **252A-D**). It is

the perfect illustration of the time required for execution, since it would not be completed until 1806. Used in August 1807 at the Tuileries for Jerome Bonaparte's wedding to Princess Catharina of Württemberg, it was eventually given to czar Alexander by Napoleon upon the signing of the Treaties of Tilsit. It is likely that this service was not really to the Emperor's taste. In fact, exceptionally in the institution's history, Intendant-General Daru wrote Brongniart a letter on April 26, 1806, conveying the Emperor's instructions for the execution of "various works and porcelains." The Emperor explicitly requested that "all the nude female figures and all the insignificant scenery" be replaced by "famous and historical things."[7]

One of the emblematic imperial services of the period is the Egyptian service, especially atypical in the manufactory's history, since it was produced twice.[8] Although in most cases the manufactory employed existing forms, which could be used for several services regardless of the final destination (imperial table or diplomatic gift), the Egyptian service was the result of a global collaboration resulting from exchanges between Denon and Brongniart. The specificity of the shaped pieces, strongly influenced by "Egyptomania," explains why they were almost never used for other services. Even though Brongniart designed it for the Emperor's use, paying tribute to one of the first campaigns that established the Napoleonic aura and imbuing it with the mythic image of the Pharaonic civilization, the Egyptian service, which was delivered to the Tuileries in October 1808, was not even unpacked, but immediately offered to the czar, who had already received the Olympic service the previous year.[9]

Aside from the official grand services, which were among the most expensive produced by the manufactory—most notably a record 48,000 francs for the Olympic service—the other prestigious services went for between 15,000 and 20,000 francs or so, whether they were intended for the Emperor or as gifts. For the less important imperial residences, the manufactory also produced simpler services, like the one with the "Caprera gold frieze" delivered to the Palais de Rambouillet (2,768 francs) or the dessert service with the "pale blue Caprera frieze with coloured ground" in 1808 for the Château de Marracq (2,208 francs).[10]

Napoleon and his manufactory
Specific commissions direct from Napoleon were rare. In general, the director received "an account of objects from the Sèvres Porcelain manufactory, necessary for the service of Their Majesties, at the Palais Impérial of . . . ," from the Imperial Household, which itemized the number of pieces required without any

idea of form, colour or decoration. For the Palais de Stupinigi, for example, the order made on January 18, 1805, simply mentioned a complete table service, accompanied by biscuit: "5 assorted groups, 24 figures ditto, 24 vases ditto."[11] Nevertheless, the Sèvres archives has letters that retain remnants of a few instructions conveyed by the Emperor, which are notable exceptions in the history of the manufactory.

It is well known that Napoleon wanted to ensure a certain level of control over his manufactory, whose production costs weighed heavily on the Household budget. On February 23, 1805, the Household Intendant-General proclaimed:

"His Majesty, Sir, wishing to have a detailed description of production at the establishment you manage, I invite you to give me a sense of the general state of your production and progress, from the First of Vendémiaire last (September 23), up to today. You will wish to provide as much detail as you think necessary to give His Majesty a good idea of the manufactory's circumstances; and to ensure that, once this information has been received, it will be possible, without resorting to fresh enquiries, to have the state of the situation entirely before him, please in future send me at the end of each month an additional account of production from this period."[12]

When Brongniart was doing everything in his power to restore operations, the ruler, in August 1807, went so far as to threaten the director with closure if quality did not improve.[13]

In 1806, at the same time as the aforementioned ban on nude female figures, Daru sent Brongniart one of the rare commissions clearly coming from Napoleon. The Emperor requested the production of four tables, each representing a member of the imperial family, the generals and commanders of the seven corps of the Grande Armée surrounding him, the top military leaders of classical antiquity and museum statues. He also recommended "placing in the services thus completed, or subsequently made for the service of His Majesty, images of the Adige River, Venice, Genoa and the Kingdom of Italy, more interesting and more historic than those which one takes pains to find elsewhere."[14]

Finally, in 1807, Napoleon wished to have his own "personal" service, a statement that earned it its customary designation, *service particulier*. Daru thus wrote to Brongniart that "his intention for these drawings is that they not be of battle, nor of men, but on the contrary depict subjects offering but vague allusions that awaken agreeable memories."[15] The Emperor gave a preliminary list of twenty-eight specific subjects, which was passed on to the manufactory, that assembled the sites of countries crossed during his campaigns: Italy, Egypt, Austria, Prussia, and more, as well as the Schloss Schönbrunn, where he

stayed twice, in November and then in December 1805, alluding to the Austrian campaign and the stunning victory at Austerlitz. The seventy-two plates were painted between 1808 and early 1810, and the set, worth 44,124 francs, including a main service, a dessert service (255-259) and a biscuit centrepiece (260-263), was delivered to the Tuileries on March 27 for placement on the *Grand Couvert* table for the banquet celebration of the Emperor's marriage to Marie-Louise on April 2.[16] This banquet was certainly the most sumptuous of these rarely staged political feasts under the Empire. It is known that the Emperor greatly admired his service, considered to be an archetype of taste under his reign, with the chrome wing against a green ground and its frieze of gilded antique swords. At the end of the Hundred Days, sixty of these plates accompanied him to Saint Helena, along with the other objects he was allowed to take with him.

In December 1813, a service for the little King of Rome was commissioned. The papers of Grand Marshal of the Palace Duroc at the Département des Manuscrits of the Bibliothèque nationale de France retain remnants of correspondence between Grand Marshal of the Palace Bertrand (recently appointed following Duroc's death), Dominique-Vivant Denon and Brongniart on this very subject. Napoleon wished to see "plates with depictions of subjects from Roman history, French history, geographic maps and various animal species,"[17] imbuing the group with an educational function for the edification of his young heir. Denon suggested a list of seventy subjects, and Brongniart a work schedule for the production of twenty-four plates a year (twelve historical subjects, six plates with landscapes and six with animals). Napoleon abdicated the following April, and the service never went beyond the planning stages.

The Sèvres services show that under the First Empire, as under the Restoration that followed, the protocol implemented under the Ancien Régime, notably for the *Grand Couvert*, would endure. It was only under the reign of Louis-Philippe after 1830 that it gradually faded away. For the most sumptuous dinners, the style of serving *à la française* remained in the nineteenth century the image of France's glory and the pomp of court, but it was gradually replaced by service *à la russe*. Thus, even in the case of a "mixed" service, in which the first dishes are served *à la russe*, dessert was the only course in which the serving dishes remain on the table before the guests, who serve themselves. Throughout the century, during official dinners, the shaped pieces that accompanied these grand porcelain services would generally be placed on the table from the start of the meal, contributing to the decor, and the decorated plates would be presented to the guests only at dessert time. It is easy to understand the care Brongniart, who held his position until his death in 1847, lavished on the design and execution of these grand services. The illustration of France's brilliance, ambassadors of a living art and exceptional know-how, their purpose was nothing less than the staging of power.

255

The Emperor's personal service:
dessert service (255-259)

255
Sèvres Imperial Manufactory
Decoration painted by Nicolas-Antoine Lebel
Sugar bowl from a series of four
1809 (sugar bowl), 1810 (base)
Montreal, Alexandre de Bothuri Báthory /
Élaine Bédard de Bothuri
On loan to Musée du Château Dufresne-Nincheri

256
Sèvres Imperial Manufactory
Etruscan fruit dish with handles
1810
Geneva, Collection of the comte and
comtesse Charles-André Colonna Walewski

257
Sèvres Imperial Manufactory
Ice pail
1810
Château de Fontainebleau, Musée
Napoléon Iᵉʳ

258
Sèvres Imperial Manufactory
Plate: *Imperial Bivouac*
About 1810
Private collection

259
Sèvres Imperial Manufactory
Decoration by Jean-François Robert
Plate: *Construction of the Triumphal Arch
of Carrousel*
1807-11
Paris, Musée de l'Armée

256

257

258

259

261A 261B 261C 261D 261E 261F 261G

262

Centrepiece from the Emperor's
personal service

260
Sèvres Imperial Manufactory
Armchair called "Bacchus Throne"
1810
Château de Fontainebleau,
Musée Napoléon Ier

261
Sèvres Imperial Manufactory
Modelled by Jean-Nicolas-Alexandre
Brachard III
After designs by Alexandre-Théodore
Brongniart, père
Statuettes after antiquity
A. Asclepius
B. Hyginus
C. Emperor Augustus
D. Juno of the Capitole
E. Deidamia
F. Didius Julianus
G. Melpomene
1810
Sèvres, Cité de la céramique

262
Alexandre Brongniart
Design for the centrepiece
About 1808–9 (?)
Pierrefitte-sur-Seine, Archives nationales

263
Sèvres Imperial Manufactory
Jean-Charles-Nicolas Brachard II
Candlestick from the centrepiece
Re-edition of the model from 1809–10
Collection LUPB - Bruno Ledoux

263

ODIOT'S
DESIGNS
FOR THE
IMPERIAL FAMILY

AUDREY GAY-MAZUEL

In the first quarter of the nineteenth century, Jean-Baptiste-Claude Odiot (264) built the most prosperous and popular French silversmith firm patronized by all of Europe's courts and the prominent families of the period. Producing sumptuous tableware and prestigious sets like the dressing-table furniture for Empress Marie-Louise and the cradle for the King of Rome, Odiot was one of the most illustrious silversmiths under the Empire. Awarded a gold medal at the Expositions des produits de l'industrie in 1802, 1806 and 1819, he based his success on a production technique that enabled him to assemble a portfolio of sculptural ornaments inspired by antiquity–his brand, in a sense–and character-istic of what is now called the Empire style. Long preserved by the Odiot firm, the silversmith's graphic fonds, an invaluable group of drawings, evidence of the workshop's experiments and of plans submitted to clients, was disassembled and put up for sale in the late 1970s. In 2009, the Musée des Arts décoratifs in Paris spearheaded the acquisition of 176 sheets from the workshop, introducing into France's national collections original drawings revealing the step-by-step production of silver pieces and unveiling unfinished projects. These sheets, cross-referenced with documents in the Archives nationales, attest to the discus-sions between Odiot and the Imperial Household.

Born into a dynasty of Parisian silversmiths active from the eighteenth century, Odiot trained in his father's workshop and became a master in 1785. The following year, he purchased the holdings of his forefathers' business, including furnishings and tools.[1] Although his output prior to the Consulate is little known, it seems Odiot was seen at the time as a "silver merchant, jeweller," well-established on the Place Parisienne, Rue Saint-Honoré.[2] In October 1801, Bonaparte asked the minister of the interior to have a sword made on whose hilt would be mounted the Regent diamond, the gem set among the French Crown jewels since the early eighteenth century.[3] The proposed sabre was finally replaced by a French sword. Odiot was approached with the commission. He made the handle out of chased gold and bloodstone; it was decorated with palmettes, acanthus leaves, laurel branches, the head of a dolphin and winged dragons. Odiot also executed the gold decorations to cover the black leather sheath, and Nicolas-Noël Boutet, head of the weapons manufactory in Versailles, produced the blade. Nitot was entrusted with setting the Crown jewels, property of the Trésor national. The sword was to be delivered for the second anniversary of Bonaparte's assump-tion of power, on the 18 Brumaire, Year X (November 9, 1801). A symbol of the origins of Consular power,[4] the sword was incorporated into the *grand* and *petit habillements* (formal robes and less formal costume, respectively) of imperial dress, outlined by the decree of July 18, 1804 (272). Napoleon wore it during the

Coronation at Notre-Dame on December 2, 1804. It then became the symbol of imperial power and appears in the large portrait of the Emperor painted by Robert Lefèvre in 1806 (Musée national du château, Versailles).[5]

Odiot's career was officially established with the success he enjoyed at the Exposition des produits de l'industrie of 1802, in which silver- and goldsmiths participated for the first time. The jury awarded him and his peer Henry Auguste the gold medal. The catalogue did not specify what the "vases and other silver items"[6] that he exhibited were, but an inscription engraved on the base of a model for a tea kettle at the Musée des Arts décoratifs[7] indicates that the piece, in silver, was presented there. This kettle also appears in a silver-gilt tea set likely intended for the Imperial Household, due to the presence of an eagle below the crown.[8] The absence of the sceptre and of the hand of justice below this heraldic symbol makes it difficult to confirm whether the set was delivered to the Emperor himself. It may actually have been made for the Empress, one of Napoleon's brothers or Madame Mère. The makers' marks and hallmarks of the silver set make it possible to date its production to between 1805 and 1809. The set includes a tea kettle, a coffee pot, a pair of teapots and creamers, a chocolate pot, a sugar bowl, a tea box, a display with small dishes, along with twenty-one pieces of flatware. Embellished with female tambourine and sistrum players, the frieze that decorates the belly of the kettle incorporates neo-Attic bas-relief dancers from the 2nd century A.D. from the Borghese collection, purchased in 1807 for the Musée Napoléon, but known from the engraving since the mid-seventeenth century. The lavishly executed grey-wash drawing by Auguste Garneray in the Musée des Arts décoratifs bears the mark "C. MOREAU INV.," an indication that Charles-Jean-Alexandre Moreau, who collaborated with Odiot until he moved to Vienna in 1803, finished this model (267).

The gold medal went to Odiot once again at the Exposition des produits de l'industrie of 1806. That same year, on November 11, he sold part of a large silver-gilt table service commissioned for Madame Mère and finished in 1808 (271).[9] The service included soup tureens with handles in the shapes of kneeling women brandishing cornucopias, dessert cups held up by the Three Graces, gravy boats with mermaid handles, glassware and wine coolers with swan-neck handles borne by infant Bacchae.[10] About 1809, another large silver-gilt table service was produced for Jerome Bonaparte, the Emperor's brother, and the king of Westphalia from 1807 to 1813.[11]

In 1810, at the request of the prefect of the Seine, Nicolas Frochot, Odiot produced–along with the bronze worker Pierre-Philippe Thomire, based on the drawings by Pierre-Paul Prud'hon–the dressing table given to Marie-Louise by

265

266

the City of Paris on August 15, to mark her marriage to Napoleon. This ornate piece of furniture with silver-gilt and lapis lazuli included a large cheval glass (*psyché*), a toilet table with two candelabra, vases, jewellery boxes, a seat, a foot-stool and two *athénienne* washstands.[12] Melted down by order of Marie-Louise in 1836 to finance the battle against the cholera epidemic that hit the city of Parma, where she was living at the time, the set is known thanks to two life-sized pres-entation drawings of the mirror (**265**) and the table made by Adrien-Louis-Marie Cavelier,[13] as well as the collection of engravings published by Jean-Antoine Pierron.[14] The dressing table, seat and one of the *athéniennes* can be seen in the watercolour by Isabey, *Napoleon Presenting the Newborn King of Rome to the Empress Marie-Louise in Her Bedchamber at the Tuileries* (**15**).

It seems that the collaboration with the bronze worker Thomire, a regular supplier for the Imperial Household, threw open the imperial palace doors to Odiot. In fact, shortly after the production of the dressing table, a delivery of silver-gilt lighting fixtures by Thomire and Odiot for the Emperor's Grand Cabinet at the Tuileries, then fully furnished,[15] was approved by the Household in the fall of 1810. A letter from the manager of the Mobilier impérial, Alexandre-Jean Desmazis, to the Intendant-General, the comte Daru, reveals that at the request of the latter, the first quote from August 8, 1810, which included a silver-gilt writing case estimated at 8,000 francs, was scaled down. It was finally approved on October 26, but without the writing case and with the price of the candle-snuffer tray halved.[16] The quote for the items supplied by Thomire and Odiot,[17] intended for May 22, 1811, reports the delivery of silver-gilt total-ling 9,653.66 francs. The three pairs of candlesticks, each fourteen inches tall (about 38 cm), were billed for 8,662 francs. Three eagles, placed on each tip of a triangular base, supported a cornice on their heads topped by a ball decorated with a quiver making a *bobèche* to catch drips. A handheld candleholder, the tray decorated with a crown of laurels and a dolphin-shaped ring, for 547.66 francs, as well as a candle snuffer and its tray for 444 francs, completed the order. The writing case that had been removed from the quote was ultimately completed in silver-gilt by Biennais in 1813.[18]

Shortly after the delivery of Marie-Louise's dressing table, the prefect of the Seine Frochot requested the same team comprising Odiot and Thomire, linked to the artist Prud'hon, commissioning an official cradle for the future King of Rome.[19] The sumptuous silver-gilt cradle, covered with deep carmine velvet and accented with pearly white decoration (**266**), was offered to the imperial couple by the City of Paris on March 5, 1811, five days before the heir's birth.[20] Placed on a platform and under a canopy, this imperial piece of furniture, at once a bed

of State and a throne, was installed in the Palais des Tuileries. It appeared in the Grand Salon of the prince's apartment on March 22, 1811, during the pres-entation of tributes to the infant by the Grands Corps of the State. The cradle, belonging to the Mobilier de la Couronne, was added to the inventories of the Palais des Tuileries in July 1812.[21]

The year 1811 appears to have been crucial in the relationship between Odiot and the Imperial Household. After the marriage to Marie-Louise, the Étiquette impériale was stepped up, and 1811 was a splendid year for silver. By decree on May 20, Napoleon authorized an exceptional credit of 500,000 francs for silver.[22] Becoming close with the Imperial Household, the silversmith decided to submit proposals, written and drawn. The Musée des Arts décoratifs has two drawings of water glasses for Napoleon and for Madame Mère, annotated and dated 1811 by the metalworker (**268**). The personal table services included a water carafe, a wine carafe and a drinking cup, resting on shell-shaped trays held in place by dolphins and seahorses. A Victory brandishing a wreath forms the handle of the ensemble. The two drawings are by different hands. The crystal carafes are engraved with the crowned mark of the recipient, N or M, alternating with the imperial eagle. Neither finished water glass, intended to be in silver for Madame Mère and in silver-gilt for the Emperor, is known. It is, however, possible that the water glass for Madame Mère was produced. The inventory of Bonaparte's palace in Rome—where Laetizia sought refuge after the fall of the Empire—drawn up on October 21, 1834, in fact records in the third silver-gilt box: "two glass holders in tray for glasses and caraffes [*sic*],"[23] but it is not possible to know whether it is the one designed by Odiot in 1811. Following the service delivered between 1806 and 1808, the Household of Madame Mère remained a regular client, for whom the silversmith claimed to be the supplier in the *Almanach du commerce* of 1812 and of 1813.[24] About 1812, she purchased two writing cases for her sons Jerome[25] and Joseph, then the kings of Westphalia and Spain, respectively.[26]

On June 10, 1811, Odiot approached the comte de Montalivet, minister of the interior, seeking commissions for extraordinary silver for the Imperial Household. He offered to deliver silver and silver-gilt pieces that Napoleon could give as diplomatic gifts to foreign powers. He also recalled that "there was some question as to whether or not His Majesty's throne would be made in silver-gilt"; he offered to produce it with Thomire.[27] On June 28, the minister submitted the request to the Intendant-General of the Imperial Household, the comte Daru, which included a warm recommendation "for one of our most skilful metalworkers: "The richness, elegance and beauty of the pieces produced in his workshops make them worthy of contributing to the decoration

264
Robert LEFEÈVRE
Portrait of Jean-Baptiste-Claude Odiot
1822
Detroit Institute of Arts Founders Society

265
Workshop of Jean-Baptiste-Claude ODIOT
Adrien-Louis-Marie CAVELIER
Life-size Design for the Cheval Glass
(psyché) of the Empress Marie-Louise
1810
Geneva, Collection Comte et Comtesse
Charles-André Colonna Walewski

266
Workshop of Jean-Baptiste-Claude ODIOT
Drawing by Adrien-Louis-Marie CAVELIER
Design for the King of Rome's Crib
1811
Paris, Musée des Arts décoratifs

267
Workshop of Jean-Baptiste-Claude ODIOT
Model by Charles-Jean-Alexandre MOREAU
Drawing by Auguste GARNERAY
Design for a Vase for the Kettle
of a Tea Service
About 1810
Paris, Musée des Arts décoratifs

267

268

269

270

of the imperial palaces as well as being featured among the presents [made to foreign courts]."[28] On July 8, the Intendant-General retorted that "producing a silver-gilt throne for His Majesty is simply out of the question, despite what M. Odiot might think."[29] He took the minister's recommendation into account, but invited the silversmith himself to approach the *service de la bouche* [department of the Table] in His Majesty's Household" under the supervision of the Grand Marshal of the Palace, the department most likely to issue silver commissions. The response was conveyed to Odiot by the minister on July 20.

Between the months of June and August 1811, the Mobilier de la Couronne reviewed the submissions for the official writing cases "that His Majesty ordered to be placed in the imperial palaces:"[30] the Tuileries, Saint-Cloud, Trianon, Rambouillet, Compiègne and Fontainebleau. The quote and the drawings, submitted to the Emperor by Daru, were discussed and modified. The Musée des Arts décoratifs has a pen-and-ink proposal, showing the bottom of the writing cases with the Emperor's monogram, a winged lightning bolt and an imperial eagle, attesting to the explorations carried out in Odiot's workshop, probably for this commission (270). A letter dated August 16 tells us that at Napoleon's request, this project was finally deferred, and the drawings were handed over to the silversmiths Martin-Guillaume Biennais and Antoine Boulier.[31] Among the commission's surviving archives is a list of the names of metalworkers, including Odiot's in second place, which indicates that he may have been approached.

An ochre pen-and-wash drawing, attributed to Auguste Garneray and annotated "projet d'encrier pour / S.M Imp.ce et Rne Marie Louise / 14 000 f" and "n° 3," is proof of a proposal presented to Marie-Louise. The silver-gilt writing case is topped by a large cameo featuring the portrait of the Emperor. Two spirits bearing torches serve as the stoppers for the ink- and sand wells, placed on either side of the green leather stamped with the Empress' monogram. On the front, the base is decorated with a frieze punctuated with allegorical figures of the nine Muses (269).

Two other drawings from the Odiot workshop, submitted to Marie-Louise, are known. A graphite drawing attributed to Garneray and housed, like the plan for the writing case, at the Musée des Arts décoratifs shows the proposal for a tabletop vanity mirror topped with a portrait of Napoleon. An ochre-wash drawing, today in a private collection, shows a plan for a writing case or a portfolio stamped with Marie-Louise's monogram framed by a large silver-gilt border with medallions holding the portraits of nine famous women and the names of important painters, such as Raphael, Rubens, Le Sueur.[32] These three proposals were likely never produced, as no traces of them have been found in inventories or collections.

Aside from the delivery made with Thomire for the Emperor's Grand Cabinet at the Tuileries, it seems that, despite his talent, Odiot would never manage to obtain direct commissions from the Imperial Household. However, the dressing table made for Marie-Louise in 1810 and the cradle for the King of Rome in 1811, gifts from the City of Paris, demonstrated to the imperial couple the excellence of the silver. These exceptional pieces of furniture sumptuously decorated the imperial palaces and became an essential part of the discourse of power conveyed through imperial interior decor. Odiot also circulated among the entourage of the family's princes. He was thus approached by the Households of Madame Mère and Jerome Bonaparte, as well as Josephine, to whom he supplied an impressive dressing table in 1813.[33] Without ever having been Napoleon's supplier, Odiot made his fortune thanks to his large network of clients. In contrast with his peers Henry Auguste and Martin-Guillaume Biennais, whose activity ended with the Empire, Odiot became wealthy under Napoleon's reign and ensured stylistic continuity at the return of the Bourbons. Thus free of all political protocol, the Odiot firm reached its peak under the Restoration and served the émigrés who had returned to France, as it did the marshals of the fallen Empire and the Occupation's Russian and Polish allies, who began settling in Paris in 1814.

271

268
Workshop of Jean-Baptiste-Claude ODIOT
Design for a Water Glass for the Emperor
1811
Paris, Musée des Arts décoratifs

269
Workshop of Jean-Baptiste-Claude ODIOT
Design attributed to Auguste GARNERAY
*Design for a Writing Case for the Empress
Marie-Louise*
About 1811
Paris, Musée des Arts décoratifs

270
Workshop of Jean-Baptiste-Claude ODIOT
Design for a Writing Case for the Emperor
About 1811
Paris, Musée des Arts décoratifs

271
Jean-Baptiste-Claude ODIOT
Madame Mère's Vermeil service (some pieces)
Entrée plates, pair of tureens, covered dishes,
gravy boats, meat platter, plates, pair of
coolers, coasters, pair of saltcellars
1806
Private collection

272
Jean-Baptiste-Claude ODIOT
Nicolas-Noël BOUTET
François-Regnault NITOT
**Sword of the First Consul, later Emperor,
called the "Coronation Sword"**
About 1800–4
Château de Fontainebleau, Musée
Napoléon Ier

272

THE ALTAR FURNISHINGS FOR THE WEDDING OF 1810

Henry Auguste's commission of February 1805, for six altar candlesticks and an altar cross with a tabernacle-cabinet at its base (**275**),[1] was part of a larger-scale plan that included silver-gilt ornaments and two acolyte candlesticks,[2] a processional crucifix[3] and a gold chapel that has since disappeared. Anne Dion-Tenenbaum[4] has documented this commission, which was in fact initiated the previous year, when the Emperor was planning it as a gift for the pope. Architect François Debret, a student of Percier and Fontaine, who oversaw some of the work for the coronation, would have produced the initial drawings.[5] The tensions arising with Pius VII quickly led the Emperor to credit his gift instead to the Saint-Denis basilica. Auguste was slow to honour the commission, while his financial circumstances worsened to the point that he put his goods up for sale through 1809.[6] On September 27, he was compelled to hand over the pieces he had already completed to Martin Guillaume Biennais, who would produce them, particularly the altar silver, which was only missing some gilding. Were there already thoughts of making this set the showpiece of the design of the Louvre's Salon Carré for the imperial nuptials? The decision was quickly made, as on March 11, 1810, Grand Chamberlain Montesquiou requested that Biennais

deliver the pieces to the Louvre. The planned design for the altar and its silver is known with exactitude due to two drawings, credited to Percier and Biennais,[7] featuring the recognizable cross with palmettes at each end, as well as the candlesticks resembling classical candleholders (**273**). Auguste reiterated an ornamental vocabulary he held dear: friezes of water leaves and acanthus leaves, leaf-and-dart mouldings, gadroons, tortoiseshell, quatrefoil, and lion's paw feet. These antique-style motifs were mixed with symbols of the Eucharist (sheaves of wheat, vine branches and reeds) and angels' heads, as well as instruments of the Passion, placed on the door and the lateral sides of the tabernacle. The triangular bases of the candlesticks feature the hieratic figures of the apostles emerging two by two from matted grounds. These silhouettes may well have been designed in relation to the figures comprising the frieze of the altar's large bas-relief. As the latter is visible on the most complete of the preparatory drawings, the front of the altar offers a large late seventeenth century composition in the classical style featuring the *Adoration of the Shepherds*.[8] The reuse of this silver-gilt relief, coming from the Saint-Denis basilica's main altar, had already been planned since the 1805 commission. The arrangement of the candlesticks on the gradine of the altar reinforces the idea of a connection between their decoration and that of the frieze. In fact, although the preparatory drawings attest to a hesitation in the positioning of the candlesticks, the ultimate placement favours the

presentation of the bases on one of their sides rather than at their points. This arrangement is confirmed by the drawing that Louis-Pierre Baltard completed after the wedding ceremony.[9] Only the acolyte candlesticks, raised on pedestals, differ. Thus, the six figures of the apostles that are clearly visible mirror the relief's figures.[10] Plates affixed to the back of the tabernacle as well as on the third side of the candlestick bases feature the French Empire coat of arms,[11] a device that Auguste used on the Empress' *caddinet* in 1804. It is likely that the coat of arms was removed under the Restoration, at the same time as the date that followed Auguste's signature (**274**), when the silver was used at the Tuileries chapel.[12]

BENOÎT-HENRY PAPOUNAUD

The author wishes to thank Ludovic Mathiez and Maeva Méplain (Centre des monuments nationaux) and Étienne Royez.

273

274

273
Workshop of Martin-Guillaume BIENNAIS
Design attributed to Charles PERCIER
Design for the high altar for the Emperor's wedding at the Louvre in 1810
About 1810
Paris, Musée des Arts décoratifs

274
Detail of a candlestick: the imperial coat of arms removed and date erased

275
Henry AUGUSTE
Altar fixtures for the wedding of Napoleon and Marie-Louise, later for the chapel at the Tuileries: six candlesticks and a crucifix
1809
Reims, Palais du Tau

"Wherever the Emperor resided, he always had on duty, by day as well as by night, a page and an aide-de-camp who slept on folding beds. He also had in the antechamber a quartermaster of cavalry and a brigadier of the stables to go, when he required it, and bring forward the equipages that they were careful to keep always in marching order; horses all saddled and bridled, and coaches with two horses came out of the stables at the first sign from His Majesty. They were relieved from service every two hours, like sentinels."

Reminiscence of Constant, valet of the bedchamber to Napoleon

SERVING
THE
IMPERIAL FAMILY

SOME OBSERVATIONS ON

THE IMPERIAL BANQUET

FOR THE

WEDDING

OF NAPOLEON AND MARIE-LOUISE

BY CASANOVA

CHRISTOPHE BEYELER AND SYLVAIN CORDIER

This choice piece from the collections of the Château de Fontainebleau's Musée Napoléon I, the *Imperial Banquet for the Wedding of Napoleon and Marie-Louise, April 2, 1810* (280) is a fascinating and curious painting. At the very least, it is one of the most telling accounts of court customs and the running of the Imperial Household at the service of the imperial family. Exhibited in Paris at the Salon of 1812 under the number 175,[1] this picture seems to have arrived in London in 1814, at a Piccadilly art dealer's, where it was kept at least until 1815.[2] More than one hundred years later, other dealers, Frank Lloyd and Sons, of Whitchurch—which presented the painting as "acquired from the ancestors of the actual owners shortly after Napoleon's death"[3]—offered it, to no avail, to the French Administration des Beaux-Arts on January 20, 1938. It went up for public sale a few days later, on February 10. In 1947, Jean Bourguignon, curator at Malmaison, flagged it for acquisition by the national collections, this time for the Château de Versailles. Ultimately, in 1955, Versailles purchased it from Mrs. B. H. Mytton, in London. The painting has been at Fontainebleau since 1984.

The circumstances surrounding the execution of the canvas may have stemmed from a decision of Napoleon, expressed in a letter from Grand Marshal Duroc to the Intendant-General Daru on January 18, 1810:

"H. M. wishes to have two paintings made this year, one of which will depict an imperial banquet at the Tuileries, as it was held in the month of December [1809]. It will contain the foreign sovereigns and princes who visited Paris that winter, even those who were not in attendance then but have been since, such as the prince Eugene, the princess of Baden, the prince primate. The second picture will represent the family episode of December 15 [Napoleon divorces Josephine], a scene shown as an act of generosity and devotion. M. the Grand Master of Ceremonies can provide information regarding placement at the imperial banquet and M. the Grand Chamberlain for the December 15 scene."[4]

These two paintings were never executed. The banquet held December 3, 1809, for the foreign monarchs visiting Paris celebrated in a grand manner the Treaty of Vienna, which resulted in the marriage of the Emperor to the arch-duchess Marie-Louise in April 1810. It could ultimately have been switched for the depiction of the other banquet that, a few months later, captured more perfectly the alliance between the courts of Paris and Vienna. When Frank Lloyd and Sons put it up for sale in 1938, they stated that "this interesting picture was composed according to a horizontal architectural plan, under the direction of

the comte de Ségur, Grand Master of Ceremonies, who supplied Casanova with the ornament used at the wedding party so that it may be accurately rendered." The "architectural plan" mentioned by the art dealers was likely the "Plan of the performance hall at the Tuileries, and the arrangements made for the Imperial Banquet the day of the Emperor's Wedding," plate 10 of the album published by Percier and Fontaine in 1810 (282).[5]

The painting's speedy departure, after the Salon of 1812, for England, an enemy of the French Empire at the time, but home to many of Napoleon's adoring fans, nevertheless is strange given its status and origin.

Imperial show and the *Grand Couvert*

The marriage of the Emperor at the peak of his power and the daughter of the kaisers of Austria required much preparation, throughout Paris and at the Palais des Tuileries, whose specially outfitted performance hall was described by the *Moniteur universel* on April 10, 1810: "The beautiful performance hall became a reception hall; it had been set up for the imperial banquet held in the evening at seven. To this effect, the theatre was replaced by a design perfectly matching the hall, so that instead of a hall and a theatre, all one would find is a hall with an ordinary layout and a perfect ensemble. Two domes held up by double arches and pendentives decorated with columns constituted the design." The creators of the decoration, architects Percier and Fontaine, readily reproduced it in a drawing (281) that was used as a model for a plate in their album of prints of 1810.

Le *Moniteur universel* continued: "One of the two divisions, parallel to the other, was occupied by the table intended for the imperial banquet, placed on a platform and topped by a magnificent canopy." The *Étiquette* speaks of a *Grand Couvert* to describe the circumstances and placement of ceremonial utensils during special banquets—eight such banquets were held between 1804 and 1814. On the set table were six winged Victory-shaped candelabra and pieces of the Grand Vermeil, the silver service by Auguste given to the imperial couple by the City of Paris at the dawn of the Empire:[6] the two *caddinets* (278) placed near to the two sovereigns, and, relegated to the ends of the table, the two *nefs*, curiously reversed. The Emperor's *nef* (276), which bears a figure of Victory at its bow and Justice and Prudence at its stern, is shown at the right, on Marie-Louise's side, and the Empress' *nef*, rendered at the left, features Charity at the bow and the Three Graces at the stern. As for the Emperor's personal service in biscuit porcelain, begun in 1807, Casanova depicts the items that had already been delivered to the

276

277

278

279

Tuileries, consisting of sixteen statuettes, eight on the left and eight on the right, arranged on ice trays, and a pair of candelabra (263). Starting from the centre, the place of honour occupied by the imperial couple, they were positioned as follows: three statuettes grouped together on the same plateau, then three on a second plateau, and lastly, two on a third plateau towards the ends of the table. On Marie-Louise's side is *Minerva*–identifiable by the lance, an attribute not present on the plaster model preserved at Sèvres, but clearly visible here–and on the next tray *Venus Genitrix*. This statuette is especially fraught with political meaning: we know that Julius Caesar had placed in the Temple of Venus–which he built in Rome–the statue of this goddess from which the *Venus Genitrix* seems to descend. This was anything but a casual reference to the goddess of love, source of fertility, on the wedding day of the Emperor, who counted on an heir to firmly root his dynasty: He purportedly said he "had married a womb."

The depiction of the imperial family

The familial system governing the new Europe is here put on display. To this end, Napoleon, in a letter dated February 26, 1810, clearly commanded his younger brother Jerome, king of Westphalia, to bend to his will: "On this important occasion, I have decided to bring by my side the princes and princesses of my family. I am advising you of this with this letter, wishing that no unforeseen circumstance prevents you from being in Paris on March 20."[7] Identical letters[8] were sent the same day to other family members, who, as Fontaine noted, "were nearly all made sovereigns of various States that could be considered satellites of the French Empire, their sun."[9]

The political situation of Europe is reflected in the seating arrangement of the guests around the table. "The Emperor and Empress have taken their place amid the kings and queens, princes and princesses of the Family," states the *Moniteur universel*. The guests are positioned on either side of the imperial couple, in accordance with their rank in the family. To Napoleon's right are, in succession, Madame Mère wearing a turban-shaped diadem, and six men, each adorned with the red Grand Cordon of the Legion of Honour. The first five are dressed as French princes, in white gold-embroidered velvet: Louis, the king of Holland for another three months, Jerome, the king of Westphalia, the prince Camillo Borghese, the duke of Guastalla, husband of Pauline and governor of the domains beyond the Alps, Joachim Murat, henceforward Joachim Napoléon, the king of Naples, then Eugene, the viceroy of Italy. Lastly, at the end of the table, Charles of Baden, heir (soon on the throne from 1811 to 1818) to the grand duchy and member state of the Confederation of the Rhine, is the only one dressed in a blue uniform. On the other side of the table, to Marie-Louise's left, are her sisters-in-law, each bedecked in sparkling diamond jewellery: first, there is Julie, the queen of Spain, wife of Napoleon's eldest brother, Joseph (the only one not present, as he was held back by an insurrection on the Iberian Peninsula), followed by the others, generally positioned symmetrically vis-à-vis their respective spouses on the other side of the table–Hortense, the queen of Holland, Catharina, the queen of Westphalia, Elisa, the grand duchess of Tuscany (her husband, Félix, is absent from the picture), Pauline Borghese, the duchess of Guastalla, and the queen of Naples, Caroline. Figured thereafter is the only man on this side of the table, Ferdinand, the grand duke of Würzburg, the paternal uncle of Marie-Louise–a Habsburg here ranked after the Bonapartes–then the princess Augusta of Bavaria, wife of Eugene de Beauharnais, and lastly the princess Stephanie, Josephine's cousin and Napoleon's adoptive daughter, wife of Charles of Baden, who stands across the table from her.

Casanova has imparted on the assembled family members a dignified, rather sombre air. Marie-Louise looks sad; Julie looks coldly at her sister-in-law Hortense; Catharina, shown bringing food to her mouth, is awkwardly portrayed in a greedy, inelegant pose. Madame Mère forces a smile that is far from kind. Everyone seems to be lavishly bored.

The Household in the exercise of its prerogatives

Standing around the table and its princely spectacle, the members of the Imperial Household spread out and occupy themselves, attending to their individual tasks. The Salon catalogue of 1812 names many of these figures:

"Behind the Emperor is the colonel-general of his Guard service, the Grand Equerry, the Grand Chamberlain, who takes care of the wine service. Behind the Empress is her Grand Equerry, her Grand Chamberlain. The Grand Officers of the Crown are around the table. On either side, and in front, are the Grand Master of Ceremonies and the Grand Marshal of the Palace, who have behind them the service prefects and the assistants of ceremony. Behind the service prefects are the Grand Dignitaries. The pages perform the table service. In the loges in front are those people invited by the court. "

Interpreting this description should be accompanied by a reading of the *Étiquette du palais impérial*'s chapter on the "Service de LL. MM. en grand couvert,"[10] to have a better idea of how things unfolded and to spot some inconsistencies.

In the context of especially formal feasts, known as the *Grands Couverts*, the *Étiquette* specifies that the Emperor and the Empress sit at round-backed chairs modelled after the Throne; at their feet, under the table, there were to be two footrests. The other guests–with the exception of Madame Mère–had to sit on stools, one of which is depicted under the grand duke of Baden at the end of the table.

Behind Napoleon are standing, as per the *Étiquette*, a trio of figures described by the catalogue as the colonel-general of the Guard department, the Grand Equerry and the Grand Chamberlain. Although the first is clearly identified–it is marshal Bessières–the Grand Equerry, who became ambassador to Russia in December 1807, was not at this ceremony. Caulaincourt is in fact represented by his subordinate, First Equerry Nansouty. The Grand Chamberlain, who "takes care of the wine service," is also misidentified. The person in question does indeed have in his hands two carafes, one with wine and the other with water, and he is being followed by an officer carrying a glass on a tray. But the *Étiquette* assigns the duty of serving the sovereign wine to the Grand Marshal of the Palace and his First Prefect of the Palace: "When the Emperor asks for a drink, the First Prefect pours water and wine into glasses, which are offered to H. M. by the Grand Marshal."[11] Moreover, it is apparent that the painter also confused the roles of the Grand Officer (the glass) and the First Officer (the carafes). This cannot in any case be the Grand Chamberlain.

Partly hidden by the candles of the candelabra is Marie-Louise's First Equerry, Francesco Borghese, the prince Aldobrandini, youngest brother of Camillo Borghese, the duke of Guastalla, who, as a member of the family, sits at the table. To her right, dressed in red, is the service prefect assigned to her, and not "her Grand Chamberlain," a position missing from the Empress' Household.

The *Étiquette* specifies that the Grand Marshal of the Palace and his entourage should be positioned in front of the table on the Emperor's right side. There are in fact three officers dressed in purplish red, but the doubt raised regarding the identity of the figure carrying drinks behind the Emperor leads one to recognize not Grand Marshal Duroc, as claimed in the catalogue, but Grand Chamberlain Montesquiou and two of his chamberlains. If this is the case, Montesquiou could be the older man being addressed by an acolyte pointing out the table, as though looking for approval or some kind of acknowledgement. But here again a problem presents itself, because the figure in front of him, who is younger and shown from the back, is not an officer but rather a Grand Officer of the Household, as indicated by the embroidery on his sleeve, which would be unadorned if it belonged to a simple chamberlain.[12] And so, arising again is the theory that it could be Duroc, endowed by the painter with a strange gift for ubiquity, at once present behind and in front of the Emperor. The colours worn do not help to clarify matters,[13] and there is likely yet another mix-up between the scarlet worn by the service of the Grand Chamberlain and the amaranth red of the Grand Marshal. Standing on the other side of the table, shown from the back and dressed in a blue verging more on violet, is the Grand Master of Ceremonies, holding his Grand Officer staff, with one of his two masters of Ceremonies behind him, the baron de Cramayel or the comte de Seyssel d'Aix.

Busy carrying food-laden dishes, various pages identified by their green uniforms with gold braid[14] bustle about the table or on the way to the kitchens. At their sides are a few figures in red who are service prefects or chamberlains. A member of the imperial family and Madame Mère's half-brother, Grand

281

282

Chaplain Fesch is made conspicuous by his absence. In strict accordance with the *Étiquette*,[15] he is to have blessed the table before the meal and then retired. Grand Master of the Hunt Berthier is present not in this capacity, but rather as vice-constable: he is shown in profile near a column at left, wearing the bee-studded mantle of the Grand Dignitaries.[16] Next to him are the arch-chancellor Cambacérès and, a little further in the distance, the arch-treasurer Lebrun.

In a letter of February 26, 1810, Napoleon wrote to Eugene, viceroy of Italy, where he was king in title: "My son, having decided to celebrate my marriage to the archduchess Marie-Louise of Austria in Paris on March 29, I wish for you to invite to this occasion the Grand Officers, officers and ladies of my Italian Household, allowing them to serve you and the vicereine everything necessary."[17] The combined presence of members of the two Households serving Napoleon seems to make perfect sense with regards to protocol, yet it is tricky to find it represented in Casanova's painting.

Table manners
Napoleon and his wife speak about the dishes placed before them. He points out a dish from which she is about to serve herself. The depiction of interactions between the seated princes and the servants offer not only colourful details but also reveal the degree of service carried out by the Household. Jerome holds out a tall stemmed glass to a waiter who pours him champagne. Every guest has before him or her a glass and a pair of carafes containing water and wine.

This trio of objects refers back to a project for silver devised by Odiot for the "Emperor's water glass" and that of Madame Mère in 1811 (**268**). At the other end of the table, the grand duke of Würzburg turns towards to his service page, who respectfully presents him with a silver tray carrying a glass and carafe of wine. Pauline holds out her empty plate to her page, who is already holding a plate full of food to trade with her. The use of vermeil (silver gilding) for dishes instead of Sèvres porcelain indicates that this is probably the first course being served, featuring highly seasoned dishes, appetizers, entremets and roasts, and not the dessert course, which is served on porcelain[18]—there is also no indication of the debut of the magnificent decorated dishes of the "Emperor's personal service," used for dessert only.[19]

The *Grand Couvert* feast would conclude with coffee, served to the Emperor by the Grand Chamberlain and presented by a page, the Empress' First Chamberlain serving her in the same way.[20] Upon leaving the table, the Emperor would hold out his napkin to the Grand Marshal, and the Empress would give hers to the First Prefect of the Palace. The Equerry department (the Emperor's Grand Equerry and the Empress' First Equerry) would pull out the sovereigns' seats, and the Chamber department (the Emperor's Grand Chamberlain and the Empress' First Chamberlain) would present them with napkins with which to wipe their hands. This would bring an end to the sumptuous and cold performance of the *Grand Couvert* held in celebration of the marriage on April 2, 1810, which would seal the fate of the imperial dynasty.

THE LONG TRIP TAKEN BY A PALACE PREFECT

A REDISCOVERED SKETCH BY HORACE VERNET

This recently rediscovered small composition (283) sheds light on a history painting project dating back to the youth of the painter Horace Vernet, the existence of which had been forgotten since the nineteenth century. When Samoyault recalled in 1996 the circumstances of the commission,[1] the whereabouts of this last example of official Napoleonic painting (executed shortly before the collapse of the regime) was unknown until its recent appearance in a public sale.

In fact, it is a sketch–the only one known to date–for a large scene commissioned by marshal Berthier, prince of Neufchâtel and Wagram, Grand Master of the Hunt of the Imperial Household and vice-constable. It was probably intended for the decors glorifying the Empire adorning his residence on the Rue Neuve-des-Capucines and his Château de Grosbois. The setting is the Emperor's bivouac on the eve of the Battle of Borodino, a partial victory that was to open the gates of Moscow to the imperial armies (September 7, 1812). Napoleon is showing to his officers and generals–Murat is on his right–the portrait of his son, the King of Rome, by Gérard, which had just been brought to him from Paris by one of his palace prefects, the baron de Bausset. This episode in the Russian campaign was well-known and retold in detail, in particular by Bausset himself in his *Mémoires anecdotiques sur l'intérieur du palais*:

"I will spare you all the details of my long journey. I left, taking with me the portrait of the beautiful little child. From Saint-Cloud to headquarters I found the route covered with soldiers . . . and it was only with great difficulty that I arrived on September 6 at nine o'clock in the morning at H. M.'s tent after thirty-six hours on the road. I gave him the dispatches that the Empress had entrusted to me and asked him for his orders regarding the portrait of his son. I thought that on the eve of the great battle he had longed for, he would wait a few days before opening the case containing the portrait. I was wrong: eager to see an image so dear to his heart, he ordered me to have it taken at once to his tent. I cannot describe the joy this sight gave him . . . His eyes expressed the utmost tenderness, and he himself called on all the officers of his household and all the generals standing by who were awaiting his orders, to share with them the feelings that filled his heart. 'Gentlemen,' he said, 'if my son were fifteen, believe me, he would be here among so many valiant men, not just in a painting.' . . . A moment later, he added, 'This is an admirable portrait.'

He had it placed on a chair outside his tent so that the brave officers and soldiers of his guard could see it and take fresh courage from it. The portrait was left there all day long.

M. Gérard had a print made of this fine work and exhibited it that very year at the Museum. The portrait was perfectly engraved: the infant was shown half-reclining in his crib, holding a small sceptre and a small orb for rattles!"[2]

Berthier probably commissioned this picture after his return from the campaign in Russia in early 1813, too late for the large-format work to be executed, because in April 1814, the Emperor abdicated and

Berthier aligned himself with Louis XVIII shortly afterwards. There was no longer any need for grand Napoleonic scenes to adorn the residences of the former Grand Master of the Hunt, who had become captain of the new king's bodyguards.

The little sketch described here probably remained in Vernet's possession for some time before coming into the possession of the painter François Gérard. It is possible that Vernet gave the painting to Gérard, an artist he admired, a gift even more appropriate since the scene, mirroring as it does Gérard's own portrait of the King of Rome, is clearly an artistic homage. It appears in the catalogue of the estate sale of Gérard following his death in April 1837,[3] where it was acquired by a member of the Montesquiou-Fezensac family, probably the comtesse Aline-Ambroisine, daughter of the former Grand Chamberlain of the Imperial Household and the former Governess of the Children of France and Super-Intendant of the Household of the King of Rome. The collections of the comtesse de Montesquiou were dispersed following her estate sale on January 29 to 31, 1872, in which the painting was offered in lot 62.[4] This was the last time that the work was attributed to Vernet, before going missing. Sold for 5,250 francs, it passed into the hands of the De Brantes family at the Château du Fresne. At the last public sale in 2017, it was presented under the attribution "French school of the early nineteenth century."[5]

While the Montesquiou sale in 1872 records the last attribution of the painting to Vernet, the most undeniable evidence of it can be found in the testimony of prefect Bausset himself. In addition to telling the story of his journey to Moscow with the King of Rome's portrait, he clearly describes the sketch in his *Mémoires anecdotiques*:

"By chance, a few days ago, I came upon the sketch for a large painting that the Prince de Neufchâtel had requested, at the moment when the portrait described here was presented, from M. Horace Vernet, no less celebrated for the personal charm that endeared him to even his most illustrious rivals than for the astonishing versatility of his talent, which could be brilliantly adapted to all genres of art, so that he could rightly be called the Voltaire of the Modern School. My gratitude for the part I was able to play in this history painting was as heartfelt as my regret. It would have done me good had this unique opportunity not been lost."[6]

The scene, which celebrates the image of the heir to the throne proudly presented by Napoleon to his officers, also highlights the part played by this palace prefect of the Household, who had journeyed from Paris at the request of the Empress to take to the Emperor the portrait of his son. Bausset is superbly portrayed in his amaranth red costume, solemnly holding up Gérard's canvas. Although just sketched in, his face is perfectly recognizable when compared with his portrait painted in David's studio in the *Coronation*, where he is shown behind the princesses, to the left of Grand Marshal of the Palace Duroc.

Vernet modelled the scene in the style of the large history compositions favoured by Denon, and it is tempting to compare it to the famous *Eylau* by Gros exhibited at the Salon in 1808 (284). At this

time, Vernet was already specializing in paintings of military subjects and particularly, like his father Carle, in painting horses. He exhibited for the first time at the Salon of 1812. In 1813, he was working for the Imperial Household, which shared between him and Alexander Ivanovich Sauerweid the commission for twenty-three portraits of "His Majesty's thoroughbred horses" (291, 292).

Two copies of the portrait of the King of Rome were executed by Gérard in the course of 1812. It is a good example of a portrait of a royal child with a determined, candid gaze: he is wearing the cordon of the Legion of Honour and holding a little sceptre and an orb, symbols of the power he will one day inherit. A version of the work had been well received at the Salon of 1812. As it belonged to Marie-Louise, it probably accompanied her to Vienna after the fall of the Empire. It may well be the canvas preserved at the Château de Fontainebleau (285), in which the drapery in the background is painted red.

The second copy was the one taken by Bausset to Russia that is seen in our painting. It differs from the first in the colour of the background, which is green. In all likelihood, this canvas did not survive the disastrous outcome of the campaign in Russia. According to Bausset, "during the whole of the Emperor's time at the Kremlin, the portrait of his son remained in his bedchamber. I don't know what became of it."[7] Anatole de Montesquiou, son of the Grand Chamberlain and the King of Rome's governess, who served as Napoleon's aide-de-camp during the Russian campaign, was better informed: "At Orsha, the Emperor was obliged to abandon much of his baggage, as there were too few horses. Everything he left behind was burned. It was there that on his orders, the beautiful portrait of the King of Rome, painted by Gérard and brought by M. de Bausset on the eve of the Battle of Borodino, was destroyed."[8]

SYLVAIN CORDIER

283
Horace VERNET
Napoleon, on the Eve of the Battle of Borodino, Presenting to His Staff Officers the Portrait of the King of Rome Recently Painted by Gérard
1813
The Montreal Museum of Fine Arts

284
Antoine-Jean GROS
Napoleon on the Battlefield of Eylau, sketch for the painting at the Salon of 1808
1807
Toledo Museum of Art

285
François-Pascal-Simon GÉRARD
The Infant King of Rome
1812
Château de Fontainebleau, Musée Napoléon Ier

283

284

285

STABLES, COACHES
AND
GRAND CORTÈGES

THE EMPEROR'S DEPARTMENT
OF THE
GRAND EQUERRY

HÉLÈNE DELALEX

The revival of the Versailles Stables

As soon as the Proclamation of the Empire occurred, Napoleon sought to renew the prestige of the stables of the Ancien Régime. The horse was essential to the representation of power, and the imperial cavalry had to be the best in Europe. Although in 1804 the stables were still spread out between the Hôtel de Longueville near the Tuileries, a former Ursuline convent near Saint-Cloud, and other imperial residences, the Emperor was quick to reinvest in the Grand Écuries of the Château de Versailles. The two huge horseshoe-shaped buildings, erected by the architect Jules Hardouin-Mansart in record time (1679–82), established, in the wake of the Treaty of Nijmegen, a Louis XIV who had reached "the summit of human glory."[1] The new Grand Stables were endowed with a unique situation: symmetrically built on two trapezoidal plots between three forked avenues in the *patte-d'oie* axial design invented by André Le Nôtre, they were situated in front of the Place d'Armes, directly in line with the château, facing the windows of the king's apartment.

The Revolution emptied out the stables. The leaders and dignitaries of the Republic plundered horses, saddles, harnesses and coaches that, after the removal of the coats of arms, were assigned to public use or sent to the army. As for the buildings, they were progressively occupied by the War Administration. In 1810, Napoleon gave Guillaume Trepsat, the architect associated with the Palais de Versailles and the two Trianons, the vast program of restoring and rehabilitating the buildings. The work was completed in 1812. Since 1682, the royal stables had been an immense institution comprising one of the largest departments of the Royal Household, and activity was unrelenting and intense. Harbouring similar ambitions, the Emperor gave the department of the Grand Equerry considerable resources, and its budget became the biggest of the Imperial Household.[2] Hundreds of men worked there on a daily basis: equerries, outriders, coachmen, postilions, footmen, tack boys, firearm bearers, couriers, hostlers, grooms (**291, 292**), saddlers, chaplains, veterinarians, surgeons, farriers, and more.[3] In late 1811, in the middle of construction, Napoleon also decided to move in the École des Pages, then located at Saint-Cloud. The return to Versailles of this prestigious royal institution, which had for centuries been the holy of holies of the equestrian aristocracy, demonstrates the Emperor's determination to revive the prestige of the great French equestrian school, thus ensuring the training of future elite cavalry officers, the army's most venerated corps.

The Grand Equerry and the First Equerry

Since the reign of Francis I (about 1530) in France, the royal stables was a two-headed organization. The Grand Stables, overseen by the Grand Equerry of France, heir to the constable (*comes stabuli*, count of the stable), was in charge of the saddle horses, perfectly equipped for the hunt and for war, while the Petite Écurie, directed by the First Equerry working under the Grand Equerry, oversaw the ordinary mounts, carriage horses and coaches. Although from an organizational perspective, Napoleon kept the traditional division—the department having now been organized around three Equipages (saddle, harness and campaign)—he merged the administration of the two stables into a single entity overseen by the Grand Equerry Caulaincourt, the sole official for the whole Imperial Stables and Stud Farm.[4] With his sparkling personality and legendary rigour, ever exacting when it came to his officers' elegance, Caulaincourt restored prestige to the function.[5]

Nevertheless, with military campaigns and diplomatic missions linked together, Caulaincourt was increasingly absent from the Stables. In these circumstances, it became difficult to manage such a large department. And so, when in November 1807 he was sent to Russia as French ambassador, the position of First Equerry was created for the general and comte de Nansouty (**287**), who was given the task of filling in for Caulaincourt during his absence and then of assisting him upon his return in May 1811.[6] In the spring of 1810, organizing the grand cortège for the imperial wedding fell upon Nansouty. It was no small feat. The ever harried Emperor had given Caulaincourt only three months to prepare the coronation cortège in 1804; Nansouty was given only one month to ready the wedding cortège, which was to be even grander.

The Emperor's forty coaches

"The Emperor himself has just decided on . . . the arrangements for his wedding. There is not a minute to spare, everything must be ready within a month," stated the architect Fontaine in his *Journal* on March 3.[7] Although this marriage to a descendant of the oldest and most prestigious European dynasty was to mark the beginning of a new one, it also allowed Napoleon to align himself symbolically with the perpetuation of the monarchy. As for his coaches, as in all things, he intended to have the magnificence of his cortèges surpass those of the Ancien Régime. With Intendant-General Daru as intermediary, he entrusted Nansouty with amassing forty gala coaches, each drawn by six or eight horses. Such a thing had never been seen before: in a similar situation, the Bourbons only had thirty such vehicles. It was also a matter of outdoing the coronation cortège of 1804, which had consisted of twenty-five coaches and 152 horses (**294**). Archival material attests to this intention: the coronation had cost

287

286
Jacques Bertaux
*The Imperial Procession Arriving at Notre-Dame
for the Coronation Ceremony, December 2,
1804: Crossing the Pont-Neuf* (detail)
1805
Paris, Musée Carnavalet

287
Anonymous
After Jacques-François Llanta
*Bust-length Portrait of Étienne-Marie-Antoine,
General-Comte de Nansouty, First Equerry to
the Emperor*
About 1830-50
Musée national des châteaux de Versailles et
de Trianon

288-290
Pierre Martinet
The Emperor's Horses
288. *"Sheik"*
289. *"Triumphant"*
290. *"Distinguished"*
1806
Rueil-Malmaison, Musée national des châteaux
de Malmaison et Bois-Préau

291
Alexander Ivanovich Sauerweid
*Sara, the Emperor's Horse, in the Tuileries
Courtyard, before a Review of the Imperial
Guard*
1813
Private collection

292
Alexander Ivanovich Sauerweid
*Sara, the Emperor's Horse, in the Park
at the Trianon*
19th c.
Paris, Musée de l'Armée

three million francs, 380,000 of which went to coaches and equipages;[8] the wedding would cost 3,488,621, of which 556,983 went to coaches and equipages. In order to cover these unforeseen expenses, Napoleon allotted every department in his Household a "Special budget for wedding-related expenses," signed March 10.[9] Thus, the First Equerry was allocated 516,994 francs,[10] an amount augmented on December 28, 1810, by an additional 39,988 francs,[11] in addition to the 55,000 francs budgeted for the Grand Livery, an item from the Stables' regular budget.[12]

Nansouty started by drawing up an inventory of the imperial fleet of coaches. In a report to Daru dated March 8, 1810, he mentioned only six available coaches, including the coronation carriage delivered by Jean-Ernest-Auguste Getting, saddler-coachbuilder to the Emperor; the others were deemed too humble or too worn for such a ceremony. He wrote, "I have very little available, and even what I have is in far too poor a state due to their use this past winter. As per the Emperor's orders, I need forty for the ceremony. His Majesty had complained, with good reason, about those used in the last cortèges, and I am left with only two options, to purchase a large number or to fail to fulfill this office."[13] With tremendous resourcefulness, he immediately set about having the six ceremonial carriages restored,[14] and having thirty-four new gala berlin coaches made: Getting was commissioned for two lavish six-seat coaches for the Emperor and the Empress,[15] and orders for thirty-two retinue coaches were divided among thirteen coachbuilders in Paris.[16] After the upheavals of the Revolution, these large orders revived the French luxury coachbuilding industry in the early nineteenth century (296).

Napoleon acknowledged having underestimated the number and quality of coaches: when he ordered forty, he estimated that only about a dozen new coaches at most would have to be ordered.[17] Nansouty reassured him about the overall cost of the operation, as he had managed to negotiate gold-ground berlin coaches for the price of simple city berlin coaches. But the Emperor had his doubts about their being sound: he worried that the coaches would be "shoddily built" due to the time constraints, and instructed his loyal Intendant-General Daru to check up regularly on the quality of their manufacture in the coachbuilding workshops. The coaches were ultimately delivered and registered by the saddlers' inspector on March 31, two days before the ceremony.

"It is difficult to give an accurate picture of such splendour"[18]

Ever mindful of aligning himself with the monarchy, Napoleon demanded that the protocol adopted by Marie-Antoinette forty years earlier be followed to the letter. On March 11, 1810, an initial proxy wedding was celebrated in the Augustine church in Vienna, with the archduke Charles, Marie-Louise's uncle, standing in for Napoleon. On the 13th, the archduchess left her native land, escorted by Grand Master of the Hunt Berthier, the prince of Neufchâtel, in a splendid cortège entirely funded by the budget of the Grand Marshal of the Palace.[19] At Braunau, on the border between Austria and Germany, the traditional "giving away the bride" ceremony was held. The couple met at Compiègne on March 27, before leaving for Saint-Cloud, where the civil wedding was held on April 1. The grand cortège was planned for the following

288

289

290

291

292

293
Étienne-Barthélemy GARNIER
*The Wedding Procession of Napoleon and
Marie-Louise Passing through the Tuileries
Garden, April 2, 1810*
1810
Musée national des châteaux de Versailles
et de Trianon

294
Jacques BERTAUX
*The Imperial Procession Arriving at Notre-
Dame for the Coronation Ceremony,
December 2, 1804: Crossing the Pont-Neuf*
1805
Paris, Musée Carnavalet

295
Louis-François CHARON
*The Coach of His Majesty Napoleon on His
Wedding Day to Marie-Louise, Archduchess
of Austria*
After 1810
Montreal, McGill University Library and
Archives, Rare Books and Special Collections

296
Jean-Ernest-Auguste GETTING
Victory, the ceremonial coach with seven
windows for the coronation of Napoleon in
1804
About 1804
Musée national des châteaux de Versailles
et de Trianon

day, April 2, for the public entrance to Paris and the religious wedding cere-mony in the Louvre's Salon Carré. Before 10:00 a.m., Ségur, the Grand Master of Ceremonies, took care to gather and position every participant in the State apartments, while the 244 harnessed horses pawed the ground in the courtyard, waiting for the signal to depart. At 11:00 a.m., the imperial couple emerged from the palace, climbed into their carriage, and the cortège made its way to the capital.

Printed brochures indicating the cortège's itinerary and composition had circulated since late March throughout Paris, along with a program of the festiv-ities. At the first light of dawn, an impressive crowd had amassed along the immense avenue leading to the Porte Maillot of the Palais des Tuileries. In order to prevent any disorderliness that may have arisen from such a large crowd, the Imperial Guard lined up along the route to contain the throngs. The streets were lined with music-makers and the facades of buildings were richly bedecked. Balconies located along the route, rented out at exorbitant rates, were gradually embellished with the arrival of elegant ladies. "The night before the celebration had been stormy," recounted Percier and Fontaine in their account of the event: "torrents of rain had drowned the earth, and we feared that the immense preparations made for months would be lost or put off for another more favourable day." But suddenly, just as they were leaving, the sun miraculously appeared: "It was still rainy weather in the morning; but, with the first cannon shot announcing the departure of T. M., the sun appeared on the horizon; and when they arrived at the Étoile triumphal arch, it shone brilliantly as could be: the occasion, a happy omen, impressed every soul present."[20]

At 1:00 p.m., the Emperor's carriage entered Place de l'Étoile (298), the place to stop and receive the tributes of the municipal authorities. Following the speeches, several cannon shots sounded the start of the spectacle. Passing through the still-unfinished Arc de Triomphe, embellished for the occasion by a wooden framework decorated with painted canvases, the forty berlin coaches filed down the Champs-Élysées to the Tuileries Garden, to the cheers of a jubilant crowd. The Emperor "seemed concerned, and absorbed by the imposing spectacle's effect on the crowd," relates the comtesse Potocka in her *Mémoires*.[21] Indeed, one can only imagine the splendour of the caval-cades consisting of several dozens of gleaming coaches, the beauty of the hundreds of plumed horses and the rumble of horseshoes on pavement. Étienne-Barthélémy Garnier's large painting reconstitutes the memory of the cortège, whose striking excessiveness still makes an impression (293). "The brilliant equipages, one after the other in such great numbers, the richness and

variety of the clothes, the beauty of the women, the brilliance of the diamonds, everything was spectacular," continued the comtesse, who had a ringside seat from her balcony.

Power in motion
The cortège's organization, with everyone's place in it, defined rank more than ever. The figures at the top of the court hierarchy came at the end of the cortège, in coaches in front of and behind that of the Emperor. The cortège opened with the Imperial Guard, consisting of lancers, guides, dragoons and heralds. They were followed by the court's thirty-four berlin coaches: the first was for the masters and assistants of Ceremonies, the next nine were for the chamberlains (of ordinary and extraordinary service) of France and of Italy, the next four for the Grand Officers of the Empire; then came the four coaches for ministers, the eight for the ladies-in-waiting of France and Italy and the Grand Officers of the Crown of Italy; the Grand Master of Ceremonies Ségur and the Grand Chamberlain Montesquiou shared a berlin coach, followed by the two carrying the Princes and Grand Dignitaries, and last were the four coaches for the Princes and Princesses of the imperial family.

Then came the Empress' coach, which, according to old royal tradition, travelled empty in the cortège. In the painting, the coach is drawn by eight grey horses and precedes that of the Emperor—in which Marie-Louise sits on the left of her husband—which is also drawn by eight horses: "They marched past, proud of the role they were given to play," recounted the comtesse Potocka. Nansouty had selected Andalusian horses of a rare beauty, whose dun coat went perfectly with the leather harnesses decorated with gilded bronze and garnished with extraordinarily rich trimmings embroidered with silk and gold thread. The coach steps teemed with dozens of pages "hardly out of infancy," who were, according to the lovely description of the comtesse Potocka, "like butterflies ready to take flight at a moment's notice, making poetry of the heavy coach."[22] Nevertheless, Duchesne, the illustrious teacher and designer of coaches, found that the former coronation carriage made by Getting after the drawings of Percier and Fontaine fell short of the occasion: "Let's not speak of it: It was too small and better suited to a woman than to representing the majesty of a sovereign."[23] Although the body with its gold ground was relatively simple—that is, spare in its gilded bronze and sculpted wood ornamentation— the imperial velvet cover had at its centre a tall pedestal on which rested an imposing crown held up by four eagles with open wings (295, 297). The marshals and equerries on superb mounts surrounded Napoleon's carriage. Nansouty

VOITURE DE SA MAJESTÉ NAPOLÉON I^{ER}

Le Jour de son Mariage avec Marie Louise Archiduchesse d'Autriche (le 2 Avril 1810)

A Paris chez Jean, Rue S^t Jean de Beauvais, N°10.

Charon Del. et Sculp.

295

296

297

was positioned in the place allotted to the Grand Equerry, by the carriage's right door, with the Grand Equerry of the kingdom of Italy and the First Equerry to the Empress. He directed the cortège's progress—as evidenced in Garnier's painting—which was organized according to the traditional teams for French grand ceremonies, always with eight horses, a number reserved for sovereigns.[24] In the painting, the postilion, riding the last horse on the left, directs the lead horses and sets the pace of the cortège; from his seat, the coachman handles the reins of the first three lead horses; on foot, the tack boys hold onto the bridles of the six horses guided by the coachman; and last, standing on the platform at the back, are the footmen, whose tasks include opening the door and unfolding the steps.

The Grand Chaplain cardinal Fesch, the Grand Marshal of the Palace Duroc and the Grand Master of the Hunt Berthier shared the lavish ceremonial coach immediately following the Emperor's carriage. As seen in the painting, they in turn are followed by the ladies of honour and, finally, by the imperial family. Various squadrons of the Imperial Guard bring up the rear.[25]

The rolling throne

Intended to showcase the sovereign, the ceremonial carriage had eight windows and kept at a walking pace, at about three kilometres an hour.[26] Ostentatiously luxurious, this total artwork was designed to make a striking impression. In a cortège, the sun "consumed" it, multiplying its golden effects and producing an object that was literally "radiant." This is what the art critic and writer François-Marie Miel observed in 1825 in his description, on the occasion of the procession of Charles X, of the visceral impression the great golden carriage had on the spectators, leaving him with feelings of respect, admiration and joy.[27] In this, the carriage, like the throne, contributed to reinforcing the sacred status conferred on the figure of the monarch.

Indeed, like the throne, the monarch's carriage, called the "Carriage of the Corps," is the incarnation of the sovereign's sacred body. In a cortège, the carriage, even when empty, personifies the presence of royalty, and one must take off one's hat while it passes by. The weighty symbolism of this assimilation is manifested magnificently during political revolutions, when these wheeled emblems of power are always the first targets, which partly explains their disappearance. The most famous example of this is probably the public destruction of the coronation carriage of Louis XVI, ordered by the National Convention at a session on 2 Floréal, Year II (April 21, 1794). The painter David was even authorized to use the tip of his penknife to scratch up the panel paintings destined for the fire.[28] Likewise, Napoleon's coronation and wedding carriage was "cut up in 1815 after the return of Louis XVIII," as a loathsome relic of Bonaparte.[29]

On April 2, 1810, the imperial court was at its peak and the Emperor's power was measured, on that day, by the number and splendour of his equipages. The breadth of the stables of a prince—as for the grand ceremonial cortège—heir to the triumphant Romans, had figured for centuries as one of the most representative aspects of *dignitas majestatis*. Aware of the power of ancient symbols, Napoleon made the Grand Equerry, like the Grand Master of Ceremonies, a central figure in the staging of his power.

THE
IMPERIAL
HUNT

CHARLES-ÉLOI VIAL

Historians have long thought that Napoleon was forced to go hunting under great duress—four or five times during his reign, according to them—in order to conform with the customs and traditions of the European monarchies, so as to impress his very distinguished guests and to appease the aristocracy of the Ancien Régime. The idea that the great conqueror turned monarch could "lower himself" to take part in the same leisure activities as the former kings of France, who had all been great fans of hunting with hounds to the point that they neglected the kingdom's affairs, seems almost shameful.[1] However, Napoleon well knew that the hunt was part and parcel of a monarch's public obligations. As under the Ancien Régime, his courtiers were frequently invited to hunt, and the Emperor eventually learned to enjoy the sport. The archives reveal that Napoleon went hunting at least 320 times during his decade in power, that is once every five days, both with shooting parties and on hunts with hounds.

The office of the Grand Master of the Hunt
First Consul Bonaparte outfitted himself for the hunt as early as 1801. His doctor, Corvisart, concerned about work fatigue, advised him to take exercise. His entourage, which included a number of hunters, among them his brother Joseph, proposed the idea of going hunting with hounds. However, the introduction of these hunts, reminiscent of those of Louis XV and XVI, at the very instant Bonaparte was accused of trying to establish a self-serving monarchy, attracted public attention. It seemed to contradict the civic and republican exercise of power.

Upon the proclamation of the First Empire, the office of the Grand Master of the Hunt was entrusted to marshal Alexandre Berthier (40), minister of war and major general of the Grande Armée, a passionate hunter and one of the most powerful men in the Empire. With a budget of 445,000 francs per annum, Napoleon could maintain eighty-two huntsmen, recruited from among Louis XVI's former staff, a hundred horses and two hundred hounds.[2] The officers of the imperial hunt, selected from among the old and new nobility, collaborated with their colleagues at the Grand Stables to organize the hunt, along with the administration of the Crown forests. In 1810, the pack and horses were brought to the Grand Kennel of Versailles, an immense building erected for Louis XIV. Napoleon had the hunting lodges refurnished, including Bagatelle, in the Bois de Boulogne, La Muette, in the Saint-Germain-en-Laye forest, and Butard, near Versailles. In 1810, he launched a forest-buying campaign, for which he anticipated spending 12 million francs. He repurchased the Marly

and Raincy estates and a section of the Meudon forest. In November 1813, a few months before the fall of the Empire, he still planned to buy the lands around Paris to outfit them for shooting.[3]

A mediocre but enthusiastic huntsman
Born into a family of Corsican minor gentry, Napoleon was not familiar with the great hunts of the Ancien Régime's aristocracy. He was therefore completely ignorant of proper hunting technique. In his haste to imitate the old customs, he improvised while hunting, only to be injured by a wild boar in 1803, almost losing a finger.[4] In 1807, he took a few private lessons to learn the subtleties of hunting with hounds, which he soon found tiresome. Furthermore, he was terrible in the saddle, mistreated his mounts and narrowly missed getting himself killed on several occasions. He was just as hopeless at shooting. Because of his myopia, he often missed his target. During a hunt in 1808, marshal Masséna had an eye put out by the Emperor, who was quick to blame marshal Berthier. All that to say, the Emperor was a poor excuse of a hunter. At his salvo, some great hunts assembling the entire court were hardly pleasant: dozens of courtiers from all over Europe accompanied him into the forest hoping for a conversation, with hordes of beggars, onlookers and supplicants following him hither and yon over the forest paths. Moreover, he did not always chase after small game: when the imperial mistresses had occasion to observe events from the second floor of a hunting lodge, Napoleon would show off for their benefit by going deer hunting. The hunts from the early years of his reign were at times quite haphazard.

Observers remarked that by the end of the reign, the quality of the slipping of the hounds improved: there were less guests, the forests were better monitored and Napoleon adopted the habit of following the hunt right to the end accompanied by Marie-Louise, also on horseback. The Emperor managed to shoot a stag, his pack was good and his huntsmen better trained. Before the Russian campaign, the imperial hunt was one of the best in Europe, and Napoleon got more and more pleasure out of engaging in this supreme royal activity. Flouting protocol, he sometimes allowed himself to shoot some partridge, pheasant or hares at the end of a heavy work day: at Saint-Cloud, like at Fontainebleau, Compiègne, Trianon or Rambouillet, his ground-floor apartments opened right onto the garden, where small game was released just minutes after his arrival.

In 1811, when Napoleon was entertaining the idea of building his own Paris palace, the palace of the so-called King of Rome, on the Chaillot hill,

the residence was not only considered to be a place of power and a seat for the court, but also a palace for leisure. The plan was to make the Bagatelle hunting lodge, already refurbished in 1810, a hunting hub and the Bois de Boulogne, replanted and enclosed, a hunting reserve at the gates of the capital. In a moment of inspiration, the Emperor's first architect, Fontaine, proposed releasing wild animals from Africa and Asia for exotic hunts.[5]

The hunt and court life

From 1804 on, the imperial court moved between the various palaces of the Crown, beautified for centuries by the kings of France. Consequently, Napoleon stayed at Rambouillet during the lovely days of spring, Saint-Cloud and Trianon in the summer, and Compiègne and Fontainebleau in the fall. These palaces, surrounded by extensive forest, all lent themselves to the hunt. Every time he wished to engage in that activity, Napoleon informed his Grand Master of the Hunt, whose staff prepared the hounds and the horses, and busied themselves locating the deer in the surrounding forests. He then invited between ten and thirty people through his Grand Chamberlain. The hunt was a ritual whose proceedings were laid out in the *Étiquette du palais impérial*. The courtiers, who dreamed of receiving an invitation, never missed an opportunity to join in. For example, general Thiébault recounts showing up one summer morning in 1810 at Saint-Cloud at three minutes to ten, only to find the entire court before the château in full hunting apparel.[6] During the court's stays at Rambouillet, Fontainebleau or Compiègne, the hunt was held almost every day. In the private palaces of the Crown, Rambouillet and Trianon, shooting dress, green and without galloons, was in the same style as that normally worn by the Emperor and his courtiers, who were thus given the impression of being close to the monarch.

The Emperor followed all the hunts surrounded by members of his Household; an aide-de-camp, equerry on duty, an ordinance officer and a firearm bearer accompanied him, in addition to the Grand Master of the Hunt, the Grand Equerry and the officers of the hunt. At a gallop, Napoleon could cover up to twenty-five leagues, almost a hundred kilometres, in a hunt with hounds. After every hunt, the guests were invited to a breakfast provided by the Imperial Household, served on trestle tables and folding furniture (**304**), generally in a hunting lodge, but sometimes beneath a tent set up in the forest. The meal was laid out with country silver and the service provided by the Tuileries butlers.

The hunt, power and diplomacy

The hunt, which took pride of place in life at court, became a useful diplomatic tool. On November 26, 1804, Napoleon moved his court to Fontainebleau in order to receive pope Pius VII, who had come to France for the coronation. (**308**). A memorable greeting, staged with the designs of illustrating to the pope the Emperor's superiority.[7] Napoleon also assumed the habit of hunting to celebrate his victories in the lands of his rival monarchs. In April 1805, on the eve of his coronation as king of Italy, he was hunting near Turin, in the park of the Palace of Stupinigi (**306**), confiscated from the ex-king of Piedmont-Sardinia. Similarly, during the French occupations of Vienna in 1805 and 1809, he went stag hunting on more than one occasion in the palace park at Schönbrunn.

In 1807, Napoleon invited his allies to the great hunts at Rambouillet and then at Fontainebleau to celebrate the marriage of his brother Jerome, declared king of Westphalia. These festivities set the stage for the treaty establishing the Confederation of the Rhine.[8] In February 1808, after forming an alliance with Czar Alexander I, Napoleon invited the Russian ambassador, Count Tolstoy, grandfather of the author of *War and Peace*, to hunt at Saint-Germain-en-Laye.[9] Last but not least, to cement the ties between the two empires, in late 1808, Napoleon hunted with the czar himself during the Congress of Erfurt (**305**).[10] In 1809, Napoleon invited another ally, the king of Saxony, to hunt at Fontainebleau. In 1810, during the festivities marking Napoleon's marriage to archduchess Marie-Louise, the Austrians in turn received numerous invitations to the hunt, as in 1811, for the birth of the King of Rome.[11] During the Russian campaign, Napoleon held the most elaborate of the imperial hunts of his reign: in Dresden, he organized a great wild boar hunt on May 25, 1812, in one of the châteaux belonging to the king of Saxony, with all the sovereigns who had supplied troops for the Russian invasion invited to attend. They proceeded to the meeting place, followed by the citizenry who hailed Napoleon.

However, after the Russian campaign, Napoleon had no more monarchs to invite to the hunt, an indication that such an institution of courtiers could no longer play a significant diplomatic role, given that the Empire was now isolated in Europe. Napoleon hunted for the last time at Versailles, almost alone, in November 1813, at the very moment his former allies were launching their invasion of the Empire.

The hunt as imperial symbol

The imperial hunts were also public activities that benefited the Emperor's image and contributed to his popularity. The press and private letters mention several popular celebrations organized in the villages through which the Emperor passed on his way to or from hunting. The archives show that Napoleon distributed several thousand francs to his enthusiastic subjects. However, it was first and foremost in 1813 that he hunted in public in order to be hailed by Parisians, concerned after the announcement of the defeat in Russia. The press also seized on tales of the imperial hunt, which appeared at regular intervals in the *Moniteur*, *Journal de Paris* and the *Mercure de France*: life at court thus served as propaganda.[12]

Napoleon, extremely proud of his hunts, wished to be painted in his hunting apparel. In 1810, during a visit to the Sèvres manufactory, he invited the painter Jean-François Robert to follow his hunting parties at Compiègne.[13] In 1810 and 1811, Robert painted several porcelain plates, vases and services, many of which were offered to members of the imperial family or to European monarchs. For New Year's gifts in 1812, Madame Mère received a Sèvres service from Marie-Louise. The following year, one of the ladies-in-waiting, the comtesse de Croix, received a service from the Empress decorated with hunting scenes. The lavish *guéridon* table called "Royal Residences," commissioned for the Emperor but only finished after his downfall, featured a succession of hunting scenes in its painted decoration.

The Imperial Household also awarded several commissions to Carle Vernet, great painter of battles and horses. A first painting was exhibited at the Salon of 1806, followed by a full-length portrait of Napoleon in his hunting dress in 1808 (current whereabouts of both unknown). Hunting is also featured in a cycle of paintings depicting the life of Marie-Louise, commissioned by marshal Davout for his salon at Savigny-sur-Orge (Musée Marmottan-Monet, Paris). Several watercolours are preserved in private hands, while a large painting of the Emperor hunting at Fontainebleau in 1810, from the collections of the princesse de Faucigny-Lucinge, shows that Vernet continued to work on the subject of the hunt, which he explored in print as well as paint on paper. In 1812, a hunting scene in the woods of Boulogne (**307**) commissioned for prince Eugene created quite a sensation, the critics stunned to see Napoleon portrayed as anything but a triumphant general: the Emperor, wishing to distance himself from his military image, chose to be represented as a peaceful leader, taking his inspiration from paintings of the hunt commissioned from Oudry by Louis XV.[14] Started just months before the fall of the Empire, this iconographic development was soon forgotten, even though the Bourbons, who succeeded to the throne in 1814, took up the same idea by portraying themselves as peaceful princes, preferring to conquer stag and hare rather than the fields of battle on the other side of Europe.

Without being a great huntsman himself, Napoleon imbued his hunts with peerless flash. Although the hunts of the Ancien Régime had been part of court life, those of the Empire were an essential element of diplomatic chess, uniting the continent's monarchs, princes and ambassadors. The Emperor's successors, from Napoleon III down through to the presidents of the French Republic, have drawn on this memory by regularly inviting their important guests along on the hunt.

However, Napoleon did not only hunt like a sovereign in the limelight. For him, it was also a genuine leisure activity: on the isle of Elba, and then on Saint Helena, he continued to hunt. The exercise awoke in him profound reflections on the value of life, the use of violence and even life after death.[15] The great cavalcades through the Crown forests satisfied his need to see the trees and survey the forests. They also show that Napoleon was a great lover of nature and of beautiful landscapes, with the sensibilities of a true Romantic.

299
Antoine-Charles Horace, called Carle VERNET
Napoleon Hunting with Hounds in the Forest of Fontainebleau
19th c.
Paris, Musée de la Chasse et de la Nature

300
Jean LE PAGE
Louis XVI's flintlock rifle, used by Napoleon
About 1775
Paris, Musée de la Chasse et de la Nature
(dépôt du musée de l'Armée)

301
Nicolas-Noël BOUTET
Hunting carabine, given by the Emperor to general Rapp
About 1806–9
Paris, Musée de la Chasse et de la Nature
(dépôt du musée de l'Armée)

302
Gervais CHARDIN
Pair of riding gloves from the Emperor's wardrobe
About 1810
The Montreal Museum of Fine Arts

303
Napoleon's hunting dagger (detail)
About 1804
Château de Fontainebleau, Musée Napoléon Ier

304
Workshop of François-Honoré-Georges JACOB-DESMALTER
Chair called "parrot"
First Empire (1804–15)
Paris, Mobilier national

305
View of the Great Stage Hunt Held in Honour of the T. M. the Emperors Alexander and Napoleon
Published in Charles Augustus, duke of Saxe-Weimar, *Description des fêtes données à Leurs Majestés les empereurs Napoléon et Alexandre... le 6 et le 7 octobre*
1809
Paris, Bibliothèque nationale de France

306

306
Attributed to Louis REVIGLIO
The Palazzina di Stupinigi in Piedmont,
design for the decoration for the table called
"of the imperial palaces"
1811
Sèvres, Cité de la céramique

307
Antoine-Charles-Horace, called Carle VERNET
*H. M. Napoleon on a Hunt in the Bois
de Boulogne*
1811
Saint Petersburg, State Hermitage Museum

308
Jean-Louis DEMARNE
*The Emperor and Pope Pius VII Meeting in
the Forest of Fontainebleau* (detail)
1808
Château de Fontainebleau (dépôt du musée
national du château de Versailles)

307

THE EMPRESS
IN HER
HOUSEHOLD

ANNE DION-TENENBAUM

Although their differences in temperament and background—not to mention the increasingly rigid *Étiquette*—led to changes in day-to-day operations, the two Empresses lived in the same places, whether the Tuileries, Saint-Cloud or other imperial palaces, which were governed by the rules of court and provided a common framework. While Josephine was certainly freer and more sociable, and Marie-Louise younger, better educated and more isolated in the French court, the way they spent their days was quite similar, and for both, determined by the structure of their Household and the *Étiquette*.

Organization of the Empress' Household
Managing the life of the Empress was in large part ensured by the departments of the Imperial Household.[1] The role of the Empress' Household was thus circumscribed. Still in its infancy under the Consulate, it began to take shape as the coronation approached. It was directed by the lady of honour, who had "the same rights, prerogatives and honours as the Grand Chamberlain of the Imperial Household."[2] She oversaw the staff of women and valets of the bedchamber, made arrangements for presentations and audiences and managed the privy purse for alms and gifts. Mme de La Rochefoucauld, a relation of Alexandre de Beauharnais, was selected for the post, and Émilie de Beauharnais, the wife of Lavalette, was made the lady of the robes in charge of the Empress' wardrobe and jewellery—even though, if Mlle Avrillion is to be believed, she never really performed her functions as Josephine herself took care of every aspect of her toilette.[3] The comtesse de Luçay, former lady-in-waiting to Josephine, played a more important role as Marie-Louise's lady of the robes. She, along with Caroline Murat, put together the new Empress' lavish trousseau in February 1810. The recollections of suppliers indicate that they sometimes acted on her orders, even occasionally mentioning that objects were delivered to her directly.[4] She watched over the maintenance of objects useful to Marie-Louise, having minor repairs made under the direction of a new lady of honour, the duchess of Montebello.[5]

The Empress' Household also consisted of a First Chaplain, Ferdinand de Rohan, the former archbishop of Cambrai, a First Equerry serving as chevalier of honour (functions that were disassociated with Marie-Louise), a First Chamberlain and a secretary of orders; a Master of Ceremonies, the comte de Seyssel, who had been officiating at the Imperial Household since 1806, joined Marie-Louise's staff in 1812. Jean-Marie Deschamps, playwright and librettist, who attracted Napoleon's notice with his involvement in the opera *Bardes*, served as secretary of orders. The baron de Méneval, formerly Napoleon's

secretary until he was overcome with exhaustion from the Russian campaign, replaced him in 1812. Ballouhey was the secretary of expenses for the two Empresses. Four ladies to announce, also known as first ladies to the Empress, and readers, whose numbers increased to six for Marie-Louise—types of "female ushers," in the acerbic words of Mme de La Rochefoucauld[6]—were present in pairs from the time the Empress awoke to when she dined. Posted in the salon adjacent to the Empress' bedroom, they were in charge of vetting all visitors and making sure no man (save for the secretary of orders, the doctor or the hairdresser) entered the interior apartment. Lastly, the ladies-in-waiting played a representative role, following the Empress on her outings, to mass, on walks or to performances. Although Napoleon retained many of Josephine's ladies-in-waiting for the Household of Marie-Louise, so that their experience could be of assistance, he also brought in new ladies to announce, because the former staff had been at the root of some tensions and rivalries surrounding Josephine. The new recruits were all from the Legion of Honour's school for girls at Écouen run by Mme Campan; they kept their orange-red dresses, which led to their being called the "red women"[7] (**15**).

The Empress would spend a great deal of her day inside her interior apartment, surrounded by women. First-hand accounts, namely those of Mlle Avrillion, Josephine's lady of the bedchamber, and Constant, Napoleon's valet of the bedchamber, described how a regular day transpired.[8] The Empress would wake up about 8:00 a.m., drink a tisane or lemonade, in the case of Josephine, chocolate or coffee for Marie-Louise, and skim through the newspapers. Once ready to start her day, about 9:00 a.m., the Empress would go to her dressing room. It is known that Josephine would spend quite some time at her toilette. The hairdresser, first chambermaid and a lady of the robes helped her get ready. She would also be visited by her doctor, Corvisart. The Empress breakfasted at 11:00 a.m. with the ladies of honour, and then would return to her salon. At Saint-Cloud, or Malmaison in the case of Josephine (who would retire there whenever possible), she would go for walks, which she was not able to do at the Tuileries, where passersby would immediately flock to her. When the Empress went out in a carriage, the equerries would form an escort that would effectively guard her from the crowds. Marie-Louise enjoyed going out for horse rides. After such outings, she would take lessons in drawing, painting or music. A *grande toilette* preceded dinner, from 6:00 to 7:00 p.m., followed by receptions, concerts or performances.

Conversation, reading and the creative arts, painting, music and embroidery, or even playing games, occupied the Empress' days. Josephine, according to

310

309
Alexandre MENJAUD
The Empress Marie-Louise Painting a Portrait of Napoleon
1810
Château de Fontainebleau, Musée Napoléon I^{er} (dépôt du musée national du château de Versailles)

310
COUSINEAU PÈRE ET FILS
The Empress Josephine's harp
About 1805
Rueil-Malmaison, Musée national des châteaux de Malmaison et Bois-Préau

311
Auguste GARNERAY
View of the Music Room at Malmaison
About 1812
Rueil-Malmaison, Musée national des châteaux de Malmaison et Bois-Préau

312
ÉRARD FRÈRES
Decoration by Antoine RASCALON
The Empress Marie-Louise's pianoforte at the Grand Trianon
Dated 1809, delivered in 1810
Musée national des châteaux de Versailles et de Trianon

313
Workshop of François-Honoré-Georges JACOB-DESMALTER
The Empress Josephine's reading table used as a letterbox at the Grand Trianon
1805–10
Musée national des châteaux de Versailles et de Trianon

311

312

313

Méneval, had hardly any taste for the creative arts: "She had no creative talents, did not draw and was not musical."[9] In contrast, Marie-Louise had received an arts education and did not like being idle. She described her pastimes in a letter: "The kind of life I lead is unchanging . . . I often have evening music with Paer; I have taken up singing again after a terrible cold that forced me to stop, but I gave up drawing this winter, the days are too short to paint in oil . . . I also work on raised chenille embroidery every morning until it is time for lunch."[10] This is why, even before Marie-Louise's arrival, Napoleon had made sure she would have available "a few portable furniture pieces for writing, reading, drawing and needlework."[11] A budget of 15,000 francs was set up "for embroidery frames, chiffoniers, writing tables, money boxes and other small furniture for the Empress' use." He had made the following recommendation to his Intendant: "Draw up an inventory of these pieces of furniture, and come up with a model that will be the same for all of the Empress' apartments. It would be convenient to be able to find the same styles and the same devices for habitual use."[12]

Needlework

Embroidery was the most common pastime. Embroidery frames by Biennais were especially sumptuous. The one belonging to Josephine, made of root wood with borders of ebony fillets and embellished with finely chased gilded bronze, was furnished with small silver-gilt covered boxes attached to the side uprights (Royal Swedish Collections). In 1810, Biennais delivered one for Marie-Louise at Saint-Cloud.[13] For the other palaces (Tuileries, Compiègne, Grand Trianon, Fontainebleau and, with a simpler model, Rambouillet), the upholsterer and furniture dealer François Maigret was called upon to deliver a model equally as rich with double-column uprights, embellished with chased bronze decoration by Lucien-François Feuchère, alternately depicting lyres, hives, bees, swans and children around a compass (**314**). The furniture in the Empress' study at Fontainebleau,[14] the music rooms at Compiègne[15] and the Grand Trianon[16] exemplify the refinement of these types of pieces. The worktables were fitted with a satin bag under the edge to hold the piece being made. Embroidery *nécessaires* were cases used to hold all the necessary tools of the craft (bobbins, shuttles, thimble, needle case, scissors, reels, lace looms and more); in this too, Josephine and Marie-Louise owned very similar models provided by Biennais.[17] Some type of sewing equipment would always be included in dressing cases, like the one by Félix Rémond, delivered to Josephine after the Exposition des produits de l'industrie of 1806 (Château de Malmaison).

Josephine purchased from Mme Dubuquoy-Lalouette the canvas she would embroider with her ladies to decorate the salon armchairs at Malmaison. The ever studious Marie-Louise had a master embroider, Mme Rousseau. As dictated by the rules, a lady to announce attended every lesson. In 1811, she used money from her purse to purchase from the ornamentalist Jean-Baptiste Fay twenty-two lace designs, which she probably used as models.[18] Marie-Louise embroidered a baldric (Château de Fontainebleau) for Napoleon and a screen sheet in chenille, which Jacob-Desmalter mounted at the request of the comtesse de Luçay. A screen made of ash root wood was rejected by the Emperor in 1810, before a second model met with his satisfaction.[19]

Music

Josephine played the harp a little, but the baron Méneval was hard pressed to laud her talents: "In her apartment there was a harp; for lack of anything better to do, she would play, and always the same tune."[20] As seen in the well-known watercolour by Garneray (**311**), a mahogany harp with gilded bronze by the Cousineau father and son team (**310**) held pride of place in the Malmaison music room; the privy purse accounts show payments to the Cousineaus.[21] Related to her account, Josephine also possessed volumes of music for harp, the crisp state of which suggests infrequent use.[22]

Marie-Louise, on the other hand, was musical, having had as a music instructor Leopold Kozeluch. She could play piano, harp and a little guitar, and she sang. In Vienna, she happily accompanied the young archdukes on piano, or held her own in trios or quartets. In France, she studied under the Italian instructor Ferdinando Paer, whom Napoleon had poached from the Saxon court and, in 1806, named director of the court theatre and his own personal composer. One anecdote demonstrating the strict rule against men inside Marie-Louise's interior apartment has it that during a music lesson,[23] the attending lady to announce opened a door to relay an order, never leaving the room. At that very instant, Napoleon arrived and, not spotting her right away, gave her a scolding for this partial absence!

Paer selected for Marie-Louise a new type of harpsichord-shaped piano by Sébastien Érard;[24] it had a simple action escapement, called *à étrier*, for which Érard had taken out a patent in 1809. The Musée de la musique in Paris has a piano of this kind purchased by Paer on October 20, 1812.[25] Other pianos acquired from Érard included square pianofortes with three strings for each note. The only one to survive, at the Grand Trianon, is decorated with a *verre églomisé* panel by Antoine Rascalon[26] (**312**). A piano by Joseph Brodmann was brought from Austria, and the prefect of the département de la Roer, the baron Doucette, was reimbursed for a piano purchased in Cologne.[27] Érard also provided red-lacquered harps for the various palaces. The Empress was very demanding about the instrument's sound, and would send for Paer if by any chance the tuner Dubois had not carried out his duties to her satisfaction. Marie-Louise had a preference for a German repertoire (Steibelt, Hummel, Haydn, among others), and had scores purchased or copied. Paer took it upon himself to order a mahogany piece of furniture for her, executed by Jacob-Desmalter, to contain this collection of music.[28]

Reading and writing

It is known that Napoleon would complain about Josephine not writing him enough. Although it was true she was not a great letter writer, she did manage to write regularly to her children when she was apart from them. Recommendation letters were dictated. Josephine had a little mahogany night table that could be used for dressing or writing (Château de Malmaison). A piece by Biennais from the early Consulate days, it still adheres to the Louis XVI style by its shape; the top, covered in morocco leather, forms a desk, and a drawer contains an *écritoire*, or writing case. The stationery was purchased from the paper-maker Susse, located at the Passage des Panoramas. A few years later, Biennais adopted a rectangular writing case model with a sloping top producing a *pupitre*, with a long compartment along the front serving as a pencil box. Both Josephine and Marie-Louise had their own magnifying glass in thuja or silver-in-laid amboyna.[29] In 1812, Marie-Louise received a new, even more luxurious writing case of root wood decorated in polished-steel appliqués; aside from the compact and inkwell, the inside is also fitted with all the necessary writing utensils: candlesticks, sponge and stamp-pad box, rulers, scrapers, penknives, stamps, compass and pencil case (Národní Museum, Prague).[30]

In addition to these *nécessaires* and *écritoires* were small pieces of furniture used for writing or storing letters (**313**). A Biennais specialty was the letter-box in the shape of a shield from antiquity. Josephine had two inventoried to her boudoir after her death in 1814: the simpler one was of mahogany (Château de Malmaison), the other more extravagant in root wood (Fondation Napoléon, Paris). The latter is identical to the one supplied by Biennais to Marie-Louise in 1810, fitted with drawers at the ends and resting on four classical lionesses. This may be the letter-box referred to in an anecdote recounted by the duchess of Abrantès: Napoleon had taken umbrage at perceiving from afar the silhouette of a man in Marie-Louise's room at Saint-Cloud; the lady-in-waiting apologized "by saying that it was *Biennais*, who had probably come to explain *in person* to the Empress the secret of the letter-box he had just made for H. M."[31]

Other writing tables, closely resembling drawing tables, and letterbox tables forming a *pupitre* top, were delivered by Biennais to Saint-Cloud, and by Jacob-Desmalter to the other palaces. Examples of these are found at Fontainebleau and the Grand Trianon.[32]

Drawing

It seems that Josephine, unlike her daughter Hortense, did not indulge in drawing and painting. In contrast, the young archduchess Marie-Louise had hardly landed in Paris before the search began to find her a painting instructor. Denon recommended Prud'hon, "the man who drew the best in red and black chalk and whose talent was the most graceful."[33] The Austrian prince Clary und Aldringen recounted that Prud'hon had been given the task of giving

314
Workshop of Alexandre MAIGRET
**The Empress Marie-Louise's embroidery
frame in her study at Fontainbleau**
Delivered by Maigret, 1810
Château de Fontainebleau, fonds palatial

314

Marie-Louise "lessons, [and] overseeing her *studies and tastes* in painting in general and, presently, in the portrait she is painting of her Nana and Popo."[34] The painter Alexandre Menjaud left for posterity an edifying picture of the young bride portraying the great man in admiration (**309**). Although Prud'hon was paid as an instructor until the fall of the Empire, he was nevertheless paired with Jean-Baptiste Isabey, artist to the department of the Grand Chamberlain and the Grand Master of Ceremonies, who was entrusted with teaching the technique of watercolour to Marie-Louise beginning in late 1812. He taught her to sketch little scenes of daily life, which he thought likelier to keep her interest. The sketchbooks of Marie-Louise, going back to 1812, now at the Museo Glauco Lombardi in Parma, reveal a certain talent for Troubadour-style scenes.[35]

Marie-Louise had drawing tables and easels in every residence to help her exercise her talents. Jacob-Desmalter delivered pieces for the Tuileries and Fontainebleau[36] (still in situ in the Empress' study), including two very similar drawing tables in yew root wood with x-shaped legs in blue-varnished iron, with bronze capitals and foot mounts; the green top, covered in morocco leather, reveals a mirror when lifted, and the side drawer contains an inkwell and compact. The table at Compiègne, by the same cabinetmaker, hid a screen of steel blinds inside a back drawer. Jacob-Desmalter also delivered mahogany easels with racks, topped by the ML monogram inside a crown of myrtle, to Rambouillet, the Tuileries, Grand Trianon, Fontainebleau and Compiègne[37] (the

latter three examples are extant). Boxes of colours and of pencils and coated sheets of paper were purchased from Rey; the *tabletier* Pierre-Dominique Maire, a dealer in small objects, also sold portfolio desks and paint boxes.[38]

Games

Josephine enjoyed playing cards, especially whist, in the evenings, in society. Marie-Louise preferred billiards, at which she excelled, beating all the men she played and lying on the table if necessary to make a shot. She liked playing a game or two with her ladies inside her interior apartment. Pannetier, "maker of billiard tables for H. M. the Emperor and King," supplied the billiard tables for the various residences: the Tuileries, in November 1810, where the golden room was made into a billiard room, and Compiègne in 1811.[39] The one at Compiègne was made of ash root wood, with turned column legs and base mouldings of gilded bronze. For Saint-Cloud, a mahogany billiard table with ebony fillet and star inlay, priced at 3,500 francs, was proposed for the Empress' apartments, but was deemed too expensive by the Intendant. The Emperor ordered a nice ninepins set to be installed on the terraces for the ladies.[40]

The two Empresses each had game boxes. In May 1812, the comtesse de Luçay ordered one from Biennais for Marie-Louise. Made of black wood, it contained twelve games, including backgammon, *nain jaune*, a pope Joan card game, a Game of the Goose board game and chess.[41]

FROM MONTREAL
TO THE
TUILERIES

———

THE HAPPINESS AND MISFORTUNES
OF THE MARESCOTS,
A FAMILY IN THE
SERVICE OF THE HOUSEHOLD

SYLVAIN CORDIER

This impressive, hitherto unpublished portrait of the Marescot family (315) offers a very rare glimpse of court life under Napoleon. It also sheds light on a particularly interesting phenomenon: proof of the Canadian ancestry of one of the ladies-in-waiting and one of the Emperor's pages. This sumptuous and emotionally touching canvas executed by the painter Fortuné Dufau in 1806 is a remarkable rediscovery.

Armand-Samuel de Marescot, Grand Officer of the Empire

Born in Tours on March 1, 1758, Armand-Samuel de Marescot was the son of an officer in the security corps of the Royal Household, and a distant cousin of Josephine de Beauharnais.[1] Holding a royal engineering degree, he joined the Engineering Corps with the rank of lieutenant in January 1784. He served in the revolutionary armies in 1792 during the final days of the monarchy. As battalion commander, he distinguished himself at the siege of Toulon against the English, during which he met the young Bonaparte. The battles in the north of the country during the campaign of 1794 followed. These culminated in the dramatic siege of the city of Maastricht, at the end of which he was appointed divisional general. Between 1795 and 1799, Marescot performed the functions of commander-in-chief of engineering. With the advent of the Consulate, Bonaparte appointed him first inspector general of engineering in charge of the administration of all the French fortifications. He followed the First Consul into Italy, and earned praise for choosing to cross the Alps at the Great Saint Bernard Pass. During the early years of the Empire, he thoroughly inspected and reorganized all of France's fortresses, and was consequently placed on the list of Grand Officers. In April 1808, he was sent by the Emperor to study the Spanish fortifications in the context of the war being waged against the French invaders. It was a dangerous mission that led him, without orders, to be involved in the French defeat at Bailén (July 1808) and to inappropriately play a part in negotiations with the Spanish. His role in the capitulation provoked the fury of Napoleon. All the generals concerned, including Marescot, were arrested and charged with treason. He was dismissed from his post and thrown into prison, where he remained, at the risk of his health, until 1812, before being sentenced to retire without pay to his estates in Touraine. In April 1814, the provisional government that was preparing to call Louis XVIII to the throne returned to him his rank as first inspector general of engineering. During the Hundred Days, despite his earlier mistreatment, he prudently rallied to Napoleon. Some months after Waterloo, Marescot was retired, and thus escaped the royalist purge. Once again returning to Touraine, he was finally made a Peer of France in March 1819, in the liberal wing of the

Chamber. This final period of his life was mainly spent in his Château de Chalay, in the Vendôme, where he died on November 5, 1832.

Cécile de Marescot, lady-in-waiting to the Empress

In 1788, Marescot married Cécile d'Artis de Thiézac (1766–1863). The couple grew closer to Bonaparte with the advent of the Consulate, when her husband was appointed first inspector general of engineering. Cécile was introduced into the embryonic court that was developing around the First Consul and Josephine, who became godparents to the Marescots' second child, Joséphine-Cécile (1803–1822), baptized in the church of Saint-Thomas d'Aquin in Paris on June 10, 1803.

In 1805, Cécile became one of the Empress' ladies-in-waiting, while her eldest son, the sixteen-year-old Antoine-Samuel, was appointed a page to the Emperor. It was during these happy years that Marescot, conscious of such honours, had his family painted by Dufau. Cécile is wearing, with a sort of careless elegance reminiscent of some portraits of Josephine, a very luxurious cashmere shawl that is still extant (priv. coll.). But the happiness and honours were not to last. After having Marescot arrested, Napoleon demanded the resignation of Cécile from the Empress' Household in a letter to the principal lady-in-waiting, the lady of honour Adélaïde de la Rochefoucault, "however innocent the lady may be and whatever other merits she may possess." However, the Emperor was not unaware of the effects of the announcement of such a calamity and asked that the news should be given "as gently as possible."[2] Marescot, in prison, guessed that his disgrace would affect his family at court, and wrote to Napoleon imploring him to be lenient with them: "I beg Your Majesty to take into consideration that I am kin to Her Majesty the Empress, that I have served for thirty-two and a half years, that I believe I have rendered some service, and that the terrible blow that has been dealt me falls also on my wife, who has, or had, the honour of being a lady-in-waiting, on my son who has served Your Majesty as a page and still serves you in Spain, and finally on a little girl aged six who has the honour of being your goddaughter. After so many tasks, missions, fatigues and dangers in Your Majesty's service, I would not have expected such severity."[3]

Charlotte de Martel and her Montreal roots

On Cécile's right is her mother, Marie-Charlotte d'Artis de Thiézac (1743–1805), née Martel, whose father was descended from a family that moved to Canada during the reign of Louis XIV.[4] The story began with his grandfather Jean Martel.

Probably born in Normandy, he enrolled in the company of guards that accompanied Louis de Frontenac to take up his post as governor of New France in 1672. Being close to the local authorities, Martel was granted the seigneury of Magesse, in Acadia, eleven years later, and made a fortune trading and transporting goods. The surrender of Port-Royal to the English, which led to the loss of Acadia (1710), forced him to abandon his lands and return to Quebec City, where he was appointed the king's storekeeper. He died in 1729.[5]

One of his sons, Jean-Baptiste-Grégoire de Martel de Magesse de Saint-Antoine, was born in Quebec City in 1710. He followed in his father's footsteps, obtaining the position of king's storekeeper in Montreal in 1743 and then becoming principal writer of stores in 1750. Accusations of theft and of hoarding the goods for which he was responsible, the property of the Crown, were brought against him in 1754, in the final years of French sovereignty over Canada. Martel left for France after the fall of Montreal (September 1760). Now a wealthy man, he settled in Tours, buying a mansion in the city and the Château d'Esvres on the outskirts, and he also achieved a position as the king's counsellor and secretary for the parliament of Bordeaux.[6] His recent past and the accusations of hoarding soon caught up with him. He was arrested and imprisoned for some time in the Bastille before a notorious trial sentenced him to repay to the king 100,000 livres in damages for the previous thefts committed in the context of his employment in New France. He died in Tours in 1767 as "seigneur d'Esvres, d'Orsay, Saint-Antoine in Canada and other places."[7] Marie-Charlotte, his ninth child, was born in Montreal on May 3, 1743. As a young lady, she followed her parents when they fled to France in 1760. She was married in 1765 to a nobleman of Touraine, Antoine-Joseph d'Artis de Thiézac, an officer in the infantry regiment of Chartres. In 1766, she gave birth to little Cécile, a future lady-in-waiting to the Empress Josephine.

Little is known about the life of Marie-Charlotte in Montreal or in France. She died in Paris at 173 Rue Saint-Dominique, on January 24, 1805.[8] When Dufau completed his portrait of the Marescot family and dated it 1806, she had already died. Was she included in the painting after her death, painted from an existing portrait, or did the artist have time to have her pose for him before she died? The answer is impossible to know. But this death is clearly referred to by the black bonnet and dark-coloured gown, and especially by the mauve shawl, the colours of recent mourning in which the artist has clothed the deceased woman only.[9]

Antoine-Samuel as a page of the Emperor: A rare picture

The presence in the family portrait of the elder son of the Marescot couple, Antoine-Samuel (1789–1813), standing behind his parents, is an important piece of iconographical evidence for studies of the imperial court and the Imperial Household in particular. The youth is wearing the ceremonial garb for pages, a green jacket adorned with an aiguillette embroidered with gold bees on the left shoulder and a red waistcoat and breeches, a uniform designed by Isabey in the employ of the department of the Grand Master of Ceremonies (**316**); this is the most precise and readable of the known depictions of these garments. The appointment of this young man to a prestigious post reserved for sons of the social elite is underscored here as an undeniable source of pride for his parents and his grandmother.

Antoine-Samuel is mentioned in the *Almanach impérial* in the list of pages for the years 1806 and 1807. The year of his father's disgrace, 1805, was also the year he turned eighteen, the age when the pages had to hand in their uniforms and join the army.[10] Their education in the Imperial Household was designed to turn them into excellent soldiers as well as polished courtiers. In the fall of 1807, Antoine-Samuel was made a lieutenant in the 10th Chasseur regiment.[11] Between 1808 and 1812, he fought in the campaign in Spain and was promoted to captain on March 7, 1810. In January 1813, he became an aide-de-camp to general de Lauriston, whom he followed on the German campaign. He was wounded in the Battle of Leipzig and died a few days later in Dresden at the age of twenty-four on October 26.

At court, the pages carried out various departmental functions and delivered messages, which made them instruments of palace life and discreet witnesses to it. An accurate picture may be found in the memoirs of one of Samuel's comrades, the young Sylvain Pétiet, a page from 1808 to 1812, and in *Mémoires et révélations d'un page de la cour impériale* by Émile Marco de

Saint-Hilaire, also a page during those same years, in whose work are found amusing anecdotes, such as this strange conversation with Madame Mère—who called him Édouard—after dinner at Saint-Cloud one evening in 1810 (her speech, peppered with Corsican inflections, is herein mirrored in Scots):

> "After dinner, everyone having moved into the small blue salon, Madame Mère, who I think had eaten somewhat more than usual, or was perhaps in one of her more expansive moods, stopped me as I was picking up my hat to go in to dine in my turn, and said to me: 'Ma wee Édouard, I find you very sad today—Well, Madame, it's because I have no reason to feel particularly cheerful—Eh! Why for?—Because here, Madame, we never know the day before what we will be doing the next day—You are quite richt; as for me, do you think me blithe?—You, my lady? It seems to me that—Nay, I'm no blithe, though I'm the mither of four kings; of all my puir childer, I have nay mair in my hoose.'"

The conversation, the veracity of which is questionable, concluded in the most delightful manner, as did the young page's evening that day:

> "So you like the emperour—But, Madame, I have that in common with all my comrades and all the people who have the happiness of meeting His Majesty—Well now, ma wee Édouard, here's ane Napolione that you mustn't consume it, you must save it.' Saying this, Madame Mère opened one corner of the batiste handkerchief she was holding and took out a twenty-franc coin from among the many forty-franc pieces in it, and offered it to me. 'I don't know, Madame, if I should accept—Take it, take it, one never knows what the future holds; ane Napolione is always something.' I kissed her fingertips respectfully and put the coin in my pocket—'Always love the emperour, ma wee Édouard, and save your money. What can we do about it? But I am gey doleful. I am no' rich.' . . . Now, if anyone wants to know what I did with the Napolione she gave me as a reward for my attachment to the emperour, I will frankly admit that I did not put it aside to save it, but I took it that very same evening to the prettiest little linen maid, living on Rue de Paris, who had promised to be more approachable if I gave her a present of a black beaver hat; it was the height of fashion, all the women were wearing them. . . . In conclusion, I had only praise for the religious exactitude with which Mademoiselle O . . . kept her side of the bargain, and that same evening I was able to, as they say, kill two birds with one stone."[12]

An ambitious family portrait

A native of Saint-Domingue (now Haiti), where he was born in about 1770, Fortuné Dufau trained in David's studio in the 1780s. He continued his training in Italy before enlisting in the revolutionary armies. He began to exhibit at the Salon in 1800. A history painter but above all a portraitist under the Empire, he came to be a drawing instructor at the École militaire. He died in 1821.[13]

The portrait was presented at the Salon of 1806 with the number 166 and the title *Picture of the Family of H. E. General Marescot, First Inspector of Engineering, Grand Cordon and Grand Officer of the Empire*.[14] In this skilful composition, the scene is organized into two sections distinguishing between two lines of descent, one masculine and the other feminine, both evoking the absence of a deceased individual. The first of these unites the father and his young son in a quiet demonstration of affection and provides them with a substitute ancestor in the person of the hero Vauban, of whom Marescot thought himself the intellectual heir, since he was the chairman of the committee that transported his heart to Les Invalides in May 1808.[15] A bust of Vauban, probably based on an engraving of the portrait by Rigaud, appears at the top of the canvas. The great man of the seventeenth century calls on father and son to play a part in the military history of their country. Corresponding to this manly kinship, symbolically and visually expressed by the vertical, is the horizontal arrangement of the women. Cécile cuddles her youngest child, Joséphine-Cécile, under the attentive gaze of her own mother in a confluence of successive motherhoods. For the composition of this part of the painting, Dufau probably took his inspiration from Leonardo Da Vinci's *Saint Anne* (**317**), which he had doubtless seen exhibited at the Louvre as of 1797.

316

315
Fortuné Dufau
*Portrait of the Family of General Armand-
Samuel de Marescot with His Wife, Cécile,
His Son, Antoine-Samuel, His Daughter,
Joséphine-Cécile, and His Mother-in-law,
Marie-Charlotte d'Artis de Thiézac*
1806
France, private collection

316
Jean-Baptiste Isabey
Nancy 1767 – Paris 1855
Illustration from the *Livre du Sacre* (1804)
by Charles Percier and Pierre-Léonard-
François Fontaine
Costume of a Page (pl. XXX)
Château de Fontainebleau, Musée
Napoléon Ier

317
Leonardo de Vinci
Virgin and Child with Saint Anne
About 1503–19
Paris, Musée du Louvre

317

THE SILVER

FROM THE PAGES' CHAPEL AT SAINT-CLOUD

The silver for the pages' chapel in the Imperial Household (**318**) appears to have been commissioned shortly after Napoleon established the Pages' Household by the decree of August 2, 1805. The pages were given lodging at Saint-Cloud. Although the delivery date cannot be confirmed, it was certainly in 1805 that their residence was furnished by the usual suppliers of the Garde-Meuble, including the cabinetmaker Jacob-Desmalter, the upholsterer Boulard, the maker of soft furnishings Gobert, the bronze-worker Ravrio and the clockmaker Robin.[1]

The pages, answerable to Grand Equerry Caulaincourt, were supervised by a governor, the stern division general Gardanne, and a deputy governor, d'Assigny. Abbé Gandon was their chaplain, and although they played tricks on him, the boys all respected him nevertheless.[2]

After commissioning several items from Jean-Charles Cahier, cardinal Fesch, the Grand Chaplain, soon turned to the silversmith Pierre Paraud for the silver of the imperial chapels, and Grand Equerry Caulaincourt chose instead to call on Jean Loque, another specialist in liturgical vessels.

Born in Turin, Jean-Ange-Joseph Loque was elected a master silversmith in Paris in 1777. He set up shop on the Île de la Cité (Rue de la Juiverie, now Rue de la Cité), then close to Pont Notre-Dame, and later, after the Revolution, on Quai Pelletier (now Quai de Gesvres). His specialization in liturgical pieces was confirmed when in 1798 he took out a new maker's mark.

When the Grand Equerry gave him the commission, Loque was not unknown to the purveyors of services to the Imperial Household, as he had provided several liturgical items presented by the Emperor to the cathedral of Notre Dame for his coronation. These included two silver censers with boats, two gilded silver crosses (one of them a processional cross), a censer decorated with a circle of white stones, and covers for the volumes of the Epistles and the Gospels (*Journal des Débats*, 17 Frimaire, Year 8 [December 7, 1804]).

ANNE DION-TENENBAUM

318
Jean-Ange-Joseph LOQUE
Silver from the chapel of the pages of the Imperial Household
A. Ewer and basin
B. Cruets and basin
C. Paten and candleholder
D. Chalice
E. Ciborium
1805
Paris, Mobilier national

318A

318B

318C

318D

318E

SECOND LIEUTENANT LEGRAND

BY GROS

This portrait of a very young officer leaning against the hindquarters of his horse (**321**) might be fairly considered one of the best of the Napoleonic era preserved in North America. Yet very little information was ever found concerning its model, whose first name was only recently discovered, even though he was known to be a son of one of the Empire's many generals, the comte Alexandre Legrand.[1]

The young man's first name was Dominique-Alexandre. Born on December 11, 1790, in Metz,[2] he was motherless and virtually without a father, since Alexandre was off pursuing his military career far from home. Dominique-Alexandre entered the page department of the Imperial Household in 1805, and is mentioned in the *Almanach impérial* until 1808. Upon turning the required age of eighteen, he joined the army as second lieutenant, a rank reserved for former pages, specifically in the Hussars, and headed off to Spain, where the French were trying to quell a popular uprising. His military career would be short-lived, however, when he met his abrupt demise on May 2. While the streets of Madrid were teeming—it was *Dos de Mayo*—the young officer was killed instantly when an enormous vase, thrown from a rooftop by two women, landed on his head. Although there is no source to substantiate this description of the tragic event,[3] it seems to be true, because Napoleon himself referred to it in passing on May 8 in a letter to Murat, criticizing the deployment of troops in the Spanish capital: "I see by various letters from the officers that unfortunately they spread out throughout the city, rather than remaining together in one or two places, and they are split up in different houses. Thus, the general Lariboisière was not able to leave the house. I am told that my former page Legrand was killed in the streets. Let us learn from experience; that no one be housed in the city, but that everyone be set up in the Palais, the Palais-Neuf, or in one or two mansions. Please make the arrangements."[4]

The recruitment of pages—the *Étiquette* sets their numbers between a minimum of thirty-six and a maximum of sixty—reflected the desire to connect the families from France's political, military and financial elite to the imperial cause, by tying the sons of the most prominent men to Napoleon and those close to him. Living alongside the sovereign in their youth, when their characters were being formed, this future social elite would learn loyalty. The Household expected these adolescents to have a good education and be "most compliant."[5] Their upkeep was funded by their parents, who outfitted them and provided an allowance of 720 francs. Widowed and absent, the general Legrand likely viewed his son's establishment at court—aside from the honour to himself—as a means of securing the best living arrangements for his son.

The haughty pose, despite his tender years, shows the boy's character, conveying his pride at having joined the ranks of the Armée after his time serving in the palace. The son of a general he could not have known much about, Dominique-Alexandre no doubt dreamed of personal glory and military triumphs, as that had been the point of his training.

But let there be no mistake: this portrait by Gros is very likely posthumous, commissioned by the heartbroken father. It was first mentioned in 1810, at the Salon,[6] where Gros exhibited it alongside his portrait of the father, probably painted at the same time, along with the *The Surrender of Madrid, December 4, 1808*, destined for the Gallery of Diana at the Tuileries (**187**), and which, given this juxtaposition, can be viewed in a certain light.

Gros took his inspiration from the annals of the British aristocratic portrait from the previous century. Notably, Charles Millard established a convincing comparison with Gainsborough's *Portrait of John Hayes Saint Leger* (**319**).[7] In the distance, before the mountains, the sides of fortresses can be seen, which, as Joan Siegfried has pointed out, have a certain Spanish feel.[8] It is tempting to see it as a loose interpretation of the Alhambra in Grenada, even though the model never made it there.

A probable sketch of the painting is preserved at the Musée d'Art et d'Industrie at Saint-Étienne, showing the features of an older model with a moustache. This element supports the argument of the posthumous commission. The face may have been painted from a family miniature.[9]

The subject of former pages killed in combat is also evoked in another comparable portrait by Gros, *General-Comte Jean Ambroise de Lariboisière Bidding His Son Ferdinand Goodbye*, presented at the Salon of 1814 (**320**). Ferdinand de Lariboisière, a page from 1806 to 1809, passed away the same year as his father, in 1812, during the Russian campaign. The artist shows them together, reunited prior to departing for the front. As also evidenced by the tragic fate of Samuel de Marescot killed at Leipzig (1813),[10] the mortality rate of former pages was high. These young men, schooled in palace life and bathed in the regime's military propaganda, had barely become adults before they joined the military ranks as second officers. The untimely end of these well-born sons, in whose memories the parents commissioned portraits from more or less prominent artists, would have instigated certain depictions in which personal tragedy would blend with a worship of the soldiery that pitilessly cut down some of the youngest members of the French elite. At the heart of the output of artists like Gros and Vernet, in particular, these works represent a particular type of glorifying portraiture, whether posthumous or not. A type that was striking enough to have quickly won over and inspired the Romantic generation.

SYLVAIN CORDIER

319

320

319
Thomas GAINSBOROUGH
Portrait of John Hayes Saint Leger
1782
London, Collection of H. M. Queen Elizabeth II

320
Antoine-Jean GROS
The General-Comte Jean Ambroise de Lariboisière Bidding His Son Ferdinand Goodbye
1814
Paris, Musée de l'Armée

321
Antoine-Jean GROS
Portrait of Dominique-Alexandre Legrand, Former Page to the Emperor, in the Uniform of a Second Lieutenant of the Hussars
About 1809-10
Los Angeles County Museum of Art

THE
EMPEROR'S
"CABINET"

CHARLES-ÉLOI VIAL

Under the Empire, as under the Ancien Régime, the government was fully integrated into court operations. The palace was the setting for the monarch's Council meetings, diplomatic audiences and work sessions with his ministers, as well as the site for the networks, cabals and cliques that always surround those in power. However, with essentially all of the authority concentrated in the hands of just one man, the imperial court had unprecedented political power.

To govern his empire with its 130 départements, Napoleon also progressively implemented a government body that was called the "Cabinet de l'Empereur," a French term that at once designated the room in which the sovereign worked (the "study") and the government body entrusted with the task of assisting him (the office staff). In his very first months as head of state, the First Consul employed only one secretary, Louis-Antoine Fauvelet de Bourrienne, an old friend, from the Collège d'Autun, who early on was accused of embezzlement and disgraced, which forced Napoleon to make his exercise of power more "professional." Formed in 1802, following the Empire's proclamation, the Cabinet would become a dependant of the Imperial Household, placed under the authority of the Grand Chamberlain, a position entrusted to Talleyrand. As a direct result, Talleyrand inherited the small team of select collaborators that would make it possible for Napoleon to govern. Of the 295 people employed by the Grand Chamberlain in 1812, twenty-six worked for the Emperor's Cabinet.[1] Hidden from the eyes of the courtiers, Napoleon's study and some of the rooms reserved for the members of his Cabinet made up a discrete islet, living alongside the court while participating in its operation.

Setting the stage of power

From his Consulate days, Napoleon took great pains to set the stage of the places where he exercised power so that they were perceived to reflect his work habits and to assert his authority over ministers, diplomats and advisors received for interviews or audiences. At Malmaison in the summer of 1800, the architects Percier and Fontaine designed a vaulted study decorated with painted murals and woodwork (99), closely resembling, according to some contemporaries, a sacristy.[2] At the Tuileries, in Saint-Cloud, and then in the palaces refurbished starting in 1804–Fontainebleau (329), Rambouillet, Trianon (325), Compiègne, as well as Laeken, in Belgium–the work spaces allocated to the Emperor were always outfitted the same way: as a richly furnished study-library well-stocked with books, with a back office and a topographical office. This arrangement was prescribed for all the palaces, and even regulated by a decree dated February 3, 1806.[3] Napoleon also wished to install mechanical

tables, provided by the cabinetmaker Jacob-Desmalter, who also created superb wood furnishings ornamented with Neoclassical bronze motifs for the Compiègne study in 1808 (328).

These rooms also conveyed power. At Malmaison, frescoes depicting the great writers of antiquity and the Ancien Régime portrayed France as the heir of Greco-Roman civilization. At Saint-Cloud, busts of the major figures of antiquity decorated the Emperor's study, suggesting that he was the last in a long line of men of state and conquerors reaching as far back as Caesar and Alexander. At Compiègne, this room was decorated with a ceiling painted by Girodet depicting *Minerva between Apollo and Mercury* (327), an allegory of Napoleon, the warrior-emperor, surrounded by the gods of Arts and Trade, and the figures in the coffers evoked War, Prudence, Poetry, History, Astronomy, Navigation, Abundance, Trade, Architecture, Tragedy and Comedy: such an iconographic program was thought to exalt the role of the sovereign as protector of the economy and the fine arts.

From a practical standpoint, Napoleon required that these work spaces have *paumiers* (comfortable armchairs with one armrest lower than the other for reading while keeping one's toes warm by the fireplace), and *serre-papiers* (cabinets for holding documents (97)). To go over his files, the Emperor designed for himself a violin-shaped table that accommodated two people working face-to-face.[4] His work spaces, which very closely resembled each other from one residence to the next, turned the palaces into seats of power, and, by the same token, the Imperial Household into a central institution within the Napoleonic system throughout Europe.

The pace of government

It was within the four walls of his study that Napoleon passed most of his daylight hours. Early in the morning, he began by signing orders dictated the night before and copied out neatly by his secretary. He then read and annotated the dozens of reports and dispatches that were constantly coming in from the four corners of the Empire, dictated the day's correspondence, his orders, notes and draft decrees. He then scanned the newspapers and reports furnished by his numerous informants, handsomely paid to keep him abreast of rumours flying around all levels of society, from the literary salons to the Masonic lodges. He then took his breakfast at 10 a.m., while his secretaries recopied his correspondence. Upon his return from the meal, which he ate quickly while in conversation with some of his closest advisors, he spent several hours rereading and signing the letters he had dictated that morning and the orders prepared by his ministers that were

323

324

ready to be issued. The rest of the afternoon was spent in audiences, in closed discussions with certain ministers or advisors, or in attending meetings of the Council of State, or the Councils of Ministers, Finance, Trade, and Litigation, which always took place within the walls of the imperial palace. During these group work sessions, Napoleon proved himself to be an active contributor, attending to the comments made by others and open to disparate opinions. Surrounded by experts, he was satisfied with giving out high-level directives.[5] Occasionally, the Emperor would go out hunting or for a stroll for some of the afternoon, or more rarely in the morning. Once in a while, some days were entirely taken up with ceremonies and court life, so the Emperor would set work aside, spending just a few minutes dealing with the most pressing matters. More rarely still, Napoleon might occasionally allow himself some days to do nothing, specifically when he married Marie-Louise and when the King of Rome was born. When the situation required, however, the Emperor was able to work some twenty hours in a row, oblivious to his collaborators' exhaustion. Ironically, this packed schedule ended up exhausting him. At the close of the Empire, he was frequently incapacitated by stress, which also affected his mental faculties.

Even though he was at the centre of it all, Napoleon never worked alone. Locked up in the Emperor's study, which they exited using only the service corridor, his two closest collaborators "lived so much removed, that the chamberlains who had been in service at the palace for four years had never even caught sight of them."[6] The first of these, Claude-François de Méneval, entered the First Consul's employ in 1802 as his private secretary. Napoleon made him a baron, in recognition of the value of this collaborator, one of the only men capable of taking his dictation and deciphering his handwriting. In 1806, Napoleon added Agathon-Jean-François Fain, named "secretary-archivist." A gentle, patient man, capable of withstanding the relentless rhythm of work without flinching, Méneval nevertheless ended up collapsing in 1812, at the end of the Russian campaign. Napoleon sent him to "convalesce" as secretary to Marie-Louise, a much less exhausting position. Fain replaced him until the end of the Empire, helped by some assistants recruited late in the day, including Rathery and Fleury de Chaboulon. As their seconds, two portfolio keepers, Hangel and Landoire, took turns watching over the most confidential of papers, as well as the heating and lighting in the Emperor's study, all while serving as ushers. The man of letters Jean-Marie Deschamps was responsible for looking over the petitions and pension requests sent annually by the thousands to the Emperor. Some clerks were also hired to assist the secretaries, particularly Bary, Jouanne, Rumigny and Prévost. At the end of the regime, the Emperor's swamped secretaries had to hire secretaries of their own![7]

In the antechambers of the interior apartments, the service chamberlain on duty safeguarded access to the rooms where Napoleon worked and received visitors or ministers waiting on the monarch, thus linking the Imperial Household to the world of court. The ministers and Grand Officers of the Crown, regularly invited to work side-by-side with the Emperor, also occasionally had to play the role of secretary by taking down his dictation: dignitaries like Grand Marshal of the Palace Duroc, Grand Equerry Caulaincourt or Intendant-General of the Household Daru grew accustomed, for better or worse, to his extremely

speedy delivery. The comte Beugnot, administrator of the grand duchy of Berg, recounted a funny experience he had one day when Napoleon suddenly started to dictate a series of letters to him: "The Emperor, striding across his study, dictated with great rapidity. He would pause on the first word of the sentence; and, as soon as he found it, the rest would spew out all at once. The first day that I wrote under his dictation, I could not follow him, whatever I did, and I was able to produce only a shapeless rough draft."[8]

Napoleon also had a "Cabinet" secretary, whose title was honorary, although it did allow several important figures to earn their stripes with the Emperor: the future marshal Henri-Jacques-Guillaume Clarke thus fulfilled several important military missions before becoming war minister in 1807. His successor, the baron Mounier, Louis XVIII's future minister of police, then took charge of the Emperor's team of translators from 1807 to 1813. The officer of engineering, Charles-François Deponthon, was hired in 1808 as "second Cabinet secretary." The Emperor's Cabinet eventually operated in tandem with another institution that was outside the court, the Secretariat of State, a type of secretariat general for the government, whose head officer, with the rank of minister, was responsible for coordinating the work between the Emperor, his ministers and various sections of the Council of State, organizing meetings, transferring documents and ensuring follow-up.[9] The minister secretary of state—first Hugues-Bernard Maret, then, as of 1811, Pierre Daru—was an essential cog in the well-oiled government engine, while the Emperor's Cabinet was the fan belt in the transmission, whose decisions drove the entire Empire. In 1812, the cost of operating the Emperor's Cabinet was 244,000 francs.[10]

During the military campaigns, the Emperor's Cabinet, while following up on all of France's internal affairs—which Napoleon could oversee thanks to the couriers who kept up a constant back-and-forth to and from Paris—also served as headquarters for all military operations. The Emperor's secretaries were assisted by the aides-de-camp and orderly officers, as well as the marshal Berthier, major general of the Grande Armée. The Emperor travelled in a specially outfitted coach, where he found everything he needed to write and work. In Napoleon's eyes, the Emperor's Cabinet papers were seminal, and he was quick to burn them in 1812, at the end of the retreat from Russia, rather than to let them fall into the hands of the enemy. In 1815, the portfolio holding his letters, captured by the Prussians after Waterloo, revealed some of the arcana of the Hundred Days, which deeply upset the former members of the imperial government. Shortly before his death, Napoleon flew into a rage upon learning that Fleury de Chaboulon, one of the least experienced secretaries who had been hired in the early Hundred Days, had the audacity to publish three volumes of memoirs revealing his Cabinet operations.[11] For the Emperor, the secret machinery of the government should never have been revealed. However, two other secretaries, Méneval and Fain, would also leave behind autobiographies, itemizing in great detail the Emperor's work habits and style of governing the Empire.

Books, maps and archives

The Emperor's Cabinet also contained several small departmental offices dedicated to documentation for the head of state. Napoleon basically refused

322
Jacques-Louis DAVID
*The Emperor Napoleon in His Study at
the Tuileries*
1812
Washington, D.C., National Gallery of Art

323
Seven maps of Germany in a case
Rueil-Malmaison, Musée national
des châteaux de Malmaison et Bois-Préau

324
ANONYMOUS, FRANCE
Writing case with pen holder
After 1805
The Montreal Museum of Fine Arts

325
Workshop of François-Honoré-Georges
JACOB-DESMALTER
**Armchair in Napoleon's study at the
Grand Trianon**
1810
Musée national des châteaux de Versailles
et de Trianon

326
Jules VERNET
*Portrait of M. Barbier, Librairian to H. M.
the Emperor and H. M. Louis XVIII*
1822
Paris, Musée des Arts décoratifs

325

326

to work without information, preliminary reports or notes sufficient to aid him in decision making. The ministers regularly provided him with "pamphlets" or "status updates," sometimes in calligraphy or sealed with his coat of arms. Some took inventory of the troops and circumstances of the imperial army's regiments, while others kept him abreast of the progress made on road infrastructure in the capital or the estimated budgets and revenues of the various administrations.

In just a few years, Napoleon's librarian, Antoine-Alexandre Barbier (**326**), amassed under the Emperor's orders a significant book collection—68,000 volumes in ten years—all bound with the imperial coats of arms.[12] In all the Crown's palaces, the walls of the Emperor's studies were literally carpeted in books: on the bottom, the librarian shelved the large morocco leather-bound folio volumes, particularly the sumptuous publications funded by the Imperial Household, like the *Description de l'Égypte*, the collections of prints from the *Musée français* or the complete collections of the *Moniteur*, official newspaper of the Empire, which carried reports of imperial victories. On the upper shelves, catalogues mention works of philosophy, sciences, French and foreign law, literature, French history, as well as travelogues and geographical texts. The Emperor's favourite authors, historians like Rollin, dramatists like Racine and classical authors such as Polybius and Xenophon, brushed bindings with more complex works like *Statistique de la France*, the Ancien Régime's legal casebooks or treatises on military history. Napoleon also received thousands of books sent by authors desiring his notice, certain of which, with their magnificent binding, were admitted into his library. On his desk at the Palais de Saint-Cloud sat a bible on parchment that had belonged to Charlemagne, today at the Bibliothèque nationale de France. Moreover, every week, Barbier delivered pretty much all the newly published books, brochures, newspapers and caricatures, as the Emperor was a voracious reader of novels and tried to stay on top of new developments on the Paris literary scene.

In addition to the thousands of books Napoleon devoured, his Cabinet also had its own archives, headed by the baron Fain, who was assisted by two office boys: all the letters both sent and received, reports, ministerial budgets, records and minutes of decrees were carefully archived. Another crucial department, Napoleon's topographical offices, which consisted of a small seven-person team led by the engineer-geographer Louis-Albert-Guislain Bacler d'Albe, provided Napoleon with the maps and geographical information he needed before any skirmish (**323**). Lastly, the translation office, staffed by

eleven specialists, received on a daily basis newspapers and books published throughout Europe, so the Emperor could remain informed of public opinion outside of France, particularly in England, or glean intelligence about the geography, politics and organization of foreign armies. It was thus by controlling and concentrating on information crucial to the smooth functioning of the government and the efficacy of the army in just a few rooms of his apartments that Napoleon made the court and his Household an instrument of power. His books, maps and archives followed him to the country, safely packed into mahogany cases, making it possible for the Emperor to reconstitute, in all of his travels, an environment that replicated the ambience of the Tuileries and was perfectly suited to work.

From the Consulate until the end of the Empire, the Cabinet rooms were completely incorporated into Napoleonic propaganda: the *Journal de Paris*,[13] and the foreign press too, particularly the English and the American,[14] published descriptions of the rooms while lauding Napoleon's capacity for work. In 1807, Daru commissioned two paintings from Étienne-Barthélémy Garnier entitled *The Emperor in His Topographical Office* and *The Emperor, Surrounded by His Secretaries, in His Study Decorated by Busts of the Great Men of Antiquity*, paying 12,000 and 19,000 francs respectively, which were intended to be turned into tapestries by the Gobelins manufactory.[15] The second was exhibited at the Salon of 1808 and was even issued as a print.[16] A painting (whereabouts unknown) entitled *The Emperor Fighting Off Sleep* was also shown at the same Salon.[17] Finally, in 1812, David painted for the Duke of Hamilton, a Scottish aristocrat fascinated by the Emperor, his famous *The Emperor Napoleon in His Study at the Tuileries* (**322**). In this painting, the scattered papers, the clock indicating four o'clock in the morning and the candles burnt down to a nub sketch a characterization of the leader as a tireless worker, his face lined by fatigue. The presence of a book by Plutarch and a rolled parchment upon which reads "Code civil" reinforces the image of the hero, at once intellectual and rigorous.[18] By depicting him thus, like a leader busy toiling for the good of his country, David broke with the convention of royal portraits of monarchs in ceremonial robes or official apparel. This crucial component of the Napoleonic legend also inspired a number of heads of state, both ministers and presidents, who would do everything possible to portray themselves at the office or busy working on their brief. This sort of stagecraft has even become an essential component of contemporary political iconography.

327
Anne-Louis GIRODET DE ROUSSY-TRIOSON
Minerva between Apollo and Mercury,
ceiling decoration for the Emperor's study
at Compiègne
Between 1814 and 1821
Musée national du château de Compiègne

328
View of Napoleon's library (study) at the Palais
de Compiègne in its current state

329
View of Napoleon's library at the Château de
Fontainebleau in its current state

328

THE IMPERIAL
HOUSEHOLD
AND THE
THEATRES
OF THE
REGIME

CYRIL LÉCOSSE

Music and theatre enjoyed Napoleon's full support throughout his reign. The Emperor was genuinely fond of opera and was interested in and attentive to stage entertainments, which often reflected his politics.[1] The script, acting, directing, music and set design were all seen as expressions of his power. Under the Empire, the authorized theatres were divided into three categories: the *grands théâtres* (the major theatres Théâtre-Français, Académie impériale de musique [the former Opéra], Opéra-Comique and the Théâtre de l'Impératrice), the theatres considered "secondary" and the court theatres (Tuileries, Compiègne, Saint-Cloud, Fontainebleau and Trianon).[2] The four major funded theatres were placed under the authority of the First Chamberlain of the Imperial Household, the comte Augustin-Laurent de Rémusat. Appointed super-intendant of entertainment in 1807, he was in charge of overseeing the smooth running of performances given at court. Regarding the choice of plays, his margin of manoeuvrability remained nevertheless slim. It was Napoleon who ultimately approved all programming.[3]

Although it is possible to study the organization, operations and programming of the imperial theatres, thanks to numerous invoices, reports and letters, the purview of the following essay is rather more circumscribed. While basing the discussion on the figures of the main artists related to the department of entertainment of the Imperial Household, the focus will be on the functioning of the workshop that provided the theatres with set decoration as well as the stylistic orientation of the sets created between 1807 and 1814.[4] The plans for the sets designed by the painters and decorators working at court—archives and drawings—make it possible to illustrate in a fairly significant fashion the contribution these artists made to the history of stage design in France.

The taste for spectacle at the Consular court
After the formalization of the Consulate for life in August 1802, Bonaparte's event-driven policies ramped up. Theatre occupied pride of place in the leisure activities of the members of the small Consular court. A number of entertainments were organized at Malmaison in the theatre designed by Fontaine, the government's architect.[5] Jean-Baptiste Isabey, a Bonaparte regular since the Directory, was in charge, along with Antoine-Marie Peyre (the First Consul's architect at Malmaison), of producing the sets and overseeing the proliferation of commissions and jobs necessitated by these private entertainments.[6] The cast of the "regular actors," mostly amateurs, included such notables as Eugene and Hortense de Beauharnais, Louise Lannes, future duchess of Montebello, Caroline Murat, prefect of the palace François Didelot and Isabey

himself.[7] Rehearsals were often directed by the actors Michot and Talma. The approach reveals an urbane amateurism. But after the coronation, the Imperial Household undertook to offer from the on entertainments that equalled the ambitions of the master. A budget of 400,000 francs was allocated, as of 1806, to court entertainments, and several rooms were outfitted as theatres in the imperial residences. The festivities became regular occurrences. Two performances were programmed each week, on average—concerts, ballets, operas, plays. Alongside singers, dancers and actors recruited to perform exclusively in the palace theatres (Girolamo Crescentini, Giuseppa Grassini, and others) (330), troupes from the Paris theatres were regularly invited to perform at court—more than 400 times between 1806 and 1813.[8] The "stars" were called first, like the tragedian Talma (331), a favourite of the Emperor's, who performed at Fontainebleau in eleven different plays between September 21 and November 16, 1807 (from *Le Cid* to *La Mort de Pompée*). The steady pace of the performances frequently led to the redeployment of set elements designed previously—often for other official theatres—but also to the design of original sets whose execution was entrusted to Isabey, in his role as artist to the Cabinet.

The painters and decorators of the Opéra and court theatres (1808-14)
Renamed the "Académie impériale de musique" on June 29, 1804, the Opéra underwent a major overhaul under the Empire.[9] The building was placed under the authority of Rémusat, with Louis-Benoît Picard providing the actual management. Their supervision of the Opéra was mainly financial: the budget for this department was submitted to them for approval, and every expense had to be vetted first, with the submission of a detailed estimate. The estimates were made by the Italian painter Ignace Degotti—a friend of David's—who served as head decorator, a position he had filled under the Consulate.[10] Unhappy with the account management and irritated by the "painter's slowness," Napoleon asked Isabey to assist Degotti after 1808.[11] Isabey joined the imperial theatres' team of decorators without any special title, only to find himself under the purview of the Imperial Household's super-intendant of entertainment, the First Chamberlain Rémusat. Isabey had to satisfy the Emperor's demands, as he inherited the title of head decorator of the Opéra on February 4, 1810, replacing Degotti, who was officially dismissed. It would be incorrect to see this nomination as simply an additional favour. There was a long-standing tradition that saw renowned artists at the head of set decoration: the artists Charles-Nicolas Cochin and Moreau le Jeune are illustrious names in this field.[12] As for the rest,

330
Élisabeth Louise VIGÉE-LEBRUN
Portrait of Giuseppa Grassini as Zaïre
1804
Musée des beaux-arts de Rouen

331
Louis-Léopold BOILLY
Portrait of François-Joseph Talma
About 1800
Lille, Palais des Beaux-Arts

332
Jean-Baptiste ISABEY
Bust-length Portrait of Luigi Cherubini
1811
Paris, Musée du Louvre

333
Jean-Baptiste ISABEY
Armide, scenery sketch (Act II)
1811
Paris, Bibliothèque nationale de France,
département Bibliothèque-musée
de l'opéra

when Napoleon called on Isabey in 1808, the artist had a number of connections in the entertainment world, particularly with the composers Méhul and Cherubini, the singers Garat (**332**) and Elleviou, the actor Talma and playwrights Antoine-Vincent Arnault and François-Benoît Hoffman.[13] Several of these figures were also depicted in the painting Boilly exhibited at the Salon of 1798 with the title *Meeting of Artists in Isabey's Studio*.[14]

The added load of being decorator, heavy enough for the Cabinet artist, was recompensed by honoraria of 4,000 francs per annum, which was supplemented by five percent of the amount of the verified estimates.[15] Placed at the head of a workshop with a staff of eleven, Isabey parcelled out jobs, oversaw operations, ordered materials, made deals with the painters and other suppliers for the court theatres, supervised the workflow and, above all, once the work was done, verified the estimates and certified the bills, necessary for payment.[16] But, first and foremost, the artist had to develop the sketches—flat maquettes—for each of the ordered sets. Prior to the execution of the first sketches, Isabey had to attend a reading of each of the selected plays, along with Bichet, inspector of the court theatres, the actors, conductor and head stagehand. Then, under its own authority, the workshop painters and decorators painted the plans to actual scale—transferred to a grid—on the frame of the wings raised on posts, roof timbers (vertical, fixed panels), curtains and floating or fixed canvas. Among them, it is worth nothing, was Jacques Daguerre, the famous inventor of the diorama (1822); the workshop head Jean-Constantin Protain, in charge of all architectural tracing; Boquet, who did figures and clouds; and Pierre Ciceri for the landscapes and ruins. The artists were aided by the stagehands—some dozen men—who ensured the execution of the complex assembly.

Between 1808 and 1813, this small team connected to the Imperial Household produced a great number of sets. Some were commissioned for the production of new plays, others to supplement an ever available reserve repertoire. Although they were connected, for the most part, to plays, ballets and operas produced in the regime's four major theatres, the sets were often re-used in imperial residences, sometimes with some modifications or reductions—only the first act of *Leonara*, an opera by Ferdinando Paer (director of the Court Theatres as of January 1807),[17] was produced at Fontainebleau on November 8, 1809. For the court theatres, the Isabey-led workshop notably built the sets for *Numa Pompilio* (1808-9), *Pygmalion* (1809), *Roméo et Juliette* (1809), *La Vierge du Soleil* (1810), *Vertumne et Pomone* (1809), *Les Horaces* (1810), *Alexandre* (1810), *Éléonore* (1809), *L'Amour conjugal* (1809), *Orphée* (1810), *Télémaque* (1810), *Agamemnon* (1812), *Zaïre* (1812) and the operas

Tippo-Saël (1813) and *Sérix* (1811).[18] Isabey also designed the sets for the largest Opéra productions in the second half of the Emperor's reign, including some that were remounted at court: *Les Amours d'Antoine et Cléopâtre* (1808), *Les Bayadères* (Étienne de Jouy, 1810), *Les Amazones* (1811), *Armide* (1811) *L'Enfant prodigue* (Gardel, 1812), *Les Abencérages* (Cherubini, 1813) and *Alcibiade solitaire* (Cuvelier de Trie, 1814).

The stage in perspective

Of the considerable amount of work produced by the painters and decorators, as revealed in minute detail by the imperial archives, there remains, unfortunately, few remnants. None of the life-sized elements produced by Isabey's team for the Opéra stage—divided in some fifteen successive planes—has been preserved. Some rare drawings saved from oblivion make it possible to broach this facet of the miniaturist's work. These give a general but nevertheless specific idea of the stylistic direction of the theatre sets designed under the Empire. Most of these drawings are currently in the Bibliothèque du musée de l'Opéra in Paris.[19] They relate to the ballet *L'Enfant prodigue* (1812), set in Egypt, *Amours d'Antoine et Cléopâtre*, an opera performed in March 1808 and *Armide* (drawing dated 1811) (**333**). These line drawings are all highlighted in sepia applied with large brushstrokes, sometimes done in watercolour and generally annotated on the back by the hand of their creator. With such a technique, the artist could easily vary, accentuate or soften the interplay of light and shadow that enlivens lighting for the architectural elements, thus supporting the work of the performers. To reinforce the impression of distance, Isabey emphasized the monumentality in the foreground by playing with all the perspectival resources at his disposal, in the manner of scenes drawn by Serlio in his treatise on architecture and perspective (**334**, **335**).[20] To this end, he used a small theatre made of wood consisting of "wings and ramps" that enabled him to design and arrange miniature painted set pieces.[21] The proportions of the background constructions diminished progressively, creating a convincing optical effect. This strategy can be explained by a development in stagecraft that had already been in use in France for some years. The extended pieces of canvas that had created the illusion of space and suggested the presence of furniture were replaced by freestanding panels, of various shapes and sizes, arranged along the length of the stage: it was meant to look real.[22] The actor was placed in a convincing space, a "rectangular box," to use Catherine Join-Diéterle's expression: he could thus use the space on stage or even move to the overhanging balconies.[23] The sketches for the *L'Enfant prodigue* and the one depicting the "Vestibule of the

333

Vulcan Temple" (*Amours d'Antoine et Cléopâtre*) (**336**) attest to this attempt to take into account the three dimensions of the stage. The artist employed *per angolo* perspective. Contrary to the "The Portico of Alexandria" (**338**), whose composition is frontal and symmetrical, the vanishing point of these sketches is more often than not off-centre. This discrepancy made it possible to execute the facades of the monuments on one side of the stage, in great detail, while reinforcing the illusion of depth. The monumental scale of the foreground of the "The Vestibule of the Vulcan Temple" thus contrasts with the broad space stretching into the distance. Using the rules of aerial perspective, the painter did not hesitate to play with the sequencing of light effects. In enclosed spaces (*Les Bayadères*), the importance accorded the backstage favoured the unity of place prescribed by classical tragedy. In this, Isabey adopted David's solution for the design of stage space in *The Tennis Court Oath*: the small size of the stage upon which the story takes place imposes a tightening of the action in space (unity of place) and, by eliminating secondary plots (unity of action), rationalizes the concentrated duration (unity of time).

The repetition of specific architectural and decorative motifs is another distinguishing feature of Isabey's sketches. The analogies are also plentiful, with the Neoclassical ornamentation illustrated in the *Recueil de décorations intérieures* by Percier and Fontaine. However, antiquity was not Isabey's only source of inspiration: the Middle Ages, the Renaissance and exoticism, much in fashion in the early nineteenth century, are also evident in his drawings. Many of the set designs also align with the taste for archeology aroused by the Egyptian campaign. In the "Vestibule" of *Amours d'Antoine et Cléopâtre* (**336**), which depicts the inside of an Egyptian temple, the artist covers the rectangular ceiling and large entablatures with hieroglyphs. The space is enclosed by massive columns topped with hathoric capitals. The ramp is decorated with statues of the falcon-headed god Horus and the intercolumniation walls with vases filled with flowers. To the left, between two columns, is a door topped with a feline echoed on the right side of the composition by an identical door. Outside, a sphinx-lined path plunges into the perspective. This vision of Pharaonic art is not entirely imaginary. To be as realistic as possible, the artist probably took his inspiration from plates illustrating the *Voyage dans la Basse et la Haute-Égypte* published, in 1802, by Denon (**337**).[24] He may have also studied objects brought back from the Egyptian campaign. Generally speaking, critics lauded this "loyalty to locale," even the "striking truth" of the set design, even though the placement of the various monuments did not actually correspond to rigorous architectural reasoning.[25]

The new productions slowed down after 1811.[26] A burden on the imperial finances, the war fought on the Russian and German fronts curbed all expenses related to theatrical entertainments. Henceforward, the sets were not changed from one show to the next. Only the elements absolutely necessary to establish the context of the new plays increased the stores of ornaments. For Isabey, the creative work increasingly gave way to administrative obligations: the bulk of the bills for painting and sets amended by the painter related to the theatre at Saint-Cloud or the one at the Tuileries, where the painters Moench and Lemaire officiated.[27] Unmotivated by his role as stage manager, the Cabinet artist used any excuse to shirk his responsibilities, refusing any additions to his official duties, the source of multiple income streams.[28] Relying on his son-in-law, Ciceri, who managed operations in Isabey's absence, he no longer demonstrated any enthusiasm for or attentiveness to his office.[29] This attitude earned the artist severe rebukes from Picard. The reprimands became more and more specific and increasingly threatening as of late 1814. After the fall of the Empire, Isabey's salary was suspended in January 1815. His dismissal was made official on August 17 of that year by the Intendant-General of the Table and Pleasures, Papillon de la Ferté.[30] According to him, "The Académie does not find in Master Isabey, painter of miniatures, the type of talent necessary for the work of set decoration." However, his "imprecision" and the "lack of zeal with which he performs his functions"[31] were only part of the reason for his dismissal. Firing Isabey was, above all, a way to condemn his liberal ideas and to make him pay for his friendship with the family of the deposed emperor.[32] According to the decision made by the comte de Pradel, super-intendant of theatres, Degotti was reinstated in the position that he had lost in 1810. Ciceri became his first assistant. On August 27, Isabey was asked to hand over to the secretary general all the drawings he had produced while in office at the Opéra.[33] He did not comply with this request, keeping the important sketches at home until the death of his wife.[34] This likely accounts for the lack of Isabey's theatre plans in public collections.

334

335

336

337

334
Jean-Baptiste Isabey
"Place Italy," scenery sketch
19th c.
Paris, Musée du Louvre

335
Sebastiano Serlio
"Tragic Scene" in *Treatise on Architecture*
1550–53
New York, The Metropolitain Museum of Art

336
Jean-Baptiste Isabey
Les Amours d'Antoine et Cléopâtre, scenery
sketch ("Vestibule of the Vulcan Temple")
1808
Paris, Bibliothèque nationale de France,
département Bibliothèque-musée de l'opéra

338

337
Louis-Pierre BALTARD
After Dominique-Vivant Denon
Interior of the Temple of Apollinopolis at Edfu
Published in *Voyage dans la Basse et la Haute
Égypte*, Paris, 1802, pl. LVII
1802
Paris, private collection

338
Jean-Baptiste ISABEY
Les Amours d'Antoine et Cléopâtre, scenery
sketch ("Portico of Alexandria")
1808
Paris, Bibliothèque nationale de France,
département Bibliothèque-musée de l'opéra

339
Charles PERCIER
Pierre-François-Léonard FONTAINE
"Bed executed in Paris for M' O . . ."
Pl. 25 from *Recueil de décorations intérieures*
1812
Bibliothèque nationale de France,
département Réserve des livres rares

339

THE EMPRESS
JOSEPHINE'S HOUSEHOLD

AFTER
THE DIVORCE

BERNARD CHEVALLIER

Josephine (**340**) had known since the Consulate that she would be unable to give Bonaparte an heir, and she lived under the shadow of divorce throughout her days as Empress. She tried to deny the infertility that plagued her, declaring to whomever would listen that she had two children from her first marriage, which was not the case with Napoleon, to whom she assigned the blame. It was only upon proving with certainty that he could father children, following the pregnancies of his mistresses Éléonore de la Plaigne (1806) and then Marie Walewska (1809), that the Emperor decided to separate from Josephine. The mutually agreed-upon divorce took place at the Palais des Tuileries on December 15, 1809, in the presence of the imperial family and a large segment of the court. Josephine retired to Malmaison the very next day, and the Emperor took refuge at the Grand Trianon.

New status, new palace
Napoleon decided to let Josephine keep her title, and even though she would no longer be called H. M. the Empress and Queen, a title reserved for a reigning sovereign, she would henceforth be known as H. M. the Empress Josephine, and would maintain her status as monarch. She would continue to use the imperial coat of arms surmounted by an eagle against the bee-studded mantle, her coach would be drawn by eight horses (like that of the Emperor), and the imperial livery would be worn in her Household, which would allow members to appear at the Tuileries and thus not lose their position in court while continuing to serve her. Napoleon remained tender with her: by decree on December 16, he gave her the Malmaison property and the collections it held, in addition to the Château de Buzenval and its woods and surrounding land. For her residence in Paris, he made available the Palais de l'Élysée, considered the most sumptuous in the capital. Moreover, Napoleon wrote to her on January 28: "I have settled your affairs here and ordered that everything be brought to the Élysée-Napoleon."[1] Josephine lived there for only a short time, just six weeks in February–March 1810, content with setting up the offices of her intendance there and selecting a few pieces of furniture for her personal use at Malmaison. She made sure to have the Sèvres manufactory deliver, as early as March 9, 1810, a dinner service and a dessert service with flower bouquets at the centre and a chrome green ground marli, of which many pieces still exist. Although Napoleon took back the Élysée in 1812 for his own use, he made available to her in exchange the Palais de Laeken, near Brussels, where she never once went. But by 1810, Josephine needed a spot further from Paris than Malmaison, especially when

the wedding celebration to Marie-Louise was fast approaching. He then thought of the Château de Navarre, located near Évreux, which on March 11, 1810 he made a duchy for her; time was of the essence, and the very next day he wrote to her: "My dear friend, I hope you will be content with what I have done with Navarre. You will find yet more proof of my desire to treat you well. Take possession of Navarre; you can go there on March 25 and remain the entire month of April. Goodbye, dear friend."[2] It amounted to an order, and she was forced to come to terms with this near-exile in Normandy. Although the park was magnificent, the same could not be said of the residence, which had to be redone in its entirety and was impossible to heat in winter. Josephine stayed there only three times: in 1810 and 1811, and one last time in April 1814, when she sought refuge from the coalition armies then occupying Paris. She held a small court there that was part star-studded, part provincial, but that nevertheless maintained a semblance of etiquette, as she was still part of the imperial family and, from afar, the Emperor made sure she garnered the same respect as if she were still living at the Tuileries. Apart from the great celebration she put on for the birth of the King of Rome and the Carnival of 1811, her bland life—consisting of reading, boat outings and games of backgammon—was relieved by visits from her children, Eugene and Hortense, who were sometimes accompanied by their Tascher cousins. Usually attended by seven or eight ladies and one or two men, she found the life she led closely resembled that of a nun in a convent.

But what a luxurious convent! With an annual allowance of two million francs from the State coffers, Napoleon added by decree another million as a dower drawn from the Crown Treasury. This amounted to three million, enough to ensure she lived comfortably. Not yet satisfied, he added another 400,000 francs to purchase the Bois-Préau property, pay for her ruby jewellery and have her park planted with whatever she desired. In a letter of January 7, he added: "You should find 500,000 or 600,000 F still in the armoire at Malmaison. You can use it for your silver and linens. I have ordered a beautiful porcelain service to be made for you. They will follow your orders to make it beautiful."[3] In fact, in his eyes, Josephine's status was absolutely not to diminish; she remained crowned Empress and nothing was to change with respect to her life or lifestyle. Between 1810 and 1812, the Emperor visited her at Malmaison on four occasions; he generally stayed a little more than an hour and later recalled on Saint Helena: "I rarely went there but once a year, and it was always an unpleasant and painful experience for me: regrets, tears . . . And there was nothing I could do!"[4]

Setting up a new Household

To maintain her rank as Empress, Josephine had to have a Household, albeit slightly less grand, but it would use up nearly half of the annual three million endowment, amounting to 1,317,697 francs; the divorced monarch was still surrounded by about 170 people! Two days after the separation, on December 17, 1809, Grand Chamberlain Montesquiou wrote a letter to every member of the Empress' Household, informing them of the measures taken: "Service to the Empress shall continue as is until January 1810," and "the officers who would wish to be part of the new Household after said date will be allowed to continue rendering service."[5] In fact, it is only by a decree made on February 24 that Napoleon decided that the staff operations of the former Household should cease. This did not stop him from dictating to Grand Marshal of the Palace Duroc the rules of the new Household of Empress Josephine on January 1. Relatively brief, it consisted of sixteen articles. It started by stating that the imperial court *Étiquette* in effect would be adhered to in all of her residences. The officers and ladies-in-waiting would be appointed by the Emperor, and would include the following: the First Chaplain, assisted by two chaplains, to oversee everything having to do with worship and the distribution of alms; the lady of honour, head of the entire Household, to deal mainly with serving the apartments, wardrobe and finery; six, and soon after, nine ladies-in-waiting; a chevalier of honour to accompany and supervise the Empress' guards in the palaces and on her travels; six chamberlains, one of whom would be tasked especially with directing music, concerts and celebrations; a First Equerry, to see to everything regarding the stables, and four equerry assistants; a reader; a secretary of orders, who would act as the principal secretary; and Intendant of the Household, who would manage and collect all revenue, and settle all of the accounts of the various Household departments. Six ladies-in-waiting and six honorary chamberlains could also be enlisted independently. In notable contrast to the former Household, there were no longer ladies to announce or ladies of the robes and there was now only one reader.

Then began a period of defections, and there was no mad rush to vie for positions less prestigious than those to be created for the new Empress. There were those who remained loyal to the end, such as First Chaplain monsignor de Barral,[6] archbishop of Tours, whose brother had married a Beauharnais; he had two assistant chaplains, fathers Mondon and Malfilâtre. Equally loyal among the loyal was the lady of honour Mme d'Arberg,[7] a respectable woman who took everything upon herself. However, it would be far more difficult to hold onto the ladies-in-waiting, who were more inclined to serve at the Tuileries than stay with a repudiated empress. The exception was Mme de Rémusat[8] (344), who had been with Josephine since the Consulate era. Marshal Ney[9] had a short stint, as he was given a formal order from her husband to hand in his resignation. Six ladies-in-waiting were appointed and two others by an order of December 26, 1810. They were Mmes de Walsh-Serrant,[10] d'Audenarde,[11] de Vieil-Castel,[12] de Turenne,[13] de Colbert,[14] de Ségur[15] among the first appointments, and Mmes de Lastic[16] and de Saint-Alphonse[17] for the two new ladies. They would remain loyal to her until the end, and it was only on April 13, 1814, when Josephine was taking refuge in Navarre, that she freed them from the oath they had taken as ladies-in-waiting. The same continuity was displayed by the chamberlains, who, numbering four, carried out their duties in quarters. The appointees were MM. de Turpin de Crissé,[18] de Vieil-Castel,[19] de Montholon[20] and de Beaumont,[21] who would later assume the functions of the chevalier of honour, whose regulation would be signed by Josephine only on July 16, 1811; the post of chamberlain he left vacant went to M. de Lastic[22] by the order of December 26, 1810. The stables were managed by the baron of Monaco,[23] whose negligence eventually threw the department into such complete disarray that he was dismissed in August 1811 by order of the Emperor. He had two assistant equerries, MM. d'Andlau[24] and de Pourtalès,[25] the latter of whom became the new First Equerry in August 1811; M. de Chaumont-Quitry[26] was appointed to replace him. Deschamps,[27] secretary of orders since 1804, continued to serve Josephine after the divorce, while the beautiful Genoese, Mme Gazzani,[28] kept her post as reader. The Intendant-General of the Household was at the top of this structure. Napoleon thought he had found in Pierlot[29] a strict administrator of his former spouse's expenses. Appointed on January 1, 1810, Pierlot was entrusted with keeping the books for all of Josephine's expenses; however, neglecting his own affairs, he found himself in debt by hundreds of thousands of francs, went bankrupt in April 1811 and lost two-thirds of his wealth. The Emperor demanded his resignation and looked for a successor. There were many candidates for this rather perilous post, which ultimately went to Montlivault,[30] who was appointed by decree on June 29, 1811. With the return of the Bourbons, who had forgotten Josephine's largesse, he decided to retire as of March 30, 1814, two months before the death of his benefactress; the chevalier of honour M. de Beaumont filled in the interim.

This small court was rife with love intrigues and gossip, as there were as many as five single men. People claimed that Josephine was having an affair with her chamberlain, Turpin de Crissé, because flowers had been affixed to the album of views of Switzerland and Savoy that he had given to the sovereign.[31] The truth is that she always liked young people and being surrounded by youth, and few members of her Household were older than forty. It would seem there was nothing more than a loving friendship between them, as she hastened to marry him off in 1813. Josephine was, above all, very close to her daughter, Hortense (343), who had finally separated from her husband, Louis Bonaparte. The two women shared the same taste in the arts, both commissioning two Troubadour-inspired works from the painter Fleury Richard; moreover, one of Hortense's ladies, Pascalie d'Arjuzon, made a copy of the *Henry IV and Gabrielle d'Estrées* (342) belonging to Josephine, while she did the same for *The Renunciation of Madame de Lavallière* (341).

Finding an even keel in 1811

Everybody was aware, especially Napoleon, of the scant attention Josephine paid to her expenses. At Malmaison and Navarre, nobody could ignore the incredible waste of money across every Household department. It all came to a head in the summer of 1811, when Josephine realized that her First Equerry, M. de Monaco, had manipulated the books to hide the deficit. She confided in a letter to her daughter on August 21: "In truth, if this is not fraud, it certainly looks like it."[32] Informed of the bottomless financial pit widening under his former spouse's feet, Napoleon decided to take corrective measures and delegated no other than his treasury minister, Mollien, to review the books. The Emperor insisted that nothing more would be paid to Josephine unless proof were provided that no debt remained. Yet when confronted with Mollien's rigour, Napoleon reprimanded him by instantly ordering him not to make Josephine cry. On August 25, the Emperor wrote to Josephine: "Put your financial house in order, keep to 1,500,000 F and put aside as much every year, which in ten years will make 15,000,000 in savings for the grandchildren . . . Appreciate how little I would think of you to learn that you were in debt with an income of 3,000,000."[33] And he was not unaware that half of the amount was eaten up by her Household costs! But as was his wont, about every three years, he would put things back in order by paying off her debts. Full of good intentions, the Empress would delude herself about her abilities to keep up with expenses, to the point of writing to her son, the prince Eugene, on January 13, 1812, in honour of the New Year: "my business is settled and all of my debts paid."[34] Did she ever become careful with money? A review of her accounts may lead one to think so, but upon her death in May 1814, her heirs discovered a debt of nearly 3,000,000. Josephine was incorrigible.

340
Joseph CHINARD
Bust of the Empress Josephine
1805
Ottawa, National Gallery of Canada

341
Pascalie HOSTEN, comtesse d'Arjuzon
The Renunciation of Madame de Lavallière
1813
Paris, private collection

342
Pascalie HOSTEN, comtesse d'Arjuzon
After Fleury RICHARD
Henry IV and Gabrielle d'Estrées
1813
Paris, private collection

343
Jean-Baptiste ISABEY
Portrait of Queen Hortense
1814
Paris, private collection

344
Guillaume DESCAMPS
Presumed Portrait of Claire de Vergennes, Comtesse de Rémusat, Lady-in-waiting to the Empress Josephine
1813
Rueil-Malmaison, Musée national des châteaux de Malmaison et Bois-Préau

341

342

343

344

When, on August 22, 1810, by imperial decree, Henri Beyle (346) (who was not yet Stendhal) was appointed adjunct to Pierre Daru, Intendant-General of the Imperial Household "for the inspection and verification of various objects for the accounting and administration of the Garde-Meuble, in accordance with the decree of October 17, 1807"[1]–the decree also allotting to the Intendant-General's adjunct auditors the inspection and verification of objects for the accounting and administration of the Crown's buildings–he was not a neophyte. During the German campaign of 1806-7, as adjunct commissary to Martial Daru (345), then intendant at Brunswick, Beyle worked alongside Dominique-Vivant Denon for the removal of items related to the arts and sciences, as requested by the Emperor. Posted to the administration overseeing the imperial estates in the département of Ocker, Westphalia, in late January 1808, he then embarked on the Viennese campaign with the Daru brothers. Not only did he become familiar with art objects and works while learning administrative jargon, he also learned how to "write with clarity, spirit and precision."[2] He took up his new responsibilities by first undertaking inspections at Versailles.[3] Then, starting in October 1810, Pierre Daru entrusted him with the management of the new office in Holland, which was annexed to the Empire on July 9, after the abdication of Louis Bonaparte. In 1810, he also started to work on the Inventory for the Musée Napoléon–a project that went back to the *sénatus-consulte* of January 30 regarding the revision of the Civil List–and for the Mobilier de la Couronne by first and foremost carrying out inspections.[4] Daru also assigned him to oversee the inventories and provisions of the Tuileries and the "houses that depend upon it": the Château de Fontainebleau, de Bagatelle and de Mousseaux.[5] Satisfied with the work performed by this cousin with a somewhat whimsical bent, the Intendant-General granted him once again, two years later, in 1812, responsibility for the accounts of the Musée Napoléon and the Musée de l'École française at Versailles.[6] This favour attests to the evident skill and energy of the young auditor, then twenty-nine years old, in his many administrative duties, which gained him the favour of his superiors, including the director of the Musée Napoléon, with whom, in 1809, he attended Haydn's funeral in Vienna.[7]

It can never be overstated that Henri Beyle's contribution was decisive in the composition of the record of the General Inventory for the imperial museums, the model of which he presented to Denon on October 27, 1810.[8] Since an administrative document had to be clear and brief, he envisaged seven columns, to record the following: order number, name of the artist, the painting's title, its height, its width, the frame's height and width, the last column reserved for potential comments. Thus, as he wrote to Denon, "we can describe in a single line whichever painting, as beautiful as it may be, even the *Transfiguration* [by Raphael]. The beauty of our work will not lie in the picturesque, but in the administrative: in clarity and brevity. By this means, despite the low number of clerks, we can hope to see the work concluded."[9] Although the major points of Beyle's formula were kept, with some additions made for recording the inventories of antiques, drawings, paintings, engraved plates and precious vases and objects of the Musée Napoléon, which began in 1811, these records were never completed.[10] However, due to the novelty of their conception, they became a reference for future inventories.

The work provided by Henri Beyle in the administration of the imperial palaces entrusted to him in Paris and environs and in Holland was intense, meticulous and varied. For example, he had to verify the price of crystal objects incised and engraved with His Majesty's mark (carafes, cups and trays) produced by the glasshouse at Montcenis, near Creusot, and delivered to the Tuileries on July 20, 1810.[11] This glasshouse–awarded three times, in 1801, 1802 and 1806 at the Expositions des produits de l'industrie française, and overseen by Benjamin-François Ladouëpe Dufougerais, who became the real owner–became, in 1806, the main glass supplier to the Empress and the Household of Queen Hortense.[12] Montcenis was to glass what Sèvres was to porcelain. Its crystal, very sturdy and very expensive, was, in fact, considered "superior in quality to all of the same sort produced in the glasshouses of France and Bohemia."[13] However, Beyle was concerned about its high price, justified by the durability of the pieces, which contributed "to preserve the diamond cut without altering the refined angles."[14] For the Tuileries, in December 1810, he had already verified the provision of an embroidery frame from the master-upholsterer Maigret for the Empress' apartments as well as a "memorandum" from the upholsterer Flamand regarding the fabrication of drapes, wall hangings and slipcovers in mousseline, often embroidered, for a sum of 16,000 francs.[15] In January 1811, he took care of the delivery of a billiard table installed on New Year's Eve, "a heap of rosewood with ivory embellishments."[16] He also had to make enquiries about the salaries of cabinetmakers and the costs of their materials (horsehair, wool, mahogany).[17] In February, Daru asked him to assist with the sale of horses and old carriages belonging to the imperial stables.[18] Again for the Tuileries, in March, he received the delivery of the terrestrial globe

345

346

345
Nicolas JACQUES
Portrait of the Baron Martial Daru, Intendant of the Crown Holdings
1809
Grenoble, Musée Stendhal

346
Attributed to Edme QUENEDEY
Portrait of Henri Beyle, Called Stendhal
1807
Grenoble, Musée Stendhal

347
Giovanni Battista LUSIERI
A View of the Bay of Naples, Looking Southwest from the Pizzofalcone towards Capo di Posilippo
1791
Los Angeles, The J. Paul Getty Museum

produced "under the leadership and care" of famed geographer Edme Mentelle (1730–1815), member of the Institut, who had already made a composite globe for Louis XVI's eldest son in 1786. The foot and suspension of Mentelle's globe of 1811, commissioned by Bonaparte in 1803, were the work of L. L. Auguste Mercklein, then machinist to the Banque de France, in whose workshop (11 Rue de l'École de Médecine), the transaction occurred (**70**). The four parts of the world were "drafted by the quill" of Jean-Baptiste Poirson (1761–1831), geographer-engineer from Vosges, Lorraine, and reflected the gains from the most recent expeditions carried out by Alexander von Humboldt (1769–1859) in Mexico and Orinoco, Venezuela, and by Louis Freycinet (1779–1842) in New Holland (now Australia). Happy with the result, Napoleon authorized engraved reproductions of Poirson's drawings in a smaller format, dedicated to the King of Rome, who also received one of these small globes for the purpose of learning geography. Daru asked that the globe be mounted—"on its stand approximately one and a half metres in width by a little over a metre in height"—in the Gallery of Diana, but in the end it was put in the Emperor's Grand Cabinet.[19] For Fontainebleau, whose new furniture was finished in late 1810, Beyle had to guarantee, in June 1811, the "existence" of some of the pieces and two clocks by the Lepautes, uncle and nephew, decorated with Sèvres biscuit, one portraying the Muse Urania holding the celestial globe containing the turning dial, and the other the Three Graces (Fontainebleau), as well as materials from the Gobelins and Beauvais manufactories.[20] In early July, he had to inspect the Palais de Meudon, temporarily at the disposal of the Emperor's mother, Madame Mère.[21] But the bulk of his day was taken up with administrative and financial matters, particularly for the Dutch Office, which had to be reorganized after Holland's annexation to the Imperial Crown.[22]

In early March 1811, he cherished the hope of going to Rome to draw up an inventory of artworks and objects that had been allocated to the Crown, but Martial Daru's appointment as intendant to the départements of Tibre (Rome) and Trasimène (Spoleto) quashed those hopes as of the 12th of the month.[23] In early August, without Beyle's knowledge, Pierre Daru mentioned him to the Emperor as a possible successor to the intendant to the Crown in Holland, Willem Six van Oterleek, who had been found drowned in an Amsterdam canal a few days before.[24] But again, his efforts came to nothing, because Napoleon preferred to appoint a Dutch native to the position.[25] Beyle's work for the Dutch Office likely came to an end on January 31, 1812.[26] Thus, until July 23, the date of his departure for Russia, his main occupation was following up on the inventories for the museums and imperial palaces in Paris and its environs. Exhausted, he had asked for permission to take some time off at the end of the previous summer, which he used—possibly without authorization[27]—to go to Italy. He wrote to his sister from Rome: "I am doing very well, and in a perpetual state of admiration. I saw Raphael's loggias, and came to the conclusion that one must sell one's shirt to see them if one hasn't yet seen them, to see them again when one has already had that pleasure."[28] In Milan, he goes on, "When, by chance, one has a heart and a shirt, one must sell the shirt to see Lake Maggiore, Santa Croce in Florence, the Vatican in Rome and Vesuvius in Naples"[29]. In fact, it was during this trip to Italy that the metamorphosis of Beyle the auditor into Stendhal the art historian began to take shape. The pages of *Rome, Naples et Florence*, published in 1817 under the first appearance of the name Stendhal, emerged from the encounters and experiences of this trip, during which he planned the writing of a history of painting, his *Histoire de la Peinture en Italie depuis la Renaissance de l'art, à la fin du XIIIe siècle, jusqu'à nos jours*, intended for the Parisian visitors to the Musée Napoléon.[30] The manifold verifications of furnishings and objects required by his position in the Imperial Household, as well as

his discussions with Denon and the museum curators for the composition of the inventories, sharpened his eye and whet his curiosity. By enabling him to admire a number of masterpieces, which he had only heard and read about, the Italian trip in the fall of 1811 was also an opportunity to begin studying seminal texts on art—in particular, Italian painting—in their original language. But the clarity and concision of Stendhal's writing, as much in his writings on art as in his novels, are a result of the method learned while writing reports during his time as an auditor under the demanding, exacting eye of Pierre Daru. Interrupted during the Russian campaign and later, and finally, by the end of the Empire, on April 1, 1814, Henri Beyle's work for the Imperial Household made it possible for the future writer Stendhal to gain an artistic culture and consolidate his style.

DANIELA GALLO

347

*"For my use on the island they amassed all sorts of old pieces of furniture,
probably saying to themselves 'Let's collect all the worm-eaten bits of furniture we can find,
they'll be good enough for Bonaparte and the French.'"*

Napoleon at Saint Helena

EPILOGUE

1814

SYLVAIN CORDIER

Stemming from the French campaign, the fall of the Empire occurred during the month of April 1814. On April 2, the Senate, which understood that the time for change had come, announced the dethronement of Napoleon, deemed a traitor to his own constitution, thus relieving his entire administrative staff and soldiers of their oath of allegiance to him. Napoleon managed to reach Fontainebleau, where the staff maintained the "protective *bubble*"[1] that the Household was meant to preserve around the Emperor, whatever the circumstances. Two weeks were needed to settle the unusual situation of the French Emperor locked away in one of his palaces while the king of France and Navarre prepared to return to Paris. On April 11, the Treaty of Fontainebleau was signed between the defeated ruler and the powers allied against him: Austria, Russia and Prussia. In exchange for his renouncement of power and residency in France, he was granted the right to reign over the little Mediterranean island of Elba, off the coast of Tuscany. On April 18, Napoleon bade goodbye to his guardsmen and to some of the Household officers who had remained by his side (351).

When he was removed from power in France, Napoleon's main preoccupation was the recognition—despite his abdication—of his dignity as Emperor, as sovereign. Relevant to the context of this first exile on Elba, where, in fact, he ruled as "Emperor–sovereign of the island," the issue would gain strategic impact on Saint Helena, where he lived this time as a prisoner, guarded by an England that—aside from its hostility towards him—had never diplomatically recognized the establishment of the Empire of France. Given that the English saw him only as "General Buonaparte," Napoleon made the most of this mutual misunderstanding and disregard.

Promoted from private citizen to ruler, was Napoleon actually able to pretend—in the eyes of his contemporaries, who became his subjects—that he was anything other than a man who had risen through the ranks? Was it possible for him to assert, with the hardship of exile, the idea of a monarchical body, which he had helped to redefine without being born a king, only a few years after the bloody demise of Louis XVI? The question is undoubtedly compelling, but the answer is anything but obvious. Ever since he had achieved omnipotence over Europe, the Emperor did not hesitate to confiscate and redistribute crowns and titles to the detriment of certain princes. Moreover, since 1812, General Malet's coup had also demonstrated the lack of consensus regarding his dynasty as a perennial institution. In fact, the rumours of his death in Russia did not lead the authorities to proclaim the accession of the King of Rome, under the name of Napoleon II, and for some hours, there were doubts about

the future of the constitution.[2] The episode illustrates the continued artificiality of imperial dignity within the most influential circles.

During this period, Gros sketched a picture celebrating the Garde nationale's oath of allegiance to the young son of the Emperor and the Empress, proclaimed regent when Napoleon prepared to head off to war (January 23, 1814): it was an illusory promise to defend the imperial cause at all costs. Although a simple sketch, the drawing (350) is of great interest, as it is one of the last depictions of the Household assembled around its Emperor in the Hall of Marshals inside the State apartments at the Tuileries. Wearing their official court dress and holding their ceremonial staff, the Grand Officers on the left attend the oath ceremony.

Having left in 1789 and wandered the roads of Europe forlornly from one city and court to another, the brothers of Louis XVI never stopped embodying royalty, and the regimes following the French Revolution, including Napoleon's, never made the mistake of viewing them simply as ordinary individuals removed from power. In 1814 and then in 1815, Napoleon had to face the cruel reality of convincing the world of the value of his crown, and, ultimately, of the colour of his blood.

The Household and the court of Portoferraio
Negotiated at the Treaty of Fontainebleau, the budget allocated to the administration of the sovereign's Household on the island of Elba, charged to the regime of the Restoration, amounted to two million francs. Napoleon was permitted to keep a retinue of four hundred, which was a pittance in comparison to the more than 3,000 Household employees prior to the abdication. The situation helped, in fact, to purge the list of the former grand servants, all the Grand Officers and officers, or almost all, having abandoned their duties at the fall of the regime. Like the marshals and ministers, some made a show of allying themselves with Louis XVIII, as did Grand Master of the Hunt Berthier. Most grasped that it was in their immediate best interest to retire quietly, taking the time to align themselves among the ranks of those lauding the return of the king.

Only some forty staff members, mainly from the lower ranks, elected to follow Napoleon into his new life. In comparison, other figures from the Household decided to follow Marie-Louise, who became duchess of Parma, Piacenza and Guastalla, and the little King of Rome. This was the case, readily understandable, of the comtesse de Montesquiou, governess to the Children of France, who was very attached to the young child, and also of Méneval, the Emperor's secretary, and Bausset, a palace prefect.[3]

349

The Emperor quickly gathered some objects he wished to bring with him. A library of 168 books was assembled from the collection at Fontainebleau.[4] At Portoferraio, where he disembarked the morning of May 4, the residences were far from resembling a palace. Napoleon at first slept at the city hall, whose Grand Salon was redesigned to imitate the Throne Room, using a heavy armchair borrowed from a wealthy inhabitant.[5] Witnesses complained about his new guard's lack of manners.[6]

Napoleon quickly endeavoured to reconstitute a semblance of the Household. A regulation was established as of June 22, 1814, and on October 8, a "Household Order" was adapted, for better or for worse, from the *Étiquette du palais impérial*. The imperial estate included three residences—the Mulini Palace, Villa San Martino (352) and Fort Longone—as well as the personal possession of Pianosa, an island off the coast. The Emperor kept control of Elba's mines and saltworks, as well as the fisheries, which had to be able to finance the life at court and the maintenance of his troops and fortifications.[7]

Of the Grand Officers of the Empire, only Grand Marshal of the Palace Bertrand accepted to follow Napoleon into exile. The new Household was put under his purview. The deterioration of the relationship between the two men in this hostile context would lead the Grand Marshal and his wife, Fanny, to reduce their personal involvement with the sovereign, who retaliated by cutting their privileges. As Pierre Branda recalls, on the island of Elba, Bertrand fulfilled the duties of a palace prefect, supervising the servants and so on, rather than those of the former Grand Marshal, the high-ranking officer responsible for imperial security and the maintenance of order in the residential seats of power.[8] Alongside Bertrand were the treasurer Peyrusse, two secretaries—one for Napoleon, the other for Bertrand—and two palace adjuncts, the former quartermasters Deschamps and Baillon, one the commander of security and the servants, the other of the stables and travel, filling the role of Grand Equerry. Some of the island's inhabitants received promotions: a pharmacist, Gatti, was appointed pharmacist to the Emperor, while the former and current mayors of Portoferraio, Lapi and Traditi, as well as two other Elbans, Valentini and Gualandi, were appointed chamberlains.[9] Sixty-seven employees were recruited, particularly for the departments of the Table, the Chamber, the Livery, the Stables and the Hunt. Some had followed the Emperor, like pastry chef Jean-Baptiste-Alexandre Pierron (366) who had joined the department of the Table in 1807 as an office assistant, and the butler Charles-Aimable Totin, who had also been an office assistant since 1810. A former Household footman, Jean-Abram Noverraz, became second huntsman, and a former courier, Jean-Noël

Santini, was promoted to usher and the keeper of the portfolio.[10] A group of loyal Corsicans also came to the island and offered their services to Napoleon, once again a native son, to run security at Portoferraio, the secret police, the constabulary and the post office.[11]

A protocol adapting the principles developed for the Tuileries to the local circumstances was implemented.[12] The wearing of court dress was required at Mulini, and the Grand Levee was reinstated. Three apartments were equipped according to the regulations[13]: a State apartment, the Emperor's ordinary apartment—always separated into an apartment of honour and a private apartment—and an apartment for the Empress, who would in fact never come. The composition of the State apartment was different, however, as it included a dining room, where the Emperor dined with his visitors, which only happened at the Tuileries with the Empress. There was no longer a Throne Room, nor a Grand Cabinet, but rather a Grand Salon or Gallery, intended for receptions. In this room, music was played and concerts given. Rather than setting the stage of power, these spaces instead saw the society life of the local small elite play out.

Although Marie-Louise, who had quickly returned with the King of Rome into Austria's orbit, would never visit her husband, Napoleon soon had Madame Mère and his sister Pauline move in with him. The latter lived in the Empress' apartment at Mulini and brought a whiff of gaiety to the grieving court.

Organized in the summer of 1814, the arrival of Marie Walewska for two days (353) filled the Emperor with joy. However, her visit also provides a vivid illustration of the strict adherence to court regulations. The young lady landed the night of September 14, accompanied by Alexander, the son she had borne Napoleon, then fourteen years of age.[14] Although greatly affected at seeing them again, Napoleon in no way planned to have them stay at the palace. A small, secluded house was secured for them, away from prying eyes, while he erected a tent nearby. With discretion ensured, he enjoyed some happy times during this short visit.[15]

In the meantime, at the Tuileries

To understand what happened to the Imperial Household following the abdication of 1814 it is necessary to look beyond the island of Elba and the group of loyal followers who joined Napoleon to populate his sorry excuse for a palace in exile. The restoration of the Bourbons and reconstitution of a royal court surrounding Louis XVIII involved the constitution of a Royal Household whose organization and appointments require some elaboration. In many respects, it is important to recognize a certain continuation of the spirit of the institution

350

351

as envisaged by Napoleon, which Louis XVIII would basically pepper with references to the practices of the Ancien Régime (348).[16]

A comparison of the *Almanach impérial* for 1813 and the *Almanach royal* for 1814 is illuminating. The introduction of the latter, issued by the same publisher, Testu, is not without wit, and says much about the spirit of the times:

"The Almanach for the year 1814 was on the verge of publication, when an unforgettable revolution restored to France its legitimate sovereign. The work already completed was rendered useless; the expenses occasioned lost forever. For us, this has meant a considerable loss; but we are consoled by the hope of a happier future. This hope, shared by all good Frenchmen, is realized day by day under the paternal governance of Louis XVIII."[17]

The position of Grand Chaplain was renewed. Fesch was sent into exile with the pope in Rome. Louis XVIII appointed Alexandre-Angélique de Talleyrand-Périgord, archbishop of Reims, whom he had met in 1808 and who had already served in this post during his own exile: he was the uncle of the prince de Benevento. The former vicar-general under Napoleon, the abbé de La Rochefoucauld, became his private chaplain, a position he retained until 1815. The master of ceremonies of the Grand Chaplaincy, the abbé de Sambucy, also remained in the same position from one regime to the next. The title of Grand Marshal of the Palace disappeared, and the duties were distributed among several positions inspired by the Ancien Régime: the Grand Master of France (honorific title given to the prince de Condé), the Grand Marshal of Lodgings (the marquis de la Suze), the First Panetier of France (the comte de Cossé-Brissac) and the Grand Provost (the marquis de Tourzel). Provosts and butlers replaced the palace prefects. Grand Chamberlain Montesquiou retired. Although the position remained, it would not be filled until 1815, when it was finally given to none other than the prince de Talleyrand, who found himself back in the post he had to abandon with disgrace on January 29, 1809. The Wardrobe was graced with a new Grand Master, the comte de Blacas. The chamberlains were replaced by gentlemen of the Chamber, who numbered but four in 1814. There was also a Grand Master and masters of the Wardrobe. The post of Grand Master of Ceremonies was eliminated, and his duties were added to the roles of the Grand Master of France and the Grand Chamberlain. The positions of Grand Equerry and Grand Master of the Hunt would remain unoccupied in the early years of the Restoration, but it should be noted that marshal Berthier, who rallied to the king's cause, left the Grand Hunt to join the prestigious corps of six captains of the king's Guard, a rank that he would retain until his death in June 1815. The former First Equerry to the Emperor, Nansouty, became captain-lieutenant of the First Company of Musketeers of the king's Guard. The post of Intendant-General also evolved: a minister of the Royal Household took its place within the government. This position was entrusted to comte de Blacas, Grand Master of the Wardrobe.

Throughout the Empire, the Imperial Household had functioned as one of the best tools for having the French nobility submit to the imperial cause. As of 1814, this same nobility gave the impression—as a matter of course—of having restored its king after a paradoxical interlude that everyone was quick to forget. The case of the baron Mounier, Cabinet employee and intendant of the Bâtiments de la Couronne since 1813, is worth a closer look. He offered his services to the comte d'Artois, brother of Louis XVIII and lieutenant-general of the kingdom shortly after the abdication was announced. On April 4, 1814, he was appointed commissioner of the Intendant-General of the Crown estate. This hiring, which might seem to be nothing more than opportunism, was also and above all a sign of the spirit of permanence of certain civil servants, reflecting the non-partisan perception of serving the Crown of France and its assets, whether to the eagles or the fleur-de-lys.

Of course, the satellite Households gave way to others. Because Louis XVIII was a widower, there was no Queen's Household to replace that of the Empress. The institutions that served the Bonapartes—Children of France, Josephine (who passed away on May 29, 1814), Hortense, the Borghese couple, Elisa and Madame Mère—were replaced, in order of precedence, by the Households of Monsieur, brother to the king and the future Charles X, the duchesse and the duc d'Angoulême, the duc de Berry and the duc d'Orléans.

At the Tuileries, the king took up residence quite naturally in the former ordinary apartment of the Emperor, on the second floor of the central wing, while his brother, the comte d'Artois, took possession of the second floor of the Marsan Pavilion housing the apartments of the Children of France and the King of Rome. His youngest son, the duc de Berry, lived on the ground floor, in the space formerly occupied by the Grand Marshal. What had been the Empress' apartment, on the ground floor, was allotted to his eldest son and his daughter-in-law, the duc and duchesse d'Angoulême.[18] Taken over by the king and his supporters, the palaces that had so recently been redone for the Emperor underwent a long campaign of transitional decoration. The employees of the Garde-Meuble and the departments of architects and artisans at the now royal manufactories endeavoured to erase the heraldic and emblematic marks of the preceding regime, replacing them with the king's monogram and arms with the fleur-de-lys. The numerous examples of this *damnatio memoriae* signal the new Household's zeal. They can be noted, for example, in the transformation of parts of the tapestries on some of the furniture, the substitution of the eagles on the bedside table at the Tuileries with the cornucopia, the disappearance of the arms of the Empire, as well as the erasure of the date on each piece of decorative trimming on the marriage altar of 1810, and the replacement of the adjective "imperial" with "royal" on the religious materials in the palace chapels (349). The elimination of all imperial traces cannot obscure the fact that the aesthetic of the times—qualified, probably improperly, as "Empire style" by historians since the late nineteenth century—was not definitively cast aside in 1814. Moreover, this style persisted after Napoleon's fall. In fact, Louis XVIII moved in with the Empire furniture, feeling quite at ease and unwilling to transform anything but the emblems. The return of the king did not cause any real impact at court in terms of taste and style, and the royalist elites returning to Paris were first and foremost in step with their times. The proof is in the almost systematic refusal of Louis XVIII to repurchase Louis XVI's furnishings from Versailles, which had been dispersed during the Revolution, not even the rolltop desk delivered for his own use in 1774,[19] when he was not yet the comte de Provence.[20] The king knew that it was in the court's best interest to maintain production at the manufactories, and it was no longer a question of looking to the past from this standpoint. One exception was necessary: a new piece of furniture, appropriately royal, for the Throne Room at the Tuileries, whose fabrication would stretch out over several years, to be delivered only in 1822.[21] The style of the throne raised pointed discussions over whether it was better to opt for a seat in the "Percier et Fontaine" Empire style, or to reflect instead the spirit of the Ancien Régime, in the style of Jean-Démosthène Dugourc.[22] As for the rest, the furniture of the "Usurper" would do, as recounted by the marquis de Bonneval, in a delicious anecdote:

"Her Highness [the duchesse d'Angoulême] asked me which of the royal châteaux I preferred, to which I replied, after some reflection, that it was Fontainebleau. 'Oh, really, I am not of your mind,' replied the princess. 'Compiègne is more to my taste, as I find it admirably furnished.' The duc de Damas spoke up then: 'That is not surprising, Madame,' said he, in oracular tones,' as Bonaparte was an excellent upholsterer. 'I, who had served under Napoleon and did not want to be seen as an upholsterer's boy, retorted, 'I am completely of your opinion, Monsieur le duc, as he knew how to cover Notre-Dame and the Invalides with all the flags of Europe.'"[23]

The process of reconstituting the Royal Household was brutally interrupted, however, by the sudden announcement of Napoleon's return to Paris, following his escape from the island of Elba (355). Louis XVIII and his entourage fled on March 19 and 20, towards Ghent (354). The rest of the story is well known: after a hundred days in power with the coalition of European powers united against him, Napoleon realized that war was inevitable. On June 18, 1815, the English and Prussian troops faced the French on the Belgian plain at Waterloo.

352
Friedrich SCHROEDER
Napoleon's Residence on the Island of Elba
Published in M. de Norvins, *Histoire de
Napoléon I*, Paris, 1844
Montreal, McGill University Library and
Archives, Rare Books and Special Collections

353
François-Pascal-Simon GÉRARD
*Portrait of Marie Łacziǹska, comtesse
Walewska*
About 1810
Paris, Musée de l'Armée

354
Antoine-Jean GROS
*Louis XVIII Leaving the Palais des Tuileries on
the Night of March 20, 1815*
1817
Musée national des châteaux de Versailles et
de Trianon

355
ANONYMOUS
Napoleon Returning to the Tuileries in 1815
After 1815
Montreal, McGill University Library and
Archives, Rare Books and Special Collections

353

352

354

355

CADUTA DI NAPOLEONE

356

LE SABOT CORSE EN PLEINE DEROUTE

357

356
ANONYMOUS
The Fall of Napoleon
About 1814
Montreal, McGill University Library and
Archives, Rare Books and Special Collections

357
ANONYMOUS
The Corsican Fop in Full Spin
N.d.
Montreal, McGill University Library and
Archives, Rare Books and Special Collections

358
ANONYMOUS
Inspired by MICHELANGELO
The Last Judgment
N.d.
Montreal, McGill University Library and
Archives, Rare Books and Special Collections

D'après Michel-Ange. Déposé à la Direction.

Jugement Dernier?

358

The names in capital letters indicate the members of the imperial family and some of the key figures from the fallen Imperial Household.

1. Augustin-Joseph Caron
2. [De...T]
3. Marshal Jean-Baptiste Drouet, comte D'Erlon
4. Lazare Carnot
5. Marshal Michel Ney
6. Méhée de la Touche
7. General Auguste-Jean Ameil
8. CAROLINE MURAT (BONAPARTE), *queen of Naples*
9. ELISA BACCIOCHI (BONAPARTE), *grand duchess of Tuscany*
10. Philippe-Antoine Merlin de Douai
11. Antoine Barnave
12. Félix Le Peletier de Saint-Fargeau
13. General Honoré Reille
14. General Michel-Silvestre Brayer
15. HORTENSE BONAPARTE (DE BEAUHARNAIS), *queen of Holland*
16. CARDINAL JOSEPH FESCH, *Grand Chaplain*
17. REGNAULT DE SAINT-JEAN-D'ANGELY, secretary of state of the imperial family
18. NAPOLEON BONAPARTE
19. Alexandre Deleyre
20. JACQUES-LOUIS DAVID, *first painter to the Emperor*
21. Jean-Baptiste Bory de Saint-Vincent
22. Generals François-Antoine and Henri-Dominique Lallemand
23. General Pierre-Augustin Hulin
24. General Jean-Marie-René Savary, duke of Rovigo
25. General Charles Lefebvre-Desnouettes
26. JOSEPH BONAPARTE, *king of Spain*
27. LETIZIA BONAPARTE, *Madame Mère*
28. JEROME BONAPARTE, *king of Holland*
29. JOACHIM MURAT, *king of Naples*
30. LUCIEN BONAPARTE
31. Gilbert du Motier, marquis de Lafayette
32. Antoine-Joseph Santerre
33. General Régis-Barthélemy Mouton-Duvernet
34. Maréchal Emmanuel de Grouchy
35. General Bertrand Clauzel
36. HENRI-GATIEN BERTRAND, *Grand Marshal of the Palace*
37. PAULINE BORGHESE, *princess of Guastalla*
38. Jean-Jacques-Régis Cambacérès
39. Charles-Jean Harel
40. Charles-François La Bédoyère
41. General Pierre-Jacques-Étienne Cambronne
42. Bishop Dominque Lacombe
43. General Antoine Drouot
44. General Jacques-Laurent Gilly
45. George Couthon
46. Maximilien Robespierre
47. Jean-Paul Marat
48. Jean-Baptiste Carrier
49. François-Noël Babeuf

SAINT HELENA ISLAND
AND THE
REMNANTS
OF
IMPERIAL
DIGNITY

ÉMILIE ROBBE

Following his defeat and definitive loss of power, Napoleon sent a letter of surrender to the prince regent of England on July 13, 1815, in which he asked for nothing less than political asylum. Unwilling to accept this demand, the allied princes of Europe elected Great Britain the jailor of the "disturber of the tranquillity of the world."[1] They wished to avoid, no more, no less than a return to the island of Elba.

Lord Bathurst, England's secretary for war and the colonies, chose the island of Saint Helena, 122 square kilometres of volcanic soil in the middle of the southern Atlantic, seven thousand kilometres from Paris. The minister appointed as governor of the island Sir Hudson Lowe[2] (360), a man so careful to keep everything under tight control that he could not but enter into open conflict with the one his own instructions referred to simply as "general Buonaparte." However, the latter wished only ever to be called "His Majesty the Emperor" and to be treated with all the honours due that rank. Even before his arrival on Saint Helena, the pressing question of imperial dignity had arisen.

When he landed on Saint Helena on October 16, 1815, after two sad months travelling—he who had been surrounded by a Household whose disciplined organization provided him with a permanent "protective *bubble*"[3]—discovered there was no one there to receive him.

The duty of his first valet of the bedchamber, Louis-Joseph-Narcisse Marchand, was to ensure the maintenance of the smallest logistical detail in the life of a "monster of habit."[4] In his memoir, Marchand described the influence living conditions had on the Emperor's morale: "I arranged the Emperor's bedchamber according to his habits as much as possible.... The Emperor slept poorly . . . he often spoke to me about the discomfort he felt in this dwelling and of his desire that Longwood . . . would soon be ready to receive him."[5]

The Longwood house (363, 364) was certainly the largest residence on the island after the governor's, but making it habitable would take three months. Napoleon discovered the charming cottage "Briars" and the adjoining pavilion upon visiting the work site. Very much taken with it, he asked to settle in there. In three months, he had renewed his zest for life. "Nothing could be more cramped than this little pavilion," noted Marchand. "At Briars, it can only be called camping; the Emperor was once again surrounded by the furniture of a campaign tent."[6]

His entourage could once again see to meeting his expectations. The summary nature of the premises, which would have felt constrained at sea or in town, became an advantage: the Emperor returned to the conditions of military life. As on every campaign, he had selected the place and taken control. That was the very moment he reorganized his Household.

But at Longwood, in the middle of a windy plateau and an unstable and humid climate, hemmed in by military camps, the "general Buonaparte" had to conform to rules that forced him to see sentinels twice a day; to put up with, at home as well as beyond the estate's perimeter, the presence of a British liaison officer at his side; to ask the governor for the authorization to move around or to receive visitors, and so on. Within the perimeter, however, the British could not prevent him from living as he wished. Also, before he moved in on December 10, 1815, the Emperor took his time, as he had done so many times before, to regulate service. General Gourgaud recorded the following in his *Journal*: "December 6, 1815–The Emperor dictated the administrative regulations for Longwood; he is arranging the domestic appointments."[7]

The Exile and his men

The regulation of 1815 set up a Household with a lean staff.[8] Nevertheless, the Household was reconstituted. Some titles and functions were kept, and the *Étiquette* respected to the letter. Longwood thus became the last of the imperial palaces, and the one where Napoleon stayed the longest.

Grand Marshal of the Palace Bertrand accompanied his ruler into exile: he retained his title and the honours therein. Charles Tristan, the comte de Montholon (361), division general and the Emperor's aide-de-camp, had once been a plenipotentiary minister, then chamberlain; he could serve as Grand Chamberlain. General Gourgaud (362), baron of the Empire and the Emperor's first orderly officer, also served as Grand Equerry. Emmanuel-Auguste-Dieudonné, the comte de Las Cases (365), redonned the chamberlain's livery during the Hundred Days; his talents as a writer and his knowledge of English earned him a role approximating that of secretary of state. The Irishman Barry O'Meara, surgeon of H.M.S. *Bellerophon*, who stood in at a moment's notice for Doctor Maingault in July 1815 and quickly won Napoleon's trust, represented the health department. Later on, Longwood would even retain a hint of the Grand Chaplaincy, with the arrival of the abbots Buonavita and Vignali, in September 1819.

Under the orders of these Officers, in late 1815, eleven servants—all from his former Household—followed the Emperor out from France. The "Règlement du service à Sainte-Hélène" details their assignment for "interior service," "general service" and the "Table." Closest to the Emperor, the chamber servants operated under the orders of Marchand, first valet of the bedchamber: Louis-Étienne Saint-Denis, called "Mameluke Ali," Swiss Jean-Abraham Noverraz and Corsican Jean-Noël Santini. The footmen of the general service received

Proposition de Constitution aux Habitans de l'Ile S.^t Hélène par l'Ex Empereur et Roi

A Paris, chez tous les Marchands de Nouveautés.

Déposé à la Direction des Estampes

359

359
ANONYMOUS
*Proposition for a Constitution to the
Inhabitants of the Island of Saint Helena by the
Former Emperor and King*
In Paris, at Marchands de Nouveautés
About 1815–16
Montreal, McGill University Library and
Archives, Rare Books and Special Collections

360

361

362

and served guests, as well as maintained the Emperor's apartments, with the exception of his "interior apartment": they were the brothers Archambault, Achille-Thomas-L'Union and Olivier-Agricola, the Corsican Angelo Gentilini and Ferdinand-Théodore Rousseau. As for the Table service, it consisted of Cipriani, butler, the department head Pierron, who had already served on the island of Elba, and Michel Lepage, cook. The staff changed due to voluntary or forced departures and the rarer arrivals. Depending on demand, the real total probably amounts to several dozen people appointed close to or far from Longwood. Local service providers added reinforcements: eight to twelve sailors assisting at the stables, in the kitchens, in the administration or at the smithy: up to four additional grooms and twenty to fifty Chinese servants entrusted with the most menial tasks, as well as repairs and the garden.

Napoleon's entourage in exile was organized to fulfill all the functions of a real Household. The protocol was certainly less elaborate, even though Napoleon, wishing to improve the conditions of his exile, continued to lavish great attention on presentation. He certainly seldom received visitors, but when he did, he employed his treasures with the generosity of a sovereign, for example, offering visiting ladies a cup from the magnificent Sèvres Egyptian tea set. To the most humble guests, he would offer bowls of candies.

At Longwood, beyond securing his comfort, the Household ensured the stability of the Emperor's life down to the smallest detail. Ali used local products to reconstitute Napoleon's favourite eau de cologne. At the stables, Gourgaud engineered it so that the horses he procured were given familiar names; Napoleon thus found a Fringant, Sheik and Vizir at Saint Helena, names that were also mementoes of former glory. On this island, where he was deprived of freedom and space, time became a major issue.[9] Members of the Household well understood that, by ensuring the continuity of his daily habits and continuing to follow the Étiquette, the illusion of glory was maintained. Rather than being taken in, Napoleon was well aware of what was at play. Freezing the passage of time, the Household saved its master from past failure and from the present vexations of exile.

A fragile system

Out of necessity, each performed his multiple functions according to his abilities. Las Cases was secretary, chamberlain, translator and English teacher. The servants were also called on to perform duties that went far beyond their initial role. As department head, Pierron alone oversaw the Table department, concurrently serving as department head, butler and head cook in 1818, while

also contributing to decoration. Ali, first huntsman, served as valet of the bedchamber, librarian, copyist and even gardener!

These multiple appointments caused a certain amount of confusion, which stirred up tensions. Quarrels regarding who took precedence occurred frequently. Gourgaud argued with Las Cases about his rank with regards to the Emperor: "Bertrand assures me that I am wrong to disagree with Las Cases and wants to show that as chamberlain, he should rank above me.... There is no case in which, I, a soldier, would rank below a chamberlain, which is but a titled valet."[10]

Although the monarch's favour meant everything to a courtier, at Longwood, it became the exiles' reason for living. Gourgaud's Journal shows how his moods changed according to the attention bestowed upon him by the master for whom he had sacrificed everything.

However, Napoleon, himself destabilized, could be as cruel as he was charming. He also felt alone. Some—like Las Cases and Marchand—could play the role of confidant, even friend, but the Exile, too aware of his fall from grace, dragged his last loyal followers down with him, without sparing their greatest source of pride, that of serving him. When Gourgaud said to him one day, that he "feared some inconsideration towards His Majesty," the Emperor replied, "You still make yourself out to be the first orderly officer of the master of the world!"[11]

The last handful and its struggle to make history

The Household ultimately served as the interface with the outside world, strictly controlling access to the person of the Emperor. This system was in full effect on Saint Helena. The linchpin was the Grand Marshal of the Palace. Anyone wishing to meet with the Emperor—whether the governor or someone referred by him—had to present the request to him first. Bertrand maintained this rule rigorously, and everyone respected it. The question of visits caused terrible tension between Longwood and the governor. Napoleon never gave in, and neither did his staff. The situation verged on the comic. For his first visit, the new governor, Lowe, arrived with the admiral Cockburn, whom he was relieving of interim duty; however, at the door to the salon, the valet Noverraz adhered so strictly to instructions that he would not admit the admiral! Although Marchand reported the scene with tact, Gourgaud revealed Napoleon's reaction: He "added that he would not have given up this day for anything, not even for a million."[12] Security was another aspect of the protection the Household provided the Emperor. After the expulsion of the surgeon O'Meara, at the height of the crisis between Napoleon and the governor, the former had reasons to fear that

363

364

Lith de Langlumé

Le Comte de Las-Cases,
et son Fils ;

Recevant la lettre que l'Empereur Napoléon écrivit au premier, le 11 Décembre 1816, de Longwood, d'où il avait été enlevé le 25 du mois précédent, pour être mis au secret à Ross-Cottage ::

« Votre conduite a été, comme votre vie, honorable et sans reproches…. Combien vous avez passé de nuits pendant mes maladies !…. J'ai vu qu'on vous enlevait avec des exaltations de joie féroce …. Je crus voir les Sauvages des îles de la mer du Sud dansant autour des prisonniers qu'ils vont dévorer…. Si vous voyez un jour ma femme et mon fils, embrassez les…. Recevez mes embrassemens, l'assurance de mon estime et de mon amitié… Soyez heureux. »

Napoléon

365

364
Attributed to Louis-Joseph-Narcisse
MARCHAND
View of Longwood House
1819
Châteauroux, Musée-hôtel Bertrand

365
Joseph LANGLUMÉ
Emmanuel de Las-Cases, Former Chamberlain,
and His Son
Frontispiece of *Recueil de pièces authentiques*
sur le captif de Sainte-Hélène, de mémoires
et documents écrits ou dictés par l'Empereur
Napoléon . . . , Paris, 1821–25
1822
Montreal, McGill University Library and
Archives, Rare Books and Special Collections

366
Louis-Nicolas LEMASLE
Portrait of Alexandre Pierron, Former Butler to
the Emperor on Saint Helena
1827
Rueil-Malmaison, Musée national des châteaux
de Malmaison et Bois-Préau

367

368

367
Martin-Guillaume BIENNAIS
Pierre-Benoît LORILLON
Utensils used by Napoleon during his time on Saint Helena
Between 1809 and 1816
The Montreal Museum of Fine Arts
Loaned by Ben Weider

368
Martin-Guillaume BIENNAIS
Milk jug with imperial coat of arms, used during Napoleon's time on Saint Helena
About 1810–14
The Montreal Museum of Fine Arts

369
ANONYMOUS
Napoleon Buonaparte, from a Drawing Taken by Captain Dodgin of the 66th Regiment at Saint Helena in 1820
1820 or later
Montreal, McGill University Library and Archives, Rare Books and Special Collections

the latter would force entry. Thus, reported Marchand, "The Emperor ordered Noverraz to barricade all the doors with strong bars sunk on both sides into the wall. . . . He told Saint-Denis to load his pistols and guns, which would give him twelve shots to fire. . . . Saint-Denis slept in the dining room, defending the door between this room and the bedroom. Noverraz, in the entrance to the interior apartment, would stop anyone who came in this way, and me, in the bathroom, in front of the door to the Emperor's chamber, all three with weapons at the ready."[13]

Napoleon's interest in the organization of his Household is a perfect illustration of the issues arising from captivity and exile. In order to ensure the tranquillity of Europe, the British wanted to destroy the identity of the man they now called nothing more than "general Buonaparte." Officially, there could not be an Imperial Household on Saint Helena, as there was no Emperor on Saint Helena. In retaliation, the interested party sought at all costs to preserve the dignity and titles with which he came to identify himself. In this war of attrition, the Imperial Household was one of his best weapons. Although, according to Pierre Branda, the Household in the glory days had the primary objective of "transforming the former republican general into an incontrovertible monarch,"[14] on Saint Helena, the Household in exile's primary role was indubitably to spare the now debatable monarch from being demoted to simple general.

As exacting as it was, the operations of the Household in exile were not entirely without problems. Its sentinels—the governor's demands—knocked daily at the doors of this fortress, Lowe's way of holding sway. One of the levers he used was money, as the British government assumed all expenses for the Emperor and his entourage's food and lodging in captivity. Although the funds were increased from eight to twelve thousand pounds, the operating budget was always exceeded. A crisis broke out in fall 1816. Lowe notified "general Buonaparte" of the order to charge this overspending to his budget. By making a big show of selling his broken silver in Jamestown, Napoleon had played the part of victim to British stinginess to perfection, thus winning the battle. He could not, however, prevent the governor from expelling—always for cost-cutting reasons—four members of the Household, captain Piontkowski, assistant to general Gourgaud at the stables, and three servants: Olivier-Agricola Archambault, undergroom, Ferdinand-Théodore Rousseau, silver keeper / candle maker, and Jean-Noël Santini, Cabinet usher. The Emperor and his entourage were quite deeply affected by this deprivation.

Of the Household's eighteen members two years prior, only eight remained. Cipriani? Dead. Las Cases, O'Meara? Expelled for misconduct. Gourgaud and the Lepages? Resigned. Morale was at an all-time low.

Condemned to silence, the master strategist who had conquered Europe threw all his remaining strength into a battle against oblivion.

At first, Napoleon sought to get people talking about him so that his punishment might be commuted. After their expulsion, Santini and O'Meara, among others, did their best to spread the word throughout Europe, obtaining support from Britain's powerful enemies, meeting members of the former Imperial family, and publishing articles in newspapers. In 1822, O'Meara published a first-hand account that created quite a stir,[15] to the point that he was recognized some years later as the first of the "Evangelists" of Saint Helena.[16]

Little by little, the fallen Emperor understood that he had to resign himself to this exile, which suited the European powers so well. Now he had to conquer the ground of history. By standing firm against the demands of the governor, by fully assuming the roles in which their master had cast them, the Household Officers contributed to transforming his failure into victory, his jailor into tyrant, his exile into martyrdom. He made Bertrand, Montholon, Las Cases and Gourgaud his secretaries, dictating night and day the history of the Italian, Egyptian and Belgian campaigns. Returning to France, they faithfully published these *Mémoires*, destined from the first to eclipse Caesar's *Commentaries*.

Wishing to control every word in order to remain in command of history, Napoleon requested that the members of his entourage destroy their diaries. Only Ali complied immediately, only to come back stronger than ever later on. All of them, wishing to serve him better, disobeyed this directive. Expelled in 1816, Las Cases published the *Mémorial de Sainte-Hélène* in 1823, and the book made a considerable stir. Antommarchi, and then Montholon, inspired by its success, published their own *Mémoires* in turn. Gourgaud, Bertrand and Marchand carefully kept their notes and notebooks that would enrich our perception of the Exile years later. Fanny Bertrand and Antommarchi also deprived the British of the death mask made in May 1821 (**378**). Bertrand, Marchand, Coursot, Archambault and many others exhibited the objects they brought back from Saint Helena attesting to the ultimate deprivations around Paris, and then distributed their own recollections in the shape of boxes that immediately became the reliquaries of a new religion (**375, 376**).

Napoleon believed himself alone on the island of Saint Helena. He was not. The Household that he created became his true strength. If he succeeded in becoming the figure held today in the collective memory, it is in large part due to those, from the titled to the most humble, who continued to believe in him when he himself had lost all hope.

NAPOLEON BUONAPARTE,

from a Drawing taken by Capt.ⁿ Dodgin of the 66.ᵗʰ Regiment,
at S.ᵗ Helena during 1820.

Publish'd by H.R.Young, Printseller, 157, Fenchurch Street.

THE BIRDCAGE AT SAINT HELENA

In November 1819, to distract himself from English surveillance,[1] Napoleon commissioned some major landscaping projects,[2] which is when he came up with the idea for a birdcage:

"The Emperor had a Chinaman . . . build a large cage or birdcage in bamboo, crowned with a species of bird the Chinaman said was an eagle. To fill the cage, the Emperor bought dozens of canaries. These birds were left for a couple of months in their tiny cages, suspended in the arbour, while waiting for the construction of the birdcage to be completed. But they were all struck by "spots," so that one by one, almost all died. . . . In the end, when assembled and in position, the birdcage had as its first inhabitants a maimed pheasant and some chickens. So as to prevent their demise, they were removed from the cage a few days later. As for the unhappy pheasant, he ended his days in prison. The idea then struck the Emperor to put pigeons in the birdcage. . . . For a few days, new inhabitants moved in; but, as soon as the door was opened, they returned to their previous residence."[3]

Since the early eighteenth century, the governor of Saint Helena, Robert Patton, had suggested that the East India Company bring Chinese workers from Pinang and Macau, as "they are excellent artisans and farmers, who provide quality labour at a good price. . . . Their names being unpronounceable, they are identified by number."[4] According to Mameluke Ali, it was the artisans answering to the numbers 146, 174 and 178 who designed and made the birdcage.[5]

Chinese traditional motifs decorate the lintels of the three main doors and the lateral panels on either side of the birdcage.[6] Although of uneven quality of execution, these images still evoke the rich iconographic vocabulary appearing in Chinese works of art over the centuries. They convey messages well beyond pure visual representation. Carved

above the door on the ground floor, a flying egret is pictured holding a flower basket in its beak. The basket (*hualan* 花篮) is an attribute of Lan Caihe, one of the Eight Taoist immortals, symbol of longevity. Generally, a flying egret evokes the pun "may you be successful all the way" (*yilu shunfeng* 一路顺风). In this specific scene, the term for "single egret," *yilu* 一鷺, is homophonous with the phrase "all the way" (*yilu* 一路), while the hanging ribbon (*shoudai* 綬帶) is a pun for longevity (*shou* 壽), suggesting endless blessings.

The overdoor decoration on the second floor depicts two egrets fighting over a fish (*yu* 魚). This conflation refers to the wish for plenty and ten abundances (*yiduo shiyu* 一多十餘). The ancient name for egret was "*duo*," the same character as "a lot" (*duo* 多). The words for "eat" (*shi* 食) and "ten" (*shi* 十) sound alike. The fish (*yu*) sounds like abundance (*yu* 餘). Together, they form the rebus for "plenty and ten abundances," meaning richness and fortune.

The top-floor overdoor is decorated with the image of a red bat holding a ribbon in its mouth. "Bat" (*fu* 蝠) sounds like the word for fortune (*fu* 福), and, with the addition of a tasselled ribbon (*shoudai* 綬帶), stands for longevity (*shou* 壽). The combination again conveys the wish for good fortune and long life.

The six side panels, also poorly executed, feature other traditional rebuses, all granting wishes for a prosperous and long life. Starting from the top, a badly drawn rooster among cockscombs (*jiguanhua* 雞冠花) supposedly conveys the wish for a continuous rise in rank (*guanshang jiaguan* 官上加官), the second character in the name of the flower being homophonous with the word for official (*guan* 官). The rooster also bears a cockscomb, yet another pun for "official." The phrase literally means "adding one official above another." This was a popular motif for Chinese paintings, snuff bottles and embroidered wallets. Its counterpart on the right side of the cage reiterates the subject, although the rendering is even less successful.

The second floor is embellished by two lateral panels featuring a sketchy rendition of yet another popular motif that elicits the phrase "may you have

peace and prosperity": the vase (*ping* 瓶) with peony (*mudan* 牡丹). The vase is a pun for peace (*ping'an* 平安). Another name for the peony, the flower of wealth and rank, is *fuguihua* (富貴花). Napoleon might have adapted the peony's symbolism to suit himself, even if the Chinese artisans likely employed the motif without considering how the exiled leader might reinterpret it. The two remaining side panels on the bottom show several birds among crab-apple blossoms, a fitting pun for "may your noble house be blessed with wealth and honour" (*yutang fugue* 玉堂富貴). In this case, the inclusion of such images could be construed as an appropriate commentary on Napoleon and his political allure.

The great eagle dominating the birdcage was removed upon the order of the Emperor, perhaps struck by the ludicrousness of the symbol. This element, exhibited at the Musée de Châteauroux, has never been remounted.[7]

When Napoleon's ashes were returned in 1840, the birdcage was offered by Governor Middlemore to general Bertrand,[8] who in turn gifted it to his brother, Bertrand-Boislarge. The latter placed it in the orangery on his Touvent estate, not far from Châteauroux.

In 1921, the curator of the museum "started putting the pieces together."[9] The birdcage was then remounted–with the major reinforcement of nails and screws–to be presented in the new museum recently built in the Hôtel Bertrand. After a second, more respectful restoration, it was installed in pride of place in the collections, where it continues to evoke the Exile of Saint Helena.

MICHÈLE NATUREL AND LAURA VIGO

TWO YOUNG PRINCESSES IN EXILE

BY DAVID

More than a dozen years separates these two depictions of Charlotte and Zénaïde Bonaparte, king Joseph Bonaparte's daughters and Napoleon's nieces. In the first portrait (371), painted by François Gérard and his workshop between 1808 and 1810–after the original of 1807 at the National Gallery of Ireland[1]–the two little princesses, five and six respectively, frame their mother, Julie Clary. The painting was commissioned from the First Painter to the Empress, by Joseph, the king of Naples, shortly before he ascended the throne of Spain.[2] Gérard depicts the queen consort and her children in a room at the Château de Mortefontaine, acquired by Joseph in 1798, in the département of Oise, near Paris. The family is depicted before a large window opening onto a lake surrounded by trees. As is always the case with Gérard, the elegant furnishings, costumes and accessories are captured with a great attention to detail. Dressed in pink satin dresses under gauzy muslin overlay, the two little girls hold contrasting poses: Charlotte looks at her mother with a smile, while her older sister, Zénaïde, gazes at the viewer with confidence. Like the portrait of Caroline Murat surrounded by her children (104), this painting, at once an official portrait and a family portrait, satisfied concerns about dynastic legitimacy and the celebration of the regime, following a long-established tradition. The presence of signs evoking the concept of power serves as proof: the red velvet court mantle and the white satin dress embroidered with gold worn by Julie, the gilded wood armchair with the armrests and headrest ornamented with balls and the trimmed green velvet cushion under the young woman's feet.

In a broader sense, the importance conferred on the notion of filiation in the official portraits produced during the Empire is explained by the necessity of ensuring that a close family member be recognized as a possible heir to the throne–in this case, one of Napoleon's nephews. The plan to create a gallery of portraits of the imperial princesses at the Tuileries is further proof. Of course, Napoleon's marriage to Marie-Louise and the birth of the King of Rome in 1811 ended the concerns regarding the dynastic continuity and survival of the Napoleonic regime. But history moves inexorably forward, and, in 1821, when Jacques-Louis David painted his double portrait of Zénaïde and Charlotte Bonaparte (372), Joseph's two daughters had lost their princess status. Fourteen years had passed since the first portrait. France was once again a kingdom. Louis XVIII ruled the country, the imperial court was but a memory and the members of the Bonaparte family, outlawed, had all left France to live in exile. In Joseph's family, conjugal equilibrium was put to the test. After Waterloo, Napoleon's older brother took refuge in the United States, settling in New York State alone. His wife, Julie, and their daughters refused to leave the "Old Continent." They stayed first in Vienna, then in Frankfurt, finally settling in Brussels in 1821. David, living in Belgium since 1816, was a regular visitor to their home and taught Charlotte drawing.[3] It was in this context that he received the commission for a large portrait of Joseph's daughters. Two other versions of the work are extant. A receipt dated June 25, 1821, shows that David would earn 4,000 francs for the first canvas and 2,000 francs for the copies. The presence of pentimenti in the version at the J. Paul Getty Museum suggests that it is the original.[4] The silhouette of the two sisters, now nineteen and twenty years old, emerge from a modulated ground of brown and grey, in the manner of David's portraits from the revolutionary period. Dorothy Johnson draws attention to the psychological approach favoured by the painter.[5] She notes that David "wished to contrast two very different personalities" by juxtaposing their dress and their poses. In blue, Charlotte, well-behaved and discreet, conveys the modesty of a growing adolescent unsure of herself. At her side, her sister wears an elegant, tightly fitted black velvet gown low-cut in front. Zénaïde fully owns her femininity and seems well aware of her powers of seduction–despite a face with ordinary features and little charm, which David evidently did not seek to improve. This Ingres-inspired portrait was conceived some months before Zénaïde's marriage to her first cousin, Charles Lucien, eldest son of Lucien Bonaparte. According to Antoine Schnapper, the wedding "drew a great number of relatives and Bonaparte supporters, which alarmed the local authorities."[6] This unease can be explained by the political conflict roiling in France. Louis XVIII was considered by many to be a usurper. At a time when investigations and warnings were proliferating against the most active opponents to the regime–the liberal opposition made up of those nostalgic for the Empire, constitutionalists and republicans–the meeting of a great number of Bonapartists in Brussels could only unnerve the monarchists.[7] The assassination of the duc de Berry by a Bonapartist labourer in 1820 caused the press to be muzzled and images to be further controlled. From then on, the following would be "declared guilty of seditious acts: the producers, dealers, distributors, exhibitors of drawings or images whose printing, exhibiting or distributing seeks to" undermine by "calumny or injury, the respect due to the person of the King, or the person of members of his family, or whomever utters the name of the usurper [Napoleon] with the same aim."[8]

The many symbols of the Napoleonic spirit appearing throughout David's painting, far from being anecdotal, must be viewed in the light of this tension between the liberals and the royalists. Worthy of particular note are the gold diadems worn by both sisters, an explicit reference to their former status as princesses, the purple velvet sofa embroidered with gold bees and the letter from Joseph Bonaparte that Zénaïde seems to be showing to the viewer; as revealed by Philippe Bordes, the placement of the sheet of paper draws attention to a bee.[9] Painted a few short months after the death of Napoleon on Saint Helena, this painting–like so many others–attests to an undeniable nostalgia for France under the Empire, and at the same time, beyond all formal considerations, it is the tragic opposite to the portrait painted by Gérard in 1807.

CYRIL LÉCOSSE

371

371
Workshop of François-Pascal-Simon GÉRARD, possibly Marie-Éléonore GODEFROID
Portrait of Marie-Julie, Queen of Naples and Later of Spain, with Her Two Daughters, the Princesses Zénaïde-Laetitia-Julie and Charlotte-Napoléone
1808–10
Château de Fontainebleau, Musée Napoléon Ier

372
Jacques-Louis DAVID
Double Portrait of Zénaïde-Laetitia-Julie and Charlotte-Napoléone, Daughters of Joseph Bonaparte, the Former King of Spain
1821
Los Angeles, The J. Paul Getty Museum

NAPOLEON ON HIS DEATHBED

The assistant commissary general of the British army from 1808 to 1857, Denzil Ibbetson (1775-1857), sailed on the convoy taking Napoleon Bonaparte to the island of Saint Helena after his defeat at Waterloo in 1815.[1] In 1818, after he had been appointed purveyor of the Household, he was in frequent contact with the French staff at Longwood, particularly the Grand Marshal of the Palace Bertrand, to oversee the provisioning of Napoleon's residence. The post was not a sinecure, since it represented Great Britain's involvement in the final configuration of the Imperial Household on Saint Helena. In the course of his mission, Ibbetson kept a diary and made numerous sketches of the Emperor and his everyday life and surroundings, leaving invaluable evidence of the conditions of life on the island (373).

On the morning of May 6, 1821, the day after Napoleon's death, between ten o'clock and noon,[2] Ibbetson was allowed to enter the bedchamber of the deceased. The Englishman took advantage of these circumstances to make a drawing of the body. It was his last chance to do so. The following day, Doctor Antommarchi made the cast for the Emperor's death mask, which was used to make the famous bronze model so widely disseminated throughout France under the July Monarchy (378).

From his sketches, Ibbetson was able to execute two "reliquary" paintings. The work presented here (374) is one of them. Ibbetson gave it to Sir Hudson Lowe, the governor of Saint Helena, who on his return to London gifted it to king George IV as visual proof of the death of the English nation's great enemy. The Crown disposed of it in the twentieth century.

The death of a sovereign is a particularly important subject in political and cultural iconography, primarily to assert the representational codes for the principle of the political regime's continuity despite the mortality of the rulers themselves. The case of Napoleon, the first Emperor of his dynasty, obliged in the end to abdicate and go into exile, was in this respect quite unique, as indeed was the remarkable execution of this work, painted by an amateur with no real artistic training.

The bloated cadaver is that of a man alone, worn down by prolonged suffering. The splendours of power and the gilded halls of the Tuileries are long gone, and this is the cold image of a dynasty condemned to extinction. And yet Ibbetson seems conscious of the mute grandeur conveyed by this dead body. It is crucial to compare his unassuming little picture to the romantic compositions that sprang from the imagination of French painters fascinated by the Emperor's destiny and his final moments, which were so widely diffused in the form of prints that they came to be regarded as actual depictions of the end of the Napoleonic saga. Steuben's *Death of Napoleon* (376), for example, carefully reconstructs the scene in which the Emperor is surrounded by the last members of his Household.

The result is undoubtedly touching but also theatrical and hagiographic. The same is true of the admirably executed drawing by Vernet showing Grand Marshal Bertrand sobbing over the corpse (375), but it too is imaginary. In contrast, Ibbetson's *Napoleon*, in its naïveté, is a surprisingly sincere portrait.

The painting should not be viewed without thinking of the iconographic codes of the English anti-Bonaparte caricatures that flooded Europe during the two first decades of the nineteenth century. Napoleon's puffy face and portly figure must have appeared even more striking to Ibbetson because they totally contradicted the depictions of a skinny, hard little general produced by cartoonists like Argus, Cruikshank and Gillray that had formed the sinister image of "Boney" in the British popular imagination. Ibbetson may also have seen in Europe some splendid representations that could have played a part in his way of painting the Emperor. The sparse locks of hair soaked by the dying man's sweat recall, tragically, his formerly thick head of hair seen in portraits of the First Consul by David and his colleagues.

SYLVAIN CORDIER

373

375

MORT DE NAPOLÉON , 15 Mai 1821.

376

377

375
Carl von Steuben
*Grand Marshal of the Palace Bertrand
Weeping by the Body of Napoleon*
1830 or before
Rueil-Malmaison, Musée national des
châteaux de Malmaison et Bois-Préau

376
Jean-Pierre-Marie Jazet
After Carl von Steuben
Death of Napoleon (May 5, 1821)
1830
The Montreal Museum of Fine Arts

377
Charles-Auguste Bouvier
After Carl von Steuben
*The Eight Epochs of the Life of Napoleon
by a History Painter*
1842
The Montreal Museum of Fine Arts

378
François Antommarchi
Cast L. Richard et Quesnel, Paris
Death Mask of Napoleon
After 1833
The Montreal Museum of Fine Arts

379
Henry Thomas Alken
Thomas Sutherland
After Captain Frederick Marryat
The Funeral Procession of Bonaparte
1821
Montreal, McGill University Library and
Archives, Rare Books and Special Collections

378

Drawn on the Spot by Capt. Marryat, R.N.

THE FUNERAL PROC

as it proceeded from Old Long Wood along the edge of Ruperts Valley. __ The Troop

London, Published July 25, 1

SION OF BONAPARTE,

...wn up with arms reversed, after the Procession had passed, followed up in the rear.

CHRONOLOGY

1768

France purchases Corsica from the Republic of Genoa.

1769

August 15
Napoleone di Buonaparte is born in Ajaccio, Corsica.

1774

May 10
Louis XVI succeeds Louis XV as king of France.

1785

October 28
Bonaparte graduates from the École militaire de Paris as a second lieutenant of artillery.

1789

Callet's *Portrait of Louis XVI in Coronation Robes*, painted in 1775 (Versailles), is exhibited at the Salon; this is the last State portrait of the Ancien Régime.

June 17
During the opening session of the Estates-General, the Third Estate declares itself the National Assembly.

August
The National Assembly abolishes feudal privileges and drafts the *Declaration of the Rights of Man.*

October 5-6
The royal family is forced to move from Versailles to the Palais des Tuileries in Paris.

1790

July 12
The *Civil Constitution of the Clergy* is enacted, which will soon lead to the deterioration of relations between France and the Holy See.

1792

April 20
France declares war on Prussia.

August 10
Invasion of the Tuileries Palace: Revolutionaries overthrow the monarchy of Louis XVI.
Bonaparte is in Paris during the upheaval.

September 2-5
The September Massacres (The First Terror).

September 21-22
The National Convention meets for the first time; France is declared a Republic.

1793

January 21
Louis XVI dies at Place de la Révolution by guillotine; Marie-Antoinette will meet the same fate on October 16.

February 1
France declares war on England.

July 13
Robespierre is appointed to the Committee of Public Safety; the period known as the Terror intensifies.

August 10
The Louvre opens to the public as Muséum central des arts de la République.

October 5 (15 Vendémiaire, Year II)
The French Republican Calendar is adopted by the National Convention; it is implemented retroactively to September 22, 1792 (1 Vendémiaire, Year I).

December 22 (2 Nivôse, Year II)
Bonaparte is named brigadier general.

1794

July 27-28 (9-10 Thermidor, Year II)
Thermidorian Reaction; Robespierre is arrested and sent to the guillotine.

1795

June 13 (25 Prairial, Year III)
Bonaparte is appointed general of the Western Army.

August 22-September 23
(5 Fructidor, Year III-1 Vendémiaire, Year IV)
A new constitution is drafted, which will form the basis of the Directory.

October 26 (4 Brumaire, Year V)
Bonaparte becomes general-in-chief of the Armée de l'Intérieur.

1796

March 9 (19 Ventôse, Year IV)
Napoleon marries Josephine de Beauharnais, whose husband died by guillotine during the Terror.

April (Germinal/Floréal, Year IV)
First Italian campaign: Recently appointed head of the Army of Italy (12 Ventôse, Year IV/March 2) Bonaparte leads the French army into Italy against Austria.

1797

January 14 (25 Nivôse, Year V)
Bonaparte defeats the Austrians in Italy at the Battle of Rivoli.

December 25 (5 Nivôse, Year VI)
Bonaparte is made a member of the Institut de France (Académie des sciences).

1798

July 1-2 (13-14 Messidor, Year VI)
Egyptian campaign: As head of the French Army, Bonaparte arrives in Egypt to confront the British.

August 1 (14 Thermidor, Year VI)
Battle of the Nile: Britain's Admiral Nelson destroys the French fleet at Aboukir.

1799

April 21 (2 Floréal, Year VII)
Josephine buys Malmaison; this purchase was approved by Napoleon on November 21 (30 Brumaire, Year VIII).

October 16 (24 Vendémiaire, Year VIII)
Bonaparte escapes the dire situation in Egypt and returns to politically unstable Paris.

November 9-10 (18-19 Brumaire, Year VIII)
Coup of 18 Brumaire: Bonaparte leads a *coup d'état* to overthrow the Directory, thereby establishing the Consulate.

December 15 (24 Frimaire, Year VIII)
Bonaparte is proclaimed First Consul of the Republic.

1800

February 19 (30 Pluviôse Year VIII)
Bonaparte moves into the Palais des Tuileries.

March 14 (23 Ventôse, Year VIII)
Barnaba Niccolò Maria Luigi Chiaramonti is elected pope, taking the name Pius VII.

Spring (Floréal/Prairial, Year VIII)
Second Italian campaign against Austria: Bonaparte crosses the Alps at the Great Saint Bernard Pass in May and declares victory over Austria at Marengo in June.

December 24 (3 Nivôse, Year IX)
Royalists attempt to assassinate Bonaparte.

The events highlighted in bold relate more closely to Napoleon's personal life and to significant moments for the imperial court and the Imperial Household.

1801

David begins *Bonaparte, First Consul, Crossing the Alps at the Great Saint Bernard Pass* (Malmaison), which will be given to Charles IV of Spain.

February 9 (20 Pluviôse, Year IX)
Treaty of Lunéville: Peace is pronounced between France and Austria.

June 4-8 (15-19 Prairial, Year IX)
The Consulate receives the sovereigns from Etruria and presents them with Bonaparte's first documented diplomatic gift.

July 15 (26 Messidor, Year IX)
Bonaparte and Pius VII sign the Concordat; Catholicism is re-established as the religion of the majority in France.

1802

Gros executes the *Portrait of Napoleon as First Consul* (Musée national de la Légion d'honneur, Paris).

January 25 (5 Pluviôse, Year X)
Bonaparte is elected president of the Italian Republic.

March 25 (4 Germinal, Year X)
Treaty of Amiens: France and England agree to peace.

August 3 (15 Thermidor, Year X)
Bonaparte is declared First Consul for Life by plebiscite.

November 19 (28 Brumaire, Year XI)
Denon is named director of the Musée Central des Arts (now the Musée du Louvre), which he will rename the Musée Napoléon in 1803.

1803

May 3 (13 Floréal, Year XI)
France sells Louisiana to the United States.

May 16 (27 Floréal, Year XI)
The Treaty of Amiens is broken by England and war resumes with France.

1804

Gros presents, *Napoleon Bonaparte Visiting the Plague-stricken in Jaffa* at the Salon (Musée du Louvre).

March 21 (30 Ventôse, Year XII)
Declaration of the *Civil Code*.

May 18 (28 Floréal, Year XII)
Proclamation of the First Empire: Napoleon is declared Emperor of the French.

The Grand Dignitaries of the Empire are named.

May 19 (29 Floréal, Year XII)
The eighteen Marshals of the Empire are appointed.

July 10 (21 Messidor, Year XII)
The Grand Officers of the Imperial Household are announced:
- Cardinal Fesch as Grand Chaplain
- Duroc as Grand Marshal of the Palace
- Talleyrand as Grand Chamberlain
- Ségur as Grand Master of Ceremonies
- Caulaincourt as Grand Equerry
- Berthier as Grand Master of the Hunt.

Fleurieu is named Intendant-General of the Imperial Household.

Madame de la Rochefoucauld is named lady of honour to Josephine.

July 17 (28 Messidor, Year XIII)
Decree on the organization and administration of the imperial palace officially creates the Imperial Household.

July 18 (29 Messidor, Year XIII)
Decree on official court costumes and civil uniforms.

December 2 (11 Frimaire, Year XIII)
Coronation of Emperor Napoleon I and Empress Josephine at Notre-Dame Cathedral in Paris.

December 5 (14 Frimaire, Year XIII)
Ceremony of the Distribution of the Eagles on the Champ-de-Mars.

December 18 (27 Frimaire, Year XIII)
David is named first painter to the Emperor.

1805

Gérard paints the *Portrait of Emperor Napoleon in Imperial Robes*.

The portraits of the Marshals of the Empire are commissioned from various artists; they will hang in the Salon des Concerts (renamed the Hall of Marshals) at the Tuileries between 1806 and 1808.

March
The department of the Grand Master of Ceremonies issues the first *Étiquette du palais impérial*.

March 17 (26 Ventôse, Year XIII)
Napoleon is proclaimed King of Italy.

March 28 (7 Germinal, Year XIII)
Elisa Bonaparte is made princess of Lucca and Piombino.

July 24 (5 Thermidor, Year XIII)
Fleurieu is replaced by Daru as Intendant-General of the Imperial Household.

July 25 (6 Thermidor, Year XIII)
Grand Marshal of the Palace Duroc issues an edict on the rules of furnishing the official residences of the Emperor.

August 2 (14 Thermidor, Year XIII)
Creation of the Pages' Household.

October 21 (29 Vendémiaire, Year XIV)
British victory against the French and Spanish at Trafalgar.

December 2 (11 Frimaire, Year XIV)
Victory at the Battle of Austerlitz: Napoleon's Grande Armée defeats Austrian and Russian forces led by Czar Alexander I and Holy Roman Emperor Francis II.

December 26 (5 Nivôse, Year XIV)
Treaty of Pressburg: Napoleon and the Holy Roman Emperor Francis II sign a peace agreement.

1806

Ingres presents the *Portrait of Napoleon on His Throne* (Musée de l'Armée, Paris) at the Salon; it is not well-received.

Napoleon commissions portraits of the Grand Officers of the Crown for Fontainebleau, then the Tuileries; they are in fact installed at Compiègne between 1808 and 1810.

January 1
The Gregorian calendar is restored.

March 15
Joachim Murat and Caroline Bonaparte are named grand duke and grand duchess of Berg and Clèves (1806-8).

March 31
Napoleon names, Joseph Bonaparte as king of Naples (1806-8).

April
The department of the Grand Master of Ceremonies reissues the *Étiquette du palais impérial*.

June 5
Louis Bonaparte and Hortense de Beauharnais are made king and queen of Holland (1806-10).

July 12
The Confederation of the Rhine is established, with Napoleon as its "Protector." Less than a month later, on August 6, the Holy Roman Empire dissolves with the abdication of Francis II, who then becomes Francis I of Austria.

1807

February 7-8
Battle of Eylau: France defeats the Russian army.

June 14
Battle of Friedland: French victory over the Russian Army.

June 25-July 9
Napoleon and Czar Alexander I at Tilsit: Signing of the Treaties of Tilsit (July 7).

August 16
Jerome Bonaparte is named king of Westphalia (1807-13).

October
Beginning of the Peninsular War.

November 3
Grand Equerry Caulaincourt is named ambassador to Saint Petersburg; he serves in that position until 1811.

November 30
France takes Lisbon.

1808

The third *Étiquette du palais imperial* is published by the department of the Grand Master of Ceremonies.

David's *Coronation* is exhibited for the first time at the Musée Napoléon.

March 1
Creation of the imperial nobility.

May 2
The Dos de Mayo Uprising in Madrid: The Spanish revolt against the French invasion.

May 5
Abdication of Charles IV of Spain.

June 4
Napoleon names Joseph Bonaparte king of Spain (1808-13).

July 15
Joachim Murat and Caroline Bonaparte are named king and queen of Naples (1808-15).

September 27-October 14
Napoleon and Czar Alexander I at Erfurt: Convention signed between France and Russia.

December 4
Fall of Madrid to French forces.

1809

January 29
Disgrace of Talleyrand, who is forced to relinquish the key of the Grand Chamberlain; Montesquiou-Fezensac is named the new Grand Chamberlain.

March 3
Napoleon appoints Elisa Bonaparte as the grand duchess of Tuscany (1809-14).

May 13
French occupation of Vienna.

May 17
France annexes the Papal States, allowing Rome the special status of a "free imperial city."

July 5-6
Battle of Wagram: France defeats Austria.

Pope Pius VII is taken prisoner by Napoleon's army and brought from Rome to Savona.

October 14
Peace of Vienna.

December 15
Napoleon and Josephine are officially divorced.

1810

The *Organisation de la Maison de l'empereur et l'impératrice et règlement sur l'étiquette du palais impérial* is issued by the department of the Grand Master of Ceremonies.

Napoleon dictates to Duroc "Le règlement de la nouvelle Maison de l'impératrice Joséphine," establishing the former Empress' new Household.

February 17
Rome is annexed by France; creation of the title "King of Rome" for the heir to the imperial throne.

March 11
Napoleon is married to Marie-Louise of Austria by proxy; he is officially represented in Vienna by the marshal Berthier, prince of Neufchâtel, and Grand Master of the Hunt.

March 27
Commissioned in 1807, the Emperor's personal service is delivered to the Tuileries in time for Napoleon's wedding.

April 1-2
Marriage of Napoleon and Marie-Louise: The religious ceremony is performed at the Louvre by the Grand Chaplain, cardinal Fesch.

The duchess of Montebello is named lady of honour to Marie-Louise.

July 3
Due to rising tensions with his brother, the Emperor, Louis Bonaparte abdicates the throne of Holland.

July 9
France annexes the Netherlands by decree.

October 22
The comtesse de Montesquiou is named Governess of Children of France.

1811

March 20
The King of Rome, Napoleon François Charles Joseph Bonaparte, son of Napoleon and Marie-Louise, is born.

June 9
The King of Rome is officially baptized at Notre-Dame Cathedral in Paris by the Grand Chaplain, cardinal Fesch.

September 9
The duke of Cadore replaces Daru as Intendant-General of the Imperial Household.

1812

March
Napoleon sends Grand Chaplain Fesch into exile in Lyon.

June
Beginning of the Russian campaign.

June 19
Pope Pius VII, still Napoleon's prisoner, arrives at Fontainebleau.

September 14
Napoleon arrives in Moscow; Russian inhabitants set fire to the city.

October–December
Russia defeats the French Grande Armée, which begins to retreat to France.

November 14
Cancellation of the Concordat of 1801.

1813

January 25
Napoleon and Pius VII sign the Concordat of Fontainebleau.

May 13
Grand Marshal of the Palace Duroc dies at Markersdorf, succumbing to wounds sustained in the Battle of Bautzen in Saxony.

March 17
Beginning of the German campaign: Prussia declares war on France.

June 21
France loses Spain to the allied forces of Britain, Portugal and Spain.

August 12
Austria declares war on France.

October 16-19
Battle of Leipzig: France is defeated by the coalition army of Russia, Prussia, Austria and Sweden. Napoleon's Confederation of the Rhine collapses.

November 9
The Frankfurt Proposals: Coalition forces propose to Napoleon that he surrender in exchange for retaining his title as Emperor and the territory within France's 1792 borders. He refuses.

November 18
Bertrand replaces Duroc as Grand Marshal of the Palace.

December 11
With Ferdinand VII, the Bourbon dynasty is restored to the Spanish throne; Joseph Bonaparte must leave Spain.

1814

January
Coalition forces enter northern France.

January 17
Defection of Murat to the coalition forces; French control of Italy is threatened.

February 4-March 17
Congress of Châtillon-sur-Seine: Coalition forces unsuccessfully try to negotiate peace with France.

March 29
Marie-Louise flees Paris with the King of Rome, never to see Napoleon again.

March 30-31
Fall of Paris to coalition forces.

Napoleon arrives at Fontainebleau.
April 4
Napoleon abdicates in favour of his son, the King of Rome; he abdicates without conditions two days later (April 6).

April 11
Treaty of Fontainebleau: Napoleon is forced into exile on the island of Elba.

May 3
Louis XVIII, of the House of Bourbon, enters Paris and is recognized as King of France and Navarre.

May 4
Napoleon arrives on Elba.

May 24
Pius VII is released from French custody and returns to Rome.

May 29
Josephine dies at Rueil-Malmaison.

May 30
First Treaty of Paris.

November 1
Opening of the Congress of Vienna.

1815

February 26
Napoleon escapes the island of Elba.

March–June
The One Hundred Days.

March 19
Louis XVIII flees Paris for Ghent.

March 20
Napoleon arrives in Paris.

June 1
Napoleon presents the revised Constitution on the Champ-de-Mars.

June 18
Battle of Waterloo: Napoleon's army is defeated by the British.

June 22
Napoleon abdicates for the second time.

July 15
Napoleon boards the H.M.S. *Bellerophon* for England. The British government decides Napoleon will go into exile on Saint Helena.

July 8
The monarchy is restored with the proclamation of Louis XVIII as king of France and Navarre; the Napoleonic era has come to an end.

August 28
Having fled France, Joseph Bonaparte arrives in New York, assuming the name the comte de Survilliers; he remains there until 1832.

October 16
Napoleon arrives in Saint Helena and settles in the Briars pavilion.

November 20
Second Treaty of Paris.

December 6
The "Règlement du service à Sainte-Hélène" is issued, appointing the members of the Household in exile:
- Bertrand as Grand Marshal of the Palace
- Montholon as Grand Chamberlain
- Gourgaud as Grand Equerry (until 1818)
- Las Cases as Secretary of State.

December 10
Napoleon moves into Longwood House.

1816

May-December
George Bullock's furniture for Longwood arrives.

November 25
Las Cases is arrested and accused of clandestine correspondence by the British; he is forced to leave Saint Helena the following month.

1819

September
The abbot Buonarita arrives on Saint Helena and serves as Grand Chaplain.

1821

May 5
Napoleon dies on Saint Helena at 5:49 p.m.

1823

Las Cases publishes the *Mémorial de Sainte-Hélène*.

1840

December 15
Napoleon's ashes are ceremonially transferred from Saint Helena to the Invalides in Paris.

1852

December 2
Louis-Napoleon Bonaparte, son of Louis Bonaparte and Hortense de Beauharnais, establishes the Second Empire after a *coup d'état;* he is proclaimed Emperor Napoleon III.

NOTES

Abbreviations:
A.M.S.: Archives de la manufacture de Sèvres
A.N.: Archives nationales, Paris
B.N.F.: Bibliothèque nationale de France

"What a romance my life has been . . ."
Nathalie Bondil

1. Antoine Reverchon, "La fabrique du Mémorial," *Le Monde*, September 29, 2017, regarding the book *Le mémorial de Sainte-Hélène. Le manuscrit retrouvé d'Emmanuel de Las Cases*, eds. Thierry Lentz, Peter Hicks, Francois Houdececk and Chantal Prévot (Paris: Perrin, 2017).
2. In *Mémoires d'outre-tombe*, 1848.
3. Read the work by Montrealer Sylvain Pagé, *Le Mythe napoléonien. De Las Cases à Victor Hugo* (Paris: CNRS Éditions, 2013).
4. Serge Joyal, *Le Mythe de Napoléon au Canada français* (Montreal: Del Busso Éditeur, 2013), see, in particular, pp. 7-21. We should recall that in order to fund his European campaigns, in 1803 Napoleon sold Louisiana, a vast territory stretching as far as Canada. His myth is still powerful on this continent, from north to south, as a military forerunner of the wars of independence.
5. Claude Galarneau, "La légende napoléonienne au Québec," in *Imaginaire social et représentations collectives. Mélanges offerts à Jean-Charles Falardeau*, eds. Fernand Dumont and Yves Martin (Quebec City: Les Presses de l'Université Laval, 1982), pp. 163-174.
6. *Le Devoir* (Montreal), February 10, 2007.
7. Ben Weider encouraged this sport by founding the International Federation of Body Builders in 1946.
8. As a benefactor, Ben Weider contributed to the restoration of Mary Queen of the World Cathedral and donated items of clothing belonging to the Manitoban Métis hero Louis Riel to the Musée de la civilisation de Québec. As an amateur historian, he wrote about figures such as Louis Cyr, *The Strongest Man in History* (1976).
9. *All for Art! In Conversation with Collectors*, exh. cat., ed. Nathalie Bondil (Montreal: The Montreal Museum of Fine Arts, 2007), p. 64.
10. A cancer or an ulcer may have been responsible for his death.
11. *All for Art!* 2007, p. 64.

Napoleon: A Modern-day Hero
Serge Joyal

1. François-Xavier Garneau, *History of Canada, from the Time of Its Discovery till the Union Year (1840–41)* (Montreal: John Lovell, 1860), pp. 429-30, trans. of *Histoire du Canada* (Quebec City: Napoléon Aubin, 1845-52).
2. Serge Joyal, *Le Mythe de Napoléon au Canada français* (Montréal: Del Busso Éditeur, 2013).

Foreword: Mobilier national

1. Jules Guiffrey, *Les Gobelins et Beauvais, les manufactures nationales de tapisseries* (Paris: H. Laurens, 1908).

Art and Court Life in the Imperial Palace: An Exhibition
Sylvain Cordier

1. Charles-Éloi Vial, "La cour consulaire," in *La Cour impériale sous le Premier et le Second Empire*, ed. Jacques-Olivier Boudon (Paris: Éditions SPM, 2016), pp. 13-29.
2. See author's essay herein on court dress, pp. 114-129.
3. For a bibliographic overview of the subject of the Imperial Household, see Pierre Branda, *Napoléon et ses hommes. La Maison de l'empereur, 1804-1815* (Paris: Fayard, 2011), pp. 19-21.
4. See author's essay herein on the Marescots, pp. 260-263.
5. Serge Joyal, *Le mythe de Napoléon au Canada français* (Montréal: Del Busso Éditeur, 2013).
6. See entry herein on the sketch by Vernet, p. 236.

I. THE IMPERIAL HOUSEHOLD: PORTRAITS

The Imperial Household: Functions, Customs and Destinies
Sylvain Cordier and Charles-Éloi Vial

1. William Ritchey Newton, *La petite cour. Services et serviteurs à la cour de Versailles au XVIII^e siècle* (Paris: Fayard, 2006), p. 215.
2. Alexandre Maral, *Le roi, la cour et Versailles :le coup d'éclat permanent (1682-1789)* (Paris: Perrin, 2013), p. 436; Jean-François Solnon, *La cour de France* (repr. Paris: Perrin, 2014), p. 675.
3. Pierre Branda, *Napoléon et ses hommes. La Maison de l'Empereur, 1804-1815* (Paris: Fayard, 2011), p. 11.
4. See, for example: *Journal politique de Mannheim*, no. 119 (April 30, 1802), p. 2.
5. Stanislas de Girardin, *Journal et souvenirs, discours et opinions* (Paris: Moutardier, 1828), vol. 3, p. 286.
6. Branda 2011, p. 16.
7. Registre des déplacements de la Cour, 1804-1813, Paris, Bibliothèque Thiers, fonds Masson, carton 109.
8. Décret sur l'organisation du palais impérial, Paris, July 17, 1804, A.N., AFIV, pièce 170.
9. Jean Dumont, *Le Cérémonial diplomatique des cours de l'Europe, ou collection des actes, mémoires et relations qui concernent*

les dignités, titulatures, honneurs et prééminences . . . (Amsterdam: Janssens; The Hague: P. de Hondt, 1739), vol. 2, p. 559, "Cérémonial domestique de la cour de Prusse."
10. Branda 2011, p. 55.
11. "Plan du château de Querqueville," B.N.F. Manuscrits, Français 6585, fol. 105.
12. Branda 2011, p. 55.
13. Louis-Philippe de Ségur, *Étiquette du palais impérial* (Paris: Imprimerie impériale, 1806), titre I, chap. IV, art. XCIX-CLIII, pp. 43-51.
14. Hélène Meyer, "Postérité de décors historiques : trois galeries à Compiègne sous l'Empire," in *1810, la politique de l'amour. Napoléon I^{er} et Marie-Louise à Compiègne*, exh. cat., eds. Emmanuel Starcky and Hélène Meyer (Paris: Réunion des musées nationaux, 2010), p. 59; Yveline Cantarel-Besson, "La peinture napoléonienne," in *Napoléon : images et histoires. Peintures du château de Versailles (1789-1815)*, by Yveline Cantarel-Besson, Claire Constans and Bruno Foucart (Paris: Réunion des musées nationaux, 2001), p. 59; Charles-Otto Zieseniss, "Les portraits des ministres et des Grands officiers de la Couronne," *Archives de l'art français*, vol. 24 (1969), p. 133. For example, Berthier, as Grand Master of the Hunt, was informed of the project on June 21, 1806 (A.N., O² 187, fol. 2).
15. For an exact identification of every figure depicted in the painting, please refer to the list "Acteurs et spectateurs du sacre," published in the exhibition catalogue *Le sacre de Napoléon peint par David*, ed. Sylvain Laveissière (Paris: Musée du Louvre; Milan: 5 Continents, 2004), pp. 197-199: English adaptation, "People Represented in *Le Sacre* (The Coronation)," in *The Coronation or Napoleon Painted by David* (Paris: Musée du Louvre; 5 Continents, 2004).
16. De Ségur 1806, titre III: "Des Levers et des Couchers de LL. MM., des Présentations, des Audiences," chap. I, art. XI.
17. Ibid., art. I.
18. Jean Tulard, *Napoléon au jour le jour* (Paris: Taillandier, 2002), p. 402.
19. De Ségur, 1806, titre IX: *Cérémonies*, chap. I: "Des Cérémonies pendant lesquelles Sa Majesté est sur le Trône," art. VII.
20. Versailles, inv. 1850, no. 1274.
21. Sylvain Laveissière, ed. *Napoléon et le Louvre* (Paris: Musée du Louvre; Fayard, 2004), p. 101.
22. Budget des Maisons de l'Empereur et de l'Impératrice pour 1813. A.N., ABXIX 4260.
23. Charles-Éloi Vial, *Les derniers feux de la monarchie. La cour au siècle des révolutions, 1789-1870* (Paris: Perrin, 2016), p. 171.
24. Louis-Constant Wairy, *Mémoires de Constant, premier valet de l'Empereur, sur la vie privée de Napoléon, sa famille et sa cour* (Paris: Ladvocat, 1830), vol. 4, p. 212.

25. *Almanach impérial* (Paris: Testu, 1810), p. 77.
26. Travaux de peinture et de dorure, 1812 et 1813, A.N.S, VJ' 19, fol. 8v and 9r and VJ' 20, fol. 11r.
27. Hortense de Beauharnais, *Mémoires de la reine Hortense* (Paris: Plon, 1927), vol. 2, p. 61.
28. Florence de Baudus, *Caroline Bonaparte, sœur d'empereur, reine de Naples* (Paris: Perrin, 2015), p. 100.
29. Vial 2016, p. 172, and *Le Grand veneur de Napoléon I^{er} à Charles X* (Paris: École nationale des chartes, 2016), pp. 154-157.
30. Athanase Garnier, *Mémoires sur Louis Napoléon et sur la Hollande* (Paris: Ladvocat, 1828), p. 12.
31. Jacques-Oliver Boudon, *Le Roi Jérôme : frère prodigue de Napoléon* (Paris: Fayard, 2008), p. 300.
32. André-François Miot de Mélito, *Mémoires du comte Miot de Mélito, ancien ministre, ambassadeur, conseiller d'État et membre de l'Institut* (Paris: Michel Lévy frères, 1858), vol. 2, p. 339.

The Grand Chaplain: Joseph Fesch, Cardinal and Prince of France
Sylvain Cordier

1. *Étiquette du palais impérial, année 1806* (Paris: Imprimerie impériale, 1806), titre I, chap. I, arts. V-VIII, XII.
2. *1810, la politique de l'amour. Napoléon I^{er} et Marie-Louise à Compiègne*, exh. cat., eds. Emmanuel Starcky and Hélène Meyer (Paris: Réunion des musées nationaux, 2010), p. 162.
3. On the Fesch collection, see, in particular, *Le cardinal Fesch et l'art de son temps*, exh. cat., ed. Philippe Costamagna (Paris: Gallimard, 2007).
4. In retaliation for Pius VII's refusal to participate in the Continental Blockade against England (1806), the Holy See was seized (1808) and then annexed (1809) to France, and the pope was arrested and held prisoner, notably at the Château de Fontainebleau, from June 1812 to January 1814.

The Grand Marshal of the Palace: Géraud-Christophe-Michel Duroc, Duke of Friuli
Sylvain Cordier

1. *Étiquette du palais impérial, année 1806* (Paris: Imprimerie impériale, 1806), titre I, chap. I, art. I.
2. *1810, la politique de l'amour. Napoléon I^{er} et Marie-Louise à Compiègne*, exh. cat., eds. Emmanuel Starcky and Hélène Meyer (Paris: Réunion des musées nationaux, 2010), p. 162.
3. Gérard Hubert and Guy Ledoux-Lebard, *Napoléon, portraits contemporains, bustes et statues* (Paris: Arthena, 1999), p. 154.

**The Grand Master of Ceremonies:
Louis-Philippe de Ségur, Comte of the Empire**
Sylvain Cordier

1. *Étiquette du palais impérial, année 1806* (Paris: Imprimerie impériale, 1806), titre I, chap. VI, arts. IV, IX, XII and XVII.
2. Jean Tulard, ed., *Dictionnaire Napoléon* (Paris: Fayard, 1987), p. 1556.
3. *1810, la politique de l'amour. Napoléon Ier et Marie-Louise à Compiègne*, exh. cat., eds. Emmanuel Starcky and Hélène Meyer (Paris: Réunion des musées nationaux, 2010), p. 1.

The Grand Chamberlains: Charles-Maurice de Talleyrand-Périgord, Prince of Benevento, and Pierre de Montesquiou-Fezensac, Comte of the Empire
Sylvain Cordier

1. *Étiquette du palais impérial, année 1806* (Paris: Imprimerie impériale, 1806), titre I, chap. III, arts. I and II.
2. It would be a moot exercise to describe the biography of such a figure. For more on him, see the excellent biography by Emmanuel de Waresquiel, *Talleyrand, le prince immobile* (Paris: Fayard, 2003).
3. Pierre Branda, *Napoléon et ses hommes. La Maison de l'Empereur, 1804-1815* (Paris: Fayard, 2011), p. 164.
4. Comte Anatole de Montesquiou, *Souvenirs sur la Révolution, l'Empire, la Restauration et le règne de Louis-Philippe*, presented and annotated by Robert Burnand (Paris: Plon, 1961), p. 154.
5. *Étiquette du palais impérial 1806*, titre IX, titre of chap. II.
6. Ibid., chap. II, art. XIII.

**The Lady of Honour to the Empress:
Louise de Guénéheuc, Maréchale Lannes, Duchess of Montebello**
Sylvain Cordier

1. Hortense de Beauharnais, *Mémoires de la reine Hortense* (Paris: Mercure de France, 2006), p. 233.
2. Ibid.

**The Grand Equerry:
Armand de Caulaincourt, Duke of Vicenza**
Sylvain Cordier

1. *Étiquette du palais impérial, 1806* (Paris: Imprimerie impériale, 1806), titre I, chap. IV, arts. I and II.
2. *1810. La politique de l'amour. Napoléon Ier et Marie-Louise à Compiègne*, exh. cat., eds. Emmanuel Starcky and Hélène Meyer (Paris: Réunion des musées nationaux, 2010), p. 162.

**The Grand Master of the Hunt:
Louis-Alexandre Berthier, Prince of Neufchâtel, Valengin and Wagram**
Sylvain Cordier

1. Charles-Éloi Vial, *Le Grand veneur de Napoléon Ier à Charles X* (Paris: École nationale des chartes, 2006), p. 46.
2. Ibid., p. 52.

The Intendant-General of the Imperial Household: Pierre-Antoine-Noël Bruno Daru, Comte of the Empire
Sylvie Le Ray-Burimi

1. A.N., Archives des musées nationaux, 20150538/216: Denon to the duke of Cadore, March 11, 1813 (AA8, p. 292), request for approval of the artist selected for the Daru portrait; see also Denon to Gros, March 15, 1813 (AA8, p. 294), commission for Daru portrait; Denon to the duke of Cadore, June 19, 1813 (AA9, p. 7), request for payment of 4,000 francs to Gros for the portrait of Daru.
2. Another example, likely a copy, is at the Musée national des châteaux de Versailles et de Trianon (MV4727, inv. 5077, LP 4973).

II. THE HOUSEHOLD AND ITS PALACES

The "Imperial Palace" and the Imperial Palaces: A Collection of Residences
Sylvain Cordier

1. *Almanach impérial pour l'an XIII, présenté à sa Majesté l'Empereur, par Testu* and *Almanach*

impérial pour l'an M. DCCC. VI, présenté à S. M. l'Empereur et roi, par Testu (Paris: Testu, Imprimeur de sa Majesté, 1805 and 1806).
2. Sylvain Cordier, *Bellangé, ébénistes. Une histoire du goût au XIXe siècle* (Paris: Mare & Martin, 2012), p. 71.
3. Charles Percier and Pierre-François-Léonard Fontaine, "Discours préliminaire," in *Recueil de décorations intérieures* (Paris: Chez les auteurs, au Louvre, 1812), p. 2.
4. Iris Moon, "La postérité du *Recueil de décorations intérieures*," in *Charles Percier (1764-1838), architecture et design*, exh. cat., ed. Jean-Philippe Garric (Paris: Réunion des musées nationaux-Grand Palais, 2016), pp. 132-133.
5. Cited by Jean-Philippe Garric, *Percier et Fontaine. Les architectes de Napoléon* (Paris: Belin, 2012), p. 139.
6. *Étiquette du palais impérial, année 1806* (Paris: Imprimerie impériale, 1806), titre II, p. 84.
7. See the essay herein on the imperial palaces by Jean-Pierre Samoyault, pp. 98-105, and the entry on the Grand Cabinet by Thomas Bohl, p. 182.
8. "*Ameublement des appartemens à destination de la cour et du personnel,*" letter from Duroc to Daru, March 16, 1806, A.N., O² 556.
9. "Projet de règlements pour l'ameublement des palais impériaux," March 25, 1806, A.N., O² 556. See Cordier 2012, pp. 72-73.
10. Guillaume Fonkenell, *Le Palais des Tuileries* (Arles: Honoré Clair; Paris: Cité de l'architecture et du patrimoine, Musée des Monuments français, 2010), pp. 71-109, and Yves Carlier, "Décor et mobilier sous le règne de Louis XIV," in Geneviève Bresc-Bautier, Yves Carlier, Bernard Chevallier, et al., *Les Tuileries. Grands décors d'un palais disparu* (Paris: Éditions du patrimoine, Centre des monuments nationaux, 2016), pp. 27-65.
11. Charles-Éloi Vial, *Les derniers feux de la monarchie. La cour au siècle des révolutions, 1789-1870* (Paris: Perrin, 2016), pp. 38-44.
12. Cited in Bernard Chevallier, *Napoléon, les lieux du pouvoir* (Versailles: Artlys, 2004), p. 32.
13. Cited in Pierre Debofle, "Tuileries et Louvre," in *Dictionnaire Napoléon*, ed. Jean Tulard (Paris: Fayard), 1987, p. 1663.
14. It is visible on other versions of the same panorama published under the Restoration: B.N.F., collection Destailleurs, no. 27, rés. V[e] 53c fol., mf A28429.
15. *Étiquette du palais impérial*, titre II, chap. II, and titre III, chap. I.
16. Fonkenell 2010, pp. 150-151.
17. Anne Dion, "D'un empire à l'autre : les Tuileries de 1800 à 1851," in *Les Tuileries. Grands décors* 2016, p. 99.
18. Chevallier 2004, p. 43.
19. Pierre-François-Léonard Fontaine, *Journal, 1799-1853*, vol. 1 (1799-1824) (Paris: École nationale supérieure des Beaux-Arts; Institut Français d'Architecture; Société de l'Histoire de l'Art français, 1987), p. 30 (September 5, 1801).
20. The whole Throne Room was damaged in April 1810 by a fire that broke out at the conclusion of the festivities organized for the civil marriage of the imperial couple: Sylvain Laveissière, *Prud'hon ou le rêve du bonheur*, exh. cat. (Paris: Réunion des musées nationaux, 1997), p. 168.
21. Jean-Pierre Samoyault, "L'ameublement des salles du Trône dans les palais impériaux sous Napoléon Ier," *Bulletin de la Société de l'Histoire de l'Art français* (1985), p. 192.
22. Saint-Cloud, which remained a secondary residence for the monarchs of the nineteenth century, was devastated by a fire during the siege of Paris in 1871 and demolished by the Third Republic.
23. On Napoleon's sojourns at Fontainebleau, see the articles herein by Christophe Beyeler, pp. 90-94, and Jean-Pierre Samoyault, pp. 98-105.
24. See the essays herein by Christophe Beyeler and Jean Vittet, pp. 96-97.
25. See the essay herein by Charles-Éloi Vial, "The Emperor's 'Cabinet,'" pp. 268-272.
26. On the Élysée, see *Caroline, sœur de Napoléon. Reine des arts*, exh. cat., eds. Maria Teresa Caracciolo and Jehanne Lazaj (Milan: Silvana, 2017).
27. See the entry herein by Jean-Jacques Gautier, pp. 86-89.
28. Pierre Branda, *Napoléon et ses hommes. La Maison de l'Empereur, 1804-1815* (Paris: Fayard, 2011), p. 30.
29. Pierre Arizzoli-Clémentel and Chantal Gastinel-Coural, eds., *Il progetto d'arredo del Quirinale nell'età napoleonica*, double supplement of no. 70 *Bolletino d'Arte* (Rome: Istituto Poligrafico e Zecca dello Stato, 1995).

30. See the entry by Christian Omodeo on Ingres in *Caroline, sœur de Napoléon* 2017.
31. Branda 2011, p. 29.
32. Chevallier 2004, p. 79.
33. Jehanne Lazaj, "Un palais tissé : repos et stratégie sous la tente," in *Le bivouac de Napoléon. Luxe impérial en campagne*, exh. cat., ed. Jehanne Lazaj (Milan: Silvana Editoriale, 2014), pp. 16-25.
34. Guillaume Desouches, *Un artisan ferronnier sous Napoléon Ier : Marie-Jean Desouches, serrurier du Garde-Meuble et de Sa Majesté l'Empereur et Roi* (Saint-Germain-en-Laye: Chez l'auteur, 2017).
35. Bernard Chevallier, *Versailles, deux siècles d'histoire de l'art* (Versailles: Société des amis de Versailles, 2007), pp. 187-193, and Jérémie Benoît, *Napoléon et Versailles*, exh. cat. (Paris: Édition de la Réunion des musées nationaux, 2005), pp. 47-57.
36. On the Versailles commissions, see the essay herein by Marie-Amélie de Taraud, pp. 188-191.
37. Baulez 2007, p. 188.
38. Garric 2012, p. 139.
39. Ibid., pp. 143-144.
40. Ibid., p. 147.

**A Monument in Porcelain:
The Table of Imperial, Later Royal, Palaces**
Sylvain Cordier

1. See the entry in the catalogue of Sotheby's New York, *Important French Furniture and Decorations, European Ceramics and Carpets*, November 9, 2007, lot 73.
2. Christophe Huchet de Quénetain and Guillaume Séret, "Du Directoire à l'Empire: vers une résurgence du mobilier de porcelaine," in *Napoléon Ier et la manufacture de Sèvres. L'art de la porcelaine au service de l'Empire*, exh. cat., ed. Camille Leprince (Paris: Feu et talent, 2016), pp. 137-144.
3. Tamara Préaud et al., *The Sèvres Porcelain Manufactory: Alexandre Brongniart and the Triumph of the Art and Industry, 1800-1847*, exh. cat. (New Haven; London: Yale University Press, for Bard Graduate Center for Studies in the Decorative Arts, New York, 1997), p. 182.
4. On this table, see particularly Geoffrey de Bellaigue, *French Porcelain in the Collection of Her Majesty The Queen* (London: Royal Collection Publications, 2009), vol. 3, cat. 305, pp. 1062-1078.
5. Letter from Grand Marshal of the Palace Duroc to Intendant-General of the Household Daru, April 22, 1806, A.N., O² 151, dossier 175.
6. Charles-Éloi Vial, *Le Grand veneur de Napoléon Ier à Charles X* (Paris: École nationale des chartes, 2016), p. 480.

Plans, Sections and Elevations of the Crown Estates: Five Large Folios
Jean-Jacques Gautier

1. Jean-Pierre Samoyault, "L'appartement de la générale Bonaparte, puis de l'impératrice Joséphine aux Tuileries (1800-1807)," *Bulletin de la Société de l'Histoire de l'Art français*, 1999, p. 215.
2. Jean-Pierre Samoyault, "Le château de Fontainebleau sous Napoléon Ier," *Médecine de France*, no. 250 (1974), pp. 25-40.
3. Jean-Marie Moulin, *Guide du musée national du château de Compiègne* (Paris: Réunion des musées nationaux, 1992).
4. *Le Faubourg Saint-Germain. La rue de Varenne*, exh. cat., ed. Françoise Magny (Paris: Musée Rodin, 1981), p. 32.
5. Denise Ledoux-Lebard, *Versailles. Le Petit Trianon. Le mobilier des inventaires de 1807, 1810 et 1839* (Paris: Éditions de l'Amateur, 1989).
6. Annick Heitzmann, "Hameau de Trianon : une salle de bal dans la grange," *Versalia*, no. 6, 2003, pp. 36-44.
7. Denise Ledoux-Lebard, *Le Grand Trianon. Meubles et objets d'art* (Paris: F. de Nobele; Éditions des Musées nationaux, 1975).
8. Léon Rey, *Le Petit Trianon et le hameau de Marie-Antoinette* (Paris: Vorms, 1936).

Evoking the Former "Abode of Kings": Fontainebleau, the "House of Ages" Attached to the Imperial Household
Christophe Beyeler

1. Pierre-François-Léonard Fontaine, *Journal, 1799-1853* (Paris: École nationale supérieure des Beaux-Arts; Institut Français d'Architecture;

Société de l'Histoire de l'Art français, 1987), vol. 1 (1799-1824), p. 61.
2. Ibid., p. 84.
3. See Arnaud Denis, "Un appartement pour le pape," in *Le Pape et l'Empereur. La réception de Pie VII par Napoléon à Fontainebleau, 25-28 novembre 1804*, exh. cat., ed. Christophe Beyeler (Paris: Somogy; Musée national du château de Fontainebleau, 2004), p. 36-41; see also "Rome à Paris. Pie VII auprès de la fille aînée de l'Église, novembre 1804-mai 1805," in *Pie VII face à Napoléon. La tiare dans les serres de l'Aigle : Rome, Paris, Fontainebleau, 1796-1814*, exh. cat., ed. Christophe Beyeler (Paris: Réunion des musées nationaux-Grand Palais; Musée national du château de Fontainebleau, 2015), pp. 90-128, especially Beyeler's description of the nankeen service acquired for the imperial table at Fontainebleau, pp. 106-107.
4. Fontaine, *Journal*, November 22, 1804, p. 91.
5. Christophe Beyeler, "Un mariage sous le regard de l'Europe. Vie de cour et fêtes de Fontainebleau en 1807" and "Projet d'aménagement de la salle de bal de Fontainebleau pour les fêtes d'automne 1807," in *Jérôme Napoléon, roi de Westphalie*, exh. cat., Christophe Beyeler and Guillaume Nicoud (Paris: Réunion des musées nationaux; Musée national du château de Fontainebleau, 2008), pp. 26-34, 36-39.
6. Sylvia Pressouyre, "Sculptures du Premier Empire au château de Fontainebleau," in *Archives de l'art français*, new period, vol. XXIV, *Les arts à l'époque napoléonienne* (1969), pp. 201-212.
7. For an idea of the grandeur of these spaces used to stage the spectacle of power, see the essay herein by Jean-Pierre Samoyault on the State apartment furnishings, pp. 98-106.
8. *Napoléon Bonaparte. Correspondance générale*, vol. XII: *La campagne de Russie, 1812*, published by the Fondation Napoléon (Paris: Fayard, 2012), letter no. 32018, p. 1239.

Two Examples of the Princely Accommodation at Fontainebleau: The Apartments in the New Wing (1810)
Jean Vittet

1. *Napoléon Bonaparte. Correspondance générale*, published by the Fondation Napoléon, vol. VIII (Paris: Fayard, 2011), no. 17474.
2. Duroc to Leroy, March 25, 1808, Fontainebleau, archives du château, 1D1 art. 224.
3. A.N., O² 6, pièce 275, October 23, 1808.
4. Possibly the design drawn up for four or eight princely apartments preserved at Fontainebleau (carton 11, dossier 12, liasse 1).
5. A.N., O² 6, p. 288.
6. Pierre-François-Léonard Fontaine, *Journal, 1799-1853* (Paris: École nationale supérieure des Beaux-Art; Institut Français d'Architecture; Société de l'Histoire de l'Art français, 1987), vol. 1, p. 234, with ill. of the elevation of the new wing with the planned pavilion.
7. The archives of the Château de Fontainebleau housing (carton 11, dossier 12) various elevations for the princes' bathrooms, designs for mantelpieces (attributed by Muriel Barbier to Hurtault, but which are undoubtedly by Leroy), designs for panelling and a large watercolour drawing for the foot of the handrail of the central staircase corresponding to the work of Leroy completed by Hurtault.
8. A.N., O² 294, dossier I.
9. Hurtault to Duroc, letter annotated by Duroc, May 1810, Fontainebleau, archives du château, 1D1 art. 223.
10. Costaz, Intendant-General of Crown Buildings, at Hurtult, July 15, 1810, Fontainebleau, archives du château, 1D1 art. 225.
11. The reports of the entrepreneurs and artisans who worked on the new wing are in the château's archives: 1D2 art. 16.
12. A.N., O² 294, dossier I.
13. The fireplaces were identical on both floors; Muriel Barbier, "De marbre et de bronze : un ensemble unique de cheminées conçues sous le Premier Empire au château de Fontainebleau," *Bulletin de la Société de l'Histoire de l'Art français* (2009), in particular, pp. 264-275, figs. 6-20, pls. XII and XIII.
14. Jean-Pierre Samoyault, *Musée national du château de Fontainebleau. Catalogue des collections de mobilier*, vol. 1: *Pendules et bronzes d'ameublement entrés sous le Premier Empire* (Paris: Réunion des musées nationaux, 1989), no. 83, ill.
15. Jean-Pierre Samoyault, *Musée national du château de Fontainebleau. Catalogue des collections de mobilier*, vol. 3: *Meubles entrés*

sous le Premier Empire: meubles d'architecture, de rangement, de travail, d'agrément et de confort (Paris: Réunion des musées nationaux, 2004), nos. 44-46 and 172, ill.

16. Samoyault 1989, vol. 1, no. 117, ill.
17. Still at the Château de Fontainebleau are two bergère chairs (inv. F 3514, F 3362 C, the second repurchased in 1979), two footstools (inv. F 3551, F 6198.2), four armchairs (inv. F 3516, F 3363 C, the latter repurchased in 1979) and two chairs (inv. F 3472, deposited at Malmaison and the Mobilier national).
18. Samoyault 2004, nos. 56, 160, 293 and 363, ill.
19. Samoyault 1989, nos. 126, 292 and 327, ill.
20. These pieces are still at Fontainebleau. Jean Coural, with the coll. of Chantal Gastinel-Coural and Muriel Müntz de Raïssac, Paris, Mobilier national. Soieries Empire (Paris: Réunion des musées nationaux, 1980), no. 17; Jean-Pierre Planchon, Pierre-Benoît Marcion (1769-1840), ébéniste de Napoléon (Saint-Rémy-en-l'Eau: Monelle Hayot, 2007), pp. 166-167, ill.; Yves Carlier and Nicolas Personne, La Galerie des meubles du château de Fontainebleau (Paris: Somogy, 2009), no. 16, ill.
21. Samoyault 2004, nos. 183 and 276, ill.
22. Samoyault 1989, nos. 120, 286 and 330, ill.
23. Coural 1980, no. 118. The chairs left the palace in 1856 and 1865.
24. Samoyault 2004, nos. 61, 62, 160, 184, 207 and 405, ill.
25. Samoyault 1989, nos. 74, 127 and 169, ill.
26. Samoyault 1989, no. 24, ill. Bernard Chevalier, Musée national du château de Fontainebleau. Catalogue des collections de mobilier, vol. 2: Les Sèvres de Fontainebleau: porcelaines, terres vernissées, émaux, vitraux (pièces entrées de 1804 à 1904) (Paris: Réunion des musées nationaux, 1996), no. 365, ill.
27. Samoyault 1989, no. 232, ill.
28. The bed is at Fontainebleau (inv. F 4051, F 4052). Jules Roussel, Le palais de Fontainebleau. Décorations intérieures et extérieures (Paris: Armand Guérinet, 1904), vol. 5, pl. 472; Hector Lefuel, François-Honoré-Georges Jacob-Desmalter, ébéniste de Napoléon Ier et de Louis XVIII (Paris: A. Morencé, 1925), p. 281.
29. Coural 1980, no. 76. The chairs and the fire screen, covered in their former fabric, are found between Fontainebleau (inv. F 302 C-F 307 C; Roussel 1904, pl. 496) and the Mobilier national.
30. Samoyault 2004, nos. 96, 141 and 160, ill.
31. Samoyault 1989, nos. 20, 113 and 151, ill.
32. Still at Fontainebleau, partially covered in their older fabric, the bergère chair (inv. F 3480), the two footstools (inv. F 2656, F 4025), the four armchairs (inv. F 3481—Jean-Pierre Samoyault, Mobilier français Consulat et Empire (Paris: Gourcuff Gradenigo, 2009), p. 171, fig. 282; inv. F 2014.15.1 and 2, the latter two were recently repurchased—Jean Vittet, La Revue des musées de France. Revue du Louvre (2015), no. 3, pp. 83-84, ill.; three chairs (inv. F 3482) and fire screen (inv. F 3486).
33. Samoyault 2004, nos. 100, 103, 221 and 227, ill.
34. Samoyault 1989, nos. 119 and 253, ill.
35. Coural 1980, no. 49. These pieces, which left the palace in the late nineteenth century, were in part alienated; the four armchairs reappeared on the art market in 1961 and 1984; the four chairs were sold at the Hôtel Drouot, salle 10, June 29, 2011, no. 182.
36. Samoyault 2004, nos. 109, 152 and 301, ill.
37. Samoyault 1989, no. 236, ill.
38. Samoyault 2004, nos. 44, 46, 106 and 208, ill.
39. This group still belongs to the Château de Fontainebleau (inv. F 125 C-F 129 C [en dépôt, Mobilier national], F 1916 C); Roussel 1904, pl. 494.
40. Samoyault 2004, nos. 160, 191, 295 and 296, ill.
41. Samoyault 1989, no. 328, ill.
42. Pierre Arizzoli-Clémentel and Chantal Gastinel-Coural, Soieries de Lyon : commandes royales au XVIIIe siècle (1730-1800), exh. cat. (Lyon: Musée historiques des tissus, 1988), no. 61, ill.
43. Some of this furniture is at Fontainebleau, still covered in its original fabric. Jean Vittet, Dans les rêves de Napoléon. La première chambre de l'Empereur à Fontainebleau (Dijon: Faton, 2016), pp. 19 and 44, no. 18, ill.
44. These chairs are at Fontainebleau, covered in their older fabric (inv. F 117 C, F 82 C, F 7427).
45. Samoyault 2004, nos. 160, 183 and 276, ill.
46. Samoyault 1989, no. 291.
47. This group is almost entirely preserved at Fontainebleau (inv. F 969 C-F 974 C). Coural 1980, no. 118; Jean Coural and Chantal Gastinel-Coural, "L'Élysée. Histoire et décors depuis 1720," Dossier de l'art, no. 23 (April-May 1995), pp. 92-93, 99, ill.; Samoyault 2009, p. 163, fig. 260.

48. Samoyault 2004, nos. 55, 176 and 292, ill.
49. This standing clock was provisional; another one, with a figure of Urania in Sèvres biscuit, was to replace it. Samoyault 1989, no. 25, ill.; Chevalier 1996, no. 366, ill.
50. Fontainebleau, inv. F 153 C.
51. Fontainebleau, inv. F 154 C, F 155 C (Roussel 1904, vol. 3, pl. 246; Lefuel 1925, pp. 283-284). A part of the textile decoration in the room was reinstalled with imagination in 1904 over the bed used by the pope in 1804 (inv. F 5602).
52. Coural 1980, no. 48; Jean-Marcel Humbert, Michael Pantazzi and Christiane Ziegler, Égyptomania. L'Égypte dans l'art occidental, 1730-1930, exh. cat. (Paris: Réunion des musées nationaux; Ottawa: National Gallery of Canada, 1994, no. 51 [entry by Samoyault]; Jean-Jacques Gauthier and Bertrand Rondot, Le Château de Versailles raconte le Mobilier national. Quatre siècles de création, exh. cat. (Paris: Skira-Flammarion; Versailles: Château de Versailles, 2011), pp. 122-123, 203, ill. (entry by Rondot). A modern méridienne (whereabouts unknown) was matched with the old chairs. After remaining at Fontainebleau for nearly two centuries, sheltered from covetousness, the group was deposited at Versailles in 1999.
53. Samoyault 2004, nos. 104, 160 and 314, ill.
54. Samoyault 1989, no. 29, ill.
55. Still at Fontainebleau are the settee (inv. F 4021), the bergère chair (inv. F 4022), a stool (inv. F 3483), the four armchairs (inv. F 4023; Samoyault 2009, p. 166, fig. 266), the four chairs (inv. F 4024) and the fire screen (inv. F 4027).
56. Samoyault 2004, nos. 109, 141, 228 and 383, ill.
57. None of the chairs from this group are still at Fontainebleau. The four armchairs, four chairs and possibly the bergère chair, made into a settee, were sold in London, Sotheby's, June 24, 1988, no. 14.
58. Samoyault 2004, nos. 101 and 110, ill.

The Manifestation of Power in the Furnishings of the Imperial Palaces
Jean-Pierre Samoyault

1. Jean-Pierre Samoyault, "L'ameublement des salles du Trône dans les palais impériaux sous Napoléon Ier," Bulletin de la Société de l'Histoire de l'Art français, 1985, pp. 185-206. For the chambers of the Legislative Corps, Jacob-Desmalter delivered an armchair destined for the Empress' tribune, based on the model of those in the Throne Rooms (ill. 87).
2. Pierre Arizzoli-Clémentel and Chantal Gastinel-Coural, "Il projetto d'arredo del Quirinale nell'età napoleonica," Bolletino d'Arte, supplement no. 70, 1995, pp. 91-94.
3. Manuscript version, titre II, chaps. I-III, A.N., O² 137.
4. Château de Fontainebleau, Archives de la Conservation, inventaire de 1810.
5. A.N., O² 504, dossier 1, pièce 3.
6. A.N., O¹* 3445.
7. Philippe de Courcillon, marquis de Dangeau, Journal, with additions by the duc de Saint-Simon, vol. VI, 1856, December 19, 1696, p. 44.
8. For example, Grand Marshal Duroc wrote in his note of August 31, 1807, regarding the Tuileries, that the "Emperor's Cabinet was not right and that this was the room that had to be extremely well-appointed" (A.N., O² 506, dossier 1, pièce 8).
9. Château de Fontainebleau, Archives de la Conservation, inventaire de 1807, 1er vol. Regarding the arrangements of the Throne Room and Council Chambers, see Samoyault 1985 and "La salle du Conseil du château de Fontainebleau sous le Premier Empire," La Revue du Louvre (1974), nos. 4-5, pp. 292-300.
10. Inventaire de Compiègne, 1811, 1er vol, A.N., O² 645.
11. Pierre Arizzoli-Clémentel and Jean-Pierre Samoyault, Le mobilier de Versailles. Chefs-d'œuvre du XIXe siècle (Dijon: Faton, 2009), no. 64, pp. 206-208.
12. Arizzoli-Clémentel and Gastinel-Coural 1995, pp. 119-128; René, Guy and Christian Ledoux-Lebard, "La décoration et l'ameublement du Grand cabinet de Napoléon Ier aux Tuileries," Bulletin de la Société de l'Histoire de l'Art français, 1941-44, pp. 185-258; Jean-Pierre Samoyault, "Le remeublement du palais de la Légion d'honneur depuis sa reconstruction," in L'Hôtel de Salm : Palais de la Légion d'honneur, coll. pub. (Paris: Monelle Hayot, 2009), p. 291.
13. Sylvain Cordier, Bellangé, ébénistes. Une histoire du goût au XIXe siècle (Paris: Mare et Martin Arts, 2012), pp. 112-114.
14. A.N., O² 556, dossier 1, pièce 23.

15. Inventaire des Tuileries 1809, 1er vol., A.N., O² 680; Arizzoli-Clémentel and Samoyault 2009, no. 53, pp. 174-177. The lit à la duchesse, a name that goes back to the first half of the eighteenth century, and which was no longer in use during the First Empire, is a canopy bed suspended from a frame and attached at the head to the wall.
16. Tuileries inventory 1807, 1er vol, A.N., O² 675.
17. See the Tuileries inventory 1809, cited in note 15.
18. See the Fontainbleau inventory 1807, cited in note 9. Regarding railings in the bedrooms of the imperial palaces, see Arizzoli-Clémentel and Samoyault 2009, pp. 166-167, no. 48.
19. See Compiègne inventory 1811, cited in note 10.
20. A.N., O² 556, dossier 1, pièce 34.

At Napoleon's Bedside: The Headboard of the Emperor's Bed at the Tuileries
Sylvain Cordier

1. Pierre Verlet, Le mobilier royal français (Paris: Picard), vol. 1, pp. 100-104.
2. Guillaume Fonkenell, Le palais des Tuileries (Arles: Honoré Clair; Paris: Cité de l'architecture et du patrimoine, musée des Monuments français, 2010), pp. 151-152; Anne Dion-Tenenbaum, "D'un empire à l'autre: les Tuileries de 1800 à 1851," in Les Tuileries. Grands décors d'un palais disparu, Geneviève Bresc-Bautier, Yves Carlier, Bernard Chevallier et al. (Paris: Éditions du patrimoine, Centre des monuments nationaux, 2016), pp. 105-106.
3. Pierre Arizzoli-Clémentel and Jean-Pierre Samoyault, Le mobilier de Versailles : chefs-d'œuvre du XIXe siècle (Dijon: Faton), p. 174.
4. Daniel Alcouffe, Anne Dion-Tenenbaum and Amaury Lefébure, Le mobilier du musée du Louvre (Dijon: Faton, 1993), p. 298.
5. Musée du Louvre, Paris, inv. OA 10278. See Sylvain Cordier, "Pierre-Gaston Brion, menuisier et sculpteur sur bois," L'Estampille-L'Objet d'art, no. 403 (June 2005), p. 46.
6. Denise Ledoux-Lebard, Le Grand Trianon : meubles et objets d'art (Paris: F. De Nobele; Éditions des musées nationaux, 1975), p. 54.

The Dream of Ossian by Ingres: A Poet in the Emperor's Bedchamber
Christian Omodeo

1. Marina Natoli and Maria Antonietta Scarpati, eds., Il Palazzo del Quirinale. Il mondo artistico a Roma nel periodo napoleonico, 2 vols. (Rome: Istituto Poligrafico e Zecca dello Stato, 1989).
2. For a study of Ingres' Roman years and his involvement in the work on the Napoleonic Quirinale, see Christian Omodeo, "Rome, 1806-1820 : Ingres et le monde des arts," in Ingres, un homme à part ? Entre carrière et mythe, la fabrique du personnage, colloquium proceedings of the École du Louvre, eds. Claire Barbillon, Philippe Durey and Uwe Fleckner (Paris-Rome: May 2006) (Paris: La Documentation Française; École du Louvre, 2009), pp. 251-274.
3. Nicolas Schlenoff, Les sources littéraires de J.-A.-D. Ingres (Paris: Presses universitaires de France, 1956), p. 90.
4. Daru mentions the subject of Ossian for the first time in a letter to Pietro Nocchi, dated December 17, 1812 (Paris, Bibliothèque Thiers, Fonds Masson, carton 125, f° 165 v°).
5. Ossian, exh. cat., eds. Hanna Hohl and Hélène Toussaint (Paris: Éditions des musées nationaux, 1974).
6. Léo Joubert, entry on the baron Martial Daru, in Nouvelle Biographie Universelle (Paris: Imprimerie Firmin-Didot frères, 1855), note 6.
7. Cited in Charles-Augustin Sainte-Beuve, "Poètes et critiques littéraires de la France. - XXXI. M. de Fontanes, première partie," Revue des deux Mondes (Paris: 1838), vol. XVI, p. 660.

Public Access to the Imperial Apartments
Charles-Éloi Vial

1. Pierre Verlet, Le Château de Versailles (Paris: Fayard, 1985), pp. 160-163.
2. Roger Chartier, Les origines culturelles de la Révolution française (Paris: Seuil, 2000), p. 254.
3. Jacques-Pierre de Montchanin in Lettres de Héléodore adressées à Napoléon Bonaparte, depuis le 13 ventôse an 8 jusqu'au 17 mars 1814 (Paris: Bossange, 1833), vol. II, p. 19, letter of September 18, 1807.
4. Charles-Emmanuel de Rivaz, Mes souvenirs de Paris, 1810-1814 (Martigny: Pillet, 1967), p. 178.
5. Charles de Clary-et-Aldringen, Souvenirs (Paris: Plon-Nourrit, 1914), pp. 177-179.

6. Recueil de pièces authentiques sur le captif de Sainte-Hélène (Paris: Alexandre Corréard, 1822), vol. 5, p. 27.
7. Karl Christian von Berckheim, Lettres sur Paris (Heidelberg: Mohr & Zimmer, 1809), p. 287-288.
8. Émile de Perceval, Dans les archives du vte Lainé, ministre et pair de France (Paris: Champion, 1929), p. 153.
9. Ninian Pinkney, Travels through the South of France and the Interior of Provinces of Provence and Languedoc in the Years 1807 and 1808 (London: T. Purday and Son, 1809), p. 111.
10. Letter from Costaz to Duroc, February 20, 1810, A.N., O² 243, dossier 2.
11. The criteria upon which visitors were authorized to enter the palaces are unknown. They likely had to produce a written request, and perhaps undergo a police investigation.
12. Réglement de Fleurieu, gouverneur des Tuileries, May 30, 1809, B.N.F., Français 6585, fol. 17.
13. Registre d'ordre des Tuileries, p. 11. Bibl. Thiers, ms. Masson 103.
14. "Règlement pour le service du Grand maréchal du palais," March 1, 1812, B.N.F., Français 11212, fol. 41.
15. Pierre-François-Léonard Fontaine, Journal, 1799-1853 (Paris: École nationale supérieure des Beaux-Arts; Institut Français d'Architecture; Société de l'Histoire de l'Art français, 1987), vol. 1, p. 393.
16. Georgette Ducrest, Mémoires sur l'impératrice Joséphine . . . (Paris: Ladvocat, 1828), vol. I, p. 304.
17. Anne Potocka, Mémoires (Paris: Plon, 1897), p. 258.

A Special Lexicology for the Imperial Protocol: Court Dress
Sylvain Cordier and Chantelle Lepine-Cercone

1. Some of the most important studies include: Madeleine Delpierre, Costumes de cour et de ville du Premier Empire, exh. cat. (Paris: Musée du costume de la ville de Paris, annexe du Musée Carnavalet, 1958); Madeleine Delpierre, "Les costumes de cour et les uniformes civils du Premier Empire," Bulletin du musée Carnavalet (November 1958), pp. 2-23; Modes et Révolutions, 1780-1804, exh. cat. (Paris: Musée de la Mode et du Costume, Palais Galliera; Éditions Paris-Musées, 1989); Katell Le Bourhis, ed. The Age of Napoleon: Costume from Revolution to Empire, 1789-1815, exh. cat. (New York: The Metropolitan Museum of Art; Harry N. Abrams, 1989); Alice Mackrell, Art and Fashion: The Impact of Art on Fashion and Fashion on Art (London: BT Batsford, 2005); Philip Mansel, Dressed to Rule: Royal and Court Costume from Louis XIV to Elizabeth II (New Haven; London: Yale University Press, 2005); Aileen Ribeiro, The Art of Dress: Fashion in England and France, 1750-1820 (New Haven; London: Yale University Press, 1995); Philippe Séguy, Histoire des modes sous l'Empire (Paris: Tallandier, 1988); and Susan L. Siegfried, "Fashion and the Reinvention of Court Costume in Portrayals of Josephine de Beauharnais (1794-1809)," Se vêtir à la cour en Europe (1400-1815) in Apparence(s), no. 6, 2015, http://apparences.revues.org/1295.
2. Delpierre 1958, Costumes de cour . . .; Delpierre 1958, "Les costumes de cour . . . "
3. Christophe Beyeler, "Percier et le Livre du Sacre: Un ornemaniste et son collaborateur," in Charles Percier (1764-1838), architecture et design, exh. cat., ed. Jean-Philippe Garric (Paris: Réunion des musées nationaux-Grand Palais, 2016), p. 141.
4. Étiquette du Palais impérial, année 1806 (Paris: Imprimerie impériale, 1806), titre I, chap. VI.
5. Pierre-François-Léonard Fontaine, Charles Percier and Jean-Baptiste Isabey, Le Sacre de S. M. l'Empereur Napoléon dans l'Église Métropolitaine de Paris, le XI frimaire an XIII, Dimanche 2 Décembre, 1804 (commonly referred to as the Livre du Sacre) (Paris: Imprimerie impériale, 1804-15), unpag.
6. Ibid., p. 19.
7. Colombe Samoyault-Verlet and Jean-Pierre Samoyault, Musée Napoléon Ier : Napoléon et la famille impériale, 1804-1815 (Paris: Réunion des musées nationaux, 1986), p. 22.
8. Memoirs of Madame de Rémusat, 1802-1808, vol. 1 (London: Sampson Low, Marston, Searle and Rivington, 1880), p. 313.
9. Le Sacre de S. M. l'Empereur Napoléon 1804-15, unpag. It is worth noting that the inclusion of the Empress (and the princesses and the ladies-in-waiting) in the Livre du Sacre is a departure from the Albums du Sacre of Louis XV and Louis XVI, which only included male costumes.

10. Ribeiro 1995, p. 160.

11. *Le Sacre de S. M. l'Empereur Napoléon* 1804-15, p. 20.

12. Ibid., p. 21.

13. Michael Eissenhauer, ed., *Konig Lustig!? Jérôme Bonaparte und der Modellstaat Königreich Westphalen*, exh. cat. (Munich: Hirmer Verlag, 2008), p. 146.

14. A.N., O² 32, fol. 14.

15. Samoyault-Verlet and Samoyault 1986, p. 104.

16. *Le Sacre de S. M. l'Empereur Napoléon* 1804-15, unpag.

17. Fiona Foulkes, "'Quality Always Distinguishes Itself': Louis Hippolyte Leroy and the Luxury Clothing Industry in Early Nineteenth-century Paris," in *Consumers and Luxury: Consumer Culture in Europe, 1650-1850*, eds. Maxine Berg and Helen Clifford (Manchester; New York: Manchester University Press, 1999), p. 190.

18. *Le Sacre de S. M. l'Empereur Napoléon* 1804-15, p. 22.

19. Ibid., p. 23.

20. See the essay herein by Émilie Robbe, pp. 296-303.

21. *Le Sacre de S. M. l'Empereur Napoléon* 1804-15, p. 24.

22. A.N., O² 138, fol. 34.

23. Ibid., fol. 36.

24. *Le Sacre de S. M. l'Empereur Napoléon* 1804-15, p. 25.

25. Ibid., p. 23.

26. See the essay herein by Anne Dion-Tenenbaum, pp. 254-259. See also, Agathon-Jean-François Fain, *Mémoires* (Paris: Plon-Nourrit, 1908), pp. 195-196.

27. On the *grand* and *petit uniforme* see: A.N., O² 86, f. 37. On the responsibility of the parents to pay for the uniforms, see: *Étiquette du Palais imperial* 1806, titre I, chap. IV, art. cı.

28. *Le Sacre de S. M. l'Empereur Napoléon* 1804-15, p. 29. This description is corroborated and expanded in the records of the Grand Equerry in the Archives nationales, which contains many documents regarding the maintenance of the pages' uniforms and the ordering of new garments: See A.N., O² 86.

29. A.N., O² 86, fol. 2, 9-11, 15.

30. A.N., O² 158, fol. 232r. See also the letters from David in A.N., O² 158, fol. 233-235.

31. Ibid., fol. 232v.

32. The parallels between Napoleon's court and those of the monarchs of the Ancien Régime is also echoed in the continuous nomination of members of the nobility surrounding the imperial family to the posts of chamberlain and equerry.

33. Hervé Pinoteau, "Le roi et la reine de France en majesté," in *Fastes de cour et cérémonies royales : le costume de cour en Europe, 1650-1800*, eds. Pierre Arizzoli-Clémentel and Pascale Gourguet Ballesteros, exh. cat. (Paris: Éditions de la Réunion des musées nationaux, 2009), p. 110.

34. Madeleine Delpierre, "Le retour aux costumes de cour sous le Consulat et l'Empire," in *Modes et révolutions, 1780-1804* 1989, p. 38; Antoine Danchet, *Le Sacre de Louis XV roy de France de Navarre, dans l'Église de Reims, le Dimanche XXV Octobre MDCCXXII* (n.p., 1772), unpag. Thomas Jean Pichon, *Sacre et couronnement de Louis XVI, roi de France et de Navarre, à Rheims, le 11. juin 1775* (Paris: Chez Vente et chez Patus, 1775), unpag.

35. Colombe Samoyault-Verlet, "The Emperor's Wardrobe," in *The Age of Napoleon* 1989, p. 209.

36. The *habit à la française* appeared for the first time at some point between 1660 and 1670. See Pascale Gorguet Ballesteros, "Caractériser le costume du cour: propositions," in *Fastes de cour et cérémonies royales* 2009, p. 56. Philippe Séguy, "Costume in the Age of Napoleon," in *The Age of Napoleon* 1989, p. 111.

37. Mansel 2005, pp. 80-81.

38. For example, Berthier, in his role as vice-constable, had a court costume made of satin, which is still preserved in the Musée de la Légion d'honneur, Paris, and one made of velvet, which is now in the collection at the Musée de l'Armée, Paris.

39. Ibid., p. 80.

40. A.N., O² 6, fol. 495.

41. Delpierre "Le retour aux costume . . ." 1989, p. 37.

42. Ribeiro 1995, p. 140.

43. Séguy 1989, p. 73.

44. In the end, sandals were considered indecorous and were exchanged for proper shoes. However, allusion to Roman sandals was made by using gold embroidery to mimic laces on the Emperor's tights. See Ribeiro 1995, p. 155.

45. Séguy 1989, p. 86.

46. Philip Mansel, "Monarchy, Uniform and the Rise of the *Frac*, 1760-1830," *Past and Present*, vol. 96, no. 1 (August 1982), p. 109.

47. François Pupil, "Isabey 'dessinateur du cabinet et du théâtre de S. M. l'Empereur et Roi,' 1807-1815," in *Jean-Baptiste Isabey (1767-1855), potraitiste de l'Europe*, exh. cat. (Paris: Réunion des musées nationaux, 2005), p. 66; Mackrell 2005, p. 65.

48. Ribeiro 1995, p. 162.

49. Siegfried 2005, p. 16. According to French legend, the tapestry had been embroidered by the wife of William the Conqueror, Queen Matilda.

50. Mackrell 2005, p. 55.

51. Madame de Rémusat 1880, p. 313. Madame de Rémusat in fact notes this collar was brought to France by Catherine de' Medici.

52. Ribeiro 1995, p. 155.

III. ART AND MAJESTY

The Artists of the Imperial Households and Others Artists: Emulation, Rivalries and Low Blows
Cyril Lécosse

1. Denon to Napoléon, September 25, 1804, in *Vivant Denon, directeur des musées sous le Consulat et l'Empire. Correspondance (1802-1815)*, eds. Marie-Anne Dupuy, Isabelle le Masne de Chermont and Elaine Williamson (Paris: Réunion des musées nationaux, 1999), vol. II, AN 23, p. 1260.

2. Denon to Napoléon, October 15, 1804, in ibid., vol. II, AN 25, p. 1265.

3. Étienne-Jean Delécluze, *Louis David, son école et son temps. Souvenirs* (Paris: Didier, 1855), p. 198. See also L[éon] de Lanzac de Laborie, *Paris sous Napoléon* (Paris: Plon-Nourrit, 1913), vol. VIII, p. 370.

4. Letter from Bonaparte to his brother Lucien, 23 Fructidor, Year VIII (September 9, 1800), A.N., F¹⁷1232.

5. Joseph Lavallée, "Exposition des esquisses du 15 frimaire an XI," *Journal des arts, des sciences et de la littérature*, Collection Deloynes, no. 1795, p. 653.

6. See David O'Brien, *Antoine-Jean Gros : peintre de Napoléon* (Paris: Gallimard, 2006), pp. 74-79.

7. Denon to Napoleon, October 15, 1804, in *Vivant Denon . . .* 1999, vol. II, AN 25, p. 1265.

8. Denon to Daru, January 12, 1810, in ibid., vol. I, no. 1699, p. 601.

9. Cited in Pierre Lelièvre, *Vivant Denon, homme des Lumières, « ministre des arts » de Napoléon* (Paris: Picard, 1993), p. 145.

10. See in particular Bruno Foucart, "L'artiste dans la société de l'Empire : sa participation aux honneurs et aux dignités," *Revue d'histoire moderne et contemporaine*, vol. XVII (July-September 1970), pp. 709-719.

11. On the operations of the Imperial Households, see Pierre Branda, *Napoléon et ses hommes. La Maison de l'Empereur, 1804-1815* (Paris: Fayard, 2011).

12. See, in particular, Agathon-Jean-François Fain, *Mémoires du baron Fain, premier secrétaire du cabinet de l'Empereur* (Paris: Plon, 1908), p. 64.

13. See Régis Spiegel, *Dominique-Vivant Denon et Benjamin Zix : acteurs et témoins de l'épopée napoléonienne (1805-1812)* (Paris: L'Harmattan, 2000), p. 70, note 149.

14. See, for example, A.N., O² 33-358.

15. A.N., O² 33-372.

16. Ibid.

17. Ibid.

18. A single example will suffice here: in May 1808, Isabey was promised the large sum of 2,500 francs for the creation of a large miniature depicting a standing Louis Bonaparte (whereabouts unknown). For a similar work, he would only earn 1,200 francs when the work was destined for the department of foreign affairs. See Isabey to Baure, secretary to the Intendant-General of the Imperial Household, May 13, 1808, in Eva de Basily-Callimaki, *J.-B. Isabey, sa vie, son temps, 1767-1855, suivi du catalogue de l'œuvre gravée par et d'après Isabey* (Paris: Frazier-Soye, 1909), p. 79.

19. In fact, no other painter's name appears on the list of gift suppliers.

20. This is an average for the years 1805 to 1807. For 1807 alone, the miniaturist received 2,083 francs a month for the fruit of his labours.

21. See Graham Reynolds, *Wallace Collection: Catalogue of Miniatures* (London: The Trustees of the Wallace Collection, 1980), nos. 181, 184, 215, 220, 229.

22. Duroc to Daru, Saint-Cloud, August 8, 1807, A.N., O² 30-39; see also A.N., O² 6-102.

23. Denon to Daru, September 25, 1807, repr. in *Vivant Denon . . .* 1999, vol. I, no. 1196², pp. 444-445.

24. Delécluze 1855 p. 284.

25. Denon to Bonaparte, May 13, 1803, in *Vivant Denon . . .* 1999, vol. II AN 7, p. 1245, and David's reply, p. 1246.

26. Denon to Napoléon, October 15, 1804, in *Vivant Denon . . .* 1999, vol. II, AN 25, p. 1265.

27. Isabey to Daru, Sèvres, August 27, 1807, A.N., O² 30-45.

28. Daru to Duroc, August 17, 1807, A.N., O² 30-40.

29. Duroc to Daru, September 15, 1807, A.N., O² 6-128.

30. Dumont to Daru, December 12, 1809, A.N., O² 30-86.

31. Bernd Pappe, *Jean-Baptiste Jacques Augustin, peintre en miniature*, exh. cat. (Saint-Dié-des-Vosges: Musée Pierre-Noël, 2010), p. 20.

32. A.N., O² 30-82 à O² 30-85.

33. Daru to Duroc, September 12, 1807, A.N., O² 30-48.

34. Duroc to Daru, October 22, 1807, A.N., O² 6-155.

35. Notably Marie-Victoire Jaquotot, who transferred fourteen jasmine tea cups for the portrait that Isabey painted of Marie-Louise. Regarding the use of Sèvres porcelain as diplomatic gifts, see in particular A.N., O² 151-175 and A.N., O² 6-365 à O² 6-371.

36. A total of 20 figures (A.M.S., carton Pb 2, liasse 2).

37. Duroc to Daru, October 1, 1807, A.N., O² 6-136; see also Duroc to Daru, September 15, 1807, A.N., O² 6-128.

38. Cited by de Lanzac de Laborie 1913 p. 384.

39. Gaston Lavalley, *Le peintre Robert Lefèvre : sa vie, son œuvre* (Caen: L. Jouan, 1902), pp. 84-85.

40. *Girodet 1767-1824*, exh. cat., ed. Sylvain Bellenger (Paris: Gallimard; Musée du Louvre Éditions, 2005), p. 367.

41. Denon to the comte de Blacas, August 6, 1814, *Vivant Denon . . .* 1999, vol. I, no. 3173, p. 1080.

42. See the note on Gérard, Denon to Duroc, September 25, 1807, in Dupuy *Vivant Denon . . .* 1999, vol. I, no. 1196², pp. 444-445.

43. See *Le Sacre de Napoléon peint par David*, exh. cat. (Paris: Musée du Louvre; Milan: 5 Continents Éditions, 2004), p. 64.

44. See *Vivant Denon . . .* 1999, vol. I, no. 710, pp. 274-275.

45. Denon to Napoléon, February 19, 1806, in *Vivant Denon . . .* 1999, vol. II, AN 48, pp. 1292-1293.

46. Denon to Daru, January 12, 1810, in *Vivant Denon . . .* 1999, vol. I., no. 1699, p. 601.

47. Denon to Napoleon, February 19, 1806, in ibid., vol. II, AN 48, pp. 1292-1293. Denon was already alarmed in 1803, as expressed in a letter addressed to the First Consul; see Denon to Napoleon, May 13, 1803, in *Vivant Denon . . .* 1999, vol. II, AN 7, p. 1245.

48. Denon to Fleurieu, April 8, 1805, in ibid., vol. I, no. 666², p. 259.

49. Denon to Napoléon, April 8, 1805, in ibid., vol. II, AN 34, pp. 1276-1277.

50. Gérard to Daru, April 25, 1808, cited in de Lanzac de Laborie 1913, p. 385.

51. On this point, see the series A.N., O² 30.

52. Montesquiou to Daru, August 7, 1810, A.N., O² 35-620.

53. In fact, we are far from the description given by Anaïs de Bassanville, who recalls a devout man, charming and ordinary, blessed with "an amiable spirit, simple and distinguished, good company, sweet and easy-going:" Anaïs de Bassanville, *Les Salons d'autrefois, souvenirs intimes* (Paris: Brunet, 1862), p. 89.

54. A letter from the duke of Friuli, dated September 19, 1808 (A.N., O² 6-261), shows that Gérard continued to enjoy Napoleon's support, despite Denon's admonitions; the Emperor did not "disapprove" of the artist despite the large sum he demanded for a portrait (of the Queen of Spain and her children). For David, see, in particular, Alain Pougetoux, "De la République des Arts au peuple artiste," in *Dominique-Vivant Denon. L'oeil de Napoléon*, exh. cat., ed. Marie-Anne Dupuy (Paris: Réunion des musées nationaux, 1999), p. 341.

When François Gérard was Planning the Portrait of the Emperor
Sylvain Cordier

1. It was last seen in public at the sale of the collections of the duc de Talleyrand, Valencay and Sagan, May 29-June 1, 1889, where it went to an anonymous purchaser.

2. The most up-to-date list of these versions was published by Xavier Salmon in *Peintre des rois, roi des peintres, François Gérard (1770-1837) portraitiste*, exh. cat. (Paris: Réunion des musées nationaux-Grand Palais; Château de Fontainebleau, 2014), p. 86.

3. Deutsches Historisches Museum de Berlin (Ségur) and private collection (Caulaincourt).

4. Letter from Denon to Talleyrand, March 2, 1806, in *Vivant Denon, directeur des musées sous le Consulat et l'Empire. Correspondance (1802-1815)*, eds. Marie-Anne Dupuy, Isabelle le Masne de Chermont and Elaine Williamson (Paris: Réunion des musées nationaux, 1999), vol. I, no. 818, p. 318.

5. Letter from Denon to Gérard, March 2, 1808 (ibid., no. 1348, p. 490).

6. Ibid. See author's essay herein on the gift-giving policy, pp. 192-211.

7. Letter from Denon to the minister of foreign affairs, August 22, 1806 (ibid., no. 1010, p. 388).

8. Under no. 790 in the booklet.

9. Salmon 2014, p. 86.

10. See, in particular, the letter from Denon to the duke of Friuli, Grand Marshal of the Palace, January 5, 1811, in *Vivant Denon . . . Correspondance (1802-1815)* 1999, no. 1963, p. 683.

11. Letter from Denon to Daru, February 26, 1808, ibid., no. 1341, p. 683.

12. Letter from Denon to the comte de Préameneu, the minister of worship, February 28, 1811, ibid., no. 2001, p. 696.

13. See Thomas Crow, *Emulation: Making Artists for Revolutionary France* (New Haven; London: Yale University Press, 1995), pp. 238-245, and Philippe Bordes, *Study for a Portrait of General Bonaparte*, exh. cat. (New Haven; London: Yale University Press; Williamstown, Connecticut: Sterling and Francine Clark Art Institute, 2005), pp. 75-79.

14. Entry by Alain Pougetoux in *Joséphine*, exh. cat., ed. Amaury Lefébure (Paris: Réunion des musées nationaux-Grand Palais; Musée national des châteaux de Malmaison et Bois-Préau, 2014), cat. 13, p. 74.

15. Carrie Rebora Barratt and Ellen G. Miles, *Gilbert Stuart*, exh. cat. (New York: The Metropolitan Museum of Art; New Haven; London: Yale University Press, 2004), cat. 49, pp. 186-190.

16. Gail Feigenbaum, *Jefferson's America and Napoleon's France*, exh. cat., ed. Victoria Cooke (New Orleans: New Orleans Museum of Art; Seattle; London: University of Washington Press, 2003), p. 50.

17. Philippe Bordes, *Le Serment du Jeu de Paume de Jacques-Louis David : le peintre, son milieu et son temps, de 1789 à 1792* (Paris: Réunion des musées nationaux, 1983), p. 59.

18. Jean-Pierre Samoyault, "L'ameublement des salles du trône dans les palais impériaux sous Napoléon I," *Bulletin de la Société d'Histoire de l'Art français* (1985), p. 195.

19. Bordes, "In the Service of Napoleon," in *Jacques-Louis David: Empire to Exile* 2005, p. 44.

20. Paris, Musée du Louvre, RF 41 385 13 to RF 41 385 17.

21. Bordes "In the Service of Napoleon," in *Jacques-Louis David: Empire to Exile* 2005, pp. 44-45.

22. Todd Porterfield and Susan L. Siegfried, *Staging Empire: Napoleon, Ingres, and David* (Penn State University Park: The Pennsylvania State University Press, 2006); Alain Pougetoux, "Images de l'Empereur," in *Girodet 1767-1824*, exh. cat., ed. by Sylvain Bellenger (Paris: Gallimard; Musée du Louvre Éditions, 2005), pp. 364-373.

23. Letter from Denon to Drölling, May 7, 1808, in *Vivant Denon . . .* 1999, no. 1421, p. 510; see also the letter from Denon to Daru, May 2, 1810, no. 1793, p. 631.

24. Inventaire après décès de Louise-Élizabeth Belot, épouse Drölling, 30 ventôse, an XI (March 2, 1803), A.N., minutier central, étude CIV, liasse 8.

About the "Weider Napoleon": The Imperial Image and Its Frame
Sylvain Cordier, Agata Sochon, Sacha Marie Levay

1. Acquired by the donor from Sotheby's Monaco, February 23, 1986, lot 559.

2. Denon to Gérard, March 2, 1808, in *Vivant Denon . . . Correspondance (1802-1815)*, eds. Marie-Anne Dupuy, Isabelle le Masne de Chermont and Elaine Williamson (Paris: Réunion des musées nationaux, 1999),vol. I, no. 1348, p. 490.

3. Maurice Fenaille, *État général des tapisseries de la manufacture des Gobelins, depuis son origine jusqu'à nos jours, 1600-1900*, vol. V, compiled by Fernand Calmettes: *Période du dix-neuvième siècle, 1794-1900* (Paris: Imprimerie nationale, 1912), pp. 377-380.

4. May have come from the Murat family: Jean-Pierre Chalençon, Brett Topping and Russell Hull Etling, *Napoléon: An Intimate Portrait*, exh. cat. (Gainesville, Florida: Russell Etling Company, 2005), p. 32.

5. *Napoléon I in His Imperial Robes* (buste), about 1814 (after François-Pascal-Simon Gérard, *Bust Portrait of Napoleon in Ceremonial Robes*, 1805-11), wool and silk, gilded frame decorated with the crown of Charlemagne, Lady Lever Art Gallery, Port Sunlight, England: Todd Porterfield and Susan L. Siegfried, *Staging Empire: Napoleon, Ingres, and David* (University Park: The Pennsylvania State University Press, 2006), p. 80.

6. Bernard Chevallier, "Vase 'forme fuseau' en porcelaine de Sèvres avec portrait de l'Empereur en costume de sacre," *Objets d'Art. Mélanges en l'honneur de Daniel Alcouffe* (Dijon: Faton, 2004), pp. 298-307.

7. Among copies identified on the art market, see the sales at Christie's New York, November 14, 1979 (lot 135), Sotheby's New York, October 27, 1988 (lot 172), Ader-Picard-Tajan, December 14, 1989 (lot 82), Koller Zurich, March 30, 2001 (lot 101), Sotheby's New York, June 5, 2008, lot 122, Osenat, Fontainebleau, April 12, 2015 (lot 122) and Osenat Fontainebleau, April 10, 2016 (lot 67, same as previous).

8. See the letters from Denon to Daru of February 14, 1806 and July 9, 1806, in *Vivant Denon . . . 1999*, no. 801, p. 312 and no. 953, p. 370.

9. Ibid., letter of June 15, 1807, no. 1083, p. 411.

10 On the subject, see Sarah Medlam, "Callet's Portrait of Louis XVI: A Picture Frame as Diplomatic Tool," *Furniture History*, vol. 43, 2007, pp. 143-154.

Portrait of Napoleon, by Belloni's Imperial School of Mosaics
Sylvain Cordier

1. Gérard Hubert, "Un portrait en mosaïque de Napoléon par Belloni d'après Gérard, contribution à l'étude de l'École impériale de mosaïque de Paris et des manufactures italiennes," in *Florence et la France. Rapports sous la Révolution et l'Empire*, colloquium proceedings, Florence, June 2-4, 1977, organized by the Institut français de Florence in collaboration with the University of Florence, the Superintendence of Artistic and Historical Holdings of Florence and Pistoia and the Musée du Louvre (Florence: Centro Di; Paris: Quatre chemins-Éditart, 1979), pp. 251-271.

2. Ibid., p. 257.

3. Anne Dion-Tenenbaum, "Les manufactures," in *Napoléon et le Louvre*, ed. Sylvain Laveissiere (Paris: Musée du Louvre; Fayard, 2004), pp. 159-160.

4. Pierre Arizzoli-Clémentel, "Retour aux sources : Belloni et la mosaïque de Melpomène au Louvre," *Gazette des Beaux-Arts*, vol. 122, no. 1497 (October 1993), pp. 149-160.

5. Hubert 1979, p. 259.

6. Catalogue of the Salon of 1810, p. 108.

7. Catalogue of the Salon of 1812, p. 106.

8. Letter from Denon to the minister of the interior, repr. in Hubert 1979, p. 270 (appendix).

9. Ibid.

10. Ibid., p. 253.

11. Dion-Tenenbaum 2004, p. 160.

12. Hubert 1979, p. 262.

Denon and His Masters: Old Master Paintings in the Tuileries' Decor under the Empire
David Mandrella

1. "Demande de gravures pour les appartemens de S. M. l'Impératrice aux Tuileries," February 19, 1810, A.N., O² 841. The idea of decorating the Tuileries with prints was not new. As of 1806, in a letter addressed to Lauzan, curator of the imperial museum in Versailles, Denon requested that all the framed prints be sent to him from the museum's holdings to decorate the Tuileries: *Vivant Denon, directeur des musées sous le Consulat et l'Empire. Correspondance (1802-1815)*, eds. Marie-Anne Dupuy, Isabelle le Masne de Chermont and Elaine Williamson (Paris: Réunion des musées nationaux, 1999), vol. I, letter no. 808, p. 315.

2. Unpublished letter from Denon to Daru, February 22, 1810, in the dossier "Demande de gravures pour les appartements de S. M. l'Impératrice aux Tuileries" (A.N., O² 841).

3. List of eighty-eight paintings prepared by Denon on July 5, 1806, for Fontainebleau and Rambouillet, A.N., O² 840.

4. See Ferdinand Boyer, "Le sort sous la Restauration des tableaux à sujets napoléoniens," *Bulletin de la Société de l'Histoire de l'Art français*, year 1966 (published in 1967), p. 32.

5. Charles Otto Zieseniss, "Le décor pictural de la galerie de Diane aux Tuileries sous le Premier Empire," *Bulletin de la Société de l'Histoire de l'Art français*, year 1966 (published in 1967), pp. 199-235; see, in particular, pp. 203-204 (withdrawal of the paintings of the Austrian defeats), pp. 206-207 (withdrawal of *The Revolt of Cairo*).

6. Ibid., p. 201. The archives are a treasure trove on the subject; see, for example, the dossier on the portraits of the marshals of the Empire and their marble busts (A.N., O² 835).

7. See, in particular, the inventories of the furnishings of the Tuileries (A.N., O² 740).

8. See, for example, Daniel Meyer, "Les tableaux de Saint-Cloud sous Napoléon Ier," *Nouvelles Archives de l'Art français*, vol. XXIV, 1969, pp. 241-271.

9. See Guillaume Fonkenell, *Le Palais des Tuileries* (Paris: Cité de l'architecture et du patrimoine; Arles: Honoré Clair, 2010), and Geneviève Bresc-Bautier et al., *Les Tuileries. Grands décors d'un palais disparu* (Paris: Éditions du patrimoine, 2016).

10. *Journal du comte P.-L. Roederer* (Paris: H. Daragon, 1909), pp. 84-85.

11. See Ferdinand Boyer, "L'installation du Premier consul aux Tuileries et la disgrâce de l'architecte Leconte (1800-1801)," *Bulletin de la Société d'Histoire de l'Art français*, 1941-44 (published in 1947), pp. 142-184.

12. *Vivant Denon . . . 1999*, letters nos. 49, January 27, 1803, and no. 59/2, February 24, 1803. For the First Consul's chapel on the north ground floor of the Palace des Tuileries, Rubens' *The Last Supper* was first selected, definitely the painting that is now at the Brera in Milan (Jaffé 1066A), but this plan would be abandoned. At the Salon of 1806, Charles-Nicaise Perrin exhibited the painting commissioned as the time for the chapel, *France, Supported by Religion, Dedicating the Captured Enemy Standards to Our Lady of Glory* (Paris, Val-de-Grâce); this painting would be replaced after 1815 by an *Ascension* by Pierre-Paul Prud'hon: see Sylvain Laveissière, *Prud'hon ou le rêve du bonheur*, exh. cat. (Paris: Réunion des musées nationaux, 1997), p. 291.

13. These ceilings would remain intact until the fire at the Tuileries in 1871. See the beautiful book by Pierre-Nicolas Sainte-Fare-Garnot, *Le décor des Tuileries sous le règne de Louis XIV* (Paris: Réunion des musées nationaux, 1988), pp. 120-127. See also the *Notice historique sur le palais des Tuileries et description des plafonds, voussures, lambris, etc., qui décorent les salles occupées par l'exposition* (Paris: Vinchon, 1849).

14. Damas Hinard, *Napoléon, ses opinions et jugemens sur les hommes et sur les choses* (Paris: Duféy, 1838), vol. II, pp. 72-74 and 323.

15. Boyer 1947, pp. 142-144.

16. See A.N., O² 313, Palais des Tuileries, no. 1: Invoice for the "Palais Impérial des Tuileries. Bâtiment. Année 1806. Rétablissement [14,160 francs] du plafond & des peintures du 1er salon des grands appartemens." The paintings were restored by Simon-Frédéric Moench; some dossiers further on, the issue is the "Rétablissement [9,519 francs] du plafond & des peintures de la salle du trône." Again, Moench oversaw the restoration of the paintings.

17. Pierre-Yves Kairis, *Bertholet Flémal (1614-1675). Le "Raphaël des Pays-Bas » au carrefour de Liège et de Paris* (Paris: Arthena, 2015), pp. 34 and 169, no. PM.174.

18. Sainte-Fare-Garnot 1988, p. 118.

19. A.N., O² 312, box containing many documents regarding the restoration of the palace, particularly the Tuileries.

20. Alexandre Lenoir, curator of the Dépôt des Petits-Augustins (future Musée des Monuments français), in a letter addressed May 2, 1793, to the minister of the interior (see Sainte-Fare-Garnot 1988, p. 117).

21. Zieseniss 1967, p. 200. Moreover, "Mémoire d'ouvrages de dorure" in the Archives nationales (carton O³ 312 cited above) mentions the gilding Chaise did in 1807 in the Gallery of Diana "at 9 paintings on the ceilings," "to the 12 paintings above the cornice" and "the 8 paintings between the casement windows and the glass doors" for 41,299 francs.

22. Zieseniss 1967, p. 201 and onwards.

23. The first room in the queen's apartments, the Guard room, was decorated with a *Minerva Fighting the Harpies*, probably a Jean Nocret, but this decor seems to have disappeared at

the end of the eighteenth century. This room would also serve as the Guard Room the Emperor's living quarters.

24. Until 1808, oratory and water closet, then back-office or topographical office of the Emperor's living quarters.

25. Also called the "appartement de commodité du roi en bas."

26. In a room called "Grand cabinet du roi."

27. Jean-Claude Boyer, "Le plafond de la chambre du Roi aux Tuileries, une redécouverte majeure," *L'Estampille/L'Objet d'art* (March 2016), pp. 36-43. See also, about the removed and saved decor, the very fine chapter by Guillaume Fonkenell, "Les décors du palais des Tuileries," in *Peupler les cieux. Les plafonds parisiens au XVIIe siècle*, exh. cat., ed. Bénédicte Gady (Paris: Musée du Louvre, 2014), pp. 234-239. Several of these Appollonian paintings by Mignard from the king's lower private apartment were placed on March 9, 1798, in a storeroom: see Antoine Schnapper, *Mignard d'Avignon (1606-1668)*, exh. cat. (Avignon: Palais des Papes, 1979), pp. 114-115.

28. For the art objects, there are a plethora of documents in the Archives nationales, in the série O², and the Archives des musées nationaux, which we have gone through in its entirety for the Tuileries. See also Guy and Christian Ledoux-Lebard, "L'Inventaire des appartements de l'Empereur Napoléon Ier aux Tuileries," *Bulletin de la Société de l'Histoire de l'Art français*, year 1952 (published in 1953), pp. 186-204.

29. "Inventaire général du musée Napoléon," Paris, Archives nationales, microfilms 2MI 112 (anciennes cotes 1DD 16: Peintures, t. I: Peintures italiennes et espagnoles; 1DD 17: Peintures, t. II: Peintures allemandes et flamandes) and 2MI 113 (anciennes cotes 1DD 18: Peintures, t. III: Peintures françaises anciennes et modernes; 1DD 19: Peintures [supplément], t. IV: Peintures italiennes, allemandes, flamandes et françaises). Started in late 1810, the Inventory listed up to the start of the Restoration all of the paintings preserved at the time in the Musée Napoléon and the imperial palaces. The list of paintings obviously encompasses the many works returned to neighbouring countries at the end of the Empire. For each painting, the Inventory details the name of the artist, subject, dimensions, provenance, price, price of the frame and the location (museum or imperial palace). It also often includes observations indicating the support and, eventually, the removal when returned (notes can sometimes be found in the margin). Unfortunately, not all of the boxes were systematically filled. All the paintings, without exception, presented according the Inventory at the Palais des Tuileries, were itemized in this essay. Their current whereabouts is given in notes 30 to 45 below. On the Inventory of 1810, see also the essay herein by Daniela Gallo, pp. 284-285.

30. Domenico Zampieri, called Domenichino, *Erminia and the Shepherds*, about 1622-25, Musée du Louvre, Paris, inv. 799.

31. Francesco Solimena, *The Annunciation*, about 1690-1700, Musée des Beaux-Arts, Angers, inv. 2013.22.36.

32. This attribution is far from meaningless, as Guardi was inspired by drawings of Canaletto printed by Brustolon.

33. Francesco Guardi, *The Coronation of the Doge on the Scala dei giganti of the Doge's Palace in Venice*, about 1775-80, Musée du Louvre, Paris, inv. 323, and *The Doge of Venice Thanks the Maggior Consiglio*, between 1766 and 1770, Nantes, Musée des Beaux-Arts, inv. 20800. See Antonio Morassi, *Guardi. Antonio e Francesco Guardi*, Venice, Alfieri, 1973, nos. 245 (*The Coronation of the Doge on the Scala dei Giganti*) and 246 (*The Doge Thanking the Maggior Consiglio*), ill.

34. Jan Brueghel the Younger, *Eine Dorfstrasse* [Village Street], 1609, Gemäldegalerie Alte Meister, Cassel, GK 54; David Teniers the Younger, *Ecce Homo*, 1646, and *Bauer mit Schubkarren* [Peasant with Wheelbarrow], 1645/50, Gemäldegalerie Alte Meister, Cassel, GK 141 and 142. See, for these three paintings, Bénédicte Savoy, *Patrimoine annexé. Les biens culturels saisis par la France en Allemagne autour de 1800*, vol. II (Paris: Éditions de la Maison des sciences de l'homme, 2003), no. 322 (Brueghel), nos. 589 and 586 (Teniers), ills.

35. Gerard Dou, *Brustbild eines alten Mannes mit Federbarett und Halsberge* [Bust of an Old Man with a Feathered Cap and Collar], and *Brustbild einer alten Frau mit Pelzkragen* [Bust of an Old Woman with a Fur Collar], about or after 1630/31, Gemäldegalerie Alte Meister, Cassel, GK 257 and 258.

36. Adriaen de Vois, *Der liederliche Student* [The Idle Student], 1678, Gemäldegalerie Alte Meister, Cassel, GK 302; Willem Kalf, *Alte Frau in der Küche* [Old Woman in the Kitchen], n.d., Schwerin, Staatliches Museum, G 2356. See Savoy 2003, nos. 615, ill., and no. 451, ill.

37. Paulus Potter, *Vier Kühe auf einer Weide* [Four Cows in a Meadow], 1644, Gemäldegalerie Alte Meister, Cassel, GK 368. See Savoy 2003, no. 517, ill. Another painting, *Return of the Herd at Sunset*, was given to Adriaen van de Velde (see Savoy 2003, no. 610, whereabouts unknown then), also at the Tuileries, would be sent to Schwerin (*Herde auf der Weide* [Herd in the Meadow], inv. Schlie, Kat. 563); it was attributed by Friedrich Schlie to Aalbert Klomp: G. Seelig, "Paris und Retour. Die Schweriner Gemäldesammlung 1807-1815," in *Unter Napoleons Adler. Mecklenburg in der Franzosenzeit. Veröffentlichungen der Historischen Kommission für Mecklenburg*, vol. 2, eds. Matthias Manke and Ernst Münch (Lübeck: Schmidt-Römhild, 2009), pp. 313-362.

38. Cornelis van Poelenburgh, *Imaginary View of Campo Vaccino in Rome with a Donkey*, 1620, Musée du Louvre, Paris, inv. 1083.

39. Cornelis van Poelenburgh, *Das Urteil des Paris* [The Judgement of Paris], n.d., and *Landschaft mit Badenden und Merkur* [Landscape with Bathers and Mercury], n.d., Gemäldegalerie Alte Meister, Cassel, GK 199 and 194. See Savoy 2003, nos. 512 and 513, ill.

40. Rembrandt, *Winterlandschaft* [Winter Landscape], 1646, Gemäldegalerie Alte Meister, Cassel, GK 241. See Savoy 2003, no. 539, ill.

41. Jacob van Ruisdael (imitation of), Landscape with Winding Road, n.d., Musée du Louvre, Paris, inv. 1821. Today, the painting is not considered to be an original: see Jacques Foucart, *Catalogue des peintures flamandes et hollandaises du musée du Louvre* (Paris: Gallimard, 2009), p. 250, ill. The Tuileries also preserved the two paintings by Frederick de Moucheron, sent to the Herzog Anton Ulrich-Museum, Brunswick. The case of one of these two paintings—*Italienische Landschaft mit Herde* (Italian Landscape with Cattle), inv. 391—is interesting (and shows all the difficulties the Allies later encountered), as, according to Seelig (2009, p. 355, ill. 7), it came from Schwerin's collections. It was not possible to identify the second of Moucheron's paintings sent to Brunswick.

42. Jan van der Heyden, *An der Burgmauer* [The Long Château Wall], n.d., Staatliches Museum, Schwerin, G 2362. See Savoy 2003, no. 418, ill.

43. Adam Elsheimer, *Morgenschaft (Aurora)* [Morning Landscape (Dawn)], n.d., and after Adam Elsheimer, *Die Verspottung der Ceres* [Ceres Scorned], n.d., Herzog Anton Ulrich-Museum, Brunswick, GG 550 and 1086. See Savoy 2003, nos. 385 and 384, ill.

44. This painting is sometimes identified as coming from the Prussian collections, which is false.

45. Carl Ruthart, *Bear Hunt*, n.d., Musée du Louvre, Paris, inv. 1823. See Savoy 2003, no. 559. Savoy mentions under this item two *Bear Hunt* pictures by Ruthart: one that was sent to the Berlin museum and the other to the Louvre, also seized in Germany in 1806: see also Seelig 2009, pp. 317-318, ill.

46. As of March 1811, this apartment would be assigned to the King of Rome.

47. François Perrier, *The Sacrifice of Iphigenia*, seventeenth century, Musée des Beaux-Arts, Dijon, inv. 4931. The Inventory of 1810 also mentions that, in Duroc's apartment, there was an *Abduction of Orithyia* by Luca Giordano (current whereabouts unknown) and a copy on wood after the *Vision of Ezekiel* by Raphael, from the collections of the Orléans family.

48. In a letter of April 10, 1813, to the duke of Cadore (*Vivant Denon . . . 1999*, letter 2785), Denon suggested that the King of Rome's salon show *Saint Mark and the Theological Virtues* by Veronese (Musée du Louvre, Paris, inv. 148), but the work would not be sent to the Tuileries; on October 19, 1814, he asked the comte de Blacas to send the Veronese to Versailles: *Vivant Denon . . . 1999*, letter 3259.

49. Denon to Daru, June 19, 1811: *Vivant Denon . . . 1999*, letter 2123.

Contemporary Painting in the Decor of the Tuileries: The Example of the Gallery of Diana
Sylvain Cordier

1. Yveline Cantarel-Bresson, Claire Constans and Bruno Foucart, *Napoléon, images et histoire : peintures du Château de Versailles (1789-1815)* (Paris: Réunion des musées nationaux, 2001), pp. 55-57.

Weaving Majesty: The Imperial Household and the Gobelins and Beauvais Manufactories
Thomas Bohl

1. Pierre Branda, *Napoléon et ses hommes. La Maison de l'empereur, 1804-1815* (Paris: Fayard, 2011), p. 88.
2. Caroline Girard, "Charles-Axel Guillaumot (1730-1807), architecte et administrateur de la manufacture des Gobelins," *Livraisons d'histoire de l'architecture*, vol. 8, no. 1 (2004), pp. 104-105.
3. A.N., O² 877; Girard 2004, p. 104.
4. On Huet's activities at the Beauvais manufactory, see Jules Badin, *La manufacture de tapisseries de Beauvais depuis ses origines jusqu'à nos jours* (Paris: Société de Propagation du Livre d'art, 1909), pp. 43-45, and Chantal Gastinel-Coural, *La manufacture de Beauvais : du Consulat à la IIe République*, exh. cat. (Paris: Administration générale du Mobilier national, 1998), pp. 7-9.
5. Badin 1909, p. 43.
6. He asked for these models in May and August 1806; see Gastinel-Coural 1998, p. 9.
7. Maurice Fenaille, *État général des tapisseries de la manufacture des Gobelins, depuis son origine jusqu'à nos jours, 1600-1900*, vol. V, compiled by Fernand Calmettes: *Période du dix-neuvième siècle, 1794-1900* (Paris: Imprimerie nationale, 1912), pp. 48-51.
8. Duroc to Daru: "H. M. complains of what the Gobelins does with paintings. She wishes they would make only hangings or furniture." A.N., O² 161; Chantal Gastinel-Coural, *La manufacture des Gobelins au XIXe siècle* (Paris: Administration générale du Mobilier national, 1996), p. 101.
9. A.N., O² 162; Gastinel-Coural 1996, p. 102.
10. A.N., 400AP4; Gastinel-Coural 1996, p. 102.
11. Fenaille and Calmettes 1912, p. 39.
12. A.N., O² 877.
13. Chantal Gastinel-Coural, "Denon et la manufacture des Gobelins," in *Dominique Vivant-Denon. L'œil de Napoléon*, exh. cat., ed. Marie-Anne Dupuy (Paris: Réunion des musées nationaux, 1999), pp. 317-320.
14. Gastinel-Coural 1996, p. 21.
15. *The Plague Victims of Jaffa*, Walters Art Gallery, Baltimore; *Bonaparte Crossing the Alps at the Great Saint Bernard Pass* (the tapestry was given to the princess Pauline in 1811), municipal collections, Martigny; *Bonaparte, First Consul, Distributing Sabres of Honour to the Grenadiers of His Guard after the Battle of Marengo*, Mobilier national, Paris, GMTT 249; *General Desaix Mortally Wounded in the Battle of Marengo*, Mobilier national, Paris, GOB 35.
16. The destination of the *Four Parts of the World* portieres was specified by Gastinel-Coural 1996, p. 19.
17. Fenaille and Calmettes 1912, pp. 374-395.
18. Napoleon to Duroc, August 10, 1810, A.N., O² 164; Gastinel-Coural 1996, p. 103.
19. Fenaille and Calmettes 1912, pp. 432-436; Gastinel-Coural 1996, pp. 14-18.
20. Gastinel-Coural 1998, p. 8.
21. Ibid.
22. Badin 1909, pp. 45, 98-99.
23. Ibid., p. 99.
24. Ibid., p. 98.
25. Ibid., nos. 1, 5, 7, 8, 21 and 25, p. 103.
26. Ibid., p. 94. A letter from July 27, 1802, also shows that the First Consul had especially appreciated the tapestries of the *Military Convoys* after Casanova installed by Bellanger at the Château de Saint-Cloud in 1802 (ibid., p. 95).
27. Thomas Bohl, "Du modèle au tissage. Les cartons peints pour tapisserie de sièges des manufactures des Gobelins et de Beauvais au XVIIIe siècle," in *Sièges en société. Histoire du siège du Roi-Soleil à Marianne*, exh. cat., ed. Jean-Jacques Gautier (Montreuil: Gourcuff Gradenigo, 2017), p. 60.
28. Badin 1909, p. 98.
29. Ibid., nos. 3, 4 and 26, p. 103.
30. Gastinel-Coural 1998, p. 9.

The Four Parts of the World Together at the Tuileries
Thomas Bohl

1. Duroc to Lemonnier, October 21, 1813, Archives du Mobilier national, G. 151.
2. Chantal Gastinel-Coural, *La manufacture des Gobelins au XIXe siècle, tapisseries, cartons, maquettes*, exh. cat. (Paris: Administration générale du Mobilier national, 1996), p. 19.
3. Invoice of March 20, 1806, approved on April 2 by Daru (A.N., O²689). I wish to thank M. Philippe Le Pareux for bringing this document to my attention.

4. It is worth mentioning Pierre Blanchard's book, *Le Voyageur de la jeunesse dans les quatre parties du monde* (Paris: Le Prieur, 1804), and the subsequent re-editions (1806, 1812, 1818), which attest to the popularity of this theme in the early nineteenth century.
5. Gastinet-Coural 1996, p. 18.
6. "État des produits de la manufacture royale des Gobelins exposés au Louvre en décembre 1817," Archives du Mobilier national, GOB 75. The date of 1816 given by Fenaille and Calmettes—Maurice Fenaille, *État général des tapisseries de la manufacture des Gobelins, depuis son origine jusqu'à nos jours, 1600-1900*, vol. V, compiled by Fernand Calmettes: *Période du dix-neuvième siècle, 1794-1900* (Paris: Imprimerie nationale, 1912), p. 437—and by Gastinel-Coural 1996, p. 19, is definitely erroneous, as none of these tapisseries appears on the known lists of works exhibited in 1816. Moreover, two of the tapestries were still being woven at this time.

The Furnishings of the Emperor's Grand Cabinet at the Tuileries
Thomas Bohl

1. A.N., O² 161.
2. Duroc to Daru, September 2, 1807, A.N., O² 161.
3. The seats of the first piece of furniture would nevertheless be used under the Empire: they were placed in the Palace of Monte Cavallo as of 1812: Alvar González-Palacios, *Il gusto dei principi: arte di corte del XVII e del XVIII secolo* (Milan: Longanesi, vol. 1: 1987; vol. 2 1989; new edition 1993), p. 958; Pierre Arizzoli-Clémentel and Chantal Gastinel-Coural, eds., *Il progetto d'arredo del Quirinale nell'età napoleonica*, suppl. of *Bolletino d'Arte*, no. 70 (Rome: Istituto Poligrafico e Zecca dello Stato, 1995).
4. Maurice Fenaille, *État général des tapisseries de la manufacture des Gobelins, depuis son origine jusqu'à nos jours, 1600-1900*, vol. V, compiled by Fernand Calmettes: *Période du dix-neuvième siècle, 1794-1900* (Paris: Imprimerie nationale, 1912), pp. 434-435.
5. David would even add gold thread and fringe, despite the Emperor's opposing wishes: Anne Dion-Tenenbaum, "D'un empire à l'autre : les Tuileries de 1800 à 1851," in Geneviève Bresc-Bautier, Yves Carlier, Bernard Chevallier et al., *Les Tuileries. Grands décors d'un palais disparu* (Paris: Éditions du patrimoine, Centre des monuments nationaux, 2016), p. 95.
6. Letter from David repr. in Édouard Gerspach, "Le meuble en tapisserie de Napoléon Ier," *Gazette des Beaux-Arts*, vol. VI (August 1, 1891), pp. 159-160.
7. González-Palacios 1993, p. 958.
8. Paris, Mobilier national, GOB 23.
9. González-Palacios 1993, p. 955.
10. Ibid., p. 956.
11. Jean-Jacques Lequeu, *Un Harpocrate, dieu du Silence, pour avertir que l'on cessera de parler dans la 2me antichambre qui précède le cabinet de Mr. de Montholon. Lequeu, fondé du pouvoir de Soufflot* (1786) (Paris: Bibliothèque nationale de France, département Estampes et photographie). Lequeu also conceived of a temple of silence for the pediment, which was to have had a sculpted large-scale winged Harpocrates: Jean-Jacques Lequeu, *Orthographie, côté de l'entrée d'une maison de campagne appellée le temple du Silence* [1788] (Paris: Bibliothèque nationale de France, département Estampes et photographie, DON 7123).
12. Regarding the drawings of antiquity from David's first Roman trip, see, in particular, Arlette Sérullaz, "Les dessins du premier séjour romain," in Antoine Schnapper and Arlette Sérullaz, *Jacques-Louis David, 1748-1825*, exh. cat. (Paris: Réunion des musées nationax, 1989), pp. 65-71.
13. Fenaille and Calmettes 1912, p. 436.
14. Ibid.

The Fabrique Lyonnaise at the Service of the Imperial Court
Marie-Amélie Tharaud

1. Jean Coural, in coll. with Chantal Gastinel-Coural and Muriel Müntz de Raïssac, *Paris, Mobilier national. Soieries Empire* (Paris: Éditions de la Réunion des musées nationaux, 1980), pp. 19-20.
2. Jean-Pierre Planchon, in coll. with Carole Damour and Dominique Fabre, *Tassinari et Chatel, la soie au fil du temps* (Saint-Rémy-en-l'Eau:

Éditions Monelle Hayot, 2011), p. 74; *Soies tissées, soies brodées chez l'impératrice Joséphine*, exh. cat., eds. Claudette Joannis and Philippe Verzier (Paris: Réunion des musées nationaux, 2002), p. 13.
3. *Mémoires pour servir à l'histoire de France sous le règne de Napoléon, écrits à Sainte-Hélène sous sa dictée par les généraux qui ont partagé sa captivité* (Paris: Firmin Didot Père et Fils; Bossange Frères, 1823), p. 392.
4. Joannis and Verzier 2002, pp. 13-14.
5. Ibid., p. 14.
6. See the decree of 29 Messidor, Year XII (July 18, 1804); Joannis and Verzier 2002, p. 13.
7. Claudette Joannis, *Joséphine, impératrice de la mode. L'élégance sous l'Empire* (Paris: Réunion des musées nationaux, 2007), p. 30. See also, the essay herein on court clothing by Sylvain Cordier and Chantelle Lepine-Cercone, pp. 114-129.
8. Marie Bouzard, *La soierie lyonnaise du XVIIIe au XXe siècle dans les collections du musée des tissus de Lyon*, exh. cat. (Lyon: Éditions Lyonnaises d'Art et d'Histoire, 1997), p. 10. The old royal palaces were Versailles, Marly, Meudon, Saint-Germain-en-Laye, Saint-Cloud, Rambouillet, Compiègne, Fontainebleau and Pau. The new imperial palaces were the Pitti in Florence, Monte Cavallo in Rome (the Quirinale), Laeken near Brussels, Rohan in Strasbourg, and the Élysée in Paris. Not all had orders delivered: Versailles, Marly, Saint-Germain, Pau, Pitti, Rohan did not receive any orders.
9. Jean Coural and Chantal Gastinel-Coural, *Fabriques et manufactures sous le Premier Empire : Lyon, Beauvais, Les Gobelins. Collections du Mobilier national*, exh. cat. (Paris: Ministère de la culture, Délégation à la création, aux métiers artistiques et aux manufactures, 1981), p. 4.
10. Coural 1980, p. 21.
11. Joannis 2007, p. 30.
12. Coural 1980, pp. 481-483.
13. Planchon 2011, p. 82.
14. Bouzard 1997, p. 10.
15. Anne Forray-Carlier, Florence Valantin and Guillaume Verzier, *L'art de la soie, Prelle, 1752-2002 : des ateliers lyonnais aux palais parisiens*, exh. cat. (Courbevoie [Paris]: ACR Édition; Paris-Musées, 2002), pp. 23-24.
16. List based on Coural 1980.
17. These were studied in detail in the reference work by Coural 1980.
18. On the Garde-Meuble's approval and control processes, see ibid.
19. Ibid., pp. 289-291.
20. Joannis and Verzier (2002), p. 16. The regulator was used for the lampas in the first salon of the Empress' apartment at Versailles (ill. 209).
21. Daisy Bonnard, François Jarrique, Lilian Pérez et al., *Lyon innove, inventions et brevets dans la soierie lyonnaise aux XVIIIe et XIXe siècles* (Lyon: EMCC [European Mentoring and Coaching Council], 2009), p. 129.

Diplomatic Treasures: Sèvres and the Gobelins in the Gift-giving Policy of the Imperial Household
Sylvain Cordier

1. On the other forms of gifts, especially the gold boxes painted with miniature portraits of the imperial family, see the essay herein by Cyril Lécosse, "The Artists of the Imperial Households," pp. 132-141, and Karine Huguenaud, "L'impact diplomatique des cadeaux de Napoléon," in *Pour l'honneur et pour la gloire. Napoléon et les joyaux de l'Empire*, exh. cat., ed. Lesja Vandensande (Brussels: Fonds Mercator; Antwerp: Provinciaal diamantmuseum, 2010), pp. 177-195.
2. See, in particularly Marc Favreau, "Les Gobelins, la Savonnerie et Beauvais : trois manufactures royales au service de la diplomatie française au XVIIIe siècle (1715-1791)," in *De l'usage de l'art en politique*, eds. Marc Favreau, Guillaume Glorieux, Jean-Philippe Luis and Pauline Prévost-Marcilhacy (Clermont-Ferrand: Presses universitaires Blaise-Pascal, 2009), pp. 11-12.
3. Dorothée Guillermé Brulon, *Le service de la princesse des Asturies ou l'histoire d'un cadeau royal pour la cour de Madrid* (Paris: Massin, 2003).
4. See, primarily, the admirable book edited by Camille Leprince, *Napoléon Ier et Sèvres. L'art de la porcelaine au service de l'Empire* (Paris: Feu et talent, 2016).
5. Huguenaud 2010, p. 179.
6. On these three sets, see Tamara Préaud, "Grande vaso," Amalia Donatella Basso, "Tavolo da centro (Guéridon)" and Diletta Clery, "Servito

da tavola decorato 'a ghirlande di viti,'" in *Lusso ed Eleganza. La porcellana francese a Palazzo Pitti e la manifattura Ginori (1800-1830)*, exh. cat., ed. Andreina d'Agliano (Florence: Giunti; Livorno: Sillabe, 2013), pp. 72-79.
7. *Étiquette du palais impérial, année 1806* (Paris: Imprimerie impériale, 1806), titre I, chap. III, art. IV, p. 24.
8. His role in the commissioning of gifts in the form of snuffboxes with the Emperor's portrait should also be underscored (see the cited article herein by Lécosse).
9. Letter from Duroc to Daru, April 22, 1806, A.N., O² 151, dossier 175.
10. Manufacture des Gobelins, "État des tableaux en tapisserie qui peuvent être mis à la disposition de LL. MM. l'Empereur et l'Impératrice pour faire des presens," December 28, 1810, A.N., O² 202, dossier 291.
11. See, in particular, Bernard Chevallier, "Vase 'forme fuseau' en porcelaine de Sèvres avec portrait de l'Empereur en costume de sacre," in *Objets d'art. Mélanges en l'honneur de Daniel Alcouffe* (Dijon: Faton, 2004), pp. 298-307.
12. Manufacture impériale de porcelaine de Sèvres, état de livraison, December 4, 1809, A.N., O² 925.
13. Chantal Gastinel-Coural, "À propos des présents de Napoléon au Pape. Deux tapis de la Savonnerie," *L'Estampille/L'Objet d'art*, no. 407 (November 2005), pp. 48-59.
14. Manufacture impériale des Gobelins, letter from Guillumot to Intendant-General Daru, May 14, 1806, A.N., O3 878.
15. "An 1806. Présens faits à S. Ém. le Cardinal Légat," A.N., O³ 878.
16. Bayerisches Nationalmuseum, Munich, inv. BNM R 6141. See Christophe Huchet de Quénetain and Guillaume Séret, "Du Directoire à l'Empire : vers une résurgence du mobilier en porcelaine," in Leprince 2016, pp. 136-137.
17. Chevallier 2004, pp. 299-300.
18. Musée du Louvre, Paris. See the study headed by Anne Dion-Tenenbaum and Tamara Préaud, *Le service « Encyclopédique » de la manufacture de Sèvres* (Paris: Musée du Louvre; Somogy, 2010).
19. On this service, see Leprince 2016, pp. 95-96.
20. "Crédits au gouvernement, an 8-1810," fol. 53v, A.M.S., Vbb2. See Leprince 2016, p. 186, and Rosemarie Stratmann-Döhler, "Zur Hochzeit von Stephanie de Beauharnais. Höfische. Geschenke aus der kaiserlischen Porzellanmanufaktur Sèvres," *Weltkunst*, vol. 65, no. 1 (1995), p. 16.
21. Leprince 2016, no. 6, p. 309, and no. 13, p. 310.
22. Anne Dion-Tenenbaum, "Les fournitures de Biennais pour le mariage : un luxe sans precedent," in *1810. La politique de l'amour. Napoléon Ier et Marie-Louise à Compiègne*, exh. cat., eds. Emmanuel Starcky and Hélène Meyer (Paris: Réunion des musées nationaux, 2010), pp. 98-104.
23. "État des présens qui restent à faire à l'occasion du mariage de Sa Majesté," A.N., O² 158, dossier 159.
24. "État de proposition de paiement . . . pour raison d'une pièce de tapisserie livrée le 11 mars 1812," A.N., O² 41, dossier 213.
25. Manufacture impériale de porcelaine de Sèvres, état de livraison, December 13, 1811, A.N., O² 41, dossier 208.
26. Manufacture impériale de porcelaine de Sèvres, état de livraison, December 31, 1810, A.N., O² 203, dossier 85.
27. A.M.S., Vbb3, June 28, 1810 and Manufacture impériale de porcelaine de Sèvres, état de livraison, June 28, 1810, A.N., O² 156. These porcelain pieces are today at the Palazzo Pitti: inv. O.d.A 1911, nos. 928-929 (Cordelier vases) and no. 1525 (spindle vase with portrait). See also Chevallier 2004, p. 302, and Virginie Desrante, "Vaso a forma di fuso con rittrato di Napoleone," and "Coppia di vasi Cordelier," in *Lusso ed Eleganza* 2013, pp. 164-165 and 168-169.
28. Letters from Grand Marshal of the Palace Duroc and Grand Chamberlain Montesquiou to comte Estève, treasurer of the Household, May 9 and 13, 1811, A.N., O² 156, dossiers 232 and 233.
29. Notably the service called "vine pink ground" (priv. coll.). See Leprince 2016, p. 280, no. 147.
30. Manufacture impériale de porcelaine de Sèvres, état de livraison, March 6, 1812, A.N., O² 41, dossier 210.
31. Manufacture impériale de porcelaine de Sèvres, état de livraison, 31 December 31, 1810, A.N., O² 41, dossier 208.
32. Smithsonian Institution, National Museum of Natural History, Washington, D.C.
33. Vase in the Musée national de la Légion d'honneur, Paris: Chevallier 2004, p. 302.

34. Manufacture impériale de porcelaine de Sèvres, état de livraison, February 23, 1812, A.N., O² 41, dossier 365.

35. Manufacture impériale de porcelaine de Sèvres, état de livraison, February 13, 1812, A.N., 41, dossier 368, and Manufacture impériale des Gobelins, état de proposition de paiement, February 14, 1812, dossiers 378 and 379.

36. Chevallier 2004, pp. 306-307.

37. Manufacture impériale de porcelaine de Sèvres, état de livraison, June 21, 1811, A.N., O² 41, dossier 391. These objects are today for the most part preserved at the Palazzo Pitti, Florence: inv. A.G. 1890, no. 8749 (portrait of the Emperor), O.d.A 1911, no. 212 (bust of the Empress), M.P.P. 1811, no. 16969 (egg vase), O.d.A. 1911, no. 158 (large Medici vase), O.d.A. 1911, nos. 492-493 (pair of Medici vases), O.d.A. 1911, nos. 932-933 (Cordelier vases). See *Lusso ed Eleganza* 2013, pp. 176-195.

38. Manufacture impériale de porcelaine de Sèvres, état de livraison, June 21, 1811, A.N., O² 41, dossier 391.

39. Ibid.

40. Manufacture impériale de porcelaine de Sèvres, état de livraison, July 13, 1811, A.N., O² 41, dossier 396.

41. Nitot, état de livraison, July 18, 1811, A.N., O² 41, dossier 395, and letter from Grand Chamberlain Montesquiou to the Emperor, June 20, 1811, A.N., O² 203, dossier 188.

42. Aileen Dawson, "Two Napoleonic Sèvres Ice-Pails: A Present for an Emperor. A New Acquisition for the British Museum," *Apollo* (October 1986), vol. 124, no. 296, pp. 328-333.

43. Manufacture impériale des Gobelins, état de livraison, May 9, 1806, A.N., O² 880, dossier 289.

44. Manufacture impériale des Gobelins, "Présent fait par ordre de S. M. à S. A. R. le prince Guillaume de Prusse, état des tapisseries . . ." October 15, 1808." A.N., O² 880.

45. Possibly after the painting by Joseph-Benoît Suvée of 1787 (Musée des Beaux-Arts, Dijon, inv. CA 64 and 755).

46. "Crédit au gouvernement, an 8-1810, présens et ventes à crédit," pp. 87-89, A.M.S., Vbb2, Christophe Beyeler, "Parer la table du souverain et éblouir l'Europe. La collection de porcelaines de Sèvres du musée Napoléon Iᵉʳ au château de Fontainebleau," in Leprince 2016, pp. 102-103.

47. Beyeler, in Leprince 2016, p. 76. See also the essay herein by Virginie Desrante, "The Imperial Table, pp. 212-219."

48. Tamara Nosovitch, "Paire de vases avec des scènes tirées des *Géorgiques* et des *Bucoliques* de Virgile," in *Destins souverains. Napoléon Iᵉʳ, le tsar et le roi de Suède*, exh. cat., eds. Emmanuel Starcky and Hélène Meyer (Paris: Réunion des musées nationaux-Grand Palais, 2011), p. 96.

49. Manufacture impériale de porcelaine de Sèvres, état de livraison, February 11, 1809, A.N., O² 925.

50. Letter from minister of foreign affairs Champagny to Intendant-General of the Household Daru, February 29, 1809, A.N., O² 155, dossier 165.

51. Serge Grandjean, "Autour d'un nécessaire donné par Napoléon Iᵉʳ à Alexandre Iᵉʳ de Russie," *Archives de l'art français. Les arts à l'époque napoléonienne*, new series, vol. XXIV (1969), pp. 57-63; Anne Dion-Tenebaum, "Les nécessaires sous le Premier Empire," in *Indispensables nécessaires*, exh. cat., by Gérard Mabille and Anne Dion-Tenebaum (Paris: Réunion des musées nationaux, 2007), p. 36, and Dion-Tenebaum, "Ensemble de pièces à déjeuner du nécessaire de voyage de Napoléon Iᵉʳ," *Destins souverains* 2011, p. 97.

52. The Museum of Ceramics, Kuskovo, and State Hermitage Museum, Saint Petersburg. See Ian Vilensky, "Pièces du "service égyptien," in *Destins souverains* 2011, pp. 94-95.

53. "Présens," September 20, 1808, A.N., O² 155, dossier 166.

54. Letter from Grand Marshal Duroc to Alexandre Brongniart, December 1, 1809, A.N., O² 6, dossier 367.

55. Maurice Fenaille, *État général des tapisseries de la manufacture des Gobelins, depuis son origine jusqu'à nos jours, 1600-1900*, vol. 5, compiled by Fernand Calmettes: *Période du dix-neuvième siècle, 1794-1900* (Paris: Imprimerie nationale, 1912), p. 378.

56. "Projet de présent pour LL. MM. le roi et la reine de Bavière," February 2, 1810, A.N., O² 156.

57. Manufacture impériale de porcelaine de Sèvres, état de livraison, February 5, 1810, A.N., O² 925.

58. Fenaille and Calmettes 1912, p. 378.

59. "Présent fait à S. M. le roi de Wurtemberg, le 29 décembre 1809," A.M.S., Vbb 2 and 3, and Manufacture impériale de Sèvres, état de livraison, December 29, 1809, A.N., O² 925.

60. Private collection, Australia.

61. Letter to Grand Marshal of the Palace Duroc, July 17, 1810, A.N., O² 158, dossier 41.

62. Manufacture impériale des Gobelins, "État de proposition de paiement d'un portrait en buste de l'Empereur," November 21, 1810, A.N., O² 158, dossier 31.

63. "Projet de présent pour M. le comte de Metternich," October 4, 1810, A.N., O² 156, dossier 249.

64. Manufacture impériale des Gobelins, "État de proposition de paiement," December 29, 1811, A.N., O² 156, dossier 313.

65. Manufacture impériale de porcelaine de Sèvres, état de livraison, June 29, 1810, A.N., O² 203, dossier 81. On the pair of egg vases, see *The Sèvres Porcelain Manufactory: Alexandre Brongniart and the Triumph of Art and Industry, 1800-1847*, ed. Tamara Préaud (New Haven; London: Yale University Press, 1997, for the Bard Graduate Center for Studies in the Decorative Arts, New York), pp. 341-342.

66. "Présens faits par Sa Majesté," April 21-22, 1806, p. 15, A.M.S., Vy 17, letter from Grand Marshal of the Palace Duroc to Intendant-General Daru, April 22, 1806, A.N,. O² 151, dossier 175, "État des présens faits par S. M. depuis l'an 13," A.N., O² 155, dossier 166, "Porcelaines données en présens par S. M. l'Empereur et Roi lors de sa visite à la manufacture, le 20 août 1808" A.M.S., Vbb 3, "Porcelaines données en présens par ordre de S. M. l'Empereur le lendemain de sa visite à la manufacture, 3 décembre 1809," A.M.S., Vbb 3.

67. "Présent fait à S. M. le roi de Wurtemberg, le 29 décembre 1809," A.M.S., Vbb 2 and 3, and "Présens," letter from Intendant-General Daru, n.d. ("The king noticed at Sèvres a porcelain cameo set, I will include it in the body of the present."), A.N., O² 155, dossier 178.

68. Musée du palais de Compiègne: See Chevallier 2004, pp. 300-302.

69. "Porcelaines données en présent par ordre de S. M. l'Empereur le lendemain de sa visite à la Manufacture, le 3 décembre 1809," A.M.S., Vbb 3.

70. Jean-Marcel Humbert, "Second service égyptien," in *Égyptomania. L'Égypte dans l'art occidental, 1730-1930*, exh. cat., by J.-M. Humbert, Michael Pantazzi and Christiane Ziegler (Paris: Réunion des musées nationaux; Ottawa, National Gallery of Canada, 1994), p. 235.

71. "Ordre à M. Guillaumot, administrateur de la manufacture des Gobelins, 10 Nivôse Year XIII [December 31, 1804]," A.N., O² 897.

72. Letter from Grand Marshal of the Palace Duroc to Intendant-General Daru, December 25, 1810, A.N., O² 202, dossier 294.

73. Museo di Capodimonte, Naples.

74. See above in the present text.

75. Cup in the Musée Napoléon Iᵉʳ, Château de Fontainebleau.

76. "État des tapisseries des Gobelins dont a disposé S. M. l'Impératrice et reine à l'occasion du 1ᵉʳ janvier 1812," A.N., O² 524.

77. "État des porcelaines livrées au palais des Tuileries pour être données en présens par S. M. l'Impératrice à l'occasion du 1ᵉʳ jour de l'an 1813," December 28, 1812, A.M.S., Vbb4.

78. "Présens ordonnés par S. M. à l'occasion du Jour de l'an, exercice 1813," A.N., O² 856.

79. Stratmann-Döhler 1995, p. 17.

80. Fondation Napoléon, Paris. See Bernard Chevallier, "Vase étrusque," *Trésors de la Fondation Napoléon. Dans l'intimité de la Cour impériale*, exh. cat., eds. Chevallier and Karine Huguenaud (Paris: Nouveau Monde, 2004), p. 125.

81. Chevallier 2004, "Vase 'forme fuseau'," p. 300.

82. Fondation Napoléon, Paris. See Bernard Chevallier, "Vue des vues des environs de Sèvres," in *Trésors de la Fondation Napoléon* 2004, p. 80.

83. Cited in Geoffrey de Bellaigue, *French Porcelain in the Collection of Her Majesty The Queen* (London: Royal Collection Publications, 2009), vol. 3, cat. 305, p. 1065.

84. Humbert 1994, p. 235.

The Imperial Table: The Great Sèvres Table Services
Virginie Desrante

1. Jean-Pierre Samoyault, "La Table impériale," in *Versailles et les tables royales en Europe : XVIIᵉᵐᵉ-XIXᵉᵐᵉ siècles*, exh. cat., (Paris: Réunion des musées nationaux, 1993), p. 202.

2. Olga Totka, "La création des formes des services de table à la manufacture de Sèvres entre 1800 et 1847," master's thesis, Université Paris-Sorbonne (Paris IV), 2010-12, vol. 1, p. 32.

3. On this point, see *La cave de Joséphine. Le vin sous l'Empire à Malmaison*, exh. cat., eds. Élisabeth Caude and Alain Pougetoux (Paris: Réunion des musées nationaux, 2009).

4. A.M.S, registre Vy14.

5. A.M.S, registre Vy16, folio 10, for the first: 10 shaped pieces, and Vy 16, folio 8, for the second: 38 shaped pieces.

6. A.M.S, carton T 2, liasse 2, cited in *The Sèvres Porcelain Manufactory: Alexandre Brongniart and the Triumph of Art and Industry, 1800-1847*, exh. cat., Tamara Préaud et al. (New Haven; London: Yale University Press, for the Bard Graduate Center for Studies in the Decorative Arts, New York, 1997), p. 78.

7. A.M.S, carton T2, liasse 1, year 1806, feuillet no. 80.

8. It was reproduced at Josephine's request when they got divorced, but, in the end, judged too austere, it stayed in the Sèvres warehouses until Louis XVIII gave it to the Duke of Wellington in 1818.

9. Tamara Préaud, "Le service égyptien offert par Napoléon Iᵉʳ au tsar Alexandre Iᵉʳ de Russie en 1808," and Pierre Arizzoli-Clémentel, "Le surtout en biscuit du service égyptien," in *Versailles et les tables royales en Europe* 1993, pp. 358-360, 362-363.

10. Regarding the different services produced and delivered under the Empire, see *Napoléon Iᵉʳ et la manufacture de Sèvres. L'art de la porcelaine au service de l'Empire*, exh. cat., ed. Camille Leprince (Paris: Feu et Talent, 2016), pp. 244-293.

11. A.M.S, carton T1, liasse 6, correspondance générale, 1805, feuillet no. 12.

12. A.M.S, carton T1, liasse 6, correspondance générale, 1805, feuillet no. 19.

13. Leprince 2016, p. 23.

14. A.M.S, carton T1, liasse 6, correspondance générale, 1805, feuillet no. 19.

15. A.M.S, carton T3, liasse 1, dossier 1, correspondance générale, 1807.

16. Jean- Pierre Samoyault, "Les 'assiettes de dessert' du Service particulier de l'Empereur en porcelaine de Sèvres," in *Le Souvenir napoléonien*, no. 369 (February 1990), p. 8.

17. B.N.F., département des manuscrits, FR. 6586.

Silver on Paper: Odiot's Designs for the Imperial Family
Audrey Gay-Mazuel

1. For Jean-Baptiste-Claude Odiot, see Audrey Gay-Mazuel, *Odiot, un atelier d'orfèvrerie sous l'Empire et la Restauration*, exh. cat. (Paris: Musée des Arts décoratifs, 2017), pp. 8-17.

2. Based at 1, rue l'Évêque, as of 1811.

3. Stopped on 18 Vendémiaire, An X (October 2, 1801), Archives nationales. See Karine Huguenaud, "L'épée consulaire dite 'Épée du sacre,'" *Ordres et distinctions. Bulletin de la Société des amis du musée national de la Légion d'honneur et des ordres de chevalerie*, no. 17 (2014), p. 6.

4. A number of portraits show the First Consul with this sword: Ingres (Musée des Beaux-Arts, Liège), Gros (Musée de la Légion d'honneur, Paris), Meynier (Hôtel de Ville, Brussels), and Vien the Younger (Hôtel de Ville, Bruges).

5. After its diamonds were removed to ornament a glaive in 1812, the sword was with the Nitot family until 1905. It was acquired in 1979 by the Musée national du château de Fontainebleau (inv. PN 217). Glass replaced the diamonds.

6. *Exposition publique des produits de l'Industrie française. Catalogue des productions industrielles* (Paris: Imprimerie de la République, Fructidor, Year X [August/September 1802]), p. 32.

7. Musée des Arts décoratifs, Paris, inv. 2016.100.1. See Gay-Mazuel 2017, pp. 140-145.

8. Collection princesse Napoléon (Paris, silver, makers' mark and hallmark, 1798-1809). Ill. in *Cinq années d'enrichissement du patrimoine national, 1975-1980*, exh. cat. (Paris: Réunion des musées nationaux, 1980), pp.138-139; Jean Babelon, Yves Bottineau and Olivier Lefuel, *Les grands orfèvres de Louis XIII à Charles X* (Paris: Hachette, 1965), pp. 292-293; Gay-Mazuel 2017, p. 142.

9. *Journal de l'Empire ou Courrier de l'Europe*, September 29, 1808, p. 3.

10. Today, the plates, dishes and tableware are at the Musée national du château de Fontainebleau (inv. F 1983.4.1-95), and pieces at the Fondation Napoléon and in private hands. On Madame Mère's service, see the Christie's sales catalogue, Manson and Woods, *Glory of the Goldsmith: Magnificent Gold and Silver from the Al-Tajir Collection* (London: 1989), pp. 30-31; Anne Dion-Tenenbaum, *Orfèvrerie*

française du XIXᵉ siècle. La collection du musée du Louvre (Paris: Musée du Louvre; Somogy, 2011), p. 205; Gay-Mazuel 2017, p. 10.

11. See Hans Ottomeyer and Lorenz Seelig, "Das Silber- und Vermeil-Service König Jérômes von Westfalen in der Münchner Residenz," *Münchner Jahrbuch der Bildenden Kunst*, vol. XXXIV (Munich: Prestel Verlag München, 1983), pp. 117-164. The service has been housed at the Residenz in Munich since 1817.

12. Frochot's statement of April 1810, preserved in the archives of the Musée des Arts décoratifs, Paris, specifies the dressing table's price was as much as 480,000 francs. See Christian Baulez, "La toilette de l'impératrice Marie-Louise, le berceau du roi de Rome et Henri Victor Roguier," *Antologia di belle arti*, vol. 1, no. 2 (June 1977), pp. 194-200.

13. Collection Comte et Comtesse Charles-André Colonna Walewski for the drawing for a *psyché*; Collection Chalençon for the one of a dressing table.

14. *Description de la toilette présentée à Sa Majesté l'impératrice-reine, et du berceau offert à S. M. le roi de Rome par M. le conseiller d'État comte Frochot, préfet du Département de la Seine . . .* (Paris: Ballard, 1811).

15. A.N., O² 511. A credit for 240,000 francs was freed up in 1810 to furnish the Emperor's Grand Cabinet at the Tuileries. No trace of these silver-gilt works has been found.

16. A.N., O² 511. See also O² 560 and O² 517.

17. A.N., O² 687.

18. A.N., O² 519 and O² 523.

19. The cradle is still in Vienna, in the Kaiserliche Schatzkammer (National Treasury) of the Kunsthistorisches Museum (inv. SK XIV 28). See Baulez 1977, pp. 194-200; Gay-Mazuel 2017, pp. 182-183.

20. A.N., O² 535. The price of making the cradle went up to 182,168.50 francs, not including the fabrics invoiced for 29,150.50 francs.

21. Duke Cadore, Intendant-General of the Imperial Household, to Hector Lefuel, curator of the imperial palace furniture, July 21 and 25, 1812, and Lefuel to the Duke of Cadore, July 25, 1812, A.N., O² 535, 10 and 19.

22. Jean-Pierre Samoyault, "L'orfèvrerie de table de la couronne sous le Premier Empire," in *Versailles et les tables royales en Europe*, exh. cat. (Paris: Réunion des musées nationaux, 1993), p. 213.

23. Copy with the documents of Château de Fontainebleau.

24. *Almanach du commerce de Paris*, 1812, p. 283, and 1813, p. 287.

25. Paris, Musée de la Légion d'honneur, inv. O 3038.

26. Gay-Mazuel 2017, p. 178. Odiot delivered to him on May 25, 1813, silver burettes and tray for his chapel: Serge Grandjean, *L'orfèvrerie du XIXᵉ siècle en Europe* (Paris: Presses universitaires de France, 1962), p. 98.

27. Odiot to Montalivet, June 10, 1811, A.N., F¹² 2265

28. Montalivet to Daru, June 28, 1811, A.N., F¹² 2265.

29. Daru to Montalivet, July 8, 1811 A.N., F¹² 2265.

30. Demazis to Daru, August 16, 1811, A.N., O² 535. The file also contains Biennais and Boulier's quotes and tenders.

31. Serge Grandjean, *Inventaire après décès de l'impératrice Joséphine à Malmaison* (Paris: Ministère d'État-Affaires culturelles, 1964), p. 77; Grandjean 1962, p. 44.

The Altar Furnishings for the Wedding of 1810
Benoît-Henry Papounaud

1. Cast, repoussé, chased, matted, gilded silver; wrought iron alloy (internal structure) and wooden core. Silversmith's signature engraved on each piece: Hᵞ. AUGUSTE Fᵀ. PARIS, followed by the date, 1809 (?), erased. Marks stamped several times on each piece: H.A. (two wolf heads), Henry Auguste's maker's mark stamped in 1798-99 and crossed out in 1809; *essai* (Grecian woman's head name 1). The hallmark and warranty mark are not visible. Old inventory number marked on the lower ring of the candlesticks' baluster leg: *5299*.

2. Palais du Tau, Reims, inv. D-TAU2000000148 and 149.

3. Palais du Tau, Reims, inv. D-TAU1935000266, signed and dated 1809.

4. Anne Dion-Tenenbaum, "Les fournitures de Biennais pour le mariage : un luxe sans précédent," in *1810. La politique de l'amour. Napoléon Iᵉʳ et Marie-Louise à Compiègne*,

exh. cat., eds. Emmanuel Starcky and Hélène Meyer (Paris: Réunion des musées nationaux, 2010), pp. 98-104.

5. Jean-Michel Leniaud, *Saint-Denis de 1760 à nos jours* (Paris: Gallimard-Julliard, 1996), pp. 60-61.

6. Yves Carlier, "Aspects inédits de la carrière de l'orfèvre Henry Auguste (1759-1816)," in *Bulletin de la Société de l'Histoire de l'Art français*, 2001, pp. 195-219.

7. Kapandji Morange sale, December 18, 2015, Drouot-Richelieu, salle 9, lot 55 (76.5 x 117.5 cm); the more complete second drawing (acolyte candlesticks and bas-relief of the *Adoration of the Shepherds*), Musée des Arts décoratifs, Paris, inv. CD3258 (53.5 x 55.3 cm).

8. Executed from a model attributed to Nicolas-Pierre Loir (1624-1679) or Alexis Loir (1640-1713), this 45-kilogram bas-relief was given to the Saint-Denis basilica by Dom Tarteron in 1682. Housed at the Musée des monuments français by Alexandre Lenoir in 1793, the relief was still at the Monnaie de Paris in 1805. Restored to the Saint-Denis basilica in the years following the wedding, it was stolen overnight on December 30-31, 1963. On the preparatory drawing at the Musée des Arts décoratifs, the relief is reversed.

9. Louis-Pierre Baltard, *Album du mariage de Napoléon et Marie-Louise. Célébration du mariage de Napoléon et Marie-Louise dans le salon Carré du Louvre*, Fontainebleau, inv. F 1985.3.5. Regarding the album, see Christophe Beyeler, *Noces impériales. Le mariage de Napoléon et Marie-Louise dessiné par Baltard*, exh. cat. (Paris: Somogy; Château de Fontainebleau, 2010).

10. The cohesion is reinforced by the position and attributes of some of the figures. Moreover, the leaf-and-dart frieze added by Auguste or his successor around the perimeter of the bas-relief echoes that of the ornamentation (this detail is visible on the drawings as well as on the photographs of the bas-relief taken in 1958 and housed at the Médiathèque d'architecture et du patrimoine).

11. The recessed outline of the purple imperial mantle, the hand of justice and the sceptre are totally recognizable against the matted ground. Regarding this topic, see Jean-Pierre Samoyault, "The Creation of Napoleonic Symbolism and Its Spread throughout the Decorative Arts in the Imperial Era," in *Symbols of Power: Napoleon and the Art of the Empire Style, 1800-1815*, exh. cat., ed. Odile Nouvel-Kammerer (New York: Abrams; Paris: Les Arts Décoratifs, 2007), pp. 52-61.

12. The ornaments were then returned to the Garde-Meuble's coronation cabinet. In July 1935, the group was allotted to Compiègne, and then sent to Reims in 1938.

IV SERVING THE IMPERIAL FAMILY

The Étiquette in Action: Some Observations on the Imperial Banquet for the Wedding of Napoleon and Marie-Louise by Casanova
Christophe Beyeler and Sylvain Cordier

1. Another version is at the Hermitage State Museum, Saint Petersburg, and a third, a sketch or reduction, at the Musée Carnavalet, Paris, inv. P 1844: Fontainebleau, file on the work, information provided by Macé de Lépinay, March 1989.

2. References kindly forwarded by Dr. Gerald L. Carr: Fontainebleau, file on the work—"Fine original paintings, just imported from Paris, and now exhibiting at the London Gallery, 22, Piccadilly (Haymarket end)—For sale, with many others, fine Tapestry, &c. an elegant painting, representing the Banquet as given by the Emperor Napoleon on the day of his Marriage with the Empress Maria Louisa, painted by the order of Bonaparte, and is the only picture extant which contains the portraits of nearly all his family, and considered as excellent likenesses, approved by the best French artists, and exhibited in the Musée [*sic*]: *The Times*, no. 9412, January 7, 1815, p. 1.

3. Letter from Frank Lloyd and Sons of the Administration française des Beaux-Arts, January 20, 1938, Fontainebleau, file on the work.

4. Letter from Grand Marshal Duroc to Intendant-General Daru, January 18, 1910, A.N., 400AP 4. The authors wish to thank Charles-Éloi Vial for having generously shared the reference to this archive specimen.

5. Ch. [Charles] Percier and P.-F.-L. [Pierre-François-Léonard] Fontaine, *Description des cérémonies et des fêtes qui ont eu lieu pour*

le mariage de S. M. l'Empereur Napoléon I^{er} avec S. A. I. Marie-Louise d'Autriche (Paris: P. Didot l'aîné, 1810), fol. 45 p., 13 pl.

6. Jean-Pierre Samoyault, "L'orfèvrerie de table de la Couronne sous le Premier Empire," in *Versailles et les tables royales en Europe : XVII^e-XIX^e siècles*, exh. cat. (Paris: Réunion des musées nationaux, 1993), pp. 207-209.

7. *Napoléon Bonaparte. Correspondance générale*, published by the Fondation Napoléon, vol. IX (Paris: Fayard, 2013), letter no. 23214.

8. Ibid., note 1.

9. Pierre Fontaine, *Mia Vita. Mémoires privés*, revised and annotated by Jean-Philippe Garric (Paris: Éditions des Cendres, 2017), p. 116.

10. Department of the Grand Master of Ceremonies of the Imperial Household, *Étiquette du palais impérial* (Paris: Imprimerie impériale, 1806), titre V: "Des Repas de Leurs Majestés," chap. I: "Service de LL. MM. en grand couvert."

11. Ibid., art. XI.

12. See the essay herein on court dress by Sylvain Cordier and Chantelle Lepine-Cercone, pp. 114-119.

13. Some colours may have changed with time or a (or various) restoration(s). That of 1984-85 is only confirmed by a mention in the file on the work.

14. See the essay cited above by Cordier and Lepine-Cercone.

15. *Étiquette du palais impérial*, 1806, titre V, chap. I, art. VIII.

16. See the essay cited above by Cordier and Lepine-Cercone.

17. *Napoléon Bonaparte. Correspondance générale*, 2013, letter no. 23213.

18. Samoyault 1993, p. 203.

19. See the essay herein by Virginie Desrante, "The Imperial Table," pp. 212-219; see also Christophe Beyeler, "Parer la table du souverain et éblouir l'Europe. La collection de porcelaines de Sèvres du musée Napoléon I^{er} au château de Fontainebleau," in *Napoléon et Sèvres. L'art de la porcelaine au service de l'Empire*, ed. Camille Leprince (Paris: Feu et talent, 2016), pp. 63-112, in particular pp. 80-93.

20. *Étiquette du palais impérial* 1806, titre V, chap. I, art. XIV.

The long Trip Taken by a Palace Prefect: A Rediscovered Sketch by Horace Vernet
Sylvain Cordier

1. Jean-Pierre Samoyault, "Fontainebleau, Musée Napoléon I^{er} : dix ans d'acquisitions," *Revue du Louvre, la Revue des musées de France* (April, 1996), p. 50.

2. Louis-François de Bausset, *Mémoires anecdotiques sur l'intérieur du palais et sur quelques événements de l'Empire depuis 1805 jusqu'au 1^{er} mai 1814 pour servir à l'histoire de Napoléon*, vol. II (Brussels: H. Tarlier, 1827), pp. 89-91.

3. *Catalogue des tableaux, esquisses, dessins de M. le baron Gérard, peintre d'histoire*, Paris, April 27-29, 1837, lot 78: "The subject of this sketch is that in which the emperor received from the hands of M. de Bausset the portrait of the king of Rome, painted by Gérard, and presented it to his staff officers."

4. *Succession de Feue Mme la Comtesse de Montesquiou-Fezensac. Objets d'art, tableaux, aquarelles*, Paris, January 29-31, 1872, lot 62: "Vernet (Horace). The emperor Napoleon receives from the hands of M. de Bosset [*sic*] the portrait of the king of Rome painted by Gérard and presents it to his staff officers. Sale of the baron Gérard. Height, 32 cm; width, 48 cm."

5. *Étude Beaussant-Lefevre*, Paris Drouot, September 29, 2017, lot 32.

6. De Bausset 1827, p. 92, note 1.

7. Ibid., pp. 91-92.

Stables, Coaches and Grand Cortèges: The Emperor's Department of the Grand Equerry
Hélène Delalex

1. François-Timoléon, abbé de Choisy, *Mémoires pour servir à l'histoire de Louis XIV* (Utrecht: Van de Water, 1727), p. 37.

2. According to Charles-Éloi Vial's excellent study, the funds annually allocated to the department of the Grand Equerry never dropped below the three million mark; see "Les écuries de Napoléon : une parenthèse dans l'histoire de l'équitation ou la chance d'un renouveau ?," *In Situ* (online), 2012, par. 19.

3. "États du Personnel des Écuries de Sa Majesté au 1^{er} janvier 1814," A.N. O² 149, pièces 159-168.

4. In fact, Louis XVI had already merged the two stables by the end of his reign: in 1787, as a cost-cutting measure, the Petite Écurie was eliminated and connected to the Grand Stables, and the number of personnel was divided in two, as was the number of horses.

5. See the entry herein on the portrait of Caulaincourt, p. 54.

6. In 1810 and 1811, Nansouty signed as follows: "In the absence of the Grand Equerry of France, the Division General, First Equerry to the Emperor, Nansouty," A.N., O² 77.

7. Pierre-François-Léonard Fontaine, *Journal, 1799-1853* (Paris: École nationale supérieure des Beaux-Arts; Institut Français d'Architecture; Société de l'Histoire de l'Art français, 1987), vol. I (1799-1824), p. 258.

8. The number was given by Rudolf H. Wackernagel in *Der französische Krönungswagen von 1696-1825, ein Beitrag zur Geschichte des repräsentativen Zeremonienwagens* (Berlin: W. de Gruyter, 1966), p. 253.

9. "1810 Mariage. Pièces relatives aux Dépenses," A.N., O² 149, pièces 263-269. The Intendant-General had available funds amounting to 460,000 francs, the Grand Marshal 670,000 francs, the Grand Master of Ceremonies 136,626 francs and the Grand Chamberlain 1,705,000 francs, a final amount that covered the "diamonds and jewellery given by the Emperor to the Empress and to serve as gifts, trousseau, wedding presents, shawls and lace, medals struck on the occasion of the marriage."

10. "An 1810. Budget des Dépenses relatives au Mariage de Sa Majesté. Service du Grand écuyer," signed by Napoleon and the comte Estève, treasurer-general of the Crown, on March 10, 1810 (A.N., O² 77, pièce 159). The 516,995 francs were divided as follows: 368,177 francs for coaches and tack; 3,024 francs for spurs; 6,000 francs for incidentals and repairs required by the ceremony; 139,794 francs for the expenses of H. M. the Empress and her retinue. See also O² 77, pièces 160 to 162.

11. "Décision du 28 décembre 1810. Supplément au Budget du Mariage de Sa Majesté. Fonds de 39 988 francs," A.N., O² 77, pièces 252 and 253; see also pièces 207-212 and 214.

12. "Dépenses extraordinaires en supplément au Budget de 1810," A.N., O² 77, pièces 341 and 343: "Grand livery for the grooms, stableboys, coachmen, postilions, tack boys, and every one of the seventy-two men required for the ceremony: 55,000 francs."

13. A.N., O² 77, pièce 324. In the letter, Nansouty asks Daru for reimbursement of the coach offered to the Austrian embassy, of 23,566 francs (price given in O² 77, pièces 163); see also the letters dated March 5, 7 and 8, O² 77, pièces 345, 349 and 339.

14. A.N., O² 77, pièces 163 and 207 to 212.

15. The Empress' service coach was valued 17,000 francs (A.N., O² 77, pièce 182), the Emperor's coach was 26,000 francs (A.N., O² 77, pièces 184 and 254: 20,000 F + 6 000 F of embellishments).

16. The coaches were of an average value of 8,564,74 francs each (A.N., O² 77, pièce 324); archives contain estimates (O² 77, pièces 320-346) and invoices (O² 77, pièces 166-186) of these coaches, with tack and ornamental trimmings.

17. Letter from Daru to Nansouty, March 8, 1810 (A.N., O² 77, pièce 339), in which the Intendant quoted the Emperor's words.

18. Charles Percier and Pierre-François-Léonard Fontaine, *Description des cérémonies et des fêtes qui ont eu lieu pour le mariage de S. M. l'Empereur Napoléon avec S. A. I. Madame l'Archiduchesse Marie-Louise d'Autriche* (Paris: P. Didot L'Aîné, 1810).

19. "Service du Grand maréchal du Palais. Dépenses du mariage. Voyage de l'Impératrice, 1810," A.N., O² 19, pièces 1-217, and O² 77, pièces 201-206 and 344, i.e. 139,794 francs.

20. Percier and Fontaine 1810, p. 27.

21. *Mémoires de la comtesse Potocka (1794-1820)* (Paris, Plon, 1897), description of the wedding, pp. 199-201.

22. Ibid.

23. Cited by Wackernagel 1966, p. 265; for details on the coronation coaches and the coronation carriage, see pp. 253-275.

24. Only the first two horses, called the *chevaux timoniers*, are required to pull the carriage; the other six, called the *chevaux de volée*, because of their number, give the team of horses its magnificence.

25. The major sources on the order of the cortège are "Dispositions" given by the comte de Ségur (A.N., O² 19, pièce 118), printed in brochures (A.N., O² 19, pièces 120-122), the account of

Percier and Fontaine 1810, and the *Gazette nationale ou Le Moniteur universel*, no. 100, April, 10, 1810, p. 396.

26. Although technically the Emperor's vehicle was a berlin coach, the term "carriage" is used for the great ceremonial coaches characterized by their rich and abundant decoration.

27. See F[rançois] M[arie] Miel, *Histoire du sacre de Charles X, dans ses rapports avec les Beaux-Arts* (Paris: C.L.F. Panckoucke, 1825).

28. *Gazette nationale ou Le Moniteur universel*, April 22, 1794.

29. L. Rosier, "Musée des Voitures historiques de Versailles," *L'Illustration*, vol. 18, 1851, p. 313.

The Imperial Hunt
Charles-Éloi Vial

1. Charles-Éloi Vial, "La vénerie royale sous Louis XV et les chasses de Fontainebleau," in *Louis XV à Fontainebleau. La «demeure des rois» au siècle des Lumières*, exh. cat., ed. Vincent Droguet (Musée national du château de Fontainebleau; Paris: Réunion des musées nationaux, 2016), pp. 189-193.

2. A.N., O² 200, dossier "budget 1810," pièce 259, draft budget for 1811, n.d.; AB^{XIX} 4260, dossier 1, general de la Maison de l'Empereur, 1813; O² 132, register des dépenses de la vénerie pour 1811.

3. On this subject, see Charles-Éloi Vial, *Le Grand veneur de Napoléon I^{er} à Charles X* (Paris: École nationale des chartes, 2016).

4. *Napoléon Bonaparte. Correspondance générale*, vol. III, issued by the published by the Fondation Napoléon (Paris: Fayard, 2006), letter no. 6952 to Josephine, Malmaison, 4 Messidor, Year X (June 23, 1802), p. 1000.

5. Pierre-François-Léonard Fontaine, entry, March 26, 1811, in *Journal, 1799-1853* (Paris: École nationale supérieure des Beaux-Arts; Institut Français d'Architecture; Société de l'Histoire de l'Art français, 1987), vol. 1, p. 287.

6. Paul Thiébault, *Mémoires* (Paris, Plon, 1895), vol. 5, pp. 543-544.

7. Jean-Jacques-Régis de Cambacérès, *Mémoires inédits* (Paris: Librairie Académique Perrin, 1999), vol. 2, p. 14.

8. *Journal de Paris*, October 9, 1807, p. 2018.

9. *Journal de Paris*, February 20, 1808, p. 2.

10. Ibid., October 15, 1808, p. 1.

11. Charles de Clary-et-Aldringen, *Souvenirs* (Paris: Plon-Nourrit, 1912), pp. 9-12; *Journal de Paris*, March 28, 1811, p. 617.

12. Charles-Éloi Vial, "Napoléon et les Parisiens," in *Napoléon et Paris : rêves d'une capitale*, exh. cat. (Paris: Musée Carnavalet; Paris-Musées, 2015), pp. 121-123.

13. Letter from Brongniart to Duroc, Sèvres, March 24, 1810, in A.M.S., carton T5, liasse 1.

14. Vial, *Le Grand veneur*, 2016, pp. 496-511.

15. Gaspard Gourgaud, *Sainte-Hélène, journal inédit de 1815 à 1818* (Paris: Flammarion, 1899), vol. 2, p. 311.

The Empress in Her Household
Anne Dion-Tenenbaum

1. Pierre Branda, *Napoléon et ses hommes. La Maison de l'Empereur, 1804-1815* (Paris: Fayard, 2011), pp. 287-289.

2. *Étiquette du palais impérial* (Paris: Imprimerie impériale, 1808), titre I, chap. III, article XXXVII, p. 55.

3. *Mémoires de Mademoiselle Avrillion, première femme de chambre de l'impératrice, sur la vie privée de Joséphine, sa famille et sa cour* (1833), presented and annotated by Maurice Dernelle (Paris: Mercure de France, 1969), pp. 71-72.

4. A small fragrance box was delivered to Mme de Luçay, at Compiègne, by Biennais: A.N., O³ 30.

5. See the entry herein by Sylvain Cordier on the portrait of the duchess of Montebello, p. 52.

6. *Mémoires de Mademoiselle Avrillion* 1833, p. 73.

7. *Baron Fain : Mémoires*, introduction by Christophe Bourachot (Paris: Arléa, 2001), pp. 153-154.

8. *Mémoires de Mademoiselle Avrillion* 1833, pp. 77-79; Louis Constant Wairy, called Constant, *Mémoires intimes de Napoléon I^{er} par Constant, son valet de chambre*, presented and annotated by Maurice Dernelle (Paris: Mercure de France, 1967), p. 455.

9. Baron Claude-François de Méneval, *Mémoires pour servir à l'histoire de Napoléon I^{er} depuis 1802 jusqu'à 1815* (Paris: Dentu, 1893), vol. I, p. 138.

10. Letter from Marie-Louise, December 22, 1810, cited by Ernest d'Hauterive in *Sainte-Hélène au temps de Napoléon et aujourd'hui* (Paris: Calmann-Lévy, 1933), p. 395.

11. Duroc to Daru, February 2, 1810, A.N., O² 511, dossier 3.
12. Napoleon to Daru, February 18, 1810, A.N., O² 164.
13. Delivery in June 1810 to Saint-Cloud, A.N., O² 517.
14. Jean-Pierre Samoyault, *Musée national du château de Fontainebleau. Meubles entrés sous le Premier Empire* (Paris: Réunion des musées nationaux, 2004), no. 272, p. 338.
15. Hélène Meyer, "Marie-Louise à Compiègne," in *1810. La politique de l'amour. Napoléon Ier et Marie-Louise à Compiègne*, exh. cat., ed. Emmanuel Starcky and Hélène Meyer (Paris: Réunion des musées nationaux, 2010), pp. 79–80 and no. 152.
16. Pierre Arizzoli-Clémentel and Jean-Pierre Samoyault, *Le mobilier de Versailles. Chefs-d'œuvre du XIXe siècle* (Dijon: Faton, 2009), pp. 170–171. Samoyault discovered the participation of the bronze-worker Feuchère on these frames.
17. The one belonging to Josephine is in the royal collections of Sweden: See *Destins souverains, Napoléon Ier, le tsar et le roi de Suède*, exh. cat., eds. Emmanuel Starcky and Hélène Meyer (Paris: Réunion des musées nationaux-Grand Palais, 2011), no. 76. The one owned by Marie-Louise (former collection of Bernard Franck) was recently put up for sale: Fontainebleau, master Osenat, April 12, 2015, no. 312).
18. Albert Pomme de Mirimonde, "Les dépenses d'art des impératrices Joséphine et Marie-Louise," *Gazette des Beaux-Arts*, vol. 50 (September 1957), p. 149.
19. A.N., O² 511, dossier 3, and 522, dossier 6.
20. Baron Claude-François de Méneval 1893, p. 138.
21. "Journal des recettes et dépenses faites pour le service de S. M. l'Impératrice et Reine," 500 francs, then 602.46 for year 12 and year 13: Gray, Bibliothèque municipale, fonds Jean-Claude Ballouhey.
22. *Joséphine*, exh. cat., ed. Amaury Lefébure (Paris: Réunion des musées nationaux-Grand Palais; Musée national des châteaux de Malmaison et Bois-Préau, 2014), nos. 112 and 113.
23. Générale Sophie Cohonset Durand, *Mémoires sur Napoléon et Marie-Louise, 1810-1814* (Paris: Calmann-Lévy, 1886), p. 44.
24. A.N., O² 513, dossier 6.
25. Paris, Musée de la musique, inv. E.979.2.7. On Érard, see Michel Robin, "Erard Frères, facteurs de pianos et de harpes. Fournisseurs de 'Leurs Majestés impériales et royales,'" in *La reine Hortense. Une femme artiste*, exh. cat., by Jacqueline Pottier, Maurice Catinat, Dorothea Baumann et al. (Paris: Réunion des musées nationaux; Musée national des châteaux de Malmaison et Bois-Préau, 1993), pp. 32–33.
26. Michel Robin and Jean-François Weber, "Antoine Rascalon, décorateur de pianos-forte d'apparat," *L'Estampille / L'Objet d'art*, no. 377 (February 2003), pp. 72–73.
27. De Mirimonde 1957, p. 152.
28. For 300 francs in October 1810 (A.N., O² 515, dossier 16, and O² 750, dossier 3). The Biblioteca Palatina in Parma has a collection of Marie-Louise's music books.
29. Josephine's *écritoire-pupitre* with monogram, Château de Malmaison, inv. 40.47.6939; écritoire with the ML monogram (Christie's, November 20, 1980).
30. Mémoire of May 7, 1812, A.N., O² 1204.
31. *Mémoires de Mme la duchesse d'Abrantès ou souvenirs historiques sur Napoléon, la Révolution le Directoire, le Consulat, l'Empire et la Restauration* (Paris: Ladvocat, 1834), vol. XIII, p. 283; the same anecdote was recounted by the valet of the bedchamber Constant, *Mémoires* 1967, p. 411.
32. Samoyault 2004, no. 170, pp. 240–241; Arizzoli-Clémentel and Samoyault 2009, no. 39, p. 152.
33. Denon to Duroc, April 5, 1810, in *Vivant Denon, directeur des musées sous le Consulat et l'Empire. Correspondance (1802-1815)*, eds. Marie-Anne Dupuy, Isabelle le Masne de Chermont and Elaine Williamson (Paris: Réunion des musées nationaux, 1999), vol. I, no. 1763, p. 623.
34. Clary-et-Aldrigen to his mother, April 21, 1810, in *Souvenirs du prince Charles de Clary-et-Aldringen. Trois mois à Paris lors du mariage de Napoléon et de l'archiduchesse Marie-Louise*, published by the baron de Mitis and the comte de Pimodan (Paris: Plon, 1914), p. 161.
35. Meyer 2010, p. 79.
36. Samoyault 2004, no. 169, pp. 239–240.
37. Starcky and Meyer, eds., 2010, no. 151, p. 189.
38. "Journal des recettes et dépenses faites pour le service de S. M. l'Impératrice et Reine" (cited note 21): June 19, 1811, August 14, 1812, February 9, 1813, January 10, April 30 and September, 1814.

39. A.N., O² 689, dossier 3, for the Tuileries, and O² 522, dossier 1, for Compiègne.
40. June 16, 1810, A.N., O² 515.
41. A.N., O² 1104.

From Montreal to the Tuileries: The Happiness and Misfortunes of the Marescots, a Family in the Service of the Household
Sylvain Cordier

1. Gérard Ermisse and F. Robert, "La vie et la carrière d'Armand-Samuel de Marescot, Premier inspecteur général du Génie de Napoléon Bonaparte," *Bulletin de la Société archéologique, scientifique et littéraire du Vendômois* (2016), pp. 164–165.
2. Letter from Napoleon to the comtesse de La Rochefoucauld, September 6, 1808, in *Napoleon Bonaparte. Correspondance générale*, vol. VIII: *Expansions méridionale et résistances, 1808–janvier 1809*, published by the Fondation Napoléon (Paris: Fayard, 2011), entry 18835.
3. Letter from Marescot to Napoleon, September 27, 1808, A.N., BB 30 97.
4. On the genealogy of the Martels in Canada, see "La famille Martel de Magesse," *Le Bulletin des Recherches historiques*, vol. 40, no. 12 (December 1934), pp. 713–720.
5. "Martel de Magos (Magesse)," in *Biographical Dictionary of Canada*, accessed, http://www.biographi.ca/fr/bio/martel_de_magos_jean_2F.html.
6. J.-X. Carré de Busserolle, *Armorial général de la Touraine. Mémoire de la société archéologique de Touraine*, vol. XIX (1867), p. 633.
7. Register of baptisms, marriages and burials of the parish of Saint-Hilaire de Tours, death certificate, May 19, 1767.
8. Register of death certificates of the Year 13 (1805), city hall of the 10th arrondissement of Paris, death certificate, 4 Pluviôse (January 24).
9. I wish to thank Michel Pastoureau for his help in interpreting the colours of the character's garb.
10. Pierre Branda, *Napoléon et ses hommes. La Maison de l'Empereur, 1804-1815* (Paris: Fayard, 2011), p. 231.
11. Charles-Éloi Vial, "La cour impériale," *Colloque Marescot. Bulletin de la Société archéologique, scientifique et littéraire du Vendômois* (2016), p. 200.
12. [Émile Marco de Saint-Hilaire], *Mémoires et révélations d'un page de la cour impériale de 1802 à 1815*, vol. II (Paris: C. Malot, 1830), pp. 15 and 18–20.
13. Ambroise Duchemin, "Fortuné Dufau, Portrait d'enfant, vers 1800," in Ambroise Duchemin, online gallery at http://www.ambroise-duchemin.com/fortune-dufau-1770-1821, accessed August 2017.
14. *Explication des ouvrages de peinture, sculpture, architecture et gravure, exposés au Musée Napoléon le 15 septembre 1806* (Paris: Imprimeur des sciences et des arts, 1806), p. 31.
15. Gérard Ermisse, "Introduction aux actes du colloque Marescot," *Colloque Marescot*, 2016, p. 159.

The Silver from the Pages' Chapel at Saint-Cloud
Anne Dion-Tenenbaum

1. "Compte des dépenses faites pour l'établissement de MM. les pages à St-Cloud pendant l'an XIII, 80834,43 francs," A.N., O² 499, dossier 4.
2. James Rousseau, "Les pages de l'Empereur," *Journal des enfants rédigé par toutes les sommités littéraires*, vol. 1, 1832, pp. 335–339.

Posthumous Portrait of a Former Page: Second Lieutenant Legrand, by Gros
Sylvain Cordier

1. Charles Millard, "Baron Gros' 'Portrait of Lieutenant Legrand,'" *Los Angeles County Museum of Art Bulletin*, vol. 10, no. 2, 1974, pp. 36–45; James B. Byrnes, "A Portrait by Baron Gros," *Los Angeles County Museum Bulletin of the Art Division*, vol. 4, no. 1, 1951, pp. 12–14.
2. Jérôme Fehrenbach, *Le général Legrand, d'Austerlitz à la Bérézina* (Saint-Cloud: Soteca, 2012, pp. 66–67.
3. Ibid., p. 378, where the act is reported with specific reference.
4. *Correspondance de Napoléon Ier, publiée par ordre de l'empereur Napoléon III* (Paris: Plon, 1865), vol. XVII, letter 13830, p. 88.
5. "All those presenting [to become a page] must have the instruction fitting for the youth their age, and be in conformity": *Étiquette du palais impérial, année 1806* (Paris: Imprimerie impériale, 1806), titre I, chap. IV, art. c.

6. N. 393 du livret, p. 49.
7. Millard 1974, p. 49.
8. Joan Siegfried, "The Romantic Artist as a Portrait Painter, " *Marsyas* (1957–59), p. 40.
9. Millard 1974, p. 36.
10. See the author's entry herein on the portrait of the Marescot family, pp. 260–263.

The Emperor's "Cabinet"
Charles-Éloi Vial

1. Pierre Branda, *Napoléon et ses hommes. La Maison de l'Empereur, 1804-1815* (Paris: Fayard, 2011), p. 181.
2. Pierre-François-Léonard Fontaine, *Journal, 1799-1853* (Paris: École nationale supérieure des Beaux-Arts; Institut Français d'Architecture; Société de l'Histoire de l'Art français, 1987), vol. 1, pp. 13, 14 and 15.
3. *Correspondance de Napoléon Ier, publiée par ordre de l'empereur Napoléon III* (Paris: Plon, 1863–69), vol. IX, p. 574, décret 9740, Paris, February 3, 1806.
4. Agathon-Jean-François Fain, *Mémoires* (Paris: Plon-Nourrit et Cie, 1908), p. 13.
5. Jean-Baptiste Auzel, "Essai de typologie des documents d'archives produits par le Cabinet de Napoléon et sa Secrétairerie d'État (A.N., AF IV)," in *Napoléon Bonaparte. Correspondance générale*, vol. 5, published by the Fondation Napoléon (Paris: Fayard, 2008), p. 943.
6. Claude-François de Méneval, *Mémoires pour servir à l'histoire de Napoléon Ier depuis 1802 jusqu'en 1815* (Paris: E. Dentu, 1893–94), vol. 1, p. 153.
7. Branda 2011, p. 178.
8. Jean-Claude Beugnot, *Mémoires du comte Beugnot* (Paris: E. Dentu, 1868), vol. 2, p. 5.
9. Thierry Lentz, *Nouvelle histoire du Premier Empire* (Paris: Fayard, 2002–10), vol. 3, p. 76.
10. A.N., O² 52, fol. 57.
11. *Mémoires de Fleury de Chaboulon . . . avec annotations manuscrites de Napoléon Ier* (Paris: Édouard Rouveyre, 1901), 2 vols.
12. Report from Barbier to Louis XVIII, May 12, 1814, A.N., O⁵ 2200, dossier 4.
13. Jean Tulard, *Le mythe de Napoléon* (Paris: Armand Colin, 1971), p. 35.
14. For example, in *The Monthly Anthology and Boston Review, Containing Sketches and Reports of Philosophy, Religion, History*, vol. 2 (November 1805), p. 574.
15. "Tableaux ordonnés par décret du 3 mars 1806," B.N.F., Français 6586, f. 106.
16. Charles-Paul Landon, *Annales du Musée et de l'École moderne des Beaux-Arts, Salon de 1808* (Paris: Landon, 1808), pls. 23–24.
17. "Registre d'inscription des productions des artistes vivants présentés à l'exposition," n.d. [1810], A.N., Archives des musées nationaux, X-Salon, dossier 1810.
18. Sudhir Hazareesingh, *La légende de Napoléon* (Paris: Tallandier, 2005), p. 212.

The Imperial Household and the Theatres of the Regime
Cyril Lécosse

1. See, in particular, David Chaillou, *Napoléon et l'Opéra. La politique sur la scène* (Paris: Fayard, 2004), and, for music, Pierre Branda, *Napoléon et ses hommes. La Maison de l'Empereur, 1804-1815* (Paris: Fayard, 2011), pp. 188–199.
2. Chaillou 2004, pp. 28–29. Regarding the activities of the theatres at court, see, in particular, the series O² 30, the Archives nationales et Bibliothèque du musée de l'Opéra (hereafter BMO), Opéra arch.
3. "You should not put forward a new play for study without my consent," he wrote to Rémusat in February 1810, cited in Alphonse Maze-Sencier, *Les fournisseurs de Napoléon Ier et des impératrices d'après des documents inédits* (Paris: Renouard, 1893), pp. 113–114.
4. See the series O², Archives nationales and BMO.
5. Pierre-François-Léonard Fontaine, *Journal 1799-1853* (Paris: École nationale des Beaux-Arts, Institute Français d'Architecture; Société de l'Histoire de l'Art français, 1987), vol. I, p. 44, 1 Germinal, Year X (March 22, 1802), and Bernard Chevallier, *Malmaison, château et domaine des origines à 1904* (Paris: Réunion des musées nationaux, 1989), pp. 77–81. See also Germain Bapst, *Essai sur l'histoire du théâtre : la mise en scène, le décor, le costume, l'architecture, l'éclairage, l'hygiène* (Paris: Hachette, 1893), p. 523.
6. See Isabey's letter to Peyre, Paris, 9 Frimaire, Year XI (November 30, 1802), in S. d'Huart,

"Trois lettres inédites sur Malmaison," *Bulletin de la Société des Amis de Malmaison* (1979), pp. 24–26.
7. See L.-A. Fauvelet de Bourienne, *Mémoires de M. de Bourrienne, ministre d'État, sur Napoléon, le Directoire, le Consulat, l'Empire et la Restauration* (Paris: Ladvocat, 1829), vol. IV, p. 44. See also Isabey's story in Edmond Taigny, *J.-B. Isabey, sa vie et ses œuvres* (Paris: E. Panckoucke, 1859), p. 24, and Caroline d'Arjuzon, *Madame Louis Bonaparte* (Paris: Calmann Lévy, 1901), pp. 41–43.
8. Branda 2011, p. 195.
9. *Règlement pour les théâtres du 25 avril 1807*, titre premier, art. 1, A.N., AJ13 72.
10. Order of 18 Messidor, Year XI (July 7, 1803), A.N., AJ13 63-11.
11. See the report the director of the Opéra submitted to the prefect of the palace, the comte de Luçay, 3 Floréal, Year XI (April 23, 1803), BMO, Opéra arch. 19–56. See also Mathias Auclair, "L'atelier des décors de l'Opéra (1803-1822)," *Revue de la Bibliothèque nationale de France*, 2011, no. 37, pp. 5–10.
12. See Arthur Pougin, *Dictionnaire historique et pittoresque du théâtre et des arts qui s'y rattachent* (Paris: Firmin-Didot, 1885), vol. I, pp. 285–286.
13. See Taigny 1859, pp. 26–27.
14. See Sylvain Laveissière, "L'atelier d'Isabey : un panthéon de l'amitié," in *Boilly, 1761-1845. Un grand peintre français de la Révolution à la Restauration*, exh. cat. (Lille: Musée des beaux-arts, 1988), pp. 52–63.
15. See, in particular, "Salle de spectacle des Tuileries / Année 1810 / Décoration pour le Service du Théâtre," A.N., O² 33-344.
16. *Appointements. Dépenses concernant les spectacles, les bibliothèques, la garde-robe, le service de santé*, A.N., O² 33; this series covers the period from 1806 to 1815. See also the series O² 37 (Grand Chamberlain) teeming with information relative to the imperial theatres. The artists working under Isabey included Moench, Matis, Desroches, Protain, Daguerre, Boquet, Lemaire, Ciceri and Lébé-Gigun: A.N., AJ13 63.
17. Branda 2011, pp. 190 and 196.
18. Several of these plays were produced to mark Napoleon's marriage to Marie-Louise in April 1810. See Bapst 1893, p. 525.
19. Five set-design plans, three destined for *Amours d'Antoine et Cléopâtre* and two for *L'Enfant prodigue*, are in portefeuille no. 10, dossier de la bibliothèque de l'Opéra (BMO, Esq. 19/18; 19/19; 19/20; 19/14; 19/15).
20. Hubert Damisch, *L'origine de la perspective* (Paris: Flammarion, 1987), pp. 219–220.
21. See the inventory after the death of Justine de Salienne Isabey, A.N., Minutier central ET- CXV – 1235, March 11, 1829, p. 4.
22. The historical costume that was not yet a trend about 1760 became standard after 1789. See Mark Ledbury and Olivia Voisin, "De l'étoffe au costume. Rêves et réalités au XVIIIe siècle," in *L'art du costume à la Comédie-Française* (Paris: Bleu autour; Centre national du costume de scène, 2011), pp. 18–32.
23. Catherine Join-Diéterle, *Les décors de scène de l'Opéra de Paris à l'époque romantique* (Paris: Picard, 1988), p. 204. See also Anne Surgers, *Scénographie du théâtre occidental* (Paris: Armand Colin, 2007), pp. 169–173; A. Ch. Gruber, "La scénographie française à la fin du XVIIIe siècle et l'influence de l'Italie," *Bollettino del Centro internazionale di studi di architettura A. Palladio*, 1975, no. 17, pp. 56–70; Barry Daniels, *Le décor de théâtre à l'époque romantique. Catalogue raisonné des décors de la Comédie-Française, 1799-1848* (Paris: Bibliothèque nationale de France, 2003); Mathias Auclair, "Les décors de scène à l'Opéra de Paris de 1810 à 1873," in *De la scène au tableau*, exh. cat., eds. Guy Cogeval and Beatrice Avanzi (Paris: Skira Flammarion, 2009), p. 215.
24. Vivant Denon, *Voyage dans la Basse et la Haute Égypte pendant les campagnes du général Bonaparte*, 2 vols. (Paris: P. Didot l'aîné, 1802).
25. See the *Mercure de France* of September 22, 1810 (on the subject of *Bayadères*) and the *Journal de l'Empire* of January 26, 1813 (on the subject of the Prodigal Son).
26. David Chaillon, "La politique sur la scène : histoire des œuvres crées à l'Académie impériale de musique de 1810 à 1815," doctoral thesis, Université Paris-Sorbonne, 2001, vol. 2, p. 345.
27. On these estimates is the Archives nationales, see the series O² 33, O² 34, O² 37 and O² 51, 57 and 58.

28. See the artist file on Jean-Baptiste Isabey, "Observations sur l'organisation projetée de l'atelier de peinture aux Menus-Plaisirs," January 26, 1812, BMO.

29. On Ciceri, see Catherine Join-Diéterle, "Ciceri et la décoration théâtrale à l'Opéra de Paris pendant la première moitié du XIXᵉ siècle," in Victor Louis et le théâtre (Paris: Éd. du CNRS, 1982), pp. 141-142.

30. Picard to Talleyrand, February 25, 1815, cited in Eva Basily-Callimaki, J.-B. Isabey, sa vie, son temps, 1767-1855, suivi du catalogue de l'œuvre gravée par et d'après Isabey (Paris: Frazier-Soye, 1909), p. 215, and letter from Picard to Isabey, August 21, 1815, Jean-Baptiste Isabey artist's file, BMO.

31. Letter from Papillon de la Ferté, cited in Join-Diéterle 1988, p. 168.

32. A.N., O3 1639. On Isabey's Bonapartism under the Restoration, see Cyril Lécosse, "Le 'Roi de Rome poussé par la France' : Isabey, Latouche et le bonapartisme libéral sous la Restauration," Annales Benjamin Constant, Art et libéralisme en France (1814-1830). La contestation par l'image, no. 41 (Paris: H. Champion; Geneva, Slatkine, 2016), pp. 31-45.

33. Nicole Wild, Décors et costume du XIXᵉ siècle, vol. 1: Opéra de Paris (Paris: Bibliothèque nationale de France, 1987), p. 320.

34. These are estimated at 300 francs in the inventory made after the death of Justine de Salienne Isabey (cited note 21), no. 180.

The Empress Josephine's Household after the Divorce
Bernard Chevallier

1. Napoléon, lettres d'amour à Joséphine, presented by Jean Tulard (Paris: Fayard, 1981), letter 245, p. 375.

2. Ibid., letter 251, p. 381.

3. Ibid., letter 242, p. 371.

4. Général Bertrand (Louis-Gatien Bertrand), Cahiers de Sainte-Hélène, 1816-1817 (Paris: Sulliver, 1951), p. 308.

5. B.N.F., Manuscrits, Français 6593.

6. Louis-Mathias de Barral (1746-1816), comte de l'Empire (1808) and archbishop of Tours (1804).

7. Françoise-Claude de Stolberg-Gedern (1756-1836) was a second cousin to the queen dowager of Prussia and had married Nicolas-Antoine, count of Arberg and Valengin.

8. Claire-Élisabeth-Jeanne Gravier de Vergennes (1780-1821) had married Augustin-Laurent, comte de Rémusat. Appointed a lady-in-waiting as of 1802, she was the great niece of minister Vergennes.

9. Aglaé-Louise Auguié (1782-1854), wife of marshal Ney, was the niece of Mme Campan.

10. Louise-Charlotte-Élisabeth-Marie Rigaud de Vaudreuil (1770-1831), wife of Antoine-Joseph-Philippe Walsh, comte de Serrant.

11. Agathe-Sophie Peyrac (1759-1829), wife of Eugène-François-Thérèse-Fabien de Lalaing, vicomte d'Audenarde.

12. Annette-Caroline-Antoinette de Lasteyrie du Saillant (1780-1867), wife of the Empress' chamberlain.

13. Claire-Élisabeth-Joséphine-Françoise-Agathe de Brignac de Montarnal (1781-1866), wife of Henry-Amédée-Mercure, comte de Turenne, the master of the wardrobe to the Emperor.

14. Marie-Geneviève-Joséphine Canclaux (1785-1849), wife of Auguste-François-Marie, baron de Colbert.

15. Marie-Félicité-Henriette d'Aguesseau (1778-1847), wife of Octave-Gabriel-Henry, comte de Ségur.

16. Gertrude-Charlotte-Marguerite de Lastic-Sieujac (1785-1868) married her cousin the comte de Lastic, chamberlain to the Empress.

17. Annette de Mackau (1790-1870), wife of Pierre Wattier, comte de Saint-Alphonse. She had been a lady of honour to Stephanie of Baden.

18. Lancelot-Théodore Turpin de Crissé, baron of the Empire (1782-1859).

19. Charles de Salviac, baron de Vieil-Castel (1766-1821), who was married to a lady-in-waiting.

20. Louis-Désiré, comte de Montholon (1785-1863), brother of Napoleon's companion in captivity on Saint Helena.

21. André de la Bonninière, baron de Beaumont (1761-1838).

22. Pierre-Annet-Joseph, comte de Lastic-Vigouroux (1772-1866), who has married to a lady-in-waiting.

23. Honoré V Grimaldi, prince of Monaco from 1819 until his death (1778-1841), made baron of the Empire in 1810.

24. Hardouin-Gustave, baron d'Andlau (1787-1850).

25. Jules-Henri-Charles-Frédéric, comte de Pourtalès (1779-1861).

26. Guy-Jacques-Victor-Marie-Eugène-Pierre-Vincent de Paul de Chaumont-Quitry (1787-1851); in 1827, he married Stéphanie de Tascher de la Pagerie, second cousin to the Empress.

27. Jean-Marie Deschamps (about 1750-1820), playwright.

28. Carlotta Brentano Cimaroli (1789-1827), mistress to Napoleon, in 1804 married Carlo-Francesco Gazzani, whom the Emperor made receiver general of Eure.

29. Louis Pierlot (1768-1826) was manager of the Banque de France from 1806 to 1812.

30. Casimir-Marie-Victor Guyon, comte de Montlivault (1770-1846); he rallied behind Louis XVIII in 1815 and built a career as a prefect in the Vosges, Isère and Calvados.

31. Album at the Musée de Malmaison, MM 40.47.236.

32. Impératrice Joséphine, correspondance, 1782-1814, eds. Bernard Chevallier, Maurice Catinat and Christophe Pincemaille (Paris: Payot, 1996), letter 420, pp. 298-299.

33. Napoléon, lettres d'amour à Joséphine 1981, letter 266, p. 397.

34. Impératrice Joséphine, correspondance 1996, letter 434, p. 309.

Stendhal in the Employ of the Imperial Household
Daniela Gallo

1. A.N., AF IV 474 plaquette 3601, no. 2, cited by Elaine Williamson, introduction to Stendhal et la Hollande. Correspondance administrative inédite, 1810-1812 (London: Institute of Romance Studies, University of London School of Advanced Study, 1996), p. XVII. See also Ferdinand Boyer, "Stendhal inspecteur du mobilier de la Couronne (1810-1814)," Le Divan (April 1942), p. 151.

2. Letter from Pierre Daru to Hugues-Besnard Maret, duke of Bassano, Amsterdam, August 1, 1810, cited by Boyer 1942, and Williamson 1996, pp. XV-XVI. See also Elaine Williamson, "Denon et Stendhal," in Dominique-Vivant Denon. L'œil de Napoléon, exh. cat., ed. Marie-Anne Dupuy (Paris: Musée du Louvre; Réunion des musées nationaux, 1999), p. 134; and Daniela Gallo, "Arts et lettres. Le regard de l'épistolier," in Lire la correspondance de Stendhal, colloquium proceedings (University of London Institute in Paris, December 15-16, 2006), eds. Martine Reid and Elaine Williamson (Paris: Honoré Champion, 2007), pp. 129-144.

3. Letter from Henri Beyle to his sister Pauline Périer-Lagrange, Meudon, September 19, 1810, in Stendhal, Correspondance générale, vol. II (1810-16), eds. Vittorio Del Litto, Elaine Williamson, Jacques Hubert and Michel E. Slatkine (Paris: Honoré Champion, 1998), p. 65.

4. See Elaine Williamson, "Stendhal inspecteur du mobilier de la Couronne : administrateur ou artiste ? (Lettres et documents inédits)," Stendhal Club, no. 128 (July 15, 1990), pp. 337-364; no. 129 (October 15, 1990), pp. 49-71; and no. 130 (January 15, 1991), pp. 115-133. See also Tatiana Aucler, "La rédaction de l'Inventaire Napoléon," in Les Antiques du musée Napoléon. Édition illustrée et commentée des volumes V et VI de l'Inventaire du Louvre de 1810, ed. Jean-Luc Martinez (Paris: Réunion des musées nationaux, 2004), pp. 9-11; Daniela Gallo, "The Galerie des Antiques of the Musée Napoléon: A New Perception of Ancient Sculpture?," in Napoleon's Legacy: The Rise of National Museums in Europe, 1794-1830, eds. Ellinoor Bergvelt, Debora J. Meijers, Lieske Tibbe and Eva van Wezel (Berlin: Staatliche Museen zu Berlin-Stiftung Preußischer Kulturbesitz; G+H Verlag, 2009), series Berliner Schriftenreihe zur Museumsforschung, vol. 27, pp. 111-123; and Bénédicte Savoy, "'Invaluable Masterpieces': The Price of Art at the Musée Napoléon," Journal for Art Market Studies, vol.1, no. 1 (2017) (https://www.fokum-jams.org/index.php/jams/article/view/4, accessed February 21, 2017).

5. Letter from Comte Daru to Stendhal, Paris, November 22, 1810, in Stendhal, Correspondance générale, vol. II (1810-16), p. 91. In Mousseaux (now Monceau), Napoleon planned to transform the very recent pavilion by Pierre-Nicolas Bénard (?-1817) into "a small summer cottage for the Children of France, where they could stay a few days during their Parisian residence and enjoy the fresh air": Pierre-François-Léonard Fontaine, Journal 1799-1853, vol. I (1799-1824) (Paris: École nationale supérieure des Beaux-Arts; Société de l'Histoire de l'Art français, 1987), p. 271 (December 29, 1810).

6. See, in particular, Stendhal, Correspondance générale, vol. II (1810-16), pp. 271-272. Noël Daru (1729-1804), father of Pierre and Martial, was first cousin to Dr. Henri Gagnon (1728-1813), Stendhal's maternal grandfather.

7. See Stendhal, Correspondance générale, vol. II (1810-16), p. 73, Dominique-Vivant Denon to Pierre Daru, Paris, October 17, 1810, and vol. I (1800-9), 1997, p. 839.

8. Ibid., vol. II, pp. 75-76.

9. Ibid.

10. Ibid., pp. 96-97. In the final version, the columns increased from seven to ten, because, after arriving at the museum and realizing, with Denon, the variety of works to be housed, he decided to identify the school to which the author of the work belonged, to mention the origins of the object and to remove the dimensions of the frame, to add instead an appraisal of the work and its support–frame or pedestal–and its current placement. Daru requested that the exact information regarding the acquisition and installation of the objects in the museum be provided; however, as this information was redundant and problematic, his request was not honoured. See Aucler 2004, p. 10.

11. Williamson, "Stendhal inspecteur du mobilier de la Couronne," 1996, no. 128, pp. 354-356.

12. See Fernando Montes de Oca, L'Âge d'or du verre en France, 1800-1830. Verreries de l'Empire et de la Restauration (Paris: F.M., 2001), pp. 29-44.

13. Sullau, "Observation générale," Paris, December 28, 1810, in Stendhal, Correspondance générale, vol. II (1810-16), p. 119. On this subject, see "Visa" written by Stendhal about January 7-16, 1811 (ibid., p. 127). At Malmaison, pieces that belonged to Hortense and the wife of Eugène de Beauharnais are preserved, while the Château de Fontainebleau still houses the twenty-four-light chandelier (inv. F 3406), which was put in the Emperor's small bedchamber on September 15, 1812. But one of the manufactory's masterpieces is the Greek-style ewer from the Montes de Oca collection, engraved with a scene inspired by the Odyssey, depicting the moment Penelope recognizes Ulysses. See Jean-Pierre Samoyault, Pendules et bronzes d'ameublement entrés sous le Premier Empire (Paris: Réunion des musées nationaux, 1989), pp. 108-109, no. 75, and Montes de Oca 2001, pp. 168-170, no. 141.

14. Sullau 1810, p. 119.

15. See Williamson, "Stendhal inspecteur du mobilier de la Couronne," 1996, no. 128, pp. 345, 347, 349-351.

16. Ibid., no. 129, pp. 49-50.

17. Ibid., no. 128, pp. 357-360.

18. Ibid., no. 129, pp. 53-54. The question was raised again at the end of June (ibid., pp. 54-55).

19. Ibid., no. 129, pp. 56-60. On this globe (1.37 x 1.56 m), at the Tuileries until 1829 and moved to Château de Fontainebleau (inv. F 717 C) in 1861, see François Labourie and Daniel Nordman, "Leçons de géographie de Buache et Mentelle. Introduction," in L'École normale de l'an III, vol. 2: Leçons d'histoire, de géographie, d'économie politique. Volney. Buache de La Neuville, Mentelle, Vandermonde, ed. Daniel Nordman (Paris: Éditions Rue d'Ulm; Dunod, 1994), p. 152. I would like to thank Christophe Beyeler for providing this invaluable information.

20. Williamson, "Stendhal inspecteur du mobilier de la Couronne," 1996, no. 129, pp. 67-69. Produced after a model by Charles-Auguste Taunay from 1805–inspired, at Denon's suggestion, by a painting of Herculanum found at Malmaison since 1802–the Urania clock in hard-paste biscuit, wood and gilded bronze, is still part of the collections of the Musée national du château de Fontainebleau (inv. F538C), which it entered on August 27, 1810, as well as the one with the Three Graces encircling the shaft and bearing on their heads a glass globe containing the turning movement (inv. F4040). The latter, conserved in the petits appartements, was produced for the Empress in 1809. In August 1810, it was placed in the third salon of the prince's apartment, no. 1 on the first floor of the new wing of the Cheval Blanc Courtyard, while the Urania clock was destined for the corresponding salon of the prince's apartment, no. 2 on the second floor. The Three Graces model was produced by Chaudet. See Samoyault 1989, pp. 15, 20, 63, nos. 24 and 64, no. 25; Tamara Préaud, "Denon et la Manufacture impériale de Sèvres," in Dominique-Vivant Denon. L'œil de Napoléon, 1999, p. 296; and Fabio

Benedettucci, "Nel segno di Urania. Vicende, modelli e fortune di una pendola napoleonica," in Le ore dell'imperatore. La Pendola Urania del Museo Napoleonico. Studi, incontri e restauro, ed. Fabio Benedettucci (Rome: Gangemi, 2015), pp. 17-26. More generally, on the subject of the renovation of the Château de Fontainebleau under the First Empire, see Vincent Cochet, "Les Petits Appartements de l'Empereur et de l'Impératrice," in "La vraie demeure des rois, la maison des siècles," Fontainebleau (Paris: Swann; Château de Fontainebleau, 2015), pp. 269-345.

21. Williamson, "Stendhal inspecteur du mobilier de la Couronne," 1996, no. 130, p. 118.

22. See first and foremost Stendhal et la Hollande 1996.

23. Williamson, introduction to Stendhal et la Hollande, 1996, p. XXIX.

24. Stendhal, Correspondance générale, vol. II, pp. 212-213.

25. Williamson, introduction to Stendhal et la Hollande, 1996, p. XXX.

26. Ibid., p. XXXVII.

27. See, for example, Stendhal, Correspondance générale, vol. II (1810-16), p. 245.

28. Letter from Stendhal to Pauline Périer-Lagrange, October 2, 1811 (ibid., p. 237).

29. Letter from Stendhal to same, October 29, 1811 (ibid., p. 241).

30. Draft of a letter addressed to "the newspapers" and dated, according to his diary, on October 31, 1811 (ibid., p. 244). See Daniela Gallo, "La leçon de l'antique," L'Année Stendhalienne, no. 6, 2007, pp. 9-24, and Gallo 2006; Pascal Griener, "Stendhal historien de l'art 'inactuel' après l'Empire. L'Histoire de la peinture en Italie de 1817 et son contexte historiographique," in Stendhal, historien de l'art, ed. Daniela Gallo (Presses universitaires de Rennes, 2012), pp. 15-29, and in the same publication: D. Gallo, "Des manuels sur l'art et des guides pour un nouveau public," pp. 31-42; See also, Charlotte Guichard, "Le Cours de cinquante heures : du manuel d'amateur aux Happy Few," pp. 59-70; and Barbara Steindl, "Quelques considérations en marge du Cours de cinquante heures," pp. 71-77.

V. EPILOGUE

1814
Sylvain Cordier

1. Pierre Branda, Napoléon et ses hommes. La Maison de l'Empereur, 1804-1815 (Paris: Fayard, 2011), p. 16.

2. Charles-Éloi Vial, Les derniers feux de la monarchie. La cour au siècle des révolutions, 1789-1870 (Paris: Perrin, 2016), p. 234.

3. Branda 2011, p. 453.

4. Ibid.

5. Ibid., p. 71.

6. Ibid.

7. Ibid., p. 79.

8. Ibid., p. 84.

9. Ibid., pp. 455-456.

10. Ibid., pp. 457-458.

11. Ibid., p. 148.

12. Ibid., p. 109.

13. Ibid., pp. 110-111.

14. This illegitimate son of Napoleon would be, between 1855 and 1863, the minister of foreign affairs and secretary of state for his cousin, Napoleon III.

15. Branda 2011, pp. 185-186.

16. Vial 2016, pp. 247-248.

17. Testu, "Avis des éditeurs," in Almanach royal, pour les années M. DCCC. XIV et M. DCCC. X (Paris: Testu, 1814), n. p.

18. Colombe Samoyault-Verlet, "L'ameublement des châteaux royaux à l'époque de la Restauration," in Un âge d'or des arts décoratifs, 1814-1848, exh. cat. (Paris: Réunion des musées nationaux, 1991), p. 42.

19. Waddesdon Manor, Rothschild Collection.

20. Christian Baulez, "Versailles à l'encan," in Versailles, deux siècles d'histoire de l'art (Versailles: Société des amis de Versailles, 2007), p. 96.

21. Chantal Gastinel-Coural, "Salle du Trône du château des Tuileries," in Un âge d'or des arts décoratifs, 1991, p. 76.

22. Sylvain Cordier, "Deux projets pour le fauteuil du trône de Louis XVIII par Dugourc et Saint-Ange," Revue de l'art, 2008, 2nd trim., pp. 59-72.

23. Général Marquis de Bonneval, Mémoires anecdotiques (Paris: Plon-Nourrit, 1900), p. 141.

Saint Helena Island and the Remnants of Imperial Dignity
Émilie Robbe

1. This was how Napoleon was described in the declaration signed by the powers assembled at the Congress of Vienna on March 13, 1815.
2. Hudson Lowe assumed his duties on April 14, 1816; Rear-Admiral Sir George Cockburn, commander of the Saint Helena squadron filled in in the interim.
3. The term is Pierre Branda's *Napoléon et ses hommes. La Maison de l'Empereur, 1814-1815* (Paris: Fayard, 2011), p. 16.
4. Once again, Pierre Branda is the source of this expression, this time from *Les secrets de Napoléon* (Paris: La Librairie Vuibert, 2014), p. 10.
5. *Mémoires de Marchand, premier valet de chambre et exécuteur testamentaire de l'empereur Napoléon* (Paris: Taillandier, 2003), p. 287.
6. Ibid., p. 292.
7. Gaspard Gourgaud, *Journal de Sainte-Hélène, 1815-1818*, ed. Octave Aubry (Paris: Flammarion, 1947), 2 vols. "Le Règlement du service à Sainte-Hélène" has been transcribed in the appendices.
8. On the members of the Household in exile and the details of daily life, see, in particular, *Napoléon à Sainte-Hélène. La conquête de la mémoire*, exh. cat. (Paris: Gallimard; Musée de l'Armée, 2016): Pierre Branda, "La Maison de l'Empereur à Sainte-Hélène," pp. 38-42; Thierry Lentz, "Décor et acteurs : le 'drame' de Sainte-Hélène," pp. 43-48; and Bernard Chevallier, "Les témoins silencieux de l'exil," pp. 98-102.
9. On this subject, see Luigi Mascilli-Migliorini, "Le temps perdu de Sainte-Hélène," in *Napoléon à Sainte-Hélène*, 2016, pp. 83-89.
10. Gourgaud 1947, November 18, 1816.
11. Ibid., Friday, May 10, 1816.
12. Ibid., Wednesday 17 [April 1816].
13. *Mémoires de Marchand*, 2003, pp. 464-465.
14. Branda 2011, p. 17.
15. Barry O'Meara, *Napoleon in Exile or a Voice From Saint Helena* (London: W. Simpkin and R. Marshall, 1822).
16. The expression comes from Heinrich Heine (*Das Buch Legrand*, 1827).

The Birdcage at Saint Helena
Michèle Naturel and Laura Vigo

1. Mameluke Ali (Louis-Etienne Saint-Denis), *Souvenirs sur l'empereur Napoléon*, presented by Christophe Bourachot (Paris: Arléa, 2000), p. 186.
2. Général Bertrand (Louis-Gatien Bertrand), *Cahiers de Sainte-Hélène. Journal 1818-1819* (Paris: Éditions Albin Michel, 1959) p. 511.
3. Mameluke Ali (Louis-Etienne Saint-Denis), *Souvenirs sur l'empereur Napoléon* (Paris: Payot, 1926), pp. 199-200.
4. Michel Dancoisne-Martineau, *Chroniques de Sainte-Hélène : Atlantique sud* (Paris: Perrin, 2011), pp. 250-258.
5. Mameluke Ali 1926, pp. 209, 199-200.
6. Some of the vertical cartouches have traced letters: on the left, "ZC" and "ZA," and on the right, "PA" and "IA."
7. Musée de Châteauroux, inv. 347.1.
8. Jacques Macé, *Dictionnaire historique de Sainte-Hélène* (Paris: Tallandier, 2011), p. 451.
9. Henry Ratouis de Limay, "Les souvenirs de Napoléon Ier du maréchal Bertrand et de sa famille," *Revue du Berry et du Centre* (October 1921), p. 75.

**Imperial Illusions:
Two Young Princesses in Exile, by David**
Cyril Lécosse

1. National Gallery of Ireland, Dublin.
2. Regarding the various versions of this portraits, see the entry on the work in *Peintre des rois, roi des peintres : François Gérard portraitiste* by Xavier Salmon (Paris: Réunion des musées nationaux, 2014), no. 29, p. 116.
3. Several letters addressed to David from Charlotte and Joseph Bonaparte attest to the close relationship between the painter and Napoleon's brother during the Restoration. See *Jacques-Louis David, 1748-1825*, exh. cat., eds. Antoine Schnapper and Arlette Sérallaz (Paris: Réunion des musées nationaux, 1989), no. 231, p. 532.
4. The two other versions that have been identified include the one at the Museo Napoleonico in Rome (former Primoli Collection), and the one at the Musée d'art de Toulon (1822). See

Philippe Bordes, *Jacques-Louis David: Empire to Exile* (New Haven; London: Yale University Press, 2005), pp. 319-323.
5. Dorothy Johnson, "L'expérience de l'exil," in *David contre David*, colloquim proceedings, Musée du Louvre, 1989, ed. Régis Michel (Paris: La Documentation française, 1993), vol. II, pp. 1027-1029. See also, by the same author, *Jacques-Louis David: The Farewell of Telemachus and Eucharis* (Los Angeles: Getty Museum Studies on Art, 1997), pp. 31-37.
6. See *Jacques-Louis David* 1989.
7. On this point, see Cyril Lécosse and Guillaume Poisson, eds., *Art et libéralisme. La contestation par l'image 1814-1830*, Lausanne, Institute Benjamin Constant (Geneva: Éditions Slatkine, 2016), pp. 7-11.
8. Jean-Baptiste Duvergier, *Collection complète des lois, décrets, ordonnances, règlements, avis du Conseil d'État* (Paris: A. Guyot, 1836), vol. XIX, p. 107 (*Loi relative à la répression des cris séditieux et des provocations à la révolte*).
9. Bordes 2005.

Napoleon on His Deathbed
Sylvain Cordier

1. Alexander Meyrick Broadley, "The Knowledge of the Dead Napoleon," *Knowledge: A Monthly Record of Science*, vol. 35 (1912), pp. 97-100.
2. George Leo de St. M. Watson, *The Story of Napoleon's Death-Mask: Told from Original Documents* (London; New York: John Lane, 1915), p. 137.

LIST OF ILLUSTRATIONS

24. MRKF
Workshop of Jacques-Louis
DAVID (1748–1825)
*Study for the Coronation
of Napoleon: Bust-length
Portrait of the Comtesse de La
Rochefoucauld, Lady of Honour
to the Empress, and the Hand
of Eugène de Beauharnais*
About 1805-7
Oil on canvas
55.5 x 46 cm
Montpellier Méditerranée
Métropole, Musée Fabre
Inv. 876.27

25.
ANONYMOUS
*Portrait of the Baron Adrien
de Mesgrigny in the Costume
of an Equerry of the Imperial
Household*
Ill. in *Carnet de la sabretache :
revue militaire rétrospective*,
no. 216, December 1910, p. 753
Paris, Bibliothèque des arts
décoratifs
Collection Maciet 174/2/90

26. F
Workshop of Augustin-François-
André PICOT (1756–1822)
1804
Gouache
A. Design for the embroidery
on the mantle of a Grand
Master of Ceremonies
23.3 x 26.7 cm
B. Design for the embroidery
on the jacket of a Chamberlain
20.3 x 19 cm
C. Design for the embroidery
on the jacket of the assistants
of Ceremonies
20 x 19.5 cm
Pierrefitte-sur-Seine, Archives
nationales
Inv. AF IV 1220, dossier 1, pièces
12, 11, 13

27.
Charles MEYNIER
Paris 1763 – Paris 1832
*Portrait of Joseph Fesch, Prince
of France, Grand Chaplain, in
the Costume of a Cardinal*
1806
Oil on canvas
219 x 149 cm
Musée national des châteaux de
Versailles et de Trianon
Inv. MV4715

28.
Hyacinthe RIGAUD
Perpignan 1659 – Paris 1743
*Portrait of Jacques-Bénigne
Bossuet, Bishop of Meaux*
1702
Oil on canvas
240 x 165 cm
Paris, Musée du Louvre
Inv. 7506

29.
ANONYMOUS, ROMAN (?), circle of
Jean-Baptiste WICAR (1762–1834)
*Portrait of Cardinal Joseph
Fesch*
After 1808
Oil on canvas
200 x 148 cm
Château de Fontainebleau,
Musée Napoléon Ier
Inv. N3102

30. MRK
ANONYMOUS (initialled SCF)
*Portrait of Henri-Gatien, Comte
Bertrand, Future Grand Marshal
of the Palace, at the Age of
Thirty-five*
1808
Pastel
43.5 x 32.5 cm
Châteauroux, Musée-hôtel
Bertrand
Don Boisrémond, 1951
Inv. 51.2.1

31. MRKF
Antoine-Jean GROS
Paris 1771 – Meudon 1835
*Portrait of Géraud-Christophe-
Michel Duroc, Duke of Friuli,
in the Costume of a Grand
Marshal of the Palace*
1801-5
Oil on canvas
204 x 137 cm
Nancy, Musée des Beaux-Arts
Inv. MV 207

32. MRKF
ANONYMOUS, possibly Marie-
Guillemine BENOIST (1768–1826)
*Portrait of Louis-Philippe de
Ségur, Comte of the Empire,
in the Costume of a Grand
Marshal of Ceremonies*
1806 (?)
Oil on canvas
92.5 x 74.4 cm
Musée national des châteaux de
Versailles et de Trianon
Inv. MV 5963

33. MF
Pierre-Paul PRUD'HON
Cluny 1758 – Paris 1823
*Portrait of Charles-Maurice de
Talleyrand-Périgord, Prince of
Benevento, in the Costume of a
Grand Chamberlain*
1807
Oil on canvas
212 x 138 cm
Paris, Musée Carnavalet
Inv. P1065

34.
Robert LEFÈVRE
Bayeux 1755 – Paris 1830
*Portrait of Anne-
Élisabeth-Pierre de
Montesquiou-Fezensac, Comte
of the Empire, in the Costume
of a Grand Chamberlain*
1810
Oil on canvas
Dimensions unknown
Whereabouts unkown

35.
Jean-Baptiste ISABEY
Nancy 1767 – Paris 1855
*Marie-Louise Visiting the
Duchess of Montebello, Taken
to Her Bed, in the Company
of the Baron Corvisart, First
Physician*
About 1811
Watercolour
42 x 36.4 x 5.3 cm
Parma, Museo Glauco Lombardi
Inv. 44

36.
Jean-Charles PERRIN
Paris 1754 – Paris 1831
*Portrait of Jean Lannes, Duke
of Montebello, Marshal of
France, in the Uniform of a
Colonel of the Hussars*
Between 1805-10
Oil on canvas
215 x 140 cm
Musée national des châteaux de
Versailles et de Trianon
Inv. MV1133

37. MRK
François-Pascal-Simon GÉRARD
Rome, 1770 – Paris, 1837
*Portrait of Louise-
Antoinette-Scholastique de
Guénéheuc-Lannes, Duchess of
Montebello, with Her Children*
1814
Oil on canvas
260 x 183 cm
Houston, Museum of Fine Arts
Museum purchase funded
by the Brown Foundation,
Accessions Endowment Fund
and the Alice Pratt Brown
Museum Fund
Inv. 2007.1202

38.
Attributed to
Jean-Baptiste ISABEY
Nancy 1767 – Paris 1855
After Féréol BONNEMAISON
(1767–1827)
*Bust-length Portrait of Armand
de Caulaincourt, in the
Costume of a Grand Equerry*
About 1810
Crayon
20 x 30 cm (approx.)
Private collection

39.
Ferréol BONNEMAISON
Montpellier about 1770 – Paris
1827
*Portrait of Armand de
Caulaincourt, Duke of Vicenza,
in the Costume of a Grand
Equerry*
1806
Oil on canvas
200 x 120 cm (approx.)
Private collection

40.
Jacques-Augustin-Catherine
PAJOU
Paris 1766 – Paris 1828
*Portrait of Louis-Alexandre
Berthier, Prince of Neufchâtel,
Valengin and Wagram, in the
Costume of a Grand Master of
the Hunt*
1808
Oil on canvas
215 x 133 cm
Musée national des châteaux de
Versailles et de Trianon
Inv. MV 1113

41. MRKF
Andrea APPIANI
Milan 1754 – Milan 1817
*Bust-length Portrait of Louis-
Alexandre Berthier in the
Costume of a Grand Master of
the Hunt*
After 1807
Oil on canvas
75 x 60 cm
Château de Fontainebleau,
Musée Napoléon Ier
Inv. F 2009.5

42.
Théodore-Auguste ROUSSEAU
Saumur 1822 – Havana 1857
After Antoine ANSIAUX
(1764–1840)
*Portrait of Jean-Baptiste de
Nompère de Champagny, Duke
of Cadore, Intendant-General
of the Imperial Household, in
the Costume of a Minister*
1853
Oil on canvas
216 x 139 cm
Musée national des châteaux de
Versailles et de Trianon
Inv. MV4721

43. MRKF
Antoine-Jean GROS
Paris 1771 – Meudon 1835
*Portrait of Pierre-Antoine-
Noël-Bruno Daru, Comte of the
Empire, Former Intendant of
the Imperial Household, in the
Costume of a Secretary of State*
1813
Oil on canvas
215 x 142 cm
Paris, Musée de l'Armée
Dépôt de la famille Daru, 2006
Inv. 4747 DEP

44.
Charles PERCIER
Paris 1764 – Paris 1838
Pierre-François-Léonard
FONTAINE
Pontoise 1762 – Paris 1853
*Civil Wedding Ceremony of
Emperor Napoleon and Marie-
Louise of Austria in the Galerie
at Saint-Cloud*
1810
Watercolour
52.7 x 40.4 cm
Paris, Musée du Louvre
Inv. RF41482

45.
Charles PERCIER
Paris 1764 – Paris 1838
Pierre-François-Léonard
FONTAINE
Pontoise 1762 – Paris 1853
*The Emperor and Empress
Receiving Tributes from all
Bodies of State on Their
Wedding Day, in the Throne
Room at the Tuileries*
1810
Watercolour
28 x 26 cm
Paris, Musée du Louvre
Inv. RF 41492-24

46.
Antoine-Ignace MELLING
Karlsruhe 1763 – Paris 1831
*The Palais des Tuileries in
Restoration Times*
1815 (?)
Graphite, gouache, white
highlights
61 x 95.5 cm
Paris, Musée du Louvre
Inv. INV30965-recto

47.
Étienne ALLEGRAIN
Paris 1644 – Paris 1736
*Bird's Eye View of the Château,
Lower Gardens and Town of
Saint-Cloud (detail)*
About 1675
Oil on canvas
300 x 383 cm
Musée national des châteaux de
Versailles et de Trianon
Inv. MV743

48.
Pierre-Paul PRUD'HON
Cluny 1758 – Paris 1823
*Wisdom and Truth Descending
to Earth to Dispel the Darkness
That Covers It*
About 1799
Oil on canvas
355 x 320 cm
Paris, Musée du Louvre
Inv.7341

49.
Attributed to Louis-Martin
BERTHAULT
Paris 1770 – Tours 1823
*General Elevation of the
Facade of Château de
Compiègne*
About 1813
Ink, wash
86.3 x 21.3 cm
Musée national du château
de Compiègne
Inv. C2005-003

50.
*View of the Empress'
Bedchamber at the Palais de
Compiègne in its current state*

51.
Auguste GARNERAY
Paris 1785 – Paris 1824
*View of Malmaison: Facade of
the Château on the Park Side*
Between 1812 and 1823
Watercolour
16.3 x 24.3 cm
Rueil-Malmaison, Musée national
des châteaux de Malmaison et
Bois-Préau
Inv. M.M.40.47.7150

52.
Antoine-Charles-Horace, called
Carle VERNET
Bordeaux 1758 – Paris 1836
Jean-Joseph-Xavier BIDAULD
Carpentras 1758 - Montmorency
1846
*Break of Cover in front of the
Grand Trianon*
1810-11
Oil on canvas
210 x 95 cm
Paris, Musée Marmottan Monet
Inv. 1067

53.
SÈVRES IMPERIAL MANUFACTORY
Plate "Château du Petit
Trianon"
About 1825-30
Hard-paste porcelain
Diam. 24 cm
Private collection
Inv. 4º R A 007

54.
Jean-Thomas THIBAULT
Montier-en-Der 1757 – Paris 1826
*View of the Palazzo del
Quirinale (Monte Cavallo),
Rome*
Between 1786 and 1790
Graphite, brown ink, blue and
brown wash
9.9 x 16.7 cm
Paris, Musée du Louvre
Inv. RF14406-recto

55.
ANONYMOUS, FRANCE
*View of the Courtyard of the
Palazzo Pitti, Florence*
Early 19th c.
Ink, wash, white highlights
14.5 x 26 cm
Paris, Musée du Louvre
Inv. REC120-recto

56.
Antoine-Pierre MONGIN
Paris 1761 – Versailles 1827
*Napoleon's Bivouac near the
Château d'Ebersberg, May 4,
1809 (detail)*
1810
Oil on canvas
135 x 203 cm
Musée national des châteaux de
Versailles et de Trianon
Inv. MV1563

57.
DEPARTMENT OF THE GRAND
MARSHAL OF THE PALACE
*Annotated plan of the Château
de Querqueville for the
Emperor's stay*
1802-14
Ink, watercolour
82.3 x 64 cm
Paris, Bibliothèque nationale
de France
Inv. FR 6585, fol. 105

58.
Pierre-François-Léonard
FONTAINE
Pontoise 1762 – Paris 1853
*Proposed Design for the Grand
Projet to Reconstruct the
Palais de Versailles, Side of the
Entrance Courtyards*
About 1811-13
Ink, wash over traces of pencil,
watercolour highlights
32.5 x 91.6 cm
Musée national des châteaux de
Versailles et de Trianon
Inv. DESS 1258

59.
Attributed to Jacques GONDOUIN
Saint-Ouen 1737 – Paris 1818
*Designs for the Palais de
Versailles*
1810
Watercolours bound in an
Italian-format album
34 x 44 cm
Private collection
A. Second floor, State apartment:
Antechamber–Concert Hall
First floor: Antechamber of the
Ambassadors
B. Second floor, State apartment:
First Salon–Second Salon
First floor: Hall of the
Ambassadors–Dining
Room–Antechamber
C. Second floor, State apartment:
Throne Room–Emperor's Salon
D. Second floor, State apart-
ment: Salon of War
E. Second floor: Ceremonial
Hall–Grande Galerie
First floor: Vestibule
F. Second floor, the Empress'
ordinary apartment:
Guardroom–Hall of Banquets,
Balls and Concerts
G. Second floor, the Empress'
ordinary apartment: First Salon
First floor, the Emperor's
ordinary apartment: First Salon
H. Second floor, the Empress'
ordinary apartment: Second
Salon–Empress' Salon
First floor, the Emperor's
ordinary apartment: Second
Salon–Emperor's Salon
I. Second floor, the Empress'
ordinary apartment: Empress'
Chamber–Salon of Peace
First floor, the Emperor's
ordinary apartment: Emperor's
Chamber–Study

60-62.
Pierre-François-Léonard
FONTAINE
Pontoise 1762 – Paris 1853
*Designs for the King of Rome's
Palace*
60. First version: Sections,
elevations
44.5 x 37.5 cm
61. First version: Bird's eye view
64.2 x 97 cm
62. Second version: Bird's
eye view
40.2 x 58 cm
About 1812
Ink, wash
Paris, École nationale supérieure
des Beaux-Arts
Inv. PC65936-26, -22, -46

63. MRKF
SÈVRES IMPERIAL MANUFACTORY
Tabletop decoration painted by
Jean-François ROBERT (1778–1855)
Table called "of the imperial
palaces," then "of the royal
palaces"
1811–14, altered between 1814
and 1817
Hard-paste porcelain, gilded
bronze
92 x 105.5 x 57 cm
Private collection

64.
SÈVRES IMPERIAL MANUFACTORY
Guéridon table called "of the
Seasons" (tabletop)
1803–6
Hard-paste porcelain, gilded
bronze and patina, yew wood
91 x 98 cm
Château de Fontainebleau,
Musée Napoléon I er
Inv. F669c

65.
SÈVRES IMPERIAL MANUFACTORY
Tabletop decoration painted by
Louis-Bertin PARANT (1766–1851)
and Antoine BÉRANGER
(1785–1867)
Table called "of the Great
Commanders" (tabletop)
1806–12
Hard-paste porcelain, gilded
bronze, wooden core
92.4 x 104 cm
London, Collection of H. M.
Queen Elizabeth II
Inv. RCIN 2634

66.
SÈVRES IMPERIAL MANUFACTORY
Design by Charles PERCIER
(1764–1838)
Tabletop decoration painted by
Jean-Baptiste ISABEY (1767–1855)
Bronze work by Pierre-Philippe
THOMIRE (1751–1843)
Table called of Austerlitz,
or of the Marshals (tabletop)
1808–10
Commissioned in 1806 by the
Emperor
Hard-paste porcelain, gilded
bronze, oak core
H. 90 cm; Diam. of tabletop:
97 cm
Rueil-Malmaison, Musée national
des châteaux de Malmaison et
Bois-Préau
Inv. M.M.40.47.7190

Albums of imperial residences
67–69
Edited by Pierre-François-
Léonard FONTAINE (1762–1853)
Folio albums
About 1811–12
Bindings: red morocco leather
Drawings: ink, watercolour
65.5 x 54.5 cm (Paris)
65.5 x 53 cm (Fontainebleau)
51.5 x.56.5 cm (Trianon)
Paris, Mobilier national
Inv. n° 120 / n° 50 J.G., ED 28,
ED 30

67. MRKF
Paris et dépendances
A. Section of the Tuileries
Second floor: Gallery of Diana
in the State apartment and the
Grand Salon in the Emperor's
ordinary apartment
First floor: Concert hall and
second salon of the Empress'
ordinary apartment
B. Section of the Benevento
mansion, residence of the
Grand Chamberlain (1804–9)
C. Section of the page's
mansion in Paris
D. Section of the Tuileries
Imperial chapel and premises of
the Council of Sate
E. Section of the Tuileries
Performance hall
F. Section of the Tuileries
Second floor: Hall of Marshals
First floor: Vestibule
G. Section of the Tuileries
Marsan Pavilion: Salons leading
to the quarters of the Children of
France and the apartment of the
Grand Marshal of the Palace

68. MRK
Fontainebleau
A. "General plan of the
palace, park, gardens and
outbuildings"
B. "General plan of the Palais
de Fontainebleau. First floor"
C. Fountain Courtyard

69. MRK
Plans des Deux Trianon
A. "Hamlet at the Petit Trianon"
B. "Plan of the Grand Trianon"
C. "Marlborough Tower and
Dairy"
D. "Petit Trianon's imperial
park. Music room, Corinthian
Temple, French pavilion"

70.
View of the Gallery of Diana
in the State apartment at
Fontainebleau in its current
state

71.
View of the Gallery of Francis I
at Fontainebleau in its current
state
Paris, collection Raphaël
Gaillarde

72.
View of the private salon in the
Emperor's interior apartment
at Fontainebleau in its current
state

73.
View of the Emperor's second
salon at Fontainebleau in its
current state

74.
View of the Empress' bathroom
at Fontainebleau in its current
state

75.
View of the bedchamber in the
Emperor's ordinary apartment
at Fontainebleau, (fitted in
1808) in its current state

76.
André-Charles BOULLE
Paris 1642 – Paris 1732
Chest-high cabinet with
drawers called "Parrot
Cabinet"
About 1680–1700
Oak, ebony, chased and gilded
bronze, deep blue marble
105 x 118 x 52.5 cm
Musée national des châteaux de
Versailles et de Trianon
Inv. Vmb 932

77.
Workshop of François-Honoré-
Georges JACOB-DESMALTER
(1770–1841)
Armchair
1810
Mahogany, gilded bronze
102.5 x 65.4 x 56 cm
Château de Fontainebleau
Inv. F 2014.15

78.
Throne Room in the State
apartment at Fontainebleau in
its current state

79. MRK
Workshop of François-Honoré-
Georges JACOB-DESMALTER
(1770–1841)
Presentation armchair for the
Throne Room at Saint-Cloud,
intended for the Empress or for
Madame Mère
1804
Gilded wood, red silk velvet,
gold thread, *clou touchant*
105 x 70 x 56 cm
Paris, Mobilier national
Inv. GMT 1306

80.
Workshop of François-Honoré-
Georges JACOB-DESMALTER
(1770–1841)
The Emperor's armchair throne
at the Tuileries
1804
Carved and gilded wood, silk
velvet, gold and silver thread
120 x 88 x 62 cm
Paris, Musée du Louvre
Inv. GMTC2

81. MRK
JACOB FRÈRES (active between
1796 and 1803)
Stool from a series of thirty
delivered for the Grande
Galerie at Saint-Cloud
1803
Gilded wood, silk
52 x 61 x 52 cm
Paris, Mobilier national
Inv. GMT 1441/1

82. MRK
Workshop of Pierre-Benoit
MARCION (1769–1840)
Folding stool in the Salon of
Officers, State apartment at
Fontainebleau
1805 (?)
Painted wood, gold setoff
53 x 65 x 50 cm
Château de Fontainebleau,
fonds palatial
Inv. F 3640.1

83. MRK
BEAUVAIS IMPERIAL MANUFACTORY
Upholstery by François-Louis-
Castelnaux DARRAC (about
1775–1862)
Folding stool from the
Emperor's Grand Cabinet at
the Grand Trianon
1810
Gilded wood, low-warp tapestry,
wool, silk
55 x 61.5 x 50.6 cm
Musée national des châteaux de
Versailles et de Trianon
Inv. T175 C.1

84. MRK
Workshop of François-Honoré-
Georges JACOB-DESMALTER
(1770–1841)
Four folding stools from the
Throne Room at Saint-Cloud
1804
Carved and gilded wood, gilded
bronze, Beauvais tapestry
50 x 68 x 48 cm
Musée national des châteaux de
Versailles et de Trianon
Inv. V 1032

85.
Workshop of François-Honoré-
Georges JACOB-DESMALTER
(1770–1841)
Design by Charles PERCIER
(1748–1825) and Pierre-François-
Léonard FONTAINE (1762–1853)
Presentation armchair (from
a pair), from the Emperor's
Grand Cabinet at the Tuileries
1807–10
Carved and gilded wood,
high-warp tapestry in wool,
gold braid
114 x 82 x 65 cm
Reggia di Caserta

86. MRK
Workshop of François-Honoré-
Georges JACOB-DESMALTER
(1770–1841)
The Emperor's throne armchair
at Monte Cavallo, Rome
About 1810
Carved and gilded wood, silk
velvet, grenat with large gold
braid
120 x 90 x 62 cm
Paris, Mobilier national
Inv. GME 1673

87. MRK
Pierre-Antoine BELLANGÉ
Paris 1757 – Paris 1827
Presentation armchair for
the Grand Salon of the King
of Rome's apartment at the
Tuileries, intended for the
Emperor and Empress
1804–15
Gilded wood, silk
115 x 82 x 66 cm
Paris, Mobilier national
Inv. GMT 1228

88.
View of the Empress'
bedchamber in the ordinary
apartment at Fontainebleau
with its new furniture in its
current state

89.
Grand Cabinet or Salon of the
Emperor in the State apart-
ment at Fontainebleau in its
current state

90. MRKF
Workshop of François-Honoré-
Georges JACOB-DESMALTER
(1770–1841)
After the design by Charles
PERCIER (1764–1838) and Pierre-
François-Léonard FONTAINE
(1762–1853)
Decorative top from the head-
board of the Emperor's bed
at the Tuileries: two imperial
eagles holding a victory
garland
1808–9
Carved walnut, traces of gilding
56 x 178 x 15 cm
Château de Fontainebleau,
Musée Napoléon I er (dépôt du
musée national des châteaux de
Malmaison et de Bois-Préau)

91.
Workshop of François-Honoré-
Georges JACOB-DESMALTER
(1770–1841)
Napoleon's ceremonial bed at
the Tuileries
1809
Carved and gilt walnut, chased
and gilded bronze, ivory
223 x 204 x 246.2 cm
Musée national des châteaux de
Versailles et de Trianon
Inv. T29C

92.
Jean-Baptiste-Claude SÉNÉ
Paris 1748 – Paris 1803
Louis-Alexandre RÉGNIER
France, 1751–1802
Altered by Michel-Victor
CRUCHET
Paris 1815 – Paris 1899
Louis XVI's bed at Saint-Cloud
1787
Wood, gilding
170 x 206 x 260 cm
Château de Fontainebleau,
fonds palatial
Inv. F1041.C

93.
Jean-Auguste-Dominique INGRES
Montauban 1780 – Paris 1867
*Romulus, Defeater of Acron,
Carries the Spoils to the Temple
of Jupiter*
1812
Oil on canvas
265 x 530 cm
Paris, Musée du Louvre (dépôt
de l'École nationale supérieure
des Beaux-Arts)
Inv. MU2572

94. MRK
Jean-Auguste-Dominique INGRES
Montauban 1780 – Paris 1867
The Dream of Ossian, ceiling in
the Emperor's bedchamber at
the Palais de Monte Cavallo
1813
Oil on canvas
348 x 275 cm
Montauban, Musée Ingres
Inv. MI. 867.70

95.
Philibert-Louis DEBUCOURT
Paris 1755 – Belleville 1832
*Illumination of the Grande
Cascade at Saint-Cloud on
April 1, 1810, for the Wedding
of Napoleon and Marie-Louise*
1813
Coloured aquatint
29 x 37.4 cm
Paris, Bibliothèque nationale
de France
Inv. VA-92B (5)-FOL

96.
ANONYMOUS
*Design for the Installations and
Decorations in the Empress
Josephine's Painting Gallery at
Malmaison*
1807
Ink, watercolour, gouache
highlights over traces of pencil
crayon
25.1 x 28.8 cm
Private collection

97.
ANONYMOUS, Possibly JACOB
FRÈRES (active between 1796
and 1803)
Cartonnier from the Emperor's
library at Malmaison
About 1795
Mahogany, amaranth, oak,
leather, cardboard, marble,
copper, gilded bronze
151 x 102 x 41 cm
The Montreal Museum of Fine
Arts
Ben Weider Collection
2007.602.1-15

98.
Admission ticket for the mass
celebrated in the chapel at the
Tuileries, on October 4, 1812, in
recognition of the Emperor's
victories
1812
Printed monograph
8.5 x 11.4 cm
Paris, Bibliothèque nationale
de France
Inv. de Vinck 8770

99.
Library of the First Consul, later
the Emperor, at Malmaison in
its current state

100.
Jean-Baptiste ISABEY
Nancy 1767 – Paris 1855
*Portrait of Napoleon in the
"Petit Habillement" Costume
He Wore for His Wedding in
1810*
1810
Gouache on ivory
24.8 x 16.5 cm
Vienna, Kunsthistorisches
Museum
Inv. Schatzkammer, WS XIV 148

101. F
Workshop of Augustin-François-
André PICOT (1756–1822)
Design for the embroidery on
the mantle of the Emperor's
ceremonial robes
1804
Gouache
29 x 40 cm
Pierrefitte-sur-Seine, Archives
nationales
Inv. AF IV 1220. dossier 1,
pièce 40

102. F
Workshop of GERMANY (active in
the first quarter of the 19th c.)
A. Design for the embroidery
on the mantle of the Grand
Dignitaries of the Empire
26 x 19 cm
B. Design for the embroidery
on the mantle of the marshals
of the Empire
40.5 x 26.2 cm
1804
Watercolour
Pierrefitte-sur-Seine, Archives
nationales
Inv. AF IV 1220. dossier 1. pièces
14, 15

103.
Robert LEFÈVRE
Bayeux 1755 – Paris 1830
*Portrait of Joseph Bonaparte,
King of Spain, in the Costume
of a French Prince*
About 1811
Oil on canvas
210 x 145 cm
Tokyo, Fuji Art Museum

104.
François-Pascal-Simon GÉRARD
Rome 1770 – Paris 1837
Portrait of Caroline Murat, Queen of Naples, with Her Children
About 1809–10
Oil on canvas
237 × 191 cm
Château de Fontainebleau, Musée Napoléon Iᵉʳ (dépôt du musée national des châteaux de Malmaison et Bois-Préau)
Inv. M.M.73.1.1

105.
Marie-Éléonore GODEFROID
Paris 1778 – Paris 1849
Portrait of Queen Hortense and Her Two Sons, the Princes Napoléon-Louis and Louis-Napoléon
1812
Oil on canvas
30 × 21.5 cm
Musées de l'île d'Aix
Inv. MGA965

106.
Marie-Éléonore GODEFROID
Paris 1778 – Paris 1849
The Sons of Marshal Ney
1810
Oil on canvas
162 × 173 cm
Gemäldegalerie, Staatliche Museen zu Berlin
Inv. 74.1

107.
Robert LEFÈVRE
Bayeux 1755 – Paris 1830
Portrait of François-Nicolas Mollien, Comte of the Empire, in the Costume of a Treasury Minister
1806
Oil on canvas
214 × 137 cm
Musée national des châteaux de Versailles et de Trianon
Inv. MV8653

108.
René-Théodore BERTHON
Tours 1776 – Paris 1859
Portrait of Denis, Duc Decrès, in the Costume of a Minister
About 1806
Oil on canvas
216 × 141 cm
Musée national des châteaux de Versailles et de Trianon
Inv. MV4728

109.
Attributed to the workshop of Augustin-François-André PICOT (1756–1822)
Jacket from the costume of a Chamberlain of the Imperial Household
About 1804–14
Silk velvet and silk serge, gold and silver thread
115 × 55 × 13.5 cm
Château de Fontainebleau, Musée Napoléon Iᵉʳ
Inv. F2014.9

110. MF
Attributed to the workshop of Augustin-François-André PICOT (1756–1822)
Jacket from the costume of a prefect of the palace or a chamberlain of the Imperial Household
About 1804–14
Woollen cloth, silver thread, silk
109 × 38 cm
Château de Fontainebleau, Musée Napoléon Iᵉʳ
Inv. F 2016.1.1

111. RK
Attributed to the workshop of Auguste-François-André PICOT (1756–1822)
Jacket from the costume of a Grand Master of the Hunt, worn by marshal Berthier, prince of Neufchâtel
1804
Silk velvet, silk, silver thread
113 × 42 cm
Paris, Musée de l'Armée
Inv. 21252.1

112.
Tailored by CHEVALIER
Embroidery by the workshop of Augustin-François PICOT (1756–1822)
After a design by Jean-Baptiste ISABEY (1767–1855)
Jacket from the ceremonial costume of a marshal of the Empire, formerly belonging to marshal Ney
About 1804
Silk velvet, gold thread
L. 110 cm (back with collar); 39 cm (shoulder width)
Paris, Musée de l'Armée
Inv. 2014.29.1

113. M
ANONYMOUS, FRANCE
Jacket from the costume of a Grand Marshal of the Palace, worn by the comte Bertrand
1813
Silk velvet, silver and gold thread
150 × 50 cm
Palais Galliera, Musée de la Mode de la Ville de Paris
Inv. GAL 1988.2.31

114. MRKF
Martin-Guillaume BIENNAIS
La Cochère 1764 – Paris 1843
Key of the Chamberlain of the Imperial Household, carried by the general-baron Guyot
About 1810
Gilded bronze
17 × 11 cm
Paris, Musée de l'Armée
Inv. 999.1273

115. MRKF
Martin-Guillaume BIENNAIS
La Cochère 1764 – Paris 1843
Ceremonial staff of a Grand Officer of the Imperial Household, formerly belonging to the comte Henri-Gatien Bertrand, Grand Marshal of the Palace
1813
Velvet, gilt silver
L. 101; Diam. 4 cm
Châteauroux, Musée-hôtel Bertrand
Inv. 226

116.
Jean-Baptiste ISABEY
Nancy 1767 – Paris 1855
Illustrations from the *Livre du Sacre* (1804) by Charles Percier and Pierre-Léonard-François Fontaine
A. *The Empress in "Grand Habillement"* (pl. XI)
B. *The Empress in "Petit Habillement"* (pl. XII)
C. *Costume of a Princess* (pl. XV)
D. *Costume of a Lady-in-waiting Bringing Gifts* (pl. XVII)
E. *Costume of a French Prince* (pl. XIV)
F. *Costume of a Grand Dignitary Prince* (pl. XVI)
G. *Costume of a Grand Officer of the Crown* (pl. XX)
H. *Costume of an Officer of the Imperial Household* (pl. XXVII)
I. *Costume of an Assistant of Ceremonies* (pl. XVIII)
Ink, wash
Château de Fontainebleau, Musée Napoléon Iᵉʳ
Inv. GMBibl.3502

117.
Jean-Baptiste ISABEY
Nancy 1767 – Paris 1855
Illustration from the *Livre du Sacre* (1804) by Charles Percier and Pierre-Léonard-François Fontaine
Costume of a Minister (pl. XXII)
Ink, wash
Château de Fontainebleau, Musée Napoléon Iᵉʳ
Inv. GMBibl.3502

118.
Jacques-Louis DAVID
Paris 1748 – Brussels 1825
The People's Deputy, Design for a Civil Costume
1794
Ink, watercolour
31.4 × 21.8 cm
Paris, Musée Carnavalet
Inv. D7059

119. MRK
Andrea APPIANI
Milan 1754 – Milan 1817
Josephine Bonaparte Laying a Wreath on the Holy Myrtle
1796
Oil on canvas
98 × 73.5 cm
Milan, duchess Salviati

120.
Antoine-Jean GROS
Paris 1771 – Meudon 1835
Equestrian Portrait of Jerome Bonaparte, King of Westphalia, in the Costume of a Prince of France
1808
Oil on canvas
321 × 265 cm
Kassel, MHK Neue Galerie
Inv. 1875/971

121.
Jean-Louis-André-Théodore GÉRICAULT
Rouen 1791 – Paris 1824
Equestrian Portrait of Jerome Bonaparte
1812–14
Oil on canvas
45.8 × 36.3 cm
Paris, Musée du Louvre
Inv. MD 2013-6

122.
Jacques-Louis DAVID
Paris 1748 – Brussels 1825
Bonaparte, First Consul, Crossing the Alps at the Great Saint Bernard Pass, on May 20, 1800
1803
Oil on canvas
267.5 × 223 cm
Musée national des châteaux de Versailles et de Trianon
Inv. MV8550

123.
Antoine-Jean GROS
Paris 1771 – Meudon 1835
Napoleon Visiting the Salon of 1808, at the Louvre
After 1808
Oil on canvas
350 × 640 cm
Musée national des châteaux de Versailles et de Trianon
Inv. MV6347

124.
Robert LEFÈVRE
Bayeux 1755 – Paris 1830
Portrait of Napoleon in His Ceremonial Robes
1812
Oil on canvas
251.1 × 191.5 cm
Boston, Museum of Fine Arts
William Sturgis Bigelow Collection
Inv. 26.789

125.
Guillaume GUILLON-LETHIÈRE
Sainte-Anne, Guadeloupe, 1760 – Paris 1832
Portrait of Elisa Bonaparte-Bacciochi, Princess of Lucca and Piombino, Grand Duchess of Tuscany
1806
Oil on canvas
217.5 × 139.5 cm
Musée national des châteaux de Versailles et de Trianon
Inv. MV 4710

126.
Workshop of Anne-Louis GIRODET DE ROUSSY-TRIOSON (1767–1824)
Executed by Jean-Baptiste MAUZAISSE (1784–1844)
Portrait of Napoleon in Ceremonial Robes
About 1812
Oil on canvas
261 × 184 cm
Château de Fontainebleau, Musée Napoléon Iᵉʳ
Inv. F2005.33

127.
Jean-Baptiste ISABEY
Nancy 1767 – Paris 1855
Bust-length Portrait of Napoleon
About 1810
Watercolour on ivory
5.5 × 3.8 cm
London, The Wallace Collection
Inv. M209

128.
Daniel SAINT
Saint-Lô 1778 – Saint-Lô 1847
Portrait of the Empress Josephine
About 1800–9
Gouache and watercolour on ivory, gold, enamel
8.1 × 5.9 cm
Toronto, Art Gallery of Ontario
Thomson Collection
Inv. AGOJD.29405

129. K
Jean-Baptiste ISABEY
Nancy 1767 – Paris 1855
Portrait of Napoleon
About 1812
Gouache on ivory, gold, glass
3.3 × 10.3 cm
Los Angeles County Museum of Art
Long-term loan from The Rosalinde and Arthur Gilbert Collection on loan to the Victoria and Albert Museum, London
Inv. L.2010.9.16

130.
SÈVRES IMPERIAL MANUFACTORY
Alexandre-Théodore Brongniart, fils (1770–1847)
Design for a secrétaire called "of the Imperial Family"
1811
Ink, wash, gouache
47 × 30.5 cm
Sèvres, Cité de la céramique
Inv. 2012.1.1664

131.
Jean-Baptiste ISABEY
Nancy 1767 – Paris 1855
Bonaparte, First Consul, Visiting the Manufactory of the Sévène Brothers in Rouen with Josephine
1804
Sepia, gouache
124 × 176 cm
Musée national des châteaux de Versailles et de Trianon
Inv. MV2574; INV27233

132.
Workshop of Georges ROUGET (1783–1869)
Portrait of Jacques-Louis David
About 1813–15
Oil on canvas
118.4 × 96.5 × 9.5 cm
Washington, D.C., National Gallery of Art
Chester Dale Collection
1963.10.212

133.
Robert LEFÈVRE
Bayeux 1755 – Paris 1830
Self-portrait
1810
Oil on canvas
Musée des Beaux-Arts de Caen
Inv. 278

134.
François-Pascal-Simon GÉRARD
Rome 1770 – Paris 1837
Self-portrait
About 1825
Oil on canvas
66 × 55 cm
Musée national des châteaux de Versailles et de Trianon
Inv. V2011.14

135.
Antoine-Jean GROS
Paris 1771 – Meudon 1835
Self-portrait
1795
Oil on canvas
51.1 × 40.9 cm
Musée national des châteaux de Versailles et de Trianon
Inv. MV 4786

136.
Jean-Baptiste ISABEY
Nancy 1767 – Paris 1855
Self-portrait
About 1795
Oil on canvas
Private collection

137.
Anne-Louis GIRODET DE ROUSSY-TRIOSON
Montargis 1767 – Paris 1824
Self-portrait, in Left Profile
N.d.
Stump drawing, charcoal
25 × 20 cm
Paris, Musée du Louvre
Inv. RF36152-recto

138.
François-Pascal-Simon GÉRARD
Rome 1770 – Paris 1837
Portrait of the Empress Marie-Louise Presenting the King of Rome
1812
Oil on canvas
240 × 163 cm
Musée national des châteaux de Versailles et de Trianon
Inv. MV4703

139.
François-Pascal-Simon GÉRARD
Rome 1770 – Paris 1837
Portrait of Napoleon, Emperor of the French, in Ceremonial Robes
1805
Oil on canvas
223 × 143 cm
Musée national des châteaux de Versailles et de Trianon
Inv. MV5321

140.
Antoine-Jean GROS
Paris 1771 – Meudon 1835
General Bonaparte at the Bridge of Arcole, November 17, 1796
1796
Oil on canvas
130 × 94 cm
Musée national des châteaux de Versailles et de Trianon
Inv. MV6314

141.
Jacques-Louis DAVID
Paris 1748 – Brussels 1825
Portrait of General Bonaparte
About 1797–98
Oil on canvas
81 × 65 cm
Paris, Musée du Louvre
Inv. RF1942-18

142.
Antoine-Jean GROS
Paris 1771 – Meudon 1835
Portrait of Bonaparte in the Costume of First Consul
1802
Oil on canvas
205 × 127 cm
Paris, Musée national de la Légion d'honneur
Inv. INV04378

143.
Élisabeth-Louise VIGÉE-LEBRUN
Paris 1755 – Paris 1842
Portrait of Charles-Alexandre de Calonne
1784
Oil on canvas
130.3 × 155.5 cm
London, Royal Collection Trust
Inv. RCIN 406988

144.
Jean-Baptiste-François DESORIA
Paris 1758 – Cambrai 1832
Portrait of Charles-Louis-François-Henri Letourneur, in the Costume of a Director
1796
Oil on canvas
225 × 147 cm
Musée national des châteaux de Versailles et de Trianon
Inv. MV4617

145. MRK
ANONYMOUS
After Gilbert STUART (1755–1828)
Portrait of George Washington
1797
Oil on canvas
71.1 × 49.5 cm
London, National Portrait Gallery
Inv. NPG 774

146. MRK
WOUTERS MANUFACTORY, Andenne, Belgium
Modelled by Jacques RICHARDOT (1743–1806)
Napoleon, Emperor
1804
Glazed earthenware
H. 77 cm
Geneva, Collection Comte et Comtesse Charles-André Colonna Walewski

147.
Workshop of Louis-Michel VAN LOO (1707–1771)
Portrait of Louis XV in Royal Ceremonial Robes
After 1761
Oil on canvas
198.3 × 142.5 cm
Ottawa, Library and Archives Canada
Inv. op0144 1990-365-1

148.
Antoine-François CALLET
Paris 1741 – Paris 1823
Portrait of Louis XVI in Royal Ceremonial Robes
1779
Oil on canvas
278 × 196 cm
Musée national des châteaux de Versailles et de Trianon
Inv. MV3890

149.
Hyacinthe RIGAUD
Perpignan 1659 – Paris 1743
*Modello for the Portrait of
Louis XIV in Royal Ceremonial
Robes*
1701
Oil on canvas
55.7 x 46 cm
The Montreal Museum of Fine
Arts, purchase, gifts of W. Bruce
C. Bailey in honour of Hilliard T.
Goldfarb, and of Dan and André
Mayer, the Montreal Museum of
Fine Arts' Volunteer Association
Fund, the Museum Campaign
1988-1993 Fund, and the Serge
Desroches, Hermina Thau, David
R. Morrice, Mary Eccles, Jean
Agnes Reid Fleming, Geraldine
C. Chisholm, Margaret A. Reid,
F. Eleanore Morrice, Harold
Lawson, Marjorie Caverhill, Harry
W. Thorpe and Mona Prentice
Bequests
Inv. 2017.51

150. MRK
*Effigy of the Emperor Augustus
(27 B.C.-14 A.D.), Model Called
"Prima Porta"*
1st quarter of 1st century
Marble
H. 35 cm
Paris, Musée du Louvre
Inv. MA 1246

151.
François-Pascal-Simon GÉRARD
Rome 1770 – Paris 1837
Belisarius
1797
Oil on canvas
91.8 x 72.5 cm
Los Angeles, The J. Paul Getty
Museum
Inv. 2005,1

152.
Jacques-Louis DAVID
Paris 1748 – Brussels 1825
*Portrait of Napoleon in
Ceremonial Robes*
1805
Oil on canvas
57 x 49.5 cm
Lille, Palais des Beaux-Arts
Inv. P.438

153. MRK
ANONYMOUS
*T[alma] Giving a Lesson in
Grace and Imperial Dignity*
N.d.
Engraving with colouring
24.5 x 14 cm
Montreal, McGill University
Library and Archives, Rare Books
and Special Collections
Inv. 4° NC 068

154.
Martin DRÖLLING
Bergheim 1752 – Paris 1817
After Élisabeth-Louise VIGÉE-
LEBRUN (1755-1842)
Portrait of Marie-Antoinette
1789
Oil on canvas
92.5 x 73 cm (approx.)
Private collection

155.
Martin DRÖLLING
Oberhergheim 1752 – Paris 1817
*Portrait of Napoleon in
Ceremonial Robes*
1808
Oil on canvas
225 x 145 cm
Private collection

156.
François-Pascal-Simon GÉRARD
Rome 1770 – Paris 1837
*Portrait of the Empress
Josephine in Ceremonial Robes*
1808
Oil on canvas
211.5 x 131.5 cm
Château de Fontainebleau,
Musée Napoléon Ier
Inv. N18

157.
ANONYMOUS
After François-Pascal-Simon
GÉRARD (1770-1837)
*Portrait of the Empress Marie-
Louise in Ceremonial Robes*
After 1812
Oil on canvas
240.5 x 155.5 cm
Château de Fontainebleau,
Musée Napoléon Ier
Inv. N19

158.
SÈVRES IMPERIAL MANUFACTORY
Jean GEORGET (1763-1823)
After François-Pascal-Simon
GÉRARD (1770-1837)
*Bust-length Portrait of
Napoleon in Ceremonial Robes*
1811
Paint on porcelain, bronze and
gilded wood frame
86 x 66 cm
Florence, Palazzo Pitti, Museo
delle Porcellane
A.G 1890, n 8749

159.
GOBELINS IMPERIAL MANUFACTORY
After François-Pascal-Simon
GÉRARD (1770-1837)
*Portrait of Napoleon in
Ceremonial Robes*
1805-11
High-warp tapestry, wool, silk,
silver and gold thread, gilded
pine frame
222.3 × 192.4 cm
New York, The Metropolitan
Museum of Art
Purchase, Joseph Pulitzer
Bequest, 1943
Inv. DC203.4 A85 1884 folio

160. MRKF
Workshop of François-Pascal-
Simon GÉRARD (1770-1837)
Frame attributed to DELPORTE
FRÈRES
*Bust-length Portrait of
Napoleon in Ceremonial Robes*
Frame with symbols of the
Empire
About 1805-14
Oil on canvas, carved and gilded
wood
Painting: 82.2 x 65 cm
Frame: 140 x 93.2 x 11 cm
The Montreal Museum of Fine
Arts
Ben Weider Collection
Inv. 2008.403

161.
GOBELINS IMPERIAL MANUFACTORY
After Joseph-Siffred DUPLESSIS
(1725-1802)
*Bust-length Portrait of Louis
XVI*
About 1774
Wool
79.3 x 65.7 cm
Baltimore, The Walters Art
Museum
Inv. 82.27

162.
Joseph-Siffred DUPLESSIS
Carpentras 1725 – Versailles 1802
*Bust-length Portrait of
Benjamin Franklin*
1778
Oil on canvas
72.4 x 58.4 cm
New York, The Metropolitan
Museum of Art
The Friedsam Collection,
Bequest of Michael Friedsam,
1931
Inv. 32.100.132

163.
Workshop of François-Pascal-
Simon GÉRARD (1770-1837)
Frame (altered?) attributed to
DELPORTE FRÈRES
*Bust-length Portrait of
Napoleon in Ceremonial Robes*
About 1805-14
Oil on canvas, carved and gilded
wood
81 x 64 cm
Private collection

164.
Workshop of François-Pascal-
Simon GÉRARD (1770-1837)
Frame possibly by DELPORTE
FRÈRES
*Bust-length Portrait of King
Charles X in Royal Ceremonial
Robes*
About 1825-30
Oil on canvas
80 x 65 cm (appox.)
Private collection

165. M
Henry AUGUSTE
Paris 1759 – Jamaica 1816
*Proposed design for the gold
borders around the portrait of
His Majesty the Emperor of the
French and King of Italy*
About 1805-8
Ink, watercolour
26.4 x 16.8 cm
Paris, Musée des Arts décoratifs
Inv. 2009.174.13

166. M
GOBELINS IMPERIAL MANUFACTORY
After François-Pascal-Simon
GÉRARD (1770-1837)
Frame attributed to DELPORTE
FRÈRES
*Bust-length Portrait of
Napoleon in Ceremonial Robes*
About 1810
Tapestry, carved and gilded
wood
103 x 90 cm
Dresden, Staatliche
Kunstsammlungen
Inv. H 0144

167.
IMPERIAL SCHOOL OF MOSAICS OF
FRANCESCO BELLONI (1772-1863)
After François-Pascal-Simon
GÉRARD (1770-1837)
*The Genius of the Emperor
Mastering Victory, Brings
Peace and Plenty*
19th century
Pietra dura mosaic, cast glass
295 x 338 cm
Paris, Musée du Louvre
Inv. MA413bis

168.
François-Pascal-Simon GÉRARD
Rome 1770 – Paris 1837
*Portrait of Napoleon in the
Uniform of Colonel of the
Grenadier Foot Guards*
About 1812
Oil on canvas
107 x 70.5 cm
Musées de l'île d'Aix
Inv. MG.A.207

169. MRK
IMPERIAL SCHOOL OF MOSAICS OF
FRANCESCO BELLONI (1772-1863)
After François-Pascal-Simon
GÉRARD (1770-1837)
*Portrait of Napoleon in the
Uniform of a Colonel of the
Grenadier of the Foot Guards*
1813-14
Pietra dura mosaic, cast glass
115 x 80 cm
Rueil-Malmaison, Musée national
des châteaux de Malmaison et
Bois-Préau
Inv. M.M.70.4.1

170.
Jean-Baptiste-Fortuné DE
FOURNIER
Nice 1797 – Paris 1864
*View of the Salon of Apollo at
the Palais des Tuileries as It
Was in the Second Empire*
1857
Watercolour
43 x 28 cm
Musée national du château de
Compiègne
Inv. C.2014.003

171.
Jean-Baptiste-Fortuné DE
FOURNIER
Nice 1797 – Paris 1864
*The Gallery of Ambassadors
at the Palais des Tuileries as It
Was in the Second Empire*
About 1857
Watercolour
37.6 x 47.3 cm
Paris, Musée du Louvre
Inv. RF34435-recto

172. MRK
GOBELINS ROYAL MANUFACTORY
After Jean-François DE TROY
Paris 1679 – Rome 1752
*Hanging of The Story of Esther:
The Fainting of Esther*
After 1752
High-warp tapestry, wool and
silk (Ancien Régime borders)
420 x 530 cm
Paris, Mobilier national
Inv. GMTT / 320

173.
François PERRIER
Pontarlier 1594 – Paris 1650
The Sacrifice of Iphigenia
About 1632
Oil on canvas
212.7 x 154.5 cm
Dijon, Musée des Beaux-Arts
Inv. 4931

174.
Domenico Zampieri, called
DOMENICHINO
Bologna 1581 – Naples 1641
Erminia and the Shepherds
About 1622-25
Oil on canvas
124 x 181 cm
Paris, Musée du Louvre
Inv. 799

175.
Francesco SOLIMENA
Canale di Serino 1657 – Naples
1747
The Annunciation
About 1690-1700
Oil on canvas
103 x 127 cm
Angers, Musée des Beaux-Arts
Inv. 2013.22.36

176. MRKF
Robert LEFÈVRE
Bayeux 1755 – Paris 1830
*Portrait of Dominique-Vivant
Denon*
1808
Oil on canvas
73.3 x 59.5 cm
Musée des Beaux-Arts de Caen
Legs Lair, 1853
Inv. 276

177.
Carl RUTHART
Danzig 1630 – known until 1703
at Aquila, Italy
Bear Hunt
N.d.
Oil on canvas
65 x 86 cm
Paris, Musée du Louvre
Inv. 1823

178.
Adam ELSHEIMER
Frankfurt 1578 – Rome 1610
Morning Landscape
About 1606
Oil on copper
17 x 22.2 cm
Brunswick, Herzog Anton
Ulrich-Museum
Inv. GG 550

179.
REMBRANDT HARMENSZ. VAN RIJN
Leyden 1606 – Amsterdam 1669
Winter Landscape
1646
Oil on canvas
16.6 x 23.4 cm
Museumslandschaft
Hessen Kassel, Gemäldegalerie
Alte Meister
Inv. GK 241

180.
Francesco GUARDI
Venice 1712 – Venice 1793
*The Coronation of the Doge
on the Scala dei Giganti of the
Doge's Palace in Venice*
About 1775-80
Oil on canvas
67 x 101 cm
Paris, Musée du Louvre
Inv. 323

181.
Francesco GUARDI
Venice 1712 – Venice 1793
*The Doge of Venice Thanks the
Maggior Consiglio*
About 1775-80
Oil on canvas
67 x 101 cm
Paris, Musée du Louvre
Inv. 20800

182.
Nicolas-André MONSIAU
Paris 1754/55 – Paris 1837
*Members of the Consulta of the
Cisalpine Republic*
1808
Oil on canvas
319 x 483 cm
Musée national des châteaux de
Versailles et de Trianon
Inv. MV1500

183.
Pierre-Narcisse GUÉRIN
Paris 1774 – Rome 1833
*Bonaparte Pardoning the
Rebels in Cairo, October 23,
1798*
1808
Oil on canvas
365 x 500 cm
Musée national des châteaux de
Versailles et de Trianon
Inv. MV1498

184.
Jean-Simon BERTHÉLÉMY
Laon 1743 – Paris 1811
*General Bonaparte Visiting the
Wells of Moses, December 28,
1798*
1808
Oil on canvas
175 x 219 cm
Musée national des châteaux de
Versailles et de Trianon
Inv. MV1685

185.
Anne-Louis GIRODET DE
ROUSSY-TRIOSON
Montargis 1767 – Paris 1824
*The Revolt at Cairo on
October 21, 1798*
First quarter of the 19th c.
Oil on canvas
365 x 500 cm
Musée national des châteaux de
Versailles et de Trianon
Inv. MV1497

186.
Anne-Louis GIRODET DE
ROUSSY-TRIOSON
Montargis 1767 – Paris 1824
*Napoleon Receiving the Keys
to Vienna at Schönbrunn,
November 13, 1805*
1806-8
Oil on canvas
380 x 532 cm
Musée national des châteaux de
Versailles et de Trianon
Inv. MV1549

187.
Antoine-Jean GROS
Paris 1771 – Meudon 1835
*The Surrender of Madrid,
December 4, 1808*
1810
Oil on canvas
361 x 500 cm
Musée national des châteaux de
Versailles et de Trianon
MV 1560

188.
Nicolas-Antoine TAUNAY
Paris 1755 – Paris 1830
*Led by the Emperor, the
French Army Enters Munich,
October 24, 1805*
1806-8
Oil on canvas
182 x 221 cm
Musée national des châteaux de
Versailles et de Trianon
Inv. MV1709

189.
Louis-François LEJEUNE
Strasbourg 1775 – Toulouse 1848
*Napoleon's Bivouac on the Eve
of the Battle of Austerlitz*
1808
Oil on canvas
180 x 220 cm
Musée national des châteaux de
Versailles et de Trianon
Inv. MV6858

190.
Pierre-Claude GAUTHEROT
Paris 1769 – Paris 1825
*Napoleon Haranguing the 2nd
Corps of the Grande Armée*
1808
Oil on canvas
385 x 620 cm
Musée national des châteaux de
Versailles et de Trianon
Inv. MV1512

191.
Charles Meynier
Paris 1763 – Paris 1832
Napoleon, Surrounded by His Staff Officers, Enters Berlin, October 27, 1806
1810
Oil on canvas
330 x 493 cm
Musée national des châteaux de Versailles et de Trianon
Inv. MV1552

192. MRKF
Gobelins Imperial Manufactory
After Gioacchino Serangeli (1768–1852)
Napoleon Receiving Army Delegates at the Louvre Following His Coronation, December 8, 1804
1809-15
High-warp tapestry, wool and silk
335 x 195 cm
Paris, Mobilier national
Inv. GMTT 250

193.
Gobelins Imperial Manufactory
After Antoine-Jean Gros (1771–1835)
Bonaparte, First Consul, Distributing the Sabres of Honour to the Grenadiers of His Guard after the Battle of Marengo (June 14, 1800)
July 1806-December 1810
High-warp tapestry, wool and silk
323 x 261 cm
Musée national des châteaux de Versailles et de Trianon (dépôt du Mobilier national)
Inv. GMTT 249

194.
Antoine-Jean Gros
Paris 1771 – Meudon 1835
Bonaparte, First Consul, Distributing the Sabres of Honour to the Grenadiers of His Guard after the Battle of Marengo (June 14, 1800)
1803
Oil on canvas
306 x 242 cm
Rueil-Malmaison, Musée national des châteaux de Malmaison et Bois-Préau
M.M.40.47.7175

195.
Gobelins Imperial Manufactory
Workshop of Jean Mozin, weaver (active at the Gobelins between 1671 and 1693)
Cartoons by Henri Testelin (1616–1695)
After Charles Lebrun (1619–1690) and Adam Frans Van der Meulen (1632–1690)
History of the King. Louis XIV Captures the City of Marsal in Lorraine, September 1, 1663
1665-80
Low-warp tapestry, wool and silk, gold thread
390 x 566 cm
Musée national des châteaux de Versailles et de Trianon (dépôt du Mobilier national)
Inv. GMTT 98.11

196.
Beauvais Imperial Manufactory
Armchair upholstery depicting subjects from La Fontaine's *Fables* for the furniture at the Palais de Compiègne
1808
Low-warp tapestry, wood and wilk
Paris, Mobilier national

197-200. MRKF
François Dubois
Paris 1790 – Paris 1871
After the designs of Jacques-Louis de La Hamayde de Saint-Ange (1780–1860)
The Four Parts of the World
Tapestry cartoons for the portieres in the Gallery of Diana at the Tuileries
197. *America*
198. *Asia*
199. *Africa*
200. *Europe*
1810
Oil on canvas
270 x 204 cm (each)
Paris, Mobilier national
Inv. GOB 535/1, 538/1, 537/1, 539

The Emperor's Grand Cabinet at the Tuileries: Furniture and Tapestry Cartoons (201-205)

201.
Workshop of François-Honoré-Georges Jacob-Desmalter (1770–1841)
Low armoire from a series of three
1811-12
Oak, ebony, gilded bronze, silver, marble, porphyry
122 x 205 x 65 cm
Musée national des châteaux de Versailles et de Trianon
Inv. Vmb13249

202. MRKF
François Dubois
Paris 1790 – Paris 1871
After Jacques-Louis de La Hamayde Saint-Ange (1780–1860)
Fame, cartoon for a portiere
1808
Oil on canvas
258 x 212 cm
Paris, Mobilier national
Inv. GOB 540

203. MRK
François Dubois
Paris 1790 – Paris 1871
After Jacques-Louis David (1748–1825)
a. *Victory*, cartoon for the upholstery of the back of the presentation armchairs
59 x 59 cm
b. Cartoon for the upholstery of the chairs for the princesses
146 x 60 cm
c. Cartoon for the upholstery of the seat of the folding stools
65 x 53 cm
d. Cartoon for the upholstery of the seat of the presentation armchairs
68 x 80 cm
e. *Silence*, or *Harpocrates*, cartoon for the fire screen tapestry
84 x 69 cm
1811
Oil on canvas
Paris, Mobilier national
Inv. GOB 255/2, /39, /16, /1, /17

204. MRKF
Gobelins Imperial Manufactory
Cartoons by François Dubois (1790-1871)
After Jacques-Louis David (1748–1825)
Screen with six panels
1812
Wool and silver thread (framework of a later date)
125 x 55 cm (each panel)
Paris, Mobilier national
Inv. GMT 23472

205.
Gobelins Imperial Manufactory
Screen with six panels from the original furniture
1811
Wool, silk
123 x 55 cm (panel)
Paris, Musée du Louvre
Inv. OA9970

206.
Charles Monnet
Paris 1732 – Paris après 1808
The First Consul Lays the Cornerstone to the Facades of the Place Bellecour in Lyon
1809-13
India ink, India ink wash
13.5 x 10.1 cm
Rueil-Malmaison, Musée national des châteaux de Malmaison et Bois-Préau
Inv. MM.54.12.6

207.
Department of the Grand Marshal of the Palace, Imperial Household
Furniture fabrics, in wool and silk, in thread and silk, and in filoselle
About 1809-11
Pierrefitte-sur-Seine, Archives nationales
Inv. O² 202, pièce 262

208. KF
Cartier, Lyon
Loom width and border with ivy leaves, ordered for the bedroom of Madame Mère at Fontainebleau
Commissioned in 1806
Delivered to the Garde-Meuble and installed in the Château de Fontainebleau in 1806
Silk
Satin, violet, 1 lat de lancé lié en sergé de 3 lie 1, jaune
Loom width: 54.3 x 100 cm
Inv. GMMP 1452
Border: 17.5 x 56 cm
Inv. GMMP 1453/1
Paris, Mobilier national

209. MR
Chuard et Cie, Lyon
Green, lilac, white and gold damask, with basket and stars. Hanging and borders for hangings and curtains at Fontainbleau
Delivered to the Garde-Meuble and installed at the Château de Fontainebleau in 1806
Satin, violet (1 lat de lancé lié en sergé de 3 lie 1, jaune)
Loom width: 54.3 x 100 cm
Inv. GMMP 1452
Border: 17.5 x 56 cm
Inv. GMMP 1453/1
Paris, Mobilier national

210. MR
Bissardon, Cousin et Bony, Lyon
Elements of hangings and borders with flower decoration, for the Emperor's room at the Palais de Meudon
1808
Delivered in 1809 to the Garde-Meuble, installed in 1811 at the Palais de Meudon, where they remained in place until 1837
Hanging (lampas fond satin de 5 jaune, 1 lat de lancé, broché à plusieurs lats, liés en sergé de 3 lie 1): 54 x 87.5 cm
Inv. GMMP 895
Border (lampas fond satin de 6 [?] blanc, 1 lat de lancé, broché à plusieurs lats, lié en sergé de 3 lie 1): 26.2 x 50.4 cm
Inv. GMMP 927
Paris, Mobilier national

211. MR
Charles Corderier, Lyon
Loom width and border with decoration of anemones and brandons, for three bedrooms for princes or Grand Dignitaries at the Palais de Versailles
Commissioned in 1811
Delivered to the Garde-Meuble in 1812, not used under the Empire, installed at the Restoration at the Élysée and Saint-Cloud, then in various other locations
Loom width (lampas fond satin vert, 1 lat de lancé lié en sergé de 3 lie 1, jaune, 1 lat de lancé lié en taffetas orange): 57 x 87.5 cm
Inv. GMMP 1245
Border (lampas fond satin strié vert et violet, 2 lats de lancé brochés à plusieurs lats, sergé de 3 lie 1): 27 cm, several metres long
GMMP 876
Paris, Mobilier national

212. MR
Chuard et Cie, Lyon
Loom width and border with Greek and hydrangea decoration, commissioned for a first salon in the Empress' apartment at the Palais de Versailles
Commissioned in 1811
Delivered to the Garde-Meuble in 1813, not used under the Empire, and installed under the Restoration in various palaces
Silk
Lampas, yellow satin ground (3 lats de lancé, 1 lat lié en sergé de 3 lie 1, blanc, 1 lat interrompu lié sergé de 3 lie 1, gris, 1 lat lié en taffetas, rose)
Loom width: 55.5 x 49.5 cm
Inv. GMMP 1456
Border: 8 x 55.5 cm
Inv. GMMP 1458/2
Paris, Mobilier national

213.
Sèvres Imperial Manufactory
Decoration painted by Jean Georget (1763–1823)
After Jacques-Louis David (1748–1825)
Spindle vase decorated with *Bonaparte Crossing the Alps at the Great Saint Bernard Pass*, given to Madame Mère in commemoration of the King of Rome's baptism
1811
Hard-paste porcelain
107 x 34 cm
Paris, Musée du Louvre
Inv. OA11056

214.
Sèvres Imperial Manufactory
Decoration painted by Pierre Nolasque Bergeret (1782–1863)
Etruscan drop vase decorated with two scenes on the subject of Napoleon as miracle-worker: *The Plague Victims of Jaffa* and *Napoleon Touching an Invalid under the Watch of Asclepius*, given to the prince of Prussia
1807
Hard-paste porcelain
H. 51.2 cm; Diam. 44 cm
Château de Fontainebleau, Musée Napoléon Iᵉʳ
Inv. F2014.24

215.
Sèvres Imperial Manufactory
Service of Plants of Malmaison: Basket and plate
1803-5
Hard-paste porcelain
Basket: H. 20.5 cm;
Diam. 26.4 cm
Plate: Diam. 23.3 cm
Boston, Museum of Fine Arts
Inv. 2001. 252, 248

216. MRKF
Sèvres Imperial Manufactory
Two plates from the service "of the Arch-chancellor"
Series of La Fontaine's *Fables* (*The Lion, the Wolf and the Fox; The Two Roosters*)
1806-7
Hard-paste porcelain
Diam. 23.5 cm
Alexandre de Bothuri Báthory / Elaine Bédard de Bothuri

217. MRKF
Sèvres Imperial Manufactory
Decoration painted by Piat Sauvage (1744–1818)
Pair of Medici vases: *The Coronation of the Emperor and the Empress*, given to the comte de Ségur, Grand Master of Ceremonies, in commemoration of the Baden marriage
1808
Hard-paste porcelain
42.5 cm
Geneva, Collection Comte et Comtesse Charles-André Colonna Walewski

218.
Sèvres Imperial Manufactory
Pair of Medici vases given to M. de Cramayel, Master of Ceremonies, in commemoration of the Baden marriage
1806
Hard-paste porcelain
H. 32 cm; Diam. 23 cm
Karlsruhe, Badisches Landesmuseum

219.
Gobelins Imperial Manufactory
After François-Guillaume Menageot (1744–1816)
Meleager Surrounded by His Beseeching Family
1798-1809
High-warp tapestry, wool and silk
419.1 x 325.1 cm
Boston, Museum of Fine Arts
Charles Potter Kling Fund
Inv. 2002,56

220. MRKF
Sèvres Imperial Manufactory
Decoration painted by Jean Georget (1763–1823)
Pair of Etruscan scroll vases: *Leaving for the Army* and *Return from the Army*, given to Jerome, king of Westphalia in commemoration of the King of Rome's baptism
1811
Hard-paste porcelain
69.2 x 35.6 x 47 cm
Hartford, Connecticut, Wadsworth Atheneum Museum of Art
Gift of J. Pierpont Morgan
Inv. 1994.40.1 and 1919.87

221.
Sèvres Imperial Manufactory
Decoration by Jean-François Robert (1778–1832)
Pair of Medici vases with scenes of the château and park of Saint-Cloud, given to Jerome, king of Westphalia, in commemoration of the King of Rome's baptism
1811
Hard-paste porcelain
69.2 x 47 x 47 cm
New York, The Metropolitan Museum of Art
Purchase, Rogers 2011 Benefit Funds, and Gift of Dr. Mortimer D. Sackler, Theresa Sackler and Family, 2011
Inv. 2011.545-546

222. MRKF
Sèvres Imperial Manufactory
Decoration painted by Jean Georget (1763–1823), Claude-Antoine Déperais (active at Sèvres between 1798 and 1822) and Christophe-Ferdinand Caron (1774–1831, active at Sèvres between 1792 and 1815)
Spindle vase with portrait of the Emperor, given to Jerome, king of Westphalia, in Februry 1812, in commemoration of the King of Rome's baptism
1811
Hard-paste porcelain
60 x 18.5 cm
Musée national du château de Compiègne
Inv. C1316

223.
Sèvres Imperial Manufactory
Pair of jam pots from the Egyptian service given to the Empress Josephine
1811
Hard-paste porcelain
11.1 x 21.2 x 8.2 cm
London, Victoria and Albert Museum
Inv. C.131-1979

224.
Sèvres Imperial Manufactory
Decoration painted by Jacques-François Swebach-Desfontaines (active at Sèvres between 1803 and 1813)
Medici vase from a pair, given to the grand duke of Würzburg in commemoration of the King of Rome's baptism
1811
Hard-paste porcelain
H. 69 cm
Florence, Palazzo Pitti, Galleria d'Arte Moderna
Inv. O.d.A. 1911, nn. 493

225. MRKF
Sèvres Imperial Manufactory
Decoration painted by
Christophe-Ferdinand Caron
(1774–1831, active at Sèvres
between 1792 and 1815)
Tea Service "Landscapes and
Fables"
1807-8
Hard-paste porcelain
Teapot: 20.3 x 20.3 x 10.8 cm
Sugar bowl: 15.8 x 14.2 x 9.5 cm
Milk jug: 20.3 x 11.7 cm
Bowl: H. 14.4 cm; Diam. 21.2 cm
Cups: H. 10.9 cm; Diam. 8.5 cm
Saucers: Diam. 15.2 cm
Minneapolis Institute of Art, The
Groves Foundation Fund
Inv. 81,101

226.
Sèvres Imperial Manufactory
Decoration painted by Jean-
François Robert
Pair of ice pails with elephant-
head handles, from the dessert
service given to the emperor
Francis I of Austria in commem-
oration of the King of Rome's
baptism
1811
Hard-paste porcelain
34.2 x 28.9 cm
London, The British Museum
Inv. 1985.1203.1-2

227. MRKF
Sèvres Imperial Manufactory
Pair of ice pails with elephant-
head handles, from the Greek
iconography service given to
cardinal Fesch in commem-
oration of the King of Rome's
baptism
1810-11
Hard-paste porcelain
33.8 x 22.4 cm
Geneva, Collection Comte
et ComtesseCharles-André
Colonna Walewski

228.
Sèvres Imperial Manufactory
Decoration painted by Jean
Georget (1763–1823)
Pair of egg vases decorated
with Bacchus and Ariadne
and Flora and Zephyr,
given to prince Louis I of
Hesse-Darmstadt
1810
Hard-paste porcelain
H. 74.9 cm
Hartford, Connecticut,
Wadsworth Atheneum Museum
of Art
Gift of Mrs. Henry B. Learned
Inv. 1948.109

229. MRKF
Sèvres Imperial Manufactory
Decoration attributed to Marie-
Victoire Jaquotot (1772–1855)
Ice pail with elephant-head
handles from the dessert
service "Gold marly with
grey-painted laurel leaves and
cameo-style heads": Mercury
and Perseus
1809
Hard-paste porcelain
H. 33.8 cm; Diam. 22.4 cm
The Montreal Museum of Fine
Arts
Purchase, gift of the Weider
family in memory of Ben Weider
Inv. 2016.337

230.
Sèvres Imperial Manufactory
Pair of Etruscan carafe vases,
given to Pauline Borghese at
the end of a visit to Sèvres,
December 2, 1809
1809
Hard-paste porcelain
H. 41 cm
Paris, Galerie
Dragesco-Cramoisan

231.
Sèvres Imperial Manufactory
Tea service called "of Famous
Women"
1810-11
Hard-paste porcelain
Varying dimensions
Private collection

232. MRKF
Sèvres Imperial Manufactory
After Antoine-Denis Chaudet
(1763–1810)
Bust of Napoleon, given to
marshal Bessières at the end of
a visit to Sèvres, April 21, 1806
1806
Hard-paste biscuit
52.5 x 26.8 x 20.3 cm
Boston, Museum of Fine Arts
Inv. 1987.489

233. MRKF
Sèvres Imperial Manufactory
Decoration painted by Jean-
François Robert (1778–1855)
Tea service called "of the
Hunt," given to Madame Mère
as a New Year's gift in 1812
1811
Hard-paste porcelain
Tray: 45 x 35 cm
Tea pot: 19 x 19 x 11 cm
Sugar plate: 16 x 14 x 10 cm
Milk jug: 21 x 11 x 9 cm
Cup: 10 x 10 cm
United Kingdom, private
collection

234.
Sèvres Imperial Manufactory
Decoration painted by Jacques-
François Swebach-Desfontaines
(1769–1823)
Bouillon cup and saucer decor-
ated with Race Dressings and
Horse Racing at the Champ-de-
mars, given to the comtesse de
Montalivet, lady-in-waiting, as
a New Year's gift in 1812
1811
Hard-paste porcelain
Cup: H. 12.5 cm
Saucer: Diam. 22.2 cm
Château de Fontainebleau,
Musée Napoléon Ier
Œuvre reconnue par l'État
français d'intérêt patrimonial
majeur, acquise grâce au
mécénat d'Aurignac Finance.
Inv. F2016.23.1

235. MRKF
Sèvres Imperial Manufactory
Decoration painted by Joseph
Deutsch (1784–1860, active at
Sèvres about 1803-19)
Pair of Etruscan carafe vases,
given to the duchess of Istra as
a New Year's gift in 1812
1811
Hard-paste porcelain
H. 24 cm
Private collection

236. MRKF
Sèvres Imperial Manufactory
Tea service called "green
ground, groups of flowers,"
and its case, given to cardinal
Fesch as a New Year's gift
in 1812
1811
Leather, gilding, brass, silk
18.1 x 50.2 x 38.1 cm
The Montreal Museum of Fine
Arts
Purchase, the Museum
Campaign 1988-1993 Fund, the
Montreal Museum of Fine Arts'
Volunteer Association Fund and
the Adrienne D'Amours Pineau
and René Pineau Memorial Fund
2013.69.9

237. MRKF
Sèvres Imperial Manufactory
Decoration painted by Gilbert
Drouet (active at Sèvres
between 1785 and 1825)
Tea service
1811
Hard-paste porcelain
Teapot: 18.1 x 18 x 10.8 cm
Sugar bowl: 15.9 x 13.8 x 9.9 cm
Milk jug: 20.4 x 10.7 x 8.4 cm
Cups: H. 7.8 and 8 cm;
Diam. 7.1 cm
Saucers: Diam. 14.8 and 14.9 cm
Tray: 44.1 x 34.4 cm
The Montreal Museum of Fine
Arts
Purchase, the Museum
Campaign 1988-1993 Fund, the
Montreal Museum of Fine Arts'
Volunteer Association Fund and
the Adrienne D'Amours Pineau
and René Pineau Memorial Fund
Inv. 2013.69.1-8

238.
Sèvres Imperial Manufactory
Decoration painted by
Christophe-Ferdinand Caron
(1774–1831, active at Sèvres
between 1792 and 1815) and
Nicolas-Antoine Lebel (active at
Sèvres between 1804 and 1845)
Egyptian tea service, given to
the duchess of Montebello as a
New Year's gift in 1813
About 1810-12
Hard-paste porcelain
Various dimensions
Œuvre reconnue d'intérêt patri-
monial majeur par l'État français,
en dépôt au musée Napoléon Ier
du château de Fontainebleau
In process of acquisition

239.
Sèvres Imperial Manufactory
Decoration painted by Marie-
Victoire Jaquotot (1772–1855),
Pierre-André Le Guay (active at
Sèvres between 1772 and 1817)
and Jean Georget (1763–1823)
Tea service with portraits of
the princesses of the imperial
family, given to Madame Mère
as a New Year's gift in 1813
1812
Hard-paste porcelain
Various dimensions
Château de Fontainebleau,
Musée Napoléon Ier
Œuvre d'intérêt patrimonial
majeur, acquise avec le concours
du Fonds du patrimoine et grâce
au mécénat d'Hermès, de Carlo
Perrone, président de la société
Mercurio, de la société des amis
du château de Fontainebleau, de
Marc Moura, président d'Alma
F.R.C., de la société Leprince et
de la galerie Vandermeersch.
Inv. F2017.19.1-9

240.
Sèvres Imperial Manufactory
Tea service with cameo
portraits of the imperial family,
given to Augusta-Amélie,
vicereine of Italy, as a New
Year's gift in 1813
1812
Hard-paste porcelain
Tray: 34 x 44.5 cm
Teapot: 14 x 19.1 x 10 cm
Sugar bowl: 17 x 14.5 cm
Saucer: 26 x 15.8 cm
Rueil-Malmaison, Musée national
des châteaux de Malmaison et
Bois-Préau
Inv. M.M.D.11

241.
Sèvres Imperial Manufactory
Decoration painted by Marie-
Philippe Coupin de la Couperie
(active at Sèvres between 1804
and 1812)
Egg vase third size, given to
the princess Aldobrandini as a
New Year's gift in 1813
About 1811
Hard-paste porcelain
H. 68 cm
Private collection

242. MRKF
Sèvres Imperial Manufactory
Tea service imitating mosaic,
given to Pauline Borghese as a
New Year's gift in 1813
1812
Hard paste porcelain
Tray: 42.8 x 34 cm
Teapot: 18.5 x 19 x 10.5 cm
Milk jug: 19 x 11.5 x 6 cm
Sugar bowl: 14 x 12 x 10 cm
Cups: 7.5 x 9.5 x 6.5 cm
Saucers: Diam. 14 cm
New York, Cooper Hewitt,
Smithsonian Design Museum
Inv. 1981-38-1 to 8

243.
Sèvres Imperial Manufactory
Decoration painted by Jacques-
François Swebach-Desfontaines
(active at Sèvres between 1803
and 1813)
Tea service, given to the grand
duchess Elisa of Tuscany as a
New Year's gift in 1814
1813
Hard-paste porcelain
Various dimensions
Tray: 44.6 x 35 cm
Hamburg, Museum für Kunst
und Gewerbe
Inv. 1912-1533

244.
Sèvres Imperial Manufactory
Decoration painted by Abraham
Constantin (1785–1855)
Spindle vase with portrait of
the Empress Marie-Louise,
given to queen Catherine of
Westphalia as a New Year's
gift in 1814
1811-13
Hard-paste porcelain
H. 56 cm
Œuvre reconnue d'intérêt patri-
monial majeur par l'État français,
en dépôt au musée Napoléon Ier
du château de Fontainebleau
In process of acquisition

245.
Sèvres Imperial Manufactory
Decoration painted by Antoine
Béranger (1785–1867) and Jean-
François Philippine (1771–1840)
Tray from a tea service given to
Julie, queen of Spain, as a New
Year's gift in 1814
1813
Hard-paste porcelain
Diam. 14 cm
Stockholm Nationalmuseum
Inv. NMK CXV 543h

246. MRKF
Sèvres Imperial Manufactory
Decoration painted by Étienne-
Charles Le Guay (1762–1846) and
Jacques-Nicolas Sinsson (active
1795–1845)
Tea service Cupids and
Nymphs Playing, given to
Augusta-Amélie, vicereine
of Italy, as a New Year's gift
in 1814
1813
Hard-paste porcelain
Tray: 2.5 x 37.5 x 33.3 cm
Teapot: H. 20.5 cm
Sugar bowl: H. 21 cm
Milk jug: H. 21.3 cm
Jasmine cups (2): H. 11.3 cm
Saucers (2): Diam. 14 cm
New York, The Metropolitan
Museum of Art
Gift of Mr. and Mrs D.N.
Heineman,1956
Inv. 56.29.1-8

247.
Sèvres Imperial Manufactory
After the design of Charles
Percier (1764–1838) and
Alexandre-Théodore
Brongniart, père (1739–1813)
Decoration painted by Gilbert
Drouet (active at Sèvres
between 1785 and 1825) and
Christophe-Ferdinand Caron
(1774–1831, active at Sèvres
between 1792 and 1815)
Estruscan scroll vase called
"Londonderry Vase"
1813
Hard-paste porcelain, gilded
bronze
H. 137.2 cm
The Art Institute of Chicago
Inv. 1987.1

248. MRK
Sèvres Imperial Manufactory
Plate from the service with
nankeen ground: Rhetoric (or
Eloquence)
1802-3
Hard-paste porcelain
Diam. 23.7 cm
Château de Fontainebleau,
Musée Napoléon Ier
Inv. F 2011.1.3

249.
Sèvres Imperial Manufactory
After the design of Charles-Éloi
Asselin (1743–1804)
Plate from the service tortoise-
shell ground figures
1803
Hard-paste porcelain
Diam. 24 cm
Château de Fontainebleau,
Musée Napoléon Ier
Inv. F.1999.10.1

250.
Sèvres Imperial Manufactory
Plate from the dessert service
called "with red ground,
butterflies and flowers," for the
Palais de Fontainebleau
1809
Hard-paste porcelain
Diam. 24 cm
Château de Fontainebleau,
Musée Napoléon Ier
F 2015.11

251. MRK
Sèvres Imperial Manufactory
Decoration painted by Marie-
Victoire Jaquotot (1772–1855)
Plate from the Olympic service:
Apollo and Daphne
1804-14
Hard-paste porcelain
Diam. 23.3 cm
Sèvres, Cité de la céramique
Inv. MNC1790

252.
Alexandre-Théodore
Brongniart, père
Paris 1739 – Paris 1813
Olympic Service
A. Overall Design for the
Centrepiece of the Olympic
Service
Between 1800 and 1813
Graphite, ink, gouache
29 x 85.7 cm
B. Design for a Bowl from the
Olympic Service
1806
Graphite, ink, gouache
32.5 x 38.8 cm
C. Design for the Form and
Decoration of a Sugar Bowl
from the Olympc Service
1806
Graphite, ink, gouache
24.8 x 27.5 cm
D. Design for Tiered Plates for
the Olympic Service
1806
Graphite, ink, gouache
39 x 32.8 cm
Sèvres, Cité de la céramique
Inv. 2012.1.796, 2011.3.2002,
.2003, .2004

253.
Sèvres Imperial Manufactory
Decoration painted by Gilbert
Drouet (active at Sèvres
between 1785 and 1825)
Sugar bowl with eagle-head
handles from the service
"garland of flowers on gold
ground"
About 1808
Hard-paste porcelain
24 x 31 cm
Private collection

254.
Sèvres Imperial Manufactory
Antique cornet vase from a
pair, from the Olympic service
1807-13
Hard-paste porcelain
44 x 43.5 x 2.5 cm
Paris, Musée du Louvre
Inv. OA11174 ; OA11175

The Emperor's personal
service: Dessert service
255-259

255.
Sèvres Imperial Manufactory
Decoration painted by Nicolas-
Antoine Lebel (active at Sèvres
between 1804 and 1845)
Sugar bowl from a series of
four
1809 (sugar bowl), 1810 (base)
Hard-paste porcelain
H. 30 cm (approx.)
Montreal, Alexandre de Bothuri
Báthory / Élaine Bédard de
Bothuri
On loan to Musée du Château
Dufresne-Nincheri

256. MRK
Sèvres Imperial Manufactory
Etruscan fruit dish with handles
1810
Hard-paste porcelain
L. 25 cm
Geneva, Collection Comte
et ComtesseCharles-André
Colonna Walewski

257.
Sèvres Imperial Manufactory
Ice pail
1810
Hard-paste porcelain, silver-gilt
H. 33.5 cm; Diam. 22.5 cm
Château de Fontainebleau,
Musée Napoléon Iᵉʳ
Inv. F.1995.3(1)

258. MRK
Sèvres Imperial Manufactory
Plate: The Imperial Bivouac
About 1810
Hard-paste porcelain
Diam. 24 cm
Private collection

259.
Sèvres Imperial Manufactory
Decoration by Jean-François
ROBERT (1778-1855)
Plate: Construction of the
Triumphal Arch of Carrousel
1807-11
Hard-paste porcelain
Diam. 24 cm
Paris, Musée de l'Armée

Centrepiece from the
Emperor's personal service
260-263

260.
Sèvres Imperial Manufactory
Centrepiece: Armchair called
"Seat of Bacchus"
1810
Hard-paste biscuit, gilded metal
44.2 x 32.6 cm
Château de Fontainebleau,
Musée Napoléon Iᵉʳ
Inv. F2007.6

261. MRK
Sèvres Imperial Manufactory
Modelled by Jean-Nicolas-
Alexandre BRACHARD III (active at
Sèvres between 1795 and 1827)
After designs by Alexandre-
Théodore BRONGNIART, père
(1739-1813)
Statuettes after antiquity
1811-19
Hard-paste biscuit
A. Asclepius
H. 37.4 x 6.1 x 10.9 cm
B. Hyginus
H. 37 cm
C. Emperor Augustus
H. 37 x 16 x 13 cm
D. Juno of the Capitole
H. 39 cm
E. Deidamia
36.8 x 12.3 x 10.9 cm
F. Didius Julianus
37 x 17 x 15 cm
G. Melpomene
H. 37 cm
Sèvres, Cité de la céramique
Inv. MNC 26656, 26657, 26654-
26555, 27711, 28216, 28217

262.
Alexandre BRONGNIART
Paris 1770 – Paris 1847
Design for the Centrepiece for
the Emperor's Personal Service
About 1808-9 (?)
Ink
98.5 x 39 cm
Pierrefitte-sur-Seine, Archives
nationales
Inv. O² 922

263. MRK
Sèvres Imperial Manufactory
Jean-Charles-Nicolas BRACHARD
II (active at Sèvres between 1782
and 1800 and between 1805
and 1823)
Elements of the centrepiece:
Victory Guiding the Horses
of Napoleon's Chariot and
antique candlestick
Re-edition of the model from
1809-10
Hard-paste biscuit
Figure: H. 52 cm
Candlestick: 86 x 32 cm
Collection LUPB - Bruno Ledoux
Inv. 2008. 1-2

264.
Robert LEFEÈVRE
Bayeux 1756 – Paris 1830
Portrait of Jean-Baptiste-
Claude Odiot
1822
Oil on canvas
157.4 x 125.1 cm
Detroit Institute of Arts Founders
Society
Purchase, Robert H. Tannahill
Foundation Fund
Inv. 81.692

265.
Workshop of Jean-Baptiste-
Claude ODIOT (1763-1850)
Adrien-Louis-Marie CAVELIER
Paris 1785 – Paris 1867
Life-size Design for the Cheval
Glass (psyché) of the Empress
Marie-Louise
1810
Ink, watercolour, wash
305 x 173.5 cm
Geneva, Collection Comte
et Comtesse Charles-André
Colonna Walewski

266.
Workshop of Jean-Baptiste-
Claude ODIOT (1763-1850)
Design by Adrien-Louis-Marie
CAVELIER (1785-1867)
Design for the King of Rome's
Crib
1811
Graphite, ink, watercolour,
gouache
43 x 56.3 cm
Paris, Musée des Arts décoratifs
Inv. 2009.174.6

267.
Workshop of Jean-Baptiste-
Claude ODIOT (1763-1850)
Modelled by Charles-Jean-
Alexandre MOREAU (about
1760- 840)
Drawing by Auguste GARNERAY
(1785-1824)
Design for a Vase for the Kettle
of a Tea Service
About 1810
Graphite, grey ink, grey wash
and sepia
72 x 44.8 cm
Paris, Musée des Arts décoratifs
Inv. 2009.174.12

268.
Workshop of Jean-Baptiste-
Claude ODIOT (1763-1850)
Design for a Water Glass for the
Emperor
1811
Graphite, ink, wash, watercolour
44.2 x 32.1 cm
1811
Paris, Musée des Arts décoratifs
Inv. 2009.174.103

269.
Workshop of Jean-Baptiste-
Claude ODIOT (1763-1850)
Design attributed to Auguste
GARNERAY (1785-1824)
Design for a Writing Case for
the Empress Marie-Louise
About 1811
Graphite, wash, watercolour
48.9 x 60.5 cm
Paris, Musée des Arts décoratifs
Inv. 2009.174.11

270.
Workshop of Jean-Baptiste-
Claude ODIOT (1763-1850)
Design for a Writing Case for
the Emperor
About 1811
Graphite, ink
41.5 x 55.5 cm
Paris, Musée des Arts décoratifs
Inv. 2009.174.176

271. MRK
Jean-Baptiste-Claude ODIOT
Paris 1763 – Paris 1850
Part of Madame Mère's Vermeil
service
1806
Silver-gilt
Pair of tureens:
38.7 x 49.5 x 29.2 cm
Pair of coolers:
13.9 x 22.2 x 36.2 cm
4 covered dishes 30.5 x 27.9 cm
4 entrée dishes: 20.9 x 29.2 cm
2 gravy boats:
27.6 x 26.7 x 13.3 cm
Pair of salt cellars:
23.5 x 18.2 x 9.2 cm
10 coasters: 11.8 x 2.7 cm
22 plates: Diam. 24.5 cm
Meat platter: 62.2 x 38.1 cm
Private collection

272.
Jean-Baptiste-Claude ODIOT
Paris 1763 – Paris 1850
Nicolas-Noël BOUTET
Paris 1761 – Paris 1833
François-Regnault NITOT
Champigny 1779 – Paris 1853
Sword of the First Consul, later
Emperor, called "Coronation
Sword"
About 1800-4
Gold-damascened steel,
diamonds, tortoiseshell, jasper
L. 96 cm
Château de Fontainebleau,
Musée Napoléon Iᵉʳ
Inv. N204

273.
Workshop of Martin-Guillaume
BIENNAIS (1764-1843)
Design attributed to Charles
PERCIER (1764-1838)
Design for the High Altar for
the Emperor's Wedding at the
Louvre in 1810
About 1810
Black ink, watercolour
53.5 x 55.3 cm
Paris, Musée des Arts décoratifs
Inv. CD 3258

274. MRK
Detail of a candlestick: the
imperial coat of arms removed
and date erased

275.
Henry AUGUSTE
Paris 1759 – Jamaica about 1816
Altar fixtures for the wedding
of Napoleon and Marie-Louise,
later for the chapel at the
Tuileries: six candlesticks and
a crucifix
1809
Silver-gilt
Candlesticks: 233 x 51 x 51 cm
Crucifix: 321 x 100 x 50 cm
Reims, Palais du Tau
En dépôt au Centre des
monuments nationaux,
actuellement déposée par le
CMN au palais du Tau
Inv. CMN (DTAU 1935000139,
439-444)

276-279
Henry AUGUSTE
Paris 1759 – Jamaica 1816
Emperor's Grand Vermeil
Service
276. The Emperor's nef
1804
68 x 72 cm
277. Glass cooler (no. 2)
1804
18 x 42 x 22 cm
278. The Emperor's caddinet
1804
14 x 35.7 x 25.1 cm
279. Pot à oille and tray
1789-1804
51 x 53.4 cm
Silver-gilt
Château de Fontainebleau,
Musée Napoléon Iᵉʳ (dépôt du
Mobilier national)
Inv. GMLC327

280.
Alexandre-Benoît-Jean DUFAY,
called CASANOVA
Paris 1770 – Paris 1844
Imperial Banquet Held for the
Wedding of Napoleon and
Marie-Louise, April 2, 1810
1812
Oil on canvas
148 x 224.5 cm
Château de Fontainebleau,
Musée Napoléon Iᵉʳ (dépôt du
musée national du château de
Versailles)
Inv. MV8071

281.
Charles PERCIER
Paris 1764 – Paris 1838
Pierre-François-Léonard
FONTAINE
Pontoise 1762 – Paris 1853
The Imperial Banquet, in the
Grand Hall at the Tuileries, Held
for the Wedding of Napoleon
and H. I. H. the Archduchess
Marie-Louise
1810
Ink
36.5 x 23.5 cm
Ajaccio, Musée Fesch
Inv. MNA 2014.1.1

282.
Étienne-Judes THIERRY
Paris 1787 – 1832 (?)
After Charles PERCIER
(Paris 1764 – Paris 1838) and
Pierre-François-Léonard FONTAINE
(Pontoise 1762 – Paris 1853)
Plan for the performance hall
at the Palais des Tuileries, and
the arrangement made for the
Imperial Banquet on the day of
the Emperor's wedding
1810
Etching
42.8 x 31.8 cm
Paris, Bibliothèque nationale
de France

283. MRKF
Horace VERNET
Paris 1789 – Paris 1863
Napoleon, on the Eve of the
Battle of Borodino, Presenting
to His Staff Officers the Portrait
of the King of Rome Recently
Painted by Gérard
1813
Oil on canvas
32 x 47 cm
The Montreal Museum of Fine
Arts
Purchase, gift of the Honourable
Serge Joyal, P.C., O.C., O.Q., in
honour of the anniversary of the
Ben Weider donation
Inv. 2017.369

284. M
Antoine-Jean GROS
Paris 1771 – Meudon 1835
Napoleon on the Battlefield of
Eylau, sketch for the painting of
the Salon of 1808
1807
Oil on canvas
104.9 x 145.1 cm
Toledo Museum of Art
Purchased with funds from the
Libbey Endowment, Gift of
Edward Drummond Libbey
Inv. 1988.54

285.
François-Pascal-Simon GÉRARD
Rome 1770 – Paris 1837
The Infant King of Rome
1812
Oil on canvas
61 x 50.5 cm
Château de Fontainebleau,
Musée Napoléon Iᵉʳ
Inv. F 1987.4

286.
(detail of 294)

287.
ANONYMOUS
After Jacques-François LLANTA
(1807-1864)
Bust-length Portrait of Étienne-
Marie-Antoine, General-Comte
de Nansouty, First Equerry to
the Emperor
About 1830-50
Lithography
21 x 14.6 cm
Musée national des châteaux de
Versailles et de Trianon
Inv. GRAV6984

288-290. MRK
Pierre MARTINET
Paris 1781 – (?), active between
1808 and 1812
The Emperor's Horses
288. "Sheik"
289. "Triumphant"
290. "Distinguished"
1806
Oil on canvas
24 x 32 cm (with frame), each
Rueil-Malmaison, Musée national
des châteaux de Malmaison et
Bois-Préau
Inv. MM 40.47.2953, .2959, .2958

291.
Alexandre Ivanovitch SAUERWEID
Courland (now Latvia) 1783 –
Saint Petersburg 1844
Sara, the Emperor's Horse, in
the Tuileries Courtyard, before
a Review of the Imperial Guard
1813
Oil on canvas
49 x 60 cm
Private collection

292. MRKF
Alexander Ivanovich SAUERWEID
Courland (now Latvia) 1783 –
Saint Petersburg 1844
Sara, the Emperor's Horse, in
the Park at the Trianon
19th c.
Oil on canvas
Paris, Musée de l'Armée
Inv. 3653 DEP

293.
Étienne-Barthélemy GARNIER
Paris 1759 – Paris 1849
The Wedding Procession of
Napoleon and Marie-Louise
Passing through the Tuileries
Garden, April 2, 1810
1810
Oil on canvas
327 x 495 cm
Musée national des châteaux de
Versailles et de Trianon
Inv. MV6354

294. MF
Jacques BERTAUX
Arcis-sur-Aube about 1745 – Paris
1818
The Imperial Procession
Arriving at Notre-Dame for
the Coronation Ceremony,
December 2, 1804: Crossing
the Pont-Neuf
1805
Oil on canvas
71 x 101 cm
Paris, Musée Carnavalet

295. MRK
Louis-François CHARON
1783 – (?) about 1840
The Coach of His Majesty
Napoleon on His Wedding Day
to Marie-Louise, Archduchess
of Austria
After 1810
Coloured engraving
19 x 48.2 cm
Montreal, McGill University
Library and Archives, Rare Books
and Special Collections
Inv. 4° V 005

296.
Jean-Ernest-Auguste GETTING
Active in Paris in the early 19th c.
Victory, the ceremonial coach
with seven windows for the
coronation of Napoleon in
1804
About 1804
Gilded and painted wood,
metal, textiles
268 x 210 x 530 cm
Musée national des châteaux de
Versailles et de Trianon
Inv. T734C

297.
Pierre-François-Léonard
FONTAINE
Pontoise 1762 – Paris 1853
The Emperor and Empress
Descending from the Coach on
Their Wedding Day
1810
Watercoloured drawing
23.7 x 28.5 cm
Paris, Musée du Louvre
Inv. RF41486-11-folio37

298.
Pierre-François-Léonard
FONTAINE
Pontoise 1762 – Paris 1853
The Emperor and the Empress
Entering Paris on Their
Wedding Day
1810
Watercoloured drawing
28.5 x 29 cm
Paris, Musée du Louvre
Inv. FR41483-5-folio31

299. MRKF
Antoine-Charles Horace, called
Carle VERNET
Bordeaux 1758 – Paris 1836
Napoleon Hunting with Hounds
in the Forest of Fontainebleau
19th c.
Oil on canvas
253.5 x 159.5 cm
Paris, Musée de la Chasse et de
la Nature
Inv. 196

300. MRKF
Jean Le Page
Tessy-sur-Vire 1746 – Paris 1834
Louis XVI's flintlock rifle, used
by Napoleon
About 1775
Wood, iron, silver
L. 138.5; Diam. (barrel) 1.6 cm
Paris, Musée de la Chasse et de
la Nature (dépôt du musée de
l'Armée)
Inv. 2462

301. MRKF
Nicolas-Noël Boutet
Paris 1761 – Paris 1833
Hunting carabine, given by the
Emperor to general Rapp
About 1806-9
Wood, steel, gold, silver,
silver-gilt
85.5 cm
Paris, Musée de la Chasse et de
la Nature (dépôt du musée de
l'Armée)
Inv. PO 948

302. MRK
Gervais Chardin
Active in Paris in the early 19th c.
Pair of riding gloves from the
Emperor's wardrobe
About 1810
Beaver pelt, embroidered with
fine gold braid
22 x 10 cm
The Montreal Museum of Fine
Arts
Ben Weider Collection
Inv. 2008.409.1-2

303. MRK
Anonymous
Napoleon's hunting dagger
(detail)
About 1804
Gold, gilded bronze, steel,
ebony, leather (sheath)
66 x 14.5 cm
Château de Fontainebleau,
Musée Napoléon Ier
Inv. N 3115

304. MRK
Workshop of François-Honoré-
Georges Jacob-Desmalter
(1770-1841)
Chair called "parrot"
First Empire (1804-15)
Mahogany, leather
87 x 41 x 40 cm
Paris, Mobilier national
Inv. GMT 2427/3

305.
View of the Great Stage Hunt
Held in Honour of the T. M.
the Emperors Alexander and
Napoleon
Published in Charles Augustus,
duke of Saxe-Weimar,
Description des fêtes données
à Leurs Majestés les empereurs
Napoléon et Alexandre . . . le 6
et le 7 octobre
1809
Coloured engraving
30 x 46 cm
Paris, Bibliothèque nationale
de France
Inv. recueil PD 91 FOL

306.
Attributed to
Louis Reviglio
Active between 1809 and 1832
The Palazzina di Stupinigi
in Piedmont, design for the
decoration for the table called
"of the imperial palaces"
1811
Gouache on cardboard
Diam. 32 cm
Sèvres, Cité de la céramique
Inv. Section P, § 1er 1811 no 18

307.
Antoine-Charles-Horace, called
Carle Vernet
Bordeaux 1758 – Paris 1836
H. M. Napoleon on a Hunt in
the Bois de Boulogne
1811
Oil on canvas
131 x 162.5 cm
Saint Petersburg, State
Hermitage Museum
Inv. GE 5671 ГЭ-5671

308.
Jean-Louis Demarne
Brussels 1752 – Paris 1829
The Emperor and Pope
Pius VII Meeting in the Forest
of Fontainebleau (detail)
1808
Oil on canvas
223 x 229 cm
Château de Fontainebleau,
fonds palatial (dépôt du
musée national du château de
Versailles)
Inv. INV6438; MV1706

309.
Alexandre Menjaud
Paris 1773 – Paris 1832
The Empress Marie-Louise
Painting a Portrait of Napoleon
1810
Oil on canvas
72 x 59 cm
Château de Fontainebleau,
Musée Napoléon Ier (dépôt du
musée national du château de
Versailles)
Inv. MV 4704

310.
Cousineau père et fils (active
between 1784 and 1805)
The Empress Josephine's harp
About 1805
Mahogany, gilded bronze
192 x 78 cm
Rueil-Malmaison, Musée national
des châteaux de Malmaison et
Bois-Préau
Inv. MM. 40.47.127

311.
Auguste Garneray
Paris 1785 – Paris 1824
View of the Music Room at
Malmaison
About 1812
Watercolour with gouache
highlights, mounted
66.5 x 91 cm
Rueil-Malmaison, Musée national
des châteaux de Malmaison et
Bois-Préau
Inv. MM.40.47.7215

312.
Érard Frères
Decoration by Antoine Rascalon
The Empress Marie-Louise's
pianoforte at the Grand
Trianon
1809, delivered 1810
Mahogany, gilded bronze
168 x 80.5 x 66.5 cm
Musée national des châteaux de
Versailles et de Trianon
Inv. V3555; Vmb14365

313.
Workshop of François-Honoré-
Georges Jacob-Desmalter
(1770-1841)
The Empress Josephine's
reading table used as a
letterbox at the Grand Trianon
1805-10
Mahogany, gilded bronze
67.5 x 71 x 42 cm
Musée national des châteaux de
Versailles et de Trianon
Inv. T 10 C

314.
Workshop of Alexandre Maigret
(active about 1775-1826)
The Empress Marie-Louise's
embroidery frame in her study
at Fontainebleau
Delivered 1810
Château de Fontainebleau,
fonds palatial

315. MRKF
Fortuné Dufau
Saint-Domingue about 1770 –
Paris 1821
Portrait of the Family of
General Armand-Samuel de
Marescot with His Wife, Cécile,
His Son, Antoine-Samuel, His
Daughter, Joséphine-Cécile,
and His Mother-in-law, Marie-
Charlotte d'Artis de Thiézac
1806
Oil on canvas
240 x 195 cm
France, private collection

316.
Jean-Baptiste Isabey
Nancy 1767 – Paris 1855
Illustration from the Livre du
Sacre (1804) by Charles Percier
and Pierre-Léonard-François
Fontaine
Costume of a Page (pl. XXX)
Ink, wash
Château de Fontainebleau,
Musée Napoléon Ier
Inv. GMBibl.3502

317.
Leonardo de Vinci
Vinci 1452 – Amboise 1519
Virgin and Child with Saint
Anne
About 1503-19
Oil on wood
168 x 130 cm
Paris, Musée du Louvre
Inv. 776

318.
Jean-Ange-Joseph Loque
1752-1835, active in Paris in 1777
until 1815-20
Silver from the chapel of
the pages of the Imperial
Household
1805
Silver-gilt
A. Ewer: 35 x 13 cm
 Basin (ewer): 11 x 44 x 25.5 cm
B. Cruets: 18 x 6.5 cm
 Basin (cruets): 6.8 x 33 x 20.4 cm
 Paten: 1.5 x 16.8 cm
 Candleholder: 7 x 33.5 x 11.5 cm
C. Chalice: 29.5 x 15.5 cm
D. Ciborium: 27 x 13.5 cm
Paris, Mobilier national
Inv. GMLC 43-48

319.
Thomas Gainsborough
Sudbury 1727 – London 1788
Portrait of John Hayes Saint
Leger
1782
Oil on canvas
277.8 x 217.1 x 10.2 cm
London, Collection of H. M.
Queen Elizabeth II
Inv. RCIN 405726

320.
Antoine-Jean Gros
Paris 1771 – Meudon 1835
The General-Comte Jean
Ambroise de Lariboisière
Bidding His Son Ferdinand
Goodbye
1814
Oil on canvas
294 x 235 cm
Paris, Musée de l'Armée
Inv. 4990 I; Ea 156

321. MRK
Antoine-Jean Gros
Paris 1771 – Meudon 1835
Portrait of Dominique-
Alexandre Legrand, Former
Page to the Emperor, in the
Uniform of a Second Lieutenant
of the Hussars
About 1809-10
Oil on canvas
281.9 x 209.5 x 13.9 cm
Los Angeles County Museum
of Art
Gift of California Charities
Foundation
Inv. 49.41

322.
Jacques-Louis David
Paris 1748 – Brussels 1825
The Emperor Napoleon in His
Study at the Tuileries
1812
Oil on canvas
203.9 x 125.1 cm
Washington, D.C., National
Gallery of Art
Samuel H. Kress Collection
Inv. 1961.9.15

323.
Seven maps of Germany in
a case
Case: Morocco leather, silk-lined
paper
24 x 14.8 x 8 cm
Prints (maps)
51.5 x 60.5 cm
Rueil-Malmaison, Musée national
des châteaux de Malmaison et
Bois-Préau
Inv. MM.40.47.6302;
MM.40.476303

324. MRK
Anonymous, France
Writing case with a pen holder
After 1805
Long grain red morocco leather,
gilded fittings
Writing case: 32.2 x 33 cm
Pen case: H. 31.5 cm;
Diam. 3.8 cm
The Montreal Museum of Fine
Arts
Ben Weider Collection
Inv. 2008.404.1-2

325.
Workshop of François-Honoré-
Georges Jacob-Desmalter
(1770-1841)
Armchair in Napoleon's study
at the Grand Trianon
1810
Mahogany, bronze, leather,
gilded veneering
110.5 x 70 x 52 cm
Musée national des châteaux de
Versailles et de Trianon
Inv. V6119

326. M
Jules Vernet
(?) 1780 – Paris 1843
Portrait of M. Barbier, Librairian
to H. M. the Emperor and H. M.
Louis XVIII
1822
Gouache on wood
22.5 x 15 cm
Paris, Musée des Arts décoratifs
Inv. 39595

327.
Anne-Louis Girodet de
Roussy-Trioson
Montargis 1767 – Paris 1824
Minerva between Apollo and
Mercury, ceiling decoration
for the Emperor's study at
Compiègne
Between 1814 and 1821
Oil mounted on canvas
320 x 260 cm
Musée national du château de
Compiègne
Inv. INV4946

328.
View of Napoleon's library
(study) at the Palais de
Compiègne in its current state

329.
View of Napoleon's library at
the Château de Fontainebleau
in its current state

330.
Élisabeth Louise Vigée-Lebrun
Paris 1755 – Paris 1842
Portrait of Giuseppa Grassini
as Zaïre
1804
Oil on canvas
133 x 99 cm
Musée des beaux-arts de Rouen
Inv. 1842.3

331.
Louis-Léopold Boilly
La Bassée 1761 – Paris 1845
Portrait of François-Joseph
Talma
About 1800
Oil on canvas
20.8 x 17.5 cm
Lille, Palais des Beaux-Arts
Inv. P.377

332.
Jean-Baptiste Isabey
Nancy 1767 – Paris 1855
Bust-length Portrait of Luigi
Cherubini
1811
Watercolour
12.5 x 9.7 cm
Paris, Musée du Louvre
Inv. RF3839-recto

333.
Jean-Baptiste Isabey
Nancy 1767 – Paris 1855
Armide, scenery sketch (Act II)
1811
Ink, watercolour
35.5 x 51.7 cm
Paris, Bibliothèque nationale
de France, département
Bibliothèque-musée de l'opéra
Inv. BMO ESQ 19-16

334.
Jean-Baptiste Isabey
Nancy 1767 – Paris 1855
"Place Italy," scenery sketch
Ink, watercolour, white highlights
19th c.
18.4 x 23.8 cm
Paris, Musée du Louvre
Inv. RF 3622, Recto

335.
Sebastiano Serlio
Bologne 1475 – Fontainebleau
1554
"Tragic Scene" in Traité sur la
scène
1550-53
Printed book with woodcut
illustrations
Bois gravé
33.7 x 23.5 x 8.9 cm
New York, The Metropolitan
Museum of Art
Bequest of W. Gedney Beatty,
1941
Inv. 41.100.143

336.
Jean-Baptiste Isabey
Nancy 1767 – Paris 1855
Les Amours d'Antoine et
Cléopâtre, scenery sketch
"Vestibule of the Vulcan
Temple"
1808
Ink, sepia
26.6 x 37.9 cm
Paris, Bibliothèque nationale
de France, département
Bibliothèque-musée de l'opéra
Inv. BMO ESQ 19-19

337.
Louis-Pierre Baltard
Paris 1764 – Lyon 1846
After Dominique-Vivant Denon
(1747-1825)
Interior of the Temple of
Apollinopolis at Edfu
In Voyage dans la Basse et
la Haute Égypte, Paris, 1802,
pl. LVII
1802
Engraving on copper
19.5 x 28.2 cm
Paris, private collection

338.
Jean-Baptiste Isabey
Nancy 1767 – Paris 1855
Les Amours d'Antoine et
Cléopâtre, scenery sketch
("Portico of Alexandria")
1808
Ink, sepia
26 x 33.7 cm
Paris, Bibliothèque nationale
de France, département
Bibliothèque-musée de l'opéra
Inv. BMO ESQ 19-18

339.
Charles Percier
Paris 1764 – Paris 1838
Pierre-François-Léonard
Fontaine
Pontoix 1762 – Paris 1853
"Bed executed in Paris for Mr
O . . ."
Pl. 25 in Recueil de décorations
intérieures
1812
49 x 33 cm
Bibliothèque nationale de
France, département Réserve
des livres rares
Inv. V-2613

340. MRK
Joseph Chinard
Lyon 1756 – Lyon 1813
Bust of the Empress Josephine
1805
Marble
71.1 x 44.4 x 28 cm
Ottawa, National Gallery of
Canada
Purchased 1967
Inv. 15265

341. MRK
Pascalie Hosten, comtesse
d'Arjuzon
Saint-Domingue 1774 – Paris
1850
The Renoucement of Madame
de Lavallière
1813
Gouache
24 x 22 cm
Paris, private collection

342. MRK
Pascalie HOSTEN, comtesse
d'Arjuzon
Saint-Domingue 1774 – Paris
1850
After Fleury RICHARD (1777–1852)
*Henry IV and Gabrielle
d'Estrées*
1813
Gouache
81.5 x 27 cm
Paris, private collection

343. MRK
Jean-Baptiste ISABEY
Nancy 1767 – Paris 1855
Portrait of Queen Hortense
1814
Watercolour
12.5 x 9 cm
Paris, private collection

344.
Guillaume DESCAMPS
Lille 1779 – Paris 1858
*Presumed Portrait of Claire
de Vergennes, Comtesse de
Rémusat, Lady-in-waiting to
the Empress Josephine*
1813
Oil on canvas
54 x 47.5 cm
Rueil-Malmaison, Musée national
des châteaux de Malmaison et
Bois-Préau
Inv. MM6771

345.
Nicolas JACQUES
Jarville-la-Malgrange 1780 –
Paris 1844
*Portrait of the Baron Martial
Daru, Intendant of the Crown
Holdings*
1809
Watercolour on ivory
7.5 x 6.5 cm
Grenoble, Musée Stendhal
Inv. n°1161

346.
Attributed to Edme QUENEDEY
Ricey-le-Haut 1756 – Paris 1830
*Portrait of Henri Beyle, called
Stendhal*
1807
Pencil, charcoal
53 x 41 cm
Grenoble, Musée Stendhal
Inv. 208

347.
Giovanni Battista LUSIERI
Rome 1755 – Athens 1821
*A View of the Bay of Naples,
Looking Southwest from the
Pizzofalcone towards Capo di
Posilippo*
1791
Graphite, ink, watercolour,
gouache
101.8 x 271.9 cm (six sheets)
Los Angeles, The J. Paul Getty
Museum
Inv. 85.GC.281

348. MRK
Louis DUCIS
Versailles 1775 – Paris 1847
*Louis XVIII, with Members
of the Royal Family
Attending from the Balcony
at the Tuileries the Return
of the Troops from Spain,
December 2, 1823*
1823-24
Oil on canvas
146 x 112 cm
Musée national des châteaux de
Versailles et de Trianon
Inv. MV6837

349. MRK
Jean-Charles CAHIER
Soissons 1772 – Marseille 1849
(cup and cup surround)
ANONYMOUS, FRANCE
(knop and stem)
*Chalice from the imperial
chapel*
About 1804-9
Silver, silver-gilt
H. 29 cm; Diam. 14.5 cm
Weight: 629.6 g
The Montreal Museum of Fine
Arts
Gift of the Honourable Serge
Joyal, P.C., O.C.
Inv. 2014.48

350.
Antoine-Jean GROS
Paris 1771 – Meudon 1835
*Napoleon Placing the Empress
Marie-Louise and the King of
Rome under the Protection of
the National Guard*
About 1814
Ink
45 x 68 cm
Château de Fontainebleau,
Musée Napoléon Ier (dépôt du
Musée national des châteaux de
Malmaison et Bois-Préau)
Inv. MM40.47.1330

351. MRK
Friedrich Philipp REINHOLD
Gera, Germany, 1779 – Vienna
1840
Léopold BEYER
Vienna (?) 1784 – Vienna (?) 1870
*Napoleon Leaving for the
Island of Elba, April 20, 1814*
After 1814
Coloured engraving
41.7 x 55.4 cm
Montreal, McGill University
Library and Archives, Rare Books
and Special Collections
Inv. 4° N IV 031

352. MRK
Friedrich SCHROEDER
Cassel 1768 – Paris 1839
*Napoleon's Residence on the
Island of Elba*
Published in M. de Norvins,
Histoire de Napoléon I, Paris,
Bureau des publications illus-
trées, 1844, vol. 2
About 1844
Etching
Montreal, McGill University
Library and Archives, Rare Books
and Special Collections
Inv. DC203 N89 1844

353.
François-Pascal-Simon GÉRARD
Rome 1770 – Paris 1837
*Portrait of Marie Łaczińska,
comtesse Walewska*
About 1810
Oil on canvas
241 x 162 cm
Paris, Musée de l'Armée
Inv. 27828 ; Ea 769

354.
Antoine-Jean GROS
Paris 1771 – Meudon 1835
*Louis XVIII Leaving from the
Palais des Tuileries on the Night
of March 20, 1815*
1817
Oil on canvas
405 x 525 cm
Musée national des châteaux de
Versailles et de Trianon
Inv. MV1778

355. MRK
ANONYMOUS
*Napoleon Returning to the
Tuileries in 1815*
After 1815
Aquatint
20.6 x 31.6 cm
Montreal, McGill University
Library and Archives, Rare Books
and Special Collections Inv. 8°
N IV 009

356. MRK
ANONYMOUS
The Fall of Napoleon
About 1814
Engraving
35.2 x 32.7 cm
Montreal, McGill University
Library and Archives, Rare Books
and Special Collections
Inv. Folio N III 039

357. MRK
ANONYMOUS
The Corsican Fop in Full Spin
N.d.
Coloured etching
27 x 32 cm
Montreal, McGill University
Library and Archives, Rare Books
and Special Collections
Inv. 4° NC 087

358. MRK
ANONYMOUS
Inspired by MICHELANGELO
(1475-1564)
The Last Judgment
N.d.
Aquatint
26 x 38 cm
Montreal, McGill University
Library and Archives, Rare Books
and Special Collections
Inv. 4° NC 079

359. MRK
ANONYMOUS
*Proposition for a Constitution
to the Inhabitants of the Island
of Saint Helena by the Former
Emperor and King*
In Paris, at Marchands de
Nouveautés
About 1815-16
Coloured etching
33.5 x 26 cm
Montreal, McGill University
Library and Archives, Rare Books
and Special Collections
Inv. 4° NC 045a; 4° NC 023

360.
ANONYMOUS
After Jacques-Noël-Marie FRÉMY
(1782-1866)
Portrait of Sir Hudson Lowe
Frontispiece of Charles-Tristan
de Montholon, *History of the
Captivity of Napoleon at Saint
Helena*, London, H. Colburn,
1846-47, vol. 3
About 1846
Engraving
20 x 12.5 cm
Montreal, McGill University
Library and Archives, Rare Books
and Special Collections
Inv. DC211 M6613 1846

361. MRK
Louis-François CHARON
Versailles 1783-about 1840
After Achille Louis MARTINET
(1806-1877)
*Portrait of Charles-Tristan,
General-Comte de Montholon,
Former Chamberlain*
About 1820
Aquatint
47.5 x 33 cm
Montreal, McGill University
Library and Archives, Rare Books
and Special Collections
Inv. 4° P 028

362. MRK
Joseph LANGLUMÉ
Active in France, 1819-30
*Portrait of Gaspard, Baron
Gourgaud, Former Aide-de-
camp to the Emperor*
Published in *Recueil de pièces
authentiques sur le captif de
Sainte-Hélène, de mémoires et
documents écrits ou dictés par
l'Empereur Napoléon . . .* , Paris,
Alexandre Corréard, 1821-25,
vol. 2
1822
Lithograph
19.5 x 12 cm
Montreal, McGill University
Library and Archives, Rare Books
and Special Collections
Inv. DC211 R438 1821

363. MRK
Ground Plan of Longwood
Engraved by Sidney HALL
(1788-1831)
Published by Henry Colburn &
Co., London
1822
Line-engraving
21 x 26.4 cm
Montreal, McGill University
Library and Archives, Rare Books
and Special Collections
Inv. DC211 L363 1855

364. MRK
Attributed to
Louis-Joseph-Narcisse
MARCHAND
Paris 1791 – Trouville-sur-Mer
1876
View of Longwood House
1819
Gouache
Dimensions unknown
Châteauroux, Musée-hôtel
Bertrand

365. MRK
Joseph LANGLUMÉ
France, active 1819-30
*Emmanuel de Las-Cases,
Former Chamberlain, and
His Son*
Frontispiece of *Recueil de
pièces authentiques sur le
captif de Sainte-Hélène, de
mémoires et documents écrits
ou dictés par l'Empereur
Napoléon . . .* , Paris, Alexandre
Corréard, 1821-25, vol. 2
1822
Lithograph
21 x 12 cm
Montreal, McGill University
Library and Archives, Rare Books
and Special Collections
Inv. DC211 R438 1821

366.
Louis-Nicolas LEMASLE
Paris 1788 – Barisis-aux-Bois 1876
*Portrait of Alexandre Pierron,
Former Butler to the Emperor
on Saint Helena*
1827
Oil on wood
28 x 23.5 cm
Rueil-Malmaison, Musée national
des châteaux de Malmaison et
Bois-Préau
Inv. M.M.2015.11.1

367. MRK
Martin-Guillaume BIENNAIS
La Cochère 1764 – Paris 1843
Pierre-Benoît LORILLON
Villeblevin (?) 1757 – Villeblevin
(?) 1816
*Utensils used by Napoleon
during his time on Saint Helena*
Between 1809 and 1816
Silver
Knife: L. 23.9 cm
Fork: L. 21.9 x 2.9 cm
Soup spoon: L. 21.8 x 4.7 cm
Teaspoon: L. 14.6 x 2.7 cm
The Montreal Museum of Fine
Arts
Loaned by Ben Weider
1422.2007.1-4

368. MRK
Martin-Guillaume BIENNAIS
La Cochère 1764 – Paris 1843
*Milk jug with imperial coat of
arms, used during Napoleon's
time on Saint Helena*
About 1810-14
Silver-gilt
18 x 10.4 x 9.5 cm
The Montreal Museum of Fine
Arts
Ben Weider Collection
Inv. 2008.405

369. MRK
ANONYMOUS
*Napoleon Buonaparte, from
a drawing taken by Captain
Dodgin of the 66th Regiment
at Saint Helena in 1820*
1820 or later
Aquatint
27.5 x 21 cm
Montreal, McGill University
Library and Archives, Rare Books
and Special Collections
Inv. 4° N V 002

370. MRK
ANONYMOUS CHINESE ARTISTANS
AT SAINT HELENA
*Birdcage from Napoleon's
garden at Longwood House*
Commissioned by Napoleon for
the Longwood House gardens
1819-20
Painted wood, metal
340 x 213 x 122 cm
Châteauroux, Musée-hôtel
Bertrand
Inv. 347 and 347.1

371. MRKF
Workshop of François-Pascal-
Simon GÉRARD (1770–1837),
possibly Marie-Éléonore
GODEFROID (1778-1849)
*Portrait of Marie-Julie, Queen
of Naples and Later of Spain,
with Her Two Daughters, the
Princesses Zénaïde-Laetitia-
Julie and Charlotte-Napoléone*
1808-10
Oil on canvas
201 x 148.5 cm
Château de Fontainebleau,
Musée Napoléon Ier
Inv. F. 3099

372. MRK
Jacques-Louis DAVID
Paris 1748 – Brussels 1825
*Double Portrait of
Zénaïde-Laetitia-Julie and
Charlotte-Napoléone,
Daughters of Joseph
Bonaparte, the Former King
of Spain*
1821
Oil on canvas
129.5 x 100.6 cm
Los Angeles, The J. Paul Getty
Museum
Inv. 86.PA.740

373.
Denzil O. IBBETSON
United Kingdom, 1785-1857
*View of Longwood House at
Saint Helena*
About 1821
Ink, watercolour
23.5 x 6.9 cm
Rueil-Malmaison, Musée national
des châteaux de Malmaison et
Bois-Préau
Inv. MM2011.1.1

374. MRK
Denzil O. IBBETSON
United Kingdom, 1785-1857
Napoleon on His Deathbed
1821
Oil on canvas
39 x 51 cm
Geneva, Collection Comte
et Comtesse Charles-André
Colonna Walewski, on long-term
loan to the Montreal Museum
of Fine Arts
Inv. 307.2016

375.
Charl von STEUBEN
Bauerbach 1788 – Paris 1856
*Grand Marshal of the Palace
Bertrand Weeping by the Body
of Napoleon*
1830 or before
Graphite
23.7 x 32.7 cm
Rueil-Malmaison, Musée national
des châteaux de Malmaison et
Bois-Préau
Inv. M.M.40.47.3284

376. R
Jean-Pierre-Marie JAZET
Paris 1788 – Paris 1871
After Carl von STEUBEN
(Bauerbach 1788 – Paris 1856)
*Death of Napoleon (May 5,
1821)*
1830
Mezzotint, coloured with
watercolour
54.5 x 67.2 cm (sight)
The Montreal Museum of Fine
Arts
Ben Weider Collection
Inv. 2008.420

377.
Charles-Auguste BOUVIER
Active in Besançon in the 19th c.
After Carl von STEUBEN
(1788-1856)
*The Eight Epochs of the Life of
Napoleon by a History Painter*
1842
Engraving, etching
28 x 30.9 cm
The Montreal Museum of Fine
Arts
Ben Weider Collection
Inv. 2009.189

378.
François ANTOMMARCHI
Baragona Mursiglia, Corsica,
1789 – Santiago, Cuba,1838
Death Mask of Napoleon
After 1833
Patinated bronze
Cast L. Richard et Quesnel, Paris
18.5 x 15.5 x 34 cm
The Montreal Museum of Fine
Arts
Ben Weider Collection
2008.416

379. MRK
Henry Thomas ALKEN
London 1785 – London 1851
Thomas SUTHERLAND
United Kingdom 1785-1838
After Captain Frederick MARRYAT
(1792-1848)
*The Funeral Procession of
Bonaparte*
1821
Coloured wood engraving
22.8 x 53.4 cm
Montreal, McGill University
Library and Archives, Rare Books
and Special Collections
Inv. 4° N VI 003a

WORKS IN THE EXHIBITION NOT ILLUSTRATED HEREIN

380. MRKF
ANONYMOUS
Shawl of Cécile de Marescot, lady-in-waiting to the Empress
About 1800-5
Cashmere wool
60 x 180 cm
Private collection, France

381. MRK
ANONYMOUS
Ceremonial glaive of marshal Ney, prince of Moscow
About 1804
Paris, Musée de l'Armée
Inv. 25151

382. MRK
ANONYMOUS
Wedding Ceremony of the Emperor Napoleon and Marie-Louise of Austria
1810 or later
Coloured engraving
24.8 x 32,7 cm
Montreal, McGill University Library and Archives, Rare Books and Special Collections
Inv. 4° N III 181

383. MRK
ANONYMOUS
Pair of candelabra from the Emperor's washroom at Saint-Cloud
Early 19th c.
Gilded and patinated bronze, sea green marble
H. 88 cm
Base: 20 x 17.5 cm
Paris, Mobilier national
Inv. GML 9836/1 et GML 9836/2

384. MRK
ANONYMOUS
The Bertrand Family Mourning by Napoleon's Tomb on Saint Helena
First half of the 19th c.
Lithograph
18.5 x 24 cm
Montreal, McGill University Library and Archives, Rare Books and Special Collections
Inv. 8° R St Helena 047

385. MRK
ANONYMOUS
Napoleon. View of the City and Château of Portoferraio on the Island of Elba
19th c.
Engraving
37.5 x 26.5 cm
Montreal, McGill University Library and Archives, Rare Books and Special Collections
Inv. 4° N IV 009

386. M
ANONYMOUS, FRANCE
Court mantle worn by the comtesse Bertrand
About 1813-15
Silk velvet, satin, silver thread
335.3 x 160 cm
Rhode Island School of Design Museum
Gift of Mrs. Harold Brown
Inv. 37.215

387. MRK
ANONYMOUS, FRANCE
Shirt worn by Napoleon
About 1815
Cambric and linen cambric
109 x 178 cm
The Montreal Museum of Fine Arts
Ben Weider Collection
Inv. 2008.408.1-2

388. MRK
ANONYMOUS, FRANCE
Collection of Imperial Guard Figurines
Second quarter of the 19th c.
Gouache on cardboard
H. 16 cm
Paris, Musée de l'Armée

389. MRK
ANONYMOUS
After Antoine-Denis CHAUDET (1763-1810)
Bust of Napoleon
About 1804-1810
Marble
43.2 x 33 cm
The Montreal Museum of Fine Arts
On loan from Yvonne Prigent Lacks
Inv. 834.2008

390. MRK
ANONYMOUS
After Jacques-Louis DAVID (1748-1825)
Napoleon Holding the Crown, after The Coronation of Napoleon by David
After 1807
Lithograph
44.6 x 26.8 cm
Montreal, McGill University Library and Archives, Rare Books and Special Collections
Inv. 4° N III 183

391. MRKF
ANONYMOUS, possibly.-
Jean-Charles DEVELLY (Paris 1783 – Sèvres 1862)
Interior View: Pauline Borghese in the First-floor apartments of the Château de Neuilly
1803-14
Oil on canvas
66 x 64.8 cm
Geneva, Collection Comte et Comtesse Charles-André Colonna Walewski

392. MRK
[J. L.] BENOIST the Younger
Active in Paris until 1840
After Innocent-Louis GOUBAUD (1783-1847)
H. M. the King of Rome
1812
Engraving
33.4 x 39.8 cm
Montreal, McGill University Library and Archives, Rare Books and Special Collections
Inv. 4° O XIV 014

393. MRK
Martin-Guillaume BIENNAIS
La Cochère 1764 – Paris 1843
Covered candlestick called hot-water bottle
Late 18th-early 19th c.
Steel, silver-gilt
90 x 43 cm
Paris, Mobilier national
Inv. GML 1319/1-5

394. K
Workshop of Martin-Guillaume BIENNAIS (1764-1843)
Design for the Emperor's Sword
About 1804-14
Ink, wash
106 x 45 cm
Paris, Musée des Arts décoratifs
Inv. 11717

395. R
Atelier de Martin-Guillaume BIENNAIS (1764-1843)
Design for the Emperor's Sword
About 1804-14
Ink, wash
106 x 33 cm
Paris, Musée des Arts décoratifs
Inv. 11725

396. MRK
Martin-Guillaume BIENNAIS
La Cochère 1764 – Paris 1843
Pierre-François GRANGERET 1776 – (?)
Jean-Joseph DUBOIS 1748-30
Napoleon's dental-care kit
After 1805
Steel, gold, mother-of-pearl, ebony
24.5 x 20.2 x 5 cm
Collection LUPB - Bruno Ledoux
Inv. 2004.7.C

397. MRK
Martin-Guillaume BIENNAIS
La Cochère 1764 – Paris 1843
Pierre-Benoît LORILLON
Active in Paris between 1788 and 1822
Collection of utensils from the Borghese service
Selection: 2 candelabra, 10 soup spoons, 10 forks, 10 knives, 10 dessert spoons, 10 dessert forks, 10 dessert knives, 10 berry spoons, 10 salt spoons
About 1809-19
Silver-gilt
Various dimensions
Art Institute of Chicago
Inv. 1966.98.1a-d, 1966.98.2a-d, 1966.116a-x, 1966.117a-x, 1966.118a-x, 1966.119a-l, 1966.120a-k, 1966.121a-l, 1966.122a-l, 1966.123a-h

398. MRKF
Martin-Guillaume BIENNAIS
La Cochère 1764 – Paris 1843
Workbox given by the Empress Marie-Louise to one of her ladies of honour
About 1811
Burr amboina (red sandalwood), mother-of-pearl, silver and polished steel
Case: 15.3 x 26.1 x 7.1 cm
Collection LUPB - Bruno Ledoux
Inv. 2014.08.H

399. MRK
François-Joseph BOSIO
Monaco 1768 – Paris 1845
Bust of Marie-Louise
1810
Marble
76 x 48 x 30 cm
Musée national du château de Compiègne
Inv. C38.1061

400. MRK
Michel-Jacques BOULARD
Paris 1761 – Paris 1825
Chair from Napoleon's bathroom at Fontainebleau
About 1810
Mahogany, dimity (cover)
90 x 46 x 39 cm
Château de Fontainebleau, fonds palatial
Inv. F 664.1

401. MRK
George BULLOCK
Birmingham 1782 – London 1818
Table from Longwood House
About 1815
Ebony, rosewood, green marble, gilded bronze
79.5 x 48 cm
Collection LUPB - Bruno Ledoux
Inv. 2011,17

402. MRK
George BULLOCK
Birmingham, About 1777 – London 1818
Chamber pot for Longwood House, on Saint Helena
1815-17
Glazed stoneware
15.2 x 33 x 29.5 cm
Minneapolis Institute of Art
Gift of H. Blairman and Sons, Ltd., London
Inv. 96.32.2

403. MRK
Jean-Baptiste CHAPPUIS
France, About 1760-1813
Angelo GARBIZZA
Montona 1777 – Treviso 1813
View of from the Imperial Chapel to the Château des Tuileries
After 1806
Coloured engraving
232 x 292 cm
Montreal, McGill University Library and Archives, Rare Books and Special Collections
Inv. 8° R 008

404. MRK
Jean-Charles COHIER (candleholder)
Soissons 1772 – Marseille 1857
Abel-Étienne GIROUX (ewer and basin)
Active in Paris from 1798
Pierre LAGU (tray)
Active in Paris from 1798
Jean-Ange-Joseph LOQUE (cruets and tray)
Active in Paris from 1777 to the years 1815-20
Pierre PARAUD (chalice and paten)
Limoges 1759 – Paris 1812
Chapel silver from the Château de Fontainebleau
1804-16
Silver-gilt, leather, brass
Various dimensions
Case: 19 x 70.7 x 41.5 cm
Château de Fontainebleau, fonds palatial
Inv. F 348 C

405. MRK
L. DESMARETS
View of Napoleon's House
1833
Lithograph
Published by LAROCHE ET CIE, lithographs, Amiens
31.4 x 46.9 cm
Montreal, McGill University Library and Archives, Rare Books and Special Collections
Inv. 4° R St Helena 026

406. MRK
Workshop of Auguste-Gaspard-Louis DESNOYERS (1779-1857)
After François-Pascal-Simon GÉRARD (1770-1837)
Portrait of Napoleon in Ceremonial Robes
1805
Engraving, only state
75 x 52.5 cm
The Montreal Museum of Fine Arts
Gift of Mr. and Mrs. Anthony E. Balloch
Inv. Gr.1970.710

407. MRK
Jean-François DE TROY
Paris 1679 – Rome 1752
Hanging of The Story of Esther: The Coronation of Esther
1744-46
High-warp tapestry, wool and silk (Ancien Régime borders)
430 x 585 cm
Paris, Mobilier national
Inv. GMTT / 317

408. MRK
Louis DUCIS
Versailles 1775 – Paris 1847
Tasso Reading an Episode from Jerusalem Delivered to Princess Eleanor, or Poetry
About 1820
Autograph replica after an original dated 1813
Oil on canvas
51.8 x 41.2 cm
The Montreal Museum of Fine Arts
Gift of Michel Descours in tribute to Liliane and David M. Stewart
Inv. 2015.305

409. KF
Workshop FOURNEL, Lyon
Loom width decorated with ivy leaves, wreaths of roses and butterflies, for the Emperor's first salon at the Palais de Versailles
1811
Delivered by the Garde-Meuble in 1812, not used under the Empire, installed at the Tuileries under the Restoration, and at Saint-Cloud under the July Monarchy
Silk
Blue satin ground lampas (2 lats de lancé, dont 1 lat lié en sergé de 3 lie 1, et 1 lat lié en taffetas)
56.5 x 360 cm
Paris, Mobilier national
Inv. GMMP 1045

410. MRKF
François-Pascal-Simon GÉRARD
Rome 1770 – Paris 1837
Portrait of Napoleon in Ceremonial Robes
1805
Oil on canvas
240 x 155 cm
Château de Fontainebleau, Musée Napoléon Ier
Inv. N16

411. MRK
James GILLRAY
London 1756 – London 1815
The Procession for the Grand Coronation of Napoleon, Emperor of France, Leaving Notre-Dame, December 2, 1804
1805
Coloured etching
3.6 x 8.9 cm
Montreal, McGill University Library and Archives, Rare Books and Special Collections
Inv. BM 10362 Folio NC 002

412. KF
GRAND FRÈRES, Lyon
Part of a hanging decorated with cameos and ivy leaves, from a bedroom in the Palais de Fontainebleau
1809
Delivered and installed in 1810 at Fontainebleau, where it remained until 1833
Silk (chaîne), linen (weft)
(Damas économique (damas-sade), fond satin de 8, orange, 1 lat lié en sergé de 7 lie 1, blanc)
55 x 50 cm
Paris, Mobilier national
Inv. GMT 5277

413. KF
GRAND FRÈRES, Lyon
Loom width and border with lozenges and flowers, commissioned for the apartments of ministers or Grand Officers at Versailles
Commissioned in 1811
Delivered in 1811 to the Garde-Meuble, not used under the Empire, installed at the Tuileries and Saint-Cloud under the Restoration, and at the Grand Trianon under the July Monarchy
Silk
Satin, green (1 lat de lancé lié en sergé de 3 lie 1, blanc)
Loom width: 55 x 970 cm
Inv. GMMP 1282
Border: 13.2 x 56 cm
Paris, Mobilier national
Inv. GMMP 1315/2

414. M
Jean-Baptiste ISABEY
Nancy 1767 – Paris 1855
Portrait of Napoleon
About 1820
Watercolour on ivory
9 x 6.5 cm
The Montreal Museum of Fine Arts
On loan from Ben Weider
Inv. 815.2008

415. MRK
Workshop of François-Honoré-Georges JACOB-DESMALTER (1770-1841)
Presentation armchair, model for the Empress
About 1804-5
Carved and gilded wood, velvet
104.5 x 68 x 56 cm
Paris, Musée des Arts décoratifs
Inv. 14422

416. MRK
Workshop of François-Honoré-Georges JACOB-DESMALTER (1770–1841)
Chair for the dining room at the Palais de l'Élysée
About 1806-09
Mahogany, silk upholstery (not original fabric)
88.3 x 44.5 x 44.5 cm
The Montreal Museum of Fine Arts
Gift of the Honourable Serge Joyal, P.C., O.C.
Inv. 2015.324

417. MRK
Giuseppe LONGHI
Monza 1775 – Milan 1831
Portrait of Napoleon Bonaparte
About 1796
Pencil, gouache highlights
18.5 x 14 cm
Collection LUPB - Bruno Ledoux
Inv. 2017. 27 bis

418. MRKF
Pierre-Dominique MAIRE
? About 1763 - ? 1827
Letter kit in burr with steel incrustation, given to general Charles-Matthieu-Isidore Decaen, probably by the Empress Josephine
After 1805
Burr elm, mahogany, precious wood
Case: L. 40.3 cm
Nécessaire: L. 31.8 cm
Collection LUPB - Bruno Ledoux
Inv. 2007.10.B

419. MRK
Antoine MAURIN
Perpignan 1793 – Paris 1860
After Pierre Paul PRUD'HON (1758–1823)
The Triumph of Bonaparte, or Peace
1824
48.4 x 70 cm
Montreal, McGill University Library and Archives, Rare Books and Special Collections
Inv. Folio N II 007

420. MRK
William McCLEARY
Active in Dublin, 1799–1820
The Inhabitants of Saint Helena Addressing Their New Governor!!
About 1815
Coloured etching
40 x 20 cm
Montreal, McGill University Library and Archives, Rare Books and Special Collections
Inv. 4° NC 022

421. MRK
Jean-Pierre MENUISIER
Metz 1783 – (?)
After Jean-Baptiste ISABEY (1767–1855)
Portrait of Napoleon-François-Charles-Joseph, King of Rome, Dressed in Blue
1814 of later
Ivory on watercolour
5.5 x 3.9 cm
The Montreal Museum of Fine Arts
Ben Weider Collection
Inv. 2009.184

422. MRK
George MOUTARD WOODWARD
United Kingdom about 1760 – London 1809
Charles WILLIAMS
United Kingdom (?) – 1830
The Metamorphoses of Empress Josephine
1808
Coloured etching
Montreal, McGill University Library and Archives, Rare Books and Special Collections
Inv. Folio NC 011

423. MRK
Charles NORMAND
Goyencourt 1765 – Paris 1840
Baptism of the King of Rome
1811
Engraving
27.4 x 20.8 cm
Montreal, McGill University Library and Archives, Rare Books and Special Collections
Inv. 8° O XIV 002

424. MRK
Jacques Nicolas PAILLOT DE MONTABERT
Troyes 1771 – Saint-Martin-ès-Vignes 1849
Portrait of Raza Roustam, Mameluke
1806
Oil on canvas
152 x 125.5 cm
Paris, Musée de l'Armée
Inv. 3659 / Ea 62

425. MRKF
Pierre PARAUD
Active about 1800-12
Aspersorium from the Imperial Chapel at the Tuileries
About 1804-09
Silver-gilt, oak
Diam. 21 cm
Paris, Mobilier national
Inv. GMLC 33

426. R
J. PARENT
Active in Paris between 1815 and 1835
After Jean-Baptiste-Jacques AUGUSTIN (1759–1832)
Portrait of Napoleon
1815
Watercolour on ivory
The Montreal Museum of Fine Arts
Ben Weider Collection
Inv. 2009.187

427. MRK
POUPARD ET DELAUNAY
Bicorne from the Emperor's wardrobe
About 1812
Felt, silk, beaver pelt
27 x 47 x 20 cm (approx.)
The Montreal Museum of Fine Arts
Ben Weider Collection
Inv. 2008.76

428. MRK
Pierre PRÉVOST
Montigny-le-Gannelon 1764 – Paris 1823
Panorama of Paris from the Roof of the Pavillon de Flore at the Palais des Tuileries
About 1805-13
Pencil, gouache, on papers mounted on canvas
64 x 817 cm
Collection Kugel

429. MRKF
Jean-Baptiste REGNAULT
Paris 1754 – Paris 1829
The Emperor's Triumphant March to Immortality, sketch for the ceiling of the Sénat conservateur
About 1804-5
Oil on paper mounted on canvas
52.4 x 93 cm
Charlottesville, Virginia, Fralin Museum of Art
Inv. 1978.44

430. MRK
Jean-Baptiste ROY-AUDY
Quebec City 1778 – Trois-Rivières before 1848
After Jean-Baptiste-Joseph WICAR (1762–1834)
Portrait of Pope Pius VII
About 1820
Oil on canvas
66 x 56 cm
The Montreal Museum of Fine Arts
On loan, Corporation archiépiscopale catholique romaine de Montréal
Inv. 25.2005

431. MRKF
SÈVRES IMPERIAL MANUFACTORY
Service of plants of Malmaison: pair of ice pails
1803-5
Hard-paste porcelain
H. 31.6 cm and 31.9 cm; Diam. 23.5 cm
Boston, Museum of Fine Arts
Inv. 2001.250a-b, 251a-b

432. MRK
SÈVRES IMPERIAL MANUFACTORY
Plate from the service called "red ground, butterflies and flowers," delivered to the Palais de Fontainebleau
1809
Hard-paste porcelain
Diam. 23.4 cm
Alexandre de Bothuri Báthory / Éláine Bédard de Bothuri
(en prêt au Musée du Château Dufresne-Nincheri, Montréal)

433. MRKF
SÈVRES IMPERIAL MANUFACTORY
Modelled by Jean-Nicolas-Alexandre BRACHARD III (active at Sèvres between 1795 and 1827)
Bust of the Empress Josephine
1809
Hard-paste biscuit
H. 30 cm
Geneva, Collection Comte et Comtesse Charles-André Colonna Walewski

434. MRK
SÈVRES IMPERIAL MANUFACTORY
Decoration pained by Marie-Victoire JAQUOTOT (1772–1855)
Cup "jasmine withfluted base" and saucer with portrait of the Empress Josephine
1809
Hard-paste porcelain
Cup: H. 12.6; D. 10.3 cm
Saucer: Diam. 15.7 cm
Sèvres and Limoges, Cité de la céramique
Inv. MNC2008

435. MRK
SÈVRES IMPERIAL MANUFACTORY
Jean-Charles-Nicolas BRACHARD II (active at Sèvres between 1782 and 1800 and between 1805 and 1823)
Elements from the centrepiece from the Emperor's personal service: *Victory Guiding the Horses of Napoleon's Chariot* **and candlestick**
Re-edition of the model of 1809-10
Hard-paste biscuit
Figure: H. 52 cm
Candlestick: 86 x 32 cm
Collection LUPB - Bruno Ledoux
Inv. 2008. 1-2

436. MRK
SÈVRES IMPERIAL MANUFACTORY
Soup dish from the Emperor's personal service
1810
Hard-paste porcelain
Diam. 24 cm
Geneva, Collection Comte et Comtesse Charles-André Colonna Walewski

437. MRK
SÈVRES IMPERIAL MANUFACTORY
Cup "jasmine with fluted base" and saucer with the portrait of the Empress Marie-Louise
1812
Hard-paste porcelain
9 x 10.5 cm
Collection LUPB - Bruno Ledoux
Inv. 2010

438. MRK
SÈVRES IMPERIAL MANUFACTORY
Marie-Victoire JAQUOTOT
Paris 1772 – Toulouse 1855
After Jean-Baptiste ISABEY (1767–1855)
Bust-length Portrait of Marie-Louise
1815
Painting on porcelain, glass, gilded wood
20 x 15 cm (approx.)
Geneva, Collection Comte et Comtesse Charles-André Colonna Walewski

439. MRK
S. T. TAW
The Crown Candidates, or a Modest Request Politely Refused
1815
Coloured etching
21.7 x 27.1 cm
Montreal, McGill University Library and Archives, Rare Books and Special Collections
Inv. 8° O XIV 062

440. MRK
Jean-Georges VIBERT
Paris 1840 – Paris 1902
Napoleon and the King of Rome Receiving Church Dignitaries
N.d.
Aquatint, etching
56 x 73.7 cm
Montreal, McGill University Library and Archives, Rare Books and Special Collections
Inv. Folio N III 033

441. MRK
Dickinson WILLIAM
London 1746 – Paris 1823
After Antoine-Jean GROS (1771–1835)
Napoleon Bonaparte, First Consul and the French Republic
Coloured mezzotint
64.2 x 43.9 cm
Montreal, McGill University Library and Archives, Rare Books and Special Collections
Inv. Folio N II 001

pp. 340, 346
François DUBOIS
The Four Parts of the World
199. *Africa* (p. 340)
198. *Asia* (p. 346)

AFRIQUE

BIBLIOGRAPHY

MANUSCRIPT SOURCES

ARCHIVES DE LA MANUFACTURE DE SÈVRES
Correspondance générale
- Carton T1 – 1805
- Carton T2 – 1806
- Carton T3 – 1807
- Carton T5 – Correspondance de Brongniart, 1810

Registres du XIXᵉ siècle : ventes au comptant et à crédit
- Registre Vy14
- Registre Vy16
- Registre Vy17

Présents, ventes à crédit
- Registre Vbb 2 – crédit au gouvernement An VIII-1810
- Registre Vbb 3 – crédit courants, An XIII-1812
- Registre Vbb 4 – crédits au gouvernement

Travaux des ateliers : journaux des travaux de peintres, doreurs, brunisseurs, 1812 et 1813
- Registre Vj' 19
- Registre Vj' 20

ARCHIVES DU MOBILIER NATIONAL
- G. 151 – lettre du 21 octobre, 1813
- GOB 75 – État des produits de la Manufacture Royale des Gobelins

ARCHIVES NATIONALES, PARIS (AN)
F¹²: Commerce et industrie
- F¹² 2265 – Orfèvrerie, platine et plomb. An III-1848
F¹⁷: Instruction publiques
- F¹⁷ 1232 – Cartons et liasses : An VIII, Costumes des fonctionnaires
O¹: archives de la Maison du roi
O¹ 3445 – Garde-Meuble. Versailles, inventaire des meubles, 1708
- O²: archives de la Maison de l'Empereur
- O² 6 – Grand Maréchal : Correspondance du grand maréchal
- O² 11 – Grand Aumônier et Grand Maréchal : Comptes de dépenses, 1810
- O² 19 – Grand Chambellan : Mariage de l'Empereur
- O² 30 – Grand Chambellan : Bijoux et diamants, pièce d'orfèvrerie, dentelles
- O² 32 – Grand Chambellan : Bijoux et diamants, pièce d'orfèvrerie, dentelles, pièces de vestiaire
- O² 33 – Grand Chambellan : Appointements. Dépenses concernant les spectacles, les bibliothèques, la garde-robe, le service de santé
- O² 34 – Grand Chambellan : Appointements. Dépenses concernant les spectacles, les bibliothèques, la garde-robe, le service de santé
- O² 35 – Grand Chambellan : Garde-robe de l'Empereur
- O² 37 – Grand Chambellan : Spectacles
- O² 41 – Grand Chambellan : Grandes cérémonies et fêtes
- O² 51 – Grand Chambellan : Comptabilité du service. Exercice 1811

- O² 52 – Grand Chambellan : Comptabilité du service. Exercice 1812. Services du grand chambellan et de la gouvernante des Enfants de France
- O² 57 – Grand Chambellan : Personnel du service
- O² 58 – Grand Chambellan : Personnel du service
- O² 77 – Grand Écuyer : Frais de voyages
- O² 86 – Grand Écuyer : Maison des pages
- O² 132 – Grand Veneur : Service du grand veneur. Registres et dépenses. Exercice 1811.
- O² 137 – Grand Maître des Cérémonies : Réglementation, correspondance, dépenses
- O² 138 – Grand Maître des Cérémonies : Dépenses relatives aux cérémonies
- O² 149 – Grand Maître des Cérémonies : Service du grand-maître des cérémonies. Dépenses du mariage de l'Empereur
- O² 151 – Administration de l'intendance générale : Textes réglementaires et décisions, An XIV-1806, et 1809
- O² 155 – Administration de l'intendance générale : Règlements de dépenses, 1809
- O² 156 – Administration de l'intendance générale : Affaires diverses, 1810-1811
- O² 158 – Administration de l'intendance générale : Services de la cour, 1810-1811
- O² 161 – Administration de l'intendance générale : Correspondance de l'intendant général, 3-22 décembre 1807
- O² 162 – Administration de l'intendance générale : Correspondance de l'intendant général, 11 janvier-26 décembre 1808
- O² 164 – Administration de l'intendance général : Correspondance de l'intendant général, 1er janvier-27 décembre 1810
- O² 187 – Administration de l'intendance générale : Enregistrement de la correspondance au départ, lettres de l'intendant, ordonnances de paiement, 21 juin 1806-30 janvier 1808
- O² 200 – Administration de l'intendance générale : Services de la cour. An XII-1813
- O² 202 – Administration de l'intendance générale : Affaires diverses, an XII-1815
- O² 203 – Administration de l'intendance générale : Fêtes et cérémonies, 1806-1812
- O² 243 – Intendance générale des bâtiments : Correspondance de l'intendant des bâtiments
- O² 294 - Intendance générale des bâtiments : Correspondance, comptabilité et pièces diverses concernant l'administration des bâtiments de la Couronne
- O² 312 et 313 – Intendance générale des bâtiments : Correspondance, comptabilité et pièces diverses
- O² 499, 504, 506, 511, 513, 515, 517-519, 522-524, 535, 556, 560 – Garde-Meuble. Ameublement des palais impériaux. Comptabilité, correspondance, prêts, entrées et sorties de meubles, affaires diverses

- O² 645 – Garde-meuble. Inventaires des étoffes, des meubles confectionnés, des diamants de la Couronne, du mobilier de l'état-major de l'Armée des Côtes : inventaires récapitulatifs de mobiliers
- O² 675, 680, 687, 689, 740, 750 – Garde-meuble. Inventaires du mobilier des palais impériaux et bâtiments de la Couronne
- O² 835, 840, 841, 844 – Musées, manufactures, monnaie et médailles. Commandes et acquisitions, restauration et copies, encouragements aux artistes, inventaires et catalogues, administration, comptabilité, émargements, mélanges
- O² 856 – Manufactures impériales. Mélanges (comptes, correspondance, demandes de place, cadeaux)
- O² 877, 878, 880 – Manufacture impériale des Gobelins
- O² 925 – Manufacture impériale de porcelaine de Sèvres
- O² 1104 – Domaine étranger. Hollande : administration, correspondance, comptabilité
- O² 1204 – Trésorerie générale de la Couronne. Budgets de la Maison de l'Empereur. Comptabilité des Domaines et des services. Personnel. An X-1815
O³: archives de la Maison du roi
- O³ 1639 – Théâtres
- O³ 2200 – Archives, bibliothèques, cabinets topographique et minéralogique
Archives des musées nationaux
- X-Salon, dossier 1810, "registre d'inscription des productions des artistes vivants présentés à l'exposition"
- 20150538/216, "Nouvelles cotes", AA8, AA9
AB/XIX: Archives de Beuselin, trésorier de la Liste civile
- 4260 – Budget général de la Maison de l'Empereur, 1813
AF/IV: Secrétairerie d'État impériale et cabinet de Napoléon Ier, 1800-1814
- 132 – Documents produits par la Secrétairerie d'État impériale, minutes des décrets
- 474 – Documents produits par la Secrétairerie d'État impériale, minutes des décrets
AJ/19: Garde-Meuble
- 234 – Château de Fontainebleau : Inventaires et journaux d'entrées et sorties de meubles
AJ/13: Archives du théâtre national de l'Opéra
- 63 – Premier Empire : Personnel
- 72 – Premier Empire : Administration : Règlements pour les théâtres
400AP: Napoléon Ier (fonds)
- 4 – Lettres diverses
BB 30: Ministère de la Justice
- 97 – Mélanges Ancien Régime et Révolutions, 1754-1817
Minutier central des notaires
- MC/ET/CXV/1235 – Minutes de Jean-Baptiste André Clairet

- Étude CIV, liasse 8, inventaire après décès de Louise-Élizabeth Belot, épouse Drölling, 30 ventôse, An XI (21 mars 1803)

BIBLIOTHÈQUE THIERS, PARIS
Fonds Masson
- Carton 103 – Registre d'ordre des Tuileries
- Carton 109 – Registre des déplacements de la cour, 1804-1813
- Carton 125 – Papiers de Martial Daru, registres de correspondance 1812

BIBLIOTHÈQUE DU MUSÉE DE L'OPÉRA (BMO)
Opéra archives
- 19 – Rapport du directeur de l'Opéra au préfet du Palais

BIBLIOTHÈQUE NATIONALE DE FRANCE, PARIS (BNF)
Manuscrits Français
- 6577-6600 – Secrétariat du grand maréchal Duroc
 6583 – VII Maison de l'Empereur. Palais impériaux I
 6585 – Maison de l'Empereur – Beaux-arts I
 6586 – Maison de l'Empereur – Beaux-arts II
 6593 – Maison de l'impératrice Joséphine
- 11212 – règlement pour le service du Grand maréchal du palais

CHÂTEAU DE FONTAINEBLEAU, FONTAINEBLEAU
Archives de la Conservation
- Inventaire de 1807
- Inventaire de 1810

GRAY - BIBLIOTHÈQUE MUNICIPAL
Fond Jean-Claude Ballouhey
- Journal des recettes et dépenses faites pour le service de S.M. l'Impératrice et Reine, An 12; An 13; 19 juin 1811; 14 août 1812; 9 février 1813; 10 janvier, 30 avril, 5 septembre 1814

PRIVATE COLLECTION
Déclaration de décès, registre des baptêmes, mariages et sépultures de la paroisse de Saint-Hilaire de Tours, 19 mai 1767
Actes de décès de l'an 13, mairie du Xᵉ arrondissement de Paris, 4 pluviôse

PRINTED SOURCES

ABRANTÈS, Laure Junot, duchesse d'. *Mémoires de Mme la duchesse d'Abrantès, ou souvenirs historiques sur Napoléon, la révolution, le Directoire, le Consulat, l'Empire et la Restauration*. Paris: Ladvocat, 1831-1835, 18 vols.
ALI, Mameluck (Louis-Étienne Saint-Denis). *Souvenirs sur l'Empereur Napoléon*. Paris: Payot, 1926.
Almanach du commerce de Paris. Paris, 1812-1813.
Almanach impérial présenté à sa Majesté l'Empereur par Testu. Paris: Testu, 1805-1813.

Almanach royal pour les années M. DCCC. XIV et M. DCCC. XV. Paris: Testu, 1814.

AVRILLION, Marie-Jeanne. *Mémoires de Mademoiselle Avrillion, première femme de chambre de l'impératrice sur la vie privée de Joséphine, sa famille et sa cour.* Paris: Ladvocat, 1833, 2 vols.

BASSANVILLE, Anaïs Lebrun, comtesse de. *Les Salons d'autrefois, souvenirs intimes.* Paris: Brunet, 1862.

BAUSSET, Louis-François-Joseph de. *Mémoires anecdotiques sur l'intérieur du palais et sur quelques événements de l'Empire depuis 1805 jusqu'en 1816, pour servir à l'histoire de Napoléon.* Paris: Baudouin, 1827-1829, 4 vols.

BEAUHARNAIS, Hortense de. *Mémoires de la reine Hortense.* Paris: Plon, 1927, 3 vols.

BERCKHEIM, Karl Christian von. *Lettres sur Paris, ou Correspondance de M. ***, dans les années 1806 et 1807.* Heidelberg: Mohr und Zimmer, 1809.

BERTRAND, Henri-Gatien, général, *Cahiers de Sainte-Hélène.* Paris: Sulliver / Albin Michel, 1949, 1951, 1959, 3 vols.

BEUGNOT, Jean-Claude. *Mémoires du comte Beugnot, ancien ministre.* Paris: E. Dentu, 1868, 2 vols.

BLANCHARD, Pierre. *Le voyageur de la jeunesse dans les quatre parties du monde.* Paris: Le Prieur, 1804.

BONNEVAL, Armand Alexandre de. *Mémoires anecdotiques du général marquis de Bonneval.* Paris: Plon-Nourrit, 1900.

BOURRIENNE, Louis-Antoine Fauvelet de. *Mémoires de M. de Bourrienne, ministre d'État; sur Napoléon, le Directoire, le Consulat, l'Empire et la Restauration.* Paris: Ladvocat, 1829, 10 vols.

CAMBACÉRÈS, Jean-Jacques-Régis de. *Cambacérès. Mémoires inédits.* Paris: Perrin, 1999, 2 vols.

CARRÉ de BUSSEROLLE, Jacques-Xavier. *Armorial général de la Touraine. Mémoire de la société archéologique de Touraine.* t. XIX, Tours: Imp. Ladevèze, 1867.

CHASTENAY, Victorine de. *Deux révolutions pour une seule vie : mémoires 1771-1855.* Presented and annotated by Raymond Trousson. Paris: Tallandier, 2009.

CHOISY, François-Timoléon, abbé de. *Mémoires pour servir à l'histoire de Louis XIV.* Utrecht: Van de Water, 1727.

CLARY-ET-ALDRINGEN, Charles. *Souvenirs du prince Charles de Clary et Aldringen. Trois mois à Paris lors du mariage de l'empereur Napoléon Ier et de l'archiduchesse Marie-Louise.* Paris: Plon, 1914.

CONSTANT, Louis Constant Wairy dit. *Mémoires de Constant, premier valet de l'Empereur, sur la vie privée de Napoléon, sa famille et sa cour.* Paris: Ladvocat, 1830, 6 vols.

Correspondance de Napoléon Ier, publiée par ordre de l'empereur Napoléon III. Paris: Plon, 1858-1870, 32 vols.

DANCHET, Antoine. *Le Sacre de Louis XV, Roy de France et de Navarre, dans l'église de Reims, le dimanche XXV octobre MDCCXXII.* S. l., s. n., 1722.

DANGEAU, Philippe de Courcillon, marquis de. *Journal du marquis de Dangeau.* Paris: Firmin Didot frères, 1854-1860, 18 vols.

DELÉCLUZE, Étienne-Jean. *Louis David, son école et son temps : Souvenirs.* Paris: Didier, 1855.

DENON, Dominique-Vivant. *Voyage dans la Basse et Haute-Égypte pendant les campagnes du général Bonaparte.* Paris: P. Didot l'aîné, 1802, 2 vols.

Description de la toilette présentée à Sa Majesté l'impératrice-reine, et du berceau offert à S.M. le roi de Rome par M. le conseiller d'État comte Frochot, préfet du Département de la Seine et par le Corps Municipal au nom de la Ville de Paris. Paris: Ballard, 1811.

DESOUCHES, Guillaume. *Un artisan ferronnier sous Napoléon Ier : Marie-Jean Desouches, serrurier du Garde-Meuble et de Sa Majesté l'Empereur et Roi.* Saint-Germain-en-Laye: Guillaume Desouches, 2017.

DUMONT, Jean. *Le Cérémonial diplomatique des cours de l'Europe, ou collection des actes, mémoires et relations qui concernent les dignités, titulatures, honneurs et prééminences [...].* Amsterdam: Janssens / The Hague: P. de Hondt, 1739, 2 vols.

DUPUY, Marie-Anne, Isabelle le Masne de Chermont and Elaine Williamson, eds. *Vivant Denon, directeur des musées sous le Consulat et l'Empire. Correspondance.* Paris: Réunion des musées nationaux, 1999, 2 vols.

DURAND, Sophie Cohondet, veuve du général. *Mémoires sur Napoléon et Marie-Louise, 1810-1814.* Paris: Calmann-Lévy, 1886.

DUVERGIER, Jean-Baptiste. *Collection complète des lois, décrets, ordonnances, règlements, avis du Conseil d'État.* t. XIX, Paris: A. Guyot, 1836.

Étiquette du palais impérial. Paris: Imprimerie impériale, 1806.

Explications des ouvrages de peinture, sculpture, architecture et gravure des artistes vivants, exposés au Musée Napoléon, le 15 septembre 1806. Paris: Imprimerie des sciences et des arts, 1806.

Exposition publique des produits de l'Industrie française. Catalogue des productions industrielles. Paris: Imprimerie de la République, Fructidor, an X (August-September 1802).

FAIN, Agathon-Jean-François. *Mémoires du baron Fain, premier secrétaire du cabinet de l'Empereur.* Paris: Plon-Nourrit, 1908.

FLEURY DE CHABOULON, Pierre-Alexandre-Édouard de. *Mémoires de Fleury de Chaboulon, ex-secrétaire de l'empereur Napoléon et de son cabinet, pour servir à l'histoire de la vie privée, du retour et du règne de Napoléon en 1815, avec annotations manuscrites de Napoléon Ier.* Paris: Édouard Rouveyre, 1901, 2 vols.

FONTAINE, Pierre-François-Léonard. *Journal, 1799-1853.* Edited by Marguerite David-Roy. Paris: École nationale supérieure des beaux arts; Institut Français d'Architecture; Société de l'Histoire de l'Art français, 1987, 2 vols.

FONTAINE, Pierre-François-Léonard, Charles Percier and Jean-Baptiste Isabey. *Le sacre de S.M. l'Empereur Napoléon dans l'église métropolitaine de Paris, le XI frimaire an XIII, dimanche 2 décembre, 1804.* Paris: Imprimerie impériale, 1804-1815.

FONTAINE, Pierre. *Mia Vita. Mémoires privés,* Edited and presented by Jean-Philippe Garric, Paris: Éditions des Cendres, 2017.

GIRARDIN, Stanislas de. *Journal et souvenirs, discours et opinions.* Paris: Moutardier, 1828, 4 vols.

GOURGAUD, Gaspard. *Sainte-Hélène, journal inédit de 1815 à 1818.* Paris: Flammarion, 1899, 2 vols.

GRANDJEAN, Serge. *Inventaire après décès de l'impératrice Joséphine à Malmaison.* Paris: Ministère d'État-Affaires culturelles, 1964.

HAUTERIVE, Ernest d'. *Sainte-Hélène au temps de Napoléon et aujourd'hui.* Paris: Calmann-Lévy, 1933.

Impératrice Joséphine. Correspondance, 1782-1814. Edited by Bernard Chevallier, Maurice Catinat and Christophe Pincemaille, Paris: Payot, 1996.

Journal de l'Empire (or Courrier de l'Europe). Paris: Lenormant, 1805-1814.

Journal de Paris. Paris: Quillau, 1777-1826.

Journal politique de Mannheim. Mannheim, 1800-1809.

LANDON, Charles-Paul. *Annales du Musée et de l'école moderne des beaux-arts, salon de 1808.* Paris: Landon, 1808.

LIMAY, Henry Ratouis de. "Les souvenirs de Napoléon Ier, du Maréchal Bertrand et de sa famille." *Revue du Berry et du Centre* (October 1921), pp. 66-86.

MARCHAND, Louis-Joseph-Narcisse. *Mémoires de Marchand, premier valet de chambre et exécuteur testamentaire de l'Empereur.* Published by Jean Bourguignon and Henri Lachouque. Paris: Tallandier, 1985.

Mémoires pour servir à l'histoire de France sous le règne de Napoléon, écrits à Sainte-Hélène sous sa dictée par les généraux qui ont partagé sa captivité. Paris: Firmin Didot Père et Fils, Bossange Frères, 1823, 7 vols.

MÉNEVAL, Claude-François baron de. *Mémoires pour servir à l'histoire de Napoléon Ier depuis 1802 jusqu'à 1815.* Paris: Dentu, 1893-1894, 3 vols.

MIOT DE MÉLITO, André-François. *Mémoires du comte Miot de Mélito, ancien ministre, ambassadeur, conseiller d'État et membre de l'Institut.* Paris: Michel Lévy frères, 1858, 3 vols.

MONTCHANIN, Jacques-Pierre de. *Lettres de Héléodore adressées à Napoléon Bonaparte, depuis le 13 ventôse an 8 jusqu'au 17 mars 1814.* Paris: Bossange, 1833, 2 vols.

MONTESQUIOU-FEZENSAC, Ambroise-Anatole-Augustin, comte de. *Souvenirs sur la Révolution, l'Empire, la Restauration et le règne de Louis-Philippe.* Presented and annotated by Robert Burnand. Paris: Plon, 1961.

Napoléon Bonaparte. Correspondance générale, published by Fondation Napoléon. Paris: Fayard, 2004-2017, 15 vols.

O'MEARA, Barry. *Napoleon in Exile or A Voice From Saint Helena.* London, W. Simpkin and R. Marshall, 1822.

PERCEVAL, Émile de. *Dans les archives du vte Lainé, ministre et pair de France.* Paris, Champion, 1929.

PERCIER, Charles and Pierre-Léonard-François Fontaine. *Description des cérémonies et des fêtes qui ont eu lieu pour le mariage de S.M. l'empereur Napoléon Ier avec S.A.I. Marie-Louise d'Autriche.* Paris: P. Didot l'aîné, 1810.

PERCIER, Charles and Pierre-Léonard-François Fontaine. *Recueil de décorations intérieures, comprenant tout ce qui a rapport à l'ameublement : comme vases, trépieds, candélabres, cassolettes, lustres, girandoles, lampes ... etc.,* Paris: by the authors, at the Louvre, 1812.

PÉTIET, Sylvain. "Souvenirs d'un page de l'Empereur," *Société historique et scientifique des Deux-Sèvres, procès-verbaux, mémoires, notes et documents,* 4e année, 2e partie, 1908, p. 40-65.

PICHON, Thomas Jean. *Sacre et couronnement de Louis XVI, roi de France et de Navarre, à Rheims, le 11 juin 1775.* Paris: Maillet, 1775.

PINKNEY, Ninian. *Travels through the South of France and the Interior of Provinces of Provence and Languedoc in the Years 1807 and 1808.* London: T. Purday and Son, 1809.

POTOCKA, Anne. *Mémoires de la comtesse Potocka (1794-1820).* Paris: Plon, 1897.

Recueil de pièces authentiques sur le captif de Sainte-Hélène, de mémoires et documents écrits ou dictés par l'empereur Napoléon. Paris: Alexandre Corréard, 1822, 12 vols.

RÉMUSAT, Claire-Élisabeth de Vergennes, comtesse de. *Memoirs of Madame de Rémusat,* edited by Paul de Rémusat. London: Sampson Low, Marston, Searle and Rivington, 1880, 3 vols.

RIVAZ, Charles-Emmanuel de. *Mes souvenirs de Paris, 1810-1814.* Martigny: Pillet, 1967.

ROEDERER, Pierre-Louis. *Journal du comte P.-L. Roederer.* Paris: H. Daragon, 1909.

SAINT-HILAIRE, Émile. Marco de. *Mémoires et révélations d'un page de la cour impériale de 1802 à 1815.* Paris: Charles Malot, 1830, 2 vols.

Stendhal. Correspondance générale, Edited by Vittorio Del Litto, Elaine Williamson, Jacques Hubert and Michel E. Slatkine. Paris: Librairie Honoré Champion, 1998, 2 vols.

THIÉBAULT, Paul. *Mémoires du général baron Thiébault.* Paris: Plon, 1895, 5 vols.

EXHIBITION CATALOGUES

1810. La politique de l'amour. Napoléon Ier et Marie-Louise à Compiègne, exh. cat. Edited by Emmanuel Starcky and Hélène Meyer. Paris: Réunion des musées nationaux, 2010.

ARIZZOLI-CLÉMENTEL, Pierre and Chantal Gastinel-Coural. *Soieries de Lyon : commandes royales au XVIIIe siècle (1730-1800),* exh. cat. Lyon: Musée historique des tissus, 1988.

BARRATT, Carrie Rebora and Ellen G. Miles. *Gilbert Stuart,* exh. cat. New York: The Metropolitan Museum of Art / New Haven and London: Yale University Press, 2004.

BENOIT, Jérémie. *Napoléon et Versailles,* exh. cat. Paris: Réunion des musées nationaux, 2005.

BEYELER, Christophe. *Noces impériales. Le mariage de Napoléon et Marie-Louise dessiné par Baltard,* exh. cat. Paris: Somogy / Musée national du château de Fontainebleau, 2010.

BORDES, Philippe. *Jacques-Louis David: Empire to Exile,* exh. cat. New Haven and London: Yale University Press / Williamstown, Connecticut: Sterling and Francine Clark Art Institute, 2005.

Caroline, sœur de Napoléon. Reine des arts. Edited by Maria Teresa Caracciolo and Jehanne Lazaj. Milan: Silvana, 2017.

Charles Percier (1764-1838), architecture et design, exh. cat. Edited by Jean-Philippe Garric. Paris: Réunion des musées nationaux-Grand Palais, 2016.

Cinq années d'enrichissement du patrimoine national, 1975-1980 : donations, dations, acquisitions, exh. cat. Paris: Réunion des musées nationaux, 1980.

COURAL, Jean and Chantal Gastinel-Coural. *Fabriques et manufactures sous le Premier Empire : Lyon, Beauvais, Les Gobelins. Collections du Mobilier national,* exh. cat. Paris: Ministère de la Culture, Délégation à la création, aux métiers artistiques et aux manufactures, 1981.

De la scène au tableau. Edited by Guy Cogeval and Béatrice Avanzi. Paris: Skira Flammarion, 2009.

DELPIERRE, Madeleine. *Costumes de cour et de ville du Premier Empire,* exh. cat. Paris: Musée du costume de la ville de Paris, annexe du musée Carnavalet, 1958.

Destins souverains, Joséphine, la Suède et la Russie, exh. cat. Edited by Emmanuel Starcky and Hélène Meyer. Paris: Réunion des musées nationaux-Grand Palais, 2011.

Destins souverains, Napoléon Ier, le tsar et le roi de Suède, exh. cat. Edited by Emmanuel Starcky and Hélène Meyer. Paris: Réunion des musées nationaux-Grand Palais, 2011.

DION-TENENBAUM, Anne and Gérard Mabile. *Indispensable nécessaires,* exh. cat. Paris: Réunion des musées nationaux, 2007.

Dominique-Vivant Denon : L'œil de Napoléon, exh. cat. Edited by Marie-Anne Dupuy. Paris: Réunion des musées nationaux, 1999.

ERMISSE, Gérard and Catherine, and Florence Robert. *Marescot : le Vauban de la Grande Armée,* exh. cat., under the patronage of Fondation Napoléon and the Ministère de la Défense, 2014.

Fastes de cour et cérémonies royales : le costume de cour en Europe 1650-1800, exh. cat. Edited by Pierre Arizzoli-Clémentel and Pascale Gourguet Ballesteros. Paris: Réunion des musées nationaux, 2009.

FORRAY-CARLIER, Anne, Florence Valantin and Guillaume Verzier. *L'art de la soie, Prelle, 1752-2002 : des ateliers lyonnais aux palais parisiens,* exh. cat. Courbevoie: ACR / Paris: Paris Musées, 2002.

GASTINEL-COURAL, Chantal. *La manufacture de Beauvais. Du Consulat à la IIe République,* exh. cat. Paris: Administration générale du Mobilier national, 1998.

GAUTIER, Jean-Jacques and Bertrand Rondot. *Le Château de Versailles raconte le Mobilier national. Quatre siècles de création,* exh. cat. Paris: Skira-Flammarion / Versailles: Château de Versailles, 2011.

GAY-MAZUEL, Audry. *Odiot, un atelier d'orfèvrerie sous l'Empire et la Restauration,* exh. cat. Paris: Musée des Arts décoratifs, 2017.

Girodet, 1767-1824, exh. cat. Edited by Sylvain Bellenger. Paris: Gallimard / Musée du Louvre Éditions, 2005.

Ossian, exh. cat. Edited by Hanna Hohl and Hélène Toussaint, 1974.

HUMBERT, Jean-Marcel, Michael Pantazzi and Christiane Ziegler. *Egyptomania: Egypt in Western Art, 1730-1930,* exh. cat. Paris: Réunion des musées nationaux / Ottawa: National Gallery of Canada, 1994.

Jean-Baptiste Isabey (1767-1855), portraitiste de l'Europe, exh. cat. Edited by François Pupil. Paris: Réunion des musées nationaux, 2005.

Jean-Baptiste Jacques Augustin, peintre en miniature, exh. cat. Edited by Daniel Grandidier and Bernd Pappe. Saint-Dié-des-Vosges: Musée Pierre-Noël, 2010.

Jefferson's America and Napoleon's France, exh. cat. Edited by Victoria Cooke. New Orleans: New Orleans Museum of Art in association with University of Washington Press, Seattle, 2003.

Jérôme Napoléon, roi de Westphalie, exh. cat. Edited by Christophe Beyeler and Guillaume Nicoud. Paris: Réunion des musées nationaux / Musée national du château de Fontainebleau, 2008.

Joséphine, exh. cat. Edited by Amaury Lefébure. Paris: Réunion des musées nationaux-Grand Palais / Musée national des châteaux de Malmaison et Bois-Préau, 2014.

König Lustig!? Jérôme Bonaparte und der Modellstaat Königreich Westphalen, exh. cat. Edited by Michael Eissenhauer. Kassel: Museumslandschaft Hessen Kassel / Munich: Hirmer Verlag, 2008.

L'aigle et le papillon. Symboles des pouvoirs sous Napoléon, 1800-1815, exh. cat. Edited by Odile Nouvel-Kammerer. Paris: Les Arts Décoratifs in association with The American Federation of Arts and Abrams, New York, 2007.

La cave de Joséphine. Le vin sous l'Empire à Malmaison. Edited by Élisabeth Caude and Alain Pougetoux. Paris: Réunion des musées nationaux, 2009.

L'art du costume à la Comédie Française, exh. cat. Edited by Renato Bianchi and Agathe Sanjuan. Moulins: Centre national du costume de scène / Saint-Pourçain-sur-Sioule: Bleu autour, 2011.

LAVEISSIÈRE, Sylvain. *Prud'hon ou le rêve du bonheur.* Paris: Réunion des musées nationaux, 1997.

Le bivouac de Napoléon. Luxe impérial en campagne, exh. cat. Edited by Jehanne Lazaj. Milan: Silvana Editoriale, 2014.

Le cardinal Fesch et l'art de son temps. Edited by Philippe Costamagna. Paris: Gallimard, 2007.

Le Faubourg Saint-Germain. La rue de Varenne, exh. cat. Edited by Françoise Magny. Paris: Musée Rodin, 1981.

Le Pape et l'Empereur. La réception de Pie VII par Napoléon à Fontainebleau, 25-28 novembre 1804, exh. cat. Edited by Christophe Beyeler.

Paris: Somogy / Musée national du château de Fontainebleau, 2005.

Le Sacre de Napoléon peint par David, exh. cat. Edited by Sylvain Laveissière. Paris: Musée du Louvre / Milan: 5 Continents, 2004.

Louis XV à Fontainebleau. La "demeure des rois" au siècle des Lumières. Edited by Vincent Droguet. Paris: Réunion des musées nationaux / musée national du château de Fontainebleau, 2016.

Lusso ed Eleganza. La porcellana francese a Palazzo Pitti e la manifattura Ginori (1800-1830), exh. cat. Edited by Andreina d'Aggliano. Florence: Giunti / Livorno, Italy: Sillabe, 2013.

Modes et révolutions, 1780-1804, exh. cat. Paris: Paris Musées, 1989.

Napoléon Iᵉʳ et la Manufacture de Sèvres. L'art de la porcelaine au service de l'Empire, exh. cat. Edited by Camille Leprince. Paris: Feu et talent, 2016.

Napoléon à Sainte-Hélène. La conquête de la mémoire, exh. cat. Edited by Émilie Robbe. Paris: Gallimard / Musée de l'Armée, 2016.

Napoléon et Paris : rêves d'une capitale, exh. cat. Edited by Thierry Sarmant, Florian Meunier, Charlotte Duvette and Philippe de Carbonnières. Paris: Musée Carnavalet / Paris Musées, 2015.

Napoleon und Europa: Traum und Trauma, exh. cat. Edited by Bénédicte Savoy. Munich: Prestel, 2010.

Notice historique sur le palais des Tuileries et description des plafonds, voussures, lambris, etc., qui décorent les salles occupées par l'exposition. Paris: Vinchon, 1849.

PAPPE, Bernd. *Jean-Baptiste Jacques Augustin, peintre en miniature*. Saint-Dié-des-Vosges: musée Pierre-Noël, 2010.

Peupler les cieux. Les plafonds parisiens au XVIIᵉ siècle, exh. cat. Edited by Bénédicte Gady. Paris: Musée du Louvre, 2014.

Pie VII face à Napoléon. La tiare dans les serres de l'Aigle : Rome, Paris, Fontainebleau, 1796-1814, exh. cat. Edited by Christophe Beyeler. Paris: Réunion des musées nationaux-Grand Palais / Musée national du château de Fontainebleau, 2015.

PINCEMAILLE, Christophe, Isabelle Tamisier-Vétois, et al. *Cap sur l'Amérique. La dernière utopie de Napoléon*, exh. cat. Paris: Artlys / Musée national des châteaux de Malmaison et Bois Préau, 2015.

POTTIER, Jacqueline, Maurice Catinat, Dorothea Baumann, et al. *La reine Hortense. Une femme artiste*, exh. cat. Paris: Réunion des musées nationaux / Musée national des châteaux de Malmaison et Bois-Préau, 1993.

Pour l'honneur et pour la gloire, Napoléon et les joyaux de l'Empire, exh. cat. Edited by Lesja Vandensande. Brussels: Fonds Mercator / Antwerp: Musée du diamant de la province d'Anvers, 2010.

PRÉAUD, Tamara et al. *The Sèvres Porcelain Manufactory: Alexandre Brongniart and the Triumph of Art and Industry, 1800-1847*, exh. cat. New Haven and London: Yale University Press for The Bard Graduate Center for Studies in the Decorative Arts, New York, 1997.

SALMON, Xavier. *Peintre des rois, roi des peintres, François Gérard (1770-1837) portraitiste*, exh. cat. Paris: Réunion des musées nationaux-Grand Palais / Château de Fontainebleau, 2014.

SCHNAPPER, Antoine. *Mignard d'Avignon (1606-1668)*. Avignon: Palais des Papes, 1979.

SCHNAPPER, Antoine and Arlette Sérullaz. *Jacques-Louis David, 1748-1825*, exh. cat. Paris: Réunion des musées nationaux, 1989.

SCOTTEZ-DE WAMBRECHIES, Annie and Sylvain Laveissière. *Boilly (1761-1845). Un grand peintre français de la Révolution à la Restauration*, exh. cat. Lille: Musée des beaux-arts, 1988.

Sièges en société. Histoire du siège du Roi-Soleil à Marianne, exh. cat. Edited by Jean-Jacques Gautier. Montreuil: Gourcuff Gradenigo, 2017.

Soies tissées, soies brodées chez l'impératrice Joséphine, exh. cat. Edited by Claudette Joannis and Philippe Verzier. Paris: Réunion des musées nationaux, 2002.

The Age of Napoleon: Costume from Revolution to Empire, 1789-1815, exh. cat. Edited by Katell Le Bourhis. New York: The Metropolitan Museum of Art / Harry N. Abrams, 1989.

Trésors de la Fondation Napoléon. Dans l'intimité de la Cour impériale, exh. cat. Edited by Bernard Chevallier and Karine Huguenaud. Paris: Nouveau Monde, 2004.

Un âge d'or des arts décoratifs, 1814-1848, exh. cat. Paris: Réunion des musées nationaux, 1991.

Versailles et les tables royales en Europe, XVIIᵉ-XIXᵉ siècles, exh. cat. Paris: Réunion des musées nationaux, 1993.

BOOKS AND ARTICLES

ALCOUFFE, Daniel, Anne Dion-Tenebaum and Amaury Lefébure. *Le mobilier du musée du Louvre*. Dijon: Faton, 1993.

ARIZZOLI-CLÉMENTEL, Pierre. "Retour aux sources : Belloni et la mosaïque de Melpomène au Louvre." *Gazette des Beaux-Arts*, vol. 122, no. 1497 (October 1993), pp. 149-160.

ARIZZOLI-CLÉMENTEL, Pierre and Chantal Gastinel-Coural, eds. "Il progetto d'arredo del Quirinale nell'età napoleonica." *Bollettino d'Arte, supplemento al no. 70*. Rome: Istituto Poligrafico e Zecca dello Stato, 1995.

ARIZZOLI-CLÉMENTEL, Pierre and Jean-Pierre Samoyault. *Le mobilier de Versailles. Chefs-d'œuvre du XIXᵉ siècle*. Dijon: Faton, 2009.

AUCLAIR, Mathias. "L'atelier des décors de l'Opéra (1803-1822)." *Revue de la Bibliothèque nationale de France*, no. 37 (2011), pp. 5-11.

BABELON, Jean, Yves Bottineau and Olivier Lefuel. *Les grands orfèvres de Louis XIII à Charles X*. Paris: Hachette, 1965.

BADIN, Jules. *La manufacture de tapisseries de Beauvais depuis ses origines jusqu'à nos jours*. Paris: Société de Propagation du Livre d'art, 1909.

BAPST, Germaine. *Essai sur l'histoire du théâtre : la mise en scène, le décor, le costume, l'architecture, l'éclairage, l'hygiène*. Paris: Hachette, 1893.

BARBIER, Muriel. "De marbre et de bronze : un ensemble d'éléments de cheminées conçues sous le Premier Empire au château de Fontainebleau." *Bulletin de la Société de l'Histoire de l'Art français* (2009), pp. 257-277.

BARBILLON, Claire, Philippe Durey and Uwe Fleckner, eds. *Ingres, un homme à part ? Entre carrière et mythe, la fabrique du personnage*, colloquium proceedings (Paris-Rome, May 2006). Paris: École du Louvre / La Documentation française, 2009.

BARREAU, Joëlle, Anne de Chefdebien, Jacques Foucart and Jean-Pierre Samoyault. *L'Hôtel de Salm : Palais de la Légion d'honneur*. Paris: Monelle Hayot, 2009.

BASILY-CALLIMAKI, Eva. *J.-B. Isabey, sa vie, son temps, 1767-1855, suivi du catalogue de l'œuvre gravée par et d'après Isabey*. Paris: Frazier-Soye, 1909.

BAUDUS, Florence de. *Caroline Bonaparte, sœur d'empereur, reine de Naples*. Paris: Perrin, 2015.

BAULEZ, Christian, "La toilette de l'impératrice Marie-Louise, le berceau du roi de Rome et Henri Victor Roguier." *Antologia di belle arti*, vol. 1, no. 2 (June 1977), pp. 194-200.

BAULEZ, Christian. *Versailles, deux siècles d'histoire de l'art*. Versailles: Société des amis de Versailles, 2007.

BELLAIGUE, Geoffrey de. *French Porcelain in the Collection of Her Majesty the Queen*. London: Royal Collection Publications, 2009, 3 vols.

BENEDETTUCCI, Fabio, ed. *Le ore dell'imperatore. La Pendola Urania del Museo Napoleonico. Studi, incontri e restauro*. Rome: Gangemi, 2015.

BERG, Maxine and Helen Clifford, ed. *Consumers and Luxury: Consumer Culture in Europe, 1650-1850*. Manchester and New York: Manchester University Press, 1999.

BERGVELT, Ellinoor, Debora J. Meijers, Lieske Tibbe and Eva van Wezel, eds. *Napoleon's Legacy: The Rise of National Museums in Europe, 1794-1830*. Berlin: G&H Verlag, 2009.

BEYELER, Christophe. *Napoléon. L'art en majesté. Les collections du musée Napoléon Iᵉʳ au château de Fontainebleau*. Paris: Jean-Pierre de Monza, 2017.

BONNARD, Daisy, François Jarrique, Lillian Pérez, et al. *Lyon innove. Inventions et brevets dans la soierie Lyonnaise aux XVIIIᵉ et XIXᵉ siècles*. Lyon: EMCC (European Mentoring & Coaching Council), 2009.

BORDES, Philippe. *Le Serment du Jeu de Paume de Jacques-Louis David : le peintre, son milieu et son temps, de 1789 à 1792*. Paris: Réunion des musées nationaux, 1983.

BOUDON, Jacques-Olivier. *Le roi Jérôme : frère prodigue de Napoléon*. Paris: Fayard, 2008.

BOUDON, Jacques-Olivier, ed. *La Cour impériale sous le Premier et le Second Empire*. Paris: Éditions SPM, 2016.

BOUZARD, Marie. *La soierie Lyonnaise du XVIIIᵉ au XXᵉ siècle dans les collections du musée des tissus de Lyon*. Lyon: Éditions lyonnaises d'art et d'histoire, 1997.

BOYER, Ferdinand. "Stendhal inspecteur du mobilier de la Couronne (1810-1814)." *Le Divan* (April 1942), pp. 150-163.

BOYER, Ferdinand. "L'installation du premier consul aux Tuileries et la disgrâce de l'architecte Leconte (1800-1801)." *Bulletin de la société de l'Histoire de l'Art français* (1941-1944 [1947]), pp. 142-184.

BOYER, Ferdinand. "Le sort sous la Restauration des tableaux à sujets napoléoniens." *Bulletin de la Société de l'Histoire de l'Art français* (1966 [1967]), pp. 271-281.

BOYER, Jean-Claude. "Le plafond de la chambre du Roi aux Tuileries, une redécouverte majeure." *L'Estampille / L'Objet-d'art* (March 2016), pp. 36-43.

BRANDA, Pierre. *Napoléon et ses hommes. La Maison de l'empereur, 1804-1815*. Paris: Fayard, 2011.

BRANDA, Pierre. *La guerre secrète de Napoléon : île d'Elbe, 1814-1815*. Paris: Perrin, 2014.

BRESC-BAUTIER, Geneviève, Yves Carlier, Bernard Chevallier, et al. *Les Tuileries. Grands décors d'un palais disparu*. Paris: Éditions du patrimoine, Centre des monuments nationaux, 2016.

BROADLEY, Alexander Meyrick. "The Knowledge of the Dead Napoleon." *Knowledge: A Monthly Record of Science*, vol. 35, 1912, pp. 97-100.

BRULON, Dorothée Guillermé. *Le service de la princesse des Asturies ou l'histoire d'un cadeau royal pour la cour de Madrid*. Paris: Massin, 2003.

BYRNES, James B. "A portrait by Baron Gros." *Los Angeles County Museum of the Art Bulletin*, vol. 4, no 1, 1951, pp. 12-14.

CANTAREL-BRESSON, Yveline, Claire Constans and Bruno Foucart. *Napoléon : images et histoire : peintures du Château de Versailles (1789-1815)*. Paris: Réunion des musées nationaux, 2001.

CARLIER, Yves. "Aspects inédits de la carrière de l'orfèvre Henry Auguste (1759-1816)." *Bulletin de la Société de l'Histoire de l'Art français* (2001), pp. 195-219.

CARLIER, Yves and Nicolas Personne. *La Galerie des meubles du château de Fontainebleau*. Paris: Somogy, 2009.

CHAILLOU, David. *La politique sur le scène: histoire des œuvres créées à l'Académie impériale de musique de 1810 à 1815*. Ph.D. dissertation, Université Paris-Sorbonne, 2001.

CHAILLOU, David. *Napoléon et l'Opéra. La politique sur la scène*. Paris: Fayard, 2004.

CHARTIER, Roger. *Les origines culturelles de la Révolution française*. Paris: Seuil, 2000.

CHEVALLIER, Bernard. *Malmaison, château et domaine des origines à 1904*. Paris: Réunion des musées nationaux, 1989.

CHEVALLIER, Bernard. *Musée national du château de Fontainebleau. Catalogue des collections de mobilier. t. II, Les Sèvres de Fontainebleau : porcelaines, terres vernissées, émaux, vitraux (pièces entrées de 1804 à 1904)*. Paris: Réunion des musées nationaux, 1996.

CHEVALLIER, Bernard. *Napoléon, les lieux du pouvoir*. Paris: Artlys, 2004.

CHEVALLIER, Bernard. *Objets d'Art. Mélanges en l'honneur de Daniel Alcouffe*. Dijon: Faton, 2004, pp. 298-307.

CHEVALLIER, Bernard, Michel Dancoisne-Martineau and Thierry Lentz, eds. *Sainte-Hélène, île de mémoire*. Paris: Fayard, 2005.

COMPIN, Isabelle and Anne Roquebert, eds. *Catalogue sommaire illustré des peintures du Musée du Louvre et Musée d'Orsay, "École française."* Paris: Réunion des musées nationaux, 1986, 3 vols.

CORDIER, Sylvain. "Pierre-Gaston Brion, menuisier et sculpteur sur bois." *L'Estampille-L'Objet d'art*, no. 403 (June 2005), pp. 40-51.

CORDIER, Sylvain. "Deux projets pour le fauteuil du trône de Louis XVIII par Dugourc et Saint-Ange." *Revue de l'Art*, no. 160 (2008), pp. 69-72.

CORDIER, Sylvain. *Bellangé ébéniste. Une histoire du goût au XIXᵉ siècle*. Paris: Mare & Martin, 2012.

CORDIER, Sylvain. "Une collection à la une. La galerie Napoléon du musée des beaux-arts de Montréal." *Dossier de l'Art*, no. 216 (March 2014), pp. 92-95.

COURAL, Jean, in coll. with Chantal Gastinel-Coural and Muriel Müntz de Raïssac. *Paris, Mobilier national. Soieries Empire*. Paris: Réunion des musées nationaux, 1980.

COURAL, Jean and Chantal Gastinel-Coural. "L'Élysée. Histoire et décors depuis 1720." *Dossier de l'Art*, no. 23 (April-May 1995)

CROW, Thomas. *Emulation: Making Artists for Revolutionary France*. New Haven and London: Yale University Press, 1995.

DAMAS-HINARD, Jean-Joseph-Stanislas-Albert. *Napoléon : ses opinions et jugements sur les hommes et sur les choses*. Paris: Dufey, 1838, 2 vols.

DAMISCH, Hubert. *L'origine de la perspective*. Paris: Flammarion, 1987.

DANCOISNE-MARTINEAU, Michel. *Chroniques de Sainte-Hélène : Atlantique sud*. Paris: Perrin, 2011.

DANIELS, Barry. *Le décor de théâtre à l'époque romantique. Catalogue raisonné des décors de la Comédie Française, 1799-1848*. Paris: Bibliothèque nationale de France, 2003.

DARCEL, Alfred and Jules Guiffrey. *Histoire et description de la manufacture nationale des Gobelins*. Paris: Plon, Nourrit et Cie., 1902.

D'ARJUZON, Caroline. *Madame Louis Bonaparte*. Paris: Calmann Lévy, 1901.

DAWSON, Aileen. "Two Napoleonic Sèvres Ice-Pails: A Present for an Emperor. A New Acquisition for the British Museum." *Apollo* (October 1986), pp. 328-333.

DELPIERRE, Madeleine. "Les costumes de cour et les uniformes civils du Premier Empire." *Bulletin du musée Carnavalet* (November 1958), pp. 2-23.

DION-TENENBAUM, Anne and Tamara Préaud. *Le service "Encyclopédique" de la manufacture de Sèvres*. Paris: Musée du Louvre / Somogy, 2010.

DION-TENENBAUM, Anne. *Orfèvrerie française du XIXᵉ siècle. La collection du musée du Louvre*. Paris: Musée du Louvre / Somogy, 2011.

D'HUART, Suzanne. "Trois lettres inédites sur Malmaison." *Bulletin de la Société des Amis de Malmaison*, 1979, pp. 24-26.

DUCHEMIN, Ambroise. "Fortuné Dufau, Portrait d'enfant, vers 1800." Ambroise Duchemin, galerie en ligne: http://www.ambroiseduchemin.com/ fortune-dufau-1770-1821.

ERMISSE, Gérard and Florence Robert, eds. "Colloque Marescot." *Bulletin de la Société archéologique, scientifique et littéraire du Vendômois*. Vendôme, 2016, pp. 157-240.

ERMISSE, Gérard and Florence Robert. "La vie et la carrière d'Armand-Samuel de Marescot, Premier inspecteur général du Génie de Napoléon Bonaparte." *Bulletin de la Société archéologique, scientifique et littéraire du Vendômois*, 2016, pp. 164-184.

FAVREAU, Marc, Guillaume Glorieux, Jean-Philippe Luis and Pauline Prévost-Marcilhacy, eds. *De l'usage de l'art en politique*. Clermont-Ferrand: Presses universitaires Blaise Pascal, 2009.

FEHRENBACH, Jérôme. *Le général Legrand, d'Austerlitz à la Bérézina*. Saint-Cloud: Soteca, 2012.

FENAILLE, Maurice. *État général des tapisseries de la manufacture des Gobelins, depuis son origine jusqu'à nos jours, 1600-1900*, t. V (Compiled by Fernand Calmettes) : *Période du dix-neuvième siècle, 1794-1900*, Paris: Imprimerie nationale, 1912.

Florence et la France. Rapports sous la Révolution et l'Empire, colloquium proceedings (Florence, 2 to 4 June 1977 / organized by Institut français de Florence in collaboration with Université de Florence, Surintendance aux biens artistiques et historiques de Florence et Pistoia and the Musée du Louvre). Florence: Centro Di / Paris: Quatre chemins-Éditart, 1979, pp. 251-271.

FONKENELL, Guillaume. *Le Palais des Tuileries*. Arles: Éditions Honoré Clair / Paris: Cité de l'architecture et du patrimoine, Musée des Monuments français, 2010.

FOUCART, Bruno. "L'artiste dans la société de l'Empire : sa participation aux honneurs et dignités." *Revue d'histoire moderne et contemporaine*, vol. XVII (July-September 1970), pp. 709-719.

FOUCART, Jacques. *Catalogue des peintures flamandes et hollandaises du musée du Louvre*. Paris: Gallimard, 2009.

GALARNEAU, Claude. "La légende napoléonienne au Québec." *Imaginaire social et représentations collectives. Mélanges offerts à Jean-Charles Falardeau*. Québec: Les Presses de l'Université Laval, 1982, pp. 163-174.

GALLO, Daniela. "La leçon de l'antique." *L'Année Stendhalienne*, vol. 6 (2007), pp. 9-24.

GALLO, Daniela, ed. *Stendhal, historien de l'art*, colloquium proceedings (Grenoble, Laboratoire de recherche historique en Rhône-Alpes and Musée de Grenoble). Rennes: Presses universitaires de Rennes, 2012.

GARNIER, Athanase. *Mémoires sur Louis Napoléon et sur la Hollande*. Paris: Ladvocat, 1828.

GARRIC, Jean-Philippe, Percier et Fontaine. Les architectes de Napoléon. Paris: Belin, 2012.

GASTINEL-COURAL, Chantal. *La manufacture nationale des Gobelins. État de la fabrication de 1900 à 1990*. Paris: Ministère de la culture, 1990.

GASTINEL-COURAL, Chantal. *La manufacture des Gobelins au XIXᵉ siècle*. Paris: Administration générale du Mobilier national, 1996.

GASTINEL-COURAL, Chantal. "A propos des présents de Napoléon au Pape. Deux tapis de la Savonnerie." *L'Estampille-L'Objet d'art*, no. 407 (November 2005), pp. 48-59.

GERSPACH, Édouard. *Documents sur les anciennes faïenceries françaises et la manufacture de Sèvres*. Paris: H. Laurens, 1891.

GERSPACH, Édouard. "Le meuble en tapisserie de Napoléon Ier." *Gazette des Beaux-Arts*, vol. VI, 1 July 1891, pp. 154-160.

GIRARD, Caroline. "Charles-Axel Guillaumot (1730-1807), architecte et administrateur de la manufacture des Gobelins." *Livraisons d'histoire de l'architecture*, vol. 8, no. 1 (2004) pp. 97-106.

GONZÁLEZ-PALACIOS, Alvar. *Il gusto dei principi: arte di corte del XVII e del XVIII secolo*. Milan: Longanesi, 1987-1989, 2 vols.

GRANDJEAN, Serge. *L'Orfèvrerie du XIXe siècle en Europe*. Paris: Presses universitaires de France, 1962.

GRANDJEAN, Serge. "Autour d'un nécessaire donné par Napoléon Ier à Alexandre Ier de Russie." *Archives de l'art français. Les arts à l'époque napoléonienne*, new period, t. XXIV, 1969, pp. 57-63.

GRUBER, Alain-Charles. "La scénographie française à la fin du XVIIIe siècle et l'influence de l'Italie." *Bollettino del Centro internazionale di studi di architettura A. Palladio*, no. 17 (1975), pp. 56-70.

GUIFFREY, Jules. *Les Gobelins et Beauvais. Les manufactures nationales de tapisseries*. Paris: H. Laurens, 1908.

HAZAREESINGH, Sudhir. *La légende de Napoléon*. Paris: Tallandier, 2005.

HEITZMANN, Annick. "Hameau de Trianon : une salle de bal dans la grange." *Versalia*, no. 6 (2003), pp. 36-44.

HUGUENAUD, Karine. "L'épée consulaire dite 'épée du sacre.' " *Ordres et distinctions. Bulletin de la Société des Amis du Musée national de la Légion d'Honneur et des Ordres de chevalerie*, no. 17 (2014), pp. 5-14.

JOANNIS, Claudette. *Joséphine, impératrice de la mode, l'élégance sous l'Empire*. Paris: Réunion des musées nationaux, 2007.

JOHNSON, Dorothy. *Jacques-Louis David: The Farewell of Telemachus and Eucharis*. Los Angeles: Getty Museum Studies on Art, 1997.

JOIN-DIÉTERLE, Catherine. "Ciceri et la décoration théâtrale à l'Opéra de Paris pendant la première moitié du XIXe siècle." *Victor Louis et le théâtre : scénographie, mise en scène et architecture théâtrale aux XVIIIe et XIXe siècles*, colloquium proceedings (Bordeaux, 8-10 May, organized by Centre de recherches sur le classicisme et le néo-classicisme and Centre d'études et de recherches théâtrales de l'Université de Gascogne). Paris: Édition du centre national de la recherche scientifique, 1982, pp. 141-151.

JOIN-DIÉTERLE, Catherine. *Les décors de scène de l'Opéra de Paris à l'époque romantique*. Paris: Picard, 1988.

JOUBERT, Léo. "Notice sur le Baron Martial Daru." *Nouvelle Biographie Universelle*. Paris: Firmin-Didot frères, 1855.

JOYAL, Serge. *Le mythe de Napoléon au Canada français*. Montreal: Del Busso, 2013.

KAIRIS, Pierre-Yves. *Bertholet Flémal (1614-1675). Le "Raphaël des Pays-Bas" au Carrefour de Liège et de Paris*. Paris: Arthena, 2015.

"La famille Martel de Magesse." *Le Bulletin des Recherches historiques*, vol. XL, no. 12 (December 1934), pp. 713-720.

LANZAC DE LABORIE, Léon de. *Paris sous Napoléon*. Paris: Plon-Nourrit et Cie, 1913, 8 vols.

LAVALLÉE, Joseph. "Exposition des esquisses du 15 frimaire an XI." *Journal des arts, des sciences et de la littérature* (Collection Deloynes), no. 1795 (1802), pp. 635-654.

LAVALLEY, Gaston. *Le peintre Robert Lefèvre : sa vie, son œuvre*. Caen: L. Jouan, 1902.

LAVEISSIÈRE, Sylvain, ed. *Napoléon et le Louvre*. Paris: musée du Louvre / Fayard, 2004.

LÉCOSSE, Cyril and Guillaume Poisson, eds. *Art et libéralisme en France. La contestation par l'image (1814-1830)*. Lausanne: Institut Benjamin Constant / Geneva: Slatkine, 2016.

LEDOUX-LEBARD, Christian. "La décoration et l'ameublement du grand cabinet de Napoléon Ier aux Tuileries." *Bulletin de la Société de l'Histoire de l'Art français* (1941 [1944]), pp. 185-258.

LEDOUX-LEBARD, Christian and Guy. "L'inventaire des appartements de l'empereur Napoléon Ier aux Tuileries." *Bulletin de la Société de l'Histoire de l'Art français* (1952 [1953]), pp. 186-204.

LEDOUX-LEBARD, Denise. *Le Grand Trianon. Meubles et objets d'art*. Paris: F. De Nobele / Éditions des musées nationaux, 1975.

LEDOUX-LEBARD, Denise. *Versailles. Le Petit Trianon. Le mobilier des inventaires de 1807, 1810 et 1839*. Éditions de l'amateur, 1989.

LEDOUX-LEBARD, Denise. *Le mobilier français du XIXe siècle : dictionnaire des ébénistes et des menuisiers*. Paris: Éditions de l'amateur, 2000.

LEFUEL, Hector. *François-Honoré-Georges Jacob-Desmalter, ébéniste de Napoléon Ier et de Louis XVIII*. Paris: A. Morencé, 1925.

LELIÈVRE, Pierre. *Vivant Denon, homme des Lumières, "ministre des arts" de Napoléon*. Paris: Picard, 2003.

LENIAUD, Jean-Michel. *Saint-Denis de 1760 à nos jours*. Paris: Gallimard-Julliard, 1996.

LENTZ, Thierry. *Nouvelle histoire du Premier Empire*. Paris: Fayard, 2002-2010, 4 vols.

LENTZ, Thierry and Jacques Macé. *La mort de Napoléon : mythes, légendes et mystères*. Paris: Perrin, 2009.

LENTZ, Thierry, Peter Hicks, Francois Houdececk and Chantal Prévot, eds. *Le mémorial de Sainte-Hélène. Le manuscrit retrouvé d'Emmanuel de Las Cases*. Paris: Perrin, 2017.

MACÉ, Jacques. *Dictionnaire historique de Sainte-Hélène*. Paris: Tallandier, 2004.

MACKRELL, Alison. *Art and Fashion: The Impact of Art on Fashion and Fashion on Art*. London: BT Batsford, 2005.

MANKE, Matthias and Ernst Münch, eds. *Unter Napoleons Adler. Mecklenburg in der Franzosenzeit*. Lübeck, Germany: Schmidt-Römhild, 2009.

MANSEL, Philip. "Monarchy, Uniform and the Rise of the Frac." *Past and Present*, vol. 96, no. 1 (1982), pp. 103-132.

MANSEL, Philip. *Dressed to Rule: Royal and Court Costume from Louis XIV to Elizabeth II*. New Haven and London: Yale University Press, 2005.

MARAL, Alexandre. *Le roi, la cour et Versailles. Le coup d'éclat permanent 1682-1789*. Paris: Perrin, 2013.

MARTINEAU, Gilbert. *La vie quotidienne à Sainte-Hélène au temps de Napoléon*. Paris: Tallandier, 2005.

MARTINEZ, Jean-Luc, ed. *Les Antiques du musée Napoléon. Édition illustrée et commentée des volumes V et VI de l'inventaire du Louvre de 1810*. Paris: Réunion des musées nationaux, 2004.

MAZE-SENCIER, Alphonse. *Les fournisseurs de Napoléon Ier et des deux impératrices d'après des documents inédits*. Paris: Henri Laurens, 1893.

MEYER, Daniel. "Les tableaux de Saint-Cloud sous Napoléon Ier." *Nouvelles Archives de l'Art français*, vol. XXIV (1969), pp. 241-271.

MICHEL, Régis, ed. *David contre David*, colloquium proceedings (Paris, Musée du Louvre, 1989). Paris: La Documentation française, 1993, 2 vols.

MIEL, François-Marie. *Histoire du sacre de Charles X, dans ses rapports avec les Beaux-Arts*. Paris: C.L.F. Panckoucke, 1825.

MILLARD, Charles. "Baron Gros' 'Portrait of Lieutenant Legrand.'" *Los Angeles County Museum of Art Bulletin*, vol. 10, no. 2 (1974), pp. 36-45.

MIRIMONDE, Albert Pomme de. "Les dépenses d'art des impératrices Joséphine et Marie-Louise." *Gazette des Beaux-Arts*, vol. 50, July-August 1957, pp. 89-107 and September 1957, pp. 137-154.

MONTES DE OCA, Fernando. *L'Âge d'or du verre en France, 1800-1830. Verreries de l'Empire et de la Restauration*. Paris: Éditions F.M., 2001.

MOULIN, Jean-Marie. *Guide du musée national du château de Compiègne*. Paris: Réunion des musées nationaux, 1992.

NATOLI, Marina and Maria Antonietta Scarpati, eds. *Il Palazzo del Quirinale. Il mondo artistico a Roma nel periodo napoleonico*. Rome: Istituto Poligrafico e Zecca dello Stato, 1989, 2 vols.

NEWTON, William Ritchey. *La petite cour. Services et serviteurs à la cour de Versailles au XVIIIe siècle*. Paris: Fayard, 2006.

NORDMAN, Daniel, ed. *L'École normale de l'an III*, vol. 2 : *Leçons d'histoire, de géographie, d'économie politique : Volney. Buache de La Neuville, Mentelle, Vandermonde*. Paris: Dunod / Éditions Rue d'Ulm, 1994.

O'BRIEN, David. *Antoine-Jean Gros : peintre de Napoléon*. Paris: Gallimard, 2006.

O'MEARA, Barry. *Napoleon in Exile; or, a Voice from Saint Helena*. London: W. Simpkin and R. Marshall, 1822.

OTTOMEYER, Hans and Lorenz Seelig. " *Das Silber- und Vermeil-Service König Jérômes von Westfalen in der Münchner Residenz.*" *Münchner Jahrbuch der Bildenden Kunst*, t. XXXIV, Munich, Prestel, 1983, pp. 117-164.

PAGÉ, Sylvain. *Le mythe napoléonien. De Las Cases à Victor Hugo*. Paris: CNRS Éditions, 2013.

PLANCHON, Jean-Pierre. *Pierre-Benoît Marcion (1769-1840), ébéniste de Napoléon*. Saint-Rémy-en-l'Eau: Monelle Hayot, 2007.

PLANCHON, Jean-Pierre, Carole Damour and Dominique Fabre. *Tassinari et Chatel, la soie au fil du temps*. Saint-Rémy-en-l'Eau: Monelle Hayot, 2011.

PORTERFIELD, Todd and Susan L. Siegfried. *Staging Empire: Napoleon, Ingres, and David*. University Park: Pennsylvania University Press, 2006.

POUGIN, Arthur. *Dictionnaire historique et pittoresque du théâtre et des arts qui s'y rattachent*. Paris: Firmin-Didot, 1885.

PRESSOUYRE, Sylvia. "Sculptures du premier Empire au château de Fontainebleau." *Archives de l'art français*, new period, "Les arts à l'époque napoléonienne," vol. XXIV (1969), pp. 201-212.

REID, Martine and Elaine Williamson, eds. *Lire la correspondance de Stendhal*, colloquium proceedings (Paris, University of London Institute in Paris). Paris: Honoré Champion, 2007.

REY, Léon. *Le Petit Trianon et le hameau de Marie-Antoinette*. Paris: Vorms, 1936.

REYNOLDS, Graham. *Wallace Collection. Catalogue of Miniatures*. London: Trustees of the Wallace Collection, 1980.

RIBEIRO, Aileen. *The Art of Dress: Fashion in England and France 1750 to 1820*. New Haven and London: Yale University Press, 1995.

ROSIER, L. "Musée des Voitures historiques de Versailles." *L'Illustration*, t. XVIII, 1851, p. 313.

ROUSSEAU, James. "Les pages de l'empereur." *Journal des enfants rédigé par toutes les sommités littéraires*, vol. 1, 1832.

ROUSSEL, Jules. *Le Palais de Fontainebleau. Décorations intérieures et extérieures*. Paris, 1904, 8 vols.

SAINTE-BEUVE, Charles-Augustin. "Poètes et critiques littéraires de la France. - XXXI. M. de Fontanes, première partie." *Revue des deux Mondes*, Paris: 1838, t. XVI, p. 660.

SAINTE-FARE-GARNOT, Nicolas. *Le décor des Tuileries sous le règne de Louis XIV*. Paris: Réunion des musées nationaux, 1988.

SAMOYAULT, Jean-Pierre. "La salle du Conseil du château de Fontainebleau sous le Premier Empire." *La Revue du Louvre*, no. 4-5 (1974), pp. 292-300.

SAMOYAULT, Jean-Pierre. "Le château de Fontainebleau sous Napoléon Ier." *Médecine de France*, no. 250 (1974), pp. 25-40.

SAMOYAULT, Jean-Pierre. "L'ameublement des salles du Trône dans les palais impériaux sous Napoléon Ier." *Bulletin de la Société de l'Histoire de l'Art français* (1985), pp. 87-206.

SAMOYAULT, Jean-Pierre. *Musée national du château de Fontainebleau. Catalogue des collections de mobilier*. Vol. 1, *Pendules et bronzes d'ameublement entrés sous le Premier Empire*. Paris: Réunion des musées nationaux, 1989.

SAMOYAULT, Jean-Pierre. "Les 'assiettes de dessert' du Service particulier de l'Empereur en porcelaine de Sèvres." *Le Souvenir napoléonien*, no. 369 (February 1990), p. 8.

SAMOYAULT, Jean-Pierre. "Fontainebleau, Musée Napoléon Ier : dix ans d'acquisitions." *Revue du Louvre, la Revue des musées de France*, (April 1996), pp. 49-65.

SAMOYAULT, Jean-Pierre. "L'appartement de la générale Bonaparte, puis de l'impératrice Joséphine aux Tuileries (1800-1807)," *Bulletin de la Société de l'Histoire de l'Art français*, 1999, pp. 215-243.

SAMOYAULT, Jean-Pierre. *Musée national du château de Fontainebleau. Catalogue des collections de mobilier*. Vol. 3, *Meubles entrés sous le Premier Empire : meubles d'architecture, de rangement, de travail, d'agrément et de confort*. Paris: Réunion des musées nationaux, 2004.

SAMOYAULT, Jean-Pierre. *Mobilier français Consulat et Empire*. Paris: Gourcuff Gradenigo, 2009.

SAMOYAULT-VERLET, Colombe. "Les Appartements des souverains en France au XIXe siècle." Karl Ferdinand Werner, ed. *Hof, Kultur und Politik im 19. Jahrhundert*. Röhrscheid: Bonn, 1985, pp. 121-137.

SAMOYAULT-VERLET, Colombe and Jean-Pierre Samoyault. *Musée Napoléon 1er : Napoléon et la famille impériale, 1804-1815*. Paris: Réunion des musées nationaux, 1986.

SANCHEZ, Pierre and Xavier Seydoux. *Les catalogues des Salons des Beaux-Arts (1801-1819)*. Paris: L'Échelle de Jacob, 1999.

SAVOY, Bénédicte. *Patrimoine annexé. Les biens culturels saisis par La France en Allemagne autour de 1800*. Paris: Éditions de la Maison des sciences de l'homme, 2003, 2 vols.

SAVOY, Bénédicte. "'Invaluable Masterpieces': The Price of Art at the Musée Napoléon." *Journal for Art Market Studies*, vol. 1, no. 1 (2017): https://www.fokum-jams.org/index.php/jams/article/view/4.

SCHLENOFF, Nicolas. *Les sources littéraires de J.-A.-D. Ingres*. Paris: Presses Universitaires de France, 1956.

SÉGUY, Philippe. *Histoire des modes sous l'Empire*. Paris: Tallandier, 1988.

SIEGFRIED, Joan. "The Romantic Artist as a Portrait Painter." *Marsyas*, 1957-1959, pp. 30-42.

SIEGFRIED, Susan L. "Fashion and the Reinvention of Court Costume in Portrayals of Josephine de Beauharnais (1794-1809)." *Apparence(s). Se vêtir à la cour en Europe (1400-1815)*. Isabelle Paresys and Natacha Coquery, eds. 2015, online: https://apparences.revues.org/1295.

SOLNON, Jean-François. *La cour de France*. Paris: Perrin, 2014.

SPIEGEL, Régis. *Dominique-Vivant Denon et Benjamin Zix. Acteurs et témoins de l'épopée napoléonienne (1805-1812)*. Paris: L'Harmattan, 2000.

STRATMANN-DÖHLER, Rosemarie. "Zur Hochzeit von Stephanie de Beauharnais. Höfische Geschenke aus der kaiserlichen Porzellanmanufaktur Sèvres." *Weltkunst* (January 1995), pp. 16-20.

SURGERS, Anne. *Scénographie du théâtre occidental*. Paris: Armand Colin, 2007.

TAIGNY, Edmond. *J.-B. Isabey, sa vie et ses œuvres*. Paris: E. Panckoucke, 1859.

The Monthly Anthology and Boston Review, Containing Sketches and Reports of Philosophy, Religion, History, vol. 2, novembre 1805, p. 574.

TOTKA, Olga. *La création des formes des services de table à la Manufacture de Sèvres entre 1800 et 1847*. Master's dissertation, Université Paris-Sorbonne (Paris IV), 2010-2012, 2 vols.

TULARD, Jean. *Le mythe de Napoléon*. Paris: Armand Colin, 1971.

TULARD, Jean (presented by). *Napoléon, lettres d'amour à Joséphine*. Paris: Fayard, 1981.

TULARD, Jean, ed. *Dictionnaire Napoléon*. Paris: Fayard, 1987.

TULARD, Jean. *Napoléon au jour le jour*. Paris: Tallandier, 2002.

TULARD, Jean. *Napoléon*. Paris: Pluriel, 2011.

VERLET, Pierre. *Le Château de Versailles*. Paris: Fayard, 1985.

VERLET, Pierre. *Le mobilier royal français*. Paris: Picart, 1990-1994, 4 vols.

VIAL, Charles-Éloi. "Les écuries de Napoléon : une parenthèse dans l'histoire de l'équitation ou la chance d'un renouveau ?" *In Situ*, vol. 18, (2012), online: https://insitu.revues.org/9707.

VIAL, Charles-Éloi. "La reconstruction de la Maison de Joséphine (1810-1811)." *Bulletin de la Société des amis de Malmaison*, no. 49, 2015, pp. 70-88.

VIAL, Charles-Éloi. *L'adieu à l'Empereur : journal de voyage de Marie-Louise*. Paris: Vendémiaire, 2015.

VIAL, Charles-Éloi. *Le grand veneur de Napoléon Ier à Charles X*. Paris: École nationale des chartes, 2016.

VIAL, Charles-Éloi. *Les derniers feux de la monarchie: la cour au siècle des révolutions, 1789-1870*. Paris: Perrin, 2016.

VIAL, Charles-Éloi. *Marie-Louise*. Paris: Perrin, 2017.

VITTET, Jean. *Dans les rêves de Napoléon. La première chambre de l'Empereur à Fontainebleau*. Dijon: Faton, 2015.

WACKERNAGEL, Rudolf. *Der französische Krönungswagen von 1696-1825, ein Beitrag zur Geschichte des repräsentativen Zeremonienwagens*. Berlin: de Gruyter, 1966.

WARESQUIEL, Emmanuel de. *Talleyrand: le prince immobile*. Paris: Fayard, 2003.

WATSON, George Leo de St. M. *The Story of Napoleon's Death-Mask: Told from Original Documents*. London and New York: John Lane, 1915.

WILD, Nicole. *Décors et costumes du XIXe siècle*. Paris: Bibliothèque nationale de France, vol. 1, 1987; vol. 2, 1993.

WILLIAMSON, Elaine. "Stendhal inspecteur du mobilier de la Couronne : administrateur ou artiste? (Lettres et documents inédits)." *Stendhal Club*, no. 128 (15 July 1990), pp. 337-364; no. 129 (15 October 1990), pp. 49-71 and no. 130 (15 January 1991), pp. 115-133.

WILLIAMSON, Elaine. *Stendhal et la Hollande. Correspondance administrative inédite, 1810-1812*. London: Institute of Romance Studies, University of London School of Advanced Study, 1996.

ZIESENISS, Charles-Otto. "Le décor pictural de la galerie de Diane aux Tuileries sous le Premier Empire." *Bulletin de la Société de l'Histoire de l'Art français* (1966 [1967]), pp. 199-235.

ZIESENISS, Charles-Otto. "Les portraits des ministres et des Grands officiers de la couronne." *Archives de l'art français*, vol. 24 (1969), pp. 133-158.

ASIE

INDEX

PHOTOGRAPHIC CREDITS
AND COPYRIGHT